German Art
in the 20th Century

Painting and Sculpture
1905 - 1985

German Art in the 20th Century

Painting and Sculpture
1905-1985

Edited by

Christos M. Joachimides
Norman Rosenthal
Wieland Schmied

With contributions by

Werner Becker · Hanne Bergius · Georg Bussmann
Matthias Eberle · Ivo Frenzel · Günther Gercken · Siegfried Gohr
Walter Grasskamp · Wulf Herzogenrath · Reinhold Hohl · Christos M. Joachimides
Jill Lloyd · Franz Meyer · Sarah O'Brien-Twohig · Harry Pross
Sixten Ringbom · Irit Rogoff · Norman Rosenthal
Wolfgang Rothe · Wieland Schmied · Uwe M. Schneede
Carla Schulz-Hoffmann · Peter-Klaus Schuster · Richard Verdi
Stephan von Wiese · Thomas Zaunschirm

Co-ordinating editor

Walter Grasskamp

Prestel-Verlag

First published on the occasion of the exhibition
'German Art in the 20th Century, Painting and Sculpture 1905 -1985'

Royal Academy of Arts, London, 11 October – 22 December, 1985
Staatsgalerie Stuttgart, 8 February – 27 April, 1986

Exhibition Organizers: Christos M. Joachimides
Norman Rosenthal
Wieland Schmied

Exhibition Assistants: Reinhard Rudolph, Tina Aujesky
Exhibition Designer: Ivor Heal
Poster Designer: Philip Miles

Typeset by Fertigsatz GmbH, Munich
Offset Lithography by Karl Dörfel, Munich
Printed by Karl Wenschow Franzis-Druck GmbH, Munich
Bound by R. Oldenbourg GmbH, Munich

Printed in Germany

Distribution of the hardcover edition in the U.S.A. by
te Neues Publishing Company, 15 East 76 Street, New York, N.Y. 10021

ISBN 3 7913 0743 6

Contents

Catalogue 151

Foreword

With this exhibition, *German Art in the 20th Century*, the Royal Academy launches a most ambitious enterprise, and one which we hope will, to a considerable extent, determine our image over the years to come. As we approach the end of the twentieth century, it seems to us highly desirable that we should begin to look back on the achievements in painting and sculpture that have taken place in the last eight or nine decades and try to make connections from the period at the beginning of our century to the present. At that time artists all over Europe, for instance Matisse and Picasso in France, Kirchner and Kandinsky in Germany, Boccioni and De Chirico in Italy, Wyndham Lewis and Bomberg in Great Britain, were setting entirely new ground rules for our perception of art, the lessons and consequences of which are still being worked out by artists today. It has been, and still is, an exciting adventure, in which the Royal Academy is proud to play a modest role. We hope with a series of exhibitions (a British and an Italian exhibition are already being planned) to make good our debt to the artists of this century and bring a wealth of information and pleasure to the British public.

German Art in the 20th Century is the first of these exhibitions and captures the tumultuous history of Germany in its painting and sculpture from the time of Kirchner and Kandinsky before the First World War, through the so-called 'golden twenties', followed by the terrible period of National Socialism when German artists, often in exile, produced many of their most powerful works, to the remarkable flowering of painting and sculpture in West Germany in recent years. Our own exhibition, *A New Spirit in Painting* in 1981, did much to reveal the complexity and vitality of new German painting and the controversial position it then took up has been to a very large extent vindicated by rapid developments in art meanwhile. Two of the organisers of that exhibition, who have been also largely responsible for selecting the works of art for this exhibition, Christos M. Joachimides, the Berlin exhibition organiser, and Norman Rosenthal, Exhibitions Secretary at the Royal Academy of Arts, have been joined by Prof. Dr. Wieland Schmied, well-known art historian and organiser of many exhibitions. It is he who has written the principle text of this lavishly illustrated and documented catalogue.

To them and to the many individuals who have contributed to the making of this exhibition, the Royal Academy owes a very special debt of gratitude. Lenders, museums and Private Collectors in Germany, in many other European countries and in the United States have once again been called upon by us to part with their masterpieces and we are most grateful to them. We would also like to thank the many contributers in Germany and in Great Britain who have helped in the realisation of the catalogue.

We are most honoured by the two patrons of the exhibition, The Chancellor of the Federal Republic of Germany, Dr. Helmut Kohl, and our own Prime Minister, The Rt. Hon. Mrs Margaret Thatcher. We must also pay our thanks to the many who have helped fund this exhibition, to the Government of the Federal Republic of Germany, to Lufthansa, the Deutsche Bank, Mercedes Benz, Beck's Bier, Bosch, Hoechst, Melitta and Siemens, who have so generously provided sponsorship.

After London, the exhibition will also be seen in West Germany in the internationally acclaimed New Wing of the Staatsgalerie in Stuttgart, designed by James Stirling. We owe a particular debt of gratitude to its director, Prof. Dr. Peter Beye, for making this spectacular new museum available. It is a great honour that the exhibition will not be shown just in London but also in Germany itself.

ROGER DE GREY

President, Royal Academy of Arts

Acknowledgments

Many individuals have contributed in various ways with advice and assistance in making this exhibition possible. In addition to the lenders, sponsors and Advisory Committee, the Royal Academy of Arts and the organizers of the exhibition would particularly like to thank the following individuals whose commitment to the project has been so invaluable. The Embassy of the German Federal Republic in London, in particular the Ambassador Baron Rüdiger von Wechmar and its two successive Cultural Attachés, Herr Reinhard Holubek and Dr. Georg von Neubrunner, have been a constant source of encouragement. Without the active support of Dr. Barthold C. Witte, Director of Cultural Affairs in the Ministry of Foreign Affairs of the German Federal Republic, together with Peter Mende and Paul von Maltzahn, this exhibition would not have taken place. The same goes for Herrn Manfred ten Brink of the Deutsche Bank, whose initial enthusiasm for the project was instrumental in persuading the other sponsors to join him in supporting this exhibition. Prof. Dr. Peter Beye, Director of the Staatsgalerie in Stuttgart where the exhibition will subsequently be seen, has been unfailing in his enthusiasm and encouragement as has Prof. Dr. Wolf-Dieter Dube, Director-General of the Staatliche Museen Preussischer Kulturbesitz. We are deeply thankful to the authors in the catalogue who support this exhibition with knowledge and scholarship. The catalogue would not have reached this standard without the committment of Prof. Dr. Walter Grasskamp who helped shape and realize the collection of essays and the documentary material. We would also like to thank the translators of the essays: Jonathan Bennington, Tristam Carrington-Windo, Gisela Kirberg, Dr. David McLintock, Helga Michie, Timothy Nevill, Stephen Reader, Elaine Robson-Scott. Without the dedication of the entire staff of Prestel Verlag in Munich, this catalogue could not have been produced in so short a time. And finally our deepest thanks to Reinhard Rudolph for his invaluable work in helping to realize this exhibition and the catalogue.

Further the Royal Academy of Arts and the organizers of the exhibition would also like to thank the following individuals: Dr. Jeremy Adler, Thomas Ammann, Anika Barbarigos, Stephanie Barron, Heiner Bastian, Peter Baum, Dr. Felix Baumann, Dr. Wolfgang Becker, Dr. W. A. L. Beeren, Ernst Beyeler, Dr. Christoph Brockhaus, Dr. Joachim Büchner, Prof. Dr. Klaus Buszmann, Krzysztof Z. Cieszkowski, Dr. Günther Coenen, Thomas Corinth, Lisa Dennison, Helen Dore, Dr. Sabine Fehlemann, Richard Feigen, Dr. Zdenek Felix, Dr. Wolfgang Fischer, Karl Flinker, Michael Foster, Dr. Rudi Fuchs, Prof. Dr. Günther Gercken, Dr. Gerhard Gerkens, Leonard Gianadda, Nehama Guralnik, Andreas Hahn, Prof. Wolfgang Hahn, Gregory Hedberg, Dr. Marianne Heinz, Dr. Wolfgang Henze, Prof. Dr. Werner Hofmann, Leonard Hutton-Hutschnecker, Prof. Dr. Gudrun Inboden, Knud W. Jensen, Prof. Dr. Rainer Jacobs, Piet de Jonge, Dr. Eugen Keuerleber, Felix Klee, Dr. Christian Klemm, Ute Klophaus, Werner Krisp, Dr. Anette Kruszynski, Michel Laclotte, Guido Lehmbruck, Dr. Barbara Lepper, Dr. Helmut Leppien, Gilbert Lloyd, Prof. Dr. Peter Ludwig, John Lumley, Dr. Karin von Maur, Colin MacIvor, Thomas M. Messer, Dr. Franz Meyer, Karl Heinrich Müller, Elisabeth Nay-Scheibler, Anthony d'Offay, Reinhard Onnasch, Dr. Rudi Oxenaar, Dr. Hans Albert Peters, Siegfried Poppe, Cora Rosevear, Prof. Dr. Eberhard Roters, William S. Rubin, Helga Rulf, Charles and Doris Saatchi, Prof. Serge Sabarsky, Marc Scheps, Dr. Carla Schulz-Hoffmann, Dr. Peter-Klaus Schuster, Hans Schwab-Felisch, Nicholas Serota, Michael E. Shapiro, Bente Skovgaard, Prof. Dr. Werner Spies, Dr. Karin Stempel, Dr. Hans Hermann Stober, Dr. Gerhard Storck, Dr. Kirby Tally, Davira S. Taragin, Dr. Hans Christoph von Tavel, Dr. Kristine Völker, Diane Waldman, Michael Werner, Heribert Wuttke, Dr. Herbert Zapp, Rudolf Zwirner.

Christos M. Joachimides

A Gash of Fire Across the World

In 1905 the first van Gogh exhibition was mounted in Germany. In the same year, inspired by visits to the Museum of Ethnology and following a trip to the Moritzburg lakes, a group of artists was founded calling itself 'Die Brücke'. Van Gogh's febrile pictures, pointing beyond painting and testifying to his search for a new spirituality in nature, and the longing for that simplicity of the primeval thought to reside in the primitive art of Africa and Oceania were important impulses for the new art emerging in Germany. Others were: Munch's figures probing the very depths of human existence; the darkly glowing, divine quality of El Greco's pictures, newly discovered at the end of the nineteenth century; and the inspiring reading of Nietzsche, who was understood as the apostle of a philosophy of direct experience. In their work German artists were more concerned with content than with form. In particular, the question of 'beauty' – which had occupied French artists since Ingres or at any rate Manet – was of minor importance to them. Instead, they were determined to penetrate behind the objects of the real world in their pictures in order to disclose an underlying significance which they felt to have been lost. Such voyages of discovery into the deepest areas of perception open to experience were undertaken with the maximum mental and spiritual effort, often producing extreme tension or ecstatic distortion in the works of art themselves. Judged according to the aesthetic canon which developed from Post Impressionism, art as an existential assertion of the self is *ugly* art. Whether manifested in the contorted figures of Kirchner or Nolde, the 'bleeding' landscapes of Schmidt-Rottluff and Heckel, the apocalyptic prophecies of Meidner, the enigmatic pictures of suffering by the young Beckmann, the grimacing, mask-like faces of society as depicted by Grosz and Dix, or in the chaos symbolized by Beuys's *Chair of Fat*, or the scream of a Baselitz figure, self-assertion allowed the ugly to become a category of hubris, a criminal act of overstepping aesthetic laws and a decisive, desperate attempt to abolish the distinction between art and life. This attitude of opposition through transgression and this highly overwrought state constitute one of German art's decisively original contributions to the development of modern art. Experiencing landscape as the location of a new spirituality is a further characteristic of German artists' search for that underlying meaning they deemed lost. The creation of a new world order often seems a matter of more importance to them than the sombre reality of the industrialized world, and this longing for a new cosmogony engendered unique pictorial worlds which transcended reality in their undreamt-of poetic force. This is particularly true of Kandinsky, whose immeasurably significant artistic achievements were always founded in an intellectually compelling view of the world. As he put it in a letter to Willi Grohmann: "I should indeed like people to see at last what lies behind my painting, because it is that, and that alone, which interests me. I am distressed to observe how much the abstract artists occupy themselves with matters of form. One ought at last to understand that for me form is only the means to an end... You once uttered the word Romanticism, and I was pleased by that."

The museums in Germany after 1945 adopted a significant role as mediators, acting as centres of information on, and as educators of taste in, new artistic developments. Not only had they been deprived of valuable possessions by the National Socialist campaign against 'degenerate art', they had also suffered extensive losses during the war. Thus they often had no alternative but to commit themselves wholeheartedly to the new and to cover the information deficit created by Germany's isolation as a result of Fascism and the war.

The course of German art since 1960 can be understood only in terms of the relationship between the two centres of Düsseldorf and Berlin. Soon after the war Düsseldorf, the prosprerous centre of the Ruhr District, also became the artistic

centre of the West German republic, the gate through which French art entered post-war Germany. Independently minded gallery owners such as Jean Pierre Wilhelm and Alfred Schmela, who gathered around them a group of enthusiastic collectors, and courageous, far-sighted museum directors like Paul Wember in nearby Krefeld, were the heralds of the new French 'Art Informel' and 'Nouveau Realisme'. At that time Tapies, and especially Yves Klein, were almost as well-known in the Rhineland as in Paris. Between 1957 and 1962 Yves Klein's visits to Düsseldorf became increasingly frequent and in 1957 he decorated the foyer of the theatre in Gelsenkirchen. In 1961 Paul Wember organized his first exhibition in the Haus Lange museum in Krefeld. At the same time Klein developed close contacts, and friendships, with the ZERO artists Uecker, Mack and Piene, whose sculptural imagery he influenced strongly. In the late 1950s a reaction set in against sterile Abstraction: Klapheck painted his first Magical Realist pictures and in 1963 three young Düsseldorf artists, Gerhard Richter, Sigmar Polke and Konrad Lueg (the latter now running a gallery under the name of Konrad Fischer), founded Capitalist Realism. Richter and Polke, by deliberately denying the connection between stance, subject and style, developed an aesthetic strategy reminiscent of Picabia, which exerted a decisive influence on the new avant-garde in Düsseldorf. In 1961 Joseph Beuys became a professor at the Academy there. His classes, art happenings and activities acquired an increasingly socio-political character from the mid-1960s, and rapidly became a magnet for numerous young artists. The dialogues and controversies which took place in Düsseldorf influenced, and significantly altered, an entire generation's ideas on art. Some of the most individual artists of the last two decades, such as Palermo, Immendorff and Kiefer, graduated from Beuys's class.

Post-war Berlin, severely destroyed and robbed of its function as the nation's capital, now found itself admist hostile surroundings and relegated to the Eastern periphery of Europe. Like no other German city in 1945, Berlin appeared bereft of its function and its future. Yet it remained a significant intellectual and cultural centre, the only German city of world standing with a character of openness. Survivors from the Expressionist generation – Karl Hofer, Karl Schmidt-Rottluff and Max Pechstein – founded the Academy of Visual Arts immediately after the end of the war. Its students later included Georg Baselitz, Eugen Schönebeck, K. H. Hödicke and Bernd Koberling. Artists' galleries, such as the legendary 'Großgörschen 35' (in whose foundation Hödicke and Markus Lüpertz were actively involved), became an important forum for the presentation and discussion of new visual ideas. And so in the early 1960s Berlin became historically significant. It was the arena for controversy and conflict about the essential role of the artist. When Baselitz, Schönebeck, Hödicke, Koberling and Lüpertz first came to the attention of the public at this time, art in Germany was overwhelmingly determined by Tachism. It is against this background that these Berlin artists' early work must be understood: in opposition to the rigid, academic Informel. However, they did not reach back into the past for forms to realize their new concept of art. The encounter with Abstract Expressionism was for them a decisive one. A major exhibition of Pollock, de Kooning, Rothko and Kline was held in Berlin in the 1950s and there the young German artists discovered new dimensions of freedom and form. This new-found freedom of expression, coupled with a romantically exaggerated self-awareness, became these artists' tools as they worked on a new image of themselves by means of a discourse with their own past. They found a supporter in Michael Werner who in 1963, together with Benjamin Katz, founded his gallery in Berlin. He was particularly interested in Baselitz, Lüpertz and Penck. His first Baselitz show immediately became a scandal when the Director of Public Prosecutions intervened, confiscating a number of pictures on the grounds of obscenity. Owing to the lack of a suitable collector's market in West Berlin, Werner moved to Cologne in 1968, where his gallery became a focal point of the new, expressive mode of painting.

In the mid-1960s, Cologne became the focus of the West German art market and, by the end of the decade, the main European centre for the dissemination of American art – initially Pop Art, later Minimal Art. This continued the cultural colonialization of West Germany which reached its peak in the mid-1970s. Following French art, it was now American art which dominated the country's artistic life.

However, recent developments in contemporary German art were by no means neglected by German galleries. In 1964 René Block presented the Düsseldorf developments to the Berlin public. In his gallery, he introduced Richter, Polke, the Fluxus artists and, above all, the work of Joseph Beuys, who was first represented by his happening *The Chief*.

The present exhibition is the result of the immense international interest awakened by contemporary German art in recent years. This renewed interest has set the scene for a fresh and more precise look at the face of German art, which had become obscured by the damage done to it in the course of the century. This exhibition demonstrates that the works of the past can only be experienced again and drawn into focus when viewed intently from the vantage point of a present which has reached an increased awareness of itself. It represents the first attempt to gather together diverse material and to examine the artistic impulses which have emanated from Germany in the course of the century. One thing was clear to us from the very beginning: that which is denoted by the term 'Nazi art' would be excluded from our exhibition. What the Third Reich celebrated as art was in fact monumental kitsch, serving the purposes of Fascist propaganda. The fact that for the period after 1945 only works by artists living in West Germany are exhibited is connected with post-war developments. Two distinct German states have emerged whose artistic developments have little in common, obey different laws and are embedded in different systems of values. In particular, the reception accorded to Modernism in the two German states has differed fundamentally. The course taken by the visual arts in West Germany since 1945 is comprehensible only in terms of a dialogue with the art of Western Europe and North America, a dialogue governed by a process of assimilation, opposition and dissension as well as by reciprocal influence. Developments in East Germany have run a quite different course. After a dogmatic period of accommodation to Socialist Realism, a new orientation towards the various traditions of realism in the 1920s began to find acceptance. Later, a certain relaxation of political and aesthetic regimentation permitted a selective and cautious preoccupation with certain Modernist problems. A conspicuously large number of artists represented in the exhibition – from Uecker, Graubner and Richter to Baselitz, Schönebeck and Penck – came from East Germany, only moving to the West in later years (the last to do so was Penck in 1980). They believed they would be more likely to be able to realize their conceptions of art here.

The exhibition closes with the generation of artists who attracted public attention in the 1960s and early 1970s, that is to say, artists whose work to date permits a comprehensive assessment. On display are pictures and sculptures from 1905 to 1985 by fifty-two artists held to be representative of Germany art in this century – representative for us, that is. For it is our experience of works of art and the background of our own time acting as a sounding board for our decisions, that enable us to develop critical tools and establish criteria. Limitation to the classical disciplines of painting and sculpture permits both the concentration and concision necessary to the exhibition. It attempts less to highlight lines of development than to present the aesthetic consolidation of meaning in the work of individual artists in their formative phases. Each room of the Royal Academy has been planned as an exhibition in itself: fourteen stages in a voyage of discovery through German art of the twentieth century.

One question of central importance which has occupied us is that of the continuity of German art. In spite of the long period during which free artistic development was inhibited in Germany from 1933 to 1945, in spite of the infamous defamation of all Modernism's creative forces as 'degenerate' in the name of a popular 'healthy' state of mind, in spite of the systematic persecution of artists and the confiscation of their work, in spite of their being forbidden to exhibit or paint – in spite of all this, National Socialism did not succeed in destroying German culture. Continuity was not only maintained intellectually, but also practically: in this period of hostility to art, deeply moving and wonderful works were created in secret. From 1936 to 1945 Emil Nolde worked in Seebüll on his extensive collection of watercolours (the 'Unpainted Pictures'). In Wuppertal, Oskar Schlemmer painted his series of mysteriously intimate *Window Pictures*. From 1935 Uhlmann developed his new metal sculptures, the 'Wire Heads', in Berlin. In particular, Max Beckmann – in Berlin and

later in Amsterdam – painted his disturbing allegories, pictures which belong among the most outstanding representatives of twentieth-century German art.

The longer and the more intensively we dedicated ourselves to the exhibition, the clearer it became that a constant system of coordinates has spanned the centuries in Germany's visual culture. It goes back to Matthias Grünewald, the Danube School and the Rhenish masters and, via Caspar David Friedrich and Philipp Otto Runge, has remained intact to this day – "a gash of fire," in Paul Celan's words, which spans Germany's cultural heritage, governed by an expressive vision and by a feeling for the world marked by Romanticism.

Norman Rosenthal

A Will to Art in 20ᵗʰ Century Germany

Nietzsche in his posthumous fragments, published in 1901 under the title *The Will to Power*, writes:

"Art and nothing but art! It is the great means of making life possible, the great seduction to life, the great stimulant of life.

Art as the only superior counterforce to all will to denial of life, as that which is anti-Christian, anti-Buddhist, anti-nihilistic *par excellence*.

Art as the *redemption of the man of knowledge* – of those who see the terrifying and questionable character of existence, but want to see it, the men of tragic knowledge.

Art as the *redemption of the man of action* – of those who not only see the terrifying and questionable character of existence, but live it, want to live it, the tragic war-like man, the hero.

Art as the *redemption of the sufferer* – as the way to states in which suffering is willed, transfigured, deified, where suffering is a form of great delight."[1]

Nietzsche epitomizes the problems involved in any kind of fundamental discussion as to the nature of German art in the twentieth century, on both sides of the Hitlerian abyss represented by the years 1933 to 1945. They inevitably concern themselves not merely with questions of simple beauty of appearance or with formal properties, though these in fact might well draw us towards one individual work of art or another. Rather, the properties of German art in this century inevitably evoke reflections of great complexity in relation to the specific moment of creation within the social and political history of that ill-fated and now divided nation. The implication of the individual work of art as we confront it is challenging and paradoxical and sometimes even appears confused. The concept of art and the artist in twentieth-century Germany, prophesied and also inspired by Nietzsche, was to make powerful and significant claims for itself. Artists from those such as Kirchner, Kandinsky or Beckmann working at the beginning of this century, to those living and working today such as Beuys, Baselitz or Kiefer, to name but a few, are all, to be sure, concerned with problems of style, but over and above these with problems of ideology for which their work acts as a vehicle. In contrast to the formal and decorative qualities prevalent in French art, to which German art in this century can be most fruitfully compared, the concern is with art as a therapeutic activity, a means towards a better, more optimistic form of life.

At the roots of Expressionism there lie any number of existential questions. Expressionism we will define as a movement, or rather as an attitude to art and life that was and still is to a considerable degree prevalent in progressive artistic literary and intellectual circles, in Germany in particular. Artist groups as different as 'Die Brücke', founded in 1905 in Dresden and headed by Kirchner, or 'Der Blaue Reiter', founded some five years later in Munich by Kandinsky and Marc, to name only the two most prominent groups of artists to emerge in Germany in the years before the First World War, were attempting in their artistic production nothing less than to exemplify a new world order as expressed through their own generation. "With the belief in the development of a new generation of creators" and with a call to youth, to whom alone the future belongs, Kirchner and his friends, amongst them Heckel and Schmidt-Rottluff, hailed the new dawn that seemed to be breaking all over Europe. Art was conceived as the battle of youth against an older generation. Franz Marc, writing in the prophetic *Almanach* of the 'Blaue Reiter', spoke of art too in terms of conflict. "In our Epoch of the great fight for the new art, we battle as the wild ones, the non-organized against the organized powers. The battle may seem unequal, but in spiritual things victory is not achieved by numbers, but by the strength of the spiritual ideas."[2] The artists of both 'Die Brücke' and 'Der Blaue Reiter' as a group and as individuals produced works of great power and seduction, as can be seen in

1 Friedrich Nietzsche, *The Will to Power*, trans. Walter Kaufmann, New York, 1967
2 Franz Marc, 'Die Wilden Deutschlands', in *Der Blaue Reiter*, ed. by Klaus Lankheit, Munich, 1979, p. 28

this exhibition, and this has led most art historians and commentators to characterize them as being largely outsiders from society. This is how they perceived themselves, of course, and in one sense they undoubtedly were. But there is another sense in which, with greater historical distance, we can perceive the artists of that time and of course those writers, art dealers and others like Herwarth Walden, the great Berlin promoter of the avant-garde at this time, who sought to present the work of the new European avant-garde to a numerous and highly responsive German audience, as profoundly characteristic of their society and capable of throwing much light on the causes of the catastrophe which befell it. This is in no way intended to belittle the artists' achievements – quite the contrary. But the historiography of Expressionism has, for very understandable reasons, sought to emphasize the role of the artist as hero or anti-hero and has tended to detach him from his larger historical and cultural context. This is as true of our perception of Kandinsky as it is of Joseph Beuys.

As is only too well known, the National Socialists, during their years of power, forbade, even attempted to eliminate, all Expressionist or, rather, modern painting as part of their policy of cleansing the German nation's culture, replacing it with an art of sentimentality. Expressionist painters and sculptors were subjected to the ridicule of the famous and also highly successful 'Degenerate Art' exhibition which was mounted in Munich in 1937 and which was subsequently seen in different forms throughout the rest of Germany. The most famous works of modern art, amongst them the Corinth painting *Ecce Homo* (cat. 95), were sold from the museums which had acquired them in great numbers, even before the First World War. Many of the works of German Expressionism are to be found today in Swiss and American museums and private collections. English museums failed to respond, despite the exhibition of New German Painting that took place in the Burlington Galleries in 1938 and which, even though Beckmann was in London at that time, provoked very little reaction from the London press and public. Artists, like their intellectual (not to mention Jewish) counterparts felt (if they were wise and lucky) compelled to emigrate. Some, like Kirchner, who in fact had been living in Switzerland since 1919, committed suicide partly as a result of a depression caused by his exclusion from the pantheon of German artists where he rightly thought he belonged. Others, like the painter Emil Nolde, unable fully to comprehend the ban on his painting (he was basically in sympathy with the nationalist stance of the new rulers of Germany) took to executing small but immensely beautiful watercolours in secret. Max Beckmann left Berlin after the 'Degenerate Art' exhibition and went to Amsterdam, where he painted many of his greatest canvases in virtual secrecy. Despite the *Malverbot* (a decree that forbade the individual artist to paint) it cannot be said that modern art came to a halt. Somehow artists like Schlemmer, Baumeister and Nay continued their production in the state known as the 'inner emigration', whereas Beckmann and Paul Klee produced some of the most powerful and emotionally charged works of this century, as a response to the terror all around them (fig. 1).

Defeated Germany after 1945 quite understandably felt compelled to make good again the losses of the museums, which they managed to do with no little success. The classic generation of German Expressionists was presented once again to an eager public by critic friends and colleagues such as Will Grohmann, friend of Herbert Read and author of numerous books on contemporary art, who had been associated with the artists in the 1920s and 1930s. Another such writer was the author Lothar Günther Buchheim, compiler of the first comprehensive books on both 'Die Brücke' and 'Der Blaue Reiter', published in the 1950s. Writing of the artists of the 'Blaue Reiter', for instance, he speaks of "the extent to which the German painters were able to distance themselves from the art of the French." Whilst in France artists took up their position from the standpoint of the art of Cézanne, German artists tended towards a greater expressive strength derived primarily from symbolism, from something mystical, and attempted to give art a metaphysical dimension. Werner Haftmann, author of a standard history of the art of the first half of the twentieth century and for many years director of the New National Gallery in West Berlin, wrote of Paul Klee in 1954 that his place "today is in the very midst of the most vital younger European painters. He is in fact the real moral criterion for the painting of our day. His spirit and his ideas should by rights inspire all present-day art schools and academies."[3] The emphasis of such writing is

Fig. 1 Paul Klee, *High Spirits*, 1939

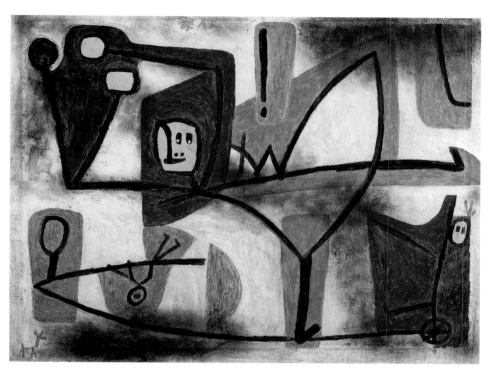

always on the independence of the artist from external social influences, on his lack of relationship to history as such. Art is discussed primarily in its relationship to form, not in terms of the ideological position it represents. Franz Marc is still discussed in the context of his relationship to Delaunay, and Kirchner is compared, often unfavourably, to Matisse.

German art history during the course of this century, for reasons not totally unconnected with the general cultural situation in Germany, has, with certain notable exceptions, separated itself to a large extent from the main body of historical reflection, to form an almost totally independent discipline with its own philosophy and methodology. The modern historian compiling a broad survey of twentieth-century German history will devote perhaps a paragraph to the question of art as a symptom of historical reality, but it will remain as a rather irrelevant aside, perhaps at best adding fuel to a general argument. K. D. Bracher in his important book on *The German Dictatorship* significantly leaves out visual artists in his perceptive comment on those increasingly irrationalist tendencies of the German intelligentsia in the first half of this century who took their cue largely from Nietzsche. "As a result of the widening gulf between Western and German political thought and in line with the diminution of humanitarian and natural law in a country without a well-founded historical tradition, the German intelligentsia and bourgeoisie, the professors and teachers, the writers, civil servants, soldiers and industrialists, were more readily seduced by the siren calls of anti-democratic, anti-individualistic and irrational ideologies than were their counterparts in other countries."[4] Perhaps it is only an oversight that led Bracher, one of the most distinguished of contemporary German historians, to omit the artist from his list of "irrationalists." But as contemplation of the works of art in this exhibition undoubtedly demonstrates, the artists, like any group of individuals, are subject to 'irrational' if often in themselves highly convincing ideologies. Artists can also be perceived by us as part of that totality of history, as expressed so forcibly by Hegel who speaks of world history representing "the evolution of the awareness of the spirit of its own freedom ... every step being different from every other one has its own determining principle. In history such a principle becomes the determination of the spirit, a national spirit *(ein besonderer Volksgeist)*. It is here that it expresses concretely all aspects of its consciousness and will, its total reality, it is this that imparts a common stamp to its religion, its political constitution, its social ethic, its legal system, its cultures and also its science, its art and its technical skills."[5]

Such statements are very much in keeping with passages in Kandinsky's *Über das Geistige in der Kunst (Concerning the Spiritual in Art)*, or indeed with the social theory

3 Werner Haftmann, *Paul Klee*, 3rd ed., Munich, 1957, p. 9

4 Karl Dietrich Bracher, *The German Dictatorship*, London, 1971, p. 28

5 Georg Wilhelm Friedrich Hegel, *Vorlesung über die Geschichte der Philosophie*, 1, Stuttgart, 1928, pp. 62, 63, 84

of Joseph Beuys as embedded in his sculpture. Kandinsky speaks of three "mystical sources" from which the work of art arises through internal necessity: "what is peculiar to himself, what is peculiar to his own time, what is peculiar to art in general."[6] It is that latter quality, the pure, the eternally artistic, that remains immortal according to Kandinsky, but this does not obviate the necessity of the work of art "being compounded of the language of the time and the language of the race, as long as the race exists as such." And Joseph Beuys, nearer our own time in his statement "I am searching for field character" published in connection with an exhibition in London in 1974, where he created *Directional Forces* (fig. 2), a blackboard environment now in the New National Gallery in West Berlin, speaks of the "condition of a radical widening of definition whether it be possible for art and the activities related to art to provide evidence that art is now the only evolutionary, revolutionary power. Only art is capable of dismantling the repressive effects of a senile social system that continues to totter along the deadline: to dismantle in order to build a social organism as a work of art."[7] Such passages derive not only from Hegel but also from those classic works of history in the nineteenth century in which art does indeed play a significant role. Jakob Burckhardt's famous book *Civilization of the Renaissance in Italy*, published in 1860, asserts for instance how the formidable cruelty of the Italian despots lives "eternally" in the small early works of Raphael. It is perhaps difficult to imagine a twentieth-century historian comparing the works of Kandinsky, on the one hand himself a profound manifestation of freedom through his works and through his writings, with the great despots of the twentieth century. But it is the artists who are the seers and who in many ways, consciously or unconsciously, are prophets of political and social realities. For instance, in the case of the comparatively minor artist Ludwig Meidner, included in this exhibition, we see in his works of 1912/13 extraordinary foreshadowings of the horrors of the First World War trenches, of revolution and even of the possible holocausts that threaten the twentieth-century world to this day. George Grosz's *Homage to Oskar Panizza* (cat. 127), too, seems to foreshadow a vision of the modern city more appropriate to the second half of our century than to the first, so dense is its representation of the built-up city. Writers and artists on the brink of the First World War were aware to an astonishing degree of the forthcoming apocalypse.

But the history of art still tends to evaluate art in terms of questions of style and form. Wölfflin, Berenson and Fry discuss art in terms of the painterly and non-painterly, the tactile and non-tactile. And it is certainly very possible and indeed extremely useful to consider the works of Kirchner and Kandinsky or indeed Max Beckmann, Georg Baselitz and Joseph Beuys in terms of their formal painterly or sculptural values. A painting such as Beckmann's *Dance of the Cut-throats* of 1938 (cat. 115) or Joseph Beuys's new sculpture *Lightning* (cat. 245), are triumphant creative achievements when considered from this perspective. It is indeed a central issue of this exhibition, and a criterion that has determined to a large extent the choice of works, to demonstrate the existence of a deep-rooted and complex painterly and sculptural tradition in Germany in this century. Yet both the aforementioned works are in addition powerful expressions of symbolic force. The Beckmann, with its overtones of Wedekind's *Lulu*, is also a powerful statement on the human condition, on life as a circus act, where we are both onlookers and performers, on the male figure who brutally and triumphantly holds the female figure over him. The painting is both a metaphor and a dramatic statement. Beuys's *Lightning* is a metaphor as well as a mystical and elusive representation of the *Stag Monuments*, where "human beings and all other spirits meet, in order to discuss work together and in so doing to discuss every decisive point of view necessary for putting the concept of capital and with that the situation of the world into the proper form."[8] It is on the one hand a political metaphor and a dramatic representation of a Valhalla for our times, perhaps too a late twentieth-century equivalent of Rodin's *Gates of Hell*. In fact much early twentieth-century writing on art in Germany did attempt to discuss art in Hegelian or in Burckhardtian terms. There is a long tradition of Marxist historical writing which attempts to evaluate European art as an aspect of socio-economic situations. More convincingly, perhaps, there is also a strongly developed psychological path of art appreciation that dates from long before Freud, inaugurated by the great nineteenth-century cultural historian Karl Lamprecht and

6 Wassily Kandinsky, *Complete Writings on Art*, ed. Kenneth C. Lendsay & Peter Vogo, I, London, 1982, p. 173

7 *Art into Society, Society into Art*, Catalogue, Institute of Contemporary Arts, London, 1974, p. 48

8 *Zeitgeist*, Internationale Kunstausstellung, Berlin, 1982, w.p.

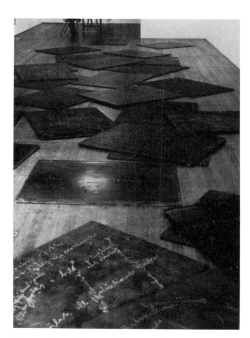

Fig. 2 Joseph Beuys, *Directional Forces*, 1974

continued by writers such as Wilhelm Dilthey, Wilhelm Wundt and Alois Riegl, the latter a Viennese art historian responsible for the important concept of *Kunstwollen*, an idea that was to be influential on artists, critics and art historians alike. *Kunstwollen* refers essentially to the will to art or the art of individuals as representatives of cultural groups (nations) to create specific art forms. As an idea first applied by Riegl to late Roman art, it was of course applicable to other epochs and styles.

The concept of *Kunstwollen* was taken up and made popular by art historians, including Wilhelm Worringer, whose book *Abstraktion und Einfühlung (Abstraction and Empathy)*, first published in 1908, laid much emphasis on the distinction between Northern (German) and Southern (Italian) art, just as countless others were drawing attention to the differences between German and French art and its different sense of priorities as regards its intentions. It is in relation to this that it might be relevant to look in some detail at the case of Kandinsky and the direction his 'ideology' was taking him. Kandinsky was of course a Russian by birth, but he wrote what is surely the most important statement on art to appear in Germany at the beginning of this century, the period when modern art as we know it was brought into being: *Über das Geistige in der Kunst*. Kandinsky has quite rightly always been perceived as one of the great innovators of twentieth-century art, with the emphasis placed on the great freedom of expression to which he aspired and which drove him towards his first so-called abstract watercolour of 1910. Kandinsky, in the great compositions and improvisations of his Munich years, which are represented in this exhibition, reflects to an extraordinary extent the explosive and elemental sense of catastrophe followed by rebirth that characterizes the extreme radicality of his painting of this period. It is indeed possible to see Kandinsky's work between 1910 and 1914 in terms of a rejection of Cubism implicit in the work of Picasso, and of the Fauve style of Matisse (both artists he admired greatly and who were widely exhibited before 1914 in the various German art centres before 1914, in Munich, Berlin, Dresden and Cologne). It can be asserted that by transcending such movements in his scale and technique, Kandinsky foreshadowed the development of painting in America, especially after 1945. However, at another level, when we examine his writings, not to mention the inherent symbolism of his art, a very different picture can emerge which is just as relevant to our understanding of this great painter.

Such millenarian preoccupations were as dominant in the work of Franz Marc, joint editor with Kandinsky of the 'Blaue Reiter' *Almanach*. For Franz Marc the world of 1912 was experiencing a profound transition "similar to the world some fifteen hundred years earlier... where the old order died and something new and unrecognized took its place."9 A new religion was to emerge and on its altars would be placed the new art. Such thoughts ran parallel to the theosophy of Rudolf Steiner, a much-discussed thinker of his time who predicted a second coming between the years 1930 and 1950. For Kandinsky in his *Rückblicke*, published as an autobiographical sketch in 1913, "Art in many respects resembles religion. Its development does not consist in new discoveries which replace old truths and lead to confusions, as seems to be the case with science. Its development comes from sudden intuition, which resembles the stroke of lightening. Such clarification shows with illuminating light new perspectives, new truths which are at base nothing else than the organic development of earlier truths, which are not in any sense annulled by them but rather, as wisdom and truth, live on. The new branch does not make the old redundant, it makes possible the new branch. Would the New Testament have been possible without the Old? Would our epoch at the crest of the third revelation have been possible without the second?"10

Such statements were typical of the intellectual climate of Central Europe at this time just before the onset of the First World War. Subsequently, of course, Kandinsky returned to Russia where he attempted to integrate himself with the revolution – itself in many respects a product of millennial and anarchic philosophies – which characterized the first years of this century. In 1922 Kandinsky returned to Germany where he was at once invited by Gropius to become a teacher at the Bauhaus. Kandinsky's painting in these years underwent considerable stylistic change, from the romantic and lyrical expressionism of the pre-war improvisations and compositions to the harder edged geometrical paintings of his later years. Some critics have interpreted this change as proof of Kandinsky's greater rationality. Like

9 Franz Marc, *op. cit.*, p. 38
10 Kandinsky, *op cit.*, p. 377

the supposed rationality of the Bauhaus itself, which in fact had a very strong mystical and anti-rationalist element within it (for instance in the work of Schlemmer, Feininger, Itten and Kandinsky himself), this new rationality of Kandinsky is largely a myth. In fact Kandinsky's objectives and deeper methods had changed very little outside his formal development which had merely become more arid and mechanical. Kandinsky was still hoping to capture, not the realistic visage of Christ but rather the form of the Holy Spirit. Another painter of considerably less importance than Kandinsky, but who was a close follower of the master was Rudolph Bauer, who also broke into non-objectivity and became a member of Herwarth Walden's circle in Berlin. Walden wrote of Bauer in an ecstatic manner that recalls earlier celebrations of Kandinsky. "His pictures allow those who look at them to participate in an inner vision." In 1919 Bauer contributed an essay entitled 'The Cosmic Movement', to one of Sturm's last important publications *Expressionismus, die Kunstwende (Expressionism, the Change in Art)*. Ten years later, in 1929, Bauer opened in Berlin his own gallery, or rather temple, called 'Das Geistreich, Tempel der Ungegenständlichkeit' ('The Spiritual Empire, the Temple of the Non-objective') in which the principal altarpieces were by Kandinsky himself. A passage in the programme of the 'Geistreich' reads as follows: "The Geistreich constitutes the circle of those who will lead to the thousand year Reich." As Sixten Ringbom has pointed out, "The spiritual and religious element in Kandinsky's art has largely disappeared from public consciousness owing to the social mechanisms conditioning twentieth century taste."[11] Kandinsky saw his works as instruments of a new, pure order. Such naivety was perhaps excusable in pre-Fascist Germany. Now, forty years after that episode in world history, which in its own way proclaimed the new order, the artist in Germany finds himself facing far greater problems of history and ideology as he attempts to produce work equal to the complex situation he finds himself in, coping with a terrible recent memory and a divided state. It is perhaps not surprising that in the years immediately after the Second World War, when artists looked to Paris and later to New York for inspiration, German artists like Werner Heldt, Ernst Wilhelm Nay or Hans Uhlman kept a low profile in their art as they attempted to pick up the pieces of the modern art movement of their country. Art life as such resumed quite rapidly, alongside the 'Wirtschaftswunder' that overtook West Germany in the 1950s and 1960s. The first 'Documenta' exhibition took place in Cassel in 1955 and has since become the great international arena in the battle of styles that is such a feature of art today. But the real problems of the recent past were perhaps faced in the first instance by Joseph Beuys, who took up and transformed the stance of artists such as Kandinsky to suit the wiser and sadder age of today. His work as manifest in his sculpture goes beyond all traditional sculptural forms to encompass materials such as fat and felt as well as bronze and wood, used to symbolize the healing and comforting purpose of art. More than any other artist's work, his sculpture can be perceived as a memorial to the suffering caused by this century's inhumanity to man. They are an appeal for comfort through the warmth and poignancy of the materials used and can be experienced as souvenirs of a complex past and present.

The work of Beuys in recent years has often contained elements of earlier work, or is based on ideas presented in his extraordinary corpus of drawings, many of which are imaginative designs for sculpture and which in themselves are amongst the most extraordinary achievements of art since 1945. One drawing of 1958, indeed, was a proposal for a monument for Auschwitz, emphasizing with unspeakable sadness and pathos the way in which its victims were brought to that place of horror on railway lines that entered its gates. *Tram Stop* (cat. 242) is described by Beuys as a monument to the future. Like all his works it is also a monument to the past, a monument to both the recent and more distant history of Europe, expressed with a terrible sense of pain which is on the one hand autobiographical and which on the other can speak to those able to identify with its complex symbolism. But Beuys too refers to a will to transform matter, however primitive, into something resembling hope. It is through transformation that a sense of optimism can be attained. In *Stag Monuments*, which form the basis of the new sculpture *Lightening*, a mound of clay serves as the indication of death but also of hope and regeneration: "Clay is a substance of the earth, clay and quartz. With a proper amount of chalk we have the subsoil on which

11 Sixten Ringbom, *The Sounding Cosmos. A Study in the Spiritualism of Kandinsky and the Genesis of Abstract Painting*, Åbo, 1970

Fig. 3 Joseph Beuys,
Monument for Auschwitz, 1958

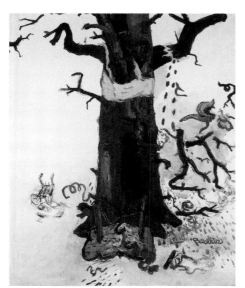

Fig. 4 Georg Baselitz, *The Tree*, 1966

we stand and out of which, from a murdered world, we will re-awaken the planet to life."[12] Beuys the social theorist, who is first and foremost a sculptor, is also striving after a new definition of art.

This art has plastic form, as in *Tram Stop* or in *Lightening*, but is above all else a metaphor for a purified life. It contains a message of optimism: out of the horrific death and destruction for which the Third Reich provides the paradigm (although, alas, not the only example in this century of man's inhumanity to man) can still come the possibility for mankind to aspire to creative forms. It is a fundamental optimism that enables Beuys to reach out across the German catastrophe – without in any way ignoring it – to Nietzsche, to Rudolf Steiner and to Kandinsky, whose search for the spiritual in art serves as a basis for an aesthetic and ideology that do indeed look to a better future for mankind. Beuys, too, belongs to that tradition of Expressionism that identifies art with extremes of suffering (fig. 3). His art is to be perceived as a channel of redemption.

There is, however, beyond the all-embracing theory of sculpture proposed by Beuys, another aspect of post-war German art, largely originating in Berlin, which seeks also to come to terms through art with the history of the recent German past and which has led to a form of reflective history painting which is perhaps something quite new in Western art. The painting of artists such as Georg Baselitz, Markus Lüpertz and A. R. Penck, all of whom originally come from what is now the German Democratic Republic, speaking in a new language in part derived from German Expressionism but also drawing on other aspects of twentieth-century visual culture, has found another way through art of coming to terms with the German past. This is an art that deals with what were taboos in its subject matter. It forms a central discussion as to the very nature of painting and its ability to be charged with political meaning, whilst at the same time being directly concerned with formal problems arising from the modern tradition and thus making a considerable contribution in that direction.

Georg Baselitz deliberately stood the world on its head in 1969 in order to detract attention from, but not entirely eliminate, that subject matter which provided him with his earlier repertoire of heroes, woodcutters and other motifs drawn primarily from the German romantic tradition, and placed in a landscape scorched by war and destruction. But even the first motif to be stood on its head, *The Forest on its Head* (cat. 263), is not only a purely abstract painting. The tree had occurred in many other earlier Baselitz paintings (fig. 4), most poignantly as a bleeding trunk, a painterly metaphor once again for the living who can and must endure even within a world of destruction and pandemonium. The inversion may also seem like a nega-

12 *Zeitgeist, op. cit.*

tive, pessimistic act, but in the case of more recent paintings such as *Supper in Dresden* (cat. 265), a painting with direct visual reference to the artists of 'Die Brücke' and particularly to Nolde's painting *The Last Supper* (cat. 64), it seems to welcome the optimism of the artists of the beginning of this century, when the young artists of Dresden were eagerly forming a new order for the world through their art. Markus Lüpertz, as Siegfried Gohr has pointed out, has also invented for himself a new form of figuration that "builds the foundations of a style that describes social realities without illustrating them."[13]

Lüpertz conceived an equivalent in paint of the dithyramb, the vehement and wild Greek choric hymn, originally composed in honour of Bacchus or Dionysos. His paintings too are political assertions that confront, with irony, German motifs of this century, placing them in close proximity to the artist and his palette, and defining the artist in his defiant role as the only possible hero for our age. Lüpertz, with great technical bravura, invents real motifs and makes them abstract, invents abstract figurations and makes them real. The work of A. R. Penck, who only came to live in the West in 1980, is also a graphic attempt through his so-called *System* and *Standart* paintings to come to terms with the two systems of a divided Germany and to reflect on the delicate though often primitive balance which the individual living within either system must face in order to live his life. Penck too has invented a new 'primitive' sign language and makes pictures that expand unwittingly the graphic pictorial solutions of the last works of Klee. These also attempted to come to terms with the catastrophe around him by means of humour and irony that help both artist and spectator to learn to live and therefore overcome the macabre dance of death.

Finally, it remains to mention the case of Anselm Kiefer, a student of Joseph Beuys, whose work has enjoyed extraordinary resonance both inside and outside Germany in recent years. Once again his landscapes refer to Germany after the catastrophe with images of dark, charred landscapes and empty Fascist palaces: *Nero Paints* and *Painting = Burning* (cat. 299) are among the ambiguous titles of his paintings. The ambiguity lies in whether the act of making art, which once again is the supreme concern of the artist, stands in opposition to or is engulfed by the destruction, by the ravaged landscape. What is beyond doubt is that art still occupies the splendid palaces when all else has disappeared for good. Kiefer in his works conjures up the whole cultural inheritance of the German past as a deathly German Valhalla. In the painting *Germany's Spiritual Heroes*, Richard Wagner and Joseph Beuys, Caspar David Friedrich, Frederick II, Robert Musil, Hans Thoma, Theodor Storm, Nikolaus Lenau, Mechthild of Magdeburg, Arnold Böcklin, Adalbert Stifter, Josef Weinheber and Richard Dehmel, represent a legitimate post-Nazi pantheon of German cultural and historical heroes. Some would have been admitted in earlier days, others excluded.

Once again the artist looks back across the abyss of the twentieth century in order to assert the aesthetic values that are indeed part of Germany's contribution to civilization. Theodor Adorno, the famous German sociologist of the Frankfurt School, is reputed to have said that after Auschwitz it was impossible for poetry ever again to be written. Georg Steiner speaks of the German language "going dead" after a last flowering of German literature that look place in the Weimar years and brought forth masterpieces by writers as different as Rilke, Musil, Thomas Mann, Brecht and Kafka. But just as the exile years produced masterpieces by Beckmann and Klee, so the literary exile that comprised both Mann and Brecht saw the realization of some of their finest works. The greatest victory for Nazism would indeed have been the total destruction of German culture, and that includes its painterly culture. The artists of the first half of this century, themselves an elite, played with something approaching cultural fire. The world was severely and horribly damaged. The artists of the post-war period who perhaps best represent the German spirit are those who, taking the fullest cognizance of the horrors of this century, incorporate with both irony and respect a reverence for the healing powers of the artist and the resonant cultural tradition of Germany.

13 Siegfried Gohr, 'The Difficulties of German Painting with its Own Tradition', in *Expressions – New Art from Germany*, Munich/Saint Louis, 1983, p. 33

Wieland Schmied

Points of Departure and Transformations in German Art 1905-1985

I

The great decisions on the development of modern art were made in France. In the first half of the nineteenth century Paris became the artistic capital of the world, where contemporary sentiment found expression, first in the spirit of Romanticism (Delacroix) and then in a comprehensive conception of Realism (Courbet). Baudelaire, the most attentive observer of the art of his times, spoke of the "heroism of modern art." He sensed what was on the way and what we should need to face up to the future. Walter Benjamin, Baudelaire's most perceptive interpreter, referred to Paris – in one of the first fragments of his *Passagenwerk* – as the "capital of the nineteenth century." But in an observation which oscillated between criticism and respect he also recognized the influence of Germany, recording with mixed feelings: "Baudelaire succumbed to the spell of Wagner."

What took shape in France in the first half of the nineteenth century developed in the second half with an intensity, complexity and rapidity unknown in art history since the time of the Renaissance. To Courbet's conception of Realism the Impressionists responded with a new mode of perceiving reality, reality condensed in a momentary impression, and they in turn were followed by Cézanne, van Gogh and Gauguin. "We had to pass that way," Cézanne remarked of the Impressionists, in order to give "permanence and stability" to art. Cézanne, van Gogh and Gauguin laid the foundations and determined the perspectives of modern art. Beside them – or soon to follow them – were Seurat, Signac, Odilon Redon, Toulouse-Lautrec, the Nabis... All these developments took place in France. Outside France there were two figures of outstanding importance – James Ensor, who buried himself in his native Ostend, spending almost his whole life there, and Edvard Munch, who flitted restlessly to and fro between the Bohemian life of Oslo, Amsterdam and Paris in the 1880s, between Aasgaardstrand in Norway, Nice and Italy, or between Berlin, Paris and Lübeck (and many other places) in the 1890s and the first decade of the new century, always returning to Berlin from time to time.

We have said that the great decisions on the development of modern art were made in France (and even the art of James Ensor or Edvard Munch would have been unimaginable without them). Yet nowhere outside France were these developments followed so eagerly, noted so fully, or taken up so early as they were in Germany – not in Italy, not in Belgium, not in England, and not even in Vienna. There the Secession led by Gustav Klimt pursued a cosmopolitan exhibition policy on a large scale between 1898 and 1905. This suddenly came to an end in 1905 (before the successor states of the old Habsburg Empire shut themselves off completely after the First World War).

However intense and however profound the discussion, reflection and reception of the new art may have been, however many champions joined the lists, this process of appropriation and coming to terms would not have been possible had it not been supported and carried forward by a new generation of artists who appeared on the scene after 1905 and responded with their own feeling and their own vision to the stimulus and the challenge of Cézanne, van Gogh, Gauguin and Seurat – and later of Munch, Matisse, Vlaminck and Picasso. There was probably no other country in which not just individual artists, but a whole generation of new artists, felt themselves stirred so quickly and so deeply by contemporary developments and reacted to them so wholeheartedly – with the possible exception of a few young Austrians like Richard Gerstl, Egon Schiele and Oskar Kokoschka.

Thus it was the German Expressionists who first took up the dialogue with the developments that had taken place in France, becoming equal partners and exercis-

ing their influence on further developments. They were followed by the Italian artists, the Futurists led by Marinetti and Boccioni and the representatives of *pittura metafisica* (Metaphysical Painting) led be Giorgio de Chirico, who was later followed by Carrà and Morandi. A little later they were joined by the English artists – Sickert and the Camden Town Group and the Vorticists led by Wyndham Lewis – the Russian and the Dutch. Yet Paris continued to be the centre of these artistic developments, drawing artistic talents under its spell and usually integrating them into the 'Ecole de Paris.' It was only in the early 1950s, when so many important artists had been forced to emigrate to the United States as a result of the Second World War, that New York took over the role which had previously been played by Paris in artistic activity (and the art trade).

II

Until 1933, when the Weimar Republic came to an end and the National Socialists seized power, German art was dominated by three great concepts or visions – those of the artists of 'Die Brücke' (Bridge) and 'Der Blaue Reiter' (Blue Rider) and those of the Bauhaus. Beside these stood the work of a few significant individual figures – the nervous restlessness of Lovis Corinth in his late period, Emil Nolde's passionate search for a lost originality, and – a phenomenon *sui generis* – the 'contemporary myth' reflecting all manifestations of human existence, which Max Beckmann created in these early years and continued to develop as an exile in Amsterdam.

If all these visions – those of 'Die Brücke', 'Der Blaue Reiter' and the great individualists (but not the ideas of the Bauhaus) can be accommodated within the expressive mainstream of German art, then there were two important movements which ran counter to this and emerged in stark contrast to it: one was 'Neue Sachlichkeit' (New Objectivity), which was vehemently opposed to Expressionism with all its dreams, its ecstasies and its excesses; the other was Dada, a movement of protest which had a longer history and at the same time pointed farther ahead. As a result of the shattering experience of the First World War Dada called into question all the cultural values of Western civilization, including the meaning of art. Whereas Futurism had been impressed by the prospects held out by modern technology and had sought simply to break with the past – and the art of the past – the break which Dada tried to provoke was far more comprehensive: it applied to our whole system of values, to inherited beliefs and to all faith in progress.

The founding of 'Die Brücke' coincided approximately with the rise of the Fauves in Paris, though its models were Gauguin, van Gogh and Seurat, together with the graphic art of Munch and Toulouse-Lautrec; it was only in subsequent years that the 'Brücke' artists became familiar with the art of the Fauves around Matisse. What linked them with the Fauves was – among other things – their enthusiasm for the world of form to be found in primitive cultures: at roughly the same time as Kirchner was discovering for himself the elemental force of negro sculpture and Oceanic wood-carvings in the ethnography department of the Zwinger in Dresden, Derain, Vlaminck and Picasso were discovering the suggestive power of African masks in Paris. What distinguished the 'Brücke' artists from the Fauves was – among other things – the rediscovery by the former of German artistic traditions such as the late Gothic woodcut, whose expressive simplifications fascinated Kirchner and his friends at least as much as the surface patterns and subtle colouring of Japanese wood engravings fascinated Matisse and some of the Fauves.

The Fauves and the 'Brücke' artists developed in different directions. The impetuosity and expressive power which mark the work of the Fauves around 1905 gradually subside, giving way to Matisse's large décors, Rouault's modern icons, and Derain's pointedly forced realism (arrived at by circumventing Cubism) and leaving only Vlaminck as a pronounced Fauve for as long as he retained his initial vitality. The artists of the 'Brücke', on the other hand, only gradually achieved the radical simplification and aggressive stridency of form and colour which they had aimed at from the beginning. What had been merely the starting point for the Fauves represented the zenith of artistic attainment for the artists in Dresden, and this was reached in 1907 or 1908. If we compare the pictures they produced then and in the years immediately following it with those painted by the French, it becomes clear

Fig. 1 Emil Nolde, *Mask Still Life*, 1911

Fig. 2 Max Pechstein, *Still Life in Grey*, 1913

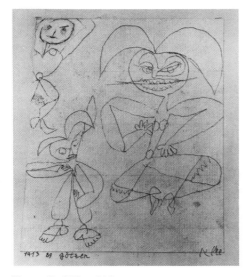

Fig. 3 Paul Klee, *Idols*, 1913

how much more 'savage' Kirchner and his fellow artists of 'Die Brücke' were than the 'Wilden', or 'savages', associated with Matisse, how much more angular and pointed the forms in their pictures, how much more aggressive, nervous and brutal their colouring, unless they were imbued with the harmonious feeling of oneness with nature, with a familiar landscape, a feeling which softened the sharpness of the forms and brought the colour values into a harmonious balance. What was true of the Fauves is also true of the 'Brücke' artists: there is such subtlety despite all the savagery, such refinement despite all the aggression, such calculation despite all the spontaneity!

The 'Brücke' artists and the Fauves were at one in their quest for "expression" as the prime aim of their painting, but by "expression" they meant different things. For the Germans expression signified passion, the ecstatic assimilation and appropriation of the world, whereas Matisse and his friends (though Matisse in particular) strove for an art of "balance, purity and repose," for *l'expression intime*. For the artists of 'Die Brücke' expression had to fuse with the objects they depicted – feeling and the object of feeling had to become one. The Fauves, by contrast, were concerned with the balance between sentiment and form, emotion and composition. For the painters of 'Die Brücke' art had to be "subordinated to experience": for the Fauves it had to be subordinated to form. Matisse tried to ban tragedy and pain from human existence: the artists of 'Die Brücke' wanted to experience them in all their extremes.

At first sight the fascination aroused in 'Die Brücke' by 'primitivism', by African and Oceanic sculptures, may seem like evidence of the Teutonic leaning towards the barbaric, but closer inspection reveals it to have been part of the 'quest for origins' which was common to so many artists at the beginning of the century. Associated with this quest are other phenomena which must be regarded as springing from parallel motives – the discovery of the art of non-European advanced cultures such as the pre-Columbian sculptures of Mexico and Peru, of naive painting (championed with such zest by Wilhelm Uhde), of child art (whose special qualities Paul Klee was one of the first to extol in 1912). Somewhat later, after 1920, came the interest in the art of the mentally sick, an interest which was a consequence of Expressionism rather than one of its preconditions and was promoted by the efforts of Hans Prinzhorn, who more than once drew attention in his writings to parallels with the formal language of Expressionism. This psychiatric art was seen as providing yet another approach to the sphere of the 'original' which artists sought so passionately (and it became a source of inspiration for later artistic movements, especially those associated with Surrealism).

It is also as part of the quest for origins – rather than as a result of weariness with civilization – that we should see the journeys made by artists, following Gauguin's example, to the remotest and most 'untouched' parts of the earth. Nolde travelled to New Guinea, Max Pechstein to the South Seas, to find confirmation of the originality they had already discovered and anticipated in their art (figs. 1-3).

In New Guinea and Java Nolde recognized the powerful rhythm and dazzling colours of his *Candle Dancers* (cat. 71), whom he had painted not long before in his island retreat of Alsen. Kirchner, on the other hand, had only to stroll across the Kurfürstendamm or Unter den Linden to discover the exotic in modern life. The cocottes in his pictures move like predatory wild cats through the jungle of the big city.

Among all the artistic groupings of the German twentieth century, 'Die Brücke', during the bare decade of its existence, was the most coherent. The ways in which Kirchner, Heckel and Schmidt-Rottluff experienced the world, their artistic intentions, their vision and its translation into pictorial form were mutually sympathetic and complemented each other most effectively. The artists maintained intimate contacts with each other, for a long time sharing the same studio and the same literary interests (Nietzsche, Strindberg, Dostoevsky, Baudelaire, Rimbaud, Whitman) and holding joint exhibitions. In 1911 they moved one by one, at short intervals, from Dresden to Berlin (where they had met Otto Mueller the previous year at the first exhibition of the 'Neue Sezession' [New Secession] and admitted him to their circle). In Berlin their studios were situated not far apart, and at first their mutual contact remained as close as it had been in Dresden, though the personal characteristics of the individual artists, their differing temperaments and interests, gradually began to show more distinctly in their work (and in their personal dealings

with each other there were the first signs of the later estrangement that led to the break-up of the group in 1913).

From the beginning the artists of 'Die Brücke' divided their time between the town, where they spent most of the year, and the country, which they visited for fairly long spells during the summer months. Either all together or in varying groups they would visit the Moritzburg lakes, the fishing village of Dangast, the islands of Fehmarn and Hiddensee, or they would go to the Flensburg Fjord, to Osterholz, or to Nidden on the Kurische Nehrung, in order to paint in the remotest natural surroundings. Schmidt-Rottluff, who was probably the most robust member of the group, went further afield, to Norway, in order to expose himself to an increasingly inhospitable nature.

The painting of 'Die Brücke' concentrates on a small number of themes: man, landscape and townscape. The landscape may be unwelcoming and forbidding (though not uninhabitable) like the Norwegian landscape which Schmidt-Rottluff experienced. It may also be a human, domesticated, peaceful landscape such as we find in many of the pictures of Heckel and Kirchner, a landscape that we feel to be 'homely'. Or it can appear as a paradisal dream, an Arcady inhabited by gypsies, as depicted by Otto Mueller, a nostalgic utopia of free men and women enjoying free love, without aggression, without conflict – but also without relevance to the present.

Human figures are nearly always shown in their natural surroundings, as nudes in interiors or in the open air, in the security of the meadow, or as bathers. Or they may be shown in their social roles, in the coffee-house, the variety theatre, the street or with friends. They always reflect their surroundings, at one with nature and part of her great harmony, or else they bear the stamp of city life, whether it is in tune with them or in contrast to them.

While naked humanity corresponds to the vision of nature as an all-embracing harmony, and while it alone can fuse with nature to form an organic unity, the human type which corresponded to the image of the big city was something the artists still had to evolve.

For Heckel the big city manifested itself in the facial expressions of the people he painted during his years in Berlin. The street terminating in a confined space (as in *City Railway in Berlin*, 1911) gives the card-players (*Two Men at a Table*, 1912; fig. 4) a strangely cramped look: one might even speak – were it not a contradiction in terms – of a resigned alertness. The women too have this same facial expression: the *Tired Woman* of 1913 is quite crushed by it, and even the *Convalescent Woman* (1912-13; fig. 5), lying on her sick-bed, needs to be surrounded by flowers if she is to have any hope of recovery. She would be lost without such renewed contact with nature, manifested especially by the sunflowers on the right.

Heckel was truly at home only in nature, and all his early interiors, while lacking the spaciousness of his landscapes, have their light-hearted freshness. Schmidt-Rottluff was by temperament almost exclusively a landscape painter, and it was in his landscapes that he did his best work. His human figures, even when – exceptionally – they are not depicted in rural surroundings, bear the stamp of the landscape. For Otto Mueller the Arcadian landscape was the projection of all his yearnings, which grew the more intense, the longer he was compelled to live in the city.

Fig. 6 Ernst Ludwig Kirchner, *Woman in front of a Mirror*, 1913

Ernst Ludwig Kirchner must be ranked foremost among the 'Brücke' artists as the painter of the modern city. He painted it in spacious townscapes with streets, roofs, church towers, bridges and avenues of trees converging at acute angles, sharp, dynamic, pulsating with a powerful rhythm, at once exhilarating and aggressive, and certainly no more forbidding than the Norwegian mountain landscapes of Schmidt-Rottluff.

Yet even more profoundly than in his townscapes, Kirchner captured the character of the modern city in the faces and figures of its inhabitants, in the way they moved, either hurrying or letting themselves be carried along, in the way they dressed or disguised themselves, in their costumes and masks. Observing the *Woman in front of the Mirror* (1913; fig. 6) as she does herself up, we know at once that she is getting ready to go out into the city, arming herself against its dangers, which she is only too glad to confront.

For Kirchner, the perfect denizen of the big city is the cocotte. She is its product and reflects its character. She seems coy, yet offers herself. She tries to attract the observer's attention with sidelong glances, yet eye-contact is fleeting, as indeed any encounter with her must be. She is for sale, but not for keeps. She is dressed up to the nines, yet remains elusive. She provokes reactions, yet pretends to be aloof. She arouses curiosity, appearing enigmatic, yet behind the enigma – although we cannot be sure – there might be a great void.

The postures, movements and clothes speak for themselves. The aggressive, jagged, angular shapes of the urban architecture are taken up by those of the feathered hats, the shawls, the fur collars, the necklaces and the coats the women wear, by their narrow eyes, the contours of their mouths and noses, their hands and even their fingertips. These figures are at once products of civilization and jungle cats. Nothing embodies the character of the modern city better than Kirchner's cocottes, these ambivalent creatures whose nature seems so obvious, yet at the same time so complex.

III

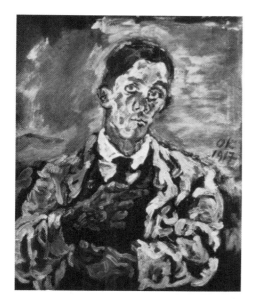

Fig. 7 Oskar Kokoschka, *Self-portrait*, 1917

Between 1911 and 1914 Erich Heckel painted subjects like the *Dying Pierrot* (1912), the *Suffering Girl* (1914) and scenes from a madhouse (*The Madman*, 1914), and was again and again drawn to themes like 'Sick Woman', 'Dead Woman', 'Tired Woman' (1912 or 1913). It was possible for a later generation to read into such pictures the reaction of a nervous, sensitive artist to the imminent and foreseeable catastrophe of the Great War: yet the real theme of these pictures was not the impending disaster – whether the artist was Heckel, Kirchner or Schmidt-Rottluff. We are more justified in discerning such a theme in the portraits which the Austrian Oskar Kokoschka painted in Berlin during these years. It has often been remarked that Kokoschka's clarity of vision enabled him, as a portraitist, to see through the faces of his sitters and to perceive their imminent decay while in their presence. There ist some truth in this observation. Yet it is equally certain that Kokoschka projected his own feelings of agitation and anguish into these portraits (fig. 7). He came to Berlin from Vienna, bringing with him recommendations from Karl Kraus and Adolf Loos, and joined the 'Sturm' circle of Herwarth Walden. He also brought with him that heightened sensitivity to all symptoms of future decline, progressive decay and universal morbidity which had evolved in the old Danube monarchy, symptoms which Alfred Kubin had described so accurately in his novel *The Other Side* (1908) and previously represented in his drawings done at the turn of the century.

The true painter of the forthcoming apocalypse was Ludwig Meidner. As an artist Meidner remained a loner all his life, despite his love of conviviality and his search for contacts with like-minded painters and men of letters. He was a great reader, especially of Hölderlin, Grabbe, Baudelaire and Nietzsche. In 1905 he walked from his native Silesia to Berlin, where he saw exhibitions of van Gogh and Cézanne. He was later drawn to Paris, where he discovered for himself the works of Picasso and the Fauves and won the friendship of Modigliani.

In 1912 he joined with Richard Janthur and Jakob Steinhardt in founding the short-lived group 'Die Pathetiker', to which Herwarth Walden devoted an exhibition in his 'Sturm' gallery. There were fleeting contacts with Kirchner, Heckel and Otto

Mueller. They felt themselves drawn to Meidner's work, but in general they found him too ecstatic, too full of exalted pathos, while he in turn found the 'Brücke' artists lacking in the kind of intensity, psychological empathy and sense of tragedy he sought.

In the two great years of his career, 1912 and 1913, Ludwig Meidner painted a series of quite extraordinary pictures, most of which he called *Apocalyptic Landscapes*, though other titles are *Burning World, Burning City, War at the Barricades, Revolution, Bombardment of a City* (1913) and such like (cat. 74-77). It is as though in these two years he had concentrated and discharged in one tremendous outburst all the energy accumulated over a lifetime.

The earth quakes and folds, the city is shaken to its foundations, housefronts are contorted and burst. Houses collapse, great ravines appear in the streets, a fiery storm blows up. Minute human figures flee in panic, not knowing where to escape to. The compositions are pervaded by a powerful uniform rhythm that leaves no form untouched. The tremendous quaking which sets everything rocking and falling and whirling seems to break forth from the earth like a seismic convulsion and at the same time to plunge down on it from the menacing cloud formations. This great shattering rhythm is not imposed from outside: it comes from within, from within the picture itself – it is part of the great expressive act of painting which embraces all pictorial forms (figs. 8, 9). This mighty rhythm, which becomes a destructive, apocalyptic force in these pictures, thus appears to be the necessary consequence of that other rhythm which Futurists and Expressionists had previously invoked to express the life and activity of the modern city, the fever and breathlessness of human existence in the age of technical civilization. It is as though the forces of progress, once awakened, were destroying themselves and devouring their own products. One may see in all this the "Mene Mene Tekel Upharsin" which a deeply religious artist writes on the wall for his contemporaries but which they are not willing to read. Or one may see this ecstatic exaggeration of the expressive style of painting as the inner consequence of an artistic and social development. It is in the obvious accord between the artistic and the social that the authenticity of these visions lies – visions with which Ludwig Meidner confronted his age and which were all too soon to be proved terribly true.

A number of German artists who survived the war were scarred by it, some more, some less, and remained affected by it long after it had ended. Among these were Kirchner, Heckel, Meidner, Beckmann, Dix and Grosz. (Macke fell in 1914, Weisgerber in 1915, Marc in 1916, Morgner in 1917...) Of those who survived it was Otto Dix who painted the most shattering pictures of the war victims – the dead in the trenches, the mutilated and crippled who survived – as the despised outsiders of society, while Grosz drew up the most passionate and angry indictments against those who had stirred up the war and then made an enormous profit from it. Beckmann translated the enormity of the events he had witnessed into disturbing parables which remind one of the fateful entanglements of ancient Greek tragedy.

Among the painters of 'Die Brücke' Kirchner reacted to the experience of war with the greatest psychic disturbance. His *Self-portrait as a Soldier* (1915; cat. 10) bears witness to this. It was preceded by *The Drinker* (1915; fig. 10), which is also a self-portrait and shows a man sitting at a table in a desperate state of mind, his face expressing helpless bewilderment. This is no drunken alcoholic, but a man seen in a critical phase of his life, who cannot go on, who seeks oblivion because he can see no other way out.

Even more radical and despairing is the situation of the artist in the *Self-portrait as a Soldier* (cat. 10). He wears his uniform as a madman wears a strait-jacket. The face is frozen into a mask, the eye-sockets appear sightless and empty. He is lifting up the bloody stump of his right arm – the hand has been amputated – and his left arm seems to be in spasm, crippled. It is as though the artist wants to use this forceful metaphor to express the idea that war mutilates man, even if it leaves him physically unharmed. At the same time this picture is meant to express Kirchner's inability to go on working as an artist. He has suffered an artistic paralysis, so to speak – and only by depicting paralysis could he momentarily overcome it. "I feel half dead with mental and physical torment," he wrote at the time to his friend and patron K. E. Osthaus.

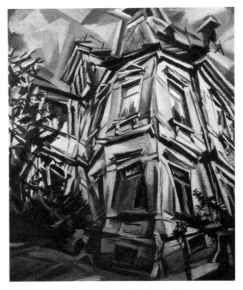

Fig. 8 Ludwig Meidner, *The Corner House*, 1913

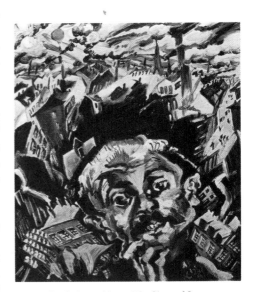

Fig. 9 Ludwig Meidner, *The City and I*, 1913

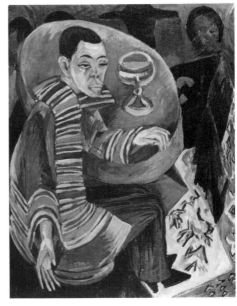

Fig. 10 Ernst Ludwig Kirchner, *The Drinker*, 1915

Fig. 11 Erich Heckel, *Springtime in Flanders*, 1916

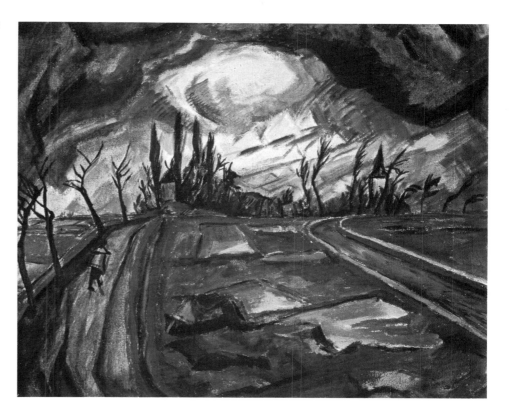

How differently Erich Heckel tried to articulate his experience of the war, by which he too was profoundly depressed. He took refuge in nature in order to overcome this mood. In 1916 he was stationed as a medical orderly in Flanders, where he met Max Beckmann and Max Kaus. In his free time he drew pictures of sick and wounded soldiers and painted occasional pictures. Among these is the landscape *Springtime in Flanders* (1916; fig. 11). It is a picture which attempts to assimilate the horrors of war by approaching them from the original experience of the world enjoyed by the artists of 'Die Brücke', putting the question – however hesitantly and softly – whether there might possibly be some meaning hidden behind it all.

Springtime in Flanders is a picture full of uneasy, restrained tension. Heckel, a lyrical artist, rarely painted anything so dramatic. The drama begins and ends in the sky. It is a storm-swept day. The sky is rent by the storm. The sun breaks through the threatening clouds. Will the weather clear? The sun behind the clouds looks more like sheet lightning. On the right is a canal, on the left a country lane, both running nearly parallel through partly flooded fields towards the horizon but without reaching it. They suddenly stop and change direction, their subsequent course unclear. The prospect is blocked by a dark barrier of bushes and undergrowth, trees and towers, farm buildings and masonry. From here the eye is led back indirectly to the sky. It is here that the real battles are being fought out. Will the light break through? A broad front of dark storm clouds is threatening to come down and obliterate everything with a curtain of rain. In the lane a man is walking, his back towards us and bending forwards, in the direction of the storm. Beside the lane are trees lashed and shaken by the wind. But are they still trees? Are they not simply stumps, bare and mutilated? Will leaves ever grow on them again?

This is one way of construing the picture. But its message is not clear. Perhaps this is only a cleansing storm, after which the clouds will drift away and the air will be pure and clear. Nature does not seem here to be finally destroyed and devastated as in Ludwig Meidner's *Apocalyptic Landscapes* of 1913. It is still full of vitalizing forces. Its harmony is impaired, but not lost. The interplay of blues, greens and yellows contrasts reassuringly with the pointed shapes of the trees, the pools and cloud formations. The spring leaves us with the hope that the great cycle of nature has not been interrupted, and that even the worst disasters cannot interfere with the perpetual alternation of growth and decay.

1905 was a significant year not only because it saw the foundation of 'Die Brücke'. In another respect it marked the beginning of an independent development of German twentieth-century art which was to have international repercussions. It was an important year for three North German painters who stood apart from the rest – and from each other – for it was in 1905 that their chosen course, which had already directed them towards an intense, emotive understanding and vividly expressive interpretation of nature, provided them with the ultimate view of the goal for which they had long been unconsciously searching. The three artists in question were Paula Modersohn-Becker, Christian Rohlfs and Emil Nolde.

In 1899 Paula Modersohn-Becker had gone to Worpswede, one of a number of artists' colonies that were springing up in Germany and elsewhere, in which creative artists sought to renew their forces by contemplating nature, away from the bustle of city life, and concentrate on their work among like-minded companions. Here she met Heinrich Vogeler and Rainer Maria Rilke and got to know her future husband, the painter Otto Modersohn. But Modersohn's views on art – like those of most of the other members of the colony – were too much taken up with a lyrical approach to nature, too reminiscent of genre-painting, for her liking. And so she repeatedly went to Paris to see exhibitions of contemporary French art and to develop her command of formal expression, which became simpler, harder and more incisive. In 1905 she saw exhibitions of Cézanne, Gauguin and the Pont-Aven group. This experience, which she began to translate into her own pictures as a matter of course, represented a decisive breakthrough. Figures like that of a pauper woman (cat. 56), of an old peasant woman, of a mother and child, of a nude girl with flowers, are painted as primeval creatures, with one-dimensional simplicity, powerful colours and little in the way of décor. The self-portraits (cat. 52) show a strong, self-confident woman who has learnt to discard not only all the elements of genre-painting, but all flourishes, arabesques and subtle nuances, and who undeviatingly goes her own way.

Christian Rohlfs was a late developer. He was nearly 50 when he first saw Impressionist art – pictures by Monet – in Weimar in 1897. The architect Henry van de Velde, who had recently been appointed director of the Weimar School of Arts and Crafts, arranged for him to meet Karl Ernst Osthaus, a patron of the arts. Osthaus invited him to join the new Karl Ernst Osthaus Museum in Hagen, and Rohlfs accepted the invitation in 1901. It was here, in Osthaus's circle, that he became acquainted with the work of the Neo-Impressionists and tried to assimilate Pointillism. However, while only too ready to set aside previous experience and commit himself to whatever was new, he had not yet discovered his own style. It was another two years before the decisive impulse came – from Edvard Munch, whom Rohlfs had met in 1904 on a visit to Weimar. In the spring of 1906, with an introduction from Osthaus, he met Emil Nolde, who was also going through a crucial phase in his development. The two men spent the whole summer painting together in Soest (where Rohlfs had painted the previous year; fig. 12). In the stimulating atmosphere of the Folkwang circle he had from now on the opportunity to follow closely all the new trends, including the work of the Fauves. Since his encounter with Munch he had gained so much self-confidence that he now needed to assimilate only a few minor elements as he moved towards the increasing freedom, lightness and spirituality which give his late work its incredible freshness. He was now nearly 60 (having been born in 1849), yet he felt that he belonged wholly to the younger generation and had an affinity with the artists of 'Die Brücke'. Pictures such as his *Amazon* (1912; cat. 59) or the *Prophet* (1917) are eloquent metaphors of this new departure with all its sensitive vitality.

Emil Nolde contributed his own highly individual tone to German Expressionism and carried it to new heights, enriching it with elements from the world of legend, nature myth and chthonic forces. He found these legendary elements everywhere in nature, in the contemplation of the surf, in dahlias and sunflowers, in the movement of the clouds, in the faces of Russian peasants, on his beloved island of Alsen or in the country surrounding his farm near Ruttebüll in western Schleswig, on his journey to the South Seas, on his way to New Guinea or New Mecklenburg, in Palau and in Java, in Burma and the Philippines. But it was not only when contemplating nature that he heard the call of legends: it came to him just as strongly when

Fig. 12 Christian Rohlfs, *The Towers of Soest*, 1916

Fig. 13 Emil Nolde,
Dance around the Golden Calf, 1916

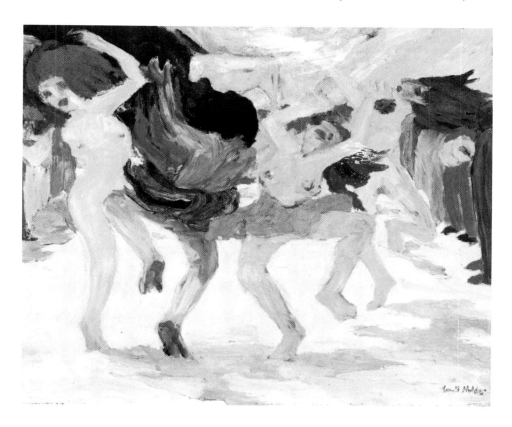

he was occupied with biblical motifs, imagining Pharaoh's daughter or doubting Thomas, when he was painting the *Dance around the Golden Calf* (fig. 13) or the *Miracle of Pentecost*, or when he turned to fairy-tale subjects such as those he painted in *Prince and Paramour* or *Devil and Scholar*.

The legendary element which Emil Nolde brought to Expressionism was nothing other than the unique colourfulness of his pictures. It is the extreme luminosity of his colours which conveys his legends. These live in the colours and cannot be divorced from them. In the work of no other Expressionist does colour glow with such uncanny intensity or burn with such unrestrained force. One of the Fauves, André Derain, once likened a tube of paint to a stick of dynamite, and one could mention a number of artists from his circle who set off explosions of colour. In Nolde's case the term 'explosion' is not quite appropriate. What distinguishes his colour is rather an intense and constant glow which seems to increase independently as one views his pictures, until it becomes hard to endure the heat.

Whereas Kirchner and Heckel, despite all the importance they attached to expression, were concerned to achieve a certain inner balance, an equipoise of composition and colouring, Nolde was not concerned with harmony, but staked everything on the expressive power of colour. Schmidt-Rottluff perhaps came closest to him in some of his landscapes, while Otto Mueller is farthest removed from him. Whereas Otto Mueller surrendered himself to his dreams of an innocent sensual paradise, now and then yielding to a sentimental nostalgia, Nolde remained vital and forceful. He was not one to indulge in reveries about nature; nature came to him for him to take her and know her.

Nolde's colour – and this is part of its magic – seems to derive entirely from the contemplation of nature, to be overtly present in nature, waiting for our eyes to discover it. Yet where in nature do we find these colours? In other words, despite all appearances, despite their power to convince, are they in fact nothing other than a psychic projection of the artist, the projection of an ecstatic sensibility? We perhaps come closest to the truth if we think of them as the result of a reciprocal process of impression and expression, as the outcome of Nolde's particular way of experiencing and reacting to nature, transforming it into pictures of orgiastic expressiveness at the moment of perception rather than during the process of painting, which is arrived at slowly and never directly. No doubt it often required no more than a slight stimulus, not necessarily a spectacular experience, to cause Nolde to see menacing mountain

ranges in approaching clouds, Dionysiac frenzy in the rapt motion of the *Candle Dancers* (cat. 71), a universal conflagration in the sunset over the sea, and liquid fire in its reflection in the water.

This expressive power of colour, which Emil Nolde achieved between 1908 and 1910 and which he used as a medium for legendary themes and nature myths, may appear as the specifically German feature of his art, but he would not have been able to evolve it without a knowledge of contemporary French painting. His first chance to study French contemporary art came when he visited Paris in 1899-1900, spending most of his time drawing nudes at the Académie Julien and copying in the Louvre. He became more deeply acquainted with it in 1906 in the circle of Karl Ernst Osthaus. It was in that year that Gustav Schiefler, the art patron and graphics collector, arranged for him to meet Edvard Munch.

Nolde was fully aware of this debt and never denied it. In 1908 he wrote in a letter to Rosa Schapire: "The big, really important battles have been fought in France. The great Frenchmen, Manet, Cézanne, van Gogh, Gauguin and Signac were the ice-breakers. The French have cut out all the old elements aiming at effect, and this is the only possible way to create an art which can be set beside the great art of the past..." The most important figures for Nolde's own development were van Gogh, Gauguin and Ensor, as well as Munch. This development took him quite close to the 'Brücke' artists, and in 1906 they invited him to join them. Nolde accepted, and in the summer Schmidt-Rottluff visited him on the island of Alsen in order to paint with him. Nolde then spent the winter in Dresden with the members of 'Die Brücke', but left the group in 1907, with no special reason for doing so.

IV

Kandinsky and Jawlensky came to Munich independently in 1896. That year also witnessed the first numbers of two of the most important new periodicals, *Jugend* and *Simplizissimus*. The two Russian painters were considerably older than the German members of 'Der Blaue Reiter', Kandinsky having been born in 1866 in Moscow, and Jawlensky in 1864 in Kuslowo. They quickly settled in Munich and might have remained there permanently if the outbreak of the First World War had not compelled them to leave Germany. In 1914 Kandinsky returned to Moscow and Jawlensky emigrated to Switzerland and they did not come back to Germany until 1921. Jawlensky then settled in Wiesbaden where he lived until his death in 1941. Kandinsky went to Berlin and in 1922 took up a teaching post at the Bauhaus in Weimar. He remained there until it was closed in 1933 when he left Germany for France, where he lived in Neuilly-sur-Seine until his death in 1944.

Kandinsky and Jawlensky both took up art comparatively late in life. Kandinsky had trained as a lawyer and had run a fine-art printing business in Moscow. Jawlensky was a cavalry officer in the army of Tsarist Russia and had attended the painting classes of Ilja Rjepin at the Petersburg Academy. In Munich the two men met while studying painting under Anton Azbé and a friendship developed between them. Kandinsky later went over to the Munich Academy in order to study under Franz von Stuck. He presided over a group of artists called the 'Phalanx' and taught at the private art school run by the group. Jawlensky worked independently from 1902.

Franz Marc (born 1880) was the only one of the 'Blaue Reiter' artists to come from Munich. August Macke (born in 1887 at Meschede near Cologne) was by temperament a typical Rhinelander. Paul Klee (born 1879) came from the district around Berne where his father taught music at the cantonal college of education. His father was German and his mother Swiss. Paul Klee came to Munich for the first time in 1898 to study under Knirr and Stuck, although he did not meet Kandinsky at that time. In 1906 he settled in Munich after a brief return to Berne. Like Kandinsky he was invited to teach at the Bauhaus in 1922. In 1930 he moved to the Düsseldorf Academy and then emigrated to Switzerland in 1933. He died at Muralto near Locarno in 1940.

The artists who made up 'Der Blaue Reiter' came from more diverse backgrounds than the community of artists making up 'Die Brücke'. The group was a much looser association of artists than the 'Brücke' partnership and it dispersed after about two

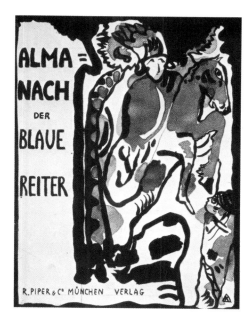

Fig. 14 Wassily Kandinsky, Cover motif of the almanac *Der Blaue Reiter*, 1911

and a half years. The artists were bound together by common ideals. They prepared a collective almanac entitled *Der Blaue Reiter* and the group took its name from this work. Joint exhibitions were organized which travelled around Germany. Yet the artists of 'Der Blaue Reiter' never developed a characteristic style. In this they again differed from the 'Brücke' artists whose style was very similar, at least initially.

Der Blaue Reiter was really the exclusive brainchild of Wassily Kandinsky and Franz Marc. It was their idea to produce an almanac and they were the editors. The original intention had been to publish the work annually (fig. 14). They prepared the important essays putting forward their aesthetic views. Franz Marc was in contact with August Macke and the latter contributed one essay and two illustrations. Paul Klee was represented by only one small reproduction, as were some of the 'Brücke' artists. Kandinsky had little time for this group, in contrast to Franz Marc who was more enthusiastic. *Der Blaue Reiter* contained a total of 144 illustrations.

The word 'almanac' was deleted shortly before *Der Blaue Reiter* was published in its final form. It essentially represented the views and opinions of Kandinsky and Marc, despite all the improvisations necessary. Kandinsky recalled in 1935: "Actually there never was an association called 'Der Blaue Reiter', neither was there a 'group' as has often been asserted. Marc and I simply took what we approved of, what we chose of our own volition, without bothering about any other opinions or desires. We decided to edit our 'Blaue Reiter' along 'dictatorial' lines. Franz Marc and myself were naturally enough the 'dictators'."

The two "dictators" also determined the content of both exhibitions which were publicized as "Exhibitions by the editors of the Blaue Reiter". These two exhibitions were held within a few months of each other in Munich. The first was held in the Galerie Thannhauser at the beginning of 1912 and the second took place at the gallery of the art dealer Goltz in March. The first was an exhibition of paintings arranged in a great hurry. The second presented work on paper, watercolours, drawings and graphic work which had been rather more carefully selected. Kandinsky's essay *Über das Geistige in der Kunst* (Concerning the Spiritual in Art) was completed in time for the Thannhauser exhibition but the volume *Der Blaue Reiter* was finally published only after the Goltz exhibition in May 1912.

Henri Rousseau was Kandinsky's great discovery at that time and he occupied the place of honour at the exhibition in the Galerie Thannhauser. Pictures by the following artists were included: Campendonk, Delaunay, Macke, Gabriele Münter, the brothers Burljuk and the composer Arnold Schoenberg. Kandinsky and Marc, the two "dictators", were of course also represented. The scope of the exhibition of graphic work at the Goltz Gallery was much wider and contained works by Delaunay and other artists from France like Derain, Vlaminck, Braque and Picasso. Paul Klee, Emil Nolde and the 'Brücke' painters were represented. Work by the Austrian Alfred Kubin was shown, as was work by Hans Arp from Switzerland, and the Russians Natalia Goncharova, Larionov and Malevich.

In some ways 'Der Blaue Reiter' had a much closer affinity to contemporary French artists than the 'Brücke' group but their approaches to art were radically different. Frequent trips to Paris brought the group into close contact with French painters and gave them intimate knowledge of new developments.

'Der Blaue Reiter' was far more alien to the French way of thinking than the vital and aesthetic sensuality of 'Die Brücke'. Work by the Slavs Kandinsky and Jawlensky revealed a prevailing mood of mysticism. Searching piety was displayed by Franz Marc, an erstwhile student for the priesthood. Mysticism, piety and the sombre earnestness of Paul Klee were the antithesis of the endeavours which at that time were proving so innovatory in Paris. Kandinsky, Macke and Marc really only felt that they had found a common spirit when they encountered the Orphism of Robert Delaunay.

Kandinsky had seen Monet's *Haystacks* as early as 1885 at an exhibition of French Impressionists in Moscow. Later he endowed the initial confusing impression conveyed by this picture with crucial significance: he felt it had sparked off his idea of an abstract art. From Munich he was a frequent visitor to Paris. In 1904 he took part in the opening exhibition of 'Les Tendances Nouvelles'. After 1904 he regularly exhibited in the 'Salon d'Automne' and was elected to the judging committee. From

1907 he showed work every year in the 'Salon des Indépendants'. Between 1906 and 1907 he lived with Gabriele Münter in Sèvres near Paris and then finally returned to Munich after a winter in Berlin.

Jawlensky's contacts with Paris were also close. In 1903 he visited Paris and Normandy, in 1905 he travelled to Brittany and Provence and in the same year he showed ten of his works at the 'Salon d'Automne' in Paris where he met Matisse. Close contact with the Fauves proved a tremendous source of inspiration to him. In rapid succession he assimilated the ideas of Gauguin and the Pont-Aven school, and those of Cézanne, van Gogh and Matisse. In 1907 Matisse invited him to work in his studio.

Franz Marc was deeply affected by the Louvre and the Impressionists during his trips to Paris and Britanny in 1903. On his visit to Paris in 1907 van Gogh made a profound impression on him. August Macke came to Paris in 1907 to study the Impressionists and during his stay in 1908 he became preoccupied with Cézanne, Gauguin and Seurat. Marc and Macke met in 1910 and in 1912 they travelled together to Paris in order to meet Delaunay. This trip also yielded closer contact with Apollinaire.

Paul Klee paid his first visit to Paris in 1905 and did not return there until very much later. He travelled with Louis Moilliet who also accompanied Klee and Macke to Tunisia in 1914. Goya, Puvis de Chavannes, Manet and Monet made the strongest impact on Klee. He first encountered pictures by van Gogh in 1908 at galleries in Munich where he also saw pictures by Cézanne and Matisse in the following year. He did not see works by Rousseau and Delaunay until 1911 at the 'Blaue Reiter' exhibition.

The artists who were later to come together in 'Der Blaue Reiter' directed their focus on developments taking place in Paris: Neo-Impressionism, Fauvism, Cubism and Orphism. Their interest in Paris was intense and it would not seem unreasonable to assume that their attention was riveted on Paris and that events in this city shaped the direction of their art. But a cursory glance at the *Blaue Reiter* almanac suffices to show that this was certainly not the case. The volume demonstrates an intellectual independence and confidence which it would have been hard to find outside Paris at that time.

The combination of texts and pictures provided the truly explosive quality of the *Der Blaue Reiter*. It was a fusion of images from antithetical cultures, regions and periods. The reader moves unrestricted and detached through different stages in the history of the mind, he rises and plunges from one extreme to the other. He is overcome by the immediate power of expression in the most varied testimonies to man's creative will, by unlikely juxtapositions and confrontations. We see the elongated figure of St John reaching high into the clouds (the background reminiscent of the hills of Toledo) by El Greco, rediscovered here as an Expressionist. He stands next to Robert Delaunay's *Eiffel Tower* stretching up to a cloudy sky in rhythmic, dynamic transitions. A ballet sketch by August Macke contrasts with a woodcut of battling stallions in a herd of wild horses by Hans Baldung Grien. Henri Rousseau is placed next to a child's drawing and the portrait of Dr. Gachet by van Gogh accompanies the grotesque features of a man with apes from a Japanese woodcut, while the gravestone of a knight in Frankfurt Cathedral is juxtaposed with the bronze relief of a warrior from Benin. Strange affinities spring up, spanning continents and centuries. Unexpected relationships are revealed. Scarcely reconcilable contrasts meet (fig. 15-18). The whole publication was a unique document which juxtaposed original and authentic forms of human expression. It collected phenomena of fundamentally similar status which had never before been united in a single volume.

A cursory enumeration would read like a confused miscellany. In fact it was anything but that. *Der Blaue Reiter* was certainly not composed according to a strict method, neither was it a systematic compendium of all the controversial artistic phenomena of the period. Rather, it was a spontaneous and inspired improvisation which had a tempo of its own moving from one entry to the next, yielding an overpowering. fascinating, unifying resonance despite weaknesses, gaps and discords. Seventy-five years later this work has lost none of its freshness and power of excitement.

Fig. 15 August Macke, Ballet Sketches from the almanac *Der Blaue Reiter*, c. 1910

Fig. 16 Russian Folk Scene from the almanac *Der Blaue Reiter*

Fig. 17 Bavarian Glass Painting from the almanac *Der Blaue Reiter*

Kandinsky expounded on principles in his erudite (and revolutionary) essay 'On the Question of Form', and Franz Marc confessed the necessity of the path he had chosen. But August Macke conveyed the spirit of 'Der Blaue Reiter' in the most moving, poetic form:

"A sunny day, a cloudy day, a Persian spear, a christening font, a heathen idol, a wreath made of everlasting flowers, a Gothic church and a Chinese junk, the prow of a pirate ship, the word pirate and the word holy, darkness, night, spring, the cymbals and their sound, and the bombardment from a battleship, the Egyptian sphinx and the beauty spot on a Parisian cocotte...

Fig. 18 Egyptian Shadow Figures from the almanac *Der Blaue Reiter*

Intangible ideas are expressed in tangible forms. Tangible through our senses as stars, thunder, flowers, as form. To us form is a mystery because it is an expression of mysterious powers. Only through form are we able to divine the hidden powers, the 'invisible God'. The senses form the bridge from the intangible to the tangible. To look at the plants and animals is to experience their secret. To listen to the thunder is to experience its secret. To understand the language of forms is to be, to live nearer the secret. To create form is to live. Are not children creators from the secret of their perception? Are they not more creative than the imitators of Greek form? Are not the savages artists who have their own form, as strong as the form of the thunder? Thunder speaks, the flowers, each power manifests itself in form. Also Man. An inner urge drives him to find words for concepts, order out of chaos, conscious out of the unconsciousness. His life is his creation. Like Man, his forms change..."

This more or less summed up the vision of 'Der Blaue Reiter'. It was expressed in the spirit of the almanac and in the art of its originators Kandinsky, Marc and Macke in the period between 1910 and 1914. The extremely varied development of the individual artists which evolved as they encountered diverse problems, can only be briefly summarized here.

Around 1909/10 Kandinsky's style appears fully developed and Franz Marc had found his métier by 1911 (fig. 19). Barely a year later August Macke also evolved his own idiom and a characteristic mode emerged rather later in Paul Klee's work after his trip to Kairouan. The spiritual background against which the individual artists brought their work to maturity yields three main intellectual aspirations. The first involved the fundamental unlimited freedom in all artistic endeavour. They "suddenly stood as if dazzled by the immeasurable freedom of art," Franz Marc said of the 'Brücke' painters. "They know no programme and no compulsion; they only want to go forward at any price..." Kandinsky possessed a far more methodical mind than Marc but insisted that the perfect freedom of artistic expression, which he

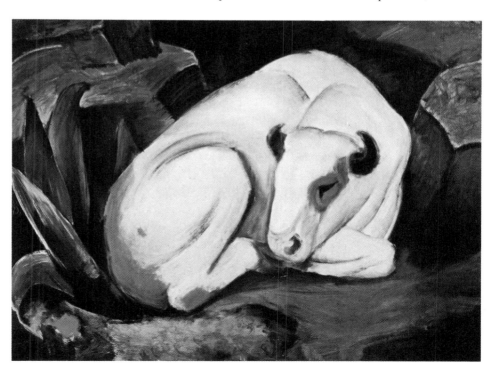

Fig. 19 Franz Marc, *The Bull*, 1911

demanded no less vehemently, had to coincide with the consciousness of inner necessity. "Most important in the question of form," he wrote in the almanac *Der Blaue Reiter*, "is that the form should have grown out of inner necessity."

Synthesis was the second theme which concerned the artists. Franz Marc complained that there was already almost too much talk of synthesis. Perhaps he had Jawlensky in mind since he had a particular affinity for synthesis. Artists of 'Der Blaue Reiter' did not only understand synthesis to mean a unity of stylistic developments in terms of colour, form and movement as in Fauvism, Cubism and Futurism. They also interpreted synthesis as the quintessence of all those philosophical, religious and intellectual ideas which were universally discussed. They considered that in the face of all the contradictions it might be possible to integrate the essential aspects of these ideas in a single unity. The word synthesis had a further, even greater significance to 'Der Blaue Reiter', but above all to Kandinsky. A discussion of synthesis always suggested the idea of synaesthesia to him, the link between different art forms, particularly between painting and music, to form a *Gesamtkunstwerk* (total work of art) or at least an integration of artistic and musical principles of composition. Colour tones and scales, abstract harmonies could be integrated as they underwent parallel development in both media.

The third thesis concerned the embodiment of art in mysticism. "Mysticism awakened in the soul and brought to life primeval elements in art," wrote Franz Marc. Invoking mysticism posed the problem of the purpose of art. What purpose does art serve if it is not embedded in man's innermost being, if it is not in harmony with nature's laws of formation and growth, if traces of cosmic bonds are not visible in its forms? Thoughts of German Romanticism, theosophy and phenomenology are interwoven in this aspiration. To Kandinsky they appeared to be unified constructively and organically in the new media and methods evolving in painting. At the end of his essay *Concerning the Spiritual in Art* he went so far as to predict the dawn of a "great spiritual epoch."

At the beginning of the century Kandinsky's paintings combined elements of *art nouveau* and memories of Russian folklore transfigured in fairy-tale form. While he experimented with Neo-Impressionism and then Fauvism he also made a study of nature. This development during the first decade of the century showed a steady progression culminating in an exuberant use of colour. A turning point occurred during his stay at Murnau in 1908 when he made a radical break and concentrated on the landscape. Until that point his landscape studies had always depicted theatrical processions of knights and princesses on horseback which gave them a truly Wagner-

Fig. 20 Wassily Kandinsky, *Improvisation 21 a*, 1911

Fig. 21 Wassily Kandinsky, *With Three Riders*, 1911

Fig. 22 August Macke,
Mounted Indians by a Tent, 1911

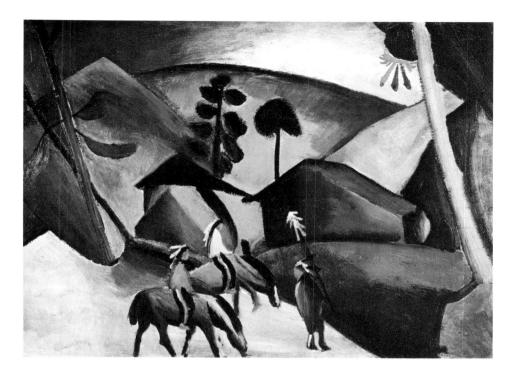

ian flavour. He now devoted all his attention to the landscape, using it as a basic pattern or foil for a rich orchestration of colour. Increasingly this became detached from the image of nature and adopted the "tonal qualities" of musical compositions to form tonal harmonies.

Wassily Kandinsky's art had its origin in the aesthetic, philosophical visions mentioned above. Art historians usually view his great achievement as the leap to abstraction and the creation of the abstract picture. Whether this achievement may be actually ascribed to the work of a single individual is a question that has often been discussed. To some extent it was certainly inherent in the spirit of the time, leading artists in different places with different backgrounds to produce similar results concurrently. This controversy need not be explored here.

We do not consider Kandinsky's major achievement of the century to be his creation of the first purely abstract watercolour in 1910. His achievement lies rather in the series of his "impressions", "improvisations" and "compositions" which he produced in the years between 1909 and 1914. They testify to a great spiritual adventure ending in a complete and dynamic departure into virgin territory (fig. 20).

We may regard these series of works and the associated studies as abstractions, as stages in a process involving abstraction of forms in nature, but they cannot be construed as pure abstract painting. The main titles and the frequent addition of an alternative title underline the survival of objective reminiscences. These continue to be significant for the subject of the picture in terms of content and form.

If we want to classify Kandinsky's series of pictures between 1909 and 1914 according to their true character we ought to describe them as cosmic landscapes. They are landscapes filled with indications of objects, symbols for mountains, valleys, rivers and clouds with church towers as landmarks. There is usually a rider or group of riders driven unceasingly, hounded by a mysterious power, by the urge for discovery, spiritual discovery: driven to meet colours and forms as concrete entities (fig. 21).

Kandinsky is the rider travelling over unknown terrain, a terrain whose forms seem familiar but which are not yet clearly revealed. They awaken associations and then withdraw again. They depict an area, a region whose motifs become less and less legible but which point to a coherence of all being, to a spiritual context, even if the figure of the rider is not yet able to discern it.

It seems appropriate to draw a comparison here with August Macke, an artist close to Kandinsky. Macke was obviously impressed by the rider figure and he took up the idea of a spiritual adventure expressed in Kandinsky's "Improvisations". He transformed it into a much more secular, earthly context which was easier to com-

prehend. I am thinking of pictures such as *Mounted Indians by a Tent* (1911; fig. 22), of which there are also various drawings like the mounted *Indians at a Watering Place* (c. 1912). It is clear that this is seen more through a child's eyes, more naïvely and much more narrowly. So many youthful dreams and childhood ideals are bound up here. And yet such a picture may be interpreted as a simile, a metaphor in a manner reminiscent of Kandinsky.

The important precepts in Franz Marc's work were "the inner truth of things" and the "mystical inward" construction of the picture. He attempted to extract the elements of crystalline form structures from his experimentation with Cubism to reproduce his animal forms. He observed animals with the deepest sensitivity, viewing them as innocent products of the divine plan of creation, and portrayed them purged of all representational and anecdotal influences. His decisive break-through occurred only after his meeting with Macke in 1910. Macke directed his attention to colour. This instantly inspired Marc, recalling memories of his trip to Paris in 1907 when the power of colour in the pictures of van Gogh had made such a profound impact on him. The crystalline structure corresponding to the pure es-sence of animals, plants and the countryside had to combine with the freedom of the expressive symbolism of colour liberated from the world of appearance. Only in this way could Marc explore that "inner truth of things" which was so important to him.

Macke was far more concerned with the secular world than his more spiritually motivated friends. For him the creative process meant "imbuing nature with joy." His light-hearted personality and irrepressible curiosity were at once contrasting and enriching, a source of inspiration and restraint to the more intellectually inclined members of 'Der Blaue Reiter'. Of all the painters in 'Der Blaue Reiter' one can most easily imagine Macke as belonging to 'Die Brücke', at least during certain phases of his brief creative period. For the 'Brücke' painters, colour and experience were supremely important. This is reflected in the 'Brücke' manifesto of 1906: "Anybody who directly and faithfully reproduces their creative source is one of us." 'Der Blaue Reiter' in addition revealed parallels with music – a subject of frequent discourse – and a deep-rooted tendency towards mysticism. Macke was always more concerned with immediate experience than ponderous reflection on the essence of life. The role played by the colour, the mode of experience and the choice of subject situated Macke oddly between 'Die Brücke' and 'Der Blaue Reiter'. In the end, perhaps, the spirit of his art lends itself more to classification within the context of Rhenish Expressionism than to membership of 'Der Blaue Reiter'.

In certain of his works August Macke reveals the experience of the big city in common with Kirchner. The city fascinated him as much as it did the 'Brücke' painter. August Macke was much more of a wanderer than Ernst Ludwig Kirchner and he walked through the streets of the city as if it were another form of nature. At first the city was nothing more than a nature 'tamed'. He was especially interested in the vegetation, the parks, the zoo with its zebras, herons and parrots. In winter the peaceful, snow-covered townscape resembled the ordered layout of the vegetable fields which had appealed to him in the landscape. He painted children playing in the garden backed by house roofs and a church tower, a woman knitting on her balcony with a row of flowerpots, tree-lined avenues and people out for a stroll, patrons in a garden restaurant or on the terrace of a coffee house. August Macke always presents domesticated nature, the town is permeated by nature, reconciled with her, with an abundance of open spaces and bordered by parks. Nature appears in the fruit shops and greengrocers, and even seems to reside in the boutiques whose windows are a favourite haunt for women. Macke's pictures of the city culminated in these boutiques which attract ladies with their parasols, gazing at hats in all shapes and colours balanced on slender stalks. Without doubt Kirchner's vision of the modern city was the result of harsher experiences seen in less congenial terms. His rhythm and the staccato of his structures are more abrupt, and the colour of his faces and clothes more aggressive. This tallies with the more primitive nature which Kirchner experienced, nature appears much less sophisticated, quite lacking that sense of harmony and music. Despite this difference in outlook they both retain the common fusion of experiences from nature and the city to form a view of the modern world phenomenon. This coalescence of city and landscape unites Kirchner and Macke despite all the differences in their temperament and fate.

V

The situation confronting the Post-Expressionists after defeat in the First World War was parallel to that which had motivated Expressionist painters in 1905. They were striving to come to terms with the disaster which had engulfed Germany and at the same time to renew contact with developments in Paris and elsewhere, particularly in Zurich and in Italy. In 1905 artists had been unable to relate to their own traditions, to the so-called German Impressionists, and had felt compelled to look beyond the borders of Germany. They had gained experience in their quest for stimulus by looking to France, but also to great individuals such as Munch, Ensor and Hodler. The new generation of painters which emerged between 1918 and 1920 did not believe they could derive inspiration from the pre-war generation, from the German Expressionists. In protest against Expressionism they looked to Paris, but also to Zurich, Rome and Amsterdam. They believed that only there (as well as in older traditions deeply rooted in their own culture) would they be able to receive the impulses which they needed in order to react to the tremendous upheavals of their era. They were keen to adopt anything that could help them in their quest for new developments in order to respond in their own idiom. In a period in which 'reassessment of all values' and the 'Decline of the West', 'alienation' and 'revolution' had become common slogans there could be no infallible artistic foundation. This atmosphere generated a frantic search for new forms as well as rapid changes in the style of many artists during the initial post-war years. Pictures demanded expression: pictures to meet the era on its own terms, to clarify their existence, pictures to formulate their anger and overcome their *angst*.

If we compare the receptivity of German artists to foreign developments around 1918/19 with that at the beginning of the century we must not let a decisive difference escape our scrutiny. In the years immediately after the turn of the century all was surging forward towards complex forms and more strident expression of colour. Now a mood of restoration was sweeping Europe. After the destruction of the war people were seeking to re-establish classical standards, particularly in art. There was a desire to return to an artistic language which was comprehensible to a wider audience, to reconstruct the ruins. Artists were striving to attain a synthesis of old and new, fusing the modern elements which had become part of the general consciousness with traditional elements which had been sustained. Jean Cocteau expressed this prevalent mood most eloquently in his famous essay *Rappel à l'Ordre* (Call to Order). In the mid-1920s he used this slogan as the title of his collected essays from that period.

Although written for specific occasions, these essays are of general interest. Cocteau's great fondness for classical spirit and style enabled him to propagate the re-adoption of older form models, but did not exclude their ironic violation or overthrow, i. e. the element of paradox. He felt that in Paris the continued adherence to avant-garde values had in turn become a convention. His non-conformist attitude prompted him to react with the following paradox: recourse to the style of bygone epochs was to present a special type of innovation; by looking back the artist could only progress more clearly and confidently. Cocteau was preoccupied with the future of style, and this prompted him to doubt the exclusive validity of a particular style. This led him to the paradox that it is important to have *style*, not just *one* style.

Here Jean Cocteau was alluding to the pluralism of style evident in Picasso's work during those years. Picasso had begun to paint his series of 'neo-classical' pictures. These were figures which seemed to be endowed with the primeval vitality of ancient myths. Whilst executing these pictures he continued to create works in the style of synthetic Cubism. Picasso was painting concurrently in these two styles as a matter of course and around 1918 he created both a 'neo-classical' Harlequin and a fragmented figure in Cubist style. This parallelism of different styles continued in Picasso's work well into the 1920s.

The 'neo-classical' or 'Ingristic' Picasso (German art critics dubbed him thus when his style of drawing resembled that of Ingres) was therefore one of the models for the painters belonging to the 'Neue Sachlichkeit' (New Objectivity) movement in Germany. Others were: Henri Rousseau, to whom Kandinsky had so emphatically referred and on whose power and naïvety he had based his conception of a 'Great

Realism'; Fernand Léger, in whose work man appears as engineer of a new age, reconciled with technology and the modern industrial world; André Derain and Auguste Herbin, who had moved along different paths and diversions from a Fauvist phase via a 'gothic' and 'decorative' phase to achieve a strict realistic idiom. Apart from Rousseau and Picasso the most important stimulus was that provided by the art of the Italians, the Metaphysical Painting of Giorgio de Chirico and Carlo Carrà. German artists encountered these painters mainly through the well-known periodical *Valori Plastici*.

This specific Realism of the 1920s prepared in the art of Picasso and a few French artists, and in the art of some foreigners living in Paris, spread quickly to other countries and did not remain an exclusively German phenomenon. Like Expressionism, Objective Realism was a European phenomenon. There were striking examples in England, Switzerland, Austria, Belgium, the Netherlands and Scandinavia. For a time the New Realism in its various forms patently dominated the artistic scene in Italy and the United States ('The American Scene', a phenomenon centred in New York during the 1920s, becoming more disseminated during the 1930s). In Germany it also played a special, if not a dominant, role. This Realism was one of the foremost artistic forces at that time. In importance it equals the main concurrent movements: Expressionism which was receding into the past; the impressive role of the Bauhaus masters; the Dada centres in Cologne (Max Ernst), Hanover (Kurt Schwitters and his *Merzbau*), Berlin (Raoul Hausmann and Hannah Höch). The neglect accorded it by critics, collectors and museums belies its importance.

Compared to other countries, Realism in Germany embraced a wealth of talent during the 1920s and became disseminated to form a wide spectrum of artistic endeavour. It encompassed both an ardent Verism and the cool sober tone of 'Neue Sachlichkeit', as well as the neo-classical idyllic mood of Magic Realism. Essentially it was the aggressive social commitment of its leading exponents which radically distinguished Realism in Germany from related phenomena in other countries. Otto Dix, George Grosz and Rudolf Schlichter were without parallel. Artists like John Heartfield, Hans Grundig and Otto Nagel, and the early work of Georg Scholz and Davringhausen, all expressed the uniqueness of the German brand of Realism. Their art has decisively moulded our view of the period covered by the Weimar Republic. Their active participation in socio-political conflicts shaped intellectual life in those years and endowed it with incisive asperity, in the same way that the progressives in literature, theatre and film used contentious themes to politicize their work. This does not diminish the power of their canvases, watercolours, drawings and graphic work. Rather it negates the direct effect of any art if its relentless descriptions are only assessed aesthetically, if its pleas are set aside or ignored and its warnings disregarded. Art was just as impotent in preventing the demise of the Weimar Republic as were literature and the stage.

Individual pictures of 'Neue Sachlichkeit' castigated the circumstances prevailing in the Weimar Republic with biting, all-embracing satire. This is best illustrated by one of the most famous pictures by George Grosz, *The Pillars of Society* (1926; cat. 129). In this work George Grosz encapsulates the essence of his socio-critical graphic cycles. We find the representatives of society with their characteristic attributes and traits: *the* Chauvinist, *the* Press, *the* Politician, *the* Military, *the* Church...

Below right the man with the sabre in front of a beer table, the 'old man' of a student fraternity, is a caricature of a cavalry officer and bigot. Hugenberg appears above him on the left, the bourgeois press baron with a chamber pot as a tin hat. In one hand he holds a palm branch and in the other he holds a pencil like a lance. To his right stands an obese man with a flag in his hand, a typical example of the conservative politician. A pile of shit steams out of his empty head. Above him stand an officer with a drawn sabre and a cleric who blesses everything including the fire which is already consuming his house. A new global conflagration is heralded here, for which the "Pillars of Society" bear the guilt.

The themes which occupied 'Neue Sachlichkeit' were essentially those which the Expressionists had already confronted: the image of the modern city (fig. 23), the image of humans cast in the mould of the cities, and the image of the country. Aggressive contemporary allegories like *Pillars of Society* were a condensation of these themes. Exponents of 'Neue Sachlichkeit' had a stronger interest in the signs of the

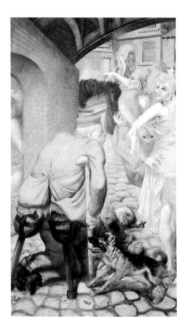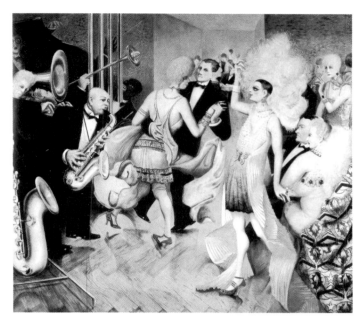

Fig. 23 Otto Dix, *City Triptych*, 1927/28

present, in the industrial world and its designs. They were also interested in the still life, the 'still life' of inconspicuous items in daily use which indirectly reflect human presence, work, sensitivity. This replaced the interest in exotic subjects, like negro sculpture and primitive art. If Nolde was spellbound by the ecstatic devotion of the *Candle Dancers*, Dix was captivated by dance-halls, jazz bands and the social set in evening dress on the dance floor. Nolde followed dreams. Dix was looking at reality. Nolde saw the unity of Man and Nature while Dix encountered the realities of well-heeled businessmen and spent prostitutes. Meidner had portrayed apocalyptic visions of a doomed world shattered by eruptions and consumed with fire. Dix, Grosz and Schlichter described with merciless accuracy the victims of the catastrophe, the war cripples, the mutilated and the disabled who had been disdainfully relegated to the fringes of society.

Christian Schad took a particular interest in society's outcasts. He discovered them in *Agosta the Pigeon-chested Man and Rasha the Black Dove* (1929; cat. 173), two figures who appeared at a funfair in the north of Berlin. Agosta disported his physical deformity and Rasha appeared as an artiste entwining herself with an enormous snake. Schad painted them in a sober manner as objects devoid of any romanticism, objects of our curiosity, our desire or our revulsion. Schad also often depicted women as objects in his pictures. In his *Self-portrait* (1927; cat. 172) the mistress is branded as the property of her lover with a razor cut on her face. This was a custom which Schad had often observed during his stay in Naples at the beginning of the 1920s. The figures do not look at each other and remain separate. Even the act of love cannot unite them. In the same way the Count in *Graf St. Genois d'Anneaucourt* (1927; cat. 171) is an outcast. He is at home neither in the world of the Salons nor in the Bohemian milieu which obviously attracts him, a stranger in both worlds. Man as an outsider and an object, estrangement of the sexes: these are three central themes of 'Neue Sachlichkeit', of which Christian Schad was only one exponent.

The differences in choice and interpretation of the themes in 'Neue Sachlichkeit' and Expressionism correspond to a completely different style of painting. Paintings of 'Neue Sachlichkeit' were not executed summarily but were realized with painstaking care, the use of a fine brush giving a detailed representation. These pictures were constructed like a collage from individual observations of different particles of reality without regard for the laws of perspective or the unity of space. The mode of experience which had motivated the Expressionists was no more, and with it had disappeared their trust in the gesture of the human hand. Gone was the gesture which can capture the world organically in a brush-stroke. This mode of experience had originated in the implicit correspondence of outer and inner nature, of world and man. It had taken for granted that man could transform the unity he experienced

when looking at nature ('in front of the subject') into a new unity. The transformation would be effected in his art, through his temperament and mode of seeing.

The Expressionist saw the world as a whole and he felt strong enough to reproduce it from the wholeness of his experience. The picture was coherent, held together by the gesture of the painting, the natural interplay of colour and form and the concurrence of all the elements. The expression of the painting might differ radically from the outward appearance. Yet hidden connections remained which established a firm bond between the image of nature and the picture created by the artist.

For the painters of 'Neue Sachlichkeit' this way of experiencing the world was irretrievably lost. The world appeared to them fragmented, broken, disintegrated. It now remained to fit it together like a jigsaw puzzle, piece by piece. In the process it often transpired that the fragments could no longer be fitted together. A fundamental mistrust in the reality of appearances bound together the painters of 'Neue Sachlichkeit', the Verists and the exponents of Magic Realism. Their task was the reconstruction of reality, using the artistic means which appeared suitable to them. Many details of their pictorial reality show reality to be artificial and contrived. Nowhere did they attempt to conceal this, in fact they emphasized the fragmentary, composite character of reality. This enabled them to confer greater truth and a harsher impact on the details with which they wanted to confront the observer. They frequently stressed horrific detail, never suppressing it in a harmonizing picture of the world. They believed such detail should be retained in the picture, stark and void, thereby inducing a more sustained sense of shock in the observer (fig. 24).

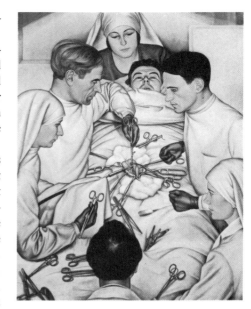

Fig. 24 Christian Schad, *The Operation*, 1929

This reconstruction of reality grew out of opposing artistic positions. The exponents of 'Magic Realism' often vainly attempted to cement the disintegrating fragments together again, hoping to recall the image of an erstwhile harmonious world. Conversely individual exponents of 'Neue Sachlichkeit' and Verism did their best to expose the numerous cracks and dichotomies in our modern existence.

The painters of 'Neue Sachlichkeit' adopted the techniques of collage and montage for this reconstruction of the reality they experienced. These were new forms which had been developed by the Cubists, the Futurists and in particular the Dadaists. Exponents of 'Neue Sachlichkeit', especially Dix and Schad, combined these new forms with the experiences they had gained from the study of old masters. They were united in rejecting the exuberance and ecstasies of Expressionism, yet it must not be overlooked that almost all these painters had gone through an Expressionist phase at the beginning of their careers. They were partially influenced by Cubism, then by Futurism for a time and Dada had had an enduring effect on their painting. Dix, Grosz, Schad and Schlichter were all affected by these currents to a greater or lesser extent.

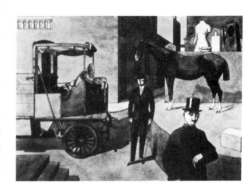

Fig. 25 Rudolf Schlichter, *The Dead World*

Grosz and Schlichter (fig. 25) and also Hausmann (fig. 26) were additionally influenced by the enigmatic, theatrical world of de Chirico and Carrà which they discovered in *Valori Plastici*. Stereotyped buildings with deceptive perspectives here appeared as backdrops. The juxtaposition of utterly incompatible elements conveyed an uncanny effect and possessed some of the quality of a collage. The figures were made of stone or plaster, consisted of wooden frames or appeared as mannequins or marionettes. Grosz transformed the mannequins of the *Pittura Metafisica* into war cripples and amputees with artificial limbs who function like robots (fig. 27).

Although the painters of 'Neue Sachlichkeit' never experienced significant problems of form, their choice of technique was deliberate. They adapted techniques which appeared most suitable for capturing reality and reproducing it in the most direct and faithful manner.

None of them believed in visions nor did they put forward any new ones. This distinguishes them from the artists of the Bauhaus. Their political involvement was directed towards concrete and attainable objectives rather than visions and utopias. They were more concerned to express sympathy for pariahs and anger at the cynicism of the ruling classes. On the whole they tended more towards sobriety and scepticism than to lasting commitment to an idea.

This fact emerges from the biographies of the individual artists as well as from the development of 'Neue Sachlichkeit' as a whole. All the participating artists were in a

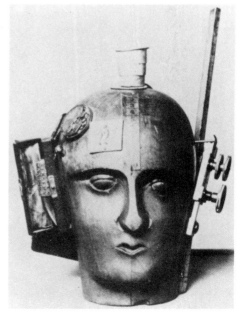

Fig. 26 Raoul Hausmann,
The Spirit of Our Time, 1919

more or less revolutionary phase. They were filled with a ferment of unrest in their search for the forms most suited to their purpose. Extreme positions attracted them in politics. These were the origins of the form which they discovered in the mid-1920s, and they succinctly expressed the mood of their epoch in a series of incisive satirical pictures. At the end of the decade this power seemed to disappear. The visual form mellowed and the inner drive became dulled.

VI

Max Ernst was one of the artists who in 1919 discovered the work of de Chirico. He too encountered it in the journal *Valori Plastici* at the gallery of the Munich art dealer, Hans Goltz. His was a more radical interpretation and the result proved far-reaching. At about that time he was beginning to assimilate Dadaist ideas in collages and montages, and he combined these ideas with the images of Metaphysical Painting, which led him to develop Surrealism.

Max Ernst's historic achievement reveals a systematic fusion of the artistic principles of Dada (principally collage) with the essential elements of Metaphysical Painting. Without this achievement we might never have seen the emergence of Surrealist painting. André Breton initially envisaged Surrealism purely as a literary movement and it was Max Ernst who convinced him of its inherent visual possibilities. In contrast to so many German painters who discovered their artistic métier through French painting, Max Ernst was himself a source of inspiration. This said, Surrealism like Dada was essentially international: in addition to the Italian precursor de Chirico, painters from all over Europe made substantial contributions to the movement: the Spaniards Miró and Dali, Masson and Tanguy from France, the Belgians Magritte and marginally Delvaux, and individual artists from England, Scandinavia, Czechoslovakia and Germany (in addition to Max Ernst, Hans Bellmer and Richard Oelze).

Collage was the decisive development for Max Ernst and became the basis for all his endeavours. He himself regarded the way in which he came across collage as a lucky find. He viewed its discovery on a "rainy day in 1919 at a town on the Rhine" as a "revelation", an "epiphany". He wrote about it in the guise of a legend and he describes his discovery of frottage, the other great find of his life, in similar terms.

Max Ernst's adaptation and development of collage from 1919 endowed the concept with a completely new meaning. For him collage meant the sudden and unexpected convergence of two disparate realities chosen at random, whose meeting released something new, a spark of poetry which casts a completely new light on the incongruous realities united in the collage. It opens an involuntary fusion to a series of fantastic interpretations and associations which are far removed from their origin and which lead to something quite new.

The nucleus for an innovation crystallized in 1919 when the discovery of the collage technique and the impressions derived from de Chirico's paintings coalesced in the personality of Max Ernst. This innovation was Surrealist art. First, the impression had an effect on the collages themselves. The irritation caused in de Chirico's works by antagonistic perspectives, vanishing lines and a system of planes can be found in collages such as *dada in usum delphini* (fig. 28). The mannequin figures of de Chirico and Carrà acted as models for the fashionably dressed women in *Fiat Modes Pereat Ars* (fig. 29). The picture *Aquis Submersus* (1919; fig. 30) is perhaps the first significant painting by Max Ernst. It portrays a submerged 'Piazza d'Italia'. The flooded square has become a swimming-pool and the arcades have been turned into changing cubicles. The moon is reflected in the water and has hands like the station clocks on de Chirico's Renaissance buildings.

In 1919 Max Ernst published the lithograph folio *Fiat Modes, Pereat Ars* in Cologne (using money which he had received as unemployment benefit). In 1920 he created the series of *Fatagaga* collages together with Arp and Baargeld. He showed his collages for the first time in May 1921 in Paris at the 'Exposition Dada Max Ernst'. According to Louis Aragon it was "perhaps the first manifestation... to permit an insight into the sources and thousand methods of a completely new art." *The Elephant of Celebes* (cat. 149) came into being in the same year and this marked the beginning of his series of proto-Surrealist pictures. In the autumn of 1922 Max Ernst moved to

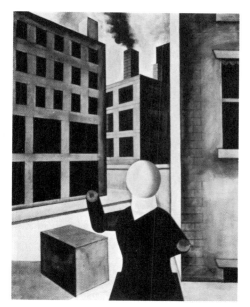

Fig. 27 George Grosz, *Untitled*, 1920

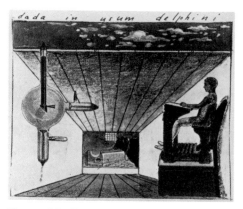

Fig. 28 Max Ernst, *dada in usum delphini*, 1919

Fig. 29 Max Ernst, *Fiat Modes, Pereat Ars*, 1919

Paris where *Les malheurs des immortels*, the book which he had prepared together with Paul Eluard, was published. Ernst nominates Dostoevsky and de Chirico as the two poles of his inspiration in *Rendez-vous of Friends* (fig. 31).

The Elephant of Celebes clearly shows how Max Ernst achieved the transition from Dada to Surrealism: a reinterpreted image originating in his collage world is placed on de Chirico's space stage. This gives it stability, it appears suspended in a complex milieu and has a more sinister and threatening effect.

In an English anthropology journal Max Ernst found a reproduction of a Sudanese clay grain vessel set on two massive 'feet'. He transformed it into a metal monster identical in shape and added a tube-like trunk, a hollow bull's head and horns. He topped the work with a Chiricoesque construction which appears to be made of draughtsman's instruments, forming a crown or antenna. A thick metal band encircles the colossus, violating all sense of space. A column and a headless mannequin stand to the right. Everything casts intrusive shadows. The plane receding to the horizon is bounded by a mountain range.

Max Ernst not only transposed his collage configurations on to de Chirico's space stage; he also took over elements of his iconography. William S. Rubin considers *Swaying Woman* (1923; fig. 32) to be a typical example of "Ernst's proto-Surrealist amalgam of de Chirico and Dada collage." The impress of de Chirico is present in

Fig. 30 Max Ernst, *Aquis submersus*, 1919

Fig. 31 Max Ernst, *Rendez-vous of Friends*, 1922

the adaptation of the space stage, the transparent style of painting and in elements of the iconography. His influence is visible in the two mighty columns reminiscent of chimneys or towers and in the isolated stone in the foreground. On the other hand it is unclear whether the figure of the swaying woman is derived from Duchamp or from the tailor's dummies of the *Pittura Metafisica*, or whether it is a result of Max Ernst's own iconography and collage work.

After 1922 Max Ernst's own creations were manifested with increasing strength on the space stage prepared by de Chirico: hermaphrodites made from nature and machines, animated relics from the pre-industrial world. Ernst's iconography and imagination gradually penetrate the deserted spaces of a 'metaphysical' landscape. Pipes and tubes slowly burgeon out of the earth, monsters stir themselves in the shells of dead equipment, metallic forests slumber. De Chirico had banished anything organic from his pictures. This petrified world had now been overcome.

The development is most obvious in a picture like *Saint Cecilia* (1923; cat. 148) which represents a triumph for the technique of collage both formally and thematically. The irrationality of the collage is full of vigour. It undermines the petrified orders which have become alien to us, and causes them to collapse. These anachronistic orders are represented here by a plaster mould of the clay model created for the equestrian statue of Louis XV. The plaster mould, divided into little numbered pieces, had been reproduced in an old book as an illustration of the casting

Fig. 32 Max Ernst, *Swaying Woman*, 1923

process. Finding it there, Max Ernst combined it with the figure of Saint Cecilia, using his collage technique. He reinterpreted the fragmented plaster mould as a chamber in which the blind Saint Cecilia, patron saint of music, sits immured. There seems to be a melody within her, and her hands reach out into the void as if to play it on an invisible piano.

Saint Cecilia was an early Christian saint. According to legend she was betrothed to a heathen, she had to endure torture and imprisonment and was finally beheaded. The organ and broken musical instruments are her iconographic attributes. The plaster mould almost completely encloses the figure of the saint. Max Ernst joined the individual components of the plaster mould with metal bars reminiscent of a spark-producing induction-coil. The sparks can rescue the immured figure and restore it to life.

The petrified visual world of de Chirico is represented here in the plaster mould of the cast model. It appears unsteady and on the point of collapse. The stone statues which de Chirico loved so much are crumbling, they are nothing more than plaster coverings. The spark of poetry invoked by the collage technique reveals the fragility of the plaster forms and will cause them to shatter. The sparks ignite and produce energy. Ernst's creatures are coming back to life in their immurement and are beginning to liberate themselves.

This picture represents a work created in the spirit of Surrealism, a year before André Breton's famous manifesto.

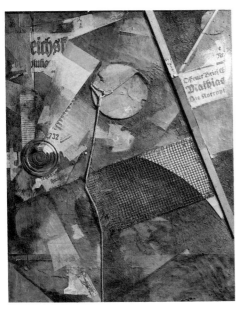

Fig. 33 Kurt Schwitters, *Constellation*, 1920

The collage technique of Kurt Schwitters from Hanover achieves quite a different effect to Max Ernst's collages. He does not aim at evoking a startling meeting of opposed realities in order to shock the observer into heightened awareness. Harmonization and reconciliation of unrelated particles of reality are his objectives. Of course it is not a superficial 'reconciliation' in Schwitters's work. It is not a reconciliation which can be easily attained. Shock, surprise, perplexity can and should precede it. The harmony which Schwitters strives for has two levels, which serve to prolong their effect.

Max Ernst was particularly concerned to endow his collages with the character of representational suggestion. He was interested in the chain of associations which they set in motion for the observer, and in the succession of interpretations. In contrast, Kurt Schwitters wanted the individual elements of his collages to undergo much greater 'deformalization' and 'dematerialization'. He wanted to liberate them from any prescribed functions and free them from all close ties and conditions. His collage elements take a few steps along the road to abstraction without ever becoming completely 'abstract'. It is not, however, permissible for them to lose completely the memory of their origin, their specific identity and the individuality of which they have been bereft.

Everything should be left undecided, maintaining a special balance between abstraction (as a general impression) and immutable originality (of the individual elements).

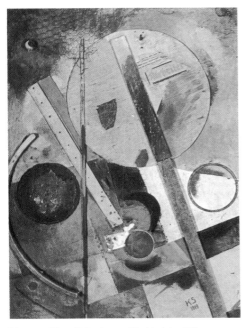

Fig. 34 Kurt Schwitters, *The 'Arbeiter' Picture*, 1919

The meeting of unrelated objects and the contradiction of different realities were central to Max Ernst's work, giving his collages the high tension which ignited the electric sparks and enabled them to arc across. Kurt Schwitters attempted to achieve a secret congruity between the elements which he brought together. His collages signified the combination of unrelated elements from a fragmented world, which 'in reality' belonged together. For Kurt Schwitters this 'reality' was art. Art brought together elements which modern civilization had separated, torn apart, disunited, alienated (figs. 33, 34).

Kurt Schwitters's point of departure was always Dada, even if this did not always remain central. "Dada and Merz belong together as opposites," was how he once described his position, but his objective took him a long way from his starting point. His aim was to produce a new type of *Gesamtkunstwerk* in which he wanted to combine all the disparate, fragmented, disunited parts of our life. It was a construction which had to be preceded by destruction. His collages, montages and assemblages were combinations of completely unrelated elements, objects and materials. We can describe them as poetic constructions but they were constructions whose components had had to undergo a process of 'deformalization', 'decontamination', metamorphosis.

This process of metamorphosis did not end with the destruction and subversion of the context in which the elements had originally been integrated. It was not satisfied with liberating them from their prescribed functions. The process continued in the stage of construction which combined the elements in a new unit, making them respond to, and 'evaluate', each other.

Kurt Schwitters created a *Gesamtkunstwerk* in the *Merzbau*. He constructed it in his house in the Waldhausenstrasse 5 in Hanover (it was destroyed in an air-raid in 1943). He worked on this construction for fifteen years from about 1921/1922 to 1937 when he left Germany and emigrated first to Norway and later to England. The *Merzbau* reflects how the term 'Merz', with all its contradictory meanings led him to a *Gesamtweltbild*, a total view of life. The different phases of the *Merzbau* reveal the different facets of a complex artistic personality which gradually grew into one inseparable unit.

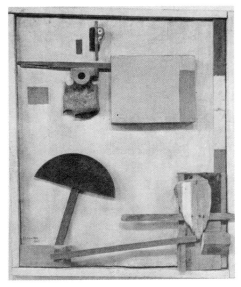

Fig. 35 Kurt Schwitters, *Untitled*, 1923

Kurt Schwitters's work is at once banal and spiritual; it provokes and harmonizes, combines the contemporary with the classical. He constructed collages and montages by nailing and glueing *objets trouvés* into his own creations. The *objets trouvés* he incorporated were the detritus of everyday life, used and worn-out things: tram tickets, chocolate wrappings, admission tickets, cloak-room discs, beer mats, pieces torn out of newspapers, but also glass splinters, chicken-wire, pieces of string, wood shavings, pram wheels and the lids of tin cans. If he used unconventional materials his aim remained the creation of art in the classical sense (fig. 35). His confirmed definition of art did not really sound Dadaist at all. He only became provocative and innovative when using materials to realize that definition. He postulated that "art is an original idea, sublime like the deity, unfathomable like life, indefinable and without a purpose." He set about creating this art out of fragments of reality from the gutter, the lumber room, the rubbish tip and from dustbins. Nothing about these elements was precious. Association with them threatened the artist with disqualification rather than ennoblement.

This is precisely what is so unusual in the achievement of Kurt Schwitters: he created a new cosmos out of all these discarded, miserable, dirty things. They appear in that cosmos as kindred equal elements in the work of art, like canvas or wooden board and the colours from the factory.

Kurt Schwitters's experience of reality was in fact no different from that of his contemporaries in that he too experienced a wicked and fragmented world devoid of sense. He perceived his task to lie in gathering up the fragments of the world in order to combine them in an immutable order. Initially it had been no more than a whim which prompted him to gather remnants of material and pieces of paper. His ultimate aim was to show that life at that time was worth living and that it could be experienced with a sense of purpose and fulfilment.

Merz was created at the end of the First World War. "I had to broadcast my jubilation [about the end of the war] to the world at large," said Schwitters. "Thrift compelled me to take what I could find because we were an impoverished country. It is quite possible to cry out with refuse, and I did this by glueing and nailing it together. I called it 'Merz' but it was my prayer of thanks for the victorious outcome of the war. Once again peace had triumphed. Everything had been destroyed anyway and everything had to be constructed from the ruins."

VII

Max Beckmann regularly appears in three connections during discourses on German art: his vital early work in the Post-Impressionist style, then in the context of Expressionism and later in that of 'Neue Sachlichkeit'. His later work marks him as the great loner, creating extensive mythological portrayals of the time which fall into no category.

All three classifications have their justifications, but their definition of his work is too constricting. Max Beckmann did not grow out of Post Impressionism, Expressionism and 'Neue Sachlichkeit' to become a unique figure in German twentieth-century art. He was not wholly part of the movements mentioned, even in the periods when he was closely associated with them or generally accepted to belong to them.

Fig. 36 Max Beckmann, *Resurrection II*, 1916

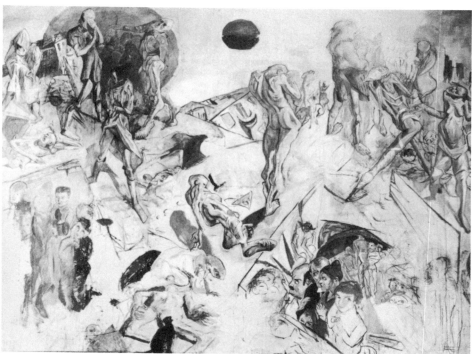

Fig. 37 Max Beckmann, *Deposition*, 1917

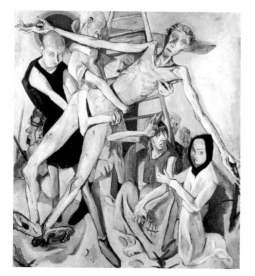

It is almost impossible to associate his early work with any contemporary movement in art, and his paintings were steeped in the traditions of the old masters. They essentially tended towards Realism and repeatedly depicted contemporary events (*The Fall of Messina*, 1909; *The Sinking of the Titanic*, 1912/1913). During a six-month stay in Paris in 1903 he was far more impressed by Delacroix than by Cézanne.

Beckmann's painting underwent a profound change as a result of his experiences in the First World War, and he adopted contemporary forms. Although his pictures now display aspects of Expressionist style – in works like *Resurrection II*, 1916-1918 (fig. 36), and *Deposition*, 1917 (fig. 37) – he is not motivated by the Expressionist vision of a uniform world which is found in Kirchner and the 'Brücke' painters. Beckmann's art is equally remote from 'Der Blaue Reiter', from Franz Marc's crystalline forms and from the enthusiastic colour of August Macke.

By virtue of his pictures of the immediate post-war period and the early 1920s Beckmann has also been ascribed to 'Neue Sachlichkeit'. The exhibition from which the movement derived its name took place in 1925 at the Kunsthalle, Mannheim. The director, Gustav F. Hartlaub, gave Beckmann a prominent place by including five of his pictures. He included a further collection of Beckmann pictures when the exhibition travelled around Germany.

Although Max Beckmann did not consider himself to be a member of any group or movement, the formula 'Sachlichkeit' (objectivity) appealed to him. He saw it as combining the two concepts 'Gegenständlichkeit' (figurative art) with 'Genauigkeit' (accuracy). His fondness for the term is already expressed in his letters from the front in 1915 when he says he "has tried... to express everything essential directly, but always... in contact with objectivity." In 1917, in a foreword to a catalogue for the Galerie I. B. Neumann, he described "objectivity towards the inner faces" as the aim of his work. In 1918 he spoke in his 'confession' of "transcendental objectivity" as being the principle of his art. Objectivity contained both vision and reality, the formula "transcendental objectivity" indicating how the metaphysical shines through the physical world. In a marginal note (made in 1934) in *Die Welt als Wille und Vorstellung* he called Schopenhauer an "objective mystic," underlined the phrase and commented: "Yes, agreeable."

The problem of the reason for our existence, the demand for knowledge of its metaphysical basis and the search for mythical order in the randomness of everyday life made Max Beckmann grow out of the bonds of 'Neue Sachlichkeit' despite his affinity with the way in which the movement regarded detail. This is shown most clearly in the different roles which objects were assigned by Beckmann and by the

artists of 'Neue Sachlichkeit'. Objects had become so important to the painters of Objectivity because they appeared to be the last fixed entity one could grasp amidst the downfall of the old orders in religion, philosophy and politics. In Beckmann's work objects are loaded with meaning and full of hidden allusions. They never appear isolated and unrelated.

To Beckmann, objects are always both things and images. They exist within the context of a stage and play their part in the great world theatre, even though we may not immediately apprehend their role. At first, the artist is only a witness to this theatre but as time passes he learns to approach the figures with more confidence and finally becomes involved in the action and the creation of the universe. He is both king and jester, plays the part of martyr and clown and acts the criminal and victim.

The demand for 'Objectivity' was applied more and more exclusively to the depiction of individual objects and not to the context they appeared in. The 'objectivity' of detail is replaced by the power of the "inner visions" and subordinated to visions of space.

Space meant to Beckmann what colour did to Nolde. It was the great theme which dominated his life.

"In the beginning there was space, this uncanny and inconceivable invention of the supreme power," said Beckmann. He returned repeatedly to this subject. "Space – space – and again space, the infinite deity which surrounds us and of which we are a part. It is this which I am striving to create in my painting." This was how he described his work in a lecture on his painting which he delivered on the occasion of the exhibition '20th-century German Art' at the New Burlington Galleries in London in 1938. "For me the metamorphosis of height, breadth and depth into the two-dimensional plane is a magical experience which gives me an inkling of that fourth dimension for which I am searching with all my soul."

How did he achieve this? How could Beckmann create his vision of space in his painting and convey to us an impression of that fourth dimension for which he was searching? The old illusionistic, perspective space had lost its validity for him as it had for de Chirico, and like the Italian he attempted to realize his experience of space by including many different individual perspectives in the same picture. As in de Chirico's paintings everything has its own perspective. In Beckmann's case this meant above all giving every figure its own perspective. Every object, every figure creates its very own space.

The picture space is thus filled with many mutually contradictory perspectives. There is a struggle between the forces of the forms and figures which create space, and the different 'psychic spaces' within the picture conflict and contradict. The enigma of space in Beckmann's work arises from its totality and from its complex interlacing and confluence.

It is a space that is not dependent on a viewpoint and simultaneously repels and includes its viewer; a space of apparent confinement but with a depth that the observer cannot resist; a space which transposes proximity into distance, and where the background suddenly becomes the foreground. It is a space filled with an almost incalculable profusion of objects but where there is still room for great breadth and diversity of perspectives; a space with a wealth of contrasts and yet with an overpowering illusion; a space which eliminates our sense of direction, an infinite space which fragments and coalesces and which forms a continuum in spite of the legion disruptions and abrupt transitions. It is a space loaded with tension which is scarcely bearable. Whoever enters this space gives himself up to a manifold spiritual reference system which has the character of an inescapable fate.

This space gives significance to everything which it contains. It lends dignity and aura to the most unobtrusive item and the smallest detail.

Of course this significance can rarely be deciphered. Beckmann is fond of leaving it open. He shows us that there is a secret hidden here but not what it consists of. The meaning of his pictures often remains hermetically sealed and ambiguous. We know that he devoted a lot of time to the study of Schopenhauer, Indian philosophy and classical mythology, Gnostic esoteric doctrine and Cabbala. Many of the ideas, the dialectic of reality and the transience of all being contained in these theories, is incorporated into his pictures. Often it only appears to be suffering, doubt or anguish which holds the figures in the world, imprisons them in space.

Fig. 38 Max Beckmann, *The Night*, 1918/19

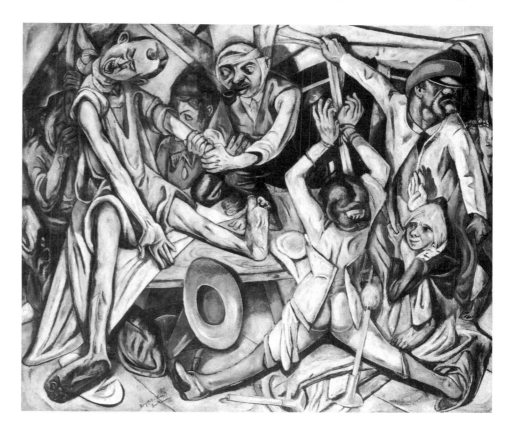

Beckmann's understanding of space was not permanently fixed from the beginning. Only as time passed did his concept truly develop in complexity and undergo subtle changes. In the pictures executed in the 1920s, probably beginning with *The Night* (1918/1919; fig. 38), the figures possess their own space and bring forth the interlacing and blocked space system. From the late 1930s the space became more powerful so that it dominates the figures (fig. 39).

Max Beckmann expressly named the "great void and uncertainty of space" in his London lecture in 1938. He called it "God." Another time he described space as the "palace of the gods." This sounds definite without being so. God, the deity, the gods – for Beckmann these are certainly not entirely positive qualities. The face of the gods is ambivalent. They cause good and evil. They are responsible for what happens. Space as deity confers life and takes it away. In his later pictures it often appears a continuum of blackness.

Immediately after the First World War Max Beckmann told a visitor: "In my pictures I accuse God of everything he has done wrong."

It was just this which Beckmann did all his life.

VIII

Oskar Schlemmer introduced a new image of man into twentieth-century German art. He had created it during his period at the Bauhaus and had experimented with it in various media.

If we regard it as a new image of man, we must ask ourselves what there is about it which is new. In order to be able to answer this question we have to consider the image of man put forward by other prominent artists of that time.

The image of man of the 'Brücke' painters was coincident with their experience of nature. For them the world was still concrete and could be experienced as a whole. Man moved about in it as naturally and freely as the *Four Bathers* of 1910 by E. L. Kirchner or his *Nudes in the Sun* from the same year (reworked in 1920), or Heckel's *Bathers in a Bay*, 1912. Immediately one notices the difference between the image of man held by Kirchner and that of his colleagues in the artists' community of 'Die Brücke': in the work of Heckel, Schmidt-Rottluff, Mueller and Nolde, man was reflected in nature, whereas in Kirchner's work, everything was reflected in the image of man – nature, the city. For Schmidt-Rottluff and Mueller, man is com-

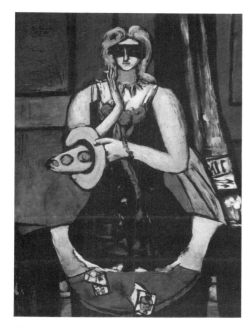

Fig. 39 Max Beckmann, *Carnival Mask, Green, Violet and Pink (Columbine)*, 1950

pletely embedded in nature. He is much more vulnerable in the work of Kirchner and Heckel.

Man remains an empty form in work by Franz Marc. He appears as a reclining nude, a shell waiting to be endowed with a living soul. A purer, higher form of existence is presented in the animal: it is the overt radiance of the animal soul which imbues Marc's pictures with spiritual life. Otto Dix painted man as a being following his natural urges. Man is entirely governed by urges. He is a being of instinct, consumed by sorrows, or exhausted, extinguished, lifeless. Behind the façade of culture Otto Dix shows us the animal and the vital aspects of human nature. He discovers an animal vitality in the lust for life exhibited by his war cripples, yet behind their façade he tentatively illuminates a questionable 'culture'.

He did this coolly and exactly without any suggestion of moralizing of sentimentality. For him instinctive human nature was an immutable fact. It had to be accepted without comment as part of nature.

The human image appeared at its most complex in Max Beckmann. Man assumes many forms in his work. He is a spiritual being and an instinctual being, ruler and jester, warrior and prisoner, and usually a combination of all of these. He is a loner and craves company, he looks to the stars and is chained to his environment, he is an actor who has been taken over by his role, a braggart and a soldier of fortune. Then again he is extremely reflective and ready to set out for unknown foreign climes.

Yet this is not a 'New Image of Man'. Cervantes, Stendhal, Dostoevsky and Hamsun did not see man any differently. Beckmann portrayed man in a plethora of surprising and unexpected situations, but we always recognize him in his dreams, his fears, his vanity, aspirations and sadness.

Of all the artists from this period the sculptor Wilhelm Lehmbruck came closest to Oskar Schlemmer's image of man. It is as though he had created its predecessor. Lehmbruck's figures are spiritual beings, rising up to the cathedral, dashed to the ground by the power of the times; contemplative, kneeling beings of incomparable tenderness, vulnerable, fragile, who seem destined to pay the ultimate price for aspiring to the spiritual (fig. 40). It is as though Oskar Schlemmer had chosen this very image as his starting point, prompting him to create humans with the same spirituality who were less vulnerable, unassailable, constructed for a harsher reality and capable of overcoming their fate.

Wilhelm Lehmbruck's fine-limbed figures aspired to the spiritual, stretching up on high and crashing to earth, but they did not provide the point of departure for Oskar Schlemmer's art. This is to be found elsewhere. Biographically speaking, it may be detected in his student years at the Stuttgart Academy. He studied there under Adolf Hoelzel between 1906 and 1914 with a few interludes. From 1912 he had his own studio as Hoelzel's postgraduate student. Spiritually, the starting point for Oskar Schlemmer's art lies at the dividing line between German and French art. This line passed right through the centre of his being. Schlemmer was fully aware of this and he often reflected on the division in his diaries. Indeed it is a key theme in all his writings, as in a letter to Otto Meyer-Amden in April 1913: "On the one hand the artists of form, and mystics on the other."

Instinctively Oskar Schlemmer was drawn to German artists who were closest to the form (i.e. to the 'French' side). Conversely, the French artists who appealed to him most were the ones in whom he found strains of mysticism, spirituality, metaphysics (i.e. the 'German' side). He found his gallery of spiritual ancestors in artists like Memling, Cranach, Holbein and, from the nineteenth century, Philipp Otto Runge, Caspar David Friedrich and Hans von Marées. Schlemmer's guiding theme is encapsulated in the following words by Runge: "strict regularity is of the essence in all art which springs from imagination and from the mysticism in our soul." This statement united both poles of his artistic sensibility in a live field of tension.

Cézanne, the Cubists and Delaunay were the French artists to whom he devoted the most attention. He constantly returned to Cézanne as if drawn by magic. He was also fascinated by Mondrian, van Doesburg and the Russian constructivists.

A further constant in his life was his love for German Romanticism. He was particularly drawn by their relation to numbers, figures, proportion, geometry, to their mathematical formulae and equations of the world. He studied Novalis, Bren-

tano and Jean Paul. He was fascinated by Kleist's essay *Über das Marionettentheater* with its confrontation between 'Puppet' and 'God' and by E. T. A. Hoffmann's tale on the Sand-man with the life-size puppet Olympia, the perfect artificial creation.

Let us return to the biographical genesis of Oskar Schlemmer's art. It was bound up in the friendships he formed during his time at the Stuttgart Academy which he retained throughout his life. While he was studying at the academy he got to know Otto Meyer (who later called himself Otto Meyer-Amden after his adoptive home) and Willi Baumeister in quick succession. The three felt spiritually drawn together and exchanged thoughts and ideas even though they never considered forming a group.

Otto Meyer-Amden was three years older than Oskar Schlemmer, being born in 1885 in Berne, and he was particularly important in the development of Schlemmer's art. In the spring of 1911 they painted their first mural together, depicting the *Annunciation*. In 1912 Otto Meyer-Amden moved to the artists' colony in Amden, near Weesen above the Walensee (in the Canton of St. Gall), but did not break off his contact with Schlemmer and Baumeister. Schlemmer showed pictures by Meyer-Amden (in addition to pictures by Kandinsky, Klee, Marc, Kokoschka, Braque and others) at his short-lived 'Art Salon at the Neckar Gate' in 1913. During the same year he visited his friend in Amden. An extensive correspondence kept them in close contact until Meyer-Amden died in January 1933. In this correspondence Schlemmer revealed to Meyer-Amden artistic problems with which he was beset, plans and doubts which he otherwise kept to himself. Following his death Schlemmer (who had meanwhile been summarily dismissed from his teaching post at the United State Schools in Berlin) administered Meyer-Amden's estate. In the Kunsthaus, Zurich, he arranged a large memorial exhibition which he opened with a eulogy.

Otto Meyer grew up in an orphanage. His mother died while he was young and his father, a blacksmith, sent him to live with another family as a foster child, whence he was sent to an orphanage. Otto Meyer grew up in the regimented atmosphere pervading this establishment, an experience which left its stamp on his personality. His studies and travels took him to Munich, Strassburg, Paris and the Stuttgart Academy. His journey ended in Amden where his experiences in the orphanage came to the surface again and became the dominant theme in his work. He recalled past memories of the boys' community and these memories completely overcame him. During these years an inner figure formed in Meyer-Amden, the figure of a child without parents, an orphan. The references and connections where this figure is located have an ambiguous character. The boys' community must replace the parental home. It provides protection. And more: it almost attains a mystical quality. Childhood mystery and magic surrounds the community. Yet this community also signifies a certain narrowness, an obligation, the restriction of precepts and rituals.

We spoke of a 'New Image of Man' for which German art is indebted to Oskar Schlemmer. The starting points for his work lay in his relationship with Meyer-Amden. The experience of the figure of youth contained in a community preceded the image of man which Oskar Schlemmer developed. This experience would not have led further if Oskar Schlemmer had not given it a form in which it has become familiar to us. 'Mysticism' and 'form' had to find each other and unite. The impulse which Schlemmer had received from the remote world of Meyer-Amden needed to be metamorphosed into a valid, modern form in order to be effective.

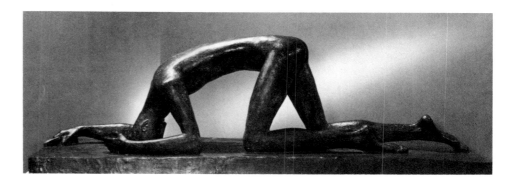

Fig. 40 Wilhelm Lehmbruck, *The Fallen Man*, c. 1915/16

This form was not merely a fortuitous event. Schlemmer had to extract it from years of hard work, drawing on a source of endless patience. There were many stages to his process of artistic development which began around 1912. He experimented consistently with techniques of style used by the Cubists and his figures underwent a process of stylisation and depersonalization. He decided to apply absolute two-dimensionality to his pictures, to heighten colour and to use abstract elements of composition with their constitutive integration within the framework of the picture. Finally he took the radical step from surface space to multi-perspective space, thereby departing from the pure contour of the figure and giving it physical reality.

When Oskar Schlemmer went to Weimar to join the Bauhaus in January 1921 the process of development for his figure studies was not yet complete. Initially Schlemmer taught life drawing, mural painting and stone sculpture. But he needed another experience in order to bring his form to complete fruition: that of the stage. Schlemmer took over the design of the stage sets for two one-act operas by Paul Hindemith which were performed at the theatre in Stuttgart. He continued to be fascinated by the opportunities this afforded in terms of a coalescence of people, space, costumes and movement. His *Triadic Ballet* emerged from this interest and in 1923 he assumed control of the Bauhaus stage. He adapted and transformed his experiences with the stage to his painting. This helped him to perfect the character and form of his presentation of man in space. By 1923 he had fully developed the style of his figure compositions.

Oskar Schlemmer grew out of the original experience with Meyer-Amden's figures of youth when he developed his own form. This emotional experience was now nothing more than a distant memory, the experience of being an orphan and being part of a protective yet oppressive community, comforted rather than illuminated by the candlelight in the schoolroom, the refectory or the chapel. Schlemmer's figures are so much stronger and freer, more resilient than the youths by Otto Meyer-Amden. They are so much more modern, more independent. But even these figures are surrounded by an air of mystery. They too are without parents. They also stand related to a community which is at heart alien to them. They are together with others in a space, they appear to form a group but they remain alone (fig. 41).

For Oskar Schlemmer the human form in a field of tension between functional and tectonic structure remained the central theme throughout his life. This form remained for him "always the great allegory for the artist." He voiced this for the benefit of his colleagues who were encouraging him to adopt a more abstract approach. But Schlemmer remained steadfast in his adherence to figurative constructivism.

"The human form [is] a being bewitched by space," he once said, and the relation between man and space is also the great theme of his essay *Mensch und Kunstfigur* (Man and Art Figure) which he published in a book on the stage at the Bauhaus. Stage is world, ballet is life, the figurine defined by spheres, cubes, pyramids, etc. is man. Or, more precisely, stage is world in time; in a particular epoch the stage is dependent on, and formed by the time in which it is realized. Ballet is life as movement, life reduced to its most simple elements, life reflected in its incipient forms of expression. While designing his Essen murals in 1928 Schlemmer said: "The human form offers the visual artist such a wealth of expression in its simple functions like the inclination of the head, raising of the arms, gestures of the hand, position of the leg, etc. that themes like standing, coming, going, turning round and similar movements suffice to fill the life of a painter."

The figurine is man, man as dancer, as actor, moving, performing, man in costume, in disguise, and that means undergoing metamorphosis, change, renewal. Schlemmer's essay *Man and Art Figure* offers the important sentence: "Everything mechanizable is mechanized. Result: recognition of the unmechanizable." At another point Schlemmer calls it "the metaphysical", a word which he loved and which he used again and again.

Schlemmer succeeded in expressing visually this variable relationship between man and space in a series of figurines appended to his essay *Man and Art Figure*. The happy synthesis is found in the "art figure", in the dancer: "It follows both the law of the body and the law of space."

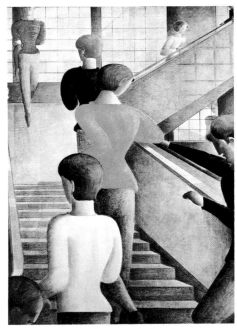

Fig. 41 Oskar Schlemmer, *Bauhaus Steps*, 1932

Fig. 42 Oskar Schlemmer, *The Mannequin*, 1924

Fig. 43 Oskar Schlemmer, *The Symbol of Man*, 1924

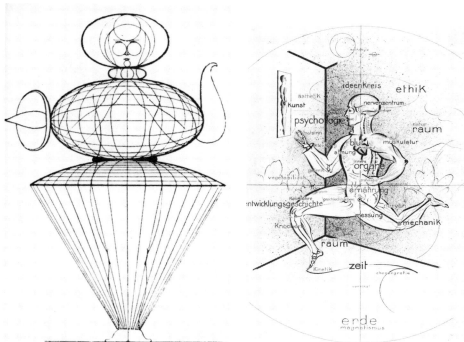

Fig. 44 Oskar Schlemmer, *Walking Architecture*, 1924

Fig. 45 Oskar Schlemmer, *A Technical Organism*, 1924

Fig. 46 Oskar Schlemmer, *Man in the Circle of Ideas*, 1928

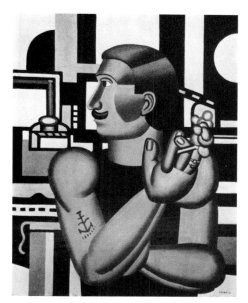

Fig. 47 Fernand Léger, *A Mechanic*, 1920

The subtle choreography which Schlemmer developed in his stage work, a subject of constant reappraisal, also determines the relationship of man and space in his pictures. His aim – or perhaps we should say his utopia – is the final victory of man over space. Yet this victory would signify not triumph but harmony, reconciliation and peace. Geometry has always been integral to space, at least space conceived and built by man. Geometry must now come to man's aid, for the construction of the human form. He said, and it reads like a resumé of his life's work: "Numbers, measure and law shall be our arms and tools, that we may not be engulfed in chaos."

Oskar Schlemmer's pictures do not show the world as it is, they show how it could be. They are constructions which are related to a conceivable reality. A kind of concrete design, a foundation, an outline of a potential world, potential spaces, potential people. Schlemmer's figures possess something temporary and typological. This should not be misconstrued. It is their general open, conceptual aspect. They are suggestions which we can adopt, designs which we can enter, constructions which we can occupy. They are forms which life has not yet fully accepted and which it has not yet completely fulfilled. They are suggestions of form made in cones, spheres, cubes, cylinders and ovoids; suggestions which can all mark only initial stages in the gradual metamorphosis of man into the mathematical, rational, spiritual realm – no more. They are not 'counterparts' of man, only a typology of forms, de-individualized; a typology of forms which can be occupied, vacated and then reoccupied, an allegory of earthly immortality (figs. 42 - 46).

We can regard the human figure which Schlemmer designed as a parallel of the human type which Léger created. Léger's vision is that of man who takes his life into his own hands, the free worker in a classless society, the engineer of the future.

This type appears in Léger's picture *The Mechanic* (1920; fig. 47). Shaped in the mould of technology, this mechanical engineer at the same time forges technology and is reconciled with it. This type has the strength to master the future. Schlemmer's figures are also related to technology and mechanics without which they are inconceivable, but they possess a different outlook. Their aim is to survive time and to this end Oskar Schlemmer has provided them with the appropriate tools. At the same time his figures do not want to lose sight of the mystical dimension, mysticism here being understood as a sober term akin to that used repeatedly by Wittgenstein.

This is self-evident if we compare Schlemmer's picture *Paracelsus, The Legislator* (1923; cat. 188) with Léger's *Mechanic* from 1920. In Léger's picture, man trusts in his physical strength, experiencing it as the organic correlative of the physical power of technology. Schlemmer's picture depicts a corporeal, spiritual being, not a strongman but a thinker. He is not flexing his muscles like the mechanic but holds up an

admonishing index finger, as if to attract our attention. His mouth is still closed but once we are ready to listen he will speak. His eyes fix the observer and prevent him from looking away. Paracelsus saw a mirror of the macrocosm in man as microcosm. All Oskar Schlemmer's figures were intended to indicate this.

Lyonel Feininger, perhaps more than any other artist, internalized the spirit of the Bauhaus as it was originally conceived by Walter Gropius. It was no accident that the pamphlet published by Gropius in 1919 outlining the programme was illustrated with one of Lyonel Feininger's woodcuts. His cathedral, enclosed by streams of energy and bundles of lines, was the visual equivalent to Gropius's demand that all artistic "works had to be filled with architectonic spirit" to avoid being lowered to Salon art. Walter Gropius's vision was that the "structure of the future" would unite architecture, sculpture and painting and "ascend to heaven conjoined as a crystalline allegory of a coming faith." This sounds like a paraphrase of the pictures which Lyonel Feininger painted in this period, designs which transformed the wealth of Cubist forms into crystalline, transparent structures. Viewed from today's perspective Feininger's structural visions are a melancholy commentary on the aims which the Bauhaus wanted to achieve in everyday experience. They project its aims to an unattainable, unearthly distance, banish them for ever into the realm of utopia (fig. 48).

Fig. 48 Lyonel Feininger, Woodcut for the Founding Manifesto of the Bauhaus, 1919

IX

Many great pictures were painted by German painters during the years in exile. Among these works are the pictures painted by Max Beckmann in Amsterdam, the silent apocalyptic vision *Expectation* painted by Richard Oelze in Paris (cat. 198), the tense allegories of coming horrors by Max Ernst: the increasingly threatening series *Barbarians moving West* (1934/35) and the series *Angel of the Hearth* (1937; fig. 49), truly destructive angels which will not allow anything living to escape. The beginning of the war brought a change of mood. The invocation of approaching hordes and monsters had suggested an unassailable dynamic which now gave way to an eerie silence. This silence was taken up by Max Ernst in a number of important pictures: *A Little Quiet* (1939), *Europe after the Rain* (1940-42; cat. 152), *Eye of Silence* (1943-44), *Rhenish Night* (1944; fig. 50). In such a period of outer upheaval he expressed silence, after being interned in France in 1939, then fleeing and being interned again by the Gestapo and then finally escaping to New York.

Wols suffered the same fate. He was interned more than once in France. After eventually being released he had to go into hiding in Marseilles, constantly pursued by German troops. During these years he painted mainly miniature watercolours in which the Surrealist "automatic writing", permeated by objective motifs, gradually gave way to the passionate freedom of Tachism. Wols's luggage consisted of nothing more than a banjo, a spirit flask, watercolours, a rusty spring, two moth-eaten brushes, a knapsack and a suitcase full of stones from the beach, pebbles, shells and

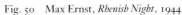

Fig. 49 Max Ernst, *The Angel of the Hearth*, 1937
Fig. 50 Max Ernst, *Rhenish Night*, 1944

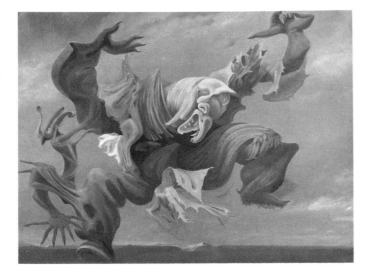
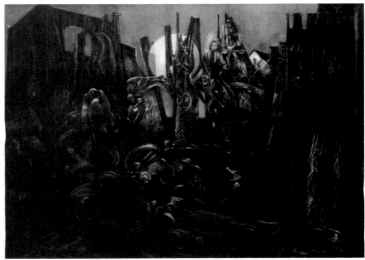

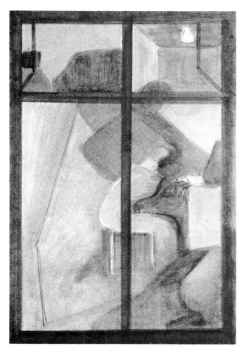

Fig. 51　Oskar Schlemmer, *Room with Sitting Woman in a Pink Dress – Window Picture VII*

Fig. 52　Willi Baumeister, *Tennis: Figures with a Black Oval*, 1937

crocks. To him all these items were nature's inventions and he took them everywhere he went. When the war finished and he was able to return to Paris this *peintre maudit* only had a few more years to live. His broken health, impaired further by alcohol consumption, could not withstand the exigencies of life much longer and in 1951 he died in Paris aged 38, as a result of food poisoning from rotten horsemeat.

Wols's destiny was not an exception. Hans Bellmer was interned together with Max Ernst, then lived for a time with the Maquis and later went into hiding near Castres. Hans Hartung joined the Foreign Legion and was severely wounded. Oskar Kokoschka, Ludwig Meidner, John Heartfield and Kurt Schwitters went into exile in England. After he had served in both the French and the English armies Richard Lindner emigrated to the United States in 1941, where he initially worked as an illustrator. Others had already gone to the United States in 1933. George Grosz taught at the Art Students' League in New York and other art schools, and made a living as a free-lance artist and illustrator. The former Bauhaus master Joseph Albers worked as a teacher at Blackmountain College. There he executed his *Graphic Tectonic* series and continued with his colour studies. He had many pupils who later became famous American artists – for instance, Robert Rauschenberg. Max Beckmann was only able to leave exile in Amsterdam after the war. He emigrated to the United States and died there in 1950.

The Nazi regime mortally threatened the continuity of German art. Artists who went into exile or went into a precarious 'inner emigration' ensured that the continuity in German art was not completely broken. The works created during this period include pictures painted in exile by Max Beckmann, Max Ernst, Paul Klee, Kurt Schwitters, Wols, and pictures painted in 'inner emigration': the series of *Unpainted Pictures* by Emil Nolde, the *Window Pictures* by Oskar Schlemmer (fig. 51) and the *Ideogrammes* by Willi Baumeister (fig. 52).

Among the most moving of all the pictures painted whilst in exile are the pictures by Paul Klee. They reveal an ever-present sense of the proximity of death, of inescapably approaching forces that pose a threat to life. The obvious signs of the time here coincide completely with personal fate. They are pictures of a dark lucidity which is without parallel in the art executed during this period. Paul Klee's art reached its zenith in these pictures.

The image world of Paul Klee had already unfolded in all its glory, in the years immediately following his crucial trip to Tunis in 1914. In autumn 1920 he was invited to teach at the Bauhaus and spent years working intensively and harmoniously together with artists like Kandinsky, Feininger and Schlemmer. Towards the end of the 1920s the inner tensions at the Bauhaus increased in concert with the increasing outer pressures from reactionary political forces. The original working atmosphere, which had been so inspiring, was destroyed. Paul Klee left the Bauhaus in 1931 and took up a post at the Düsseldorf Academy of Art. He left Germany in 1933, defamed as a "Cultural Bolshevist" and dismissed from his post. Klee's enforced departure from Germany entailed emigration but he did not emigrate to a foreign country. He returned to his native Berne where he had lived as a child. He remained there until shortly before his death in 1940 when his illness made it necessary for him to enter a sanatorium in Locarno. On 29 June 1940 Paul Klee died of paralysis of the heart at a hospital in Muralto-Locarno.

During his years of exile in Switzerland (Klee had tried to obtain Swiss citizenship right up until the end), particularly from 1935 onwards his painting reveals a tendency towards simplification and concentration. His style became more brittle, the orchestration of colour became more restrained and his imagery grew more evocative. The tone of his pictures is increasingly transposed into the major key.

The change which occurred in Paul Klee's work was not only a reaction of the quiet and sensitive artist to the signs of the time, to the events in Germany. It was also brought about by the illness which in a strange way paralleled those events. Klee was fully aware that his illness would accompany him to his death, that it would accelerate his death and shorten his remaining years and working capacity. He would have to summarize what he had to say without elaboration, expressing it in a concise, direct and compressed form.

It has often been said of Paul Klee's pictures, even by experts, that they came from a "limbo" and depicted an "anti-world". Both descriptions are not entirely with-

out substance, but they are liable to send the observer off on the wrong track. They suggest a lack of positive commitment and we can therefore only view them as having temporary validity. The inner balance was attained with great effort: a balance between the visible and the invisible, the secular and the spiritual; between play and earnest, colour and sign, chance and significance. It was the culmination of a quest which he had pursued with enduring patience.

In the final analysis Klee does not show us an "anti-world", however alien to the reality of appearances it may be. It corresponds far more closely to the inner, perhaps one can go so far as to say, spiritual laws governing our world of genesis and decline. He creates allegories of the forces which determine the cycle of waxing and waning in nature.

Rather than a "realm between life and death" Klee shows us an intermediate phase or stage. A perpetual process is being enacted in his pictures. Organically it is a process of germination, budding, flowering, burgeoning and decay, in inorganic terms it is the growth or "proliferation" of crystals which will later at some future date break open and fragment. Klee brings us into contact with the cycles of nature, and how they appear in his *Weltanschauung*. They are cycles which encompass transience and recurrence, cycles which transcend and which are governed by cosmic laws regulating the growth and decay of the images.

It is for this reason that so many of Klee's pictures – and particularly those executed in the 1920s – inspire the observer with such a sense of joy and fulfilment. The artist is at one with the natural laws of growth which at the same time stimulate his art. These laws determine the choice and application of his formal techniques and materials. His pictures are created in parallel with nature, and the painter experiences that realization as organic growth.

Fig. 53 Paul Klee, *Dances from Fear*, 1938

Growth is a decisive word for comprehending Paul Klee's work. Klee shows us the stages and phases of a continuous metamorphosis of forms and beings from one manifestation to another. Here movement is the inner being of the pictures rather than outer dynamic movement. Movement signifies growth, change of form and finally decay, the process which we could term the cycle of being.

There was always death in these pictures, just as death everywhere pervades life. Now it comes forward and stops us in our tracks. Klee sensed that, long before his own life was extinguished. He reflected on the fact of death in a way which was previously unknown in the sphere of visual arts. Here lies the significance of these pictures which are so often small and modest on a physical scale.

Klee did not resist the inevitable but attempted to accept it and integrate it, not only in man's general existence but also quite concretely in his own. In doing this he does not suppress his fear. One painting from this period is entitled *Dances of Fear* (fig. 53). *Captive* (cat. 197) shows the two sides of a being which is completely trapped in the lattice of these elusive connections. It is only a part of this lattice but it will still break through. The release of the spirit from the body is a *Dark Message* (1938; cat. 189) above all for an artist who combines the spiritual and the physical in both his work and his being.

Many of Klee's pictures and sketches display a light, capricious and delicate quality which is carried through into his later work. Occasionally this has been construed as trivial charm and aesthetic unreality. The experience of sorrow which is contained in his late work now gives it a depth, a seriousness, an ethos of reality which is impossible to ignore. In this context reality must be understood as an all-embracing reality. It is the reality of inner life for which Klee had finally found the penetrating signs, the visual symbols.

We have attempted to define the essence of Klee's pictures as growth. In his late works he transcends this concept and a new dimension manifests itself. It possesses a threatening aspect and yet it must be overcome. The all-embracing growth seems impeded. The individual appears to have been repulsed from nature's great web. It appears isolated, dejected, excluded and imprisoned (fig. 54). Characteristically Klee searches for a meaning even in these darkest hours of his life and their reflection in his work.

Klee comes very close to that meaning in his late pictures. This last experience is hard to define. The paintings speak of the meaning but they reveal it in images. Perhaps we can say that it is the cognition that growth by its very nature entails

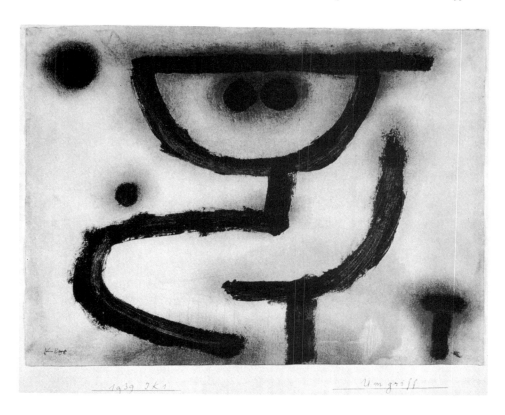

Fig. 54 Paul Klee, *Pervasion*, 1939

waning, decay, the departure from life, and that this decay and demise guides the fate of every individual. Only then can the great cycle of nature come to an end and new cycles begin.

We may offer this interpretation. These are the ultimate questions relating to our existence, the great network of being which is evoked in these penetratingly symbolic pictures, at once so simple and yet so complex, executed in such radiant colours. But it is only an echo. They resound clearly and yet elude rational interpretation. The secret of these pictures is their visibility.

X

Cultural life in Germany only recovered slowly after the destruction brought about by the Nazi regime and the war. The Nazi regime had subjected cultural life to extreme privation. It had exerted heavy powers of censorship, and burnt or destroyed thousands of books and works of art. Censors had banned the works of many authors, artists, musicians, playwrights, etc. and many exponents of all forms of art had been cruelly persecuted. It is true that Nazi rule had been overthrown by the victory of the Allied troops in Europe, but Germany was a vanquished and ravaged land, utterly drained of all resources and spirit. Economically the country had been brought to its knees. There was a shortage of everything: food, housing, fuel, jobs... A stream of refugees was flooding in from Germany's former territories in the East and they had to be provided with food and shelter. Gradually the full extent and horror of the crimes committed by the German people became known, crimes committed in the concentration camps and in the areas occupied by the German armies. A consciousness of guilt was added to the material distress and shame was heaped on the feeling of defeat.

Germany was divided into four zones of occupation and contacts were broken. Travel was almost impossible between the individual occupied zones and foreign travel to all intents and purposes excluded.

It was an end and a beginning, zero hour. After all the losses it offered the chance of a completely new start. Following years of enforced isolation from international connections there was a short period of numbness in the immediate post-war period. But then there developed a tremendous craving for information, culture and art. It seized survivors in Germany and the returning prisoners of war. The theatre was

revived on improvised stages in sheds, barns and ruins. Publishing houses applied for licenses to produce books which had been banned in Germany for the past twelve years. Artists got together for the first free exhibitions, most of which were put on in the regions in makeshift galleries.

The reading rooms of America House buildings and the facilities at British Councils and French Cultural Institutes were in great demand. Art periodicals on display there were passed from hand to hand. Even if the reproductions were of poor quality they were still studied avidly. Young artists or youngsters who dreamed of becoming artists attempted to catch up with the developments that had taken place in Paris, London and New York. They eagerly discovered innovations which had been evolving during the years immediately following the end of the war. To a certain extent the situation in 1945 paralled that in 1905 although the conditions were infinitely more severe. International developments in art were studied, discussed and adopted more intensively in Germany than elsewhere; and this time not only French ideas but also ideas from England and America. However, the situation was now quite different to that which had existed at the beginning of the century. Germany's outer existence and its relationship to its own history had been dealt mortal blows. These wounds made it impossible for artists to respond to international developments with the same vitality and wholehearted commitment as in 1905. It was to take years until individual artists found the strength to respond with more than a remote echo to what had taken place in art outside Germany.

Two generations were searching side by side for a new beginning in the years after 1945. The majority of the older generation had been active in the war whilst others had survived by entering a period of 'inner emigration', often under humiliating circumstances. The younger generation was less affected by the past. They began studying at the new art schools or searched for a direction by teaching themselves.

While many painters of the older generation tried to link up with their work from before 1933 (and many of them gradually turned away from their former work towards abstraction) the younger generation showed a much greater tendency to look at what had happened 'outside'. Increasing credence was accorded the notion that abstraction was a form which could be accredited universal validity. This was going to be the art form of the future. Abstraction seemed to be the logical and definitive consequence of the developments in art history since Cézanne and it opened up a wide enough range of possibilities to allow individual artistic innovation. German artists in particular regarded the language of abstraction as a moral force which was internationally binding as well as promoting international friendship. Post-war Germany above all yearned for internationality, it yearned to be accepted once again into the fold of nations and to be recognized as an equal partner. If one had to be German the desire was to be international, a European, a world citizen.

With hindsight this shift to Abstraction was later harshly criticized as an 'escape from reality'. At the time it was seen as a progressive stance. One decisive factor must not be forgotten: the public at large had been perverted by the pseudo-art of the Nazi era and told to use their healthy Arian common sense to judge art. The last thing it could cope with was the art of Abstraction. The new art form had to be introduced slowly through art associations, museums and a few idealistic galleries. It took many years to establish a public. The more involved an artist became in Abstraction and its various forms such as Tachism and Art Informel, the more isolated and reviled he became. In 1953 'Die Quadriga' (a group of four artists including K. O. Goetz and Bernard Schultze) held an exhibition at the Zimmergalerie Franck in Frankfurt on Main, a gallery which was also the living-room and bedroom of the gallery owners. This event marked the 'break-through' of Tachism in Germany yet the response was muted and accompanied by derision and scorn. This shows how hazardous it was for an artist to declare himself an avant-gardist or an adherent to such groups as 'Zen 49' in Munich or 'Gruppe 53' in Düsseldorf.

By the end of the 1950s the situation had changed radically. The first 'Documenta' exhibition held in 1955 showed outstanding examples of classic modern art. The second 'Documenta' exhibition in 1959 revolved around art after 1945 and this art had now been accepted without reservation in all circles and was collected as far as resources allowed.

Already in the late 1940s museums had begun to try to 'make amends' for the defamation of 'degenerate' art under the Nazis. Interest was initially focussed on the art of the Expressionists. Their work was shown individually and in group exhibitions. Great efforts were made to purchase pictures seized by the Nazis and sold off for next to nothing. The tradition of the Bauhaus was then recalled (initially centred on the newly founded Hochschule für Gestaltung in Ulm). It took a little longer to rediscover Dada and Surrealism and gradually rehabilitate these movements for a larger public. (Werner Schmalenbach led the way with a Schwitters retrospective exhibition in Hanover in 1956; Max Ernst was not given a retrospective exhibition in Germany until the exhibition in Cologne in 1963.)

At about the end of the first phase of 'reacceptance' the work of the younger generation began to be discovered. Museums, collectors and gallery owners proclaimed their interest in the work of young German artists. There were setbacks and disappointments but the spell had been broken. The world language of Abstraction had generally been accepted. At the same time sensitivity was aroused for the 'new dialects'. After the almost exclusive dominance of the Paris School attention was focussed on individual American Action painters and the masters of the New York School (even if German museums were as yet unable to purchase works by these artists). News of the monochrome pictures of Yves Klein came from France, and of the 'slit' canvasses of Lucio Fontana from Italy. At the same time other dissident influences were perceived which had arisen in parallel with Abstraction and which appealed to contemporary taste: Jean Dubuffet, Alberto Giacometti, Francis Bacon.

Dubuffet, Giacometti and Bacon were still viewed as exceptions who confirmed the rule of Abstraction, as great solitary individuals and outsiders. However, the advent and universal recognition of American artists like Jasper Johns and Robert Rauschenberg, followed by Pop Artists such as Warhol, Oldenburg, Lichtenstein and Rosenquist, caused a radical change in opinion. Although the principal significance of abstract art as a world language did not appear to have been compromised (and the contributions of Frank Stella and Ellsworth Kelly confirmed this viewpoint) it began to be accepted that other forms of expression could be regarded as equally modern. The word 'pluralism' entered the fray and since then has not been absent from discussions.

At last the time had come when the rehabilitation of German art prior to 1933 could be complete. Only with the idea of pluralism were Dada and Surrealism accepted universally as international movements which German artists had been instrumental in shaping. Only when the conflict between Pop Art and the world of advertising and consumerism was perceived to signify a general rehabilitation of objectivity, was 'Neue Sachlichkeit' conceived as a contribution in its own right rather than as a deviation from the true path of the history of art. People learned to distinguish the socio-critical stance of these artists, their sober view of everyday reality and their fascination with the magic of objects, from the Pseudo Realism of the Nazi era. The conflict surrounding Objectivity and Abstraction had been pursued with bitter acrimony in the first years of post-war Germany, focussed around Karl Hofer and Willi Baumeister. Now at last it could be shelved with the simple and dubious conclusion: both Objectivity and Abstraction are right in their way, both have their justifications and can exist side by side.

This argument had centred on the problem of how the image of reality can be adequately expressed today, by objective symbols or by pure abstraction. The scientific and physical image of the world conceives reality as a field of force, as space for vibrational energies, as electro-magnetic tension, as the vibration of minute atomic particles. One would have thought that such an image of the world could be adequately expressed only in abstract art. In its 'innermost being' the world cannot be depicted, since this 'innermost being' escapes our perception and evades our gaze.

The problem may be posed in a different way. We have experienced horrors which were previously completely beyond our ken. How can the mass extermination camps and the means of mass extermination (the atom bomb) be adequately captured in art when they have surpassed and overtaxed our powers of experience? It is impossible to portray all this in figurative images. Dix, Grosz and Schlichter attempted this after the First World War by conveying the forces of history and its

victims in personifications which were ultimately peripheral. Today that would no longer be possible, no longer credible. The horrors perpetrated totally exceed our visual power of imagination. The situation today surely calls for different responses. An appropriate response is despairing introspection; or an existential self-assertion as in the nervous style of an artist like Wols (fig. 55), an elementary form of expression which does not point beyond itself; or else Baumeister's search for archaic form motifs in which the human psyche rediscovers something of itself in spite of all the global catastrophes.

These were arguments which were repeatedly uttered in various guises at the end of the 1940s and the beginning of the 1950s. Ultimately they all agreed on Abstraction and saw the justification for figurative art only in the past.

XI

Werner Heldt emerged in the midst of this debate, without ever taking the slightest notice of it. He is without parallel in German art during the post-war years.

If we do look for some kind of yardstick it may perhaps be found rather surprisingly in Wols, although this yardstick is valid only in biographical details and not in terms of artistic conception. Both Wols and Heldt were born in Berlin and both went to Paris in rapid succession. Paris fascinated them both, and for a number of years they lived almost simultaneously in Spain, Wols on Ibiza and Heldt on Majorca. Both painters left Spain in the face of the approaching civil war. Their ways then parted: Wols stayed in France and Heldt returned to Berlin. During the war he was a soldier in Holland, Belgium and France. Both died early, soon after the end of the war. Wols was 38 and Heldt was 49 years old. Like Wols, Heldt was an impulsive, restless man driven by inner demons, addicted to alcohol, the archetypal *peintre maudit*.

Werner Heldt's painting is inseparably bound up with two themes: with the image of the city of Berlin and with the German plight in the immediate post-war period, the 'zero hour'.

Werner Heldt was Berlin's painter in a particular sense. He gives us the picture of a city devoid of local colouring. The chasm of time has passed through this city. Part of this abyss will always remain. This city has advanced into polar zones. A cold wind has emptied its streets, swept them clean. Before the catastrophe Bertold Brecht had said, "only the wind passing through will remain of these cities." Werner Heldt painted the traces of the icy storm. His Berlin is the city after the catastrophe.

At the end of 1945, immediately after returning from captivity, Heldt painted his famous picture *View from a Window with a Dead Bird* (fig. 56). The view is of a deserted city, on to walls of fire and ruins, and into dark window recesses. It focusses only on the dead crow with tattered wings and the jug on the window sill. From that time onwards Heldt always portrayed the motifs of a time to which we have returned as aliens without having returned home: the empty city, the deserted squares, the ruins, the stark tree, the dead bird, the crumbling façades, the black windows. The house façades hammer a hard, merciless rhythm, there are no flats behind them, nothing lives there.

The pictures which follow the *View from a Window with a Dead Bird* are variations on Heldt's one great theme. The crane and the jug become still lifes, initially with vase and flowers, then with bottle and medallion, with guitar and fruit and finally with a massive pipe, a monstrous leaf, a skull, a clef, until a tree is planted in the window, and a ramshackle house is placed on the table like a toy.

The metamorphosis of objects corresponds to the change in the façades. Just as the objects in or in front of the window grow constantly, the house fronts recede and become smaller. Just as the objects are often folded down into the surface, the façades also appear two-dimensional like theatre backdrops.

Werner Heldt was only able to attain this form through knowledge of Cubism. But as in the case of so many German artists, every formal style he adopted was subject to a particular interpretation. He brightened his palette and adjusted it to a pure expression of colour so that the melancholy of the empty streets and lifeless façades might become even more overt and inescapable.

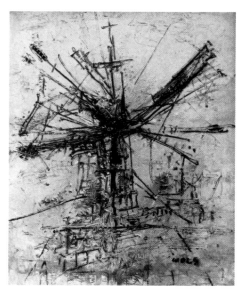

Fig. 55 Wols, *Composition on Yellow Ground*

Fig. 56 Werner Heldt, *Window View with Dead Bird*, 1945/46

Fig. 57 Richard Oelze, *The Festivity of Death*, 1967/68

Richard Oelze, who painted *Expectation* (cat. 199), also painted pictures after the war which were laden with silent mourning. He had spent the period between 1933 and 1936 in Paris in contact with Breton, Dali, Eluard and Max Ernst. Since 1946 he had lived the life of a recluse in the countryside of Lower Saxony, first of all at Worpswede and then in a village in Weserbergland. In Oelze's painting there is neither accusation nor protest, as in Heldt's work, only a profound, speechless horror. Oelze is closer to the Surrealists than Heldt, but his pictures are now different from the work he did before the war. Objectively they are hardly or not at all decipherable. We stand in front of a wall of rock, in front of petrified forests, petrified animals, petrified dreams. We look into swamps or grottoes, dense fog shrouds the memory of figures, heads, eyes. It passes by, it disappears. Bewilderment, silence and mourning remain (fig. 57).

Seen retrospectively four decades later the most typical, most important and most significant pictures painted during the period immediately following war and catastrophe, are those created by loners in situations of great isolation.

Wols was alone in Paris just as Heldt was solitary in Berlin; they both had friends and were able to show their pictures from time to time and eke out a modest existence. And yet they were both lonely, thrown back on themselves, fixated on their own visions in their work, however contradictory and incompatible these may have been. They wanted to do nothing other than work out the despair, the loneliness, the consciousness of futility and the will for obstinate self-assertion which lay within them.

Richard Oelze painted his pictures out of a related emotional situation living in a rural seclusion of his own choosing. He avoided contact with virtually all of his fellow humans and founded his inner independence in the most abject poverty.

At first glance it may appear misguided to want to add a fourth name to this list, a name which we are accustomed to hearing in quite a different context, that of Ernst Wilhelm Nay. Yet his pictures were also painted in a position of isolation during the initial post-war years. Even though imposed by external circumstances, isolation was by no means untypical of his life. In Nazi Germany his pictures had been branded 'degenerate' and he had been forbidden to exhibit his work. He therefore spent several months of 1937 and 1938 painting in the seclusion of the Norwegian Lofoten Islands. His paintings of this period represent the first highpoint in his

oeuvre. The *Lofoten Series* with their angular, pointed, tormenting forms and their aggressive colour says: here paints somebody who is defending himself, who is standing up to his fate, who is not simply going to accept what the times have prepared for him.

During the war Nay, like Oelze, was a military cartographer. In contrast to Oelze he was able to find the inner peace to paint and produced his *French Series*. These pictures are less objective than the *Lofotenbilder*, reminiscent of nature as painted by the 'Brücke' artists, and at the same time fulfilled by the vision of peace which must come one day. The forms appear fragmented, fragile, splintered, but they are held together by the force of colour which continually grows in strength.

Between 1945 and 1951 Nay lived in Hofheim in the Taunus, near Frankfurt. In no period of his life was he more isolated than during these years, but his seclusion cannot be compared with the isolation experienced by Wols, Heldt or Oelze. The answer to the threats and injuries of the time which he attempted to formulate in his pictures is fundamentally different.

It was the epoch of his *Hecate Series*, so called after the *Daughter of Hecate* (1945). They were produced against a background of intense study of classical mythology and pre-Socratic philosophy. Their intention to overcome resignation and mourning signified the possibility of a new beginning. Objective references only continue to live as relics of a perished world: rhombic forms appear with heads or at least eyes engraved upon them, accompanied by reminiscences of the inspirational sources of the Expressionists, of African masks, of Oceanic sculptures (fig. 58). Nay searches for the elementary and archaic as he did in his *Lofoten Series* but he no longer looks for it in visible nature. He now seeks it out in the imagination. In this imagination reside elementary figures which urge to appear in concrete form, striving to penetrate through the jungle of superimposed surfaces, awkward forms and eruptive colours in order to establish an existence in this world. Nay himself best described the direction of his painting in a lecture at his first post-war exhibition at Guenter Franke's gallery in Munich in 1946: to filter "radiant colour out of the conflagrations and the chaotic lava." Only the "richness of colours" may veil the erupted "volcanoes and yawning chasms", only they can "ban the demons completely."

While still in Hofheim he brought the *Hecate Series* to an end in 1948 and it was followed by the more abstract "fugal" compositions. In 1951 he moved to Cologne away from the relative seclusion of Hofheim. Here he entered the mainstream of the young Federal Republic which was seeking contact with the "world language of abstraction." Nay enriched the German art of that period by contributing a unique lyrical harmony of colour.

The fascination exerted by the depth, intensity and emotion of the *Hecate Series* does not pall even today. Their oppressive visions and faces, their brittle, angular forms, their instinctively applied colours speak of conflicts which at that time had to be overcome. This series harks back to the art of Kirchner and 'Die Brücke' and points to the painting of Lüpertz and the 'Neue Wilde'. For German art of the 1950s it signified a unifying element and endowed it with continuity.

Fig. 58 Ernst Wilhelm Nay, *Blue Seated Figure*, 1947

XII

Art is born of art. Pictures respond to pictures. They may also contradict them, and how often has art been generated by contradiction? Among the movements which provoked the most fervent contradiction was the Abstract Expressionism of the 1950s, whose varieties or facets we have become accustomed to designating as Informal Art or Action Painting, though all these labels are highly suspect and in need of revision.

The first picture to be painted in Germany as a deliberate statement against Tachism appeared in 1955. The painter was a 20-year-old art student at the Düsseldorf Academy who was keen to distance himself as far as possible from what his fellow students were doing. His name was Konrad Klapheck. The subject of his picture was an old Continental typewriter (fig. 59) – and he painted it as precisely, as soberly, and with as much aloofness as he possibly could, against a neutral background, without ornament and without any obvious point. "I wanted to confront

Fig. 59 Konrad Klapheck, *The Typewriter*, 1955

Fig. 60 Konrad Klapheck, *The War*, 1965

vagueness with something hard and precise," said Klaphek, "to set a prosaic hyper-representational style against lyrical abstraction."

Something unusual happened: the typewriter seemed to want revenge for having been portrayed so austerely. The very precision of its depiction gave it a disconcerting air, the air of a magic object, a fetish-like 'monster'.

From then on Klaphek was in thrall to the magic of objects. It became his sole theme. Of course he did not adhere to the unswervingly faithful representation of his early work. With the early work of Francis Picabia in mind, he began to simplify the objects, alienating and transforming them, until his pictures attained that curious equipoise between construction and 'thing magic' which is the distinguishing feature of works like *The Seductress* (cat. 237) – a sewing machine – or *The War* (fig. 60), both painted in 1965.

Another response to the Informel was in the makings at the time, also in Düsseldorf. In April 1957 a group of young artists who had not yet found a gallery began to meet regularly – though not all together – for 'evening exhibitions'. It was only gradually that their shared interests began to emerge clearly – a rejection of all 'gestures', of all emphasis on personal style, a predilection for series, rapport, a leaning towards monochrome – which was enormously encouraged by knowledge of Yves Klein's works – a fascination for kinetics, to which they had been introduced above all by Jean Tinguely. All these stimuli and contradictions produced a unique amalgam which made its appearance under the name ZERO, starting with the seventh 'evening exhibition' in April 1958. The name alone was part of the programme. Through the break with tradition, through a radical simplification of art and the means it employed, through the rejection of form, gesture and – to a large extent – colour, it was intended to arrive at a zone of silence, a "point zero", which could become the starting point for new artistic adventures.

Heinz Mack and Otto Piene formed the nucleus of ZERO, which was joined in 1962, at the 'Nul' exhibition in Amsterdam, by Günther Uecker, after he had for some time been involved in various of the group's activities. It is hardly possible to take in the variety of these activities – exhibitions, projects, publications – which between 1959 and 1965 extended like a spider's web over the whole of Central Europe. In Italy, the Netherlands, France, and even Yugoslavia, sympathetic groups sprang up, with whom the German artists collaborated, holding joint exhibitions and issuing manifestos.

What strikes us today when we re-read these publications, catalogues and pamphlets is the tremendous enthusiasm that informs them, the consciousness of being involved in a new departure, the feeling that new worlds were there for the conquering. The artist had achieved so much – why should he not learn to overcome the

force of gravity? The ZERO artists were imbued with a naïve confidence in their own creative power, which was matched only by the possibility of re-creating the earth – or even the universe. It was this confidence which distinguished them from the much more phlegmatic artists of Tachism, who had so much less 'sparkle' and were still imprisoned in matter. ZERO not only believed that the future lay in a better, brighter world: it believed in light. Light was the real creative force in both life and art.

In the context of ZERO Otto Piene liked to speak of the "New Idealism". In doing so he wished not only to draw a distinction between himself and the (sympathetic) group of 'New Realists' – *le nouveau réalisme* – led by Tinguely, Restany and Spoerri, but also in order to give expression to the gentler, spiritual elements of the new art through focussing on its spectacular 'cosmonautical' perspectives. Piene might equally have spoken of a "New Romanticism" – of man's clearly indestructible ideal, that of reconciling technical progress with nature, matter with mind, progress with art, of harmonizing them and establishing a kind of interplay and interaction between them.

Fig. 61 Otto Piene, *Smoke Drawing*, 1960

ZERO believed that it had a novel understanding of nature and could use this understanding in the service of art. It believed that, at the height of the scientific era, it could once more return to simplicity and begin again at a zero hour in history. ZERO's credo was back to the origins, back to the elements. Its aim was to find ways and means of directly involving the elements – light and air, water and wind, earth and sand, fire and smoke – and letting them speak for themselves so directly that the result would be a new, simple revelation of the elements, of nature, of natural forces. It was against this background that Otto Piene created his series of *Smoke Pictures* (fig. 61), *Fire Flowers* and *Black Suns*, that Heinz Mack designed his *Light Reliefs* (fig. 62) and that Günther Uecker used nails to construct his *Small Sea*, his *Currents* and *Counter-Currents*.

Despite the immediate appeal many of these works still have for us, the attitude behind them seems infinitely remote and almost impossible to imagine. Too much has happened since. The world the ZERO artists believed in has belied their belief, making it seem naïve and woolly. But were not the utopian ideas of the Bauhaus also naïve and woolly? And have we lost our respect for it too?

Of the three artists who formed the nucleus of ZERO, Heinz Mack is the only one who has remained close to its original ideals. Piene has concentrated on the fusion of art with technology and is now director of the Art Department of the Massachusetts Institute of Technology. Only Günther Uecker has reacted to changes in the intellectual climate and, without giving up his original means, has learnt to use them to express trauma, pain, grief and failure (fig. 63). An impressive example of this is the object (boat, wood, nails, sailcloth, black paint) entitled *Chichicastenango* (after a place in Guatemala where the Christianized Indians were attacked and killed with arrows), which he produced in 1980 for the exhibition 'Signs of Faith – Spirit of the Avant-garde'. Another artist whose career began in the ZERO ambience was Gotthard Graubner, though he pursued his own course independently of the group.

Fig. 62 Heinz Mack, *Sahara Project*, 1968

Graubner's great theme – indeed his sole theme – is colour. He comes close to monochrome without ever painting purely monochrome pictures. He never had any time for dogmatism. His interest lay in discovering nuances, in achieving maximum effect with minimal variations of colour. His great aim was to attain a colour-space continuum, to create a still but not quite motionless colour plane, gently vibrating and, as it were, 'breathing', which we would perceive as expanding into a colour-space continuum as our gaze wandered over the picture plane. Later, in his *Cushion Pictures* he tried to create this colour-space continuum by physically giving volume to the colour. Colour for him became increasingly corporeal – it acquired 'body' (fig. 64).

But even in his early pictures, which were still completely two-dimensional, he came close to the goal he had set himself. His method was to superimpose many thin layers of mutually corresponding colour on one another in such a way that they did not quite coincide at the edges of the picture, but remained unmixed, while fusing towards the middle. In this way he managed to create a colour plane in which there was a total absence of any personal note and which presented itself to the viewer's eye as part of a homogeneous and seemingly infinite colour space.

Fig. 63 Günther Uecker, *Light Cage*, 1966

Fig. 64　Gotthard Graubner, *Baggi Cushion, Black*, 1969

Fig. 65　Gerhard Richter, *Coffin Bearer*, 1964

Fig. 66　Gerhard Richter, *Stukas*, 1964

XIII

Also in Düsseldorf a different approach to breaking with the Informel was taken by Gerhard Richter at around the same time. Coming from Dresden and bringing with him a superb mastery of the painting craft, he studied for two more years at the Düsseldorf College of Fine Arts, where he now holds a professorship. His teacher there was the Tachist painter K. O. Goetz. Here we have a curious parallel with what was going on in Berlin, where some of the later Realists or 'Neo-Expressives' graduated from the classes of Thieler and Trier, who were also exponents of a 'gestural' or 'lyrical' abstraction.

Richter was a perfect craftsman from the very beginning, a virtuoso who could paint anything. But what was he to paint? What deserved to be painted? Or to put it another way, which objects were not yet worn out, but still fresh, new, and sufficiently surprising to match up to the painter? In his search for new paths to explore he came upon the amateur photograph. He was fascinated by those old, yellowing snapshots, indistinct, blurred or badly exposed, that are to be found in family albums, those popular albums which record, like 'wordless' chronicles, everything that matters in middle-class existence. Those albums, with their seemingly random collections of photographs, possess an aura all their own. They may strike the outsider as utterly banal, but for the people depicted in them, and for their families, they represent individual destinies, stages along the road through life: the bride, the mother, the father, the son killed in the war, the favourite aunt at the coffee table on one of her visits – all captured at particular moments, to be perpetually remembered. This pictorial world, trivial yet atmospheric, was the first theme that Richter committed to canvas, working with cool nonchalance and perfect mastery, reproducing with the utmost precision all the blurring, the indistinctness and the amateurishness of his photographic archetypes. Thus the pictures which Richter painted in this early phase of his development, and for which he first became known, have a twofold quality: they preserve the gratest possible distance from their objects, yet retain precisely the specific character of these objects (figs. 65, 66).

In the picture world of amateur photography Richter discovered his first theme but in the long term he had neither the desire nor the capacity to repeat himself, to remain in a groove. But what do you paint when it is possible to paint everything, when the pluralism of the contemporary art scene has accepted all themes, all motifs, all styles as equally valid and they are therefore all ultimately uninspiring? Richter's strength lay in his ability to thematize his dilemma and turn it into his object. While Konrad Klapheck absolutely identified with the long series of his machines and devices through all their transformations, and created strange self-portraits in his typewriters, bicycles, motorbikes and tractors, Richter consistently painted his permanent non-identity. He was not able to commit himself, nor did he want to. From this stance of deliberate non-commitment he gained a new confidence for the role of the artist. This was a role of total freedom, not only for art but also for its exponent. Gerhard Richter's painting demonstrates only one thing in all its changes: that painting will continue under all conditions and that its meaning is to be found in nothing other than this continuation.

Sigmar Polke was born in Silesia in 1941 and came to the Federal Republic in 1953. From 1961 to 1967 he was a student at the Düsseldorf Academy under Hoehme and Götz where he was increasingly subject to Beuys's influence. He exhibited shortly after Richter and then jointly with him. Like Richter with his painted photographs, Polke first achieved a reputation with his *Grid Pictures* which ironically oscillate between the Pointillism of an artist like Seurat and the raster process used in four-colour reproduction. An intrinsic feature of his art revealed itself for the first time in these pictures: irony. He never conceived this as simple parody but always made it pose the questions Whence? What for? and Why? about an object serving as a subject. Polke took the most banal subjects seriously like the cliché, a duplicated wallpaper pattern or whatever, and carried it through to absurdity (fig. 67).

Polke's irony achieves greater subtlety when he creates art about art, paints pictures about pictures. He parodies the changing modes of modernity but he does this not without loving involvement. Many of these pictures appear ambivalent. When

he subtitles a picture with "Higher beings command: paint right upper corner red", then he is not only satirizing our conventional understanding of inspiration in the production of a picture. He is invoking both mirth and grief in his view of the powers of the unconscious. Unconscious forces intervened decisively not only in the creation of his own pictures. they also exerted influence on the direction taken by modern art. What may at first glance appear as a simple parody is in reality the starting point of a long chain of reflections about artistic creativity. Polke's study under Beuys had not been without concequences.

In these 'pictures about pictures' Polke completely negated the total freedom of the artist postulated by Richter. According to him the painter is nothing more than a medium of "higher forces" which legitimize his boldest deeds with a wink and a nod.

Palermo was thus dubbed by his fellow students at the academy owing to an obvious similarity with the legendary mafia boss Blinky Palermo. He died early at the age of 34. Like Uecker, Graubner, Richter and Polke he came from East Germany. He was born in Leipzig in 1943 (as Peter Schwarze, adopted Heisterkamp) and moved to the West in 1952. His mentor at the Düsseldorf Academy (1963-67) was Joseph Beuys. Through Beuys, Palermo developed a sensitivity towards objects and forms in the environment. He was inspired to search for potential dormant signs and symbols and elucidate their identity.

Artistic strategies such as changing the painting surface (for example, to muslin or silk on wood), the irregular contour, the combination of several parts to form a unit all helped to give his pictures the character of objects and fetishes, to lend them an aura of magic. "Particularly characteristic of Palermo are the rods and rod crosses bound in material, accompanied by multi-angular or rounded colour forms. The associations of these two-part works reach from lance and shield to the palette and mahlstick, and also invoke reminiscences of the Passion," Peter-Klaus Schuster wrote in the catalogue 'Deutsche Kunst seit 1960' in 1985.

We now leave the Düsseldorf of 1960 (Klapheck, ZERO, Graubner, Richter) and the Düsseldorf at the beginning of the 1970s (Polke, Palermo) and move on to Berlin of the early 1960s.

Akt mit Geige

Fig. 67 Sigmar Polke, *Nude with Violin*, 1968

XIV

The difference between these two cities, which in the next ten years were to become the two poles of the German artistic scene, could scarcely be greater. Düsseldorf is a thoroughly western city, in a sense the point of entry for new developments, especially those which came from Paris and later New York. At the same time Düsseldorf is the place where the first attempt is made to come to terms with them, to measure up to them.

Totally different from Düsseldorf around 1960 was the situation in Berlin at that time. Berlin, by contrast, is isolated – it is like an island (to adopt a somewhat hackneyed simile). It is a meeting-point for ideas and ideologies from East and West. What in other places may seem like a cliché or an empty phrase is daily reality in Berlin. Through the city runs the wall, the symbol of a divided Germany and at the same time an exceedingly banal structure which acts as a perfect foil for the most varied graffiti. On both sides of the wall are empty buildings which once housed the Gestapo, the SS and various ministries, recalling the darkest chapter in German history and challenging us to come to terms with it.

What goes on in the other part of Germany, the German Democratic Republic, is observed more closely here than anywhere else in the Federal Republic. Contacts with the other side were never completely severed here. Many of the artists who began to work here in the early sixties and made their mark in their early exhibitions came from the East – Baselitz, Schönebeck, Lüpertz and Koberling for instance. Penck came over to the West in 1980. (And of those artists working in Düsseldorf, Graubner, Polke, Richter, Uecker and others come from the German Democratic Republic or the territories that now belong to Poland.)

The break with Tachism – and with abstraction as a whole – which took place in the early sixties was far more rigorous and radical in Berlin than anywhere else in the Federal Republic.

Nowadays when Markus Lüpertz – whose artistic development began with this break – gives interviews in which he plays it down or denies that it happened, or when he describes himself as essentially an abstract artist, we are taken right to the centre of the controversy surrounding those painters who are popularly known as "the new savages" or "the new expressives".

For them it is in fact a matter of some weight, for it confronted them with a twofold challenge, part intellectual and part formal. It was a challenge which each of them – Lüpertz, Baselitz and Schönebeck, then later Immendorff and Kiefer – met in his own way.

Let us first consider Lüpertz. In 1963 he moved to Berlin and started his 'dithyrambic' painting. In 1964 we find him among the founder members of the 'Grossgörschen 35' gallery in Berlin. In 1966 he published his *Dithyrambic Manifesto:* "The charm of the twentieth century is made visible by my invention of the dithyramb." The critic Kneubühler once called this 'dithyrambic' period the "formal phase" in Lüpertz's work. The next phase, which began in 1969 and for which Lüpertz himself uses the term "motif painting", is characterized by Kneubühler as "motif as form"; this is to be distinguished from the next phase, beginning in 1975, which is devoted to "form as motif."

Let us concentrate here on the phase of 'motif painting' covering the period from 1969 to 1975. The motifs chosen by Lüpertz are steel helmets, officers' caps, anti-tank guns, spades, army equipment rusting and rotting away in cornfields, the Siegfried Line with its rows of concrete pyramid stumps. These are very German motifs – motifs which reflect Germany's recent past and are still to some extent taboo. Lüpertz has always enjoyed provocation, and his choice of motifs was assuredly meant to be provocative; he wanted to risk incomprehension and condemnation. Of course nothing could be more wrong than to impute to Lüpertz any wish to glorify these motifs – or the period to which they belong. One has only to look at the context in which they appear: they are junk, discarded rubbish left to decay. Time has passed over them; soon they will sink into the ground or disintegrate in some corner or other.

I believe that he wanted to face up to a question which so many Germans are all too eager to push a side – that of how they can come to terms with their recent past. Lüpertz could do this only through his own métier, that of the painter. And that is precisely what he did. It was a considerable challenge: the more significant a motif is thematically – the greater its complexity and wealth of association – the greater is its resistance to any attempt to get to grips with it formally and translate it into the 'abstract' – which means transposing it into a coherent and self-sufficient combination of colours and forms. The greater the specific gravity of a given theme – in other words the more it has to convey in the way of content – the greater are the demands which this transposition makes on the artist's energy and combativeness (and Markus Lüpertz loves not only provocation, but combat) and the greater is his achievement if he succeeds in overcoming the recalcitrance of the motif. In this regard Lüpertz evolved his own strategy, which was to keep on selecting the same motif, to repeat it over and over again, until it finally disappeared as a motif – not just in the painting process, but in the perception of the viewer – and reappeared as pure painting.

Getting to grips with a motif in this way – which is what Lüpertz did for instance in the series *Black, Red and Gold – dithyrambic* of 1974 (fig. 68) – involved not only a formal, but an intellectual effort. It meant mastering a motif that had constantly obsessed him – consciously or unconsciously – and exorcizing it, as one exorcizes a demon. It meant overcoming it and arriving at a work whose abstract painterly quality we can appreciate without knowing what it represents – rather as Kandinsky was carried away by Monet's *Haystack* when he saw it at an exhibition in Moscow in 1885, not knowing at first whether the picture represented anything at all.

When Markus Lüpertz insists so vehemently today on the abstract qualities (even on the abstract character) of his pictures in the course of an interview, this seems to me to be justifiable not only as the artist's reaction to the all too frequent and thoughtless attempts to nail him firmly to the subjects of his paintings, but also from the point of view represented by Kandinsky's response to Monet's *Haystack* which was perceived as painting before the viewer recognized the motif that the artist had chosen to represent.

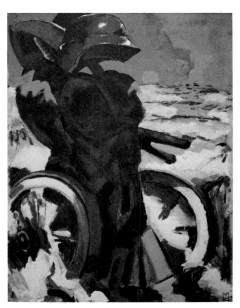

Fig. 68 Markus Lüpertz, *Black, Red and Gold – dithyrambic,* 1974

Fig. 69 Georg Baselitz, *The Great Friends*, 1965

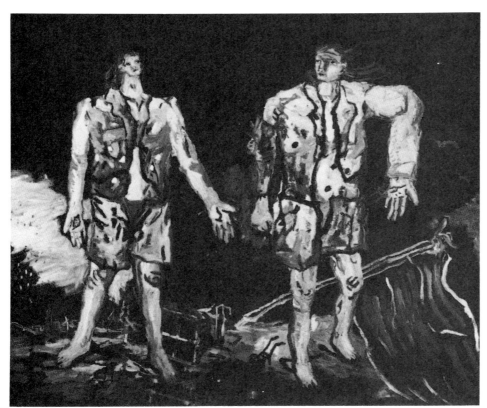

Lüpertz is a vital and volatile artist – we might even use his own term and call his nature 'dionysiac'. He takes hold of a theme, transforms it, and then abandons it. In this way he has given representational interpretations of 'invented forms' – or, to be more precise, he has evolved forms from gestures, and motifs from forms. In an interview with Walter Grasskamp he himself described this process as "making the abstract representational." Thus in his 'Stilmalerei' (style painting) he has chosen as his themes the styles and stylistic techniques of various twentieth-century artists, ranging from Picasso to abstract art (but including also German artists like E. W. Nay and Werner Gilles); he has not only invented free variations on these themes, but handled them with the same nonchalance that another artist might bring to, say, a still life or a landscape.

Quite different in temperament is Georg Baselitz. If we disregard his tempestuous youthful phase – during which the Director of Public Prosecutions actually charged him with pornography because of his picture entitled *The Great Piss-up* (1962/63) – we may say that he has organized his life with careful consistency. Even those features of it which may have been fortuitous seem in retrospect to have been deliberately planned. From about the mid-1960s he has pursued an aim which is easy to describe: to continue the Western tradition of painting; and to do it by means of figurative, non-abstract pictures – even though he has been known to use the term 'abstract' with reference to painterly quality, implying a certain distance between the artist and his subject, in order to demonstrate clearly that he is more interested in the free artistic rendering of a motif than in the motif as such. Though he likes to talk of abstraction he is even fonder of talking about 'ornament' in the sense of a generally comprehensible and available set of forms such as those which linked a variety of African cultures.

Georg Baselitz studied at the Berlin College of Fine Arts from 1957 to 1964, and in 1983 he went back there to teach. In 1961 and 1962 he collaborated with Eugen Schönebeck in publishing the first and the second *Pandämonium* (manifesto and poster). In 1965 he painted the programmatic picture *The Great Friends* (fig. 69), and his exhibition held in the following year at the Rudolf Springer Gallery was again accompanied by a manifesto.

From now on it became evident that he was trying to create pictures with an inherent monumentality which would fit in with the history of significant Western

painting and yet be contemporary in every detail. Pictures like *The Rebel* and *Bonjour Monsieur Courbet* of 1965 or *Forward Wind* and *A New Type* of 1966 demonstrate in the same way as *The Great Friends* the passionate single-mindedness with which Baselitz was working towards realizing his aim. He knew how difficult it was to paint pictures of this kind, pictures which take their subjects seriously, yet must not appear anachronistic. In the manifesto that went with *The Great Friends* he listed the formal and substantial criteria which were supposed to make it a contemporary picture despite its 'classical' motif. The manifesto made it clear what Baselitz was trying to do: he was trying to make it possible, in an age which questions the value of painting, for pictures to be painted again and assert their relevance to the contemporary world.

Whilst the early pictures, up to and including *The Great Friends*, appear to attack their subjects with enormous vigour, the methods of depiction which Baselitz evolved in the years from 1966 to 1969 become more and more subtle. One senses that he deliberately incurred difficulties in order to overcome them, setting up taller and taller hurdles for himself in order to be able to reach his goal and stay there – the goal of figurative painting. From 1966 the pictorial object appears divided or cut up into strips which do not quite fit together (recalling the way the Surrealists played with pieces of folded paper, their *cadavre exquis*). The strips are placed out of line with each other and no longer tally, making reality seem fragmented and badly assembled. Sometimes it appears to have been broken up like a jigsaw and to have lost a few pieces when put back together, the gaps being filled by extraneous bits of reality. By employing such methods Baselitz is able to stay close to his object and yet make us see how fragile and questionable reality is.

There is another point to make. As in the 'motif pictures' of Lüpertz, we find in the work Baselitz did at this period – though less explicitly – a conscious preference for motifs alluding to Germany's past. The 'hero' Baselitz stands in a landscape of ruins, larger than life in his ragged clothes, barefoot, with a heavy knapsack – more like a homeless martyr than a radiant hero (fig. 70). This is a country that has never recovered from the war and will always bear its mark. The survivors – scarred, wounded and disabled though they are – draw themselves up to preserve their dignity, having lost everything else. It is as though, in a world lying in ruins they want to save their former misused ideals, to detach them from a context of falsification and fill them once more with vitality. Thus the formal fragility of these figures exactly matches their inner condition, and the disorder and destruction we see in the individual object corresponds to the damage that has been done to it in our consciousness.

Much has been written about the puzzling fact that since 1969 Baselitz has painted his motifs upside down (fig. 71). It seems to me that this feature, once one has got used to it, has three things in its favour. First, it enables him to keep his subject at arm's length and concentrate on its pictorial realisation, its 'abstract' qualities. Secondly all the motifs appear to have a certain ambivalence: they are present and yet not present, familiar and yet alien; they confront us and at the same time elude us. And thirdly Baselitz is able in this way to achieve a complexity and density of reality which he could not achieve in any other.

This inversion of the pictorial motifs does not of course destroy our normal perception of the visible world. When we immerse ourselves in Baselitz's pictures we are not only constantly compelled to separate the motif from its representation and reconnect them. We are also faced with the dilemma of meaning and counter-meaning. As we stand in front of Baselitz's pictures two different perceptions become interwoven – that of the pictures and that of their surroundings. Two levels conjoin to form a unity, then fall apart again. We have to force ourselves to separate them, and as we do so we begin to get more and more involved in deciphering the objects in the pictures. And suddenly the motifs which Baselitz apparently endowed with such a high degree of abstraction become bewilderingly real, so that it takes us a few moments to regain our bearings in the 'normal' world.

Recently Baselitz has repeatedly taken up motifs used by Munch and Nolde. In the same way Hödicke has borrowed themes from Kirchner, Heldt or Rousseau; Koberling has moved towards a transformation of some of the landscape motifs of Heckel and Marc, and Lüpertz has taken subjects from Nay and Gilles. But this

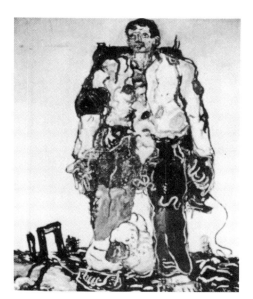

Fig. 70 Georg Baselitz, *The Hero*, 1966

Fig. 71 Georg Baselitz, *Eagle*, 1972

should not mislead us into thinking of the new expressive painting – especially as it has evolved in Berlin – as being one-sidedly dependent on the painters of German Expressionism (or their contemporaries elsewhere in Europe).

These painters are all very conscious of having been through the school of modern art and have registered the developments and movements which gave it its character, from Dada to Cobra, from Duchamp to Conceptual Art. Their attempt to come to terms with the Americans – Pollock, Gorky, Kline, de Kooning, Guston and Rothko – was certainly no less strenuous than their preoccupation with Beckmann, Kirchner or Nolde. Thus it does not seem particularly important to ask, in individual cases, where it all started – in the European Informel, which they learned about at the academies, in American Abstract Expressionism, which they were able to study at exhibitions, or in the art of Beckmann or Kirchner. What matters is what they did with it.

This may be something very German: at least this is how it strikes the art world. Yet perhaps it is the secret of their success. It is a curious phenomenon: in the years after 1945 the most fervent wish of German art was to be international, to suppress as far as possible all national characteristics in favour of a new cosmopolitanism, but with a few exceptions German art received no recognition beyond the boundaries of Germany. Today, now that German artists have decided to take up their own traditions and speak their own language again, international success has come to them on a scale which none of them would have dared to hope for in his early years.

This also holds true for the Berlin painter Eugen Schönebeck who has not been active as a painter for some time. Like Gerhard Richter, Eugen Schönebeck received an intensive training in the technique and ideology of Socialist Realism. He transferred from the postgraduate school for large-scale painting in East Berlin to the Academy of Arts in West Berlin and was initially completely taken up in the whirlwind of Art Informel and Tachism. Unlike Gerhard Richter he never completely lost sight of the ideals of Socialist Realism. He made a concerted effort to combine these ideals in a great synthesis with the forms of modern painting which had developed since Cézanne, and aimed to project the idol of a New Man. He saw this 'true Man' embodied in Lenin, Trotzky, Mao, Mayakovsky, Pasternak, Siqueiros and designed the portraits so that the observer might identify with them. They are executed more in the style of the monumental idiom of Alexander Deineka or the manifestos of Fernand Léger than in the dithyrambic style of an artist like Markus Lüpertz. Schönebeck tried to achieve a human Realism liberated from all the constraints and pettiness of 'Socialist Realism'. His was a Realism of greatness and dignity which attempted to align itself with men appearing in exemplary form. With fanatical zeal and always with the feeling of failure Schönebeck groped his way through many studies executed in painstaking detail to arrive at his vast panels (fig. 72).

The *Pandämonische Manifeste* of 1961 and 1962, conceived and realized together with his friend Georg Baselitz, were important stages in his development. With the first successes their paths gradually diverged and the morose Schönebeck became more and more subject to depression. He retreated from the art scene and completely shut himself off. Perhaps it was in objective terms impossible to realize his lofty ideals of painting with the styles of the epoch. Perhaps it was only the subjective feeling of inadequacy in a hypersensitive, overcritical man. Whatever the cause, Schönebeck apparently ceased to paint in 1966, or at least he did not exhibit any new pictures. The gradual but steadily increasing fame of his early pictures only strengthened his resolve not to paint.

If we compare Gerhard Richter with Schönebeck or Baselitz the diversity of their development from the same starting position appears to correspond precisely with the difference between the situation in Düsseldorf and Berlin. The artists in Berlin sought to evolve new concepts of Realism and experimented with new possibilities of expressing time, life, man and society without becoming enmeshed in anachronistic styles. That corresponds to changing styles and ideas in Düsseldorf and to the constant interest in all new techniques. This was just as true for Schönebeck as it was for Baselitz and Lüpertz.

Bernd Koberling is the most significant landscape painter of the Berlin scene. With Hödicke and Lüpertz he belongs to the circle round the Galerie Grossgörschen

Fig. 72 Eugen Schönebeck, *Red Army Soldier,* 1965

Fig. 73 Bernd Koberling, *Wing Spreads III,* 1982

35. His *Self-portrait with Angler's Jacket,* 1963, shows him early on as a painter tending towards expressive painting. His first one-man exhibition at the Grossgörschen in 1965 was entitled 'Special Romanticism'. Koberling then digressed extensively to become acquainted which the landscape of the north which he so loved – Iceland, Ireland, Scotland, Scandinavia. At the beginning of the seventies he succeeded in finding his own idiom.

Koberling was by nature nordic. This barren landscape refined his perception infinitely. Just as the pupils open in the dusk and accept less light in the glare of the noon, so the eyes attain a sensitivity for regularity, repetition and unobtrusiveness in viewing the barren pasture of the north.

He attempted to reproduce the regular, uniform and monotonous quality with methods of 'stretching' (fig. 73). This was the purpose of the opaque canvas hidden under layers of muslin and covered in transparent films of opaque colours shimmering through: uniformity, cohesion, spaciousness.

Uniformity, however, also signifies the power of the view, the all-embracing world view, the world feeling pulsating through everything. It indicates the harmonization and blending of all the visual elements, however spontaneous they may be and however fleetingly they may be indicated. Uniformity is the essence of the Expressionist view of the world.

When Koberling now paints his cormorants and whales, his block lava valley and block lava moon, stone fields and ash fields, his black birds in glowing volcanic space or on dark icy seas, rock and flapping wings, waterfall and human face, daybreak and day dreams, a uniform character pervades nature. A common mode of expression unites his art, the same inner dynamic of all forms oscillates through crystalline, vegetative, animal and human world. An animated, structured, spiritual uniformity arises in which everything is part of a whole and every element belongs to the great continuum.

The view is now directed towards the foreground, towards mires and marsh grasses, towards poppies and moss, moss under the trees and moss on the stones. Now nature articulates through individual boulders, heaps of stone, puddles of water, through grass, blossoms and undergrowth.

The decisive factor – and herein lies Koberling's achievement – is this: marsh and stone, moss and poppy are imbued with the same spaciousness as were his earlier boundless landscapes. The view which captures the near, the small and the unobtrusive, there discovers the laws and forces which are at work throughout all nature.

What Koberling did for the development of a new landscape painting, Hödicke did for the presentation of the Berlin cityscape. These are the first significant cityscapes of Berlin since the pictures of Werner Heldt.

Fig. 74 K. H. Hödicke, *Sleep,* 1978

Hödicke by no means restricts himself to pictures of the city. For the subjects of his large series he concentrated initially on objects of everyday life, progressing then to themes beloved of Kirchner, Beckmann and Rousseau. He sought to make the thematic aspect recede into the surrounding background so that he might develop the theme as a free artistic variation in the same way a theme can be 'developed' in music (fig. 74).

Meanwhile, as a teacher at the Academy of Arts in Berlin Hödicke has become father to a new generation of 'Junge Wilde'. Salomé and Helmut Middendorf emerged from his class and many other young painters have been permanently influenced by him.

XV

Of all contemporary German painters Anselm Kiefer is regarded as the most 'German'. And in fact he is, more than any other artist, a painter of 'German' themes. This has often been misconstrued as a symptom of reawakening nationalism. What Anselm Kiefer is trying to achieve is the much discussed 'Work of Mourning'. The experience of suffering manifested in his pictures is matched by the materials he uses. Peter-Klaus Schuster has pointed out that in Kiefer's "empty interiors and landscape panoramas with straw, sand and ashes" Germany appears as a poor, wretched country "in which every name that is called out anew throughout the centuries only awakens memories of more disasters."

On one level Kiefer's pictures are informal painting, material pictures. Oils, acrylic, aquatex, synthetic resin, sand, straw, shellac, photo elements on document paper, wood, etc. are some of the materials which he uses and then often works on with a blow torch or an axe (or both). On a second level this material, whose structures appear to be largely fortuitous, has a perspective interpretation imposed upon it through a few simple manipulations; this at once invests the picture with a wealth of associations. On a third (semantic) level – again with the utmost economy of means – objects are suggested thus allowing us to recognize, say, a room as an attic, a cellar, or a temple of fame. Yet almost always a few details from the lowest levels remain to contradict our interpretation of the room, very slightly but nonetheless irritatingly. On a fourth (interpretative) level superimposed on the last, the artist inserts names of places (in a landscape which seems infinitely wide by virtue of the paths that lose themselves in it) or names of persons (in an attic that has been transformed into Valhalla – or inside a forest clearing). The names appear foreshortened by perspective and thus give the picture added depth.

A fifth plane carries the alienation effect even farther. A palette drawn in outline over the whole picture – *Nero Painting* (1974; fig. 75) – allows us to identify the picture as a vision of the act of painting, as an artistic game, or as a catastrophe staged by its creator. The same effect is produced in other pictures – like *Operation Sea-lion* (1975; fig. 76) – by a confusion of dimensions: the sea battle is staged in an enormous bath-tub embedded in the landscape. The ships are only toy ships, but the disaster they will bring about is real. Kiefer thus exploits every imaginable formal device and technique to superimpose one level of meaning upon another, so that they merge and multiply, leaving scope for multiple interpretations.

A special case is A. R. Penck, who is fundamentally anything but a 'new expressive'. He evolved his imagery in the German Democratic Republic – in Dresden, in the country in Saxony, and in East Berlin – beginning in the early 1960s (in other words at the same time as Baselitz, Schönebeck, Lüpertz, Hödicke and Koberling), but he did not move to the West until 1980.

For Penck art is inseparable from thought. It is a matter of thinking in signs within the framework of a given system, but with as little dependence on the system as possible. He knows that thought is a process of abstraction – abstraction is the essence of thought. Art, on the other hand, is concrete and appeals to the senses. What he had to do, then, was to keep a balance between the two (such as Paul Klee had found and defined in his *Bildnerisches Denken*) a balance between vision and concept, between the concrete figure and the system it fits into, between the visual manifestation and the thought it manifests.

Fig. 75 Anselm Kiefer, *Nero Painting*, 1974

Penck's pictures appear at first sight didactic, intended to explain something to us, and yet they have an aura of mystery, almost of the hermetic. While obviously simple in their composition, they are complex and disturbing in the way their elements are combined. They seem to be easily comprehensible, but resolutely defy comprehension.

The individual symbols are easy to interpret, but in context they become multivalent and dubious. These symbols are human figures, usually reduced to the status of ciphers, depicted in various attitudes and activities and inviting us to identify them. But the way these figures combine to make up society – and society is the constant theme of these pictures – once more prevents us from determining their precise identity: they become changed and confused. The interplay of the figures – in other words the society they make up, a society which hardly ever becomes a community – gives each of them a changing role, a changed function, a new sense. Yet while the details remain opaque, our view of the whole is not impaired. There is a balance between what can be read and what remains illegible, between the decipherable and the undecipherable.

Fig. 76 Anselm Kiefer, *Operating Sea-lion*, 1975

One example of this typical balance between vision and thought, between symbolism and painting, code and plain, is afforded by the 1974 picture entitled *TM* (fig. 77). It appears to speak of the great cycle to which all human life is subject, rising to its zenith and falling to its nadir. An autonomous cyclical movement is in progress, but its progress is disturbed, interrupted by a tear or crack which separates the two halves of the picture. Yet this tear is ambivalent. It appears like a wound, but at the same time water, electricity and energy seem to be pouring into the picture. The balance which Penck seeks remains intact: division and unity, disturbance and continuum, rupture and harmony, trauma and revitalization remain in equilibrium.

The position of the Düsseldorf Beuys student Jörg Immendorff appears today in many ways more closely related to the situation of the Berlin artists than to that of his colleagues from Düsseldorf. Over the years he kept up regular contact with his friend A. R. Penck in the GDR whose position there appeared to him just as dubious as his own in the Federal Republic (fig. 78).

Fig. 77 A. R. Penck, *TM Series*, 1974

In his effort to reach a wide public he was not afraid of adopting anachronistic styles. In this he is opposed to the artists in Berlin. He was interested in a direct effect and immediate response, and never bothered in the slightest about the opinions of the cognoscenti. His theme of 'the suffering engendered by the predicament of contemporary Germany' was initially presented in the simple instructive panels and pictorial broadsheets of illustrative Realism. Gradually he moved away from this somewhat contrived simplicity and condensed his theme in penetrating metaphors. Without ever completely losing the illustrative starting point he succeeded in attaining a vital grasp of his object and a radical incisiveness in his theme. This is demonstrated in *Café Deutschland* (cat. 294), a place divided by barbed wire which could be a station concourse, a discotheque, a coffee-house or a snackbar (and which is really all of those at once). Both sides of this place are presented as rather unpleasant. They are weighed down by symbols of contemporary problems which await resolution.

This *Café Deutschland* which Immendorff modified again and again is a place not easily forgotten. *Café Deutschland* was stimulated by Renato Gruttusos's much less complex homage to *Caffè Greco* in Rome and certainly inspired by many meetings with Penck at state hostelries in Dresden and East Berlin. Here the theme of Germany's division is experienced more expressively, more forcefully and more authentically than anywhere else in contemporary German art.

XVI

This exhibition presents German art from 1905 to 1985 almost exclusively as painting and sculpture. In art there are 'highways and byways' (to adopt the title of Paul Klee's *Hauptwege und Nebenwege*). Those responsible for the exhibition believe that painting and sculpture – prepared organically or accompanied by the medium of drawing – have shaped the highways of art, even in the twentieth century, however important, however stimulating and however varied the byways may have appeared at some periods. Ever since Duchamp and Dada the 'byways' have become increasingly important, sending out impulses which have persistently affected the highways.

This is especially true of the post-war period, which is totally dominated by the progressive enlargement of our concept of art. The interplay of art and life, the utopian notion of uniting the two, the hope of overcoming all the barriers that keep them apart in our perception of the world, in our awareness and attitudes – this is a theme which preoccupies artists, constantly engaging their minds and prompting them to experiment.

One consequence of this idea of pushing back and crossing the frontiers of art was that for a time interest shifted increasingly to the byways, because by following these – by joining the vanguard of innovation – we could make greater and faster headway. Whereas in the immediate post-war years it looked as though the evolution of art had made a definitive inroad into the territory of abstraction, leaving all representational art behind it, in the late 1960s and 1970s the traditional picture (and

Fig. 78 Jörg Immendorff, *"It was us"*, 1968

sculpture) seemed finally superannuated as a result of continued artistic advance, replaced by new media and modes of expression. Video, happenings, performance, conceptual art, land art, minimal art, *arte povera*, the changed role of the photograph – these are the concepts which take in the directions in which the debate about contemporary art was moving. Hence we must not forget, as we look back, what audacious artistic potential was manifested in the new modes of expression and invested in the new media.

In this connection we must mention one movement in particular which, though not initiated by German artists, nevertheless had its beginnings in Germany. This movement was 'Fluxus', which announced itself in Wiesbaden in 1962. It was called into being by George Maciunas, who originally came from Lithuania, was employed with the American forces and was a man bubbling over with ideas, sudden inspirations and projects, able to bring people together (and keep them together for a while) and a superb organizer. He gathered round him a number of other Americans living in Europe – such as Emmett Williams, Dick Higgins or George Brecht, who were soon joined by artists from various countries. The first Germans to join the movement were Joseph Beuys, Wolf Vostell and Tomas Schmit.

What was 'Fluxus' – or what is it? This is a question on which the opinions of those who belong to it are even more divergent than they were over the definition of Dada or ZERO. The only fact beyond dispute is that 'Fluxus' existed more as an idea than a group, a movement which resisted all the strategies of the market and on principle consistently refused to be taken over. Much of what was produced in the name of 'Fluxus' belongs to the past – and was meant to be transient from the start. Some survives in documetary form, and some has acted as a stimulus, producing results and continuing to exercise an influence until today.

When Joseph Beuys linked himself to 'Fluxus' for a while and made his appearance within its context – though without ever bothering about the interpretation of 'Fluxus' by George Maciunas and his friends – he already had almost twenty years of artistic development behind him, but he was only just beginning to be noticed.

Of all the artists of our times Joseph Beuys is the one who makes the greatest demands on us. No other has so broadened our understanding of art, filling it with so many new ideas and modes of perception. What at first seemed a byway (to stay with our metaphor) turned out to be a highway. Or, to put it another way, everything Beuys did – everything he put in front of our eyes, whether it was an action or a work (and classification was at first far from easy, because new categories were being created) – proved, when viewed from a greater distance, to be a work of sculpture. Beuys has decisively changed our concept of sculpture. He has ennobled materials, created new links, given us a fresh orientation. So that in the course of time, and by numerous stages, we have become able to experience his work as sculpture. In a process which has been going on for decades, but at first received little attention (though today it has been overtaken by world-wide success), artists had been infusing new life into the classical medium of painting and making it into a vehicle for expressing contemporary sentiment. Joseph Beuys on the other hand has enlarged and enriched our vision of the world through his understanding of sculpture, demonstrating it to us with missionary zeal. He would not have been able to do this without his incomparable faith in man. He believes that man occupies a central place in the universe and has unlimited potentialities which have yet to be tapped. This explains everything he does. It explains also the difficulties we have with his work.

Joseph Beuys's image of man, unlike the one-dimensional, idealistic image that inspired the ZERO group in 1960, is ambivalent. On the one hand he demands that man should solve the most enormous problems, yet on the other he recognizes man's frailty. He relies on man's capacity as a creator, but knows that he is only a creature. He expects man to bring a new order into the state, society, the economy and the environment – and at the same time he is concerned about man's daily weaknesses and daily needs. He puts forward the most complex proposals, yet offers the simplest and most practical help.

The things his work contains are recurrent elements which indicate the constants in his thinking – fat, felt, wax, tallow, copper, aggregates and batteries, honey, pocket torches. These are all elements which time and again indicate protection,

warmth, contacts, communication, unification, movement and life. They conserve and transmit energy. Copper conducts, fat stores in the body, felt warms, honey nourishes, hats protect, batteries charge: the symbolic content of all Beuys's elements is plain to see, their spiritual context obvious. We are staggered by their simplicity. What often causes us difficulty is translating what is intended as an example into the context of our own experience or – to put it another way – to find correspondences in our own existence for the elements which make up Beuys's conception of the world, to spell out our own existence.

Thought is sculpture, says Beuys. To "think" his life means to translate it from passive experience into the possibility of active creation. Thought is sculpture: of all the statements Joseph Beuys has made, this is the one that struck me most forcefully and preoccupied me longest. It points in the direction in which modern art has long been moving. I am referring to the realization that a work of art ultimately exists only in our consciousness – that in other words its outward appearance is less important than what it corresponds to in our mind, i.e. the processes which the work sets in motion in our consciousness.

For Beuys sculpture takes place in the processes between felt and copper, between wax and honey-comb, between heat and cold, between the amorphous and the crystalline, between the transmitter and the receiver. In this way sculpture becomes for him a way of life – just that. It means expressing ourselves in space, realizing ourselves. Sculpture is born when we make use of our innate faculties – sculpture is our chance to be made man. This is what enabled Beuys to remark on one occasion that for him art was something like birth, or like incarnation.

Art aims at our lives. It seeks to help us find our bearings, to discover living powers in dead matter, to develop our own powers, to identify and name the things around us in their transcendent nature.

To the reality of this ambition the works of Joseph Beuys bear witness.

Ivo Frenzel

Prophet, Pioneer, Seducer:
Friedrich Nietzsche's Influence on Art, Literature and Philosophy in Germany

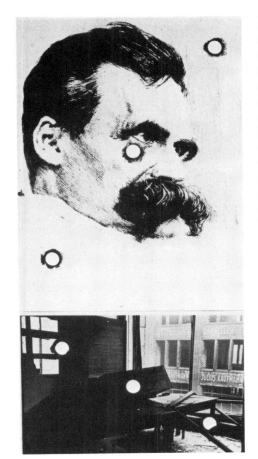

Fig. 1 Joseph Beuys, *Solar Eclipse and Corona*, 1978

In 1941 a young German airman visited the Nietzsche archive in Weimar. He had already made an intensive study of Nietzsche's works while still a schoolboy and was struck by the chaotic state of the philosopher's library. He subsequently made a small drawing which he called *May behind Schloss Belvedere, Weimar 1941*. The young artist, entirely unknown at the time, was Joseph Beuys.. The drawing itself need not concern us here, but the same sheet contains thirty-three lines of text in which the twenty-year-old Beuys set down his thoughts, perhaps the quintessence of what he had come to know about Nietzsche. One sentence reads: "Man can do whatever he wishes through his genius and his fanatical will . . . Apollo and Dionysus."[1] In 1978, when he had become a world-famous artist, Beuys produced another work, this time one expressly dedicated to Nietzsche: the collage entitled *Solar Eclipse and Corona* (fig. 1). Its composition could hardly be simpler: it consists of two photographs pasted one above the other; the artist has punched three holes in each with a paper-punch and overpainted everything in brown. The lower photograph shows a dreary interior, while the one above it is a reproduction of the well-known portrait etching of Nietzsche after he became insane, which was done by Hans Olde in 1899, a few months before Nietzsche's death. These two works not only testify to Joseph Beuys's long-standing preoccupation with Nietzsche, but also reveal something about the changes in Nietzsche's reception in Germany. The young Beuys was enthralled by Nietzsche's theory of art. Apollo and Dionysus stand for the two basic principles which, according to Nietzsche, underlie all artistic creation; the former represents beauty, harmony and intellectual clarity, the latter vitality, intoxication and ecstasy. Another central tenet of Nietzsche's philosophy is that the will is the mainspring of all life and of all human history. The title *Solar Eclipse*, which Beuys chose for the later collage, probably has a dual reference. It may refer to Nietzsche's condition in the last ten years of his life, when his prophetic mind was darkened by madness. On the other hand it may symbolize his own prognosis of things to come: the emergence of European nihilism, the reversal of all values, the decline of morality, and the death of God.

Within the ranks of artists, writers and philosophers Beuys is just one example – a relatively recent and at the same time typical one – illustrating the preoccupation with Nietzsche which has prevailed for ninety years. Apart from Karl Marx no other nineteenth-century German thinker has had a greater influence on the development of German thought. This is all the more surprising in view of the fact that during his lifetime Nietzsche was almost unknown.

An Œuvre full of Contradictions

Friedrich Nietzsche was born in 1844, the son of a protestant pastor, and educated at Schulpforta, a select boarding school. He studied theology and classics for a few terms in Bonn and Leipzig, and by the age of 24 he was professor of classics at the University of Basle. The young Nietzsche was influenced by Schopenhauer's pessimism and Richard Wagner's theory of art. As a classicist he was severely attacked by his colleagues for his essay on the origins of Greek tragedy. Having thus failed as a classical scholar, Nietzsche gradually grew into the role of philosopher, psychologist and commentator on contemporary issues, with a prophetic perception of

1 Conversations attest to Joseph Beuys's occupation with Nietzsche. See also exhib. cat. *Joseph Beuys, Zeichnungen, Aquarelle, Plastiken aus der Sammlung v. d. Grinten*, Städtisches Museum, Cleves, 1961, and *Joseph Beuys, Arbeiten aus Münchner Sammlungen*, Munich, 1981, p. 190

developments that would take place in our century. He criticized Christianity and Christian morality, and he saw in European decadence signs of the decline of the Western tradition and the consequent emergence of nihilism. After the Franco-Prussian War of 1870/71 he became a determined opponent of Bismarck's Reich and criticized the bourgeois arrogance of the Wilhelminian era. He was inimical to all communist or socialist ideas and despised parliamentary democracy. In *Also sprach Zarathustra (Thus spake Zarathustra)*, 1883-5, he envisaged a solution of the European crisis through the emergence of a new kind of human being, whom he called the superman *(der Übermensch)*, a member of a conquering race, "the master race of the Arians". Yet he was not an anti-semite in the spirit of later National Socialist ideology: one finds in his work many passages in which Judaeism is extolled and others in which the Judaeo-Christian religious tradition and its "slave morality" are criticized.

Nietzsche suffered from numerous diseases from his early youth. In 1879, when he was 35, he resigned his chair in Basle for health reasons. Early in 1889 he became insane, probably as a result of a luetic infection, and in the intervening years he travelled restlessly in the Engadine and northern Italy. This may explain why he left no systematic philosophy. The literary forms he favoured in his last creative years are the fragment, the aphorism, the essay and the polemical tract. The whole *œuvre* is full of contradictions. Almost any Nietzsche quotation can be matched with another which contradicts or qualifies it. This was to have consequences for the reception of his work: in Nietzsche's writings anyone could find whatever he sought. It is a curious fact that *Der Wille zur Macht (The Will to Power)*, which is regarded as his principal work, was not written by him in the form in which we know it. The 1,067 aphorisms and fragments which were published under this title are without exception texts which were unpublished at the time of Nietzsche's death and were arranged and edited in accordance with instructions from his sister Elisabeth. Nobody knows which of them he would have allowed to be published, or whether the work as a whole would have conformed with his intentions. It remains one of the ironies of the history of ideas that *Der Wille zur Macht*, the book to which Mussolini expressly referred when he drew up his Fascist ideology, contains a doctrine which Nietzsche might not have endorsed in its extant form. No wonder that on the one hand a philosopher like Alfred Bäumler should have claimed Nietzsche as a pioneer of National Socialism, on the basis of his doctrine of the will to power and his vision of a new heroic man, while on the other, a German *émigré* and victim of Nazi persecution like Thomas Mann considered Nietzsche to be the most important philosopher of the "new age", the prophet of the future. Nietzsche's teachings were never adopted in their entirety, but always selectively.

Nietzsche's academic reception began late. It is true that as early as 1888 the Danish literary historian Georg Brandes gave a course of lectures "On the German Philosopher Friedrich Nietzsche" at the University of Copenhagen, lectures which aroused much interest in Scandinavia and were to influence Strindberg in particular, but at first Nietzsche went virtually unnoticed by the German universities. In Germany it was artists and writers who first discovered him.

Homage to a Protest Writer

There are obvious reasons for this: Nietzsche wrote in a thoroughly modern style. He was a brilliant stylist, and the beauty of his language at its best is reminiscent of Novalis, his intellectual irony of Heinrich Heine. There is none of the academic rigour, the complicated syntax and the difficult terminology that are characteristic of most German academics. And what Nietzsche had to say was always topical, even when he was writing about history. All this was bound to strike young people at the end of the last century as quite unconventional – and justifiably so. Nietzsche was read by the young because he was not yet an author who was discussed officially in schools and universities. And the young enjoyed reading him all the more since his teachings were in marked contrast with the views of the older generation in Germany. He was seen as a protest writer. One may even say that by the turn of the century Nietzsche had become a fashionable philosopher, a phenomenon belonging

Fig. 2 Max Beckmann, *Resurrection*, 1909

more to Bohemian circles and the literary pages than to the lecture room and the learned journal.

In 1894, a society called Pan was founded by the art critic and writer Julius Meier-Graefe and his friends the poets Otto Julius Bierbaum and Richard Dehmel. In the first issue of the journal of the same name Meier-Graefe published a few extracts from *Zarathustra*. The essential message of this work is the idea of the New Man and hence of a New Age. The old norms of bourgeois morality have to be overcome. Quite different possibilities will be open to the man of the future once the conventions and mendacities of the present, the decadence and philistinism of the Wilhelminian era, have been done away with. It was this idea of a new departure, of the dawn of a new age, that dominated this early reception of Nietzsche, and it was entirely in the spirit and the style of Nietzsche that Meier-Graefe, upon the founding of the artists' colony in Darmstadt in 1899, greeted "the dawn we are living through", adding, "The noonday may perhaps bestow great things on us."

The architect Peter Behrens, a friend of Meier-Graefe, also adapted Nietzsche in his own fashion. Originally a painter, Behrens taught himself architecture and became one of the pioneers of a new concept of building (Le Corbusier, Walter Gropius and Ludwig Mies van der Rohe later worked in his office). His first building was a house he intended for himself in the artists' colony in Darmstadt. He built it in 1900/1, endeavouring by means of grand stereometric ornamentation to translate the world of Zarathustra into architecture.

At the same time another architect was influenced by Nietzsche – or, rather, utterly enthralled by him. This was Henry van de Velde, a Belgian who in 1902 was appointed director of the newly founded School of Arts and Crafts in Weimar. He remained there until 1914 and during this period became the foremost designer and architect of the German *Jugendstil*. In his autobiography he writes: "The evenings were devoted to reading *Zarathustra* and other works by Nietzsche. I meditated long on the philosopher's thoughts . . . which to me were better nourishment than real food."[2] Van de Velde was also a personal friend of Elisabeth Förster-Nietzsche, who after her brother's death in 1900 had transformed her house in Weimar into a memorial to him. It was here that the Nietzsche archive was housed. Van de Velde saw to the furnishing of the archive and drew up plans for a Nietzsche monument.

Max Beckmann and Franz Marc: an Early Controversy

One cannot strictly use the word 'reception' to describe the treatment accorded to Nietzsche by architects, among whom one should also mention Bruno Taut: it was more an act of homage, a solemn tribute. For philosophy can of course be only indirectly translated into another medium. And Nietzsche had written neither a theory of architecture nor a systematic treatise on aesthetics. At most one can speak of an artist finding his own intentions confirmed by his reading of Nietzsche. The same is true of painters, though the history of Nietzsche's reception by them is covert rather than clearly demonstrable. Most artists did not express themselves in theoretical terms, and some did not even keep diaries. And one can no more speak of Nietzschean painting than one can speak of Nietzschean architecture. Nevertheless the public was aware of the controversy between Max Beckmann and Franz Marc, which was argued out in 1912, partly in the journal *Pan*.[3] Beckmann championed van Gogh, Géricault and Goya, rejecting as "feeble" the resort to old, primitive styles exemplified by Gauguin. Beckmann was seeking instead a new, heroic man, adopting Nietzsche's conception of the creative artist as someone endowed with superior strength. All innovation, all that is artistically in tune with the times, arises from conflict with society. And the participants in this conflict are always individual creative personalities. For Beckmann this kind of heroic artistic existence was typified by Rembrandt, Cézanne, Grünewald and Tintoretto. We may possibly detect the direct influence of Nietzsche in Beckmann's picture *Resurrection* (fig. 2). Contrary to Christian tradition the risen dead are not divided into the saved and the damned. They all ascend in one endless stream into a light which dominates the upper portion of the picture. Redeemed humanity rises above itself, as it were. In this picture Nietzsche's vision of the New Man finds an idiosyncratic interpretation.

2 Henry van der Velde, *Geschichte meines Lebens*, ed. Hans Curjel, 1962, p. 32
3 See Max Beckmann, 'Gedanken über zeitgemäße und unzeitgemäße Kunst', *Pan*, Munich, 1912, pp. 499-502

The world is pure immanence: there is no hereafter; life is the ultimate value that must be affirmed. And this life belongs to the creative spirits, the men of action. These are the chief arguments which Beckmann used in his dispute with Franz Marc, who took a pessimistic view of man and hence deemed him unworthy of depiction. (We should note here that only the *young* Beckmann was so strongly influenced by Nietzschean vitalism: the experience of the First World War led to a critical revision of this heroic image of man, as we can see from Beckmann's later works.)

Nietzsche was unquestionably widely read and widely discussed in artistic circles at the turn of the century (figs. 3, 4, 5). We know, for instance, that Giorgio de Chirico read Nietzsche while studying in Munich from 1905 to 1908, and he himself stated that he was extraordinarily fascinated by him. Thus there is a direct connection between Nietzsche and the central significance accorded to the city of Turin as a motif in de Chirico's pictures: "If the experience of Turin made such a profound impression on me, it was because it was Nietzsche's city, because Nietzsche had walked across these squares and thought his thoughts here."[4] But it was not just in the centres of artistic activity that people concerned themselves with Nietzsche. In the remote world of the artists' colony at Worpswede the painter Paula Modersohn-Becker often wrote down quotations from *Zarathustra* in her diary under the influence of the poet Rainer Maria Rilke.[5] Her husband, Otto Modersohn, however, had little time for the new values he read about in Nietzsche. In his diary he complains: "Egoism, ruthlessness – that is the new disease, Nietzsche its father."[6] To a greater extent than the visual artists, however, many young poets and writers had discovered Nietzsche for themselves.

The literature of German-speaking Europe in the twentieth century is unimaginable without the poets and writers who grew up in *fin de siècle* Vienna. The most important of them read Nietzsche at an early age. Arthur Schnitzler did not care for him, but this was not the case with Hugo von Hofmannsthal and Rainer Maria Rilke. "However little Hofmannsthal may have said explicitly about Nietzsche, he was nevertheless the one prominent figure among the younger generation to whom Nietzsche was most congenial and who came to terms with him most openly."[7] Numerous notes made by Hofmannsthal demonstrate that he had read all Nietzsche's major works before the turn of the century. In 1891 he tried to translate *Jenseits von Gut und Böse (Beyond Good and Evil)* into French. However, in Hofmannsthal's own work no real influence of Nietzsche is to be discerned. This Viennese neo-romantic saw himself as an epigone of the Western Christian tradition, whose heritage he drew upon to a greater extent than almost any other writer. Nietzsche, who wanted to break with this tradition, could not be integrated into Hofmannsthal's work. It was not until two years before he died that Hofmannsthal acknowledged Nietzsche as the most influential thinker of his age, in the essay *Das Schrifttum als geistiger Raum der Nation (Literature as Spiritual Realm of the Nation*, 1927). Rilke too was an early reader of Nietzsche, but it is only in his late work that Nietzsche's influence becomes evident. In the ninth of the *Duineser Elegien (Duino Elegies)* of 1922 we find the telling lines: "Here is the time for the tellable, here is its home... Earth, my beloved, I will."

Nietzsche's Zarathustra had demanded that we should »remain true to the earth«. It is precisely in this context that Rilke's new understanding is to be seen. Man can discover his identity only by commitment to the here and now, not just accepting earthly things, but praising and extolling them. For the earth is man's home.

Fig. 3 Alfred Kubin, *The Rebel*, c. 1901

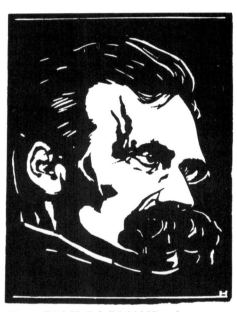

Fig. 4 Erich Heckel, *Friedrich Nietzsche*, 1904

The Philosopher Fashionable among the Expressionists

However, while not only Hofmannsthal and Rilke but also Stefan George maintained a critical distance from Nietzsche, the young poets of Expressionism took him up with unbounded and largely uncritical enthusiasm. In the spirit of the times, they had a single-minded view of Nietzsche as the initiator of the kind of philosophy of life which was being formulated in Germany by Wilhelm Dilthey and Georg Simmel, and in France by Henri Bergson. The author of *Zarathustra* was seen as the father of such thinking. "Zarathustra was the great reception event for the Expressionists... They appealed to Nietzsche as their authority with an irrationalism that

4 Quoted according to Wieland Schmied, *Giorgio de Chirico, Ruhm, Legende, Wirklichkeit*, Munich, 1980, p. 5

5 Günter Busch und Liselotte von Reincken (eds), *Paula Modersohn-Becker in Briefen und Tagebüchern*, Frankfurt, 1979

6 From Otto Modersohn's diary, 28 June 1902; see also Busch and von Reincken, *op. cit.*, p. 26

7 Bruno Hillebrandt (ed.), *Nietzsche und die deutsche Literatur*, 2 vols, Munich, 1978, vol. I, p. 26. These two volumes contain a detailed documentation and a description of the literary reception from 1873 to 1963.

Fig. 5 Otto Dix, *Portrait of Nietzsche*, 1912

was based on a misapprehension, with an activism that aimed into the void. In their aimless enthusiasm they rushed beyond and away from the reality which Nietzsche had pinned down with unique critical perception."[8] A strained pathos in the language they used replaced rationality, and ecstasy was preferred to logical argument. Representative of this mood were writers like Hanns Johst, who subsequently leaned towards National Socialism, and Johannes R. Becher, who became a Marxist, as well as Kasimir Edschmid, Georg Kaiser, Carl Sternheim and many others who are now forgotten. Kurt Hiller thought Nietzsche the greatest thinker since Plato – a grotesque exaggeration! Any critical attempt to come to terms with Nietzsche – such as Alfred Döblin's – was a rarity. Gottfried Benn, who together with Georg Heym was one of the most important lyric poets of the period, later summed up the contemporary reception of Nietzsche: "Actually everything which my generation discussed . . . had already been expressed and exhausted and given a definitive formulation by Nietzsche. His seductive way of writing, with all its thunder and lightning, his relentless diction, his refusal to allow himself any idyllic repose or any universal explanation . . . the whole of psychoanalysis, the whole of existentialism – this is all his doing. He is the universal giant of the post-Goethean age."[9]

Zarathustra, written by Nietzsche the fashionable philosopher, became the great educative experience of these writers; only Goethe's *Faust*, generations earlier, had made a similar impact. One-sided and uncritical though Nietzsche's reception was, its effect was enormous. It can probably be understood only in connection with the simultaneous rise of the youth movement in Germany. This movement, which was by no means confined to the intellectual sphere, found concrete expression in organizations like the 'Wandervogel' and the Scouts. It was characterized by protest against the moral and civilizatory hollowness and mendacity of late bourgeois culture. One must bear in mind that Heidegger, Heisenberg and Jaspers belonged to the movement as young men; so did theologians like Barth, Tillich, Bultmann, Guardini and Albert Schweitzer, sociologists like Tönnies, Vierkandt, Mannheim and Freyer, and educationists like Spranger, Litt and Nohl. Nietzsche's protest against bourgeois culture was understood in such circles as a protest against the ideals and life-styles of their fathers and grandfathers. This was quite normal and understandable. What made such a reception dangerous was the irrationalism of the whole movement, which thus acquired a political slant and made the German intelligentsia receptive to National Socialism. It is certainly necessary to defend Nietzsche against those who interpreted him in such a one-sided manner. As early as June 1884, when the fourth part of *Zarathustra* was not yet written, Nietzsche wrote to his sister expressing alarm at the thought of the kind of unqualified and utterly incompetent people who would one day cite him as their authority. However, what Nietzsche himself may have thought is of no consequence for the history of his reception: what matters is how he was understood.

Nietzsche as the Precursor of National Socialism

By 1933 at the latest, when the National Socialists came to power, Nietzsche's apprehensions were fully realized. As a result of his previous reception, metaphors and phrases taken from his vocabulary (such as "God is dead", "will to power", "superman", "master-race") had degenerated into mere slogans which could readily be linked with the rallying cries of the Nazis. The process of ideologizing Nietzsche soon got under way at German universities. It was promoted in particular by the Nietzsche expert Alfred Bäumler, who linked the philosopher's concept of the will to power, his notion of the heroic man, and his critique of Christianity with the Nazis' ideas on race, while ignoring any of Nietzsche's pronouncements which might have contradicted them.[10] This was the beginning of the darkest chapter in the German reception of Nietzsche. The official line on Nietzsche influenced the arts too. Sculptors like Breker and Thorak created monumental sculptures in which they sought to embody idealized figures whose outstanding qualities were energy and heroism. In 1937, perhaps in direct response to Nietzsche, Breker produced his *Dionysos*. In the same year Kolbe designed a Nietzsche monument, followed in 1943 by a partially executed statue entitled *Zarathustra*. Of the latter Kolbe himself wrote:

8 Hillebrandt, *op. cit.*, I, p. 37

9 Gottfried Benn, 'Nietzsche nach fünfzig Jahren' (1950), in *Gesammelte Werke*, Wiesbaden, 1959-61, vol. I, p. 482

10 See Alfred Bäumler, *Nietzsche der Philosoph and Politiker*, Leipzig, 1931, and especially Alfred Bäumler, 'Nietzsche und der Nationalsozialismus', *Nationalsozialistische Monatshefte*, Munich, 1934. See too the critical, but one-sided study by E. Sandvoss, *Hitler und Nietzsche*, Göttingen, 1969

"The tall, powerful man who freed himself – that was the task, and it was also the way to my own freedom. Zarathustra is a figure that is universally understandable."[11]

It may be said that after 1933 Nietzsche was the defenceless victim of intellectual rape. Yet philosophical theories are never altogether blameless. Precisely because he never clearly stated his political position Nietzsche aided and abetted this one-sided assumption of his ideas. Moreover, irrationality was a specifically German tendency at the time. Works like Oswald Spengler's *Der Untergang des Abendlandes (The Decline of the West)* (1918) or Ludwig Klages' *Der Geist als Widersacher der Seele (The Mind as the Adversary of the Soul)* (1929), with all their irrationality, would have been scarcely conceivable without Nietzsche. The leading Marxist exponent of literary theory, Georg Lukács, could thus write with some justification in *Die Zerstörung der Vernunft (The Destruction of Reason)*, published in 1954,[12] that Nietzsche was indirectly an apologist for imperialism: "The struggle against democracy and socialism, the myth of imperialism, the call to barbarous action cannot but appear as an unprecedented reversal of values." When one now reads essays like Alfred Bäumler's on "Nietzsche and National Socialism",[13] one is tempted to agree with Lukács. Nietzsche, as an instrument of National Socialist propaganda, accompanied a whole generation of the young German intelligentsia to the battlefields of the Second World War. One example of this is the experience of the young Beuys, an account of which was given at the beginning of this essay.

In the 1930s and 1940s the preoccupation with Nietzsche at German universities reached its first peak. To be fair, one must add that it was by no means invariably given a political slant. In 1936 Karl Jaspers published a significant and rather critical monograph on Nietzsche.[14] Yet its initial effect was slight, for Jaspers was *persona non grata* with the National Socialists. Even Martin Heidegger's lectures on Nietzsche had at first only a fairly limited influence. Heidegger's interpretations of Nietzsche, running into over 1,000 pages, were not published until 1961, and even today they have produced no more than a ripple of public interest. But here we must say a few words about Heidegger, the most significant German philosopher since Nietzsche. Since the appearance of his famous book *Sein und Zeit (Being and Time)* in 1927 Heidegger had been regarded as the founder of German existential philosophy. He presented a radical critique of traditional philosophy from Plato to Descartes, which he regarded altogether as a false trail in European metaphysics. Contrary to Aristotelian logic and Cartesian rationalism, Heidegger saw human existence as determined primarily by states of mind, by feelings of anxiety and dread, by the awareness of death, and by the need to act resolutely. Here too the initial impulse derived from Nietzsche, from his relativism which scorned all objectivity, from his vision of the heroic man who must brave all life's adversities. The enormous impact of *Sein und Zeit* between 1930 and 1950 inevitably led to an indirect reception of Nietzsche; and the significance of this reception for certain areas of German philosophy can hardly be overstated.

"Heidegger and Nietzsche agree that all man's previous aims and criteria, especially Christian charity, are out of date."[15] It was in keeping with the intellectual climate reflected in this assertion that in 1933 Heidegger, like Gottfried Benn, should have felt a brief enthusiasm for the "grandeur" and "splendour" of Germany's new departure.[16] Despite the fact that he soon distanced himself from National Socialism – employing the utmost circumspection in doing so – Heidegger's attitude remains typical of a large section of the conservative bourgeois intelligentsia in the Third Reich.

Thomas Mann, or the Other Nietzsche

Alongside this tradition, beginning with Expressionism and ending with Existentialism – both of which could cite Nietzsche as their chief inspiration – there was a literary reception of Nietzsche which was far more critical and far less single-minded, hence far more just. It too began around the turn of the century and involved writers whose names were not linked with National Socialism and whose works were banned and burned by the Nazis. Among them were Alfred Döblin, Robert Musil, Stefan Zweig, Heinrich Mann and Thomas Mann.

11 Georg Kolbe, *Auf Wegen der Kunst*, Berlin-Zehlendorf, 1949, p. 31
12 Georg Lukács, *Die Zerstörung der Vernunft*, Berlin, 1954, p. 253
13 See note 10
14 Karl Jaspers, *Nietzsche. Einführung in das Verständnis seines Philosophierens*, Berlin, 1936, 3rd ed.: 1950
15 Karl Löwith, *Heidegger. Denker in dürftiger Zeit*, 3rd ed., Göttingen, 1965, p. 103
16 See Heidegger's speech as the first National Socialist Rector of the University of Freiburg: *Die Selbstbehauptung der deutschen Universität*, Breslau, 1933

Thomas Mann is the outstanding representative. Of all the writers whom Nietzsche influenced, Thomas Mann had the closest affinity to him. He repeatedly discussed Nietzsche in his essays, and from his early short stories to his works written in old age he never ceased alluding to Nietzsche's ideas. On occasion he even incorporated direct quotations from Nietzsche into his novels: in *Der Zauberberg (The Magic Mountain)* he puts Nietzschean thoughts into the mouth of the character Settembrini, and the later novel *Doktor Faustus* is based partly on Nietzsche's own life, and partly on Nietzsche's conception of the artist's existence.[17] What fascinated Thomas Mann about Nietzsche can only be indicated here under a few headings: the brilliance of his language; the irony which makes him seem like a successor not only to Heinrich Heine, but also to the French moralists; his criticism of the German character; his psychology, which anticipates some of the insights of Sigmund Freud; his understanding of the artist's role; the creative interaction between 'healthy' life and sickness. These are all *topoi* which scarcely interested the Expressionists and were suppressed by the National Socialists.

After 1945 it seemed as though any interest in Nietzsche was taboo. He was no longer given prominence at the universities, and the new generation of German writers, of whom the best-known are Heinrich Böll, Günter Grass, Hans Magnus Enzensberger, Martin Walser and Peter Weiss, seemed neither impressed nor influenced by Nietzsche. In was not until the 1960s that the situation began to change. New editions of Nietzsche's works began to appear.[18] In particular we can now read the original versions of the texts which were not published during his lifetime and of important letters which his sister and friends published in an often distorted and deliberately falsified form. During the last decade a number of monographs have appeared in which Nietzsche's achievements are assessed with a greater variety of approach than was possible for earlier generations. By the end of the century Nietzsche will have been dead for 100 years. It remains to be seen whether this most German of all philosophers will undergo a new renascence and proceed to take his place among the classics.

17 See Peter Pütz, 'Thomas Mann und Nietzsche', in Hillebrandt, *op. cit.*, II, pp. 128 ff.

18 The most reliable editions are Karl Schlechta (ed.), *Friedrich Nietzsche, Werke in drei Bänden*, 2nd ed., Munich, 1960, and especially Giorgio Colli and Mazzino Motinari (eds), *Nietzsche. Werke. Kritische Gesamtausgabe*, Berlin, 1967 ff.

Harry Pross

Youth Movements in Germany

"The Country of your Children"

In 1900 Ellen Key, a Swedish teacher, published her book *The Century of the Child*, prefacing it with a quotation from Nietzsche: "I urge you to love the country of your children! May such a love confer on you a new nobility and represent a new-found land in the most remote of seas! I call upon you to set sail and seek this land! *Make amends* in your children for the fact that you are your fathers' children and redeem all that is past! I commit you to this new commandment!" The book became a worldwide success and the century one of world wars. Many young people read Nietzsche, who in his youth wished to be thought of as having no homeland. They were searching for 'new commandments' because the old norms were disintegrating.

In the course of the first thirty years of its short history the German Reich of 1871 developed into a modern industrial state. Young people moved away from the countryside and small towns to centres of heavy industry were established where coal was to be found – and also to Berlin and neighbouring areas. Immigration and the incorporation of surrounding districts gave the capital of the Reich a population of 4 million by 1939, and growth had continued despite the loss of German territory involved in the Treaty of Versailles in 1919.

Stenography and Training Marches

The old town of Steglitz, not far from Berlin, was no exception to this mood of general mobility. In 1895 the headmaster of the grammar school there allowed a student to give free courses in stenography at the school. Shorthand was part of the current trend towards recording more information more quickly than ever before. Accelerated communications demanded accelerated techniques. The grammar school pupils who learnt shorthand wanted to make something of their careers. Most of them were to become civil servants or salaried employees, seeking their livelihood in an expanding bureaucracy. Punctuality was of paramount importance there, and job tenure dependent on the speed with which requirements were met – hence the usefulness of stenography. The Steglitz stenographers formed an association, going on excursions – initially referred to as 'training marches' – into the surrounding countryside. They were soon describing themselves as "scholars setting off on their travels," alluding to medieval student fraternities and reflecting a yearning for self-determination.

However, there was not much opportunity for self-determination at school or in the home. The modernization of Germany at the close of the nineteenth century proceeded with military discipline. Probably nowhere else in Europe were the meticulous constraints of an absolutist military state so directly applied to the economy as in Prussian Germany after 1870. Work became a ritual performed by civil armies of labourers and office staff. The army, known as the 'school of the nation', determined individual attitudes, forms of behaviour and even styles of dress for those who had completed their 'service'. The sight of anything so casual as a dressing-gown led Nietzsche to write:

> Once the German awoke to common sense / Despite sloppy clobber and negligence. / But now, alas, all is changed. / Buttoned up in confining clothes / He follows Bismarck, the man in the know, / His mind all too willingly estranged.

The scholar-stenographers' parents saw being 'buttoned up' as conferring material authority, a guarantee of survival in the civilian armies of the economy. Young

people preparing for similar careers found a degree of compensation for such a basically desolate prospect in permitted freedoms, such as undoing their shirt-collars and crying "Unrestricted". When girls were admitted to the association ten years later, they abandoned their stays and wore loose-fitting garments instead. Neighbourhood excursions developed into rambles extending over several days, but before these youngsters named themselves *Wandervögel* in 1901 they had organized themselves in conformity with the prevailing system. The hierarchy prevailing among the travelling student-stenographers *(Vaganten)* consisted of 'Scholar', 'Bursche', 'Bachant' and 'Oberbachant' – with the latter acting as absolute monarch. The association of stenographers was a self-styled "monarchical and military Oberbachant imperium", as its leader from the Steglitz grammar school, Karl Fischer, put it in 1904.

"The Home" and "Spring's Awakening"

Jacob Burckhardt, the Swiss cultural historian, remarked in a letter (1872) to his German friend, von Preen, that the new Reich was destroying all those elements where "intellect was still to be found". When Fyodor Dostoevsky visited Germany he was impressed by the punctuality of the postal service. As an emigrant, Lenin even considered organizing the Czar's empire along the lines of that public service.

Germany was at that time the second largest economic power in Europe, after England. Only with Hitler's rearmament was it to become the world's second economic nation after the USA.

Political and economic expansion took place under the auspices of the imperial symbols of the past, subjugating to political bureaucracy people's yearning for the liberties contained in ancient rights and for clear-cut regulations. The most popular magazines among bourgeois families before the First World War were *Daheim* (At Home) and *Die Gartenlaube* (The Bower), both concentrating on home interests. *März* (March), *Jugend* (Youth), *Pan*, *Kunstwart* (Guardian of Art), the *Freie Bühne für modernes Leben* (Free Theatre for Modern Living) and many other expressions of "Spring's Awakening" (Wedekind, 1891) reflected the contradiction between the rigidly organized military and economic hierarchy and the anarchistic human needs of a society drilled to obey orders.

Industrialization and 'The Simple Life'

Groups of urban youth – young workers' associations and various ecclesiastical, political and other bodies concerned with reforming life-styles – spread rapidly throughout the country in ever-increasing numbers, and calling themselves *Wandervögel*. These young people eagerly adopted all the currently fashionable philosophies, including those from East Asia and India, seeking to attain as a personal ideal 'The Simple Life', beyond everyday complexities.

German *Landerziehungsheime* (Country Boarding Schools) were set up in emulation of British public schools; the *Pfadfinder* (Pathfinders) followed the Boy Scouts; and it was an imperial colonial officer, Hans Paasche, who published (in a pacifist magazine for the young) the only significant satire on this age: *Die Forschungsreise des Afrikaners Lukanga Mukara ins innerste Deutschland* (Lukanga Mukara's Exploration of Deepest Germany).

It could be said that with the youth movement German expansionism turned inwards on itself. All the groups involved shared aspects of 'The Simple Life', as promoted today by the leisure industry. They devoted their free time to rambling, singing, games (including war games), amateur theatricals, dancing and photography. They did their cooking on camp stoves, slept in tents, barns or village inns, and regarded the conservation of nature and avoidance of littering the countryside as a point of honour. The network of symbols involved in this 'Back to Nature' movement extended from the anarchists' colony on Monte Verità near Ascona in the south to the artists' settlement at Worpswede in the north.

Fig. 1 Title-page of Hans Breuer's Heidelberg song-book, *Zupfgeigenhansl*, with illustrations by Helmut Pfeiffer

Fig. 2 Illustration by Helmut Pfeiffer to the folk-song *Minnedienst*, from the *Zupfgeigenhansl*

Young Siegfried and the Cult of Fire

Ernst Gombrich has shown how the dazzling Siegfried, in such marked contrast to the dark, clandestine figure of the Jew, nurtured German anti-Semitism. The Nibelungen saga had become a national myth, not least thanks to the operas of Wagner. Every grammar school pupil identified with their embodiments of the forces of light, a point that was to be utilized by political propagandists in both world wars.

The wandering stenographers of Steglitz once again adopted Germanic cults celebrating light. Fire – in the form of the camp fire, the focus of an encircling dance, torches, flames, or celebrations of the solstice – united youth groups at a time when the electricity industry was announcing "a new stage of capitalism", in the words of economist Werner Sombart in 1903.

Young people were quite literally fired with enthusiasm. Their first artistic manifestations followed the *Jugendstil* – as Art Nouveau and Modern Style were called in Germany after *Jugend*, a Munich magazine – with curves and undulations, Wagnerian "Wagalawaia" and flames, contained within the confines of a rectangle. Hans Breuer's *Zupfgeigenhansl* Heidelberg song-book (fig. 1), with illustrations by Helmut Pfeiffer, brought together symbols of "new departures" with images of enclosed gardens, languid female figures symbolizing *Minne* (fig. 2) and baroque horsemen evoking conflict and war. It was very much an imitation of the *Knaben Wunderhorn* (Youth's Magic Horn), of the Heidelberg Romantics.

Ellen Key, quoting Nietzsche, had recommended loving the "country of your children", but the children themselves sought the land of their fathers and fore-fathers. "Expansion inwards" led into the past, which was not surprising since the movement inwards inevitably struck deposits of traditional material. For young people, the 'healing fountain' was fed by submerged springs, and in the process "dubious residues of tradition" (Hannah Ahrendt) came to light.

Wandervögel and Freideutsche

The movement's literati may have objected to the prevalent historicism which led to the construction of factories resembling castles or the inclusion of Gothic oriels in Berlin town houses, but many young people wanted to believe in Houston Stewart Chamberlain's apotheosis of Wilhem II as the dragon-conquering Siegfried as much as in the Aryan race as the promised people.

The movement's progress thus remained ambivalent. In 1913 many young Germans assembled on the Hohe Meissner, a mountain near Cassel, to make their own counter-contribution to the celebrations marking the hundredth anniversary of the Battle of the Nations near Leipzig in 1813. The formula behind this Freideutsche Youth Rally entailed opposition to the prevalent patterns of orders and obedience, and was acceptable to ultra-nationalistic anti-Semites, Jewish *Wandervögel* and socialist pacifists alike. "The Freideutsche youth want to shape their own lives – at their own initiative, on their own responsibility and with the most profound sincerity. They will be unanimous, whatever the circumstances, in their defence of this freedom. Alcohol and nicotine are not permitted at any meetings of the Freideutsche youth." This "Meissner formula" was the expression of a "youth culture" (Hans Bluher) without any political clout. Only a minority of those present agreed with this formula, which was a compromise reached by alliances that grew through co-option. Official Germany had in the meantime learnt to view its young as a "guarantee of the future" and to accord them freedom of action within their associations. A telegram from the 'Academic Freischar' to Wilhelm II in July 1914, aimed at averting the disaster of armed conflict, was swamped by the general enthusiasm for war, and so too was Hermann Hesse's entreaty to bellicose fellow-writers: "O friends, not these sounds . . ."

The End of the Old Regime and the 'National Community'

The enthusiasm of 1914 was for the Fatherland, not for the "country of your children". In retrospect it appears as a momentary respite in the contradiction

between private citizens' unsatisfied needs and the dominant institutions. Friedrich Gundolf, a Jewish literary historian and disciple of the poet Stefan George, wrote on 27 August 1914, that recently he had witnessed the transformation of millions of people "into a single German nation" worthy of that sacred name, and of which "a new global formation" could be expected.

Most of the youth movement's magazines were equally extravagant in their judgments. Their view of this process of the emergence of a nation was aesthetically rather than ethically motivated. Their image of a 'national community' was a romantic one. The concept of the virtues of war seemed to have been derived from medieval romance. However, the theme of national unity, surmounting all differences, was invoked time and again. The trend towards democracy, paralyzed throughout the entire nineteenth century, appeared to gain momentum through the plebiscite in favour of war. Professors compared the "ideas of 1914" with those of 1789, contrasting German "heroes" with British "shopkeepers."

This anti-Western impulse gave a direction to discontent within industrial society. The fact that the industrialization of Europe was progressing from West to East was not regarded as a matter of chance. "At the close of the bourgeois epoch" the "belated German nation" formed ranks against the Western democracies, as the anthropologist Helmuth Plessner wrote in 1935. Today new nations all over the world are allying in similar fashion against Western political traditions.

From the beginning the various youth movements felt themselves to be "close to the people". In 1914 they confirmed their plebiscite with war service. It would, however, be wrong to equate *Volkstümlichkeit* (closeness to the people), closeness to nature, reform of life-styles and religious affirmations with positive attitudes towards the war. Irrational events provoke irrational attitudes. Johannes Müller-Elmau, a prophet of reform of life-styles and publisher of the *Grüne Blätter*, thus became a popular speaker and pamphleteer on behalf of war – "The War as Destiny and Adventure", and so on. Hitler, too, remained a vegetarian throughout his life, while some young warriors of 1914 became pacifists. "I want to lie down beneath trees and sleep, no longer a soldier," wrote the young Alfred Hentschke (Klabund). Pacifism was the fruit of experience.

The 'Wandervögel warriors' nevertheless maintained their connections. The civilian structure of local groups, administrative districts, associations and national unions, which accorded with the federal structure of state, was complemented by a network of meeting-places and contacts extending from Antwerp to Constantinople. These young soldiers indulged in old dreams. The thirty-second wartime issue of the *Wandervogel* monthly magazine (October/December 1917) was devoted to "contemplation" (fig. 3): "There is an exquisite picture by Moritz Schwind. The young Siegfried lies in blissful idleness among flowers beneath trees, listening intently to the birds he is watching in the branches – 'And when he raised the horn to his lips/He understood what the birds were singing.'"

Fig. 3 Title-page of the monthly periodical *Wandervogel*, October/December 1917

The Mysticism of Defeat and "Those To Come"

"What the birds were singing" was easier to understand than the causes of the First World War and the defeat that followed. German Social Democrats had justified their support for the war credits of 1914 in terms of the indivisibility of the national community, and in 1918 they derived their strength from that very support of 1914.

The youth movement could not understand such a manoeuvre. The fact, too, that Friedrich Ebert, the first Social Democrat President, made "Deutschland, Deutschland über alles" into the Republican national anthem, replacing the imperial one, promoted the mysticism of the national community rather than democracy. The Treaty of Versailles in 1919 inevitably reinforced the general tenor of the times.

The notion of "the war as inner experience" (Ernst Jünger, 1920) reinforced prejudices against Western civilization and left unscathed dreams of a nation and a Reich upholding pure customs and noble traditions. "Wherever peoples wish to understand one another, the diplomacy of leaders genuinely rooted in the soil serves as a mediator and sure guide," the leftist magazine *Junge Menschen* proclaimed in January 1921, referring to Hugo Höppener, known as Fidus, an artist born in 1868

Fig. 4-7 Illustrations by Fidus, the highly esteemed artist of the youth movement: Cover illustration of *New Documents of Vegetarianism, Nature and the Sexes*, vignette from *Life Signs*, *The Puzzle*

and highly esteemed by the youth movement. "And of what does Fidus's art consist? Religious experience, inner destinies, the ways of the soul, the quest for the grail, and the shining, lofty paths of true mysticism." The author called for purification and intensification since pacifist radicalism could only be religious, not political or even "German" (figs. 4-7).

The Expressionist wood and lino cuts of those years also pointed away from the 'jungle of the cities.' No way led though from this mysticism into parliament. The young shouted an enthusiastic "Heil!" while other people simply wished one another "good morning." They dabbled in many of the arts but left politics alone.

Young members of the bourgeoisie – with few exceptions – refused to accept the Weimar Republic as their state. Its democratic symbolism remained alien to them, and its representatives seemed to be the successors of the bureaucrats and the minor aristocracy derided under the Kaiser. The Republic obviously did not represent the lost paradise, which had still to be attained. "The new age is ready to greet its youth as comrades-in-arms. What is branded in the souls of the young must become the predominant view of life," wrote Wilhelm Stählin on the 'new life-style.'

The apocalyptic vision of the ultimate kingdom took shape as a promulgation of a "Third German Reich" (fig. 8). Left-wing ideals had no chance against introverted nationalistic attitudes. The Left proclaimed a vision of life as it should be, but the Right interpreted the real experiences of community, landscape, tradition, military defeat and inflation as signs of "what is to come."

"Raise the Banners in the East Wind"

The 'Bündische Jugend', as the successors to the 'Wandervögel', the 'Freideutsche' and the Pathfinders were called in the late 1920s, extended their travels to Eastern Europe, visiting the isolated linguistic groups of "Ethnic Germans" which had, in many cases, existed there for centuries. The geo-political concept of Central Europe came into fashion in theoretical discussions. While the Weimar Republic was assuring itself in the 1925 Berlin Treaty of the Soviet Union's assistance in secret rearmament, the youth movement was exploring what was later to be the invasion area in Eastern Europe. Was this merely a coincidence? It was certainly not a deliberate plan or conspiracy on the part of the Politburo, the German Ministry of Defence or the 'Wandervögel', but geographical interests, political and economic calculations, and a turning away from the West did go hand-in-hand. In a 1926 article on the wood-carver Franz Masereel, Kurt Kläber, a Communist writer, asserted: "Europe is a sluggish, fetid paunch! Slash it open! Rupture it! For eight years now I've been looking for the man with the knife . . . Europe stinks to highest heaven in its capital cities. They are our continent's sodom – London the commercial sodom, Berlin the military sodom (even today!), Paris the sodom of the flesh." It was there that Kläber found Masereel, the "man with the knife", and the courage to stab "again and again, deeper and deeper."

The old themes of European degeneracy, flight from the cities and the hope of putting an end to all humbug came together in the dream of an authentic existence in the East – particularly in those regions still unaffected by industry, where Cossacks still rode their wild horses, Scipetars scaled their rocky mountains and Lapps traversed icy wastes on their reindeer sledges.

Of course these young people did also ride motor bikes – and at top speed, too. In demilitarized Germany they also discovered gliding, but most of them still preferred more traditional forms of transport. For the young, paradise meant tending a fire in an all-electric age and hiking at a time when air transport was taking over.

A need to catch up with old traditions and techniques seemed to establish itself – just as Hollywood in the age of the atomic bomb made the Colt into a fantasy weapon for young children and teenagers. Indend, "To the East" had something in common with the American dream of "Go West". Adolescent yearnings and imperial interpretations of history combined in the 'Bündische Jugend', forming a myth. The limits of imagination and perception were easily transcended. Desire and its fulfilment seemed to become one, and dream and reality could no longer be distinguished.

It would be unjust not to mention the innumerable attempts at sensible social reform in all of the youth movement's headquarters towards the end of the 1920s. It was sensible to provide community employment in the form of voluntary labour for young people thrown out of work by the world economic crisis (fig. 9); sensible to develop a sense of camaraderie among the homeless masses; sensible to protest against repressive sexual legislation; sensible in the age of the gramophone record to make music oneself, and to make films oneself, thus taking photography beyond snapshots of posed groups; sensible to strive for reconciliation with the French, as the Solberg Circle attempted, and to communicate with the youth of the world as a whole – but none of that prevented regression into the magical as endemic in the empire-building and charismatic leadership within youth groups and alliances.

The *Führer*, the "man with the knife", did not emerge out of the youth movement, however. This new version of Nietzsche's man without a homeland came from the Austrian provinces, full of hatred for the metropolis. He was an unsuccessful painter who was expert at symbolizing all the people's petty ambitions and focusing all their aggressions – the 'unknown soldier' personified. In 1926 he seemed to be just one among innumerable proclaimers of salvation wandering around Germany. In 1933 Hindenburg, the old field marshal and President, handed over power to Adolf Hitler, and he stabbed and stabbed, time and again . . .

Fig. 8 *The New Germany* – woodcut by Friedrich Wobst from *Junge Menschen*, 1922

From the "Young Man's State" to State Youth

In 1926 important youth organizations united to establish the 'Deutsche Freischar', which aimed at being a "microcosm of the people". Popular educational work, political guilds and voluntary work camps complemented a wide range of other artistic and educational activities. The youth music movement, amateur theatre troupes and artists' guilds extended their membership to include thirty- and forty-year-olds. The generation born around 1890 set the tone, the majority having taken part in the war with its trauma of defeat. Although most members of these youth organizations might still have been at school, seeking friends of the same age, the youth movement itself had become an institution alongside the parental home and school. The spontaneous eccentricities that marked the beginnings of the movement had been replaced by specific rituals which had to be complied with. Dress approached the model established by the Fascist Balila in Italy. Nothing remained of the idea of 'wandering scholars' except in small groups like the 'Nerother Wandervogel.' Outward appearances became increasingly uniform towards the end of the twenties. European Fascism made its mark and the differences between the youth movement and the state with its political parties were once again more aesthetic than ethical. This was also true of the movement's rejection of the National Socialist Party and Hitler Youth. Aspects of Fascism were evident in the German youth organizations, but to begin with there was little sympathy for the New Germany of National Socialism. This is of importance in understanding the opposition to Hitler and developments after 1945.

The last great leader in the pre-1933 youth movement was Eberhard Koebel, known as Tusk (fig. 10), a Swabian illustrator, designer of books and ornithologist, whose *Das Raubvogelbuch* (1928) became well-known. In 1927, at the age of twenty, Tusk undertook his first journey to Lapland and then wrote about it. On 1 November 1929 he established a youth group conceived as a work of art, calling itself the 'dj. 1. 11' (Deutsche Jungenschaft of 1 November). Tusk began his account of a second journey to Lapland in 1929 as follows: "We should gradually have found out that the Romantic Life is always to be found somewhere else, not where you happen to be. You learn at a fairly early age that you cannot jump with both feet on to the shadow of your own head. A Wandervogel, however, never learns that the Romantic Life can never be attained." That account was followed by magazines and mysterious enterprises, such as the *Grey-Red Campaign*, *The Drawn Bow*, *Tyrker*, *Songs of the Icebreaker's Crew*, *The Heroes' Bible*, and finally *The Pine*, a Zen Buddhist journal. In 1934 Tusk emigrated to England via Sweden, but the style he had established among his followers by way of clothes, behaviour, haircut, Cossack choirs, Zen Buddhism and Finnish daggers influenced the young of the thirties more

Fig. 9 Unemployed youth. Title-page of Working Youth's supplement to *Kultur und Leben*, about 1929

Fig. 10 Emblem *d. j. 1. 11* ('German Boys' Organisation of 1 November'), designed by its founder, Eberhard Koebel, known as Tusk. 1931

Fig. 11 "Confederate machinations" was what the Nazis called the banned activities of youth movements after 1933.

than the leaders of the Hitler Youth can have liked. Subversive activities (fig. 11) were liable to punishment, but right up to the end the Gestapo were unable to stop them, just as they were unable to stop jazz, tap-dancing and swing. *Bündische* style became an expression of aesthetic opposition among the young. It constantly verged on kitsch but did also lead to the ethical outcome of open resistance in the activities of the White Rose (1942/3) and other less well-known groups.

"The Man Outside" and the "Sceptical Generation"

Young people's susceptibility to seduction by political, commercial and religious propagandists results from the dilemma of having to present themselves in society without as yet knowing how to do so. By putting everyone in uniform the National Socialists exploited that individual problem for their own ends.

All that vanished in 1945. The uniforms, the Reich, the *Führer*, and even the People disintegrated into individuals and the smallest of groups fighting each other for food and shelter. The mythical nature of "One People, One Reich, One Führer" was thus revealed for all to see. The great bureaucracies, which had regimented German existence since 1870, had disappeared. The youth movement, which had developed in opposition to regimentation at school, within the family and in public life, seemed to be finished – and so too did German industrialization. The survivors had had enough of conflagration, and the harmony of undulation and flowing curves had given way to shattered rectangles of charred urban ruins everywhere – Germany after *Götzendämmerung* (the twilight of the idols).

Just a few months later, though, they had returned: artists with their heads in the clouds, verbose writers, advocates of educational reform, and former members of the youth movement: "What, you're still alive too?" "Homeless", a poem by the young Nietzsche, ends: "Heidideldi! Never leave me, oh bliss, oh multi-coloured dream!" Now millions were without a home, and the slightest hint of homesickness, ennui and alienation – which had been constant preoccupations within the youth movement – would now have been sheer foolishness.

"What is to be Done?" Lenin once asked, and then promptly answered his own question. His pamphlet became available in 1945 and rapidly made converts. The Occupying Powers did not demobilize their propaganda teams. They brought along Youth Officers. When in November 1945, aged just 22, I was allowed to give the first public and free speech of my life, demanding "Participation of the Young in the Development of Democracy", this was published immediately. Re-education was part of the Allies' programme. Former youth organizations and political parties were given new authority to operate. Youth committees were formed at local, district, and regional levels. The bureaucracies recovered and spread by way of co-option. In fact everything started all over again. The survivors of the generation born around 1870, who had begun to develop a youthful sub-culture in the 1890s, were by then old men. The 1890s generation was burdened by the experience of two world wars and of Auschwitz, and divided between persecutors and persecuted. Their children were the youth of 1945 – and they received an amnesty.

For the older generation, Walter Flex had in 1915 written a book about Ernst Wursche, a 'Wandervogel' warrior, whose sales exceeded 100,000 copies and brought the author the Kaiser's Order of the Red Eagle. Their sons, gradually returning home after the Second World War, recognized themselves in Wolfgang Borchert's radio play *Draussen vor der Tür* (The Man Outside, 1947). Albert Camus and Jean-Paul Sartre became favoured writers for the post-war young whom the sociologist Schelsky described as the "sceptical generation." When the Allies re-armed their respective Germans, the generation of 1922 organized the first large-scale demonstration of young people since the war. Their slogan was "Count me out," urging detachment rather than commitment.

1968 and the 'Greens'

Things went ahead even without the co-operation of the young protesters. Bureaucracies functioned at an international level. "Putrid Europe" became integrated

Fig. 12 Mural on the former Kunst- und Kultur-
centrum, Kreuzberg, in Berlin, created in 1981 by
a group of young artists from a design by Marilyn
Green and whitewashed in 1985

beneath the shadow of America's atomic bomb and the Soviet sputnik. The new medium of television, the rapid motorization of individual transportation and consumer-oriented economic activity created new conditions. The new world power within the cultural sphere was America.

It was American students and their opposition to the Vietnam war that mobilized their counterparts in Europe. In Germany student protest now invoked Hegel and Marx rather than Nietzsche, but youthful opposition continued, just as in 1900, to be directed against the swamping of the individual by giant institutions, 'compulsive consumption' and the new super-powers. The more clearly these protests were articulated, the more apparent the old unresolved problems became. The 'Greens' are the legitimate successors to the turn-of-the-century advocates of new life-styles – and are just as sectarian. The difference is that what was formerly discussed and practised in small groups is now attracting more general assent and the interest of international organizations. The cities are also again losing inhabitants to the surrounding countryside.

At a time of transition and adoption of new technologies, the main emphasis in German youth movements continues to be identification with the peer-group, and aesthetic motives continue, as ever, to predominate in the struggle involved in determining the right course of action. Alongside and behind the official youth organizations the old *Bünde* are still at work, and behind them anonymous individuals who paint their messages on houses, motorway bridges and railway stations, to the annoyance of the police (fig. 12). In their uniform of the blue jeans of the 'Pax Americana', they offer anonymous resistance to the anonymous constraints of our 'brave new world'.

Today, as in the past, groups, bands and associations of young people gather together and publicly discuss the teachings, both true and false, of previous generations.

Werner Becker

Critical Theory
The Frankfurt School and its Influence on Culture and Politics

The effect of Critical Theory on culture and politics during the 1960s and 1970s is rooted in a time-honoured German tradition. Academic philosophy has enjoyed an astonishingly wide public in Germany at least since the beginning of the last century. Hegel is an impressive testimony to this. At the zenith of his career at Berlin University between 1820 and 1830, interest in his dialectic philosophy was by no means confined to academic circles. In *Zur Geschichte der Religion und Philosophie in Deutschland*[1] Heinrich Heine gives a striking account of the public attention which Hegelian philosophy attracted at that time. The collapse of the Hegel School following the death of its founder again preoccupied intellectual and political circles. In the second half of the nineteenth century the controversies surrounding Darwinism aroused the interest of a wide public. At the beginning of this century Albert Einstein's Theory of Relativity and its implications for causality and freedom were the focus of considerable public debate. German philosophers expected to be accorded public attention for ideas which are far removed from the realities of life. This applies to Kuno Fischer, one of the most highly regarded philosophers in the reign of Kaiser Wilhelm II. It also holds true for the radical philosopher Friedrich Nietzsche who was one of the fiercest critics of the Prussian influence on German culture. Edmund Husserl, the founder of phenomenology, may be regarded as an exception. But his student Martin Heidegger reasserted the desire for public influence in an extremely naive, hence all the more revealing, manner. In 1933 he saw a genuine possibility that Hitler's National Socialist Party could, by assuming power, provide the political impetus for eliminating modern man's *Seinsvergessenheit*, or forgetfulness of being. Ever since Fichte German philosophers have always viewed themselves as being 'educators of mankind', and their claim has been acknowledged above all by the intellectual public in Germany.

In no other European country were highly theoretical debates on Marxism and its various offshoots so intensively conducted by politicians, journalists and the general public as in Germany during the 1920s. This very discussion explains a characteristic of the public interest in German philosophy which was to have far-reaching consequences. If this interest concerned itself at all with political affairs, it focused on political metaphysics, and leading philosophers avoided practical decisions on issues such as the choice between monarchy, dictatorship and democracy. This attitude reveals the deep insecurity experienced by the Germans in relation to their State ever since the fall of the Holy Roman Empire. The sense of insecurity increased in the twentieth century following the transition from the monarchy to the Weimar Republic, the overthrow of the Republic by Hitler's Third Reich, the catastrophe of 1945 and the return to democracy in West Germany in 1948. It has created an intellectual inheritance which still makes itself felt today and has determined the attitude of the intellectual public in Germany towards politics. As in the era of the Weimar Republic, recognized intellectuals – writers and artists just as much as philosophers – even now react with caution to positive declarations of loyalty towards the democratic state of the Federal Republic of Germany. In line with the German tradition of a public interest in abstract *Weltanschauung*, political standards are oriented far more readily in the direction of supranational ethics encompassing mankind rather than towards concepts of existing states. For the majority, indeed, the real contradiction between dictatorship and democracy is not the ideal by which the Third Reich should be judged. The ideal is again an abstract anti-Fascist *Weltanschauung* on a plane far above such contradictions. This supra-political *Weltanschauung* embraces both socialists and Christians. It tends to obscure the momentous difference between the democratic reality of the existing state and the dictatorship of the Third Reich.

1 H. Heine, 'Zur Geschichte der Religion und Philosophie in Deutschland', in *Heines Werke*, Berlin/Leipzig/Vienna/Stuttgart, n. d., Part 9, pp. 273 ff.

Public interest in the Critical Theory of the Frankfurt School has been integral to this mainstream of German cultural tradition spanning the last two centuries. Once again it is characterized by a typically German tension between a highly abstract philosophical theory far removed from everyday experience and an intense public involvement. Prior to continuing along these lines I would like to give an idea of the history and principal theses of Critical Theory.

Das Institut für Sozialforschung (The Institute for Social Research)

The genesis of this social philosophy was closely linked with the foundation of the Institute for Social Research at Frankfurt-on-Main in 1923.[2] The founders (in particular Felix Weil who provided financial backing) had in mind an academic research centre with no party ties, which would foster the future development of Marxism. Max Horkheimer became director of the Institute in 1931 (fig. 1). He founded the *Zeitschrift für Sozialforschung* (Journal for Social Research) which has published papers by members of the Institute since 1932. Horkheimer's principal colleagues were Henryk Grossmann, Friedrich Pollock, Karl August Wittfogel and Franz Borkenau (fig. 2). Theodor W. Adorno (fig. 3), a friend of Horkheimer's since the 1920s, initially only had a loose connection with the members of the Institute (he did not become a full member until 1938, by which time he was living in the USA). Herbert Marcuse (fig. 4), Erich Fromm (fig. 5) and Leo Loewenthal (fig. 6) were regular collaborators in the early Frankfurt years. Before Hitler assumed power Horkheimer and Pollock were able to transfer the foundation's financial resources abroad. Because the members of the Institute were without exception both Jews and Marxists there was no option but to take the hard road into exile: first of all to Geneva and then to the USA in 1935. There Horkheimer was able to establish a liaison between the Institute and Columbia University, New York. From 1935 until his death in 1940, Walter Benjamin (fig. 7), who had remained in exile in France, was counted as one of the official collaborators. In 1949 Horkheimer returned with the Institute to Frankfurt. Pollock and Adorno were soon to follow. Other members of the Institute like Marcuse and Wittfogel made their home in the USA. During the second Frankfurt era Critical Theory developed into the most influential school of philosophy in the Federal Republic beside the existential philosophy of Heidegger and Karl Jaspers. Horkheimer and Adorno concurrently held posts as professors of philosophy and sociology at the J. W. Goethe University of Frankfurt. Their teaching enjoyed enormous popularity among the young students and their intellectual influence on the contemporary West German student generation continued to grow during the 1960s.

In 1959 Horkheimer relinquished his chair in Frankfurt. In the mid-1960s Adorno, who was somewhat younger, was swept up in the turbulence of the rapidly developing student movement. He never came to terms with the sense of disillusion derived from the fact that he of all people should become a prime target of rebellion on the part of students who quite correctly described themselves as his pupils. He was unable to reconcile this conflict within himself. On the one hand, he was a traditional German professor by tacit consent. On the other hand, he was a teacher whose students had declared the old professorial university to be a bulwark of reaction opposed to progress. He lived to see his troublesome friend Herbert Marcuse return to the Federal Republic for protracted stays in the 1960s, when he was hailed as a spiritual leader by neo-Marxist students intent on revolution. In the summer of 1969 Adorno unexpectedly died.

The public effect of Critical Theory was intimately bound up in the student movement of the 1960s and 1970s. When one looks at the writings of Horkheimer[3] and especially of Adorno[4] the political influence which they undoubtedly wielded is astonishing. Their writings comprise highly abstract, abstruse philosophical reflections on history and society which require a high level of sophistication on the part of the reader. The public effect of Critical Theory is inexplicable unless one takes into account the German tradition in which abstract theories of *Weltanschauung* command such an astonishing public interest. There is certainly no trace of anything in Max Horkheimer's and Theodor W. Adorno's main works which could be grist to any political mill.

Fig. 1 Max Horkheimer

Fig. 2 Franz Borkenau

2 A comprehensive history of the Institute and its members may be found in M. Jay, *The Dialectical Imagination. A History of the Frankfurt School and the Institute of Social Research 1923-50*, London, 1953

3 Horkheimer's main publications are:
Autorität und Familie, Paris, 1936
Dialektik der Aufklärung (jointly with Adorno), Amsterdam, 1947 (*Dialectic of Enlightenment*, trans. J. Cumming, London, 1973)
Zur Kritik der instrumentellen Verkunft, Frankfurt, 1967
Kritische Theorie, Frankfurt, 1968

4 Adorno's main books are:
Dialektik der Aufklärung (jointly with Horkheimer), Amsterdam, 1947 (*Dialectic of Enlightenment*, trans. J. Cumming, London, 1973)
Philosophie der neuen Musik, Tübingen, 1958 (*Philosophy of Modern Music*, trans. A. G. Mitchell and W. V. Bloomster, London, 1973)
Minima Moralia, Berlin/Frankfurt, 1951 (*Minima Moralia. Reflections from Damaged Life*, trans. E. F. N. Jephcott, London, 1974)
Drei Studien zu Hegel, Frankfurt, 1957
Negative Dialektik, Frankfurt, 1966 (*Negative Dialectics*, trans. E. B. Ashton, London, 1973)

5 Cf. H. Radermacher, 'Kritische Theorie und Geschichte', in *Theorien in der Geschichtswissenschaft*, ed. J. Ruesen and H. Suessmuth, Düsseldorf, 1980, pp. 34-59

Fig. 3 Theodor W. Adorno

Dialectic of Enlightenment is the title of the principal work which Horkheimer and Adorno wrote jointly during their period of exile in the USA. This is one of the central themes in Critical Theory. Others are a particular conception of Marxism and the critique of positivism in science.[5]

The members of the Institute during the first Frankfurt era in the Weimar Republic were, without exception, adherents of orthodox Marxism, although they did not view their relationship as being bound by party affiliations. In the early 1930s Horkheimer and Pollock moved away from classical Marxism as it was represented in the Soviet Union. Horkheimer in particular was already being strongly influenced by his younger friend Adorno and to all intents and purposes he wanted nothing to do with a Marxist philosophy of political action. He turned instead to an attitude based on the philosophy of culture in which the Marxist fundamental categories continued to play a significant role for purposes of analysis. Hopes for the revolutionary establishment of Communism leading to the liberation of humanity ceased to play a part. This change in direction was unquestionably connected with the political events of the 1930s. The terror of Stalin's Communist Dictatorship of the Proletariat was gradually accorded critical attention even by sympathetic Western intellectuals. The peak of mistrust towards the Soviet Union was reached with the pact of 1939 between Hitler and Stalin. In addition, the Marxist exiles in the USA found that despite the severe economic crisis of the 1930s, American capitalism was in no way threatened by proletarian revolutionary consciousness as represented in Marxist theory. Yet these self-critical experiences did not affect the adherents of the Frankfurt School sufficiently for them to consider rejecting the basis of their Marxist creed. They assimilated their critical experiences through a process which is typical for 'believers' who have begun to doubt the persuasive power of their fundamental beliefs. Members of the Frankfurt School continued to regard the world in terms of Marxist fundamental categories. Henceforth, however, they abandoned those objectives on which the Marxist categories logically depend. Very early on they adopted the neo-Marxist theory of society 'without revolutionary subject'. This theory is typical of the Frankfurt School. History and society were interpreted along orthodox Marxist lines in terms of the Marxist fundamental categories: 'contradiction of capital and labour' and 'alienation of man' through universal dependence on the capitalist production sector. However, at the same time they rejected as inappropriate the function of the proletariat as 'revolutionary class' in the service of 'abolition' of class antagonism and elimination of the 'alienation of modern man'. The Marxist view of modern society inherited from Marx therefore remained intact, and a self-critical conclusion as to its fundamental inaccuracy was bypassed. This inconsistency engendered the concept of hopelessness in terms of the philosophy of history, a concept which has become the hallmark of neo-Marxist theory as propounded by the Frankfurt School. In *Dialectic of Enlightenment* Horkheimer and Adorno had relinquished the positive dimension contained in Marxism itself: the hope of a revolutionary 'abolition' of previous 'fundamental contradictions' in society. However, in this work they already compensated for it by emphasizing the

Fig. 4 Herbert Marcuse in discussion with students in the main lecture-hall of the Freie Universität, Berlin

exclusively critical approach, an emphasis which seems to border on natural philosophy. From the intrasocial contradictions which Marx had perceived in the history of class struggle they developed a dialectic of human domination of nature. For Adorno and Horkheimer the emergence of occidental rationality and 'bourgeois individuality' are intimately associated with the history of the oppression and exploitation of nature by the human race. In their view Homer's myths herald the emergence of abstract, scientific rationality and bear witness to the rationally calculating mentality of the bourgeoisie. This derives from the 'spirit of domination of nature' which coincides with the spirit of oppression of nature. The historical price for the success of the 'oppression of nature' lies in the suppression of individuality, both that of human beings and of all else in nature. A dialectic of increasing rationality and oppression of the individual has been escalating until humans as individuals are forced to conform once and for all to the norms of an increasingly 'rational' society. For Adorno and Horkheimer this process of conformity assumed such finality in the twentieth century that any positive reversal of the oppression was no longer conceivable. An irreversible trend towards domination by economic monopolies and the existence of corporate productive resources founded on modern science and technology are characteristic of modern capitalist society. This society is fast becoming the monolithic bastion for domination of nature and oppression of the individual.

These are the principal features of the theory of history based on the philosophy of nature as postulated in *Dialectic of Enlightenment*. Horkheimer and Adorno wrote this work during the 1940s whilst in the USA. Neither of them ever considered an 'intellectual emigration' during their period of exile. They continued to write in German and did not cease to think in terms of the philosophy of history derived from their German heritage. Small wonder that the *Dialectic of Enlightenment* did not reach a wide audience in the Federal Republic until the 1950s and only in the 1960s assumed the role of a 'cult book' for part of a student generation in Germany.

Fig. 5 Erich Fromm

Effect of a Theory

What was it about the tenets of the *Dialectic of Enlightenment* which so fascinated students during this period? In order to answer this question one must envisage the intellectual climate which prevailed then in the Federal Republic. To the students at the Goethe University in Frankfurt during the 1950s and 1960s Horkheimer and Adorno were quite simply the most stimulating figures in the humanities and social sciences. As their reputation grew, students flocked to their lectures in ever-increasing numbers. Horkheimer's lectures were a model of distinguished Western erudition expressed in simple language. To many, including those who did not subscribe to neo-Marxist social philosophy, he became an intellectual father figure, representing the ideal of the understanding, sophisticated professor in the classic German mould. In contrast, the fascination Adorno exerted as professor and writer lay in his deliberately stylized fusion of an academic and artistic existence, a lifelong attempt to combine the bourgeois and the anti-bourgeois in a single person. He appealed to students who possessed an acute awareness of the catastrophic effect of the Third Reich on bourgeois culture and who at the same time yearned to derive a new moral and intellectual assurance from bourgeois principles and culture. This statement may be said to sum up the dramatic effect of the Frankfurt School as a whole on the student generation of the 1960s and 1970s.

At the beginning of the 1960s the Auschwitz Trials took place in Frankfurt. They had an oppressive and macabre effect in deepening public awareness of these heinous murders committed in German concentration camps, murders which defied any military logic. The world war instigated by Hitler had claimed 50 million war dead. Students at that time were conscious that eternal shame had been cast on Germany not so much by the war and a totalitarian past as by the mass murders in the concentration camps. They sought an uncompromised and at the same time living intellectual tradition which permitted young Germans of these years to construct a link with the cultural past of their country. The first post-war student generation tried to withdraw from the pressure of shame by turning to the purely individualistic existentialism, transcending historical boundaries, of Heidegger, Jaspers and Sartre.

Fig. 6 Leo Loewenthal

The next generation had only childhood memories of the war and sought a philosophy which might explain the materialization of 'absolute evil'. There was a prevailing feeling that the 'economic miracle' in the Federal Republic of Germany and the increasingly stable liberal democracy could not be the total answer to an historical disaster. The desire to come to terms with Germany's history was the guiding motive in the trend towards the Critical Theory of the Frankfurt School. This theory of society seemed appropriate because it was a partly subconscious extension of a German tradition of public interest in philosophy – a tradition of political interest in 'abstract' historical and social philosophy as discussed above. Never in the previous 200 years of German history had there arisen a situation so conducive to a philosophical discussion of guilt. It was a national guilt which could not be justified in terms of the usual horrors of war. World public opinion would not tolerate the usual justifications for genocide and the horrors of war in a people who had been so utterly defeated. Such was the feeling in the guilty conscience of the young generation. A decisive aspect was a fundamental conviction that the Hitler phenomenon of 1933 could not have occurred with the younger generation as it had with the generation of their parents. This belief certainly had no historical foundation but created the attitude of moral superiority which characterized to such an extent the student generation of the 1960s in the Federal Republic.

Critical Theory promised to help the generation of the 1960s out of its moral dilemma for a number of reasons. First, it appeared as a philosophy which maintained an unbroken continuity of tradition with previous great German philosophical systems. The Frankfurt School was concerned with Kant, Hegel, Marx, Schopenhauer and Nietzsche, names that are all great landmarks in German intellectual history. It did not escape the students' attention that it had been German Jews who had endowed them with this cohesive tradition, and some of the most eminent achievements in Germany during the previous 100 years were linked with German Jewish names: Marx, Heine, Freud, Husserl, Cassirer. Their activities covered the social sciences, humanities and literature. To anybody who studied these subjects in the 1950s it seemed a complete reversal of reason that in Germany of all places the Jewish section of the population had been destroyed. The social and cultural critique of the Frankfurt School elevated the Auschwitz 'holocaust' to a supranational level. According to their neo-Marxist vision, Hitler's National Socialism was not an aberration of the German nation, but the most brutal climax of the social 'contradictions' in capitalism. In the context of this vision it was possible to reconcile two aspects: the fiercest moral judgment of National Socialism could be expressed without having the feeling of being implicated oneself. It was not deemed necessary to perceive and treat the Third Reich as a national phenomenon. If it had been treated as such, moral judgment on the parental generation would have released more personal involvement and a greater readiness for sympathetic understanding. By ignoring the national phenomenon it became possible to identify with people throughout the world who were critical of capitalism and condemned it as 'evil'. This ensured that one was not continually confronted with 'evil' as a specifically 'German evil'.

Two further important theses of Critical Theory were particularly influential in the 1970s. Marcuse[6] gave the anti-Establishment student movement a positive objective in terms of world history. Adorno and Horkheimer held the view that a Marxist social analysis should bury any hope of the proletariat as a 'revolutionary class'. For Horkheimer the 'Marxist heaven' had taken on such a dark aspect that he attempted to take refuge in religion during the last years of his life. Adorno's "negative dialectic" only considered works of avant-garde art capable of conveying an extremely alienated reflection of nature 'reconciled' with the human element. Neither theory any longer suited the intentions of the rebellious students in the 1970s who were set on the complete overthrow of the status quo. Marcuse provided this group with a philosophical orientation which justified as being 'indubitably good' the fight against economic liberalism and capitalism as such. He did so in the belief that after capitalism things can only get better. With this facile version of a Frankfurt neo-Marxism he initially experienced great popularity amongst the students. He lost his influence when orthodox Marxist groups connected with organized Communist parties succeeded in gaining control of the student movement in the late 1970s. These factions, together with the underground terrorist movement, the

Fig. 7 Walter Benjamin

6 The main publications of Marcuse are:
Vernunft und Revolution, Neuwied/Berlin, 1970 (*Reason and Revolution*, New York, 2nd ed., 1955)
Triebstruktur und Gesellschaft, Frankfurt, 1965 (*Eros and Civilization*, Boston, 1955)
Der eindimensionale Mensch, Neuwied/Berlin, 1967 (*One-Dimensional Man*, London, 1964)
Kultur und Gesellschaft, Frankfurt, 1965

Baader-Meinhof Group, ensured that Marxist ideology was quickly bereft of any power of attraction for the majority of students.

The Critique of Scientific Positivism was the second momentous thesis of Critical Theory. Horkheimer in particular had always retained the view based on the rational interpretation of classical Marxism that 'reason' did not merely denote explanatory reason as in the conventional empirical sciences. He rejected this interpretation of reason as purely instrumental. According to him it was incapable of controlling the industrial and above all political applications of the results of scientific research in an appropriate manner, that is to say, according to humane principles. Against it Horkheimer set the idea of an application of science 'based on reason'. This was an idea which always remained vague and unfulfilled in disproportion to its influence on many intellectuals.

The Frankfurt School once again became the subject of academic discussion in the 1960s as a result of the 'positivism controversy.'[7] It revived an old German dispute on the subject of whether the natural and social sciences should proceed according to fundamentally different or analogous methods. Here Adorno expressed his metaphysical condemnation of the 'abstract generalizing' empirical sciences. He accused them of oppressing the individual, and of proceeding according to the normal classificatory logic which subordinates the particular to the general. In contrast he put forward his model of reason. In his conception reason proceeds according to laws of 'dialectical logic' and not only encompasses the social entity but also embraces the idea of reconciliation with the oppressed individual. Adorno captivated his students not so much by the clarity of his ideas as by the romantic emotionalism which he infused into this methodological discussion. The emotion was embedded in a mourning for the decline of the European spirit which had founded scientific rationality in the classical era. In this sense of bereavement Adorno remained at one with his philosophical antipode Heidegger, who had similar metaphysical misgivings regarding modern science.

Critical Theory fulfilled a major role in maintaining continuity of the German tradition under adverse conditions, but the associated weaknesses are equally significant.[8] The Frankfurt School has bequeathed to us today its own failure to make a political statement. It never stated that intellectuals in this century, and above all intellectuals in post-war Germany, had to decide between democracy and dictatorship, the basic existential and philosophical decision. Instead it continued to elaborate the Marxist myth that the decisive difference resides in the economic basis of a society. In this respect Critical Theory belongs to a dubious German tradition which even today makes it difficult for many intellectuals, especially those with ostensibly 'progressive' inclinations, to manifest a fundamentally positive attitude towards the existing democracy in the Federal Republic.

7 Cf. Th. W. Adorno (ed.), *Der Positivismusstreit in der deutschen Soziologie*, Neuwied/Berlin, 1969 (*The Positivist Dispute in German Sociology*, London, 1976)

8 A good and comprehensible account of the Frankfurt School, which also considers the second and third generations, was produced by W. van Reijen in *Philosophie als Kritik*, Königstein, 1984. Cf. A. Honneth, *Kritik der Macht. Reflexionsstufen einer kritischen Gesellschaftstheorie*, Frankfurt, 1985, for the most recent publication on the subject.

Wolfgang Rothe

Expressionism in Literature

Literary Expressionism was not a group phenomenon – and that fact distinguished it from the German Naturalists in the Friedrichshagen Circle, the Symbolists around Stefan George, or the Paris Surrealists following Breton. It stood for new departures among the young rather than manifesting any binding and unified aesthetic doctrine. It had several important but independent centres (Berlin, Prague, Vienna), and many lesser ones (Munich, Dresden, the Rhineland). Expressionism was by no means – as is often assumed – a German prerogative. Similar developments occurred in neighbouring states to the North and the East.[1] In its opposition to established bourgeois culture, Expressionism disseminated its views through books, magazines, anthologies, yearbooks,[2] publishing houses, theatres and galleries. Young people wrote and painted for other young people. Conflict between the generations dominated the cultural sphere, and in the realm of literature the sons' rebellion against their fathers led to a counter-culture verging in some respects on a sub-culture. And yet, despite Expressionism's far-ranging programme, there did not exist any kind of aesthetic unity, let alone uniformity, among the two to three hundred mainly very young writers in the generation born between 1880 and 1890. Such early Expressionists as Georg Trakl (fig. 1) and Franz Werfel (fig. 2), Georg Heym and August Stramm, Gottfried Benn and Ernst Stadler, represented extreme opposites in terms of form, language, style and subject matter. Their basic moods, views of the world and attitudes to life embraced sombre melancholy and manic fixation on death, feelings of hopeless loneliness, dread, desperation, alienation, revulsion, boredom and world-weariness, and yet also included rapturous affirmation of life, sanctification of the world, exaltation of the 'beautiful earth' and love of humanity.

Expressionist literature can be less easily reduced to a common denominator than Expressionist painting with its formal simplification, leanings towards abstraction, intensified colour or 'Primitivism'. The 'spiritual' nature of what was committed to language as a means of expression yet went far beyond literature in the conventional sense (poetry, prose, drama) is considerably broader, richer, more complex, more psychologically differentiated, more rationally analytical, and more elementally critical and cognitive than its emanations within the visual arts. Nevertheless the aston-

1 See Ulrich Weisstein (ed.), *Expressionism as an International Literary Phenomenon*, Paris/Budapest, 1973
2 Paul Raabe records no fewer than 182 periodicals, series, yearbooks, anthologies and symposia dating from between 1910 and 1921 in his bibliographic *Die Zeitschriften und Sammlungen des literarischen Expressionismus*.

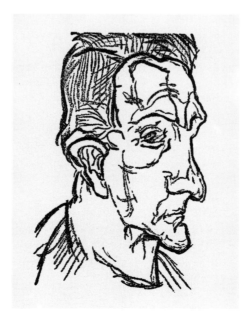
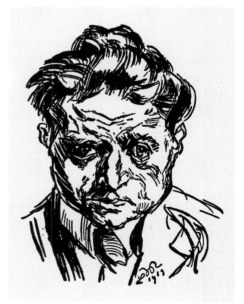

Fig. 1 Oskar Kokoschka, *Georg Trakl*, before 1920

Fig. 2 Ludwig Meidner, *Franz Werfel*, before 1920

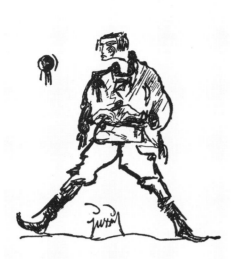 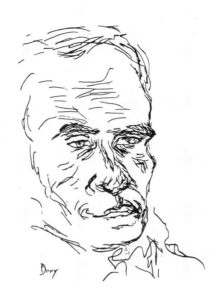

ishing fact remains that an unusually large number of people (Kokoschka, Barlach, Meidner, Else Lasker-Schüler, to mention but four) were gifted in both spheres (figs. 3-5). Literature and the visual arts were more closely linked at that time than ever since. The two spheres of expression came closest in their choice of subject matter. The city[3] was a theme common to both (fig. 6), and the same human types were to be encountered in writing and painting, drawing and sculpture – primarily the "New Man" (particularly the young writer), then circus folk, cocottes and dancers,[4] but most frequently the physically or psychologically maimed, ranging from war cripples to the mentally ill.[5]

Looking back seven decades later, what is known as Expressionism takes on the contours of a comprehensive cultural-revolutionary movement. During the final phase bourgeois humanitarianism and German classicism, within a culture largely devoted to the sentimental still received peaceful expression in literature, painting, music, dance and architecture – rather than articulating itself (as after 1968) in political ideology, Neo-Marxist social theory and, ultimately, physical violence. To view Expressionism merely as an artistic style (as the 1950s did in their rehabilitation of the past) is outmoded, testifying to the deliberate restriction of horizons by academic disciplines insisting on aesthetic immanence. Expressionism is merely a technical term today, a convenient definition in the absence of a more suitable designation for the universal spiritual and psychological awakening of young people around 1910 which received largely religious expression. That awakening was not limited to stylistic aspects of the aesthetic sphere, strictly rejecting any formalism in art. It also launched a critical onslaught on the material foundations of contemporary Europe with its bourgeois order of society, authoritarian and bureaucratic form of state, and capitalist and industrial organization of the economy. Schools, the official church and the military were attacked as instruments for the imposition of discipline – and so too were philosophical positivism and relativism, and a narrow-minded, materialistic natural science whose triumph had impaired its objectivity. Such onslaughts were directed against the lack of dynamism of a philistinism whose highest values were peace and order, security and complacency, in short, maintenance of the status quo – and against a national chauvinism that proclaimed the German people to be the leading exponent of civilization, and thus entitled to call the tune politically and economically throughout the world.

The generation of 1910 no longer believed it possible to breathe in the suffocating air of a phoney peace shaken by domestic and external crises. Young people were angered and repelled by the all too contradictory aspects of feudal aristocracy, economic expansionism and unquestioning belief in scientific progress, regression into ultra-nationalism and a deluded sense of global mission, inner consolidation of the young Reich with its aspirations to world power, the sanctification of the status quo entailed in 'education and property', and hectic industrialization's disruptive

Fig. 3 Else Lasker-Schüler, *Self-portrait*, before 1920

Fig. 4 Arthur Drey, *Ernst Blass*, 1922. Both the artist and his sitter were poets.

Fig. 5 Ludwig Meidner, *Self-portrait*, 1915

3 Cf. W. Rothe (ed.), *Deutsche Großstadtlyrik vom Naturalismus bis zur Gegenwart*, Stuttgart, 1973, especially pp. 13 ff and 107 ff.
4 *Idem, Tänzer und Täter*, Frankfurt, 1979, Chapter 2: *Der Tänzer*, pp. 47 ff.
5 *Idem*, 'Krankheit und kranker Mensch – Phänomene des Expressionismus', *Deutsches Ärzteblatt*, LXIX, 1967, pp. 1901 ff, 1961 ff, 1995 ff, 2034 ff, 2082 ff, with many illustrations

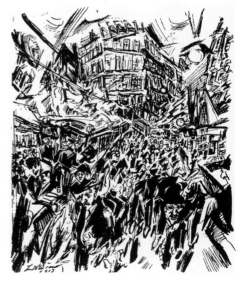

Fig. 6 Ludwig Meidner, *Berlin, Potsdamer Platz*, 1914

Fig. 7 Richard Janthur, *Mankind*, 1916

Fig. 8 Karl Jacob Hirsch, *Freedom Flies over Mankind*, 1918

6 Very revealing in this context is the long-forgotten semi-official *Denkschrift für das Deutsche Volk*, which was published in Berlin in 1919 by the Zentrale für Heimatdienst under the title *Der Geist der neuen Volksgemeinschaft*. This substantial publication with works by a great variety of authors was distributed by the celebrated S. Fischer Verlag.

7 I first drew attention to the amazing analogy between Expressionism and the ecumenical Personalism which developed in 1920 in my 'Der Mensch vor Gott: Expressionismus und

impact on established social structures. The young did not repress the clash between the empty classicism of the education provided by the Gymnasium, or grammar school, invoking the beautiful, the good and the true, as opposed to the utterly hideous and inhumane reality of proletarian existence in tenement blocks in wildly mushrooming industrial cities and of factory work and the barrack square. It was the best elements among the middle-class young which rebelled against the mendacity of Wilhelminism. Expressionism was thus synonymous with uncompromising criticism of conditions in Germany and the Austro-Hungarian Empire. It totally (and thereby admittedly unjustly) called those states into question. Extreme opposition was not to be satisfied by reformist improvements and elimination of the worst excrescences but instead called for total change and a complete transformation – in a word, Revolution. And not merely a revolution in external living conditions and the ways state, government and economy were organized, but primarily an ethical revolution in human relations. The objective was a new form of co-existence between atomized and self-alienated human particles. This Expressionist revolution in the social sphere strove for a new quality of common interest with 'You' and 'We' replacing the isolated, egotistical, narcissistic 'I', and sociability and solidarity predominating in everyday existence (fig. 7). 'Community' was a magic word for Expressionism, connoting community of the 'people' and involving a concept utterly unlike that of the ultra-chauvinistic ideologists of race, blood and atavistic Germanity before and after 1914 (and after 1933). That is why any denunciation of Expressionism as a "precursor of Fascism" is misguided.

It was no matter of chance that Late Expressionism culminated around 1918 in innumerable revolutionary works – predominantly drama – and became, in the all-too-brief hour of the November Revolution, the quasi-official philosophy of the Republic.[6] Hostility was to be replaced by friendship, and hate by love. The religious basis for the universal commandment of love to be found in many authors speaks against the Marxist rejection of such an idealistic view[7] of things as 'abstract', unpolitical, and a utopianly false form of reconciliation. Writers have always adopted a different approach to politicians and representatives of the people struggling to achieve tangible gains for particular groups and classes. The Expressionists never saw themselves as a subordinate supportive force as Communist writers did. The Marxist accusation that Expressionists subscribed to an illusory love of humanity was, unfortunately, often repeated without thereby becoming more valid. Expressionist ideas derived in the main from Jewish and Gnostic Christian religiosity, and from a progressive cosmopolitanism. The gulf between the Expressionists' idealistic concept of revolution and the Marxists' materialistic approach is in fact unbridgeable. Expressionist *Geistige* (an untranslatable word distinguishing people characterized by true intelligence and inner qualities from mere intellectuals) were convinced that any total transformation of society had to be preceded by an ethical, psychological and spiritual metamorphosis of the individual ego – a Greek Metanoia, a Christian Rebirth – if revolutionizing the external world was really to succeed and regression to the old evils of servitude and enmity to be avoided (fig. 8). The Marxists, on the other hand, believed that the revolution could still be implemented by Old Adam, and that changed material conditions would of their own accord result in the New Man proclaimed by both the Expressionists and the Communists, taking up a long-established Socialist topos. In the one case the *persona* (in the Christian rather than the liberal sense) was the starting-point, and in the other the organization of the world. History has certainly dashed the high-flying hopes of the Expressionist generation – the war-waging nations did not undergo a fundamental transformation in 1918 – but it has likewise demonstrated the falsity of the materialist thesis. The Soviet Union failed to produce either New Man characterized by love, cooperation, goodness and humility, or a community of equals.

The shattering of the illusions of Expressionist *Geistige* yearning for a completely different life, for a new state, a new church and a new world, was not long delayed. Expressionism died in 1920 when the failure of Germany's November Revolution became apparent and the former anti-democratic ruling classes – the military, civil servants, judges and lawyers, and factory-owners – staged a comeback. Expressionism was buried by its adherents rather than by its opponents.[8] It is easy to pass the purely aesthetic judgment that Expressionism was already exhausted as a stylistic

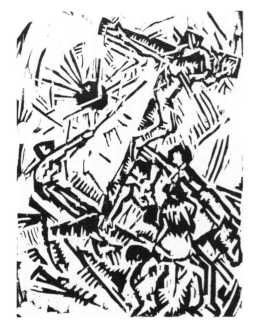

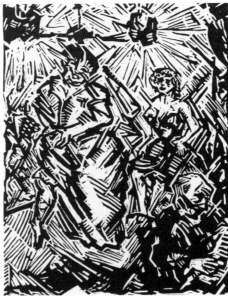

Fig. 9 Richter-Berlin, *The Raising of the Cross*, 1915

Fig. 10 Richter-Berlin, *In the Light*, 1915

movement and had degenerated into a fashion for minor talents since such a judgment cannot be refuted. No one today can say what path German literature would have taken after a successful political and social revolution.

At first glance, Expressionist literature can be categorized as Early Expressionism (1910-14) with its fixation on degeneration, decline and death; a pacifist War or High Expressionism; and an optimistic, messianic Late Expressionism (1917-19). The apocalyptic visions of the End of the World, Doomsday, a Great Flood, Planetary Cataclysm, Cosmic Night and a Last Judgement were followed (in this simplified view) a few years later by the eschatological visions of a Paradise on Earth, a "Heim", a Philadelphic Kingdom (Ernst Bloch), a Tomorrow, a Land of Cana or Garden of Eden, or a "Süden" (Benn). The darkness and oppressiveness of a Cosmic Night seemed to be abruptly succeeded by an existence suffused in heavenly light (Ludwig Rubin); and a rat's life, a dog's life (Ernst Barlach) amid putrefaction, decomposition and moral degeneration – in brief, defilement – to be followed by a Beautiful Earth inhabited by Beautiful People (Franz Werfel), an earthly Kingdom of Heaven dedicated to purity, and Trakl's Splendid Community of Humanity. Such an existence was bestowed upon a humanity relieved of its great burden of guilt, and constituted a newly gained state of innocence (figs. 9, 10).

This customary division into periods is nevertheless dubious. Such a dichotomy was in fact present within Expressionism from the very start. The 'Brücke' artists painted the naked inhabitants of such a paradise at lakes in Saxony and along the shores of the Baltic from as early as 1905. *Decay and Triumph* was the title Johannes R. Becher chose for an influential volume of verse in 1914. The absolute negativity of contemporary existence and the absolute positivity of the life to come presupposed one another. All the Expressionists expected and proclaimed a sudden transition from one to the other, from a hell of suffering to a paradise of the meek, rather than a steady growth resulting from gradual melioristic policies. Traditional intermediaries like the church, political parties, trade unions and the progressive sciences were depicted in the Expressionist world-view in terms of shabby (and correspondingly satirized) representatives. Such ideological radicality knew only satanic black and divine white, dark and light, with no shades of grey in between. The Gnostic-Manichean element was unmistakable, and so too were the metaphysics of mediaeval mysticism and German classicism. The resultant unconditionality of judgment, which knew only transfiguration or damnation, only the diabolical or the holy (an essential Expressionist category; fig. 11), must come as a particular shock to the English and the French, arousing the worst of fears about what a nation whose most critical and uncorrupted young intellects were capable of developing such extreme thought-structures might feel itself impelled to undergo. *Der Unbedingte* (The Man of Absolutes), the title of a play by Friedrich Wolf, was a stock Expressionist figure.

Theologie' in *Expressionismus als Literatur*, ed. W. Rothe, Berne/Munich, 1969, pp. 37 ff. The main representatives of Personalism were Ferdinand Ebner, an Austrian Catholic, Friedrich Gogarten and Emil Brunner as Protestant theologians, and Martin Buber as a Jew. See also W. Rothe, *Der Expressionismus*, Frankfurt, 1977, p. 27

8 Such 'obituaries' were written by Kasimir Edschmid, René Schickele, Ivan Goll, Paul Hatvani, and others. Published in Paul Raabe (ed.), *Expressionismus. Der Kampf um eine literarische Bewegung*, Munich, 1965, pp. 173 ff.

9 *Linke Melancholie* (1931). Published in Walter Benjamin, *Angelus Novus*, Frankfurt, 1966, p. 460

10 *Ibid.*

11 Cf. W. Rothe, *Tänzer und Täter*, *op. cit.*, Chapter 4: *Der Kranke*, especially p. 215 ff.

Fig. 11 Raoul Hausmann, *Francis of Assisi*, 1917

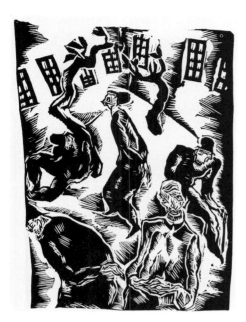

Fig. 12 Erich Goldbaum, *Lunatics*, 1918

Even though Expressionism did not believe in a slow advance from the bad to the better, it nevertheless shaped the gradual spiritual and psychological development of individuals. It did not only reject the subtle emphasis on psychology in art around 1900; it rejected all psychology, which it condemned as one of the positivistic natural sciences. The sophisticated spiritual and psychological painting of the Impressionists, the Symbolists and Neo-Romantics in literature, the visual arts and music were all viewed as being part of a contemptible bourgeois culture, and even as having been created for that culture's elitist consumer needs. Psychological nuances, subtle spiritual gradations of tone, refined soul values and highly sensitive individualists were supplanted by frequently anonymous archetypes. In August Stramm's and Oskar Kokoschka's early dramas, devoted to the never-ending struggle between the sexes, the protagonists were sometimes simply called "The Man" or "He" and "The Woman" or "She", an extreme psycho-physical reduction of the human condition, repeated innumerable times by other authors. These counter-creations to the contemporary "neurotic" State extended into the archaic and mythical. With the 'Brücke' painters the demands of visualization involved in this reduction resulted in primitive, woodcut-like simplifications, and even barbaric figures. The characters in many Expressionists writings, as we have just seen, were not given individual names but merely called "The Mother" and "The Child", "The Father" and "The Son", "The Friend" and "The Beggar", "The Girl" and "The Boy" – and time and again there appeared "The Leader" und "The Wanderer", "The Saviour" and "The Transgressor", "The Revolutionary" and "The Rebel", "The Poet" and "The Warrior".

If these nameless figures appeared prototypically *en masse* they were known as "The Mad" and "The Whores", "The Diseased" and "The Blind", "The Cripples" and "The Sucides", "The Jews" and "The Prisoners", "The Fools" and "The Drinkers", "The Poor" and "The Respectable Citizens", or even simply "The People". The carefree late bourgeois individual, the narrow-minded self-seeker, the self-idolizing great egoist, the inimitable hero and master, and the unique superman were presented as negative figures, the enemies of future inhabitants of 'heavenly light'. The ranks of the 'Great' were to be taken over by the 'Meek' in their millions and 'a democratic and collective age of equality was believed to be under way. According to Walter Benjamin, in Heym's poetry "the earth was preparing for submersion beneath the Red Flood."[9] From the very beginning Expressionist literature was radically subversive, defining "the unimaginable state of the masses" at that time.[10]

When anonymous individuals appear in Expressionist poems, short stories, plays and novels, they do so as members of collectives, which in turn have basic characteristics in common. They are allegories either of a fundamental deficiency or of a future 'pure' humanity. The inhabitants of an evil world, a "murderous earth", all lack something: they are arrested in their development, diminished, deprived, divided, alienated – in brief, diseased and crippled. In a totally negative world, presented in literature in terms of decaying nature and enslaving civilization, in an authoritarian state and a society based on a master/slave economy, man cannot be at Hegelian ease with himself, living in harmony with his inner being and the outer environment. Instead he feels cut off, his ego disintegrates, he loses his sense of identity, and develops paranoid and schizophrenic traits. The spiritually and psychologically sick man was one of Expressionism's most recurrent and important figures (figs. 12, 13).[11]

Illness, decline, degeneration and death constituted what were probably statistically the most frequently repeated themes in Expressionist literature. Amid the great demise which extended to the Christian West in Trakl and assumed cosmic proportions in Heym, a gradual recovery was inconceivable, the development of a Goethean entelechy broke down, and active self-cultivation towards attainment of 'character', extolled in Weimar classicism a century earlier as "the greatest happiness", was out of the question. An incomplete existence in a damned world could only be surmounted by way of an abrupt transition to a state of absolute positiveness, to a light-filled life. This dialectical transition was the outcome of the dichotomous basic structure of Expressionism, manifesting itself as an unexpected occurrence, as an unrepeatable event, as an absolutely mysterious positive development. Not the outcome of human action – rather a miracle.

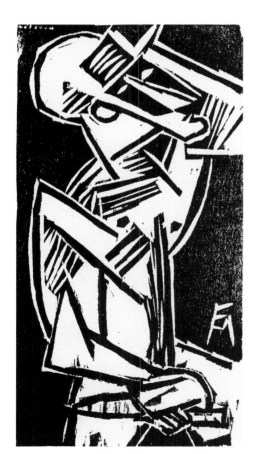

Fig. 13 Felix Müller, *Suicide*, 1917

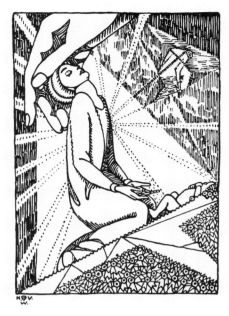

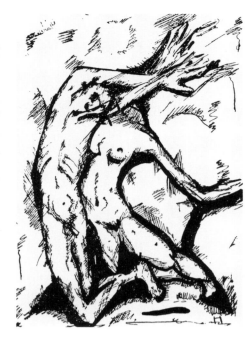

Fig. 14 Heinrich Vogeler, *Ecstasy*, 1914
Fig. 15 Karl Jacob Hirsch, *Study*, 1916

The Expressionists transposed the category of the miraculous and inexplicable, of fairytale and legend, from an intangible Neo-Romantic dream world into the harsh reality of the epoch they called so fundamentally into question. The word "miracle" is to be found again and again in their literature. Such miraculous events involved an awakening and thus a transformation for either an individual or a group of people, a sudden release from the prison of an encrusted ego, of an ossified, miserable existence and a living death in a wretched world. The miracle brought about an unfolding (*Entfaltung* was the title of the first great prose anthology in 1921) and intensification, a shock that shattered the armour of the ego. Writers referred to this elemental process as an awakening and an uplifting, as a fulfilment and renewal. This led to anger – rebellion and revolution – and a way towards paradise, and was experienced as liberation from slavery, and as cleansing and purification. An avowal of brotherhood (*Verbrüderung* was the title of a play by Paul Zech) and reconciliation with former enemies then took place. Judgment of the world was a constant judgment of the self, initiating both awareness of guilt and active expiation or a penitential pilgrimage through the world. Successful transformation was frequently demonstrated through a sacrifice made for a loved one or the human community as a whole, and through acts of existential help and devotion.

A pronounced emphasis on ethics ruled Expressionist spirituality. Its power – 'will', 'decision' and 'deed' were constantly recurring key words – none the less constituted an epiphenomenon, which was the unique outcome of a miraculous manifestation previously experienced by the ego. The attraction of things terrestrial thereby faded away, rigidity was dissolved and armour melted. Tumult and an upward flight into the state of light then followed, an elevation of the awakened and transformed individual, an uplifting and exaltation (figs. 14, 15). A state of stimulation and dynamism thus succeeded the gloomy stupor, the paralysed rigidity of the brooding melancholic. All such positive processes could be subsumed as human emergence, with man's 'second' and real birth leading to attainment of true life and quintessential reality. Man thus broke through the barriers into the open, setting out into immensity and infinity, becoming a pilgrim and wanderer through the world, sensing the divine breath of the Holy Spirit, the 'pneuma'. Such was the essence of Expressionist spirituality. Ecstatic rapture, mystical absorption, a state of gentle floating and a benign sense of swimming with the tide characterized the emotional state of those on the march, a procession of a redeemed people which was no longer a deprived horde, but individuals who had set out for the light, for God.

The grandiloquence of Revelation and rapturous hymn-like evocations of the Springtime of Humanity talking in tongues and thunderous sermons on Awakening have become somewhat alien to us today, and our enjoyment of Expressionist literature is now virtually limited to its suggestive descriptions of deprived human nature.

Fig. 16 Max Oppenheimer, *Strindberg*, 1912

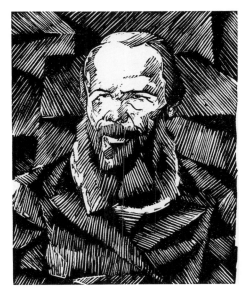

Fig. 17 M. Slodki, *Dostoevsky*, 1915

The evocative power of the Expressionists far exceeded any previous depictions of bodily devastation and psychological disturbance, and it was in this sphere that they gained their reputation for experimental literary innovation. Poems, short stories and novels about madmen and murderers, deranged artists and degenerate philistines, grotesque youths and idiot poets, and down-and-outs on the fringes of bourgeois society are among the best of Expressionist literature. These expressive conjurations of abnormal forms of existence, calling into question all supposedly 'healthy' normality and self-assurance, are still readable today, no matter how dated their language may now seem. To the complacent bourgeois such depictions of the abnormal, the anarchistic, the nonconformist, the "unruly" (Gustav Sack), and all those who went out of bounds seemed highly sinister. They aroused submerged fears, stirring up what had been repressed in the unconscious, and violating taboos. Expressionism was viewed at first as eccentric, then after 1933 as "degenerate"; and its young writers were dismissed as insane.

Even though the Expressionists categorically rejected any psychological emphasis in their work, they were the first writers to make impressive use of the insights of depth psychology and psychoanalysis. This is one of the most striking paradoxes within the movement. It is probably no matter of chance that the Expressionists' spiritual mentors – Hölderlin, Nietzsche and Strindberg (fig. 16) in literature, and van Gogh and Munch in painting – were psychologically highly problematic human beings, and that deranged murderers and holy fools were among the most memorable creations of Dostoevsky (fig. 17) and Tolstoy, the Russians they read so extensively. This fascination with the sick soul, depicted innumerable times in Expressionism, is a remarkable contradiction of the movement's violent rejection of psychological analysis.[12] So far as I know, Sigmund Freud is ironically not mentioned once within the entire range of Expressionist programmatic essays and poetics.

The main antagonist of resonant dithyrambics, vehement emotionality, clamorous pathos and concentrated, even violent language was a determinedly cerebral art which aimed at a dispassionate, searingly sharp dissection of the human condition. Paradoxically, though, the anti-rationalists were themselves the most provocative and ruthless vivisectors of their time. Their credo entailed dissociation from commonplace bourgeois realism in art but they were capable of detailed naturalistic descriptions of sickness, depraved sexuality, crime, and other horrors, with a degree of brutality that not even the dogmatic Naturalists of the early 1880s had dared achieve. Crude and often cruel Naturalism and Baroque symbolism, *Jugendstil* allegories of Love, God and Death, a classical humanitarian ethos and Gnostic

12 Paul Kornfeld's *Der beseelte und der psychologische Mensch*, published in the first issue of *Das junge Deutschland* in 1918, is viewed as the most important programmatic essay. Published in Manon Maren-Grisebach (ed.), *Paul Kornfeld, Revolution mit Flötenmusik*, Heidelberg, 1977, pp. 31 ff.

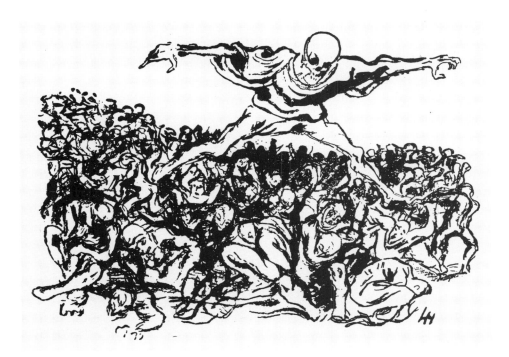

Fig. 18 Lothar Homeyer, *War*. This visionary drawing originated as early as March 1914.

spirituality combined with Neo-Romantic soulfulness, the nervous sensibility of *décadence* and a libertarian socialist criticism of society to form a literature of intensified existentiality and acutely contemporary consciousness. The oft-cited seismographic quality of Expressionism and its predictions of disaster to come (and of its own downfall) (fig. 18) were rooted in the cognitive abilities of its young intellectuals who were anything but wild irrationalists, let alone escapists. It was precisely because they suffered at the hands of the world around them, precisely because they did not, like normal citizens, applaud Europe's imperialist nationalisms, that they could see the catastrophe towards which the old world of European states was heading more clearly than the arrogant realists and 'experts', the practitioners of *realpolitik* and the educated citizens who mocked them, the sociologists and the philosophers. Their terrifying images of a war to come and the enormous destruction in its wake became reality just a few years later, demonstrating that they had been the most lucid intellects of their time, and their sworn opponents, the bourgeoisie, blind, deluded and unrealistic.

The First World War decimated the young people whose psychological preoccupations had found an outlet in Expressionism as a spiritual and intellectual movement. The mass slaughter greatly undermined the movement. Georg Trakl, Ernst Stadler, Ernst Wilhelm Lotz (fig. 19) and Alfred Lichtenstein (fig. 20) did not survive the first year of war, and in 1916 August Stramm fell in Galicia and Gustav Sack in Rumania – to mention just a few of the most important creative forces among the victims of hostilities.

Jill Lloyd

Primitivism and Modernity: An Expressionist Dilemma

1 Max Beckmann, 'Gedanken über zeitgemäße und unzeitgemäße Kunst', *Pan*, II, March 1912, p. 499 f.
2 Ludwig Meidner, 'Anleitung zum Malen von Großstadtbildern', *Kunst und Künstler*, XII, 1914, p. 299 f.
3 The main publications of this type are the exhibition catalogues *Das Ursprüngliche und die Moderne*, Akademie der Künste, Berlin, 1964, and *Weltkulturen und moderne Kunst*, Haus der Kunst, Munich, 1972. Also Britta Martensen-Larsen, 'Primitive Kunst als Inspirationsquelle der Brücke', *Hafnia*, VII, 1980, p. 90 f. which presents the most convincing evidence about Kirchner's discovery of non-European art in the Dresden Museum of Völkerkunde c. 1904. Robert J. Goldwater, *Primitivism and Modern Art*, rev. ed. New York, 1967, and L. D. Ettlinger, 'German Expressionism and Primitive Art', *Burlington Magazine*, April 1968, p. 192 f., also treat the subject. Donald Gordon, 'German Expressionism', in *Primitivism in 20th Century Art* (ed. William Rubin), New York, 1984, does tackle the subject of primitivism and modernity in Expressionist art, but he continues to cite some unconvincing tribal sources.
4 A postcard from Schmidt-Rottluff to Heckel dated 8.11.09, postmark Hamburg, depicts a Cameroon figure which he may have seen in J. F. G. Umlauff's 'Völkerkundliches Institut'. The Cameroon Grasslands were not well represented in the Völkerkunde Museum in Hamburg until 1912. Another postcard from Kirchner to Heckel dated 5.1.1911, postmark Berlin, depicts two Eskimo bone carvings from

By 1914 primitivism had become a central issue in the debates about modernism and modernity in German art. After the 1910 split in the Berlin Secession the validity of the Expressionists' primitivism was questioned in both the naturalist and avant-garde camps of German modernism. In a controversial exchange of articles with Franz Marc in 1912 Max Beckmann condemned "this dependence on ancient primitive styles which in their own times grew organically out of a common religion and mystic awareness. [I find it] weak because Gauguin and the like weren't able to create types out of their own confused and fragmented times which could serve us in the way that the gods and heroes served the peoples of old."[1]

Beckmann attacked the Expressionists' primitivism for its lack of intrinsic relation to their own historical tradition. Two years later Ludwig Meidner condemned the fake naïvety of the primitivist world view. Answering the rallying call of Futurist avant-gardism he demanded that "all the younger painters get together and flood our exhibitions with big city pictures". He continued, "Unfortunately all kinds of primitive races have impressed some of the young German painters and nothing seems more important to them than Bushman painting and Aztec sculpture. . . But let's be honest! Let's admit that we are not negroes or Christians of the early middle ages! . . . Why then imitate the mannerisms and points of view of past ages, why proclaim incapacity a virtue? Are those crude and shabby figures we now see in all the exhibits really an expression of the complicated spirit of modern times?"[2]

E. L. Kirchner's Berlin scene *Five Women on the Street*, 1913 (fig. 1) shows his engagement with city imagery. But what marks these predatory figures with their mask-like faces and jagged Africanized forms out from contemporary city painting is precisely the paradox of their primitivism, which goes hand in hand with their modernity. The polemics of primitivism and modernity have been largely ignored in subsequent discussions, which have concentrated on dates of discovery and the detection of more or less convincing tribal models.[3] The visits Kirchner and Kandinsky made to ethnographic museums in Dresden (c. 1904) and Berlin (1907) are not negligible; but we need to ask why these collections became relevant thirty years after their foundation. It would seem that such visits were not a one-off voyage of discovery but rather a continuing practice in Dresden, Hamburg and Berlin.[4] In March 1910 Kirchner wrote, "The ethnographic museum here [Dresden] is open again . . . however only a few things provide a real enjoyment and a refreshment – the famous Benin bronzes and some things by the Pueblos from Mexico are still exhibited and some negro sculptures. . . A circus is here again and in the zoo Samoans and Negroes are coming this summer. . .",[5] slipping from his description of the museum to the popular practice of importing natives from the colonies for their curiosity value. The Expressionists' primitivism, which was an aspect of their ambition from 1910 to forge a consciously modern German art in an international context, was also a response to the living fabric of experience in colonial Germany. Alongside the ethnographic museums this involved more popular sources too – Samoans at the zoo, cabaret acts, photos in illustrated weeklies and exotic presents from relatives and friends. On various historical levels these references to 'primitive' societies were used as an inverted image of ourselves to debate and to define by antithesis western notions of civilization and modernity.

The acceleration of German colonial expansion after 1896 coincided with developments in western aesthetics and ethnology which encouraged *Jugendstil* artists to look towards tribal artefacts for inspiration. The discovery that paleolithic preceded neolithic art lent credence to their own challenge to realism and commitment to abstract design. The *Jugendstil* aesthetic of rebirth and renewal encouraged them to present tribal art in their magazines as 'natural' and 'spontaneous' in contrast to the

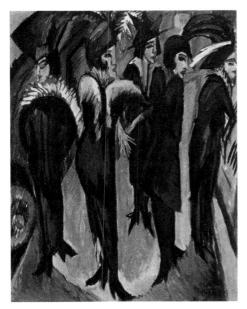

Fig. 1 Ernst Ludwig Kirchner, *Five Women on the Street*, 1913

learnt modes of design and production in recent ages.[6] Their quest for more *authentic* objects was one manifestation of the attacks on materialism and nostalgia for a lost organic unity between art and society which emerged in Germany as a reaction to the alienating changes wrought by the extreme speed and drama of late industrialization.

Karl Ernst Osthaus's Folkwang Museum in Hagen was an important testing ground for these *Jugendstil* principles; and here several of the Expressionists had a chance to view non-European art in a more sympathetic context than the scientific arrangements of the ethnographic museums. Osthaus, who had a German nationalist background, began his collection with a curious mixture of tourist art and scientific aspirations. He planned a natural sciences museum to demonstrate the wonder and unity of the natural world to industrial man. But in 1900 he was converted to *Jugendstil* and from 1902 the non-European artefacts were presented alongside his growing collection of modern European art and design to guide contemporary production with an example of "unalienated" objects.[7] From 1906 Osthaus was in touch with the Expressionist avant-garde, and after 1910 his activities encouraged many to revive their early interest in the decorative arts.[8]

Osthaus was dedicated to the revival of German culture in an international context; and the murals Kirchner and Heckel made for the 'Sonderbund' chapel (1912), like Max Pechstein's stained glass for Gottfried Heinersdorff, involved an internal primitivism with a revival of Gothic effects.[9] Wilhelm Worringer's *Abstraction and Empathy*, 1908, and *Problems of Form in Gothic Art*, 1911, proposed Gothic as the characteristic Germanic art form mediating between abstract primitive art and the empathetic realism of Western tradition. The Gothic age, too, was seen as an ideal example of a close organic unity between art and society governed by spirituality.

It was for this latter reason that northern Gothic art was taken up by Kandinsky and Marc in their battle against materialistic illusionism in post-Renaissance art, which had deteriorated into nineteenth-century academicism. The format of their almanac *Der Blaue Reiter*, 1912, may have derived partly from the ethnographic journals of the Russian Academy of Sciences, which published reports on Russian folklore.[10] In the almanac Russian popular prints or *lubki* and Bavarian glass paintings are juxtaposed with illustrations of non-European art, child art, Henri Rousseau, El Greco, and avant-garde works from France, Germany and Russia; all of which were considered authentic and expressively spiritual because of their apparent lack of respect for standards of finish and correctness. In this sense the cultural relativism of the almanac is superficial, as its wide-ranging notion of the primitive is still defined in antithesis to the norm of Western realism, which is now seen in negative rather than positive terms. In the contemporary publication of the Czech Expressionists, *Umělecký Měsícník* (1911–13), many of the 'authentic' art forms illustrated in the almanac, including Gothic and tribal art, reappear alongside photographs of modern *Jugendstil* designs.

The fact that these are missing in the Munich publication is significant. By 1912 Kandinsky had rejected the decorative bias of *Jugendstil* in favour of the "spiritual", dematerialized forms of abstraction; and his approach to non-European cultures, too, is essentially abstract and universalist. The concept of the primitive in the almanac was too wide-ranging and imprecise to be a significant formal influence. A particular aspect like Egyptian stone reliefs or biblical woodcuts and *lubki* with apocalyptic themes could be extracted from the general concept and used in the artists' own works.[11] But generally they had to rethink the implications of the primitive in terms of the stylistic possibilities of their times. In his essay *Masks*, August Macke, who collected the ethnographic material for the almanac, spoke of the need to redefine the primitive in terms of the subjects and experiences of the present, mentioning the cabaret, the cinema and military marches as modern equivalents of tribal ceremonies.[12] But the synthetic, idealist thrust of the whole project subsumed any sense of historical specificity. The juxtapositions of texts and illustrations dissolve boundaries of time and place in favour of a synthetic universalism which binds the cultural fragments together in an ahistorical continuum relying on formal and expressive criteria. In this sense the almanac was one of the first truly modernist documents, and it was indeed a model for international avant-gardism.

the Museum für Völkerkunde, Berlin (inventory nos. I VA 3243 (853) and I V A 5858, Sammlung Jacobsen). Both postcards are in the Altonaer Museum Hamburg.

5 Letter from Kirchner to Heckel dated 31.3.1910, postmark Dresden, Altonaer Museum Hamburg

6 Examples are Hermann Obrist, *Neue Möglichkeiten*, Leipzig, 1903, quoted by Martensen-Larsen, *op. cit.*, p. 91; and C. Praetorius, 'The Art of New Guinea', *The Studio*, xxx, 1903, p. 51 f., quoted by Ettlinger, *op. cit.*, p. 195.

7 The emphasis of Osthaus's collection was on oriental art until 1912, although some examples of African utilitarian objects were in the museum by 1902 (cf. Paul Vogt, *Das Museum Folkwang in Hagen 1902-1927*, Cologne, 1965, p. 12). In 1912 he purchased some African figures from Paul Guillaume via an introduction from Archipenko. In 1914 he acquired part of Frobenius's collection of west African pieces from Umlauff after an introduction via August Macke (correspondence in Karl Ernst Osthaus Museum Archives, Hagen, Sept. 1913-April 1914).

8 Osthaus was in contact with Nolde and 'Die Brücke' from 1906, and with August Macke during the preparations for the Cologne 'Sonderbund', 1912. Macke, Kirchner and Schmidt-Rottluff all contributed to the 'Gilde Westdeutscher Bund für Angewandte Kunst' exhibition in 1912. Osthaus helped organize this as well as the 1914 'Werkbund' exhibition where the Expressionists once again presented decorative projects.

9 Kirchner's statements in the *Chronik der Brücke*, 1913, and 'Über die Plastischen Arbeiten E. L. Kirchners', *De Cicerone*, 1925, stress the importance of a German tradition. But the 'Brücke's' annual Report, 1911, which announces their plans for an exhibition to include art of "other times and peoples" is firmly committed to the international avant-garde.

10 Peter Vergo, *The Blue Rider*, Netherlands, 1977, pp. 6-7

11 Donald Gordon, *op. cit.*, p. 376. His claim that Marc also used a Cameroon Buffalo Helmet for his *Donkey Frieze*, 1911, is unconvincing. R. C. Washton-Long, *Kandinsky, the Development of an Abstract Style*, ch. 6, Oxford, 1980, discusses the use of 'primitive' sources.

12 *Der Blaue Reiter*, ed. W. Kandinsky and F. Marc, Munich, 1967 (1st ed. 1912), p. 57. Macke was the only 'Blaue Reiter' artist to paint modern life subjects and more popular primitivist subjects like *Indian Horsemen by a Tent*, 1911, Städtische Galerie im Lenbachhaus, Munich.

13 Emil Nolde, *Jahre der Kämpfe*, Cologne, 1967, p. 194

14 Emile Nolde, *Welt und Heimat*, Cologne, 1965, p. 39. A letter to Gustav Schiefler, dated 14.4.1914, from Rabaul New Guinea reiterates his praise for Osthaus's display of non-European art (Max Sauerlandt (ed.), *Emil Nolde: Briefe 1894-1926*, Berlin, 1927, p. 101). A second letter to Osthaus himself, also dated 14.4.1914, also mentions Sauerlandt's plans to organize his collection of non-European art at Halle according to aesthetic criteria, and acknowledges Osthaus's precedence in this principle (letter in Karl Ernst Osthaus Museum archives, Hagen).

15 Emil Nolde, *Jahre der Kämpfe*, p. 195

16 *ibid.*, p. 238

17 See Nelson Graburn (ed.), *Ethnic and Tourist Arts*, London, 1976

Fig. 2 Display case of Amazon Indian objects in the Berlin Museum für Völkerkunde, 1886. It includes the Yuruna Indian head in Nolde's *Mask Still-Life 3*, 1911

18 Carl Einstein, *Negerplastik*, Munich, 1920 (1st ed. 1915), pp. V–VI, and *Die Kunst des 20. Jahrhunderts*, Berlin, 1931 (1st ed. 1926), p. 161. Einstein's own emphasis on the formal and religious values of African sculpture represents a modernist viewpoint, rather than as he suggests, a neutral act of observation.

19 *Briefwechsel August Macke, Franz Marc 1910–14*, Cologne, 1964, pp. 39–40. For a fuller discussion about the relationship between the rejection of history and modernism see J. Lloyd, 'Emil Nolde's Still-Lifes 1911–12, Modernism, Myth and Gesture', *RES*, IX, New York, 1985.

20 Gottfried Benn, 'Bekenntnis zum Expressionismus', *Deutsche Zukunft*, 5 November 1933. Benn stresses the abstracting and transcendent effects of this process.

Fig. 3 Emil Nolde, *The Missionary*, 1912

In 1912 Emil Nolde's notes for a book on the *Artistic Expression of Primitive Peoples* rejected classical art as "made for popes and palaces", and declared his preference for the spiritual, anonymous qualities of northern Gothic and tribal art.[13] The previous autumn he had begun to sketch South American pots and jewellery in the Berlin ethnographic museum, approaching the material with similar attitudes to Osthaus whose aesthetic rather than scientific appreciation of non-European art he praises in his autobiography.[14]

In the spring of 1911 Nolde saw a second collection of non-European art in a *Jugendstil* environment in the Palais Stoclet in Brussels. But it was his visit to James Ensor that influenced his first *Mask Still-life*, 1911. Here, as in the next three mask compositions which are based on ethnographic sketches (fig. 2), the masks are not worn, but hung as objects, which are paradoxically animated by human emotions: laughing, crying, grimacing. This peculiar middle ground between subjective and objective reality relates to Nolde's ideas about the direct and spontaneous production of tribal objects. "The natives create," he wrote, "with the actual material in their hands ... their motivation is their pleasure and love of creating." In contrast, "our age has seen to it that a design on paper has to precede every clay pot, ornament, useful object of piece of clothing."[15] Unlike modern objects the native artefacts are expressive of a direct, unmitigated relationship between producer and product; and Nolde tried to tap this quality in the childlike spontaneity of his own ethnographic sketches, which offered "a deeper penetration into the essential than mechanical reproductions and illustrations could give."[16] Although his masks lack Ensor's overt social satire Nolde too uses these animated objects to effect a more oblique critique of his own times.

Of course, many of the objects Nolde sketched would have been created for Western markets in the framework of codified traditions.[17] Wrested out of their own cultural contexts, they were, as Carl Einstein realized,[18] empty vessels into which meaning could be read. Whether these fragments were reassembled according to the code of Darwinian evolution in the ethnographic museums or according to the aesthetic and expressive criteria of the Folkwang Museum and *Der Blaue Reiter* almanac, their own history was ignored. For Franz Marc it was precisely the ahistorical status of tribal artefacts which made them relevant to a renewal of the present. Echoing Nietzsche's attack on historical positivism in *On the Uses and Disadvantages of History for Life*, 1874, Marc wrote in 1912: "I find it natural that we should look for the rebirth of our own artistic consciousness in this dawn of artistic intelligence rather than in cultures with thousands of years of history like the Japanese or the Italian ... our ideas and ideals must be clad in hairshirts, they must be fed on locusts and wild honey, not on history, if we are ever to escape the exhaustion of our European bad taste."[19]

On one level Nolde's ethnographic still-lifes, too, endow the objects with a timeless status. In 1912 he sets up mythical oppositions of 'Man' and 'Woman', often mediated by animals with sexual connotations like the cat and the fish. But in these theatrical compositions there is also a sense of an arrested, frozen moment, an interrupted narrative, which reflects something of the historical dislocation of these objects in the hands of Western interpreters. Nolde's sense of historical change *within* tribal societies is illustrated in the *Missionary*, 1912 (fig. 3), where a grotesquely masked man of God, in true Ensoresque fashion, diverts a native from her own religious practices.

Like the almanac *Der Blaue Reiter* Nolde uses a compositional method of juxtaposition which Gottfried Benn later characterized as the fundamental mode of Expressionism.[20] Once the rational, evolutionary links were removed imaginatively from the ethnographic museums one was left with a juxtapostion of fragments, which Hannah Höch satirized in the scrap-book technique of her photomontage series *To an Ethnographic Museum*, 1924. Nolde – like Höch in the 1920s – does not weld these fragments back into a seamless, universalist whole like the almanac *Der Blaue Reiter*, but leaves them, in a sense, historically stranded; and signalling both in the direction of his timeless religious paintings of 1912, and towards his contemporary Berlin scenes which juxtapose male and female figures in cafés.

By 1900 the relationship between 'primitive' and 'civilized' man was indeed a shifting and problematic one. On the one hand, tribal society could be idealized as a

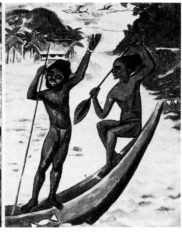

'natural' counter-image to the modern industrial world; but the impact of colonial rule could make these very same societies appear as a grotesque caricature of Western modernization. In 1913 both Nolde and Max Pechstein followed Gauguin's footsteps to the South Seas; and their memoirs reflect this complex range of available attitudes.

Pechstein's description of Palau extends a nineteenth-century tradition of romantic exoticism. The carved beams he had discovered with his 'Brücke' colleagues in Dresden from Palau had exercised more than a formal influence: they were tokens of an unalienated, original state, "a unity of man and nature where work, sleep, everything is as one, is nature itself."[21] In comparison to the Bismarck Archipelago, New Guinea, where Nolde landed in February 1914, Palau was relatively unexploited commercially. But rather than responding to the historical reality of a colonial island, Pechstein interpreted Palau – as Gauguin interpreted Tahiti – in terms of his own romantic expectations. His memoirs describe a counter-image to the commercial and materialistic values of Europe; an ideal paradise of fishing, feasting and bathing (the lifestyle in fact which the 'Brücke' artists had pursued at the Moritzburg lakes outside Dresden in 1910 under the original inspiration of the Palau beams).

Pechstein, too, hoped to capture some of the 'authenticity' he read into the native lifestyle into his own work by using their tools to carve his sculpture. But the idols he shows them carving are distinctly Gauguinesque.[22] Moreover, his own drawings which are described, and indeed made, as direct sketches from nature employ a mixture of exotic styles (Gauguin, Delacroix and even contemporary cabaret decorations), which he had already used in his European paintings and now redeployed in Palau.[23] Alternatively the Palau-style of the beams (which by 1914 were situated in men's club houses which had been converted to house the local police forces),[24] is used for his *Palau Triptych*, 1917 (fig. 4), painted on his return to Europe. This idealistic project with its religious associations shows no evidence at all of the historical reality of his journey.

On one occasion Pechstein's memoirs do give an Expressionist twist to this romantic idyll. Echoing Worringer,[25] he claimed to see in the native carvings "their trembling piety and awe before the incomprehensible powers of nature; their hopes and thrills, their fears and their subservience to unavoidable fate." Contemporary writings by Freud and Georg Simmel made links between the primal fears of 'primitive' man in the face of his environment and modern man's battle to forge his identity under the pressures of civilization.[26] It seems that Pechstein's own sense of emotional crisis in 1920-21 led him briefly to a more complex consideration of the relationship of contrast *and* analogy between modern and 'primitive' man. His portrait of *Frau Dr. Plietzsch*, 1921 (fig. 5), which is composed in an identical way to his own impressive *Self-portrait with Death*, 1920, shows a sophisticated European woman juxtaposed between a South Seas mask and a contemporary female portrait or mirror reflection.

Unlike Pechstein, Nolde did respond initially to the historical contradictions of the colonial situation in the South Seas. He accompanied unofficially a medical

Fig. 4 Max Pechstein, *Palau Triptych*, 1917

21 Georg Biermann, *Max Pechstein*, Leipzig, 1920, p. 15 (1st ed. 1919). Pechstein's *Erinnerungen*, ed. Leopold Reidemeister, Berlin, 1960, were written in 1945/6.

22 e. g. *The Carver of Idols*, 1917, illustrated in Max Osborn, *Max Pechstein*, Berlin, 1922, p. 81

23 e. g. *The Yellow Cloth*, 1909, and *The Seashore*, 1909/10. The sketch of a Palau scene in *Erinnerungen, op. cit.*, p. 58, is comparable to the background decorations in Kirchner's *Panama Girls*, 1910, a cabaret drawing. Georg Reinhardt suggests that some of Pechstein's 1910 works, including the colour woodcut *Somali Dance*, are based on cabaret decorations, cf. *Die Frühe Brücke*, Brücke Archiv 9/10, 1977/8, pp. 145-6.

24 *Deutsches Kolonialblatt*, XVI, 15 January 1905, no. 2, p. 51, describes the reform of traditional practices in the men's club houses under German colonial rule.

25 Wilhelm Worringer, *Abstraktion und Einfühlung*, Munich, 1981 (1st ed. 1908), p. 49; M. Pechstein, *Erinnerungen, op. cit.*, p. 78

26 Sigmund Freud, 'Psychoanalytic notes on an Autobiographical account of a case of Paranoia (The case of Schreber)', *The Complete Psychological Works*, ed. J. Strachey, vol. 12, p. 82. G. Simmel, 'Die Großstadt und das Geistesleben', *Jahrbuch der Gehe-Stiftung zu Dresden*, 1903, p. 14

27 Robert A. Pois, *Emil Nolde*, Washington, D.C., 1982, pp. 185-6

28 Emil Nolde, *Welt und Heimat, op. cit.*, pp. 57-8

29 Emil Nolde, *Briefe, op. cit.*, p. 103

30 Emil Nolde, *Jahre der Kämpfe, op. cit.*, p. 197

31 Lucius Grisebach (ed.), *Kirchners Davoser Tagebuch*, Cologne, 1968, p. 73

demographic expedition sent to investigate native conditions in New Guinea. To some extent the 'scientific' nature of the expedition is written into Nolde's drawings in pencil, crayon and watercolour. The frontal and profile poses of his native heads and the variations of hairstyle and decoration recall the mug-shot conventions in contemporary ethnographic photography; once again it is as if Nolde is trying to outdo photography with the expressive impact of his hand-made sketches. Other drawings record the plant life of the region and customs like the Duk-Duk dance. His sketches of native villages display a freshness of observation quite different from Pechstein's romantic conventions; here we find informal groups of natives, some in European dress.

Nolde's *Missionary* still-life posits a critical attitude to European domination of tribal societies. In 1907 he supported the Social Democrats in the Reichstag elections, who fought unsuccessfully to halt the course of German colonialism.[27] In his autobiography Nolde writes, "Colonization is a brutal matter. If a history of colonialism could be written from the point of view of the natives we white Europeans would crawl off to hide... Perhaps it is possible to comfort ourselves with ideas about the survival of the fittest as it exists in the animal and vegetable worlds as a natural law. If it is possible to draw comfort from such a law to justify the actions of Europeans here... One thing is for sure. White men are the enemies of coloured native peoples."[28]

But these enlightened criticisms of colonialism are mixed in Nolde's writings, paradoxically, with a pan-Germanic brand of German nationalism and belief in racial purity. Like Osthaus, Nolde held a precarious balance before 1914 between his commitment to a revival of German culture and his sense that quality in the visual arts transcended national boundaries. But during his South Seas trip it would seem that the potential contradictions in his position came to a head and were no longer tenable. In 1914 he wrote an enraged letter to the colonial office in Berlin condemning the rape of tribal cultures by 'civilized' powers and insisting on the aesthetic worth of tribal art. As the last traces of primal man, he concludes, they should be bagged immediately for the *German* museums before other nations make off with the spoils.[29]

Nolde increasingly sought a resolution of this type of historical contradiction in a timeless, mythic world view, which, unlike the internationalist, modernist stance of 'Der Blaue Reiter', took on a *völkisch*, Germanic character. Nolde's South Seas oils show archetypal family groups and stress the savage rather than the 'civilized' exotic. His landscapes, which were endlessly repeated after 1915 in a North German setting, depict the cyclic rhythms of nature: the tides and the seasons. And the artistic daring of these works is underlaid by conservative ideology. An addition to his 1912 notes on 'primitive' art reads, "...Everything ancient and timeless fascinated me. The great swelling sea is still in its original state, the wind, the sun, the starry sky are still the same as they were fifty thousand years ago."[30]

In his diaries Kirchner described Nolde's art as "unhealthy, often, and too primitive."[31] Despite his early admiration for Nolde it seems that by the 1920s he felt him to have lost touch with the complex rhythms of modernity, which for him – like Beckmann and Meidner – remained the central challenge for art. From 1910 his own primitivism was part of an attempt to visualize the contradictory forces underlying modernity.

Nevertheless the early 'Brücke' years are marked by the idealistic attempt to carve out an alternative space for living and art-making where the two could be brought into harmony. Their cooperative of active and passive members, which allowed them *direct* access to a select audience, their shared practices (limited in reality) and bohemian studios all testify to these aspirations. But this genuine idealism went hand in hand with a certain pragmatism: they pursued a highly organized and ambitious exhibitions policy to promote their art. Their bohemianism – rather like primitivism in relation to modernity – was an inverted image of the bourgeois codes and values of their own backgrounds and those of the professional middle-class patrons who supported their art and made occasional forays into this topsy-turvy version of their own world.

From 1909 the 'Brücke's' studio decorations (fig. 6) show their response to non-European art: the Palau beams from the Dresden ethnographic museum and the

Fig. 5 Max Pechstein, *Portrait of Frau Dr. Plietzsch*, 1921

Fig. 6 The Dresden Studio of 'Die Brücke',
c. 1910

Ajanta wall paintings illustrated in John Griffith's book which Heckel discovered in
1908.[32] The curtain rondels are reminiscent of Javanese shadow puppets (which also
featured in contemporary cabaret acts).[33] From 1910 carved furniture in Cameroon
style and African textiles began to appear in their work; and this mixture of eastern
and tribal styles results in a kind of raw-edged exoticism which often characterizes
'Die Brücke's' primitivism. In the studio decorations this is not only a matter of the
formal influence of non-European models but also the processes of making: direct
carving and hand-made wall-hangings which avoid the alienating conditions of mass
production as well as being financially expedient.[34]

In 1908 Heckel described 'Die Brücke's' aim to transform decorative practices in
art and design. He wrote, "our aim too is decoration, peaceful effects. But on the
other hand everything pushes towards spontaneity and passion."[35] The explicit sex
in Kirchner's decorations has little to do with the original tribal models.[36] Both in
terms of style and subject 'Die Brücke' *cultivated* spontaneity and passion, revealing a
peculiar mixture of intellect and intuition which is the Nietzschean core of their art.

'Die Brücke's' bathing trips to Moritzburg in 1909 and 1910 were the most suc-
cessful realization of their group aims. Their experiences here seem to have been an
essential spur to Kirchner's primitivism, despite his previous knowledge of tribal art,
and Moritzburg provided the subject matter for his studio wall-hangings. Kirchner
first used the Palau style in a postcard depicting bathers in 1909, and in the following
summer it impregnated all the 'Brücke's' Moritzburg scenes.[37] The Palau style
became relevant because 'Die Brücke' transferred the alternative space of their
studios to the open air and pursued a primitivist lifestyle: bathing nude and playing
with bows and arrows and boomerangs. Much of this crosses with the nudism cult,
which had a wide appeal at the time, ranging from the Theosophists to the *völkisch*
circles around Heinrich Pudor.[38] But the vitality and abandon of the 'Brücke's'
bathing scenes strikes a quite different mood. In Kirchner's *Nudes Playing Under a
Tree*, 1910 (fig. 7), the colours and rhythms of nature animate the figures and
liberate them from their civilized constraints. Once again this is Nietzschean in
spirit. In *The Will to Power*, 1906, we read: "Man as a species does not represent any
progress compared with any other animal. The whole animal and vegetable kingdom
does not evolve from the lower to the higher – but all at the same time, in utter
disorder over and against each other. . . the domestication (the culture) of man does
not go deep – where it does it at once becomes degeneration. . . The savage (or in
moral terms the evil man) is a return to nature – and in a certain sense his recovery,
his cure from culture. . . Where are the barbarians of the twentieth century?"[39]

Whereas the Nietzschean attack on historical positivism, and the cult of intuition
led the 'Blaue Reiter' artists and Nolde to very different forms of mythical universal-

32 J. Griffith: *The Paintings of the Buddhist cave-tem-
ples of Agant Khandesh, Indi*, London, 1896/97.
Letter from Heckel to Cuno Amiet dated
30. 1. 1908. Heckel's first wall decorations
sketched in a letter to Rosa Schapire dated
5. 2. 1909 show the influence of Ajanta in the
two standing nudes. A photograph of this
mural is illustrated in Karlheinz Gabler, *Erich
Heckel, Dokumente*, Stuttgart and Zurich, 1983,
p. 60.

33 A photograph of Ernst von Wolzogen's *Buntem
Theater*, 1901-2, shows a shadow-puppet show
(illustrated in R. O. W. Rosler, *Kabarett-
geschichte*, Berlin, 1977, p. 38).

34 L. de Marsalle (E. L. Kirchner), 'Über die
plastischen Arbeiten', *op. cit.*, pp. 695-6,
makes clear the importance of direct carving.

35 Letter Heckel to Amiet, 30. 1. 1908

36 Although there are precedents for sexual motifs
in both Indian wall painting and the Palau
beams. A Kirchner postcard dated 20. 6. 1910
depicts a Palau figure with an exaggerated
phallus (illustrated in Gordon, *op. cit.*, p. 373).
But there is no precedent in his sources for
explicit love-making scenes as a dominant sub-
ject.

37 Kirchner postcard to Heckel dated 6. 9. 1909,
postmark Dresden, Altonaer Museum, Ham-
burg. This sketch was used for Kirchner's
colour woodcut *Bathers Throwing Reeds* (Dube
160; 1910). See also Heckel's *Bathers in the Reeds*
(Vogt 1909, 3; 1910) and Pechstein's *The Black
and Yellow Costume* (1910).

38 See Janos Frecot, Johann Friedrich Geist,
Diethart Kerbs, *Fidus 1868-1948: Zur aestheti-
schen Praxis bürgerlicher Fluchtbewegungen*,
Munich, 1972. Also Heinrich Scham (Pudor),
'Nackende Menschen, Jauchzen der Zukunft',
Dresden Wochenblätter, 1893, and *Jungbrunnen,
Offenbarungen der Natur*, Leipzig, 1894

39 Friedrich Nietzsche, *Der Wille zur Macht*,
Stuttgart, 1964, p. 461 f.

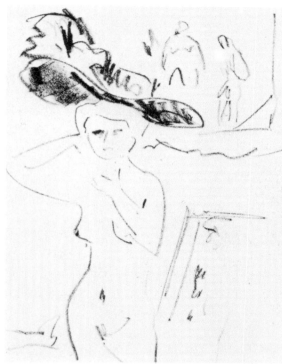

Fig. 7 Ernst Ludwig Kirchner, *Nudes Playing under a Tree*, 1910

Fig. 8 Ernst Ludwig Kirchner, *Nude with a Feather Hat*, c. 1911

40 Gordon, *op. cit.*, p. 372
41 In Nietzsche's *Also Sprach Zarathustra*, 1883-5, the tightrope walker is interchangeable with the image of the bridge *(Brücke)*, which inspired the name of the Dresden Expressionists. The dancer also occurs as an image of affirmation and renewal. Both of these are recurrent motifs in Kirchner's cabaret and circus works.
42 e.g. Julius Bierbaum, *Stilpe, Roman aus der Froschperspektive*, Berlin, 1927 (1st ed. 1897), p. 357 f.
43 Kirchner was in contact with the poets in the 'Neopathetisches Kabarett' from 1911. He illustrated Georg Heym's *Umbra Vitae*, Munich, 1924, with forty-seven woodcuts.

ism, Kirchner tried to uncover the primitive in his own times: first in a positive and regenerative sense and then, in the Berlin scenes, as a disruptive presence underlying the veneer of civilization.

Donald Gordon points out that it is in the studio paintings of 1909 to 1911 that Kirchner and Heckel begin to play off against each other references to nature and to culture.[40] It is worth mentioning that the method they use is once again the Expressionist device of juxtaposition: involving in this case both contrast *and* analogy. In *Nude in a Feathered Hat*, c. 1911 (fig. 8), Kirchner compares the vitalist and instinctive bathers behind to liberated nudity in the studio. But he also contrasts inside and outside spaces, and the 'primitive' bathers with the elegant nude. The trappings of civilization like the hat or the fan mark the studio out as a place where nature and artifice meet through art-making.

This pattern of contrast and analogy recurs in the thematic structures of Kirchner's oeuvre. The gay, artificial world of the cabaret and circus contrasts with the 'natural' bathers scenes. But these images, too, are infused with Nietzschean vitalism.[41] The mixture of urban glamour and exoticism in the cabaret – with its snake charmers, belly dancers and Chinese jugglers – provided a lively confrontation of the primitive and the modern. And in contemporary literature the cabaret was often used as a metaphor for artistic renewal.[42]

By 1913 Kirchner's attitude to modernity had changed. In Berlin he was faced with the real pressures of urban modernization, where the population grew from 826,000 to 2 million in the space of forty years. Under the conflicting pressures of the art world 'Die Brücke' was dissolved in 1913, and Kirchner was mixing in the circles of the Berlin city poets with their more critical, questioning attitude to urban experience.[43] All this is reflected in *Five Women on the Street*. High fashion has replaced nudity, and the alienating theme of prostitution supersedes the liberated sexuality of Moritzburg and the studios. As Kirchner's concept of modernity changes so too does its mirror-image, the primitive, as the two are fused into a single and powerfully contradictory image. Pushed to this extreme, the balance tips and the primitive loses its powers of regeneration. Instead it remains as a dark and threatening presence beneath the fragile surface of civilization.

Georg Bussmann

'Degenerate Art' – A Look at a Useful Myth

In the history of every European nation, and particularly of Germany, the instigator, the period of the Second World War and that of the 'new beginning' after 1945 represent a great divide. The years from 1933 to 1945, and then the period beginning in 1949, which saw the founding of two separate German states, may be termed critical chapters in the history of bourgeois society, a history in which other nations were also involved, and not just as spectators. Fascism, which can still be conceived as a possible form of government providing the ultimate means for 'settling' political crises and a 'rationalization of death', is particularly well equipped to bring bourgeois society and its acknowledged ideological values face to face with itself. In abstract terms we may find this easy to accept, but when it comes to facing realities and becoming personally involved as individuals it can amount to a lifelong preoccupation with the present. In the same way it is merely superficial to describe what happened in the two Germanys after 1949 under the slogan 'a new beginning at zero hour'. Relations between the two German states are still determined by an attitude of mutual exclusivity, which is simply updated from time to time in accordance with the general drift of the political situation. Thus, however openly or covertly the exchanges and disputes between the two states may be conducted, in the background there is always a tendency to accept the division between them in the interests of exclusivity – of excluding the socio-political alternative – and as the necessary price of German war-guilt. Loss of territory becomes loss of history and ultimately loss of guilt.[1]

1. Impotent Antifascism

Seen against this background, any account of National Socialist policy on art and culture ought not simply to describe a phase in the history of art, but to go deeper and examine the basic structures of bourgeois society in its dealings with art. The theory and practice of the operation which was mounted in 1937 against 'degenerate art' (the German term for which, *Entartete Kunst*, has untranslatable racial connotations) seem well suited, within the spectrum of Fascist cultural policy, to serve as a critical case: the works against which the operation was directed were bound up – and still are, only a few years later – with powerful and strongly contrasting emotions. Pictures which we take for granted today as part of our cultural heritage, artists' situations and careers, identification with the 'heroes of modern art' – heroes who were 'dragged through the dirt' at the Munich 'exhibition of shame' – are apt to give us cause for alarm, perhaps even for guilty embarrassment, though at the same time we can see through it all as an event prompted by chronic anxiety, which may afford some spurious relief. In the end the pictures proved the stronger, and the aura of triumph they now possess gives them additional weight and prestige. Yet how does one come to terms with the success of the exhibition, which attracted 2,009,899 visitors in Munich alone – between 19 July and 30 November 1937 – portrayed in photographs of the long queues of people waiting to get in? What is it about this that we find so disturbing? A contemporary witness, Paul Ortwin Rave, describes what it was like: "Day after day people would come in droves to visit the exhibition, and it is no use trying to console oneself with the thought that a few of them may have come to take their final leave of works that they loved. There can be no doubt that at the time the aim of the propaganda, which was to deal a death blow to genuine modern art, was in large measure achieved."[2] Some did go to pay their last respects, and at least one visitor, Bernhard Sprengel, a classic example of the bourgeois art collector, discovered at the exhibition that he had a real passion for modern art,

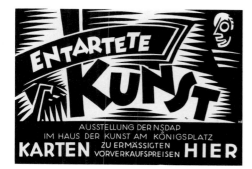

Fig. 1 Poster for the exhibition 'Degenerate Art', which opened on 19 July 1937 in Munich

which he then proceeded to collect systematically, at some personal risk. But what about all the others? Thousands of visitors, most of whom had come of their own free will, thronged past the pictures every day and found it a stimulating – and obviously meaningful – experience to share in the collective indignation, disgust and contempt. So large were the crowds that at times the exhibition had to be closed. Never before or since has an exhibition of modern art reached a greater number of people, or found a greater resonance, than this anti-exhibition. How far do we have to take our unquestioning acceptance of bourgeois culture before this ceases to surprise us?

Of course it is not difficult to regard the aggressively disparaging presentation of this touring exhibition of 'degenerate art' and the vituperative tone of the catalogue entries as 'lacking in dignity' or as a 'relapse into barbarism'. Hence one can hardly find fault with the backlash of indignation which followed after 1945, especially as it makes sense politically. The post-war reaction to Nazi policy on the arts made the works of those who had once been 'degenerate' into the "good conscience of Germany in her darkest hour"[3], i.e. after "Germany withdrew from the united endeavour of the modern European spirit, isolating herself and rejecting, in a bizarre access of iconoclasm, all that this endeavour had achieved in every intellectual sphere."[4] Now it was time to proclaim once more the European affiliations of German art and to link it once again with the traditions represented by the great exhibitions of the 1920s – the Dresden International Art Exhibition of 1926, for instance – and with what was regarded as a "model case of universal human culture". During the first phase of this process of coming to terms with the past one could still encounter unregenerate elitist attitudes such as the following: "We have a duty to ensure that such philistinism never again takes hold of Germany. . . It was only on a basis of brainless, soulless, mindless philistinism that such excesses of vulgarity, baseness and brutality could occur. Never again must intoxicated minds and knuckledusters and Browning revolvers be permitted to interfere in our dialogue with the eternal."[5] And – as was almost entirely predictable in the period of the Cold War – time and again one comes across passing references to the supposedly self-evident equation 'brown equals red'. Take the following instance: "One need only compare the products of Socialist Realism with what was spawned by the National Socialist conception of popular nationhood to recognize them as twin phenomena."[6] Or again: "What most arouses our indignation is the pretty-pretty, posturing, heroic mode of expression which became the order of the day in Russia and Germany."[7] The general trend of such revisionary efforts was not only to clear modern art of the stigma of cultural degeneracy, but to establish it from now on, after it had survived these attacks and "remained alive in the catacombs"[8], as one of the unquestionable values of the Free World. It became a "guarantee of freedom" – though admittedly this did not apply in equal measure to all artistic positions: since New Objectivity (Neue Sachlichkeit) had allegedly proved to be simply a "regressive peripheral movement", it was decided "that the chief feature of artistic development will be continued progress in the direction of abstraction".[9]

When one becomes involved in this aesthetic discussion about the direction in which art is moving one inevitably loses sight of the political circumstances which gave rise to the operation against 'degenerate art'. The argument that modern art is the free expression of the spirit, the antithesis of National Socialist barbarism and *kitsch*, rests on the view of Fascism as something different in kind, something alien and totally reactionary, determined by "peasantish attitudes and the small shop-keeper mentality". And just as Fascist art came to be judged as a "foreign body" after 1945, the same may appear to be true of Fascism as a whole. There is no little irony in the fact that we can detect here the last reflex of the Fascist strategy of blinding the public to the facts, for Fascism was a regime which constantly claimed to be revolutionary, though it not only did nothing to alter the actual economic structures, but posited them as absolute, and concealed this basic continuity behind a radical upheaval in the social superstructure: even now, decades later, we are tricked into regarding Fascism as *the* catastrophe, a unique and wholly unnatural irruption into the continuity of bourgeois history. I believe that what causes offence in the debate about Fascism, even today, is any attempt to discuss Fascism and Liberalism not as opposing movements, but as parallel forms of bourgeois rule.[10] It

3 Gunther Thiem, exhib. cat. *Käthe Kollwitz*, Cultural Week of the FRG in Israel, 1971

4 Werner Haftmann, introduction to the cat. *Documenta 1*, Cassel, 1955

5 Adolf Behne, *Entartete Kunst*, Berlin, 1947, p. 48

6 Joseph Wulf, *Die Bildenden Künste im Dritten Reich*, Gütersloh, 1963, p. 10

7 Franz Roh, *Entartete Kunst*, Hanover, 1962, p. 25

8 Werner Haftmann, *Painting in the Twentieth Century*, 2nd ed., London, 1965, p. 306

9 Franz Roh, *op. cit.*, p. 11

10 Reinhard Kühnl, *Formen bürgerlicher Herrschaft, Liberalismus – Faschismus*, Hamburg, 1971

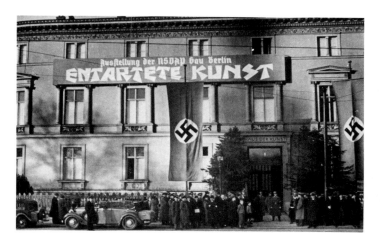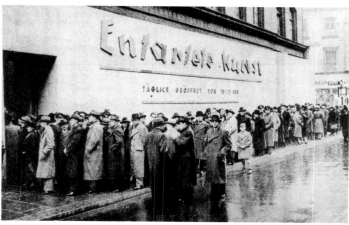

Fig. 2 Queues in front of the 'Degenerate Art' exhibition in March 1938 in Berlin

Fig. 3 The same rush on the exhibition in November 1938 in Hamburg

was this dilemma in the theory of cultural politics which Wolfgang Haug called "impotent Antifascism" in his book published under this title in 1967.

It seems to me to be a matter of crucial importance that we should not pre-judge this point, which is both a challenge and a source of internal friction, if we are to progress, in our understanding of Fascist cultural policy, beyond impotent exclusiveness and would-be superiority to a recognition of the part played by Fascist elements in the organization of bourgeois life: the Fascist view of the world and of man, reflected by art and fostered by cultural policies in attitudes and conduct, is a continuation of certain models of living to be found in bourgeois society. The fundamental tendency of such models is prompted by anxiety, and under Fascism, which promised a final resolution of all existing contradictions, this tendency was intensified into a total hostility towards life and humanity.

2. The Fascist Debate on Expressionism

A realistic assessment of the operation against 'degenerate art' is only possible if one follows the curious one-dimensional logic that is characteristic of Fascist policy. While the exhibition 'Degenerate Art', viewed in relation to the continuity of bourgeois art, appears to be the culmination of a campaign of destruction, it was from the Fascist point of view merely the final phase in a clearing-up process, an administrative reorganization of cultural activities which was meant to clear the ground upon which Fascist art could usher in a new beginning. When we consider the fact that Goebbels opened the exhibition 'Degenerate Art' in the old gallery of the Hofgartenarkaden in Munich on 19 July 1937, only one day after the officially approved Great German Art Exhibition had been opened in the 'Haus der Deutschen Kunst' close by, the link between the two events becomes obvious: what had been thrown out or expelled from the new temple of German art was to be put on display just once more – to its own shame and the indignation of the public – before it disappeared for good. At first sight therefore it seems illogical that it should have been the "exhibition of shame", the object of opprobrium, rather than the affirmative 'New German Art', which was subsequently sent on tour throughout the Reich (to Berlin, Leipzig, Düsseldorf, Hamburg and elsewhere), despite the risk that countless people would be seeing and getting to know the products of modern art for the first time. This strategy is understandable for a number of reasons:

– For any Fascist regime the image of the enemy always has sharper contours than what is intended to take its place, and 'Degenerate Art' was unmistakably characterized as the picture of the enemy by the didactic frame in which it was placed. 'New German Art', however, obviously still had to find its own form.

– Fascism could rely on the link between this operation in the field of art and the overall political situation; in other words, the exhibition was part and parcel of the "triumphal euphoria" which accompanied the ascendant phase of Fascism.

– In the debate about modern art differing voices were raised within the political institutions of the Party and the government, especially with regard to the ques-

tion of whether or to what extent it was possible or desirable to incorporate it into Fascism. All such differences of opinion were to be finally silenced by sending the exhibition on tour.

It is worth while looking more closely at these contradictions, for when we do so we find that Hitler's decision, in 1937, to go for a radical solution which would bring to an end a relatively open phase in the cultural debate loses its character of inevitability and moves out of the murky mythical realm of the outrageous and incomprehensible. Just as it was the wielders of economic power who helped Fascism to take over – in the interests of "securing undisturbed production", as was stated at the Nuremberg Tribunal – so the roots of Fascist thought go far back into the history of bourgeois philosophy – or *Weltanschauung*, as the Fascists preferred to call it. The dialectic of the individual versus the mass, from which bourgeois history had long drawn its dynamism, focusing on the individual's search for identity, his social integration and the organization of society, had entered upon a period of crisis during the late phase of industrialization. As a result of the growing social and economic threat to the middle and lower middle classes, as well as the fact that the reception and economic support of bourgeois culture was confined to an ever-diminishing circle of *cognoscenti*, the mass of society saw itself becoming increasingly cut off and alienated from a culture which it had hitherto considered generally 'humane'. Art was becoming more and more 'difficult'; it was becoming contradictory, a problem even to itself. An obvious conclusion to draw was that this was an unhealthy situation, or – more precisely – a disease of culture, especially if one disregarded the political and social conditions that gave rise to it. However, before the numerous theories of decline, decay and degeneracy could be streamlined into a Fascist 'solution' and translated into concrete prescriptions for action in the field of cultural policy – into real politics in other words – the cultural policies of National Socialism had to be given a unified direction. The conservative nationalist view of culture found expression in the 'Kampfbund für Deutsche Kultur' (Fighting League for German Culture), founded in 1927, in which Alfred Rosenberg and Paul Schultze-Naumburg were active. In various lecture programmes organized by local branches of the 'Kampfbund' the "degeneracy" of present-day art was pilloried with pseudo-Enlightenment pathos: "The physical and spiritual constitution of the body politic is different and healthier; it is only today's art which is one-sidely taken up with manifestations of decay and degeneracy" (Schultze-Naumburg 1935), an assertion which was 'proved' by means of a trick which takes one's breath away even today – by juxtaposing the stylized, primitive human figures of Expressionist painting with photographs of real physical disabilities and deformities.[11] However 'extraordinary' we may find the hypocritically scientific tone of the arguments employed, it is part of the scheme of bourgeois thinking to confuse the reality of the representation with the reality of what is represented, and it is a scheme of thinking which has a long tradition: the meta-level of art, its element of play, is denied, and so artistic freedom is liquidated, and culture becomes something that is valued for its own sake, a fetish which is placed above life to invest it with a meaning.

Having heard the negative, exclusive side of such thinking from Schultze-Naumburg, one can then turn to the propagation of the 'New German Art' in order to discover its positive formulation. Here the "achievements of culture" are seen as "the supreme expression of national *(völkisch)* existence and the very goal of human life",[12] and art becomes "one of the most effective forces for order and leadership in the life of the people".[13] The art championed by the 'Kampfbund' was to be "healthy" (meaning Nordic), and its aesthetic manifestation on the one hand traditionally representational in the academic sense and, on the other, enhanced by symbolism. Opposition to this rigidly exclusive policy and to early unspontaneous bouts of iconoclasm – such as the painting over of Oskar Schlemmer's Bauhaus murals by Paul Schultze-Naumburg, the director of the 'Vereinigte Kunstlehranstalten' (United Art Schools) in Weimar in 1930 – began to make itself felt among students, artists, art critics and art historians, who were organized in the 'Berlin League of National Socialist Students'. Their spokesman was the painter Andreas Schreiber. The forum for this debate was the periodical *Kunst der Nation* (1933-35), whose contributors included art historians who were to influence decisively the artistic life of West Germany after 1945. Without coming into direct conflict with

11 Paul Schultze-Naumburg, *Kunst und Rasse*, Munich, 1935, p. 111
12 Robert Scholz, 'Die Kunst im Europäischen Schicksalskampf', *Die Kunst im Dritten Reich*, 1943, p. 140
13 Henri Nannen, *Die Kunst im Dritten Reich*, 1937, p. 62

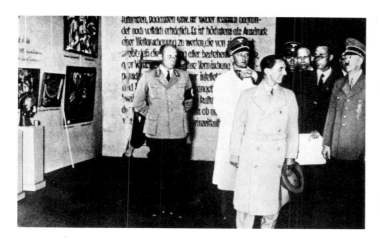 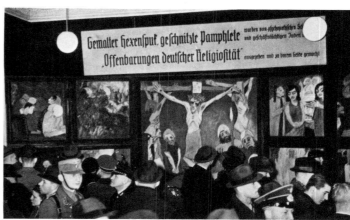

Fig. 4 Hitler and Goebbels visiting the 'Degenerate Art' exhibition in Munich

Fig. 5 Defamatory slogan above Emil Nolde's altar triptych *The Life of Jesus* in the 'Degenerate Art' exhibition: "Painted hocus-pocus, carved pamphlets, 'revelations of German religiosity'..."

the party line, they openly attacked Rosenberg's 'Kampfbund'. The reason for the attacks was the 'Kampfbund's' rejection of an application for membership from Emil Nolde, who had been a member of the Nazi party since 1920. Its systematic defamation of the Expressionists appeared to its equally National Socialist critics as "an offence against German culture". "The National Socialist students are fighting against artistic reaction because they believe in art's capacity for vital development and because they wish to forestall the rejection of the generation of German artists which preceded the present one and whose powers will flow into the art of the future. National Socialist youth ... believes in nothing so firmly as the victory of quality and truth."[14] "It cannot be denied that it was the New Art itself which prepared the way for the national revolution... The promoters of the national revolution in Germany were the artists of 'Die Brücke' such as Nolde, Otto Mueller, Heckel, Schmidt-Rottluff and Pechstein, the artists of 'Der Blaue Reiter' such as Franz Marc, Macke, Klee and Feininger, the sculptors Kolbe and Barlach and the architects Pölzig, Tessenow and Mies van der Rohe, to name but a few," wrote Bruno E. Werner in the *Deutsche Allgemeine Zeitung*, Berlin, on 12 May 1933. The battle-cries contradict each other: Rosenberg's "struggle for art" starts out from the eternal values of the German "people", while the internal opposition links its "struggle for modern art" with the demand for the "complete National Socialist revolution" which was being raised by elements in the SA and the anti-capitalist Strasser wing of the Nazi party. And in the background there is the power struggle for position and authority between Rosenberg with his 'Kampfbund' and Goebbels with his Propaganda Ministry and the institutions of the Reich Chambers of Art.

In terms of power politics it made sense for Fascism to settle its internal dissensions in peripheral theatres of war and to exploit the infighting between the various institutions as a way of neutralizing the potential for personal power-seeking – especially since Hitler, as *Führer*, always had the final word – but it is also true that at the time as is always the case in bourgeois societies a symbolic enactment of social conflicts on the cultural plane might have served to underpin the political balance of power. As in other Fascist states (Italy and Spain) a degree of openness in the cultural sphere and in the debate about cultural policy would have made sense – especially if it did not call political realities into question. The struggle *against* modern art, being a negative movement, was effective in integrating the masses, while the struggle *for* modern art might have won over the liberal educated middle class and represented a "new start and a move forward in the intellectual sphere". And the director of the piece could have been Goebbels – the one technocrat in the whole outfit – who had in any case quickly realized that no great propaganda spin-off was to be expected from "guided culture". A flexible cultural policy, a more open artistic scene, would have worked in favour of his versatile control of the media precisely because the exercise of this control could have remained hidden behind the facade of a relatively free cultural life.

It is indeed a breathtaking idea – Expressionism as the art of the Third Reich, the artists of the 'Brücke' and the 'Blauer Reiter' as the promoters of the national revolution. While we may be sure that some artists could never have been won over to

14 Quoted from Hildegard Brenner, *Die Kunstpolitik des Nationalsozialismus*, Hamburg, 1963, p. 67

15 Letter from the management committee of the 'Deutsche Kunstgesellschaft' (German Art Society), quoted from J. Wulf, *op. cit.*, p. 149

Fascism, there were many who were attracted to it ("We beg to be of service"[15]), and at this early stage others could have been attracted just as easily as millions of other Germans – perhaps more easily – had they been sure of commissions, of being given something to do. Modern art as a whole would still not have provided Germany with a 'state art' – there were too many contradictions within it – but large parts of it could have been integrated.

We cannot ignore the ultimate reality of German Fascism, and to this extent the possibility just outlined has little bearing on our image of Fascism. It is of interest, however, when we come to consider what is commonly called bourgeois culture.

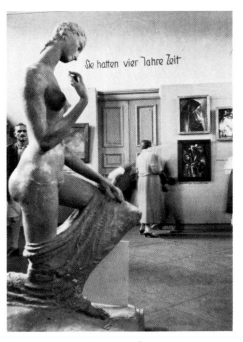

Fig. 6 A room in the exhibition, with Lehmbruck's *Kneeling Woman*. On the wall, the threatening reproach, "They had four years' time"

3. The Touring Exhibition 'Degenerate Art'

The Futurist Exhibition shown in Berlin in March 1934 brought the conflict to a head. The official art of Fascist Italy, a friendly state, was accorded an equally official welcome by the Reich government. Here was a kind of painting which claimed to be 'revolutionary' and whose progressive character found expression in the movement and technical dynamics of machines and in the spirit of geometry. It could, moreover, cite Mussolini in its support: "A new state, a new people, can prosper only if the whole of art is revolutionized."[16] All this was bound to seem like support for the Expressionist position in the debate about modern art, although the Expressionist supporters of Fascism did not go in for revolutionary exuberance so much as for emphasizing their 'Nordic roots'. The fact that Rosenberg's dogmatic claims were once more being questioned was enough to fuel the conflict. The authoritative pronouncement came from Hitler himself. Having eliminated the national revolutionary line in the stage-managed Röhm putsch and declared the National Socialist revolution to be at an end, Hitler now delivered a rebuke to both sides. In the first place he attacked the "anti-traditionalist corrupters of art, the Cubists, Futurists, Dadaists, etc.", who were not to be tolerated from either a "racial" or a "national" *(völkisch)* point of view: "They will see themselves passed over in what will probably be the greatest allocation of cultural and artistic commissions of all time, and we will move on to the next item on the agenda as though they had never existed . . . In the second place, however, the National Socialist state must take exception to the sudden emergence of backward-looking cranks who think they can spin an old-style German art out of the muddled world of their own romantic imaginings and bequeath it to the National Socialist revolution as an entail for the future."[17] This was aimed at the nationalist following of Rosenberg, whose pretensions had to be cut down to size. Hitler took the steam out of the power struggle between Goebbels and Rosenberg without putting an end to the useful rivalry between the two men. At all events the way was now clear for art to set out on a "disciplined march route". After the Berlin Olympic Games of 1936, which certainly succeeded in projecting the image of the new Germany abroad, Goebbels and his Ministry gained virtually sole control over Nazi cultural policy, which he proceeded to put into effect opportunistically in accordance with Hitler's wishes. Moves against progressive museums, of which there had already been isolated examples – "exhibitions of shame" or requisitionings – were now co-ordinated, and the president of the Reich Chamber of Art, the painter Adolf Ziegler, was empowered to "select and requisition decadent works of art from the year 1910 or later for the purpose of an exhibition". Ziegler and a commission appointed by him visited 101 German museums – all the major institutes in other words – and requisitioned 15,997 paintings, drawings and sculptures – 496 from the Städel in Frankfurt, 584 from the art gallery in Mannheim, 900 from the civic collection in Düsseldorf, 983 from the art gallery in Hamburg, and so on. The directive was set out in a decree of 2 August 1937 issued by Reich Minister Rust: "From the field of degenerate art those works are to be viewed which offend against German sentiment, destroy or distort natural form, or display obvious evidence of inadequate craftsmanship or artistry on the part of the producer."[18] With this relatively open-ended formulation a device was created for a final reckoning with modern art; an artist who might manage to escape being caught for "offending German sentiment" – like Franz Marc, who fell at Verdun in the First World War – would be certain to be caught for

16 Quoted from H. Brenner, *op. cit.*, p. 76
17 *ibid.*, p. 83
18 Quoted from the catalogue of the exhibition *Verboten – Verfolgt, Kunstdiktatur im 3. Reich*, Lehmbruck Museum, Duisburg, 1983
19 Hans Prinzhorn, *Bildnerei der Geisteskranken*, Berlin, 1922, p. 346

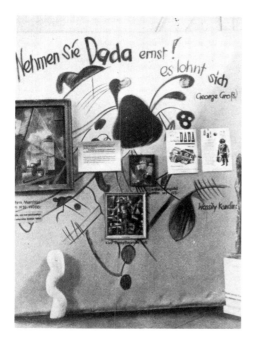

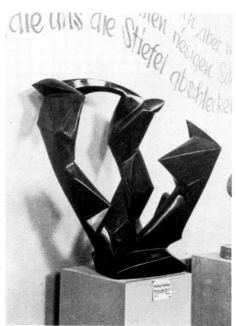

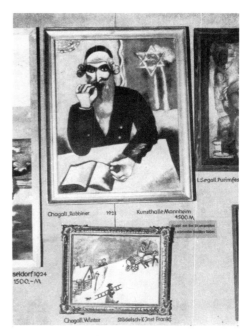

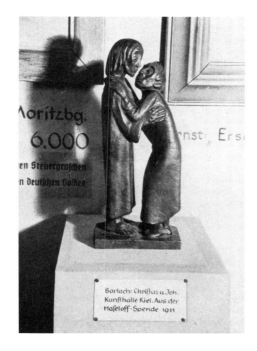

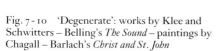

Fig. 7-10 'Degenerate': works by Klee and Schwitters – Belling's *The Sound* – paintings by Chagall – Barlach's *Christ and St. John*

"inadequate craftsmanship or artistry", as would Paul Klee or somebody like Lovis Corinth, whose works produced after the stroke he suffered in 1911 were classed as 'degenerate'.

For the exhibition 'Degenerate Art', which opened in Munich before going on tour, 730 works were selected. The presentation of the pictures, hung close together in narrow rooms so that no 'aura' could be created, some without frames and some standing on the floor against the walls, created an initial impression of chaos, though one soon realized that it was a contrived chaos, part of a didactic scheme so to speak. The works were grouped into sections, each section having its title written in bold letters on the walls – titles such as "Mockery of German Womanhood", "Vilification of the German Heroes of the World War", "Destruction of the Last Vestige of Race Consciousness", "Complete Madness" and so on. Displayed on the walls next to the pictures were texts taken from the artists' manifestos or written by critics and others, for example, Meier-Graefe and Wieland Herzfelde, to name two, who were pilloried along with the pictures. The captions gave the name of the artist, the title of the work, the year of composition, the provenance (the museum of origin) and the purchase price. Stating the price paid for a work made a fairly trivial point, though one which is not lost on us even today, because it is a sobering thought: a work of art, whose utilitarian value is realized – if at all – only through gradual familiarity, is put on display together with a statement of its money value, which at once hits the eye as something 'real' and hence nearly always appears out of place. The small exhibition catalogue, which provided a commentary together with quotations from Hitler's speeches, juxtaposed reproductions of modern works of art – much in the manner of Schultze-Naumburg – with reproductions of works by mental patients taken from the Prinzhorn Collection. A two-fold defamation – 'outrageous', one feels, but only at first sight: artists and mental patients are always kept on the periphery of bourgeois society, and both are put beyond the pale here, the exclusion of the one being used as the justification for excluding the other. Hans Prinzhorn's ironic comment made in 1922 is still apt, though hardly commensurate with this degree of aggression: "The conclusion that because this or that painter paints like this or that mental patient he himself is therefore mentally deranged is no more convincing or profound than the conclusion that because Pechstein, Heckel and others make wooden figures like those made by negroes in the Cameroons they themselves are therefore negroes from the Cameroons."[19]

If the visual impression created by the crowded hanging worked *against* the pictures, it must also be said that the organizers, by showing them under inflammatory headings, with documents and commentaries displayed next to them and slogans painted on the walls, were working *with* them. The aim was not – as in a museum –

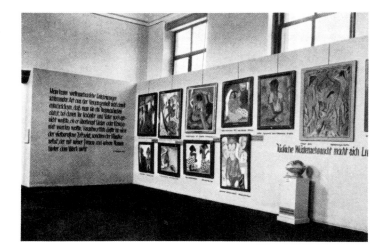

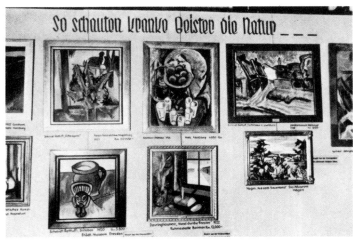

to encourage the viewer to concentrate on the picture and, through its mediation, on himself: the aim went beyond the pictures, which were used merely as 'evidence' in the service of a higher ideological end. The traditional, more or less static presentation employed in the conventional exhibition was replaced by a dynamic approach. Texts and pictures were crowded together indiscriminately for emotional effect in order to arouse disgust and indignation which, together with the judgements contained in the texts, would generate satisfaction at the demise of this kind of art and enthusiasm for the 'revolutionary' new beginning and the new political scene. If the presentation and commentaries were effective and carried conviction – as is attested by contemporaries – then this was due not only to the exploitation of unconscious anxieties and resentments, but also to the telling manner in which all this was done. Fascist propaganda, it seems, was riding on the crest of a wave. What was being employed here was a dynamic form of exhibiting like that which El Lissitzky had demonstrated at the 'Pressa' in Cologne in 1928 or the Hygiene Exhibition of 1930 in Dresden. In fact it was employed in such a careless and slovenly fashion that Lissitzky's positive mode of argumentation clearly acquired an undertone of mockery and contempt without losing its strong emotional impetus. But the message was quite different: the stirring vision of the future was replaced by the ritual of the pillory, a settling of accounts with the past. The fact that Fascism was borrowing its opponents' aesthetic need not have struck the organizers as any more inconsistent than the use of Expressionist or Constructivist styles in the posters advertising the exhibition: the hierarchy of the arts had no place for posters and exhibition design anyway – these belonged to graphics, which were to be seen here in their most up-to-date form and, moreover, employed in the right cause. Naturally it was obvious that Fascism could not escape from the dialectic of art as visualized communication. Just as on Savonarola's funeral pyre the works of art were piled up "in the finest order to delight the eye" and the whole ceremony took on the character of a politico-religious *Gesamtkunstwerk*, so the performance which was put on in the name of 'Degenerate Art' resulted in a twofold 'triumph' of art: first, the products of modern art had rarely been taken so seriously, and secondly, the mode of presentation ensured that they were viewed in a highly charged politico-aesthetic ambience. The public reception of the exhibition not only confirmed the force of the message, but vindicated the manner in which it was conveyed: with more than 20,000 visitors a day – on Sunday 2 August 1937 there are said to have been almost 36,000 – any exhibition is almost at the limit of its capacity to function properly.[20]

4. The Mastering of Anxiety

Even as the exhibition was touring the Reich, preparations were in train to dispose of the works at a profit. A commission was set up, charged with selecting from the stock deposited in Berlin and the items included in the exhibition those works which appeared suitable for sale by auction in Switzerland. The auction took place in

Fig. 11 "Giving vent to Jewish longings for the desert", was the comment on the pictures by the 'Brücke' painters

Fig. 12 "This was how diseased minds saw nature" – polemic against the works of the Expressionists (here: Schmidt-Rottluff, Kirchner, Davringhausen and Nagel)

Lucerne in 1939 and was attended by collectors, museum directors, art dealers and reporters from all over the western world – in an atmosphere of "high excitement", according to one Dutch newspaper.[21] After the auction various party functionaries – notably Göring – helped themselves, leaving a residue of 1,004 oil paintings and 3,825 watercolours. Franz Hoffmann, an official in Goebbels' Ministry, suggested to him that these should be symbolically burnt, adding: "I am prepared to deliver a suitably peppered funeral oration."[22] Goebbels hesitated at first, but eventually agreed, and on 20 March 1939, in the yard of the Berlin Fire Brigade in the Köpernickerstrasse, the "unsaleable stock" was burnt – or so we are unanimously informed by the relevant literature, starting with Paul Ortwin Rave's book published in 1949. Today, however, there are good reasons for doubting the truth of the story, and as for another burning of pictures which was reported to have taken place in occupied Paris in 1945, it now seems to be proven that this never happened.[23] The crucial point about such stories of a great *auto da fe*,[24] of blazing pyres and pictures going up in flames before a "rabid mob", is not just the question of what really happened, but the fact that we wanted to believe them – and still do. In the history of bourgeois culture the myth of the funeral pyre – "proscription by demonstration" as Martin Warnke puts it – embodies the ultimate in pathos and implacability that one can imagine as part of a 'purge' – the use of destruction to prevent debate. This myth panders to our desire to think of Fascism as the ultimate barbarity and so to distance ourselves from it. We are more fascinated by this terrifying image of Fascism than by contemplating, as we must, the inflammatory propaganda techniques employed by the Nazis and the real anxieties and needs they played upon, and by acknowledging that we are dealing here not only with traditions of exclusiveness, but also with political continuities.

The crass stupidity with which the operation 'Degenerate Art' was finally carried out and the almost unbelievable degree of unpleasantly small-minded denunciation and bureaucratic pettifogging that went with it are features peculiar to German Fascism. No such spectacular propaganda operations were mounted in Fascist Italy or Spain. Of course one can explain this away by pointing out that Mussolini was originally a journalist and Franco a professional officer, while Hitler always felt himself to be an artist. Trite though this explanation may sound, it is certainly not without a grain of truth, yet it is equally certain that it would be mistaken and facile to answer the question so simplistically.

As an exercise in power politics the operation 'Degenerate Art' was aimed at the mass following of Fascism, but as an idea it was worked out and finally put into effect by a handful of artists, art critics, teachers und academics – in other words, members of the educated middle class who were endowed with a sense of their mission, gifted with bureaucratic precision and spurred on by a constantly erupting hatred. This is yet another example of the bourgeois evading the claims of his own culture – though this time better organized and more committed than ever before – denying, excluding and annihilating thinking to rid himself of the disturbing elements in his own culture; the bourgeois who thinks that when once 'art for the people' is established he will never again be exposed to the sting of bourgeois culture, which consists in the fact that what is supposed to be meant for everyone is only ever enjoyed by the few.

5. Bourgeois Anxiety and Fascist Order

When one reads the documents relating to the operation, as collected by Joseph Wulf – the decrees, minutes, lists, letters, denunciations, etc. – one is overcome by a feeling of revulsion, an oppressive sense of complicity in collective self-deception. Coming up against the perpetrators in this way, one cannot help feeling that the whole thing was a gigantic misunderstanding, an atrocious mistake in which art was confused with life and treated with deadly seriousness.

Even in the use of language one discerns a pathological mixture of anxiety and desire, an aggressive urge to go up to the pictures and destroy them with words – though the pictures are not the only targets, nor words the only means. "Was there ever any filth, any form of indecency, especially in cultural life, in which at least one

20 H. Brenner, *op. cit.*, p. 109
21 Franz Roh, *op. cit.*, p. 56
22 H. Brenner, *op. cit.*, p. 110
23 Eckhart Klessmann, 'Barlach in der Barbarei', *Frankfurter Allgemeine Zeitung*, 13/12/1983, literary supplement.
24 Franz Roh, *op. cit.*, p. 53

Jew was not involved? Upon making a careful incision into a tumour of this kind one discovered a little Jewboy, like a maggot in the decomposing body, often quite blinded by the sudden exposure to the light" (Hitler, *Mein Kampf*, 1940, p.61). "Among the pictures submitted I have observed a number of works which actually lead one to assume that certain people's eyes show them things differently from the way they really are. In other words, there really are men who see today's Germans simply as degenerate cretins and who perceive – or as they would doubtless say 'experience' – the meadows as blue, the sky as green, the clouds as sulphurous yellow, and so on. I do not want to enter into an argument as to whether or not these people actually do see and perceive things in this way, but in the name of the German people I wish to prohibit such unfortunates, who clearly suffer from defective vision, from trying to foist the products of their faulty observation on to their fellow men as though they were realities, or indeed from dishing them up as 'art'. No, there are only two possibilities. Either these so-called 'artists' really do see things in this way and so believe in what they are representing – if so one would have to investigate whether their eye defects have arisen by mechanical means or through heredity: in the former case these unfortunate people are profoundly to be pitied; in the latter it would be a matter of great concern for the Reich Ministry of the Interior, which would then have to consider ways of putting a stop to the further transmission of such appalling defects of vision – or perhaps, on the other hand, they themselves do not believe in the reality of such impressions, but have other reasons for inflicting this humbug on the nation, in which case it would constitute an offence falling within the area of the criminal law..." (Hitler, speech on the opening of the 'Haus der Deutschen Kunst', Munich, 1937).[25] Eyewitnesses report that while delivering this speech Hitler actually frothed at the mouth, and even his supporters were alarmed to observe the Führer's mounting aggression and the intemperateness of his attacks. And one member of the audience must have had his eyes opened: Max Beckmann, who had been dismissed from his teaching post in Frankfurt as early as 1933 and was represented by several works in the exhibition of 'degenerate' art, finally realized that the bell was tolling for him, and on the day after the opening he went into exile with his wife.

This enforced reckoning with modern art took place, not at the exhibition 'Degenerate Art', but at the first exhibition of the officially approved 'New German Art' to mark the opening of its newly built palace. As one can see, the image of the enemy is more vivid than what one tries – or does not try – to set against it. This was a way of fomenting further rage and anxiety, and so here once again the *Führer* showed himself to be the true 'leader' in succumbing to anxiety and striking the first blow. And no doubt this was his role: the tendency, which is always present in bourgeois society, to refuse to acknowledge contradictions, to put them beyond the pale and – should they find expression in culture – to understand them not as signals, but as realities – this tendency found in Hitler a figure on to which it could project itself, one who demonstrated the proper way to react, who shared the general urge discernible in many individuals, transformed it into an idea, widened it into a 'movement' and made it a central plank of his policy, a policy which in the end turned words into reality.

One may describe the force of the emotions aroused against the pictures and the deadly earnest and utter humourlessness with which their destruction was pursued to its logical conclusion as "the expectorations of gross inferiority"[26] or as "totally irrational"; one may even believe that such descriptions capture the essence of Fascism. Perhaps they do, but naturally this is *also* an act of exclusion and dismissal, which leaves the reality of Fascism – in the sense of a reality which is still potent today – entirely untouched.

"Whatever one wishes to destroy one must not only know, but have felt, if one is to do the job properly", writes Walter Benjamin,[27] which brings us up against the age-old question that arises whenever 'iconoclasm' erupts: What is it about pictures that occasions anxiety? What was it about these pictures?

First of all, it was not of course the pictures themselves. Had they been so dangerous the Fascists could not have afforded to show them: it was what was behind them, in the form of content and attitude. It was the element of life, transformed, aesthetically fractured, but also suspended, which was effective in the

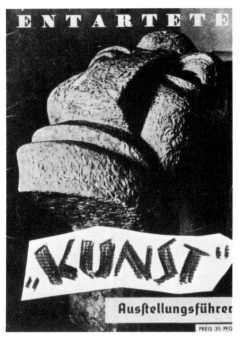

Fig. 13 Cover of the exhibition catalogue 'Degenerate Art', with Otto Freundlich's (subsequently destroyed) sculpture *The New Man*, 1912

25 Quoted from the guide to the exhibition *Entartete Kunst*, Munich, 1937
26 Berthold Hinz, *Die Malerei im deutschen Faschismus*, Munich, 1974, p. 9
27 Walter Benjamin, 'Ein Jakobiner von heute', *Angelus novus* (Ausgewählte Schriften 2, Frankfurt, 1966, p. 449)

pictures, an element which can become a highly personal challenge – as Rilke's formula has it: "You must change your life". What art has to offer is the initiation of reflection or a dialogue about history and the present and about man's place in them. It is ultimately the chance of freedom, freedom which resides in our perceiving the whole cultural spectrum as an arena in which we can move freely – or walk away. What this means for art is that it is taken seriously as something which has value, as a product of artifice, but at the same time as something whose usefulness may come to an end (which naturally does not imply the abolition of art, but is an indication of the ultimate point that might be reached in our dealings with art). If the traditional bourgeois misapprehension, to which the organizers of the exhibition 'Degenerate Art' subscribed, sees in Futurism, Expressionism, Cubism, etc. nothing but deformation, destruction and degeneracy, then the prejudice of academic artistic convention has won. The pathos of modern art, which involves constantly starting out again from scratch, is not just the expression of loss, anxiety and derangement, but also of revolt, a plea for the restitution of life, which it seeks to enforce, at least symbolically on the plane of imagery, by way of a new aesthetic. For the pressure to innovate, which permeates modern art, should never be understood simply as fashion, as the result of a consumption-orientated aesthetic, but as the artist's insistence on his freedom to demolish 'worn-out' forms and win back truth. When one realizes how few of the over two million visitors to the exhibition guessed what was on offer and how most of them missed it and were bound to miss it – especially in that kind of presentation – it becomes clear that the notion of "the people settling accounts with its culture" was only a pretence: in reality it was an attempt – by the bourgeois – to fight off the ultimate consequence of bourgeois culture – the anxiety generated by incomprehension, by the uncomprehended. The personal element in art causes

Artists shown in the exhibition 'Degenerate Art'

Jankel Adler	Otto Freundlich	Ernst Ludwig Kirchner	Emil Nolde
Alexander Archipenko	Xaver Fuhr	Paul Klee	Otto Pankok
Ernst Barlach	Robert Genin	Cäsar Klein	Max Pechstein
Rudolf Bauer	Ludwig Gies	Paul Kleinschmidt	Max Peiffer-Watenphul
Philipp Bauknecht	Werner Gilles	Oskar Kokoschka	Pablo Picasso
Otto Baum	Otto Gleichmann	Otto Lange	Hans Purrmann
Willi Baumeister	Rudolf Großmann	Wilhelm Lehmbruck	Max Rauh
Herbert Bayer	George Grosz	El Lissitzky	Hans Richter
Max Beckmann	Hans Grundig	Oskar Lüthy	Emy Röder
Rudolf Belling	Richard Haizmann	Franz Marc	Christian Rohlfs
Paul Bindel	Guido Hebert	Gerhard Marcks	Fritz Schaefler
Max Burchartz	Erich Heckel	Ewald Mataré	Edwin Scharff
Fritz Burger-Mühlfeldt	Wilhelm Heckrott	Ludwig Meidner	Oskar Schlemmer
Paul Camemisch	Heister	Moritz Melzer	Rudolf Schlichter
Heinrich Campendonk	Oswald Herzog	Jean Metzinger	Karl Schmidt-Rottluff
Karl Caspar	Werner Heuser	Minztrick	Werner Scholz
Marc Chagall	Heinrich Hoerle	Constantine von Mitschke-	Lothar Schreyer
Lovis Corinth	Bernhard Hoetger	Collande	Otto Schubert
Heinrich Maria Davring-	Karl Hofer	Laszlo Moholy-Nagy	Kurt Schwitters
hausen	Eugen Hoffmann	Margarethe Moll	Leo Segall
Walter Dexel	Otto Hofmann	Oskar Moll	Friedrich Skade
Diesener	Johannes Itten	Johannes Molzahn	Fritz Stuckenberg
Otto Dix	Franz Jansen	Piet Mondrian	Paul Thalheimer
Christof Drexel	Alexej Jawlensky	Georg Muche	Johannes Tietz
Johannes Driesch	Eric Johanson	Otto Mueller	Arnold Topp
Max Ernst	Hans-Jürgen Kallmann	Erich Nagel	Christoph Voll
Hans Feibusch	Wassily Kandinsky	Heinrich Nauen	William Wauer
Lyonel Feininger	Robert Katz	Ernst Wilhelm Nay	Gert Wollheim
Conrad Felixmüller	Ida Kerkovius	Karl Niestrath	

anxiety because it challenges us to assume personal responsibility. The element of life has to be constantly reclaimed. The 'playful maziness of art', its vagaries and contradictions, make it impossible for art – or culture in general – to confer some great all-embracing meaning upon life. None of these are 'particular' problems of bourgeois culture – the age-old problems always remain new – but it is Fascist to believe that the contradictions inherent in art can be eliminated once and for all, so that a foundation can be laid for a true culture which would have what Hitler called "eternal value", and that we can act in accordance with this belief. The barometer reads stormy, so we break the glass. The delicate balance of contradictions in the superstructure of bourgeois society is suspended; part of it is put out of action, discarded, and the remaining part claims to be 'the whole'.

In Martin Scorsese's film *Taxidriver* (1975) a man sets out on his own solitary course of Fascism. Combining in himself the roles of the leader and the led, he turns himself into a fighting machine, carries out 'mopping-up operations', frees the 'white woman' – and at the end he is back where he started, in the filth and loneliness of the city and the emptiness of his own life.

There is a short, sharp lesson to be learnt: Fascism is not only not a 'solution'; it is not even the 'alternative' system. It is the system itself – or that part of it which has to do with the destruction of life. After every Fascist phase things go on as before – for all but the dead.

Further literature on the subject:

Reinhard Merker, *Die bildenden Künste im National-sozialismus*, Cologne, 1983

Hans Platschek, 'Kunst in Uniform' in *id.*, *Über die Dummheit in der Malerei*, Frankfurt, 1984

Martin Warnke (ed.), *Bildersturm. Die Zerstörung des Kunstwerks*, Munich, 1973/Frankfurt, 1977

Jens Malte Fischer, 'Entartete Kunst'. Zur Geschichte eines Begriffs', *Merkur. Deutsche Zeitschrift für europäisches Denken*, XXXVIII/3 (April 1984), pp. 346-52

Klaus Theweleit, *Männerphantasien*, vol. 1: *Frauen, Fluten, Körper, Geschichte*; vol. 2: *Männerkörper. Zur Psychoanalyse des weissen Terrors*, Hamburg, 1980

Irit Rogoff

Representations of Politics: Critics, Pessimists, Radicals

"Beware Art!" proclaims one of Klaus Staeck's posters (1982; fig. 1), maintaining a century-long German belief that art not only performs a substantive social function, but also has a constant, alert and responsive audience.

When looking at what could constitute a tradition of politically engaged and reflective art in Germany throughout the twentieth century we are made aware that its conceptualization has to be expanded beyond those images which are direct political representations into the far wider categories of images of cultural pessimism, social criticism and radical gestures. The following attempts to look at artistic representations of politics beyond the sphere of direct, strategic responses to momentous events and moments of historical disjuncture. This attempt locates art within a radically expanded understanding of crisis as a continuous phenomenon and accommodates responses to it which stem from both action and inaction. Such an analysis necessitates advancing a typology of crisis which ranges beyond causality and in which political, economic, cultural and ideological aspects are taken into account. Similarly central to such an analysis is a discussion of the time in which the narrative is located and its identification with what have traditionally been seen as progressive or regressive tendencies. It emerges that any examination of political representations – or of representations of politics – must scrutinize the links between visionary and decisive reactions to crisis and that of an artistic avant-garde as a constant progression. Similarly, the indirect response to crisis, both in its inactivity and its inability to accommodate change, needs to be examined in relation to what have been labelled regressive tendencies manifested by reflections of the past.

This discussion revolves around works which constitute a discursive as opposed to an iconographic tradition and in which the role of the artist, his moral and social responsibility and his accountability have traditionally played a very major part. The range and diversity of this continuing discourse are strongly in evidence on both sides of the aesthetic divide limited to neither auratic (works possessing an 'aura' deriving from their uniqueness) painting nor reproduced images. Only a critical

Fig. 1 Klaus Staeck, *"Beware Art!"*, 1982

model which attempts to locate some of the main spheres of representations of politics can begin to order this vast array of political rhetoric, strategies and taboos and attempt a recognition of their political significance. The tendency has been to present overtly political art as a limited form of both aesthetic and political norm codification and as the regulating of practices on which there is total agreement. These norms within German art of the twentieth century have been located primarily in the images deriving from the First World War, the short-lived Revolution which followed it, the art of the Weimar years and some strands of artistic production between 1967 and 1974/5. The fascination with such identifiable phenomena has been described by John Willett: "The Modern Movement in the arts, under the influence of democratic social concepts and a new internationalism, was able to bloom into a civilization with a coherence and a seeming logic about it that have scarcely been matched since. Just for a few years, arts of the European avant-guard began to have what cultural pessimists, whether of the right or the left, normally accuse them of lacking: an audience, a function, a unity, a vital core."[1] What is being celebrated here are the correlations between style, content and political stances which provide the foundations for the traditional alliance between artistic and political radicalism.[2] But the cultural project we have to explore goes beyond these boundaries, and if its artistic products were not always directly and overtly political, then it is partially because what some political movements demanded was precisely a 'cultural' product. The discursive space which these varied manifestations inhabit is delineated by the crisis of Modernism at the turn of the century on the one hand and that of post-Modernism, located approximately between 1968 and 1973, on the other. The period between the two has traditionally been perceived as the long, golden summer of Modernism. Despite two world wars, holocausts and genocides, successive bouts of totalitarianism, racism and cynicism this period is nevertheless perceived in terms of its overall dynamic as a constant progression tinged with a peculiar brand of optimism and logical positivism. It is not only the exclusive Modernist myth concerning the lineage of successive, interlinked avant-garde groups moving towards a formal goal that needs to be challenged but also its accompanying claims for the autonomy of pictoral modes and discursive practices, both innovatory and traditional. This entails a widening of the parameters of identifiable political representations beyond the narrow confines of the manifestations of pictorial ideologies labelled as progressive or regressive.

The use of critical models dealing with an analysis of the nature of crisis in both of its above-mentioned manifestations can help us gain access to a recognition of a wider diversity of artistic response. This expanded concept of crisis can best be investigated on four simultaneous levels:

Economically, crisis has embraced both industrialization – with its ensuant demographic/class transitions – and de-industrialization with its barring of individuals from partaking in the common enterprise.

Politically, periods of crisis can be defined as the breakdown of the consensus of public debates which locate the issues preoccupying dominant elements of society.

Ideologically, we are faced in both cases with the absence of an overall vocabulary which in turn is a reflection of the absence of classical models for the future.

Culturally, crisis involves the need to recognize the advent of change and its concomitant diversity of unknown factors.[3]

Whilst periods of crisis breed "A great variety of morbid symptoms"[4] they also bring to the fore attempts to interrogate critically the deep irrationalism and loss of reason which have gripped society. Such discourses, with their unlimited speculation and invention, cannot be simply categorized as progressive and regressive according to the forms they adopt or the cultural models they espouse. Only an ever-increasing awareness of the conditions of artisitic production, individual formulations and an analysis of reception can hope to broaden these categories. In each case our insights into these manifestations are guided by an appreciation of the role assumed by the artist and thereby the ability to locate his audience and assess their political response or lack of response. Be they Corinth's chauvinistic cultural heroism, Kollwitz's formulation of a new proto-modernistic language, Beuys's shamanistic healer or Kiefer's demystification of public myths and historical taboos, they all arise out of the attempt to locate the individual within the public discourse and they

1 John Willett, *The New Sobriety – Art and Politics in the Weimar Period*, London, 1978, p. 13
2 Renato Poggioli, *The Theory of the Avant-Guard*, Cambridge, Mass., 1968, pp. 11-12
3 This model for the analysis of crisis is taken from a discussion between Stuart Hall and Umberto Ecco on *Voices* (Ch. 4, I+V), 5 May 1985
4 "The Crisis consists precisely in the fact that the old is dying and the new cannot be born; in this interregnum a great variety of morbid symptons appears." Antonio Gramsci, *Prison Notebooks*. Quoted by Benjamin H. D. Buchloh, 'Figures of Authority, Ciphers of Regression', *Modernism and Modernity: the Vancouver Conference Papers*, Halifax, Nova Scotia, 1983

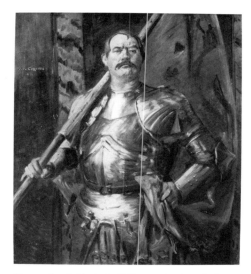

Fig. 2 Lovis Corinth, *Self-portrait as Standard Bearer*, 1911

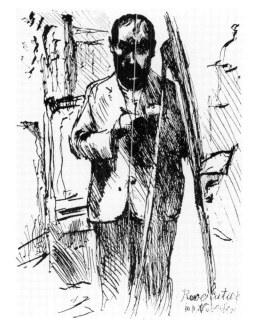

Fig. 3 Lovis Corinth, *Self-portrait*, s.l.r., "Revolution 10. November", 1918

are all guaranteed a polemical response. Alongside these we are faced in German art throughout the century with an overriding need to come to terms with the past. This ranges from investigations of cultural history aimed at establishing a lineage of artistic authenticity to a tracing of the process of growing social awareness and finally to attempts to encode the experience of post-war Germany in terms of disjunctures and continuities. No political understanding of this art can be complete without an investigation of the varied concepts of historical time, reference and progression which abound within the works.

Cultural Pessimism

Cultural Pessimism ranges from the thought of Nietzsche and the speculation on the end of ideology in the rise of order to the varied manifestations of *völkisch* thought and their dire political consequences. This is as wide a discursive terrain as one could expect from so severe a reaction to a belated crisis of Modernism as that experienced by Germany at the end of the nineteenth century. The centrality of both schools of thought to actual artistic ideology and the dire consequences of partial readings of both within the phenomenon of National Socialism necessitate that we today make sharp distinctions between them. The true nature of Nietzsche's thought which was perverted by several generations of cultural pessimists had little to do with the concept of nationhood. The radical importance and departure in his thought and the basis for the later interpretations by cultural pessimists can be located in his concern with whether universally valid values and a meaningful life are at all possible within a godless world; and secondly, in his impassioned scorn for those who simply take for granted the validity of any particular set of values which happen to have the sanction of their religion, class or society.[5] Nietzsche's inherent scepticism creates real and important links with contemporary deconstructive thought and as such could be far more profitably brought to bear on an analysis of the work of Joseph Beuys and Anselm Kiefer than on that of turn-of-the-century artists who were motivated by cultural pessimism.[6] It is the popular interpretation of these thoughts combined with a partial understanding of his celebration of creativity by *völkisch* sentiments that actually forged the links with the realm of pictorial imagery.

Julius Langbehn, whose enormously popular *Rembrandt as Educator* can be directly related to the work of such painters as Lovis Corinth and Wilhelm Trübner, was one of the most prominent of the *völkisch* thinkers to attempt these links.[7] In his masterly study of the ideologists of *völkisch* beliefs Fritz Stern has characterised the book thus: "The rejection of modernity and of the rational scientific tradition which he identified with it, was the passive element of the book. However incoherent its expression, it was dominated by a consistent aspiration towards a form of primitivism, which after the destruction of existing society aimed at the release of man's elemental passions and the creation of a new Germanic society based on art, genius and power."[8] Langbehn's work was motivated by a hatred of all natural science and constituted an attack on intellectual and emotional objectivity which he wished to replace with subjectivity, the recognition of psychic factors in the history of peoples and the yearning for mystery and religion. Socially he condemned the newly powerful urban bourgeoisie as rootless and alienated from *volkstümlichkeit* (the pure and inherent spirituality of the German people). The only solution he could find to this desolation perpetuated by the crisis of Modernism was that the age of art would replace the age of science, technology and urban industrialization – since art was the highest good of society and had a sublimity and timelessness which no other human pursuit possessed. At this point in the argument Langbehn evoked the trinity of Schopenhauer, Nietzsche and Wagner and their so-called formulations of a "Germanic ideology of art" which he invests with great healing properties. A new form of populist (*völkisch*) art would bridge the gaps created by the emergence of an artifical nation state and its attempts at modernization. What Langbehn was proposing was to emphasize the regenerative national role to be played by the artist: "Bismarck had provided the externals of unification but a secret Emperor, a great artist hero would have to furnish and deepen internal unity."[9] Seen within the context of such cultural ideologies, Corinth's *Self-portrait as Standard-bearer* (1911; fig. 2) assumes a

5 See Chapter on 'The Death of God and Revolution' in Walter Kaufmann, *Nietzsche; Philosopher, Psychologist, Antichrist*, 3rd ed., Princeton, NY, 1968

6 See Christopher Norris's discussion of Nietzsche in *Deconstruction – Theory and Practice*, London, 1982, Ch. 4, pp. 56-7

7 Julius Langbehn, *Rembrandt als Erzieher*. Originally published anonymously, it went into 44 editions when first published by the Hirschfeld Verlag in Leipzig in 1891. Between then and the late 1930s it went through repeated bouts of popularity.

8 Fritz Stern, *The Politics of Cultural Despair*, Berkely and Los Angeles, 1961, p. 118.

9 *ibid.*, p. 133

new significance as a manifestation of the active politics of cultural pessimism. This image, one of the many featuring armour goes beyond the combined characteristics of theatricality and megalomania.[10] It makes a bid for action within the realm of *Kunstpolitik* which is Langsbehn's choice of a regime dominated by the pursuit of art and spirituality and which Corinth himself discusses at length in his autobiographical writings.[11] This image of the power of the artist is enhanced by a wide array of historical references designed to lend it an aura of cultural legitimacy. These range from an allusion to Rembrandt's painting of the *Standard-bearer* to the medieval German heritage nostalgically evoked by much of *völkisch* writing. Nor can the entire enterprise be contained within an exclusive categorization of regressive historicism in view of other aspects of the painter's cultural practices, such as his affiliation with the progressive secessionist movement, and so on. Nietzsche's formulation of the "Will to Power" had greatly reduced the dichotomy and furthered a binary relationship between such opposites as the empirical and the true self. These would combine as the manifestations of the same basic drive affecting a reconciliation between nature and culture. In this painting the will to power combines social necessity with personal compulsion and the bid for an active role for the artist. This becomes all the more evident when compared to a slightly later work of Corinth's, *Self-portrait, Revolution, 10 November 1918* (fig. 3), in which the artist depicts himself as being overtaken by political realities in which he has no decisive role to play. He is on the verge of a new world which he cannot perceive and he has lost his mediating role. These widely differing representations of historical moments which are couched in terms of both the past and the present bring us to the seminal question of whether experiments with traditional forms and modes are necessarily regressive, reactionary and dominated by a nostalgia for second-hand historical experience.[12] This view, which is applied to both early and late twentieth-century painting, robs such images of any contemporary political significance and relegates their political practices to bourgeois exercises in regressive escapism. Yet the actual time explored in these images is a future-past; a clear manifestation of culture in crisis in which there is a total absence of classical models for an understanding of the future. It is therefore not a specific, identifiable historical time but rather an assessment of the present and prediction of a future in terms of the past. None of these arguments is aimed at an attempt to reinstate or even re-evaluate *völkisch* imagery but is rather presented as one of the examples of an art inspired by cultural pessimism and which has a potent political significance. The odious affiliations which such art has gained in the aftermath of the National Socialist dictatorship and the Second World War have turned these images into taboos which have in turn been dismissed for their reactionary and unoriginal pictorial language.

An entirely different visual language, radical, experimental and exploratory, is pioneered by Joseph Beuys, and yet it too comes out of a deep cultural and political crisis, it too propagates an inherent state of freedom from bourgeois social and economic strictures and it too experiments with investigations of a future past. Similarly, Beuys's work also focuses on the centrality of art to both experience and regenerative change. "Every human being is an artist who from his state of freedom, the position of freedom that he experiences first hand, learns to determine the other positions in the total art work of the future social order."[13] Despite its future orientation, Beuys's work contains a strong element of the exploration of the past via a subliminal imagery in which past and present merge and in which autobiographical experience and national myth are circuitously linked. Beuys substitutes a symbolic language for the politically motivated codification of norms discussed earlier. In a speech he gave marking the opening of an exhibition of his drawings in 1974 Beuys advanced the following observation: "these drawings show innumerable aspects of a theme. But I have tried to arrange those which are backward-looking concepts such as shamanistic concepts or evocations of the concept of the dispensation of wisdom through a PYTHONESSA or through a PYTHIA. So that all these constellations, these backward-looking concepts, are arranged in a purely formal fashion, so that they can awaken interest in the current consciousness of the spectator and should be of interest as a total vision of man in time, not only for the present, not only looking backwards, i.e. viewing history, anthropologically, but also offering solutions for the future and offering them in the sense of opening up the problems."[14]

10 Corinth had an active interest in the theatre, had designed scenery and costumes for production's of *Salome* and of *Peleas et Melisande* in 1903. He also owned a theatrical suit of armour which served as a prop. For details see Henning Rischbieter, *Bühne und Bildende Kunst im XX. Jahrhundert – Maler und Bildhauer arbeiten für das Theater*, Hanover, 1968, plates 32, 33a, 33b

11 Lovis Corinth, *Selbstbiographie*, Leipzig, 1926, pp. 89-123

12 "The aesthetic attraction of these eclectic painting practices (Contemporary European Representation) originates in a nostalgia for that moment in the past when the painting modes to which they refer had historical authenticity. But the spectre of derivativeness hovers over every contemporary attempt to resurrect figuration, representation and the traditional modes of production. This is not so much because they actually derive from particular precedents but because their attempt to re-establish forlorn aesthetic positions immediately situates them in historical secondariness. This is the price of instant acclaim achieved by affirming the status quo under the guise of innovation. The primary function of such cultural re-representations is the confirmation of the hieratics of ideological domination." B. H. B. Buchloh, see note 4

13 Joseph Beuys, 'I am searching for field character' in *Art into Society – Society into Art*, ICA, London, 1974, p. 48

14 Joseph Beuys, speech made at Haus Lange Museum, Krefeld, on 19 May 1974. Reprinted in ICA catalogue, *op. cit.*, p. 52

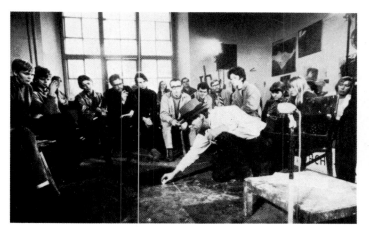

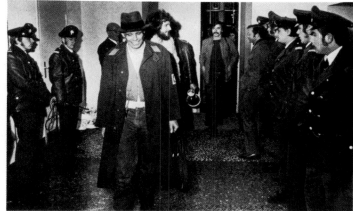

Fig. 4 Joseph Beuys and members of the German Students' Party in Düsseldorf, 1967

Fig. 5 The police in the Academy of Arts in Düsseldorf, following the dismissal of Beuys from his teaching post, October 1972

Within this construct there seems to be eternal time, historical time and personal time, none of which forms a linear progression and all of which are interconnected. Beuys too locates his art within the sphere of a specific crisis and has noted its characteristics in terms remarkably similar to those of the previously mentioned social critics and political theorists. In a text written for the 'Documenta 7' in 1982 and entitled *An Appeal for an Alternative* aimed at "all people belonging to the European cultural sphere and civilization", he addresses himself to the main issues of the crisis. Relations between East and West (communism and capitalism), North and South (the regulation of production, consumption practices and wealth), says Beuys, must be re-examined in terms of co-existence and cooperation and the degree to which the social organism which we maintain interacts with the natural order; "whether these have led to the appearances of a healthy existence or have made humanity sick, inflicted wounds on it, brought disaster over it and today are putting its survival in jeopady".[15]

The symptoms of this crisis are typified by Beuys as:

A. The military threat – atomic destruction, intensification of the arms race and the wastage of energy and raw materials.

B. The ecological crisis – the destruction of our fundamental natural foundations, unscrupulously exploited by both Eastern and Western capitalism.

C. The economic crisis – mass unemployment, strikes and industrial unrest. Subsidized over-production leading to monstrous quantities of surplus foods being destroyed concurrently with uncontrollable famine in other areas of the world. Business practices and the discrimination of a market economy which undermine the real needs of humanity and subvert the laws of democracy.

D. The crisis of consciousness and meaning – "Most people feel helplessly at the mercy of their surrounding conditions. In the destructive processes they are subjected to, in the impenetrable tangle of political and economic power, in the distractions and diversion gambits of a cheap entertainment industry, they cannot find any existential meaning."[16]

E. The causes of the crisis – these can be located in the roles accorded to money and the state, i.e. power belongs to those in whose hands lies the money and/or the state.

F. The way out: a conceptual revolution, a corrective rethinking of the concepts which would embrace the individual's opportunity to develop his faculties freely and put them to use for a meaningful purpose. The individual's desire to be an equal among equals without privilege. The individual's willingness to give solidarity and claim solidarity in a social organism determined by mutual help. Finally a change in the function of money so that production will be determined by the needs of the consumer rather than by profit. This analysis of cultural crisis ends with "anyone who envisages this picture of the evolutionary alternative has a clear understanding of the social sculpture which man as an artist is helping to build."[17]

This manifesto of comprehensive cultural criticism is the culmination of twenty-five years of direct action through such projects as the formation of the German Students' Party of 1967 and its takeover of the Düsseldorf Academy in a bid against authoritarianism and pro creativity (figs. 4, 5). Not since the days of Dada had art

15 Joseph Beuys, 'An Appeal for an Alternative', in catalogue *Documenta 7*, Vol. 2, Cassel, 1982, pp. 370-371
16 *ibid.*
17 *ibid.*

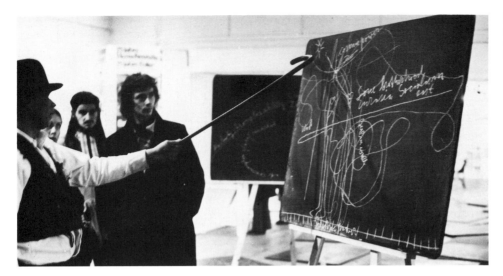

Fig. 6 The environment *Directional forces* with one hundred blackboards came out of discussions during the 'Art for Society' exhibition in London 1974

so totally reflected every facet of the cultural and economic polemic around it. The reception of this action by the authorities of the Düsseldorf Academy helps locate its motivation and define its audience: "With the help of the German Students' Party which he founded, Joseph Beuys has influenced the development of reforms at our academy in a disquieting fashion ... meetings degenerate into pseudo-political waffle and provocative criticism which exalts to unrealistic demands and betrays open hostility to parliamentary criticism."[18] A careful reading of this statement reveals all the traditional ailments; the upholding of authority and order, the blind faith in parliamentarism without accepting the need constantly to safeguard it, and the demise of a relevant ideology. These too have wide-ranging historical links with the recent political past and provide a historical framework for this uprising. Official reaction such as this continued, and yet through a series of actions and happenings during the 1960s and 1970s and via the platforms of the ecologically oriented Green Party which he co-founded, Beuys has remained at the centre of several generations' cultural engagement with politics. This unique position and his continuing impact as an artist have been due primarily to three factors: his non-Modernism, his personalization of political rhetoric and his codification of historical taboos within an organic language. By non-Modernism, I mean a refraining from invention in favour of exploring anew the common personal and national experience. Images made up of fat, blood, bodily excretions, felt, everyday objects and references to nature are an account of birth, fear, death and destruction as well as exploring a codification for those experiences within the national past.[19] *Directional Forces* (fig. 6) is simultaneously an account of the educational process experienced by a youth in the 1930s and 1940s with their combined emphasis on knowledge, romantic nature and the physical valorization of the body as well as reflections on authority and romantic delusions. The predominance of such images as wounds creates an aura of indirect awareness around the work which accrues to both a personal mythology of birth and a far wider sense of unease. These organic and nature-related deliberations on the continuity and disjuncture of human experience are never specific and rarely located in identifiable historical moments. Their polemical significance is, however, extended via a series of conceptual texts, which do not resolve the ambiguities inherent in the works but locate them within the context of the artist's own critical discourse.

The painter Anselm Kiefer, a student of Beuys, has in turn evolved a much more direct imagery for reflecting on the mythological aspects of recent political culture. Like Beuys, he makes no obvious value judgements, preferring to explore instead the entire realm of the reception of and fascination with Fascist culture and its use of earlier Germanic traditions. By not taking a clear and censorious position but admitting to an obsessive need, Kiefer has laid himself open to repeated criticism of guilt by association. The taboos which Beuys illuminated in a subliminal fashion have been brought into the limelight by Kiefer, with the distancing of another generation. Repeated references to the Nibelungen legends, to Wagnerian cultural constructs,

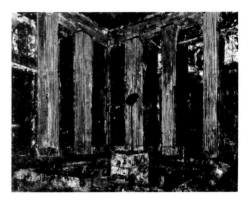

Fig. 7 Anselm Kiefer, *To the Unknown Painter*, 1982

18 Joseph Beuys and F. W. Heubach reporting on the response to their demands in 'die ideale akademie', *Interfunktionen*, II, Cologne, Feb. 1969, pp. 22-24

19 Ann Seymour's excellent introduction to the catalogue *Joseph Beuys – Drawings*, London, 1983, explores in some detail Beuys's continuing researches into the organic, sensual, emotive and mythological properties of the materials he uses.

Fig. 8 Anselm Kiefer, *Quaternity*, 1973

Fig. 9 Anselm Kiefer,
Iconoclastic Controversy, 1976/77

to the Edda, to well-known battlefields and to Fascist architecture have created an aura of enigma around Kiefer's work. Paintings such as *To the Unknown Painter* (1982; fig. 7), with their re-creations of the burnt and empty halls of Fascist neo-classical architecture, pose uneasy questions. According to Rudi Fuchs, however, it would be ridiculous to accuse Kiefer of liking this type of architecture. One must therefore assume that he uses architecture of this type because as a cultural taboo it would give the painting the unavoidable brutality of form and confrontational aspects of meaning which Kiefer likes his work to have. The painting thus becomes a dramatic form of extremism.[20] But painting strategies are only a part of this particularly austere form of cultural pessimism. Other aspects of it have to do with the exploration of the contamination of culture, not through history painting – for Kiefer is a supremely contemporary artist – but through an investigation of the reception of history and a concern with those parts of the present which are lost to it. Kiefer's constant and conceptual process of examination of the uses of the past is not aimed at containing or overriding change. Rather, these discussions promote a close analogy to a definition of 'tradition' proposed by Raymond Williams in which "tradition is an active and continuous selection and reselection which even at the latest point in time is always a set of specific choices."[21] Many of Kiefer's images, particularly those of landscape and of legend, are about the loss of innocence; of nature, culture and mythology. Simultaneously they are about the painter's fascination with this loss and attempts to work out whether the artist, who is no longer a cultural hero, can do any more than simply take part in this process of reception. In Kiefer's own words, "You cannot just paint a landscape after tanks have passed through it, you have to do something with it."[22] Both the space and the time in which Kiefer locates his works are of primary importance to their understanding. The device of locating so much of his work in the confines of an attic has been identified by Walter Grasskamp as an aspect of his artistic strategy, a combination of the traditional nineteenth-century theme of the marginalization of art and the perception of the attic space as one to which the discarded dregs of cultural history are relegated. There is also a traditional unease around the motif of the attic which is somehow outside the sphere of norms associated with the life of the house/home.[23] In *Quaternity* (1973; fig. 8) three little fires entitled 'Father', 'Son' and 'Holy Spirit' burn determinedly in the wooden attic and have been joined by a forest snake entitled 'Satan' – the physical/sensual in juxtaposition with the cultural/mythical, both relegated to that subconscious space of the attic where they burn "without consuming".[24] But the attic is also a distancing device; high above the house, lost in time and offering a different and wider perspective on the landscape, it plays a part in that dialogue between the past and the present which is at the core of all Kiefer's work. Within this interplay the ancient past (Christian and pagan), Parsifal and the Nibelungen legends are reconstituted according to Wagnerian interpretations of the nineteenth century. In *Iconoclastic Controversy* (1977; fig. 9) the eighth-century dispute between iconoclasts

20 Rudi Fuchs in *Anselm Kiefer*, exhib. cat., Städtische Kunsthalle, Düsseldorf, 1984, see p. 8
21 Raymond Williams, 'Literature and Society, In memory of Lucien Goldman', *Problems in Materialism and Culture*, London, 1980, p. 16
22 Quoted by Rudi Fuchs, see note 20, p. 8
23 Walter Grasskamp in *Ursprung und Vision – Neue Deutsche Malerei*, Berlin, 1984, pp. 33–35
24 See Jürgen Harten's notes on the paintings in the above-mentioned Düsseldorf catalogue (note 20), particularly pp. 22 and 24

and image-worshippers in Byzantium (the historical protagonists are named in the painting) is filtered through a theatre of war in which tanks do battle. These in turn are located on a palette-shaped plateau of scorched earth which focuses on art as a source of energy.[25] Politics here are the agent of the symbolic occupation which both nature and culture have been forced to undergo. Within this occupation the ancient past, the recent past and the efforts at deliverance made by the artist/palette are all synthesized within a non-historical time. Kiefer's explorations investigate the nature of banality and of the mythos which have become his generation's pornography of evil. His subjects are not only what happened during the Fascist era and its exploitation of previous cultures but also the reception and readings of this process for the present time.

Fig. 10 Käthe Kollwitz, *The Ploughmen*, 1906

Social Criticism – an Evolving Language for Modern Realities

Images of social criticism have a direct relationship to objective crisis and to its ensuing transitions couched in overt social and political terms. This is a tradition that is particularly celebrated within readings of German art for the clarity of its political and ideological allegiances and for the critical and satirical language which it evolved in the work of such artists as Grosz, Hubbuch, Schlichter, and so on. As a modern tradition it has its roots in the turn-of-the-century work of Hans Baluschek and Käthe Kollwitz which documented transformations in production, manufacturing and living conditions. Most of the images within this tradition also have in common the medium of reproduced images – prints, photomontages, etchings, posters and occasionally drawings. Here we have a distancing from the auratic tradition which anchors itself in culture and nature, and a preference for an artistic practice which is urban and mechanical and defines itself as a commodity within the new market-dominated economic structures. Encompassed in the work of Käthe Kollwitz we see a transition from the language of a crisis of Modernism (the inability to embrace change and the diversity of possibilities inherent therein) to the language of the modern world and its realities which acknowledges these changes. The first important series of etchings which Kollwitz executed were *The Weavers' Revolt* of 1898 and *The Peasants' War* of 1903 (figs. 10, 11). These are illustrations for an historically based narrative which had been repeated through cultural readings in plays and poetry. It is conceived in terms of dramatic narrative in which moments of tension and tragedy are depicted. Even formally the artist strikes an accord between the form of land-oriented labour and the great horizontal lines which sweep across the image. During the first decade of the century and spurred on by the observation of urban growth and industrialization in Berlin, where she moved to, Kollwitz began to formulate a new visual language. This reflected changing socio-political realities and advanced the articulation of visual codes for the new urban proletariat as opposed to the previously dominant peasants. It also meant abandoning the narrative of an heroic struggle for one of a state of being. With great sympathy and humanity, Kollwitz created countless images of hunger, homelessness, unemployment and the dehumanization of urban squalor. In images such as *Dive* we find her expounding on traditional differentiations between authenticity and artificiality within urban life. Unlike the peasants of the earlier series who declared their allegiance to the earth and were rooted in it, these city-dwellers are entirely rootless. Their moral code is one of cynicism and self-benefit, they do not form any sort of community and have little cultural autonomy. The only sphere of Kollwitz's work where either solidarity or authenticity is to be found is her depictions of mothers with children and her expressions of humane political solidarity.

In fact, Kollwitz's politics came into their own when they could be described in terms of the negation of human suffering. Such well-known images as the funeral of the murdered Spartacist leaders, Luxemburg and Liebknecht, or the anti-war posters of the 1920s attest to her ability to create succinct and abbreviated images of great communicative power.[26] Nevertheless, it was her vocabulary of anonymous, rootless individuals within an urban setting that helped to forge a language of modern social criticism with an emphasis on alienation and being, rather than narrative and action.

Fig. 11 Käthe Kollwitz, *Julen*, 1909

25 *ibid.*, p. 88
26 For a range of these images, see M. C. and H. A. Klein, *Käthe Kollwitz – Life in Art*, New York, 1975

Fig. 12 George Grosz, *Metropolis*, 1916/17

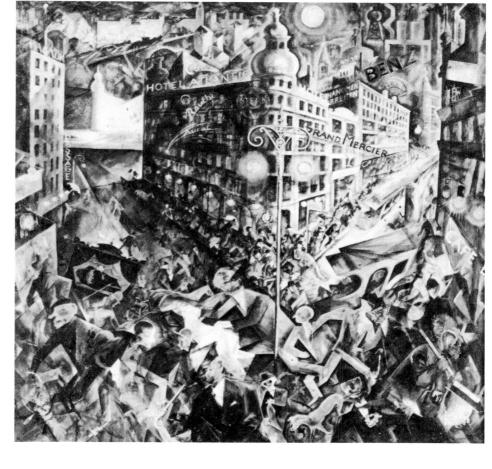

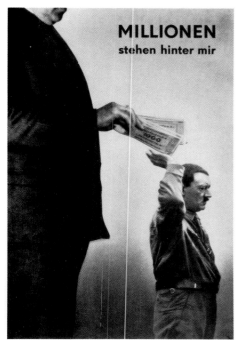

Fig. 13 John Heartfield,
Millions Stand Behind Me, 1932

27 For an analysis of the impact of the war on
Grosz's complex view of the city see Beth
Irwin Lewis, *George Grosz – Art and Politics in
the Weimar Republic*, Madison, 1971, chapter 2:
"In Anti-War Berlin", pp. 41–61.

All these works were made with an awareness of their disseminative potential as propaganda or popular forms of criticism which would reach a wider audience than that of the secessionist exhibitions or the liberal galleries. Kollwitz, however, did not take up criticism of specific institutions, policies or persons representing them. Her first steps in differentiating between traditional concepts of labour and contemporary ones of a proletariat were given greater precision and a new and independent formal idiom by artists like George Grosz. In works such as *Metropolis* (1916; fig. 12) urban society is condensed into a visual code and a cast of characters which represent social and economic hierarchies. Representations of sound, movement, energy and artificiality borrowed from the Futurists and a radically new understanding of space influenced by Cubism are here combined to render the distilled experience of city existence.[27] But Grosz, whose involvement with Berlin Dada also meant a visual articulation of political rhetoric, began in the creation of specific figures which represented the newly formed classes and their economic interdependence. These figures remain on the whole anonymous stereotypes which are representative of the various interests at play within modern German society, viewed satirically and without specificity. Another Berlin artist, John Heartfield, who pioneered photomontage, took on those tasks during the 1920s and 1930s. Coming out of the post-war Berlin Dada movement, his images evolved from anarchic obfuscation to images of the utmost simplicity, conceived as direct political weapons. Everything in Heartfield's work is geared towards getting the message across: images, lettering and an ironic bid for attention through shock or humour. They are, in their strange way, somewhat optimistic images since they set up the premise that political decline can only go so far, that by exaggerating the political representations from a critical point of view, it may be possible to halt them. Heartfield's images of the rise of Fascism are particularly valuable since they examine the phenomenon from every conceivable aspect: financial, propagandistic, via the manipulation of existing institutions and of popular sentiments. In *Millions Stand Behind Me* (1932; fig. 13) Heartfield manages in one image to examine two myths involving political support; one concerning Hitler as a popular leader chosen by and representing only the interests of

the people and the other of the supposed distance between big business and politics. The huge anonymous figure which towers over the leader handing him money but not seeking acknowledgement combines with a line of contemporary political propaganda used by the National Socialists to expose the cynicism and duplicity of both parties with succinct irony. Photomontages such as *Have no fear, he is a Vegetarian* (1936; fig. 14), showing Hitler in an apron about to slaughter the French Cockerell, are ruthless in their expression and break completely new ground with regard to the role of the artist. Here he becomes a documenter; using commonly available information and images, he creates works which have documentary credibility and belong automatically to the realm of mass circulation. The media afford the artist authenticity and he redefines himself in terms of a distributor of information strategies. Heartfield's alliance with the *AIZ* (Worker's Illustrated Paper) from 1929 onwards combined the process of basic political informing through pictures with critical and subversive efforts.[28] This emphasis on information and common fears as opposed to shared utopias distinguishes these efforts from the great poster project of 1918/19. Here a group of radical artists such as Heinz Fuchs, Max Pechstein and Heinrich Richter–Berlin used such avant-garde devices as simplification of form, non-linear perspective and geometric faceting in order to intensify the expression of a spontaneous reaction to events. The emphasis on formal visions of a social Utopia, however, served, to a large degree, to distance these works from their intended audience.[29] In the 1960s and 1970s Klaus Staeck was to take up this form of criticism with the making and distributing of posters which echoed Heartfield's original photomontages. The fact that in the meantime Fascism had succeeded and failed at a horrible cost, gave Staeck's political pronouncements a valuable liberal pedigree. Using Heartfield's image in the context of a West German election in which there is democratic choice, Staeck presented a conservative politican with apron and knife and caption *Castrate all Libertines!* (1972). The implications of this message were then superimposed on the horror of the consequences of the previous message. Heartfield's legacy of abbreviations is continued, as are his use of photographs and typography, in such succinct images as *Thoughts are Free* (1979; fig. 15). However, no alternative political ideology is propagated; Staeck remains within the realm of criticizing existing social states, political actions and institutions by ridicule, empathy or fear.

NUR KEINE ANGST – ER IST VEGETARIER

Fig. 14 John Heartfield, *"Have no fear, he is a Vegetarian"*, 1936

Radial Gestures – "La Prise de la Parole"

Of all the German artists working today, Joseph Beuys and Hans Haacke are the two who can most clearly be seen as striking radical gestures. Beuys's change through a revolution of awareness, his political actions and his part in a number of emergent parties have already been discussed. Haacke, on the other hand, is a true 'Commando of Culture', making series of images that depend not on the formulation of subliminal myth but on precise investigative journalism.

His well-known series of works such as those on the Guggenheim Museum in New York and the real estate interests of some of its governors, the ones on the making of Dr. Peter Ludwig into Germany's foremost art collector and enterpreneur (*The Chocolate Master*, 1981) or those exposing Mobil Oil's political sabotage activities within a democratic electoral system, have gained scandalous acclaim throughout the art world. But they are very much more than carefully crafted images made up of a great concentration of precise information of a less than flattering nature to those being documented. They are a political bid for art to speak for itself and to take over areas in the understanding of the immediate past which have traditionally been submissive to authority. These bids for action and autonomous power, for taking hold of the entire 'utterance' of the art world, have taken two forms: the investigation of existing structures and the creation of alternative ones. In 1971 Dieter Hacker opened the '7. Produzentengalerie' in Berlin with the aim of taking over the entire process of art: making, exhibiting, disseminating and commenting. The ideas behind this enterprise were not only a pragmatic attempt at the control of both process and market but also at redressing the trend away from the wide-scale alienation from reality which Hacker saw as dominating the world of art.

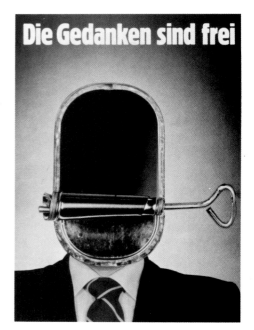

Die Gedanken sind frei

Fig. 15 Klaus Staeck, *"Thoughts are Free"*, 1979

28 Friedrich Pfäfflin, 'Heartfield's Photomontages of 1930-1938' in *John Heartfield* (ed. Wieland Herzfelde), New York, 1958, pp. 27-29
29 Ida Katherine Rigby, 'German Expressionist Political Posters 1918-1919: Art and Politics, A Failed Alliance', *Art Journal*, Spring 1984, pp. 33-39

Fig. 17 Hans Haacke, *Manet-Project '74*, 1974

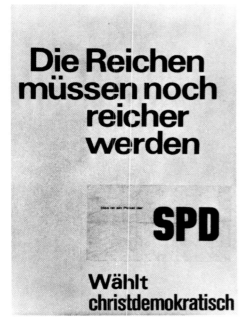

Fig. 16 Klaus Staeck, *"The Rich Must Get Richer, Vote CDU"*, 1972

"The idea behind this was to hold exhibitions in my gallery that were not possible anywhere else, i.e. in other galleries, museums and art centres. I had in mind in particular theme-exhibitions for which material is especially collected and created . . . In the course of this work a certain exhibition catalogue has evolved, one situated between two poles. One of these poles is represented by the critical involvement with my own conditions of work: the state of avant-garde art, its limitations, its possibilities and those cultural institutions connected with it (i.e. 'Our National Gallery'). The other pole is the search for alternatives (i.e. 'Volkskunst'-Popular Art)".[30] At a later stage the transient quality of this project eventually brought about the production of accompanying newspapers which could be sold separately, had greater permanence and served as textual expansions on the material exposed. All of these actions aimed not only at allowing the artist a greater degree of autonomy but also at the return to an artistic 'public sphere' in which the devisions between broad masses and educated classes promoted by the institutions of education and culture are no longer perpetuated. However the temporaneous quality of the individual projects and the necessity of having numerous similar enterprises in order to have an effect have limited the impact of Hacker's gallery activity.

Hans Haacke on the other hand, like Staeck in his election poster actions *Die Reichen müssen reicher werden* (fig. 16), opts for taking direct action and amalgamating it into art via series of condensed images. Staeck speaks of "exposing what has presented" and of using irony as a means to puncture the acridity and dullness that characterize most political discussions.[31] He emphasizes the necessity to rise above traditional art if one is to effect change, to achieve an exact identification of his audience and then to reach it; Staeck's *The Rich Must Get Richer, Vote CDU* posters did in fact sell over 300,000 copies and became an intrinsic part of the regional election compaign of Heidelberg in 1972 via censorship motions and legal battles. Haacke's work, on the other hand, combines a personalized relationship between viewer and work which is instigated in the first instance through the physical proximity which is necessitated by the wealth of information which must be read. Secondly, it engages the spectator's aesthetics on a level rarely used in art: the juxtaposition of objective information and subjective decorative modes. Haacke's descriptions of his working methods on the *Chocolate Master* series; research on the mutual effect of newsprint lettering and photographs on the colours and kitsch decorations of gaudy chocolate boxes, make us aware of the unique position his work holds between auratic and reproduced art.[32]

Haacke sets up confrontations with both the political and economic bodies he is investigating but predominantly with the interrelations between the two. In a work such as the *Manet Project '74* (fig. 17), first commissioned and then rejected by the Wallraf Richartz Museum in Cologne, Haacke traces the pattern of sales and owner-

30 ICA catalogue, *op.cit.*, pp. 71–76.
31 Klaus Staeck in ICA catalogue, see note 13.
32 Hans Haacke, 'Working Methods' in *Hans Haacke*, Tate Gallery, London, 1984

ship of a single work by Manet, the *Asparagus Still Life* of 1880. As the painting changes hands its price increases and so does its status; it enters the art market as a commodity, becomes a coveted symbol of its native French culture, emmigrates to America and finally returns to Germany as the triumphant and vastly expensive symbol of cultural continuity. Through a detailed survey of the different buyers and collectors and of the ever increasing prices they paid Haacke gives us an incisive analysis of the evolution of the art world and its growing institutionalisation and links with capitalist sponsorship as opposed to private patronage. The factual data unearthed by the artist is then transmuted into a potent and abbreviated visual language. In his own words Haacke creates parallels between form and content, a contemporary codification for a visual ideology which he describes thus: "The Reagan piece *Oil Painting – Hommage à Marcel Broodthaers* (fig. 18) dealt with a highly charged political situation; the deployment of a new generation of nuclear missiles with potentially horrendous consequences. In the subtext you find allusions to the myths of power and art and to the waves of conservative painting engulfing 'Documenta 7', the exhibition for which the piece was made."[33] The work is devided into an oil painting of President Reagan in a haughty and defiant pose and executed in a manner reminiscent of *Juste Milieu* painting with their licked and sealed surfaces. This is installed opposite a blown-up photograph of a German anti-nuclear demonstration; popular sentiments and the representations of power engage in direct conflict within one work. Furthermore they are distanced by a plush red carpet and a red velvet rope, the trappings of both officialdom and high culture. As is often the case in Haacke's work different media represent differing political forces and simultaneously maintain an open discourse between the work and the context in which it is exhibited.

　　Haacke is truly an artist who lives out in his work what Gramsci has described as "the dilemma of the optimism of will, the pessimism of the intellect."[34] The pessimism of the intellect is a result of Haacke's clear knowledge of the present state of affairs, the interplay of money, power and authority within both culture and politics. The very desire to investigate these structures, confront them, make and display works exposing them, manifests an optimism of the will in which are included possibilities for change and the belief that if only these were exposed they would be rejected. As a radical artist, Haacke works constantly against the forces which are structuring the field via economic realities, political practices and cultural institutions. He maintains that century-long belief in the potential power, immediacy and response provoked by politically engaged art.

33 Jeanne Siegel, 'Leon Golub/Hans Haacke: What Makes Art Political', *Arts Magazine*, New York, April 1984, p. 110.

34 For full documentation of these projects see Hans Haacke, *Nach allen Regeln der Kunst*, Berlin, Neue Gesellschaft für Bildende Kunst, 1984

Walter Grasskamp

Images of Space

*"Images of space are the dreams of society. Wherever the hieroglyph of any such image can be deciphered, what emerges is the basis of social reality."*Siegfried Kracauer

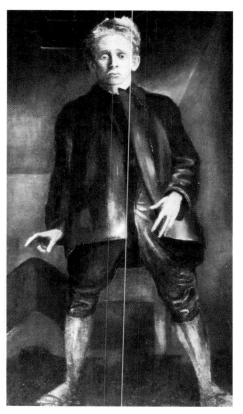

Fig. 1 Gert Wollheim,
Self-portrait in the Garret, 1924

Attic and Cellar

The beholder of Gert Wollheim's *Self-portrait in the Garret* (fig. 1) of 1924 feels like a visitor, almost an intruder. He stands at the feet of the painter, who, irresolute, appears to be blocking the way into his refuge. It is as though the viewer had the last rungs of a steep ladder still to climb. What could the visitor be seeking here – and what could the painter have found? A room which like no other can symbolize his position in society as the marginal one that it is. Since the early nineteenth century, artists and writers have chosen the garret as the symbol of their position on the edge of society.[1] It stands as a place of exile for poverty in Carl Spitzweg's painting, *The Poor Poet* (1839; fig. 2) as in Honoré Daumier's wood engraving, *The Poet in the Attic* (1842; fig. 3) and in the illustration, *A Poor Poet in a Garret* (fig. 4) which Jean Michel Moreau the Younger may well have completed before the end of the eighteenth century.[2] The draughty, cheerless and confined attic room, a remote adjunct to the rest of the house, was the setting where the launching of artistic genius, its missionary zeal and its demise were played out, on the edge of bourgeois society. Tommaso Minardi's *Self-portrait of the Artist in his Garret* (1807; fig. 5) might define one pole of this critical situation – the self-aware, even defiant acknowledgement of the miserable conditions of artistic independence. Henry Wallis's painting *The Death of Chatterton* (1856; fig. 6) marks the opposite pole, the collapse of a poet's existence, having never found public acclaim and ending in suicide, in the very room from which fame should have helped to lead him.[3]

Wollheim's room under the roof is not a place of poverty. Wollheim was the son and later, the heir of a wealthy German Jewish family. The room is reduced to its contours and devoid of any narrative props. This lends all the more weight to the pose which the painter adopts *vis-à-vis* his onlooker. The monumentalising worm's eye view of the painter towering against the confines of the room heralds a new self-awareness, the missionary sense of a generation of artists which, at the beginning of the twentieth century, had left the periphery of bourgeois society, and as the avant-garde, set itself *at its head*. It is the same room in which Ernst Ludwig Kirchner gathers the painters of 'Die Brücke' (p. 426, fig. 1) in 1925 – it is no longer the most wretched room of the house, rather it is the highest; no longer the caricature of the artist's studio, but the Olympia of the tenement block. It had become the place from which Charles Baudelaire wished to capture the image of the city *(Paysage)*, akin to that *Attic Studio* of Rudolf Schlichter's (1920; fig. 7) which confronts science and art with an urban reality.

But does Wollheim really look like a 'man of triumph' as he elevates himself here upon the pedestal of perspectival illusion? In his gesture of muted defensiveness, the scepticism of his expression, is there not also the impression of an unwelcome interruption caused by the intruding observer? Does he not seem as if caught out, knowing that the open skylight offers him no opportunity for flight? Today it is no longer possible to look at this painting without having at least some sense of the fear which, not ten years later, was to dog the lives of all those who had taken to the attic to hide from the investigations of the Fascist Gestapo – Jews and socialists like Wollheim, who were forced from their bourgeois existences to the edge of society in one fell swoop; some of them might have received the uninvited visitors to their attic with the kind of glance that we see anticipated in this self-portrait.

1 Cf. Margret Rothe-Buddensieg, *Spuk im Bürgerhaus. Der Dachboden in der deutschen Prosaliteratur als Negation der gesellschaftlichen Realität*, Kronberg/Taunus, 1974
2 Wolfgang Becker, *Paris und die deutsche Malerei 1750-1840*, Munich, 1971
3 Karlheinz Nowald, *Carl Gustav Carus "Malerstube im Mondschein"*, Publications of the Kunsthalle, Kiel, vol. 2, 1973

Fig. 2 Carl Spitzweg, *The Poor Poet*, 1839

Fig. 3 Honoré Daumier, *The Poet in the Attic*, 1842

Fig. 4 Jean Michel Moreau le Jeune, *A Poor Poet in the Garret*

In 1933 Wollheim's friend Karl Schwesig offered his studio as a sanctuary for refugees such as these. On 11 July he was arrested by the SA and tortured in a cellar for three days. The name he gave to his cycle of drawings – *Schlegelkeller* (1937; fig. 8) – is that of this cellar in Düsseldorf. It is more than merely the architectural antipode of the attic room, not the Olympia but the Hell of the tenement landscape, the Fascist version of a peripheral situation. The SA seized Schwesig the socialist and opponent of the regime; his stunted growth inspired their sadism; but it was also Schwesig the *painter* whom they tortured. His pictures were brought from the studio to the torture-chamber in the cellar, not to be destroyed before his eyes, but very much to have him humiliated before *their* eyes. A peripheral existence which had begun and celebrated its triumphs in the attic came to an end in this cellar. And there the history of the garret as a statement of the artist's place would seem to have been closed once and for all.

Fig. 5 Tommasi Minardi, *Self-portrait of the Artist in his Garret*, 1807

In 1972 Jörg Immendorff painted a self-portrait in a garret – but at an ironic distance (fig. 9). It shows him lying on the bare attic floor, where he dreams of becoming a Famous Artist; though he painted it at a time when he had already begun to suspect this dream. Immendorff's attic painting deals not only with the theme of poverty and self-assertion; it expressly denounces the garret as an ivory tower for narcissistic dreams of fame and success. Born in 1945, Immendorff belongs to the generation who, in their opposition to the Vietnam War, came across the traces of a history which could have been their own, had every effort not been made in West Germany to suppress it from the beginning – the history of Germany. Neither the socialist revolutionary culture of the Weimar Republic, nor the Fascists' counter-revolution has suited the historical image of the Federal Republic. The student revolt confronted both memory gaps with an explosive process of coming to

Fig. 6 Henry Wallis, *The Death of Chatterton*, 1856

Fig. 7 Rudolf Schlichter, *Attic Studio*, 1920

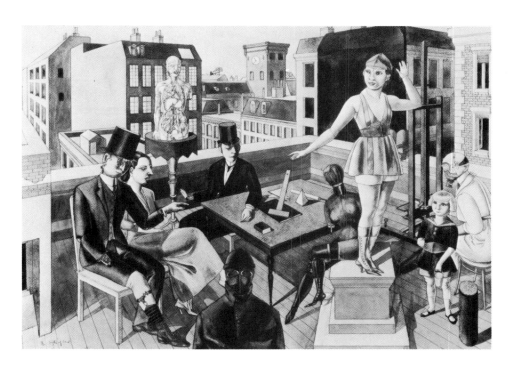

terms with the past, which ultimately took on the appearance of the sons' generation sitting in judgement over the fathers' and availing itself of its grandfathers' writings, the rediscovered Weimar classics from Wilhelm Reich to Walter Benjamin, to justify its verdict.[4] From this angle, Immendorff caricatured a stock romantic image of the artist which he himself had once fallen prey to, and which had cost him no little effort to relinquish.[5]

At about the same time as Immendorff was painting his *Self-justification*, Anselm Kiefer was in his own attic studio, beginning to sift through a quite different inheritance of the German Empire. His theme was not the code of the student revolt, not the newly discovered and ubiquitously quoted classic writers of the Weimar Republic. His subject was the nationalistic mythology of the nineteenth century, and this in the recognisable, explicit form into which Fascism had disfigured it. His attic pictures, painted in 1973, stage his attic studio as the place of forbidden memory,

Fig. 8 Karl Schwesig, *Schlegelkeller*, 1937

4 Cf. the essays by Werner Becker and Harry Pross in the present catalogue; also, Odo Marquard's *Abschied vom Prinzipiellen. Philosophische Studien*, Stuttgart, 1981, pp. 4-22

5 Jörg Immendorff, *Hier und jetzt: Das tun, was zu tun ist*, Cologne/New York, 1973

banished tradition.[6] He, too, passed the way to the cellar, but again as the place of a paradoxical memory. He painted the cellar mausoleum planned by the Fascists for German soldiers as the place of another readily repressed memory, that of the extermination of the Jews (*Sulamith*, 1983; fig. 10). The painting corresponds to a charcoal drawing of a *Cellar Vault* (fig. 11), which Werner Heldt completed in about 1930 for his series of *Dream Drawings*. A voluminous chest stands there, its lid open, suggesting a treasure chest and coffin at once, the secret exit into an underground network of escape passages or the entrance to the underworld.

Kiefer's attic, however, is more than simply an architectural and historical place. Wooden beams and boards dominate this room, as though it were meant to represent a civilised version of the forest which is another place of self-discovery in Kiefer's pictures. The painting *Father, Son, Holy Ghost* (1973; cat. 297) completes this cycle. In *Resurrexit* (1973) the stairway to the attic studio rises above a cutting through the forest as though constructed from the wood of the trees cleared beneath it.

Forest and Sea

Kiefer's painting *Man in the Forest* (1971; fig. 12) shows him with a burning branch, standing in an impenetrable part of the forest. To what dark is the torch bringing light, what forest is this where a game is being played with the risk of fire? Is it the medieval hermit's Wilderness, where it is his task to withstand temptation, or the peculiar forest solitude of the German Romantics?[7] Another drawing of Werner Heldt's supplies a clue. *A Dream of War* (c. 1930; fig. 13) shows two people in woodland; of war there is no trace, at best the suggestion of a uniform, and this perceptible only to those looking for some echo of the title in the drawing. The solution to the puzzle is to be found in a book which Elias Canetti worked on from 1925 to 1960, entitled *Masse und Macht*. In the chapter on 'Mass symbols of nations,' we read of the Germans, "The mass symbol of the Germans was the *army*. But the army was more than that; it was *the forest on the march*. Not in any modern nation in the world has the spirit of identification with the forest ['Waldgefühl'] remained so vital as in Germany. The rigidity and parallel lines of the trees, standing upright, their density and number fill the German's heart with deep and mysterious joy. Today he still takes eagerly to the forest inhabited by his forebears, and feels at one with trees. Their neatness and strict separation one from the other, the emphasis on vertical lines, distinguish this from the tropical forest, where creepers grow intertwining in all directions. In the tropical forest one's gaze is lost in its closeness, it is a chaotic unstructured mass, teeming with the most vivid life, and it defies any feeling of order or regular repetition. The forest of the temperate zone has its perceptible rhythm. One's gaze wanders along visible tree-trunks into an ever-identical distance. An individual tree is taller than a human individual and grows on eternally, ever more the warrior. Its steadfastness shares much of the warrior's virtue; in the forest,

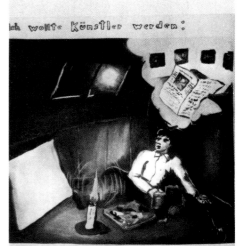

Fig. 9 Jörg Immendorff, *I Wanted to Become an Artist*, 1972. "I dreamed of appearing in the newspaper, of numerous exhibitions, and of course I wanted to do something 'new' in art. My guiding star was egoism."

6 Walter Grasskamp, 'Anselm Kiefer – Der Dachboden', in Christos M. Joachimides (ed.), *Ursprung und Vision. Neue deutsche Malerei*, Berlin, 1984, pp. 32 – 35
7 Jacques le Goff, 'Die Waldwüste im mittelalterlichen Abendland', *Bauwelt*, 28/30 (1981), pp. 1176 - 1184

Fig. 10 Anselm Kiefer, *Sulamith*, 1983
Fig. 11 Werner Heldt, *Cellar Vault*, about 1930

Fig. 12 Anselm Kiefer, *Man in the Forest*, 1971

Fig. 13 Werner Heldt, *A Dream of War*, about 1930

where so many trees of a kind are side by side, the bark that might have appeared like armour when seen in isolation now seems more like the uniforms of a military detachment. For the German, without his being aware of the fact, the army and the forest were melted into one. What others might find bare and desolate about the army, possessed for the German the life and light of the forest. Here he was not afraid; he felt protected, one of them all. The abruptness and straightness of the trees he made a rule for himself. The experience of the boy who felt driven from the close confines of home out to the forest, as he thought, to dream and to be alone, was an anticipation of his admission to the army. In the forest the others were already standing by, loyal, true and upright like he wanted to be, one like the other, because each grew *straight* and was yet quite different in height and girth. The effect of this early romanticism of the forest upon the German should not be underestimated. He took it up in a hundred songs and poems, and the forest that occurred in them was often called 'German'. The Englishman liked to see himself *upon the sea*; the German liked to see himself *in the forest*; a more concise expression of what separated them in their national sensibility would be hard to find."[8]

8 Elias Canetti, *Masse und Macht*, 2 vols, Munich, n. y., vol. 1, p. 190 f.

Fig. 14 Georg Friedrich Kersting, *On Outpost Duty*, 1815

Fig. 15 Georg Friedrich Kersting, *Wreath-Binder*, 1815

Fig. 16 Werner Heldt, *Berlin-by-the-Sea*, 1949
Fig. 17 Rudolf Schlichter, *Deluge*, 1949

The connection of forest and army postulated in Canetti's text is also illustrated in two paintings of 1815 by Georg Friedrich Kersting, in which it is immediately obvious to what manner of war the simile must be confined. His painting *On Outpost Duty* (fig. 14) shows his friends, Theodor Körner, Friesen and Hartmann, on guard duty in some part of a forest which seems to stand for everything there was to defend in this war against Napoleon's France. His *Wreath-Binder* (fig. 15) likewise sits in the midst of a wood, making wreaths for the fallen friends, Körner, Friesen and Hartmann, whose names are carved each *into the bark* of a tree as if death at last had assimilated them to the forest which before they had guarded and defended. The artist's contemporaries could not have failed to see the reminder in these paintings of another forest war, the battle of the Cherusci against the Romans in the Teutoburg Forest. As the *Hermannsschlacht*, Arminius's Battle, it became a Romantic legend, not least because it was so easy to see in the forest the critical, topographical ally for the Teutons' victory. Following victory against Napoleon it was resolved to erect an Arminius Memorial: a metaphor of that victory over France, it was begun in 1838 and dedicated after the next, in 1875.[9] Kiefer has dealt with this legend of *war in the forest* in several of his pictures; notably by incorporating woodcut portraits of those German writers who have made the *Hermannsschlacht* the subject of their work from the eighteenth century on, thus contributing to the growth of the legend (p. 476, fig. 5).

Without doubt that form of war which permitted comparisons between forest and army was already obsolete by the time of Canetti's analysis and Heldt's drawing; Kiefer is right in treating it from a historiographical point of view. The trench as the place where annihilation ceased and of the battle of *matériel* had already become the new symbol of modern warfare to dominate the pictures with which Beckmann, Meidner and Dix worked out their war experience, but it took over from the symbol of the forest on the march only as long as the post-war period remained that: the air-raids of the Second World War, which razed whole cities to the ground, also made the trench redundant as a symbol of war. After the Second World War, painters like Werner Heldt reacted to this change by looking for a different symbol to represent the modern form of war. They found it in *the sea*. Many of Heldt's drawn and painted 'landscapes' of Berlin in ruins bear the title *Berlin-by-the-Sea* (fig. 16); the bomb-devastated city becomes for him in the post-war era a landscape of ruins and of dunes at once. As if an overwhelming flood had destroyed man's architectural handiwork, bombed-out streets and wasteland appear as canals that the sea has eroded in a city not sunken but drowned. For Rudolf Schlichter, too, the ruins of Munich become the set of a *Deluge* (1949; fig. 17). The sea, where Imperial German armament planners thought the future of Europe was to be decided in the war

9 "German national consciousness attempts to base itself in history, in a view of the actual beginnings, but all that it ever finds as such a base is unsophisticated originality. When, proud of its eternal barbarism, it defends itself against the older, happier, more sober West, it seems as if all the great upheavals in German history – the war against Napoleon, Luther's Reformation, Widukind's campaign of resistance against Charlemagne – formed the one Battle of the Giants against Rome, of which Armin, the Cheruscan, was the initiator." Helmuth Plessner, *Die verspätete Nation. Über die politische Verführbarkeit bürgerlichen Geistes*, Frankfurt-on-Main, 1974, p. 64

10 Carl Schmitt, *Land und Meer. Eine weltgeschichtliche Betrachtung*, Cologne, 1981, first publ. 1944. It is worth mentioning that Heldt was not the only German artist to find the sea an alien quantity (one of his drawings of about 1930 bears the title, *il vivait toujours au bord de la mer [on the brink of despair]*). The overall impression is that in twentieth-century German painting, the sea appears as the counterpart of the land, as an external force of nature or as a meditative projection surface, but not as an invitation to travel. Although an exhaustive map of the routes of travel of these artists and where they chose to settle would reveal an astonishing density of population along the coast and on the islands, the subject of the sea never gets beyond the shore. Only the mark of Fascism provokes Beckmann, who remained loyal to the sea theme from the beginning, to paint scenes of *setting out* to sea; Feininger's ships are homeward bound or cruise close to shore as its outposts. Nolde, like Feininger one of the few travellers at sea, paints the sea approaching, not calling away. Behind his low clouds on the horizon one would never presume the alluring faraway places he sought and often found.

against the maritime power of Britain, thus becomes the metaphor of a defeat not fifty years later. But this was a defeat not determined exclusively on land or at sea, but in no small way *in the air.*

If the association of the Flood betokens the interpretation of Germany's defeat as just punishment, then the preparations for and causes of the war remain in the mists of a diffuse, biblical and unhistorical notion of guilt while victory brought about by military means would appear as that of a force of nature. A certain helplessness becomes evident in this line of metaphor that in the image of the *sea vanquishing the land,* takes up the traditional metaphor in which Germany as a land power is shown inundated by England as the victorious naval power. These metaphors are not of the same level of insight as Carl Schmitt's almost contemporary inference from his analysis of the two world wars, which was that the development of aerial warfare had made the traditional military contrast between maritime and land power obsolete at a stroke.[10] Ernst Jünger's *Storms of Steel* were already pointing towards the source of metaphors to come, so that Max Ernst's way was not totally unprepared when, in *Europe after the Rain* (1940/42; cat. 151), he had the sea tumbling from the skies. It was Ernst, too, who discerned in the romantic 'German' forest not his ally, but (and at the right time) his foe: '*What is a forest?* Mixed feelings, as he steps into the forest for the first time; delight and oppressiveness. And what the Romantics called "feeling for nature." The marvellous exhilaration of breathing free in open space, yet the oppression of being imprisoned on all sides by hostile trees; outside and in at once, free and captive. Who will solve the riddle?' is the question in his biographical notes.[11] It is the "hostile trees" that constantly recur in his paintings; a sombre counterpart from which the menacing *Hordes* which he has painted repeatedly are on the verge of escaping. These do not stand for the army of national war, as personified in the forest; this is the latent barbarism which was also part of the romantic image of the forest as an element of the Counter Enlightenment, as it can be identified for instance in *Rübezahl* by Moritz von Schwind (1845/50; fig. 18). In *Die verspätete Nation*, Helmuth Plessner demonstrated how the romantic notions that moulded the way Germany saw itself, including politically, were due to a certain historical dilemma. As there was not the glory of the Enlightenment nor a bourgeois tradition to become the quintessence of a national identity, as they had done in France and England, that identity was simulated by adopting medieval concepts which could also be activated as myths of the Counter Enlightenment. That this counter enlightenment would rise in aggression not only against the nations that had found their national identity in the Enlightenment – England and France – but also against the German representatives of enlightenment, this was the disquieting feeling that Ernst articulated in the image of the forest and the horde before events proved him all too right indeed. In this light, a seemingly naturalistic water-colour like *Valepp (Auf dem Weg zum Schinder*; fig. 19)[12] painted by Christian Schad in 1938, when he and his peers found themselves spiritual, 'inner' émigrés in their own country, becomes more like an accout of the political status quo. The tree in the foreground has been struck by lightning, but more than this, it stands isolated against the panorama of a dense forest which seems to encircle it: it does not take a great leap of the imagination to see this forest as a marching army, albeit one that is closing *in*. The way to the *Schinder* loses its geographical significance and becomes a metaphor for the 'Inner Emigration'.

Fig. 18 Moritz von Schwind, *Rübezahl*, 1845/50

Fig. 19 Christian Schad, *Valepp (On the way to Schinder)*, 1938

The unloved City

In the pictures of Heldt and Schlichter Germany vanquished appears far less as a country freed of Fascism than a country punished. But the setting for the purge of the *Deluge* is the city, not the nation which had begun and prosecuted the war. The city's representative role is no coincidence; it is shown as one of the roots of the evil avenged by the deluge of bombardment. It is not too far-fetched to perceive in these pictures an element of relief that destruction had hit the cities in particular. German writers and artists have always had a fraught relationship with the modern city. The tardiness of German literature in dealing with modern aspects of life in the great cities may well be explained by the fact that Berlin itself had only become a modern

11 Cited in Werner Spies (ed.), *Max Ernst, Retrospektive 1979*, Munich, 1979, p. 123. Also cf. the notes on catalogue nos. 156 & 157 by Ulrich Bischoff in that work.

12 *Auf dem Weg* translates easily as 'on the way'; the *Schinder* the way leads to evidently refers, as Schad would originally have intended, to the name of a mountain. In retrospect it is not without its symbolic portent, the term covering: knocker, skinner, flayer; slave-driver, hangman, extortioner, oppressor, shaver, sweater. . .

metropolis towards the close of the nineteenth century. But artistic reserve toward this motif and its representation persevered into the twentieth. It suggests that this distance in relation to the city was motivated less by a lack of experience than by an opposition to the city as the *incarnation of modernity*. The continuity of this literary opposition which can be followed from Wilhelm Raabe's attempt to make an idyll of the city in the motif of the *Sperlingsgasse* in 1856, through to the work of Rilke and George, who even tried to deny the city its reflection in their poetry.[13] The lateness of German literature in tackling the motif of the city and the long-lasting resistance to this form of life have to be considered if we are to understand why the German painters and other artists who did suddenly turn full-face to the theme at the beginning of the century, were unable to sustain the confrontation for more than a few years. For Käthe Kollwitz the site for class wars is still *in the country* (*The Weavers' Uprising*, 1893/98, or *Peasants' War*, 1903/08), not the city where she lives – not even the Berlin of 1848. Ludwig Meidner projects the panorama of the *Protest March* (1913; fig. 20), the *Fighting at the Barricades* (1913) and the *Street Battles* (1914) as an urban backdrop; but he shows the metropolis if anything as an apocalyptic place; his focus on the subject has not altered his critical and distant stance. Max Beckmann and Ernst Ludwig Kirchner, who took up the challenge after 1910, also reveal an almost sociological interest in the anonymity and alienation of city life. Beckmann significantly chose to introduce the motif of the city into his work with the *Downfall of Messina* (1909). Like Kirchner, what he finds in the social amorphousness and restricted space of the crowded streets is the motif of anonymity; in the figure of the prostitute, that reduction of social relationships to material terms for which she had already stood in nineteenth-century France. In the work of Dix, Grosz, Schlichter and Schad, this scepticism toward the city is given radical form, Grosz even availing himself of the artistic devices of Italian Futurism, not at all an anti-urban art, to express his criticism of the city. In their paintings the city is treated both as the place of extreme political confrontation and even more as the setting of a dissolution of elementary social patterns. If the milling crowds in the streets supply the public image of the blending of a social and political heterogeneity, the sexual subculture becomes the pivot for the more intimate metaphor of the city. Ranging from the sex murderer, a recurrent theme for Grosz and Schlichter, to the fetishim which Schlichter did not stop at simply depicting and the heroes of the sexually unconventional subcultures documented by Schad, their works show the city in the form in which it insinuates itself into apparently intimate relations, transforming and distorting their social grammar. In these versions the metropolis is not a place of urbane liberality, not the historical premise and political location of enlightenment; it is patently the lesser and unpolitical edition of liberality, namely that of libertinage. Later, in Frankfurt, Beckmann paints views of the city that lend the subject a new, unmistakable contour. In these vistas the city appears as if frozen in aspic (*The Synagogue*, 1919, or *The Iron Footbridge*, 1922; fig. 21). At the same time he transposes the conflicts and horrors of society into oppressive interiors, and this enables him to paint a city almost devoid of people. That life is screened off; instead, the city's architectural configurations are moulded into an enigma of stone. None of the painters who took up this subject have portrayed it from a greater distance than Beckmann in these paintings.[14] In them the city appears so hermetic and uncompromisingly alien that Beckmann's late works, esoteric and full of inuendo, seem almost *recherché* in comparison.

Kirchner and Meidner had taken up the city theme independently of him and of each other at about the same time; by the time Beckmann was engaged on these pictures, the other two had already given it up. Kirchner, shattered by the war experience and fearing the possibility of being recalled, had fled to rural Switzerland. Meidner had returned from the war to Berlin, but had given up the theme of his own accord. The separate ways in which Kirchner and Meidner relinquished the motif of the city is reflected in the biographies of those artists who painted its image in the Weimar Republic. The 'banished' Kirchner is echoed by painters like Dix, fleeing in the 'Inner Emigration' to the countryside in body and to landscape in their art. The 'deserter' Meidner finds his counterpart in Rudolf Schlichter. Even before the advent of Fascism, Schlichter had dropped the subject of the city of Berlin from which (like Meidner, but ten years later) he had derived some extreme forms of

13 Cf. Volker Klotz, *Die erzählte Stadt. Ein Sujet als Herausforderung des Romans von Lesage bis Döblin*, Munich, 1969; and Wolfgang Rothe (ed.), *Deutsche Großstadtlyrik vom Naturalismus bis zur Gegenwart*, Stuttgart, 1973

14 Perhaps with the exception of Max Ernst, who lent the subject an archaeological and mineralogical slant, presenting his cities as if upon a tray of nature that is about to proliferate over the whole terrain.

expression. As Meidner before him had turned to the Jewish themes of his origins, Schlichter returned to another religious tradition, Catholicism, and moved to the cathedral city of Rottenburg before settling in the Catholic counterpart of Protestant Berlin, Munich. In both artists this change looks most like a sudden shock reaction to their own foolhardiness in having so recklessly entered upon the phenomenon of the city. Like prodigal sons they return from it. Nothing is more striking testimony to the latent reserve towards the city in German painting than the histories of these two artists who for a few years had given the motif its sharpest contours. Certainly Schlichter's *Deluge* is a metaphor for the destruction of the city by war; but it is not too far-fetched to see in it, too, the continuing tradition of scepticism toward the city.

If modern German artists could not celebrate the city as the scene of enlightenment and urban liberty, they could at least have acknowledged it as the prerequisite and breeding-ground for avant-garde art as such. The connection was guessed at (if no more) by the Italian Futurists, and the urban novels of Louis Aragon (*Le Paysan de Paris*, 1926) and André Breton (*Nadia*, 1928) show that the Surrealists knew Paris, the metropolis, not only as an indispensable topographical prerequisite of their art but also as the landscape of their dreams. In the image of the city they affirmed a myth of modernity. Such celebrations of the city are absent in the German avant-garde for a number of reasons apart from those cited above. In the few years before and after the First World War, they had not even the time to reflect upon the German tradition of aversion towards the city, let alone do anything about it; so they simply updated it. They had still less time to recognise the city as the condition for the development and effectiveness of avant-garde art – any reflections of this kind were terminated by the exodus unter the pressure of Fascism, at the latest. Beckmann's last pictures do not even tell the viewer that they were painted in New York.

As it was, Berlin, *the* German city, hardly encouraged the introspective approach. The problems of this incomplete and young city under the cloud of defeat in the Great War and the subsequent political tension, must have so dominated the perception of artists living there that the paradoxes of the city would have made the paradoxes of artistic existence in it seem of minor importance. Even then the withdrawal of Meidner and Schlichter into religion must be regarded in retrospect as a double retreat. They both withdrew from the contradictions that urban life in Berlin bestowed upon them and freed themselves of the microcosmic paradoxicality that marked their positions as artists in such a city. Perhaps it is not by accident that the artists of a group which worked through this reflection at speed and thoroughly to the point of its own dissolution, the Dadaists, came the closest to the subject of the city even in those times. Perhaps one should say especially in those times, for they invented and developed the medium whose own qualities made it capable of matching the self-contradictions and heterogeneity of the urban experience: collage and assemblage. Collages like *Cut with a Cake Knife* by Hannah Höch (1920; fig. 22) or *The City* (fig. 23) by Paul Citroen demonstrate the same kind of qualitative leap forward as the collages of Kurt Schwitters. In comparison to paintings devoted to the city hardly ten years before by August Macke, the distance covered becomes plain. In Macke's paintings, passers-by stand in front of shop-windows; the city is shown in a context which only he manages to render so potent (cat. 47). In Kirchner it appears in this light only peripherally, in Beckmann and Meidner it is completely absent. The context is that of the *sphere of circulation of material goods*, although even Macke sees the subject in a static light. The goods circulating through the city are shown in static display, the window-shoppers contemplating them as they might a still life. These idylls of the urban consumer's world are hardly likely to show the city in its other functions, as the site where these goods are produced; even the transfer point and market is only evident in the shape of the retail shop, whose displays will not perturb any viewer. Not ten years later, in the Dada collages and assemblages, all hell is let loose. Images of merchandise and of the city seem to have crashed in upon them like a shower of meteorites; like some modern lime-twig, Schwitters's assemblages catch the bits of paper, objects and fragments that mould the pattern of experience of city life. Here the image of the city is not imprinted via its social face, but by the particles of traffic in goods and images that circulate within

Fig. 20 Ludwig Meidner, *Protest March*, 1913

Fig. 21 Max Beckmann, *The Iron Footbridge*, 1922

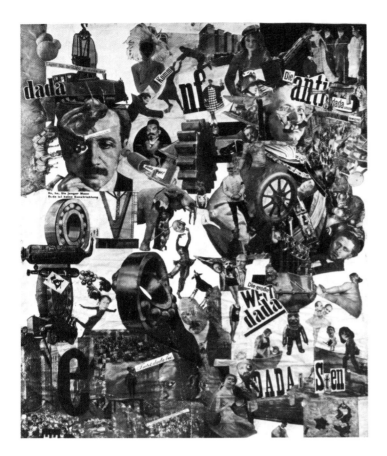

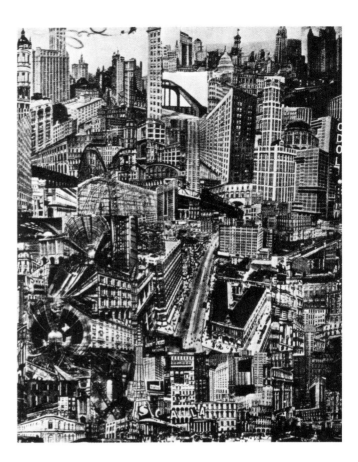

it and are now caught in the fine mesh of Schwitters's collages and assemblages. These are snapshots of the great urban disarray; in them, some of the particles floating erratic and free in urban life come to rest. They stand for the innumerable products of the city as it produces, exhausts and forgets them; the collages and assemblages pick a few of them out, assuring them of contemplation and permanence – qualities which that urban traffic in images and commodities undermines.[15]

A process of abstraction already lies behind the selection of elements to enter these collages; for it is images, photographed, reproduced, short-lived and fast-lived images that the city sets up and circulates, of itself and of its products; not to mention the printed material with which it regulates this traffic. All are caught in the fly-paper trap of these collages and the collages leave no doubt that theirs is the only glue capable of giving them some cohesion. But, like Franz Biberkopf in Döblin's *Berlin Alexanderplatz* (1929), the collagists had to concede defeat when it came to pretending that there was some unified experience called city life. They found refuge from the flood of heterogeneous impressions in a strategy of fixation, remaining in the abstract because aesthetic formulae are the only means left to group that which is no longer capable of consistent shaping into models of experience.

The Closing of a Free Trade Zone

When the city is referred to as a subject of German painting and literature, then, for the period from 1871 to 1933, what is meant is mostly the capital city. It was indeed the greatest challenge, but not the only one. Its few decades as the capital were not enough for Berlin to dominate to the extent that Munich, Stuttgart, Karlsruhe, Dresden, Düsseldorf, Cologne, Hagen, Frankfurt or even Hanover should have forfeited their significance as centres of modern art. On the contrary, in Weimar and Dessau, the Bauhaus put two further provincial cities on a map that would not yield to centralisation upon a single capital. This decentralism was the political and cultural legacy of that ancient collection of petty and not-so-petty states that had been Germany until Bismarck's Empire. It was the basis for a modernist movement which, at the beginning of this century, took off simultaneously in the capital and a

Fig. 22 Hannah Höch, *Cut with a Cake Knife*, 1920
Fig. 23 Paul Citroen, *The City*, n. d.

15 Cf. the essay by Hanne Bergius in this
 catalogue

host of traditional smaller centres, not to mention Munich, still capable of offering the Prussian capital strong Bavarian competition. The connections between these minor and major centres were at least as developed as their common orientation towards Berlin; prior to the First World War and in the Weimar Republic they set their mark on the arts in Germany at all levels. A topography of where artists settled, their travels and visits would suffice to demonstrate this network of widely-distributed, widely-spaced centres; and the itineraries of the more important exhibitions showed again how enmeshed the centres were, even in the case of touring exhibitions originating in Munich or Berlin. Thus it was no coincidence that the Conference of the Union of Progressive International Artists of 1922 should have taken place in Düsseldorf and the participants then have moved on to reconvene at the Constructivists' and Dadaists' Conference at Weimar.[16]

Germany's unique artistic topography becomes evident if one compares it to that of France during this period. For German artists it was a foregone conclusion that they must go to Paris to familiarize themselves with the state of the French avant-garde – a duty most of them attended to, and mostly more than once. A visitor in the opposite direction had to buy an area season ticket if he hoped to acquaint himself even partially with the state of art in Germany. His hosts would be distributed from Hanover to Munich, from Düsseldorf to Dresden, if they did not happen to be commuting between these centres themselves or staying in Prague, Holland, Norway or Russia. Whereas Paris was still acknowledged as the artistic centre of Europe, Germany presented the vista of an 'art landscape', a wide mesh of numerous centres. Now these, too, began to attract foreign artists, initiating a competition between the metropolitan centre that was Paris and the highly varied landscape and art of the art *zone* that was Germany. It was Fascism which tipped the scales in this competition of two unlike quantities to the advantage of Paris.

16 Stephan von Wiese, 'Ein Meilenstein auf dem Weg in den Internationalismus. Die 1. Internationale Kunstausstellung und der Kongreß der Union fortschrittlicher internationaler Künstler 1922 in Düsseldorf', in Ulrich Krempel (ed.), *Am Anfang: Das Junge Rheinland. Zur Kunst- und Zeitgeschichte einer Region 1918-1945*, Düsseldorf, 1985, pp. 50-63

Artists in the Exhibition

Ernst Ludwig Kirchner (cat. 1-17)

Karl Schmidt-Rottluff (cat. 18-21)

Erich Heckel (cat. 22-26)

Otto Mueller (cat. 27-29)

Wassily Kandinsky (cat. 30-36)

Franz Marc (cat. 37-43)

August Macke (cat. 44-47)

Alexej Jawlensky (cat. 48-50)

Paula Modersohn-Becker (cat. 51-56)

Christian Rohlfs (cat. 57-61)

Ernst Barlach (cat. 62-63)

Emil Nolde (cat. 64-73)

Ludwig Meidner (cat. 74-78)

Oskar Kokoschka (cat. 79-85)

Lovis Corinth (cat. 86-97)

Wilhelm Lehmbruck (cat. 98-105)

Max Beckmann (cat. 106-126)

George Grosz (cat. 127-130)

Raoul Hausmann (cat. 131-134)

Hannah Höch (cat. 135-138)

Kurt Schwitters (cat. 139-144)

Max Ernst (cat. 145-157)

Otto Dix (cat. 158-166)

Rudolf Schlichter (cat. 167-168)

Christian Schad (cat. 169-173)

Käthe Kollwitz (cat. 174-175)

Lyonel Feininger (cat. 176-181)

Oskar Schlemmer (cat. 182-188)

Paul Klee (cat. 189-197)

Richard Oelze (cat. 198-202)

Willi Baumeister (cat. 203-206)

Ernst Wilhelm Nay (cat. 207-211)

Wols (cat. 212-217)

Werner Heldt (cat. 218-221)

Hans Uhlmann (cat. 222-224)

Günther Uecker (cat. 225-227)

Heinz Mack (cat. 228-229)

Otto Piene (cat. 230)

Gotthard Graubner (cat. 231-234)

Konrad Klapheck (cat. 235-239)

Joseph Beuys (cat. 240-245)

Gerhard Richter (cat. 246-250)

Sigmar Polke (cat. 251-256)

Blinky Palermo (cat. 257-258)

Georg Baselitz (cat. 259-268)

Eugen Schönebeck (cat. 269-270)

A. R. Penck (cat. 271-277)

K. H. Hödicke (cat. 278-281)

Bernd Koberling (cat. 282-285)

Markus Lüpertz (cat. 286-293)

Jörg Immendorff (cat. 294-296)

Anselm Kiefer (cat. 297-299)

Note on the captions:

The medium is oil on canvas unless otherwise indicated.
Dimensions are given as height preceeding width; sculpture
as height preceeding width preceeding depth.

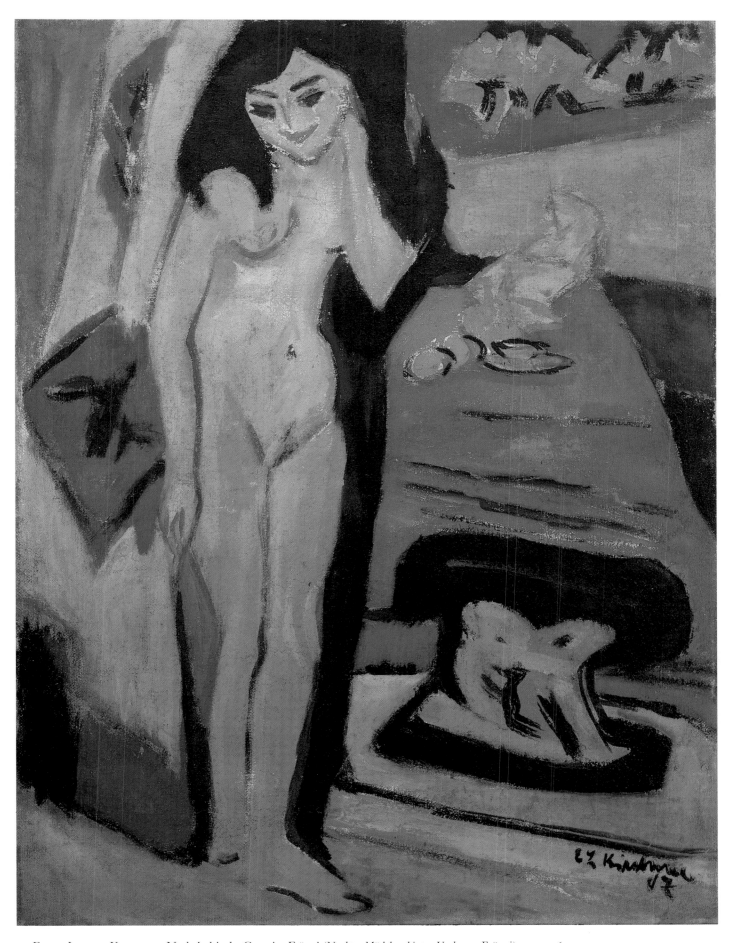

1 ERNST LUDWIG KIRCHNER, Nude behind a Curtain; Fränzi *(Nacktes Mädchen hinter Vorhang; Fränzi)*, 1910-26
120 x 90 cm; Stedelijk Museum, Amsterdam

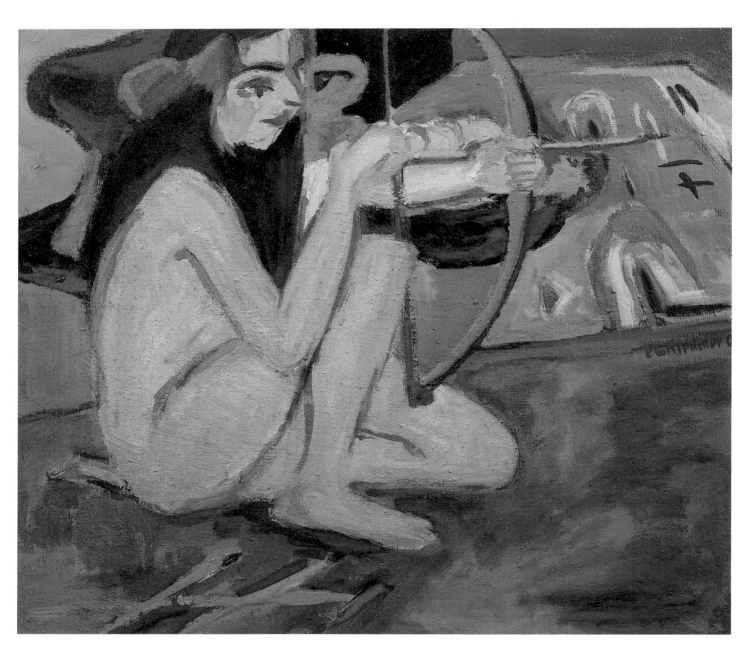

2 ERNST LUDWIG KIRCHNER, Fränzi with Bow and Arrow *(Fränzi mit Pfeilbogen)*, 1909-11
70 x 80 cm; Private Collection

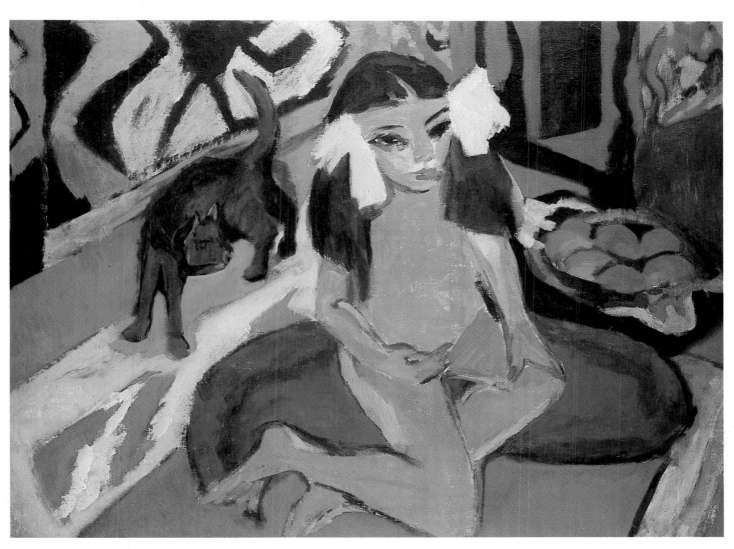

3 ERNST LUDWIG KIRCHNER, Girl with Cat, Fränzi *(Mädchen mit Katze, Fränzi)*, 1910
88.5 x 119 cm; Private Collection

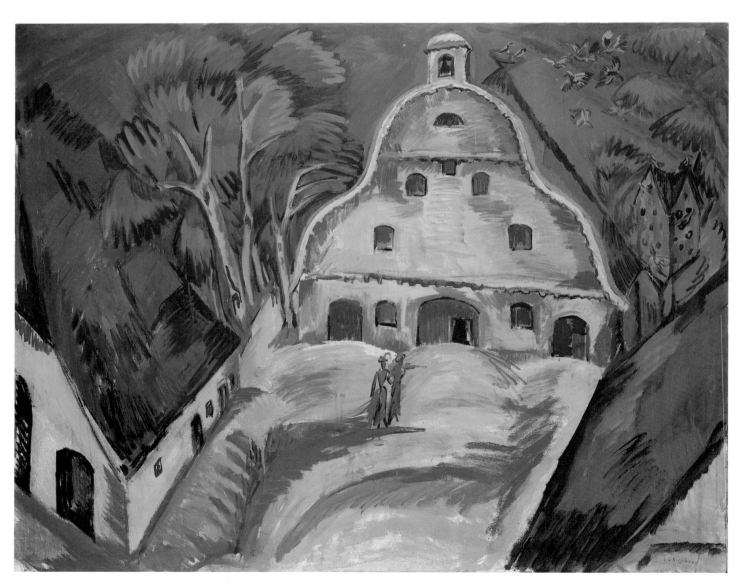

4 ERNST LUDWIG KIRCHNER, Staberhof Countryseat, Fehmarn I *(Gut Staberhof, Fehmarn 1)*, 1913
121 x 151 cm; Hamburger Kunsthalle

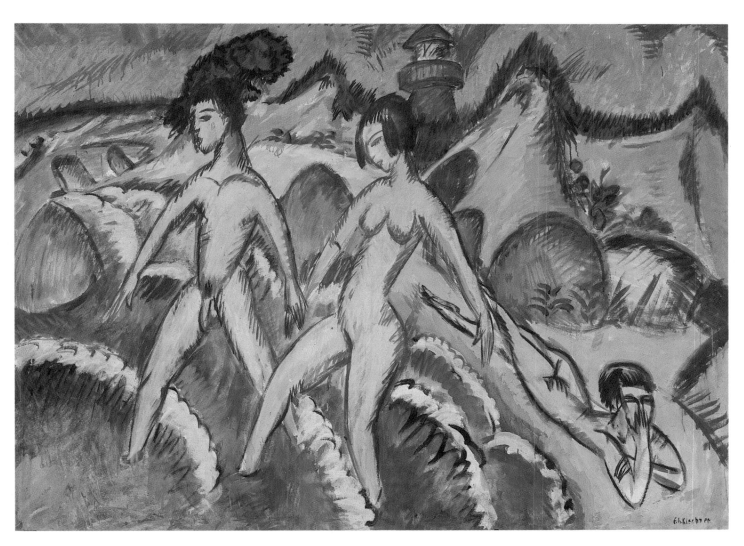

5 ERNST LUDWIG KIRCHNER, Striding into the Sea *(Ins Meer Schreitende)*, 1912
146.4 x 200 cm; Staatsgalerie Stuttgart

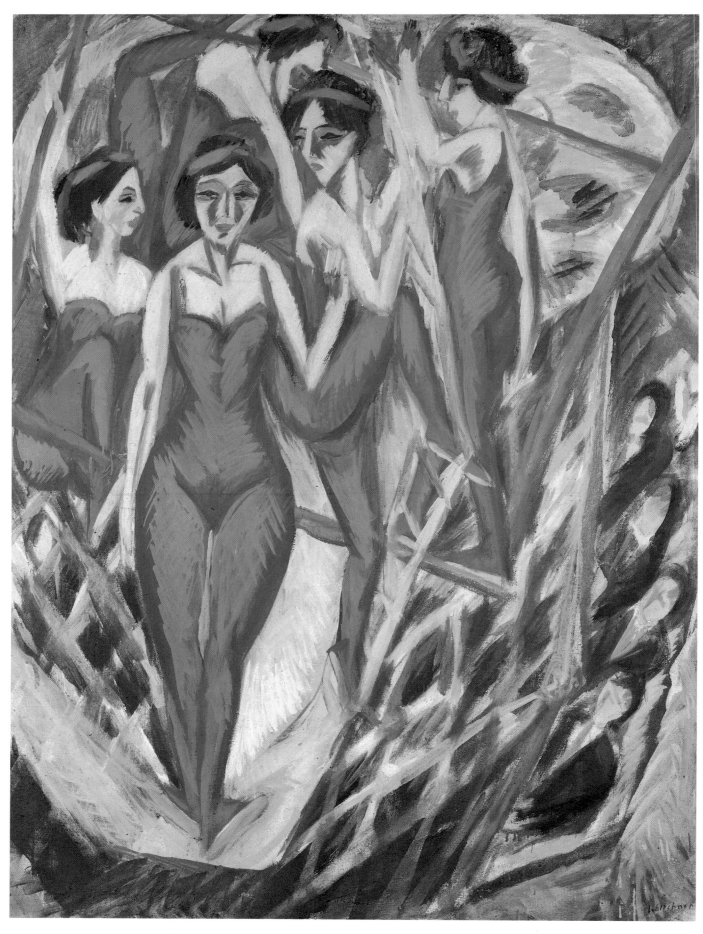

6 ERNST LUDWIG KIRCHNER, Blue Trapeze Artists *(Blaue Artisten)*, 1914
119 x 89 cm; Private Collection

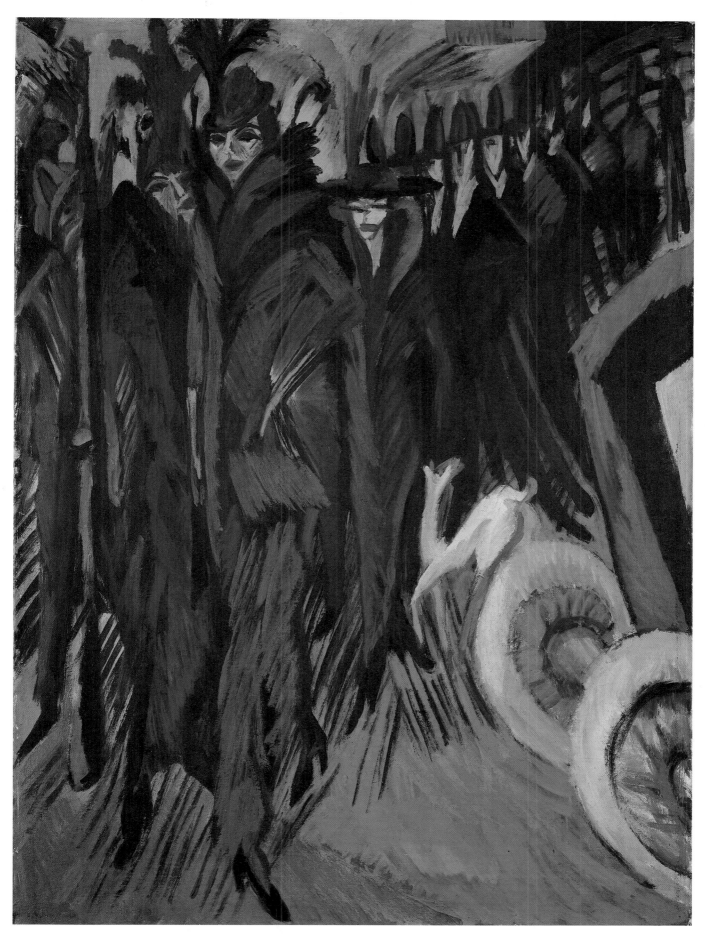

7 ERNST LUDWIG KIRCHNER, Street Scene – Friedrichstrasse Berlin *(Straßenszene – Friedrichstraße Berlin)*, 1914
125 x 91 cm; Staatsgalerie Stuttgart

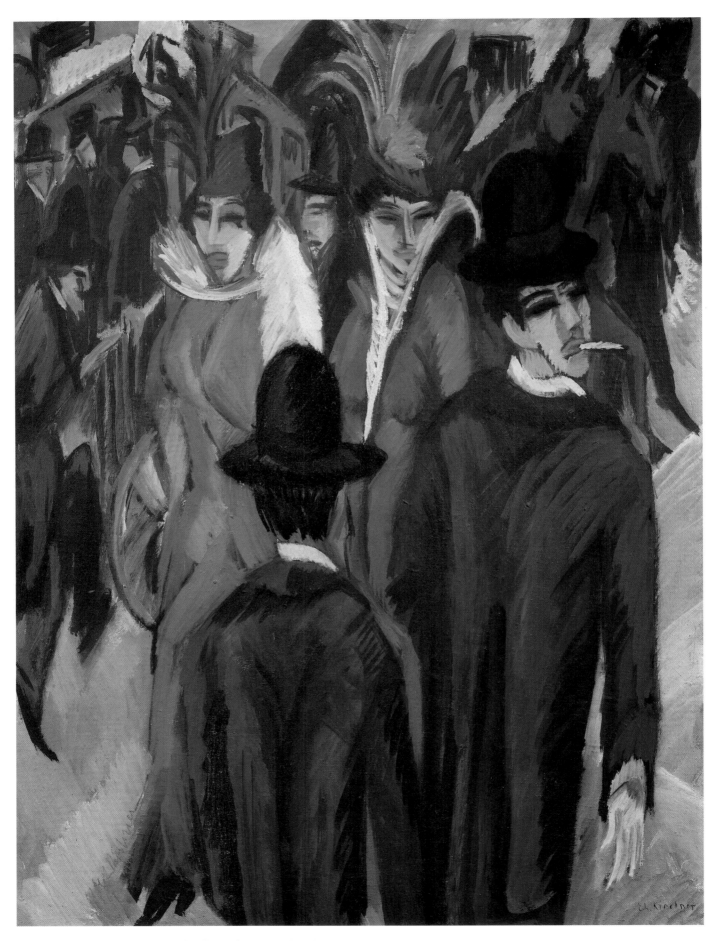

8 ERNST LUDWIG KIRCHNER, Berlin Street Scene (*Berliner Straßenszene*), 1913
121 x 95 cm; Brücke Museum, Berlin

9 ERNST LUDWIG KIRCHNER, The Red Tower in Halle *(Der Rote Turm in Halle)*, 1915
120 x 90.5 cm; Museum Folkwang, Essen

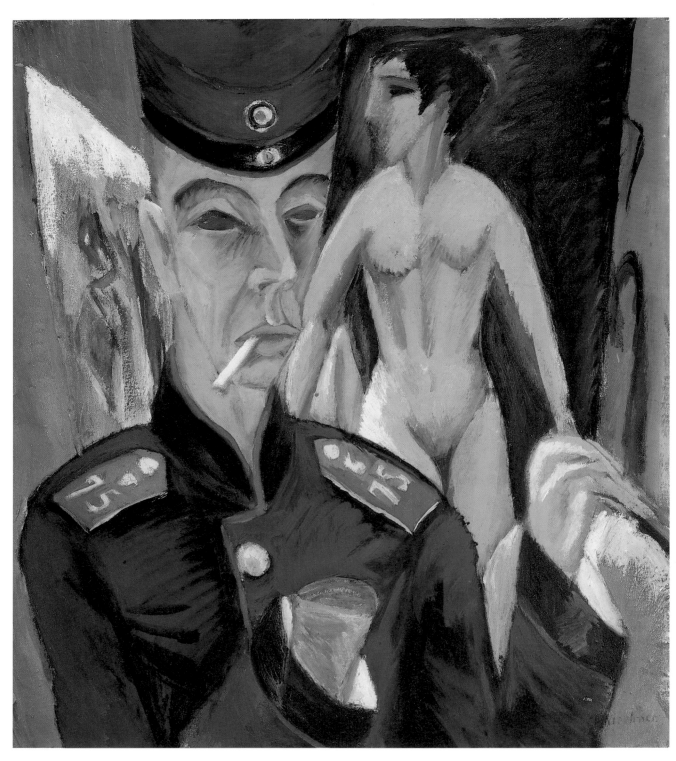

10 ERNST LUDWIG KIRCHNER, Self-portrait as a Soldier *(Selbstbildnis als Soldat)*, 1915
69.2 x 61 cm; Allen Memorial Art Museum, Oberlin College, Charles F. Olney Fund

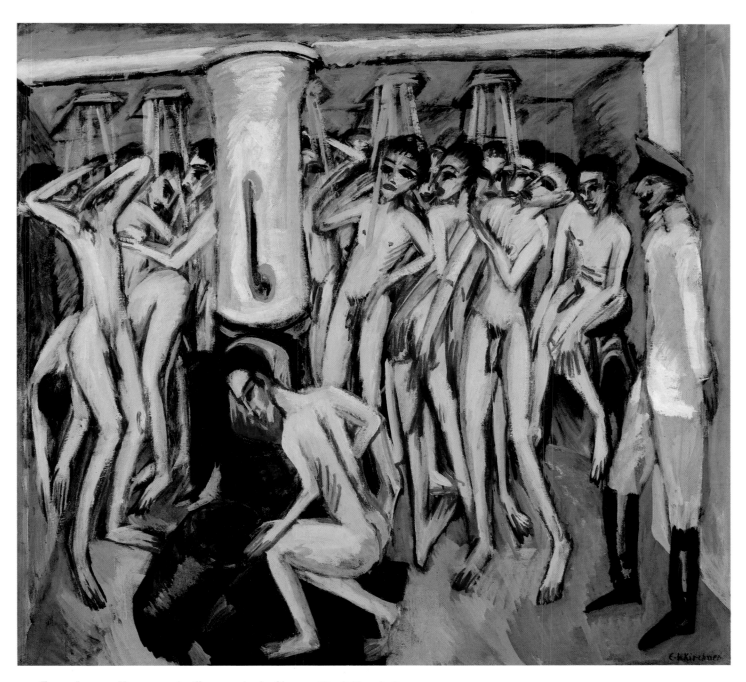

11 ERNST LUDWIG KIRCHNER, Artillerymen in the Shower *(Das Soldatenbad)*, 1915
 140.3 x 150.8 cm; The Museum of Modern Art, New York, Gift of Mr and Mrs Morton D. May

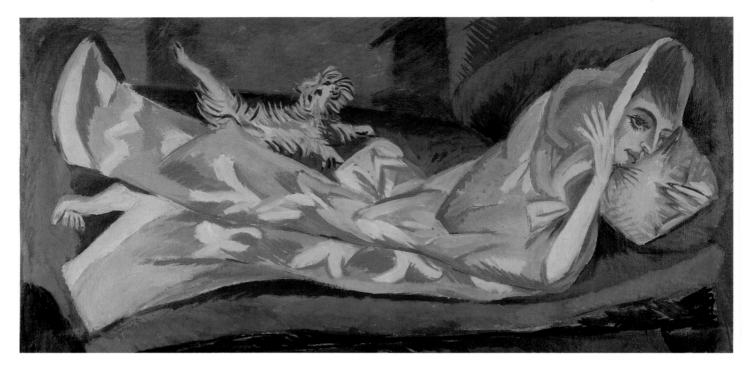

12 ERNST LUDWIG KIRCHNER, Olympia, 1914/15
73.5 x 148.5 cm; Gregory Callimanopulos

13
ERNST LUDWIG KIRCHNER,
Head of a Woman, Head of Erna, 1913
Frauenkopf, Kopf Erna
Oak, painted ochre and black
35.5 x 15 x 16 cm
The Gore Robert Rifkind Collection,
Beverly Hills, California

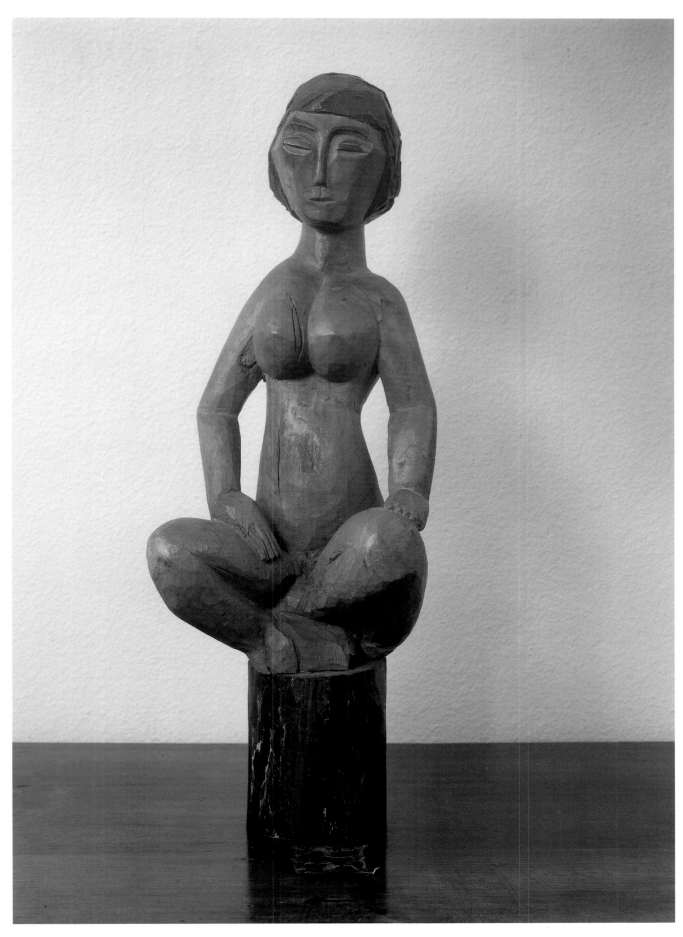

14 ERNST LUDWIG KIRCHNER, Nude Woman, Sitting with her Legs Crossed *(Nackte, mit untergeschlagenen Beinen sitzende Frau),* 1912
Sycamore, hair painted black; 47 x 22.9 x 19 cm; Private Collection, Zürich

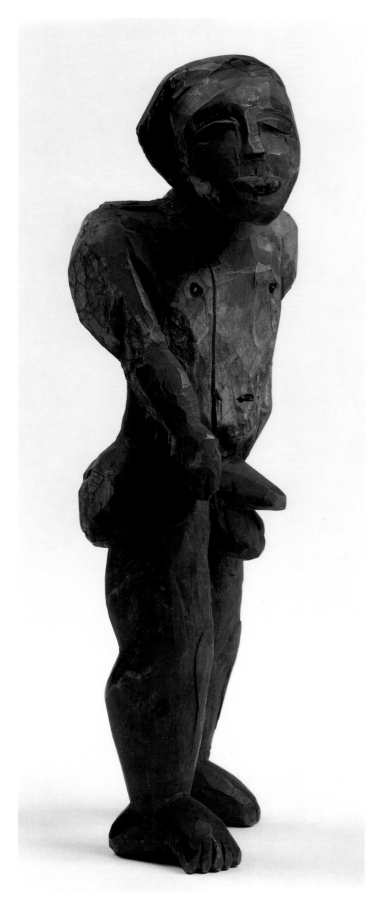

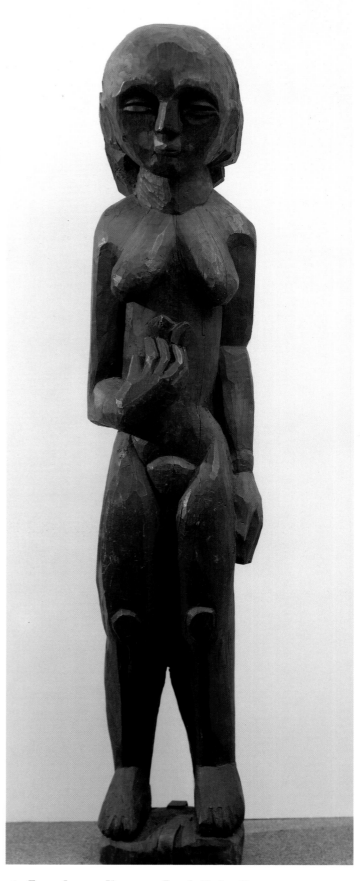

15 ERNST LUDWIG KIRCHNER, Male Nude – Adam, 1923
Männliche Aktfigur – Adam
Wood; 169.6 x 40 x 31 cm; Staatsgalerie Stuttgart

16 ERNST LUDWIG KIRCHNER, Female Nude – Eve, 1923
Weibliche Aktfigur – Eva
Wood; 169.8 x 30 x 22 cm; Staatsgalerie Stuttgart

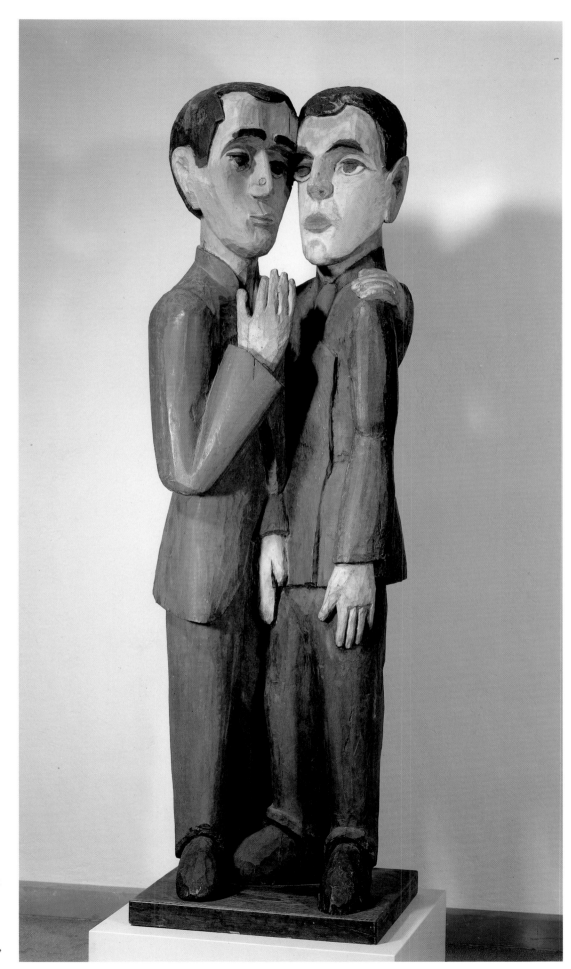

17
ERNST LUDWIG KIRCHNER
The Friends, 1925
Die Freunde
Painted larch
175 x 50 x 44 cm
Öffentliche Kunstsammlung,
Kunstmuseum Basle

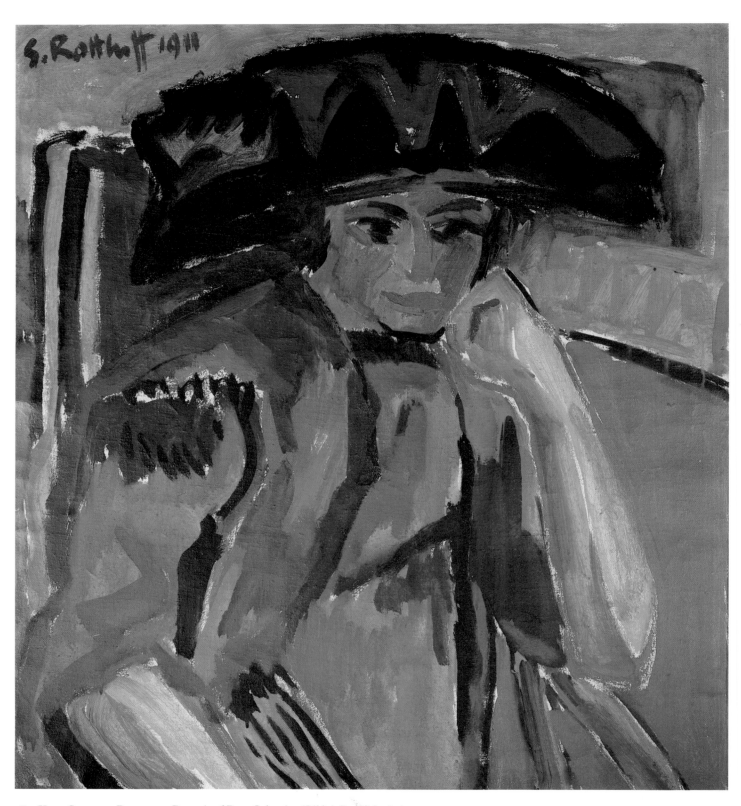

18　KARL SCHMIDT-ROTTLUFF, Portrait of Rosa Schapire *(Bildnis Rosa Schapire)*, 1911
84 x 76 cm; Brücke Museum, Berlin

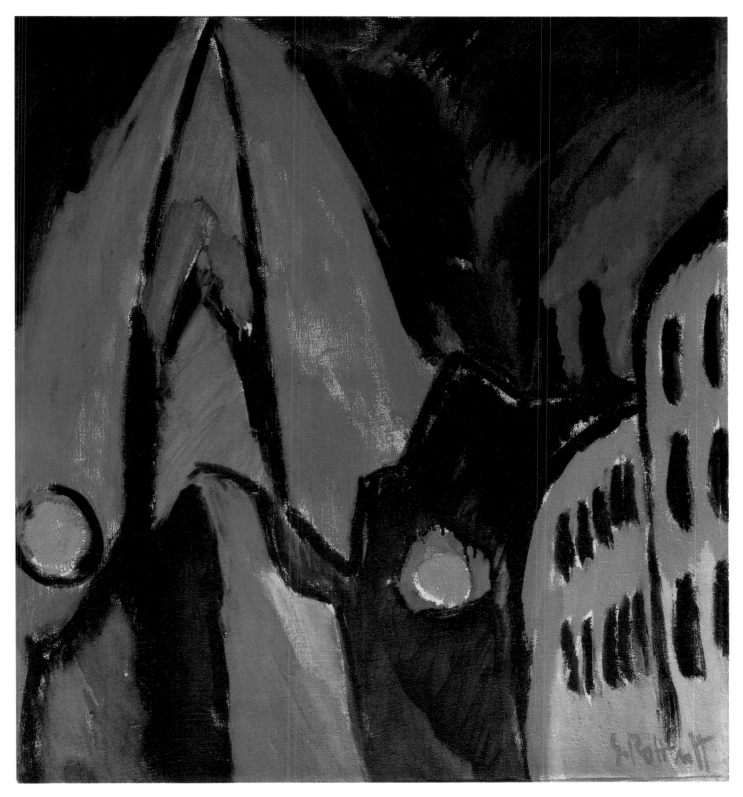

19 KARL SCHMIDT-ROTTLUFF, St. Peter's Tower in Hamburg *(Petriturm in Hamburg)*, 1912
84 x 76 cm; Private Collection

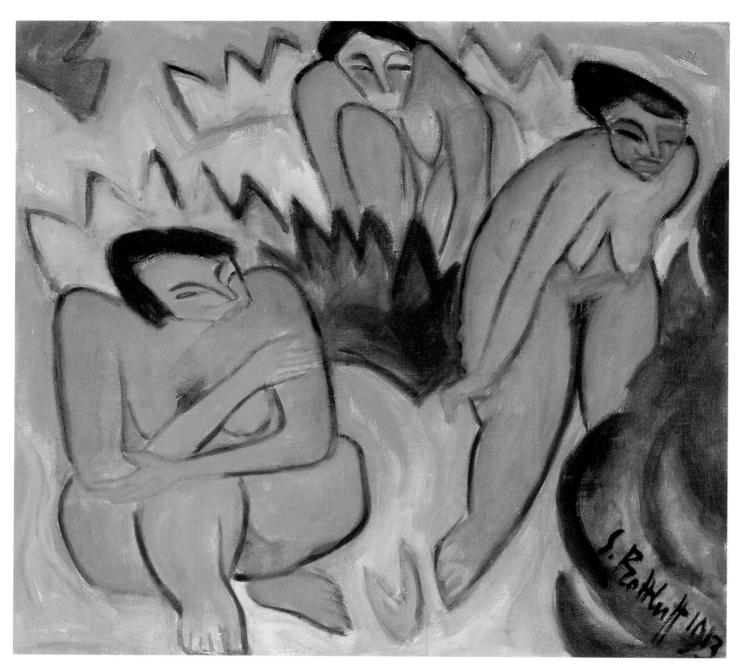

20 KARL SCHMIDT-ROTTLUFF, Three Nudes – Dune Picture from Nidden *(Drei Akte – Dünenbild aus Nidden)*, 1913
98 x 106 cm; Staatliche Museen Preussischer Kulturbesitz, Nationalgalerie Berlin

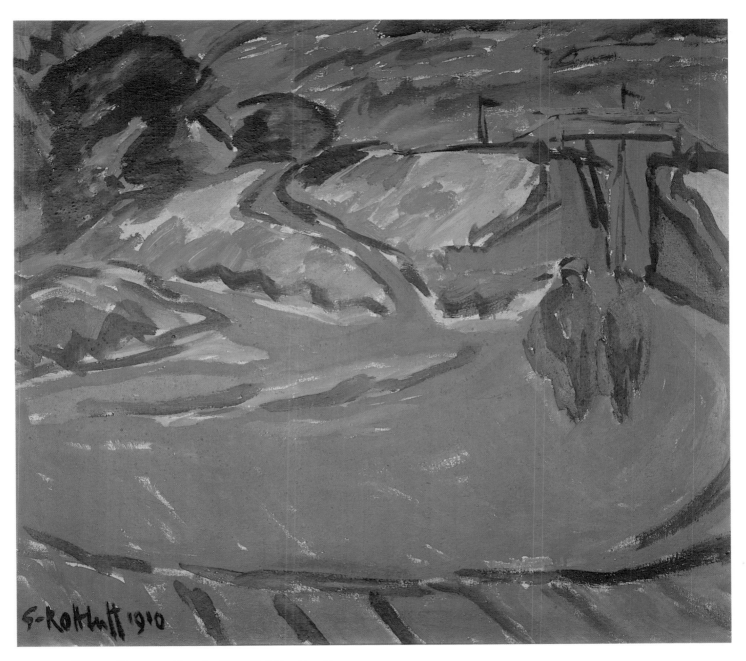

21 KARL SCHMIDT-ROTTLUFF, Bursting Dam *(Deichdurchbruch)*, 1910
 76 x 84 cm; Brücke Museum, Berlin

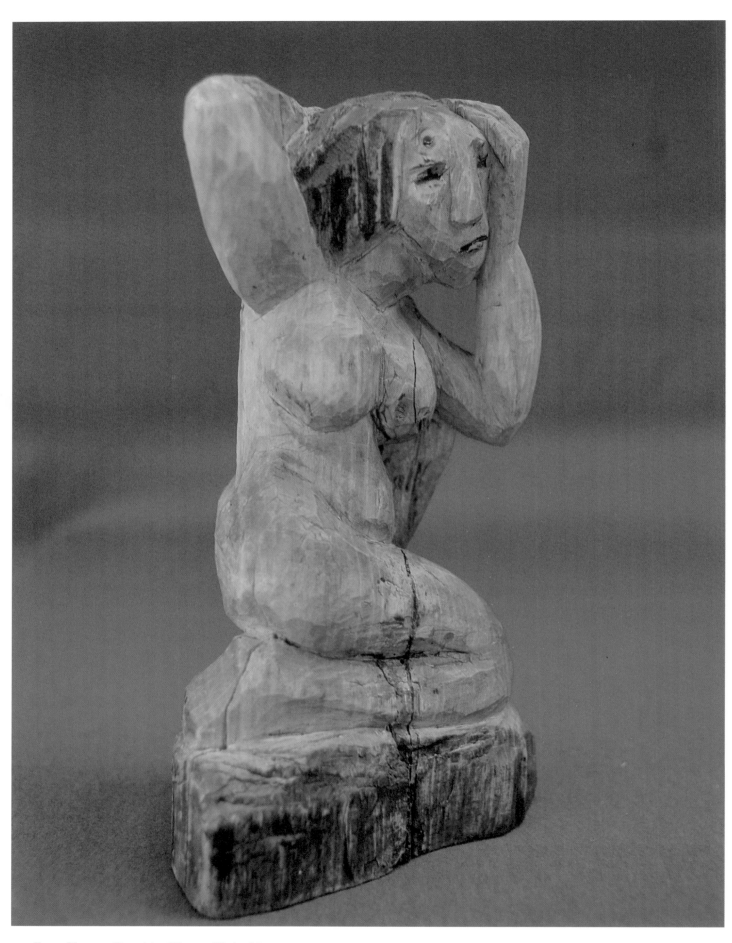

22 ERICH HECKEL, Crouching Woman *(Hockende)*, 1912
Painted linden; 30 x 17 x 10 cm; Erich Heckel Estate, Hemmenhofen

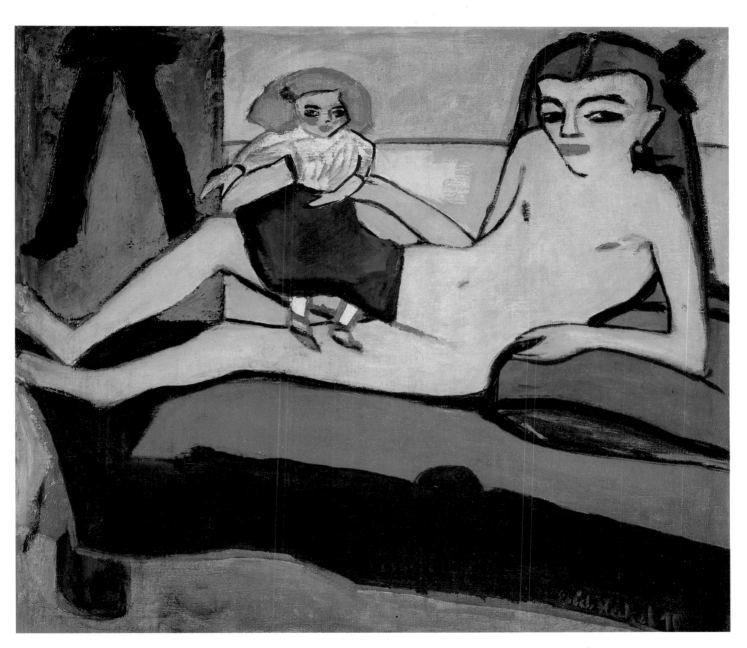

23 ERICH HECKEL, Fränzi with Doll *(Fränzi mit Puppe)*, 1910
65 x 70 cm; Private Collection, Courtesy of Serge Sabarsky Gallery, New York

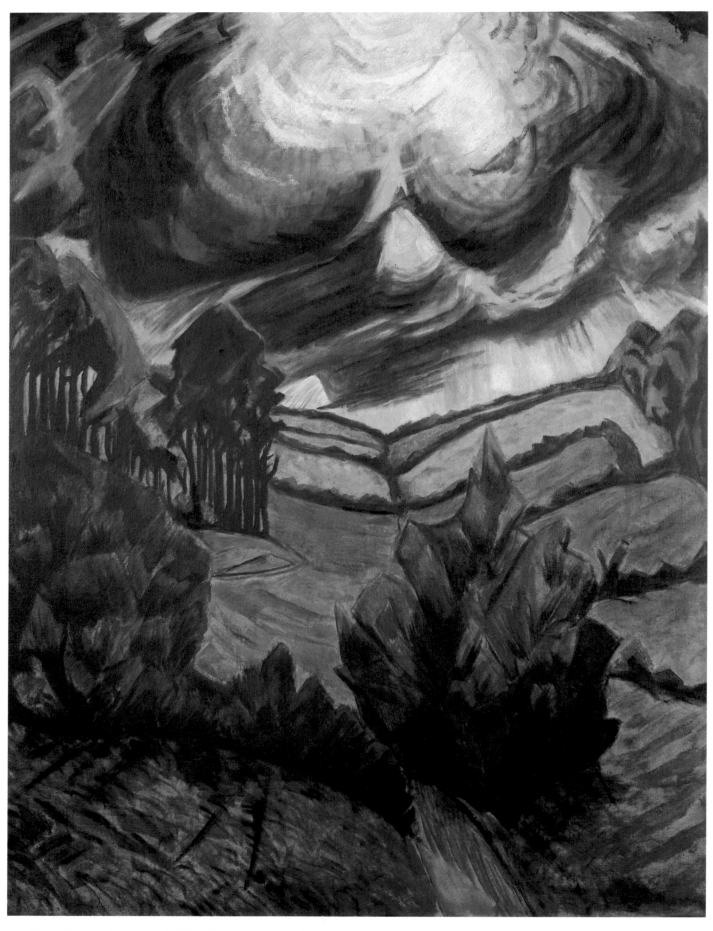

24 ERICH HECKEL, Landscape in Thunderstorm *(Gewitterlandschaft)*, 1913
146 x 110 cm; The Tel Aviv Museum

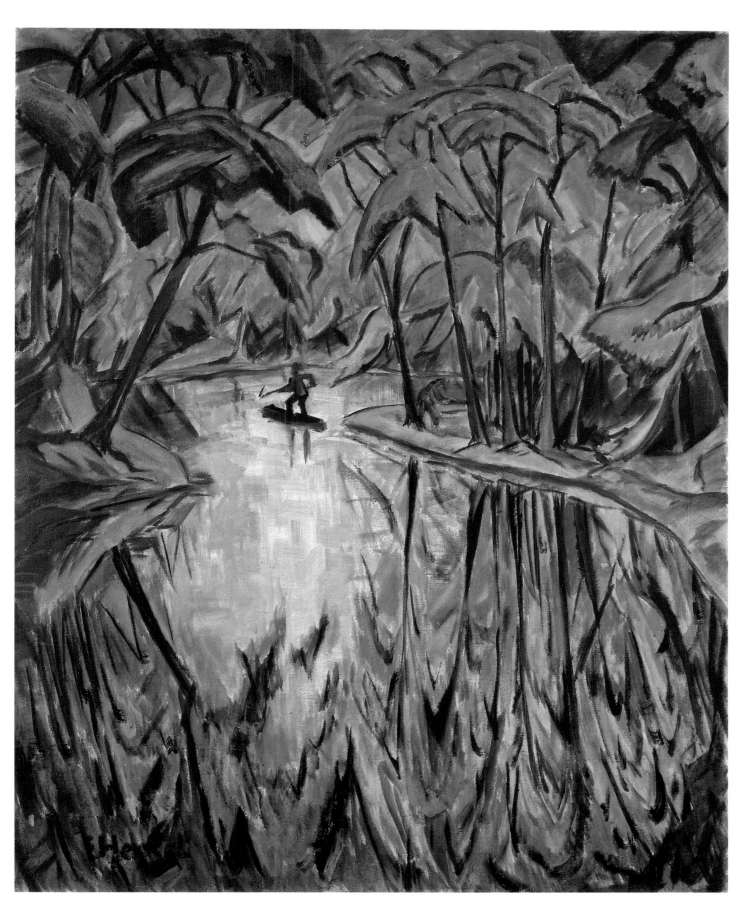

25　ERICH HECKEL, Park Lake *(Parksee)*, c. 1914
120 x 96.5 cm; Munich, Bayerische Staatsgemäldesammlungen, Staatsgalerie moderner Kunst (Loan)

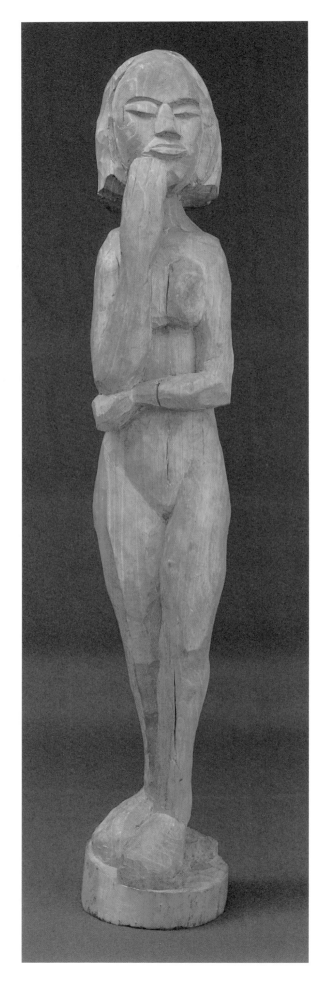

26
ERICH HECKEL
Standing Figure *(Stehende)*, 1920
Poplar; 79 x 13 x 15 cm
Erich Heckel Estate, Hemmenhofen

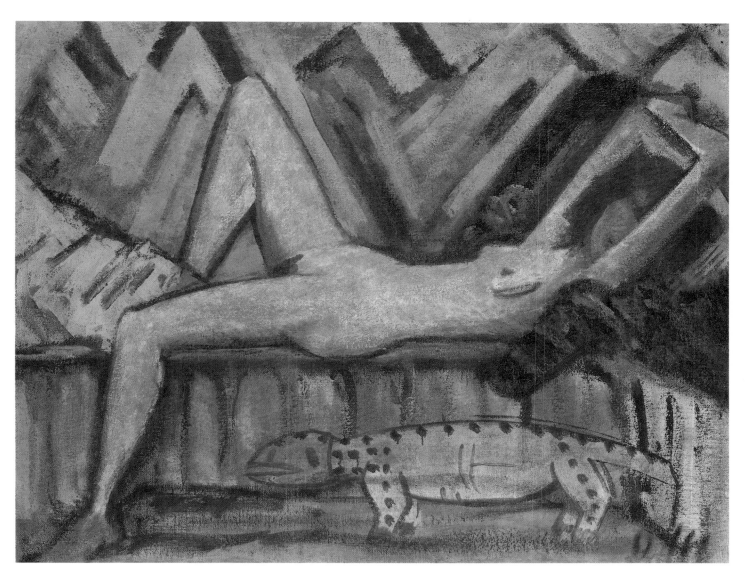

27 OTTO MUELLER, Nude Lying on a Sofa *(Akt auf Sofa Liegend)*, n. d.
Tempera on hessian; 95 x 120 cm; Bayerische Staatsgemäldesammlungen, Staatsgalerie moderner Kunst, Munich (Loan)

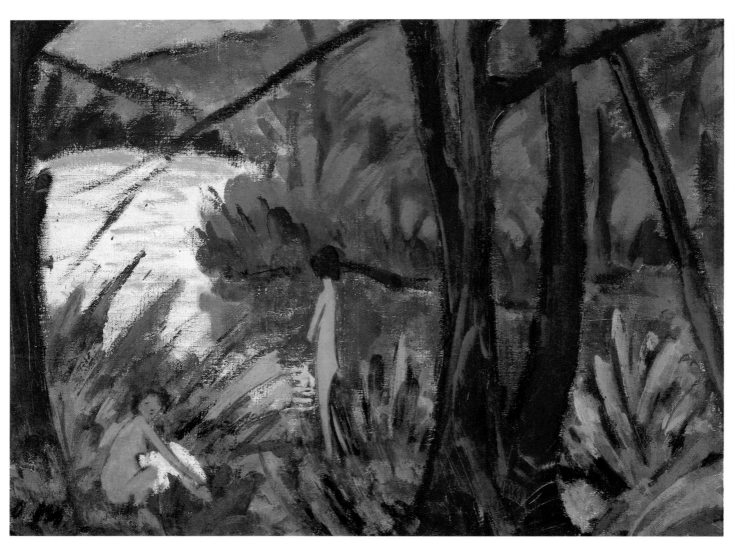

28 OTTO MUELLER, Forest Lake with two Nudes *(Waldsee mit zwei Akten)*, c. 1915
 Tempera on hessian; 80 x 105.5 cm; Museum am Ostwall, Dortmund

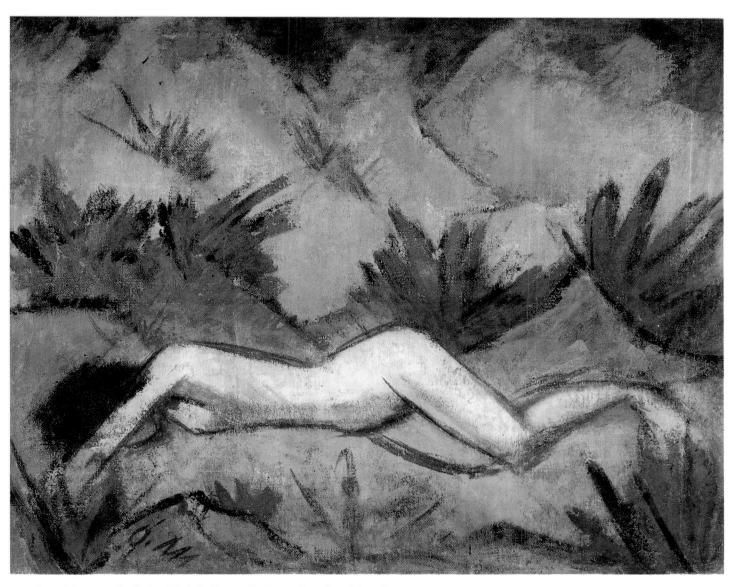

29 OTTO MUELLER, Reclining Nude in Dunes *(In Dünen liegender Akt)*, n. d.
 Tempera on hessian; 87 x 108 cm; Collection Henry G. Proskauer

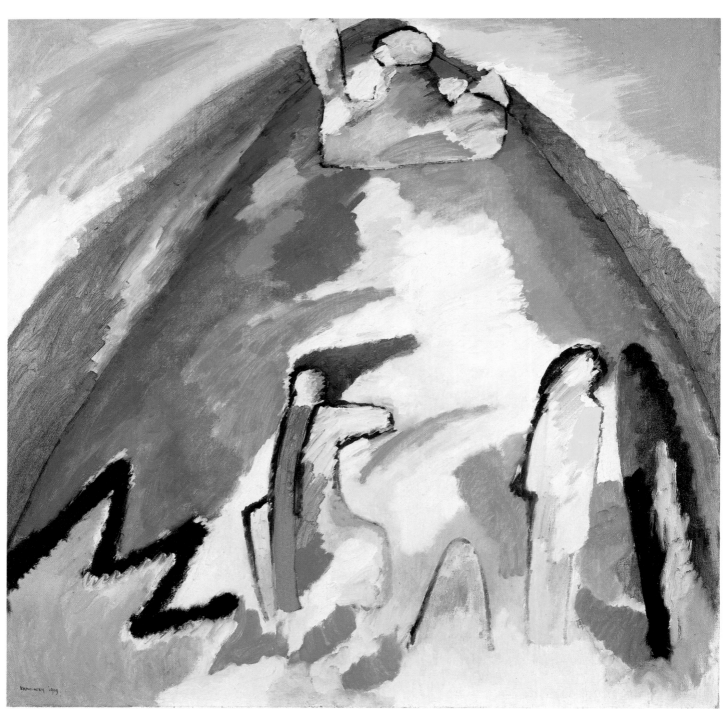

30 WASSILY KANDINSKY, Mountain *(Berg)*, 1909
 109 x 109 cm; Städtische Galerie im Lenbachhaus, Munich

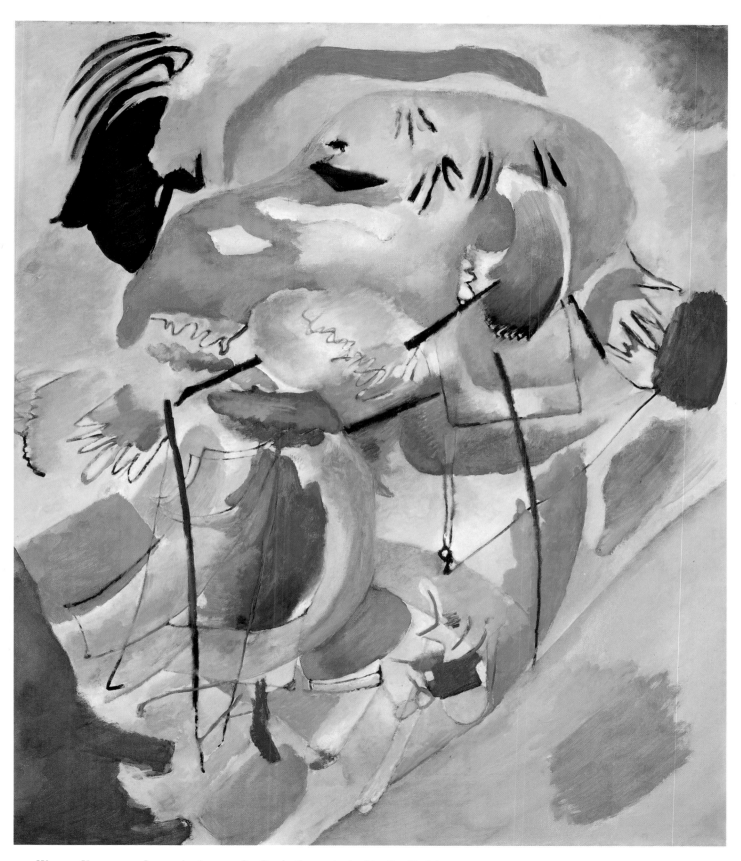

31 WASSILY KANDINSKY, Improvisation 31 – Sea Battle (*Improvisation 31 – Seeschlacht*), 1913
140 x 120 cm; The National Gallery of Art, Washington D. C., Alisa Mellon Bruce Fund

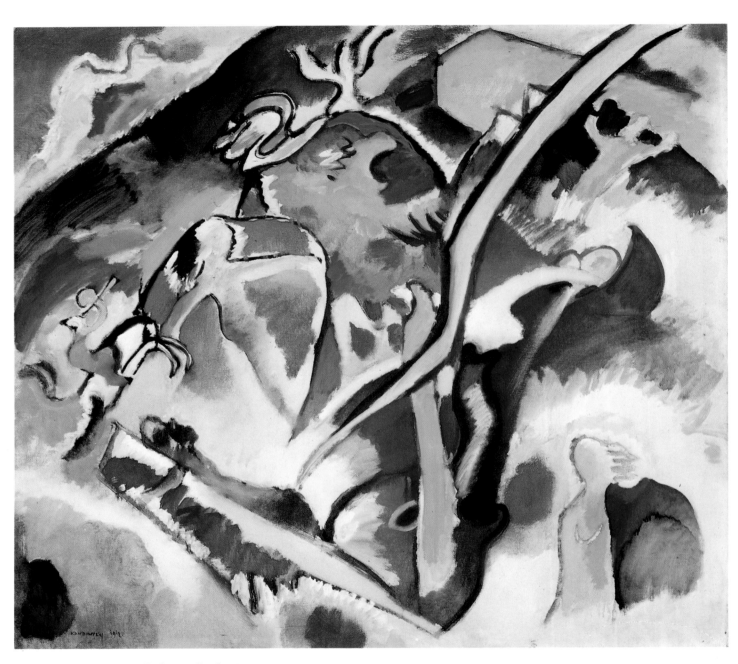

32 Wassily Kandinsky, Deluge I *(Sintflut I)*, 1912
100 x 105 cm; Kaiser Wilhelm Museum, Krefeld

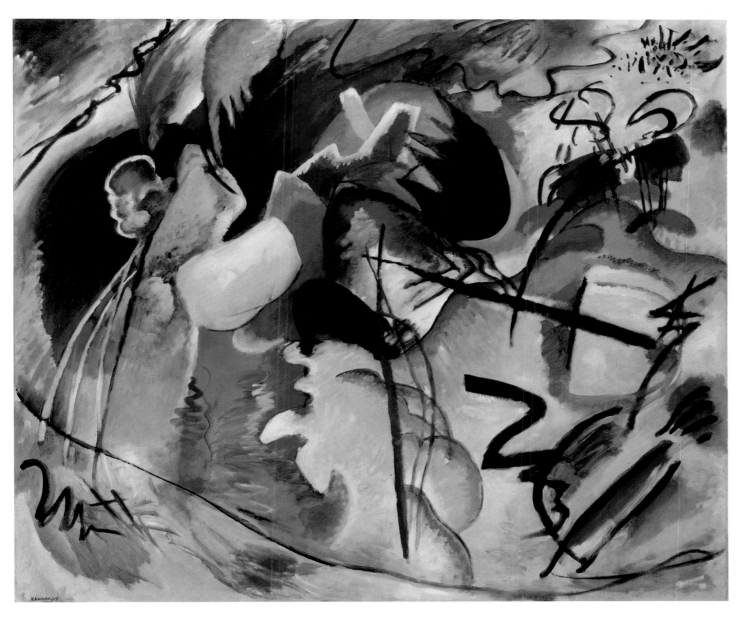

33 WASSILY KANDINSKY, Painting with White Form No. 166 *(Bild mit weißer Form No. 166)*, 1913
120.4 x 140 cm; The Solomon R. Guggenheim Museum, New York (on loan to Gemeentemuseum, The Hague)

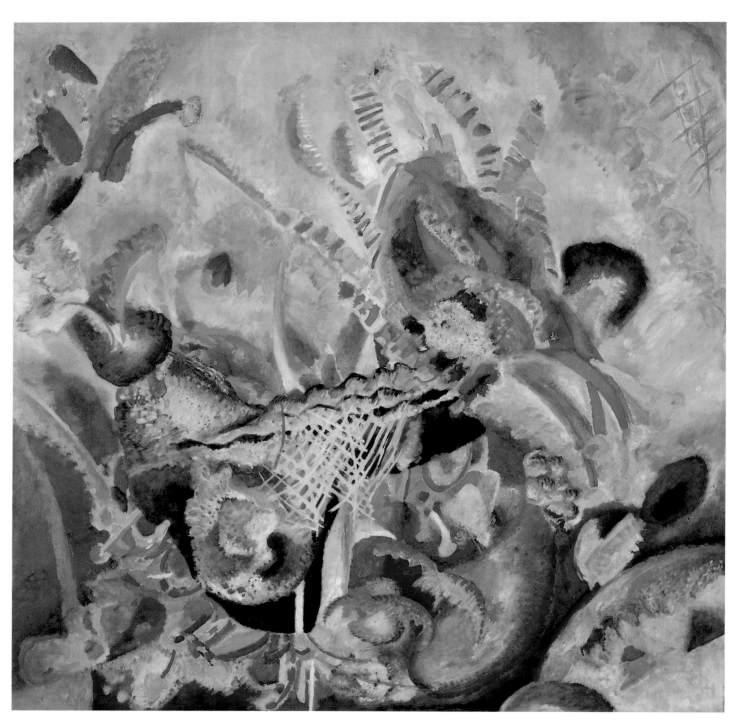

34 WASSILY KANDINSKY, Fugue *(Fuge)*, 1914
130 x 130.2 cm; The Solomon R. Guggenheim Museum, New York

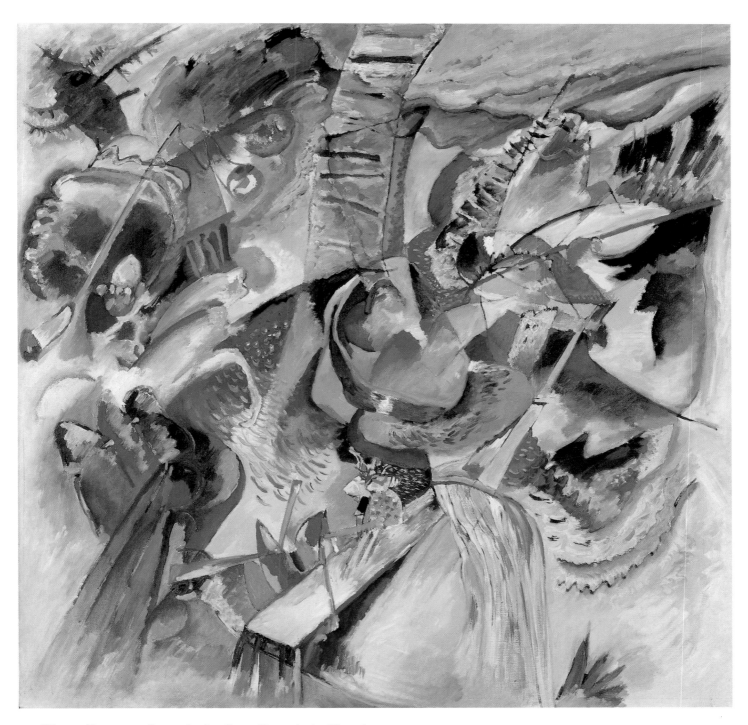

35 WASSILY KANDINSKY, Improvisation Gorge *(Improvisation Klamm)*, 1914
110 x 110 cm; Munich, Städtische Galerie im Lenbachhaus

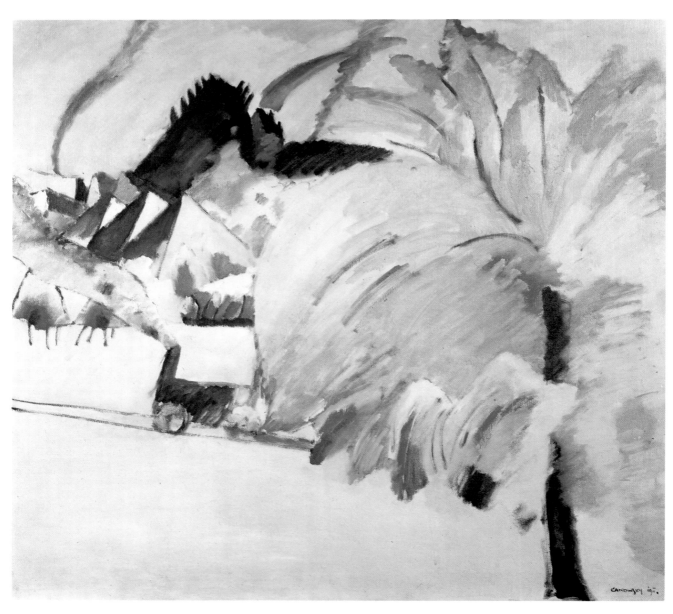

36 WASSILY KANDINSKY, Winterlandscape *(Winterlandschaft)*, 1911
 95.3 x 102.4 cm; Private Collection

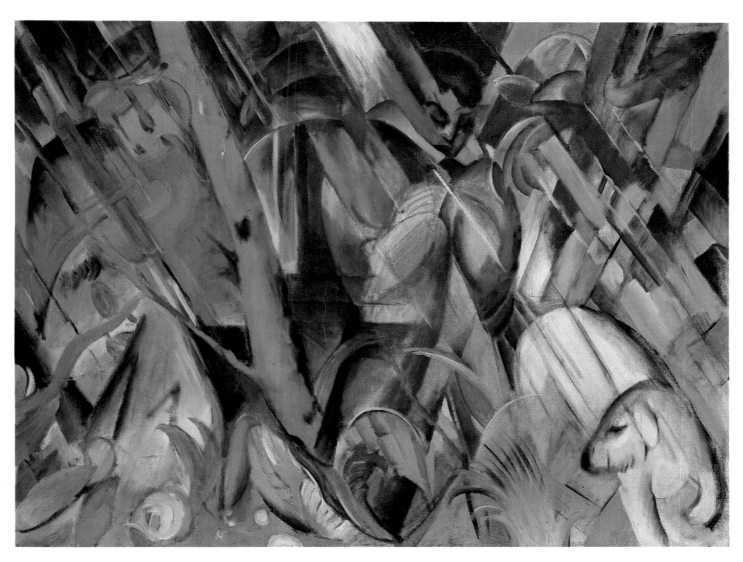

37　FRANZ MARC, Rain *(Im Regen)*, 1912
81 x 105 cm; Munich, Städtische Galerie im Lenbachhaus

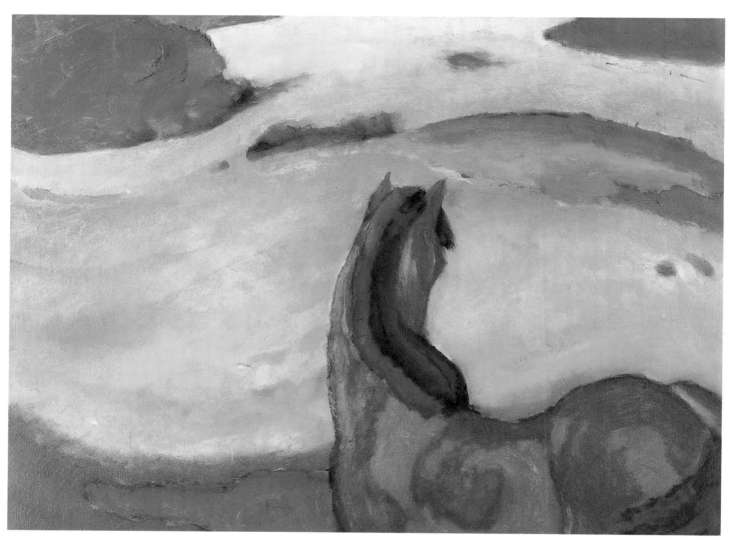

38 FRANZ MARC, Horse in Landscape *(Pferd in der Landschaft)*, 1910
85 x 112 cm; Museum Folkwang, Essen

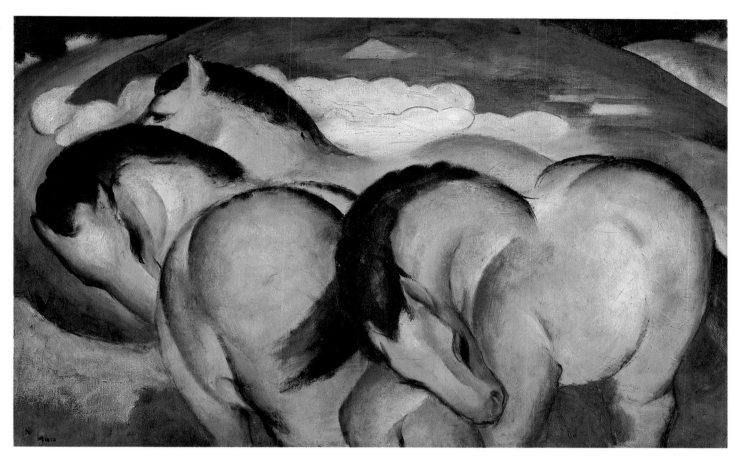

39 FRANZ MARC, The Little Yellow Horses *(Die kleinen gelben Pferde)*, 1912
 66 x 104 cm; Staatsgalerie Stuttgart

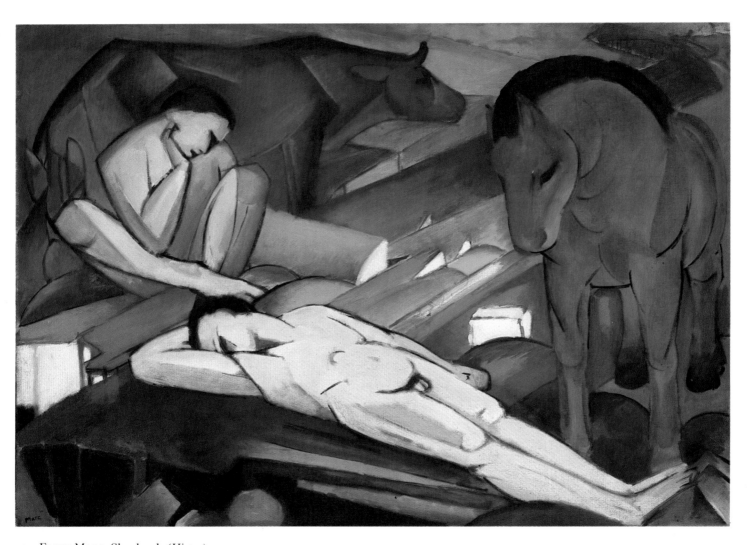

40 FRANZ MARC, Shepherds *(Hirten)*, ca. 1911
 100 x 135 cm; Munich, Bayerische Staatsgemäldesammlungen, Staatsgalerie moderner Kunst (Loan)

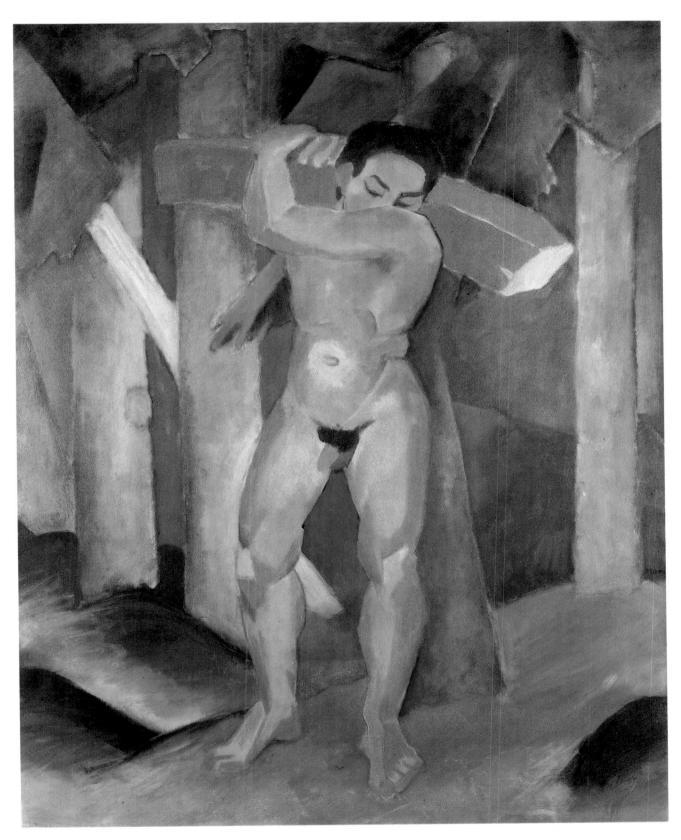

41 FRANZ MARC, Woodcutter *(Der Baumträger)*, 1911
141 x 109 cm; Gregory Callimanopulos

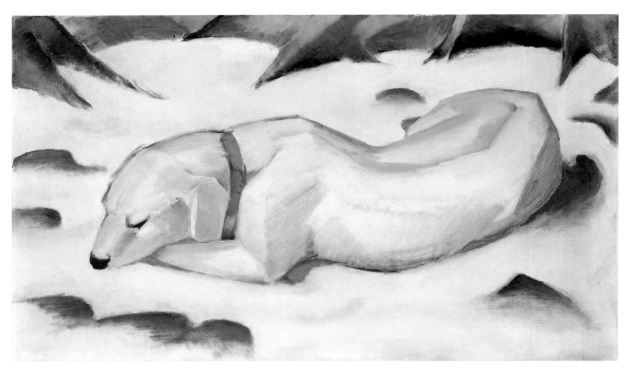

42 FRANZ MARC, The White Dog *(Der weiße Hund)*, ca. 1913/14
 62.5 x 105 cm; Städelscher Museums-Verein e. V., Frankfurt
 (on loan to Städelsches Kunstinstitut, Frankfurt)

43 FRANZ MARC, Pigs *(Schweine)*, 1912
 58 x 84 cm; Private Collection, Switzerland

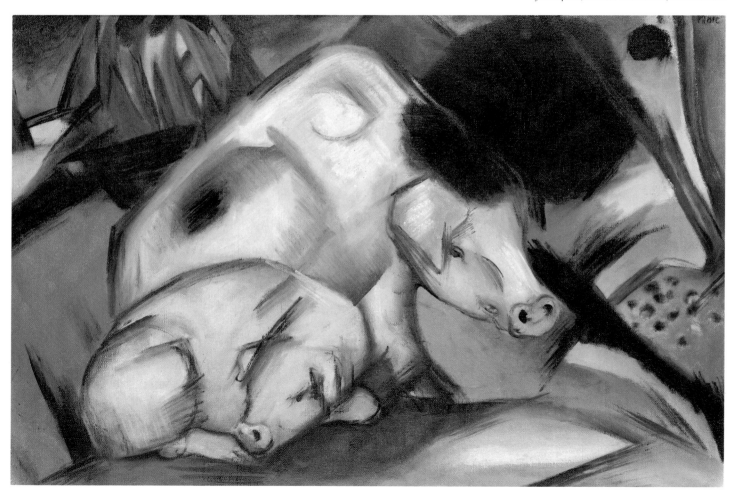

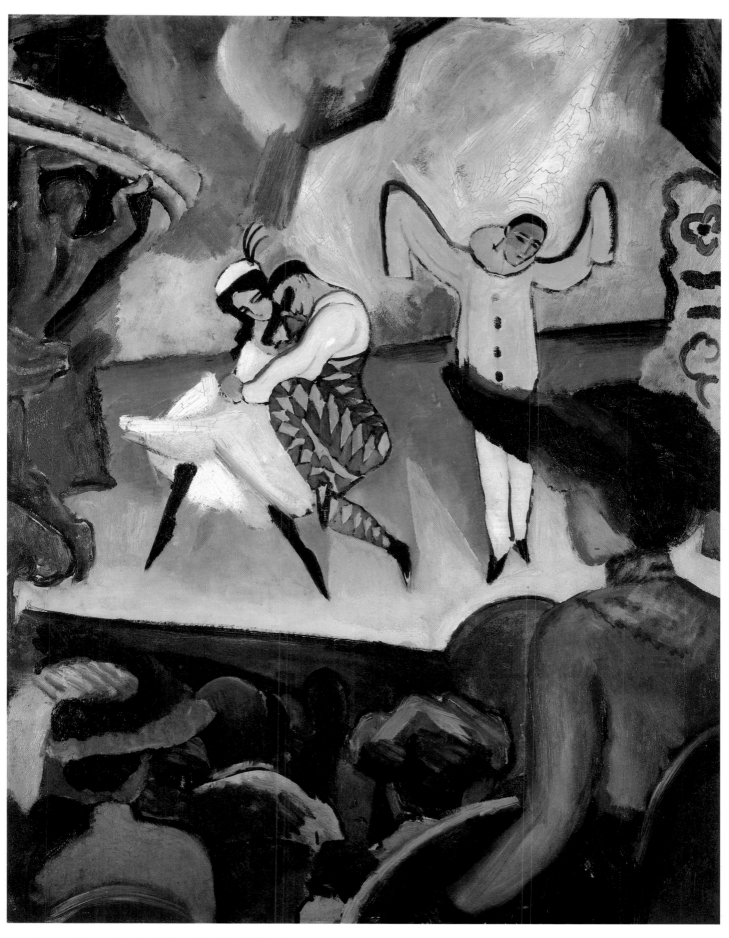

44 AUGUST MACKE, Russian Ballet I (*Russisches Ballett I*), 1912
103 x 81 cm; Kunsthalle Bremen

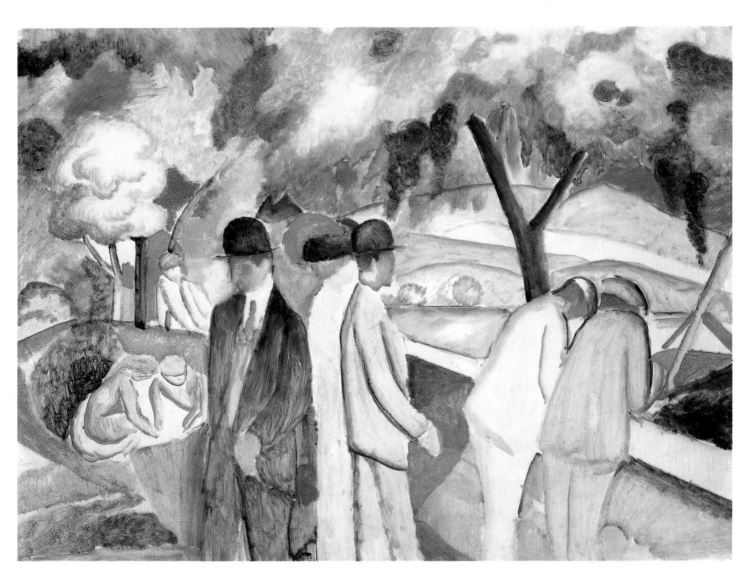

45 AUGUST MACKE, Large Bright Walk *(Großer Heller Spaziergang)*, 1913
 Oil on board; 81 x 103.5 cm; Westfälisches Landesmuseum für Kunst und Kulturgeschichte, Münster

46 AUGUST MACKE, Walk in the Garden *(Spaziergang im Garten)*, 1914
 73 x 103 cm; Private Collection

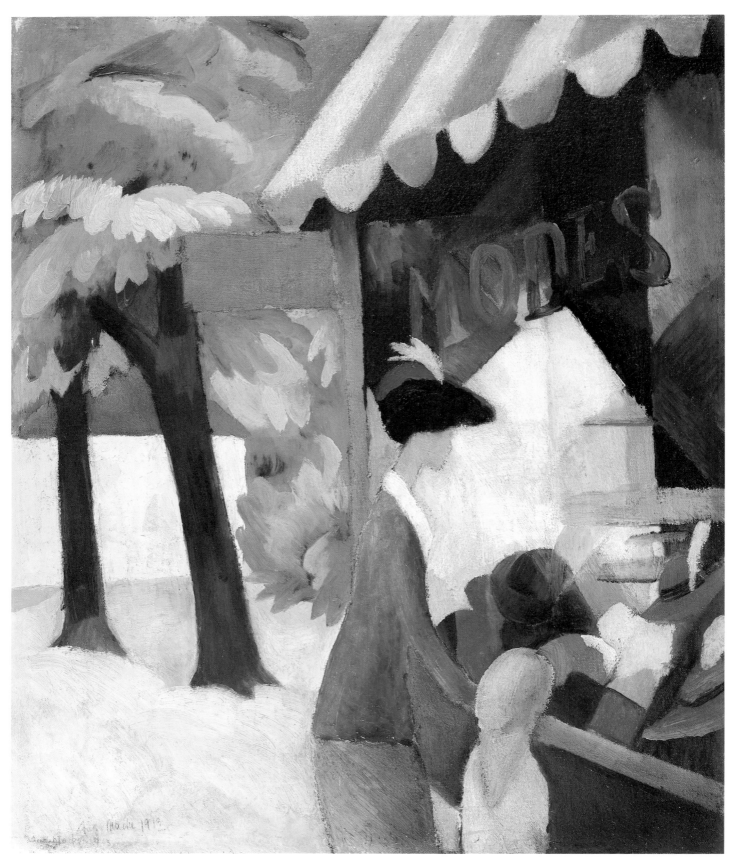

47 AUGUST MACKE, In Front of the Hat Shop *(Vor dem Hutladen)*, 1913
54.7 x 44.5 cm; Private Collection

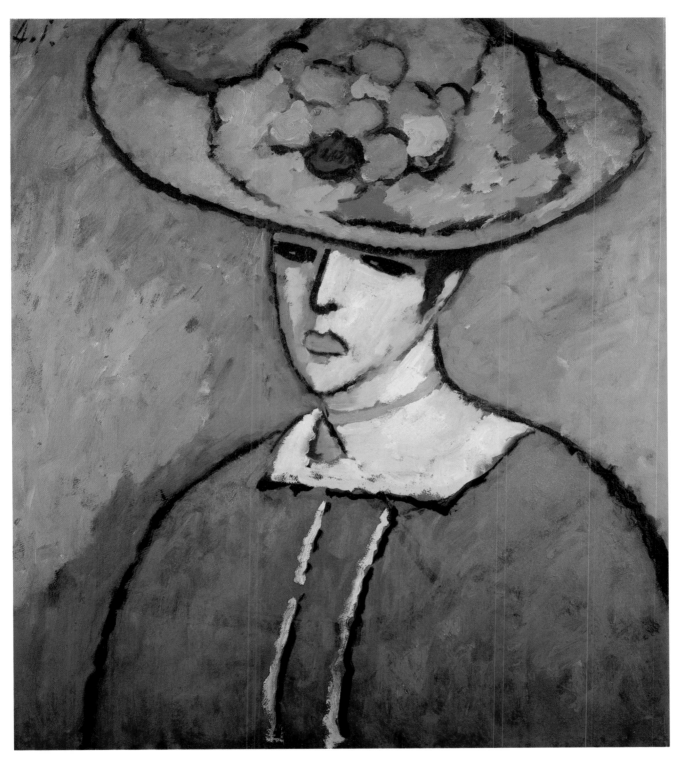

48 ALEXEJ JAWLENSKY, Schokko with Flat Hat *(Schokko mit Tellerhut)*, 1910
 Oil on board, mounted on canvas; 73.7 x 68.8 cm; Leonard Hutton Galleries, New York

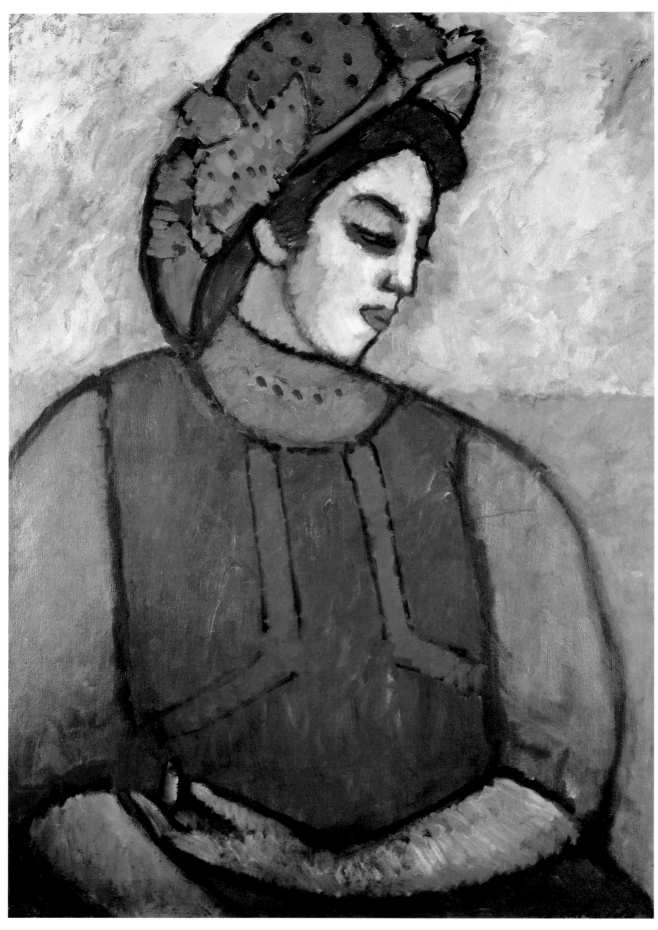

49 ALEXEJ JAWLENSKY, Girl in a Grey Apron *(Mädchen mit grauer Schürze)*, 1909
Oil on board; 101 x 70 cm; Private Collection, Zürich

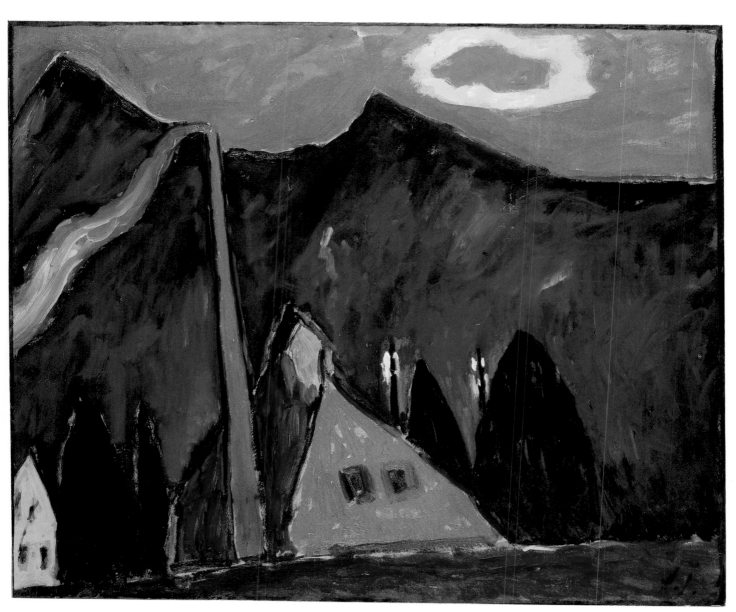

50 ALEXEJ JAWLENSKY, The Factory *(Die Fabrik)*, 1910
Oil on board, mounted on wood; 72 x 85 cm; Courtesy of Leonard Hutton Galleries, New York

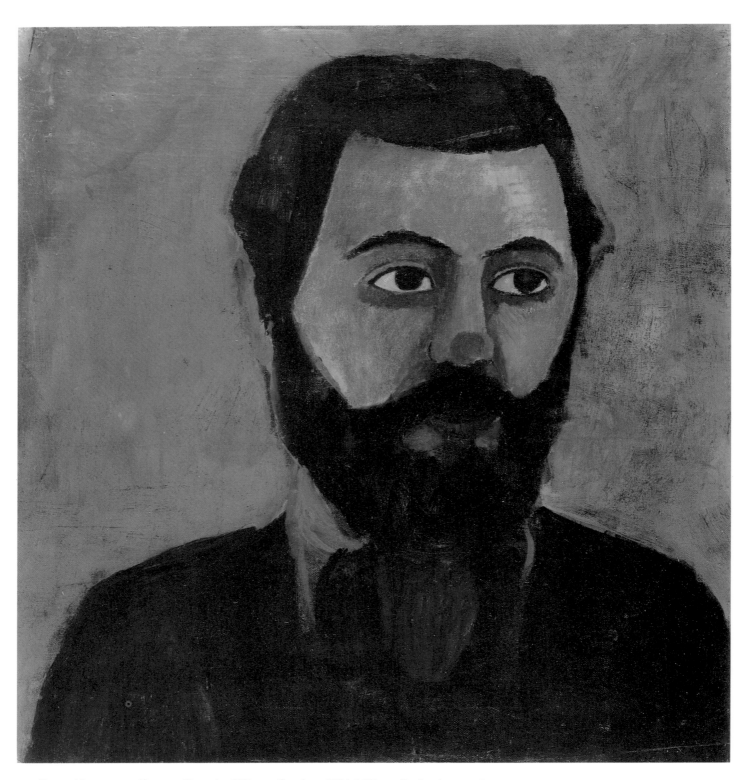

51 PAULA MODERSOHN-BECKER, Portrait of Werner Sombart *(Bildnis Werner Sombart)*, c. 1906
Oil on canvas on plywood; 50 x 46 cm; Kunsthalle Bremen

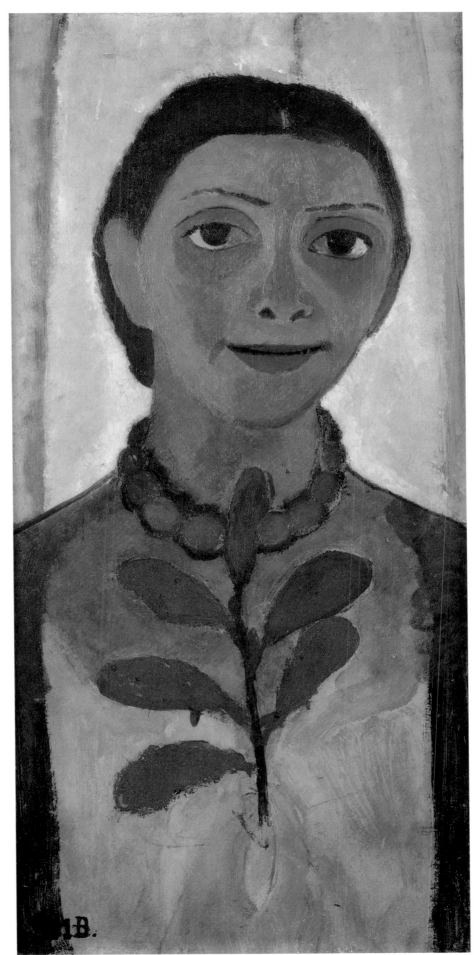

52
PAULA MODERSOHN-BECKER
Self-portrait with Camellia
Branch, 1907
Selbstbildnis mit Kamelienzweig
Oil on panel
61.7 x 30.5 cm
Museum Folkwang, Essen

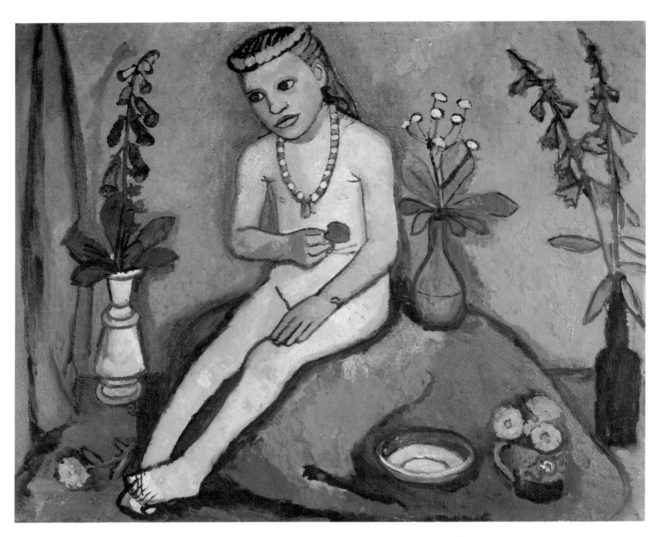

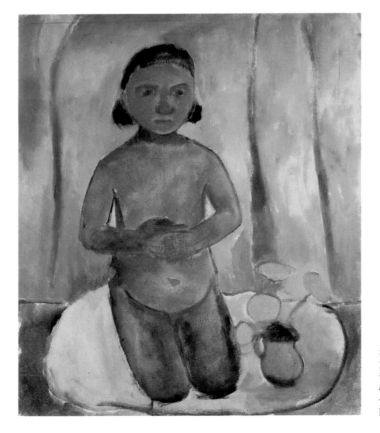

53
PAULA MODERSOHN-BECKER
Seated Nude Girl with Flowers, 1907
Sitzender Mädchenakt mit Blumen
89 x 109 cm
Von der Heydt-Museum, Wuppertal

54
PAULA MODERSOHN-BECKER
Kneeling Girl in front of a Blue Curtain, 1907
Kniendes Mädchen vor blauem Vorhang
72 x 60 cm
Landesmuseum Oldenburg

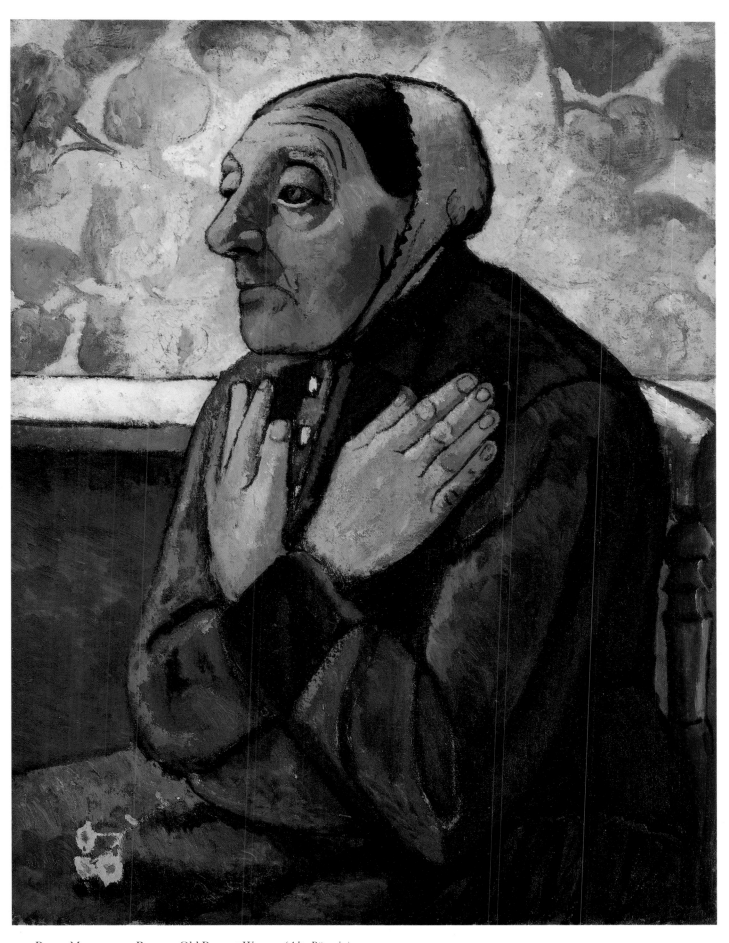

55 PAULA MODERSOHN-BECKER, Old Peasant Woman *(Alte Bäuerin)*, c. 1905-07
75.5 x 57.7 cm; The Detroit Institute of Arts, Gift of Robert H. Tannahill

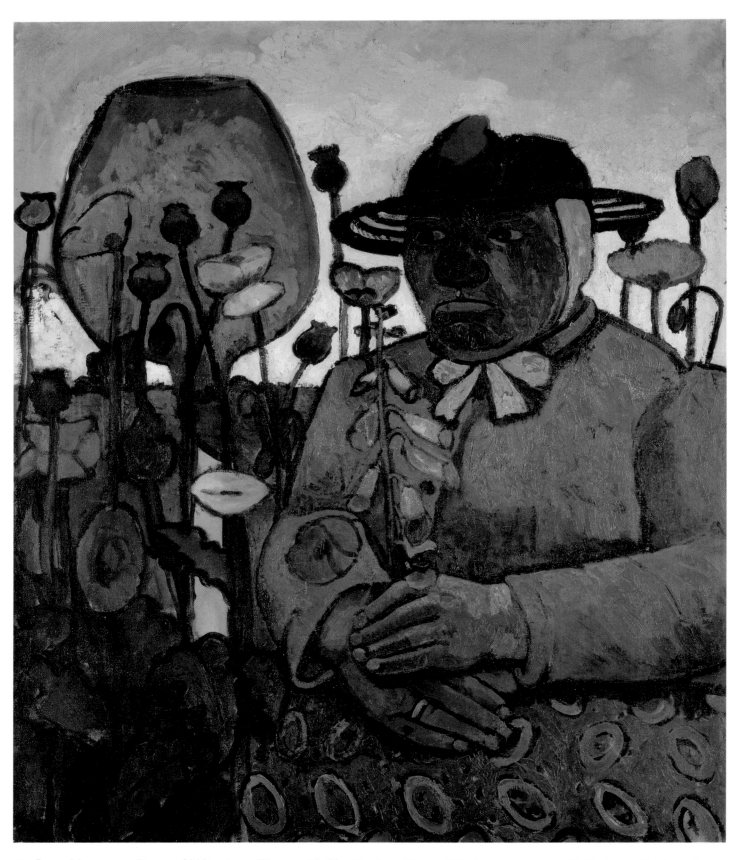

56 Paula Modersohn-Becker, Old Poorhouse Woman with Glass Bottle and Poppy *(Alte Armenhäuslerin mit Glasflasche und Mohn)*, 1906
96 x 80.2 cm; Private Collection

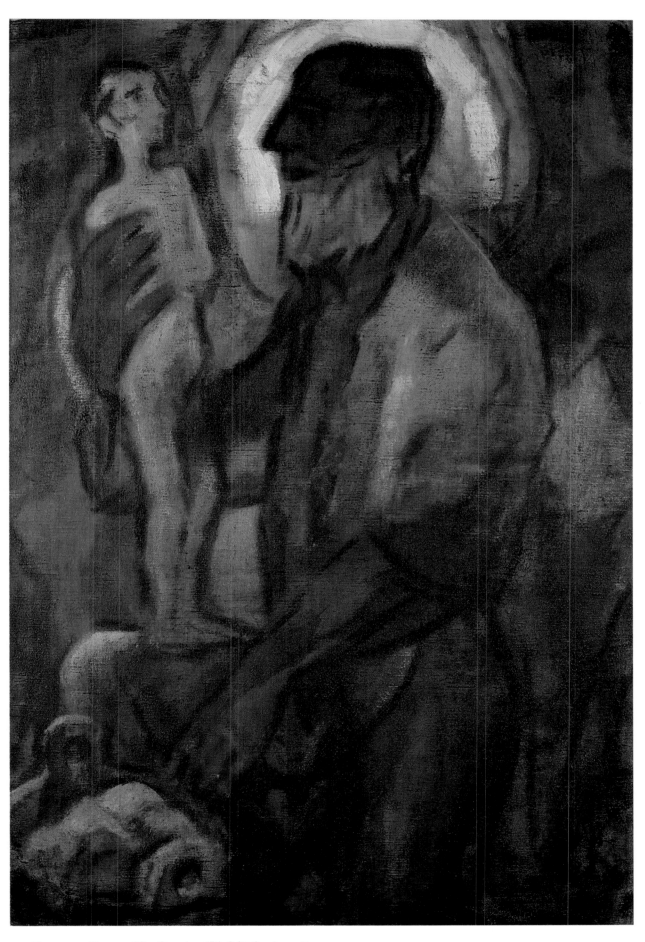

57 CHRISTIAN ROHLFS, The Creation *(Die Schöpfung)*, 1916
Tempera on canvas; 109 x 75 cm; Städtisches Museum Abteiberg, Mönchengladbach

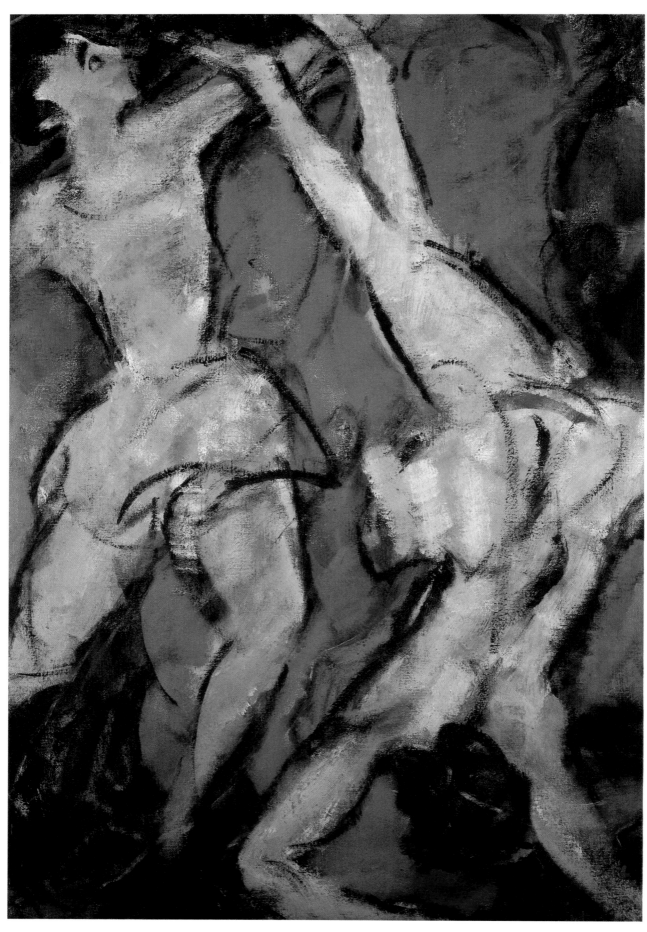

58 CHRISTIAN ROHLFS, Acrobats *(Akrobaten)*, 1916
Tempera on canvas; 110 x 75.5 cm; Museum Folkwang, Essen

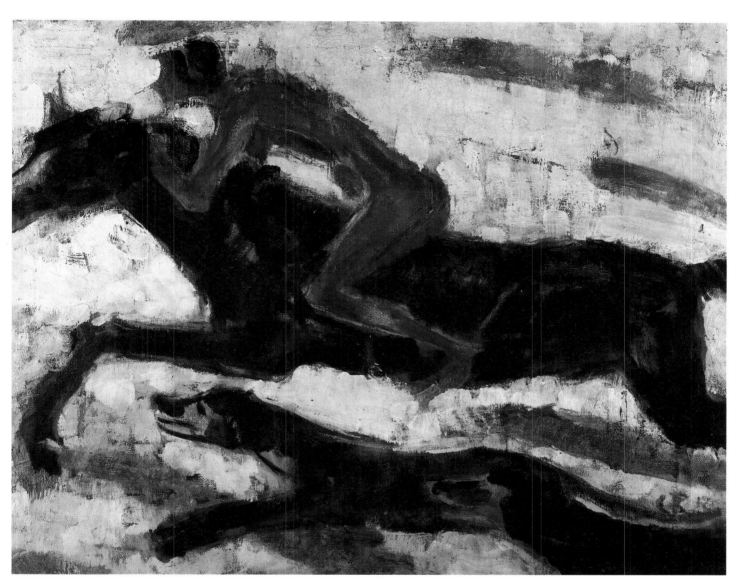

59 CHRISTIAN ROHLFS, Amazon *(Amazone)*, 1912
Tempera on canvas; 81.4 x 100 cm; Museum Folkwang, Essen

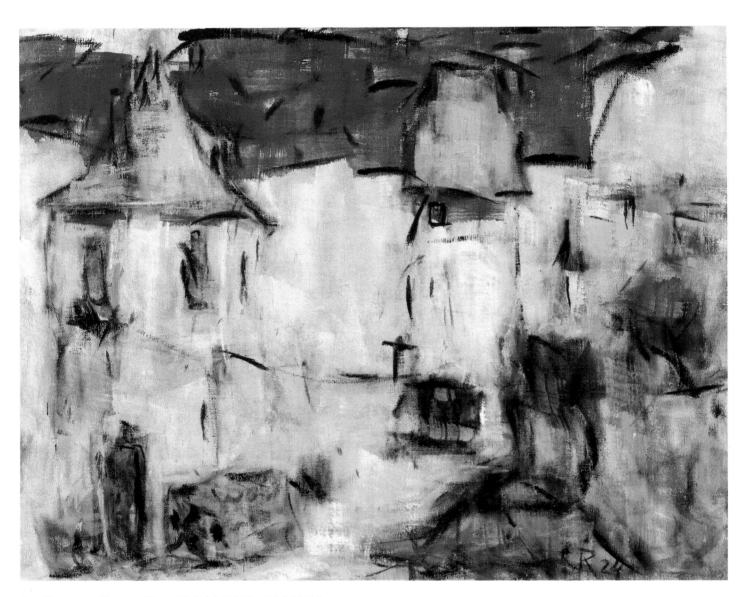

60　Christian Rohlfs, From Dinkelsbühl *(Aus Dinkelsbühl)*, 1924
　Tempera on canvas; 80.6 x 100 cm; Helene Rohlfs Foundation, Essen

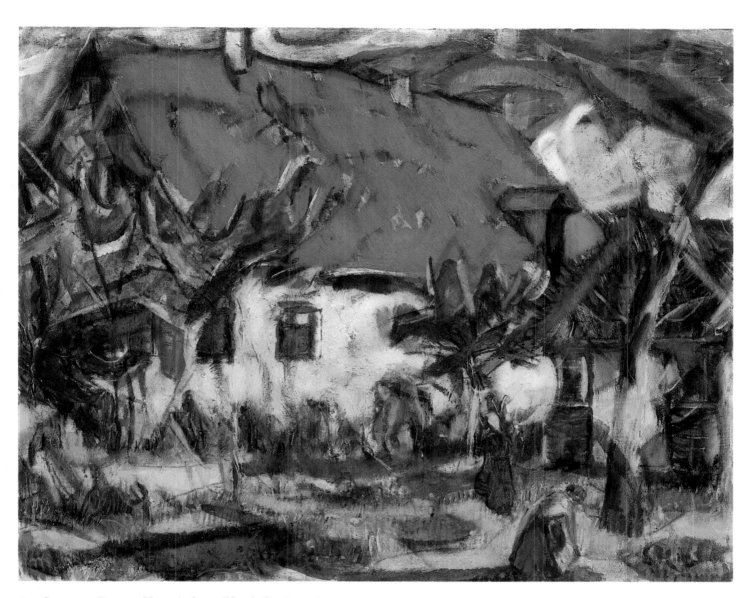

61 CHRISTIAN ROHLFS, House in Soest *(Haus in Soest)*, 1916
Tempera on canvas; 80 x 100 cm; Private Collection

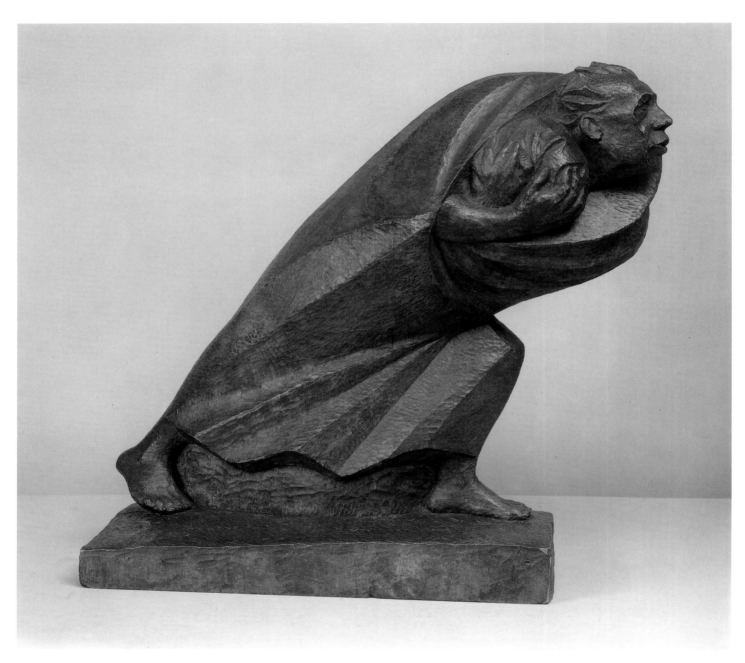

62 ERNST BARLACH, The Refugee *(Der Flüchtling)*, 1920
 Oak; 54 x 57 x 20.5 cm; Kunsthaus Zürich

63
ERNST BARLACH
The Ecstatic One *(Der Ekstatiker)*, 1916
Oak; 52 x 16 x 35 cm
Kunsthaus Zürich

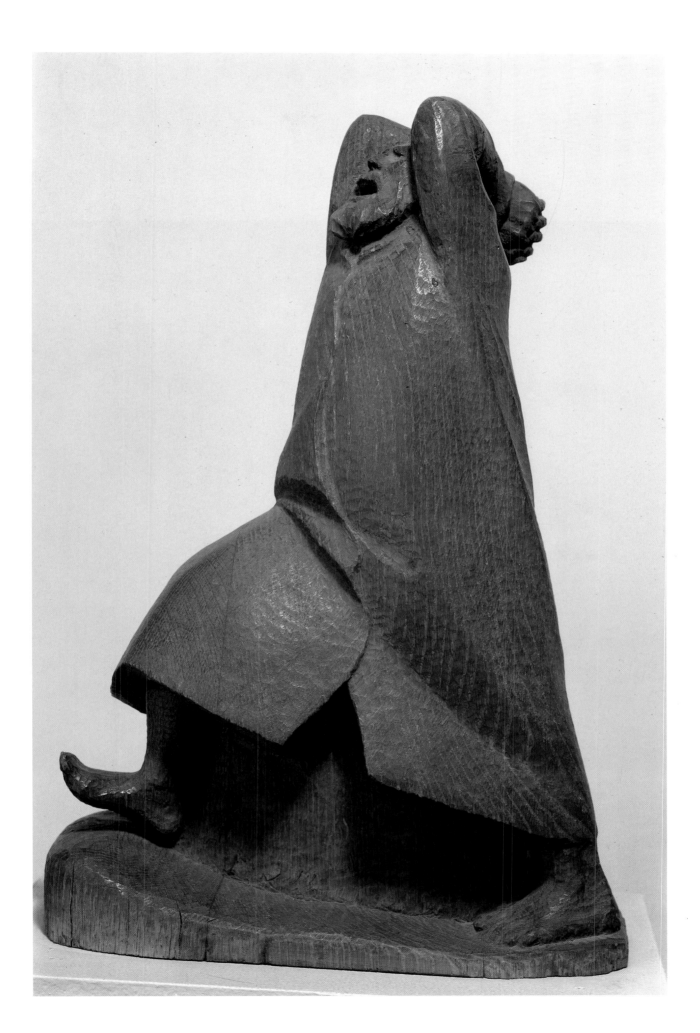

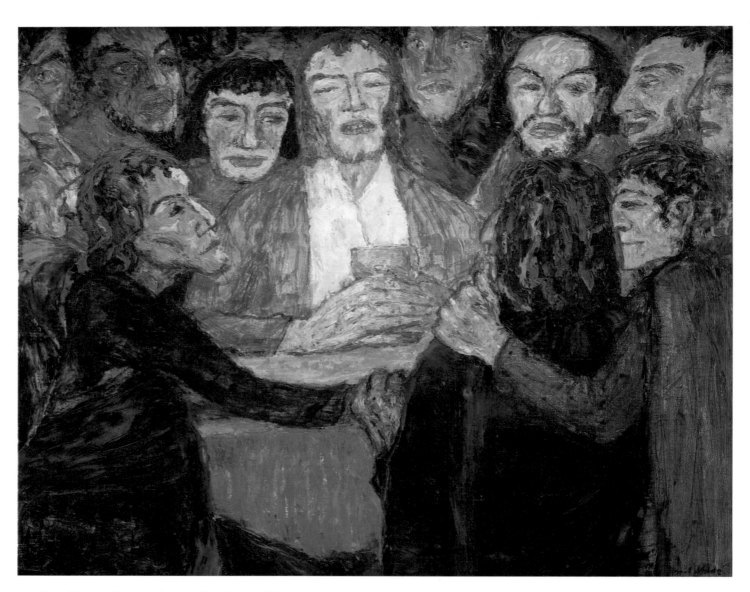

64 EMIL NOLDE, The Last Supper *(Das Abendmahl)*, 1909
 86 x 108 cm; Statens Museum for Kunst, Copenhagen

65 EMIL NOLDE, St. Mary of Egypt *(Hl. Maria von Ägypten)*, 1912
 87 x 100.5 cm; Museum Folkwang, Essen

66 EMIL NOLDE, In the Café *(Im Café)*, 1911
 73 x 89 cm; Museum Folkwang, Essen

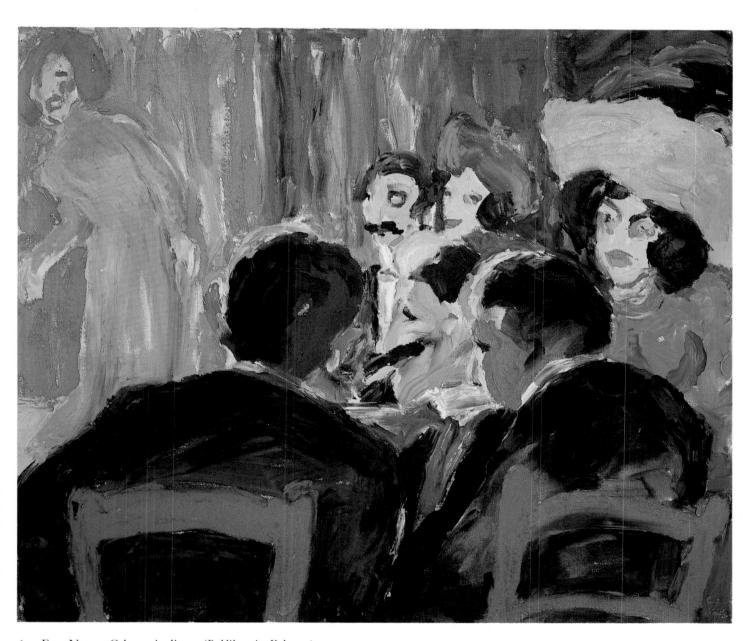

67 EMIL NOLDE, Cabaret Audience *(Publikum im Kabarett)*, 1911
86 x 99 cm; Nolde Foundation, Seebüll

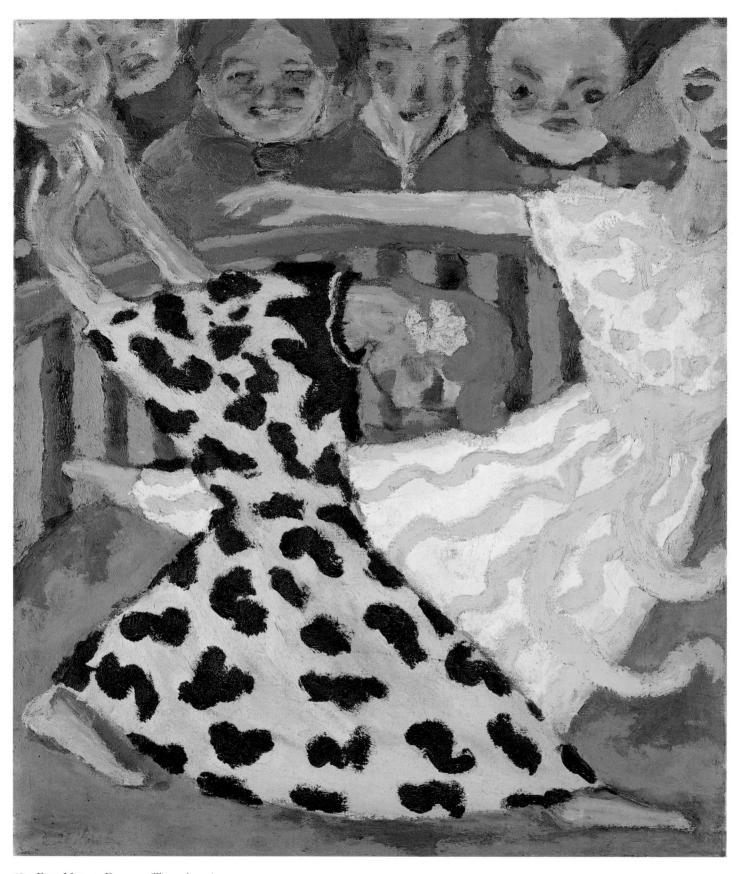

68 EMIL NOLDE, Dancers *(Tänzerinnen)*, 1920
 106 x 88 cm; Staatsgalerie Stuttgart

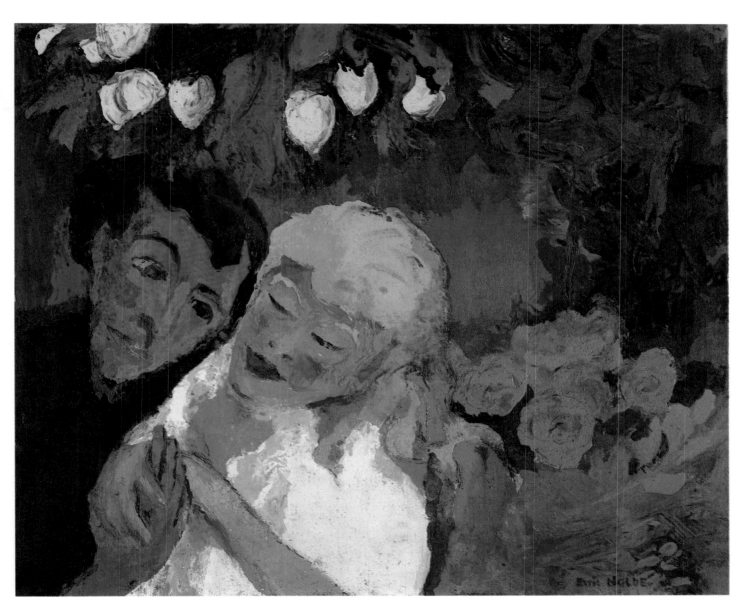

69　EMIL NOLDE, In the Lemon Garden (*Im Zitronengarten*), 1920
　　73 x 88 cm; Staatsgalerie Stuttgart

70 Emil Nolde, Tropical Sun *(Tropensonne)*, 1914
 71 x 104.5 cm; Nolde Foundation, Seebüll

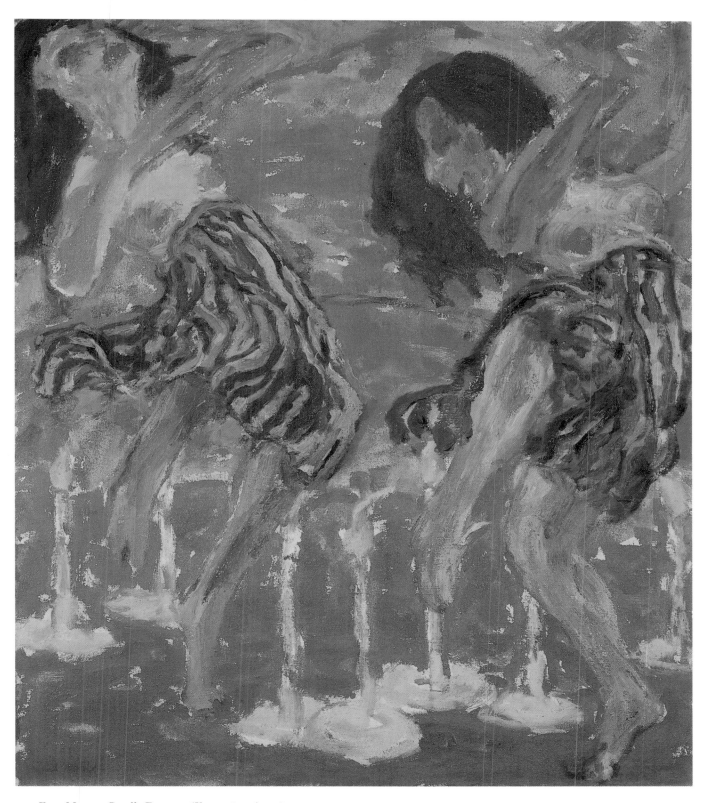

71 EMIL NOLDE, Candle Dancers *(Kerzentänzerinnen)*, 1912
100 x 85 cm; Nolde Foundation, Seebüll

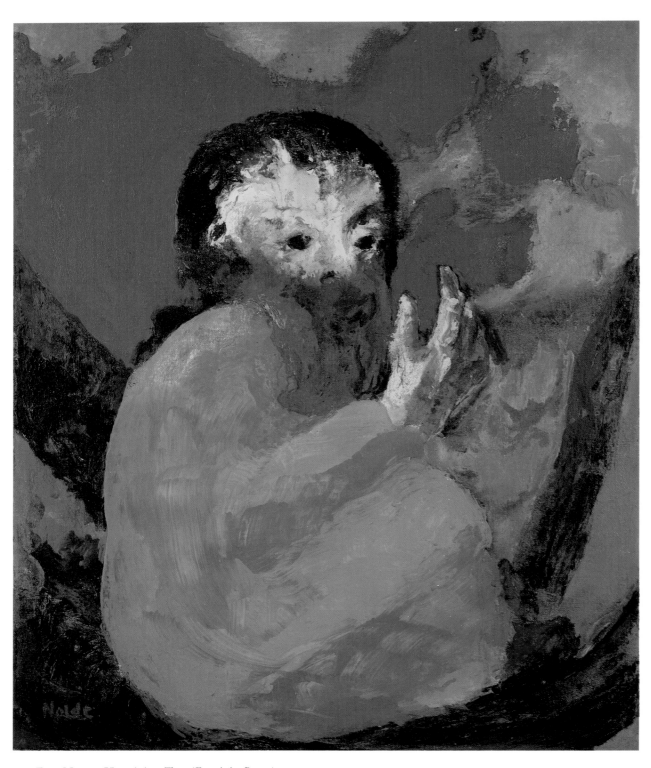

72 Emil Nolde, Hermit in a Tree *(Eremit im Baum)*, 1931
88.5 x 73.5 cm; Nolde Foundation, Seebüll

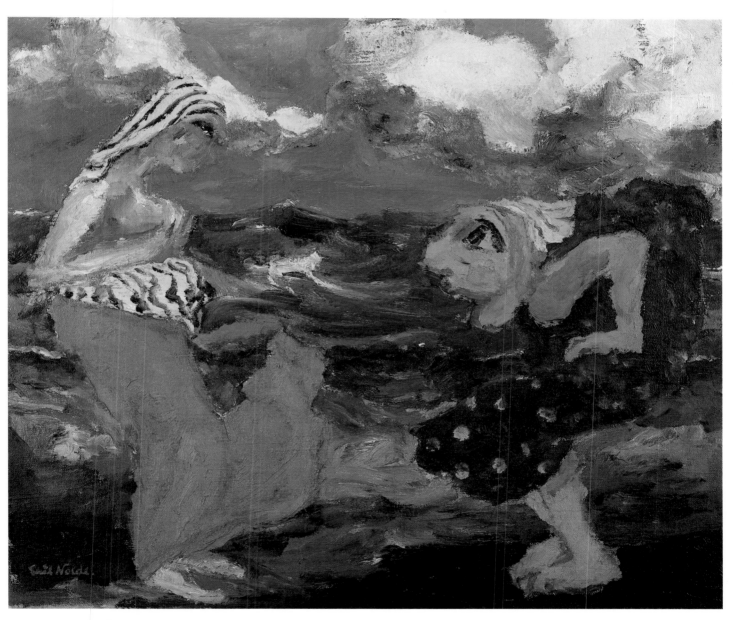

73　EMIL NOLDE, Meeting on the Beach *(Begegnung am Strand)*, 1921
　　86.5 x 100 cm; Nolde Foundation, Seebüll

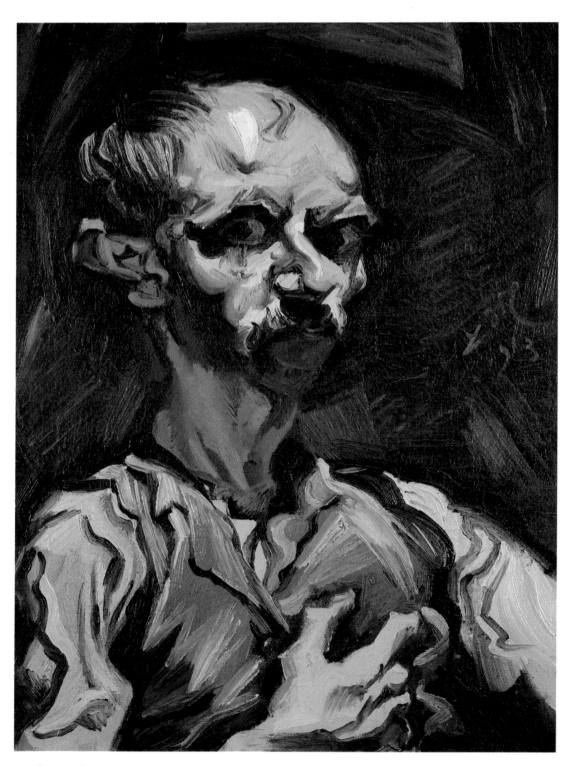

74 LUDWIG MEIDNER, My Night Visage *(Mein Nachtgesicht)*, 1913
66.7 x 48.9 cm; Mr and Mrs Marvin L. Fishman

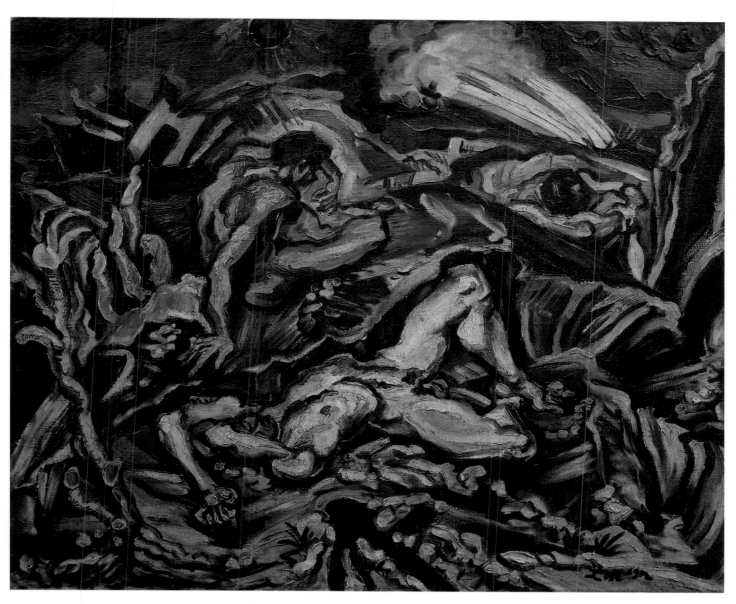

75 LUDWIG MEIDNER, Apocalyptic Vision *(Apokalyptische Vision)*, 1912
72.5 x 88.5 cm; Leicestershire Museums and Art Galleries

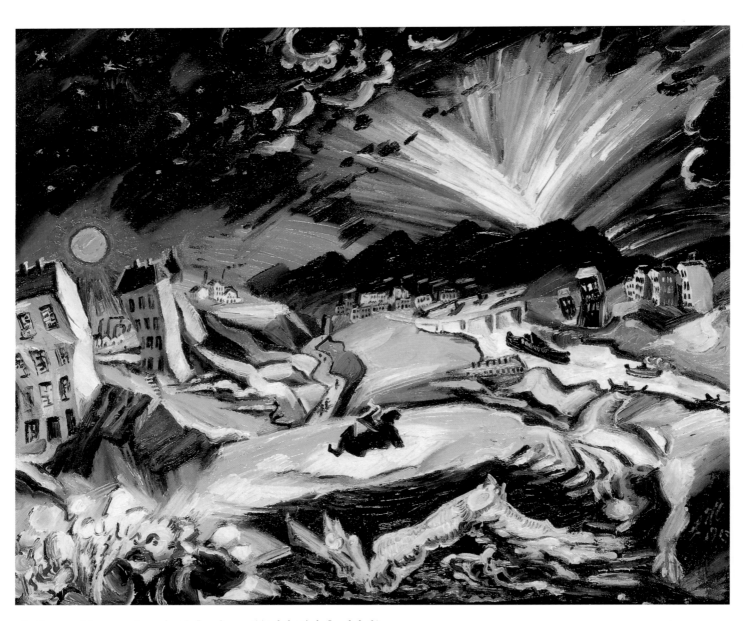

76 LUDWIG MEIDNER, Apocalyptic Landscape *(Apokalyptische Landschaft)*, 1913
 67.3 x 80 cm; Mr and Mrs Marvin L. Fishman

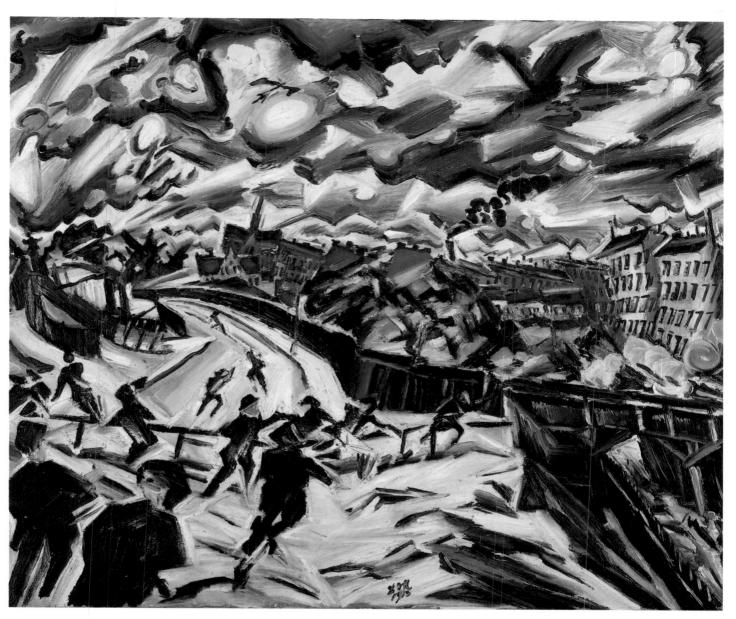

77　Ludwig Meidner, Apocalyptic Landscape *(Apokalyptische Landschaft)*, 1913
　　81.5 x 97 cm; Los Angeles County Museum of Art, Gift of Mr Clifford Odets

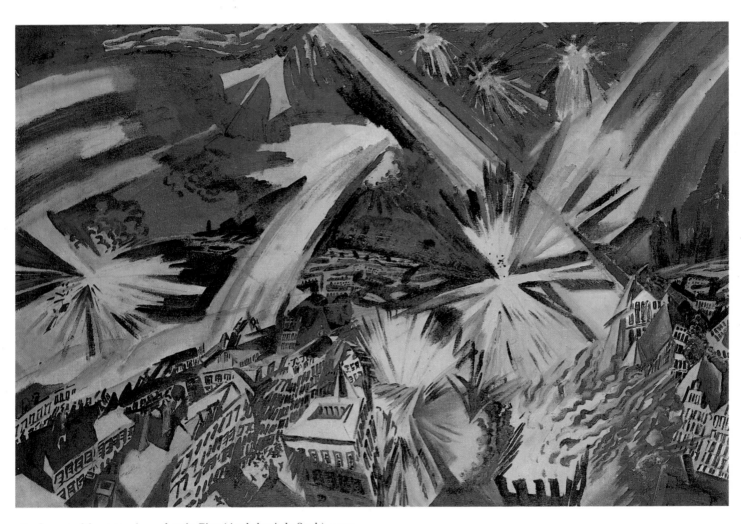

78 Ludwig Meidner, Apocalyptic City *(Apokalyptische Stadt)*, 1913
79 x 119 cm; Westfälisches Landesmuseum für Kunst und Kulturgeschichte, Münster

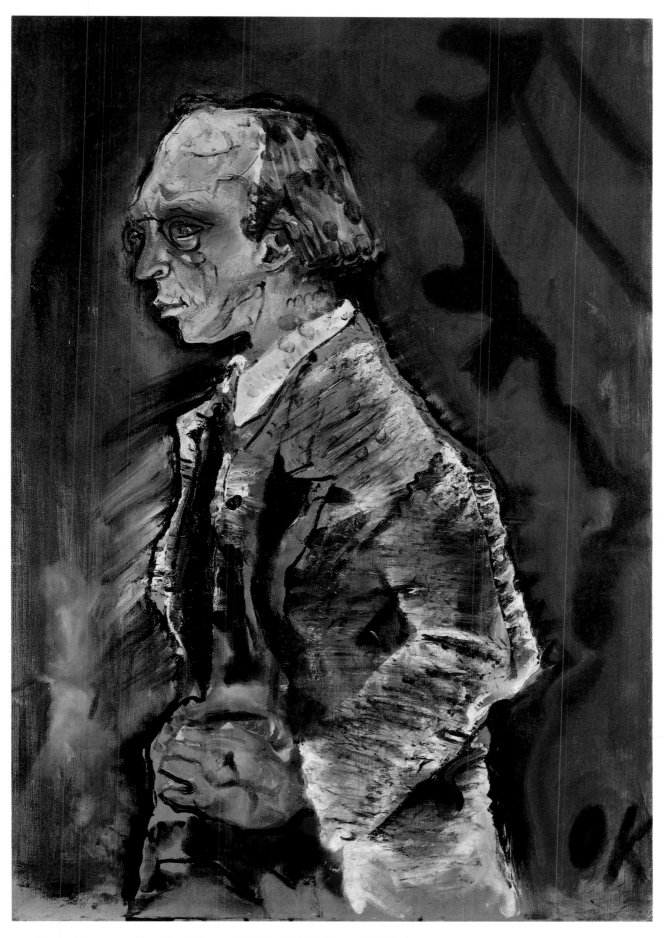

79 OSKAR KOKOSCHKA, Portrait of Herwarth Walden (*Bildnis Herwarth Walden*), 1910
100 x 69.3 cm; Staatsgalerie Stuttgart

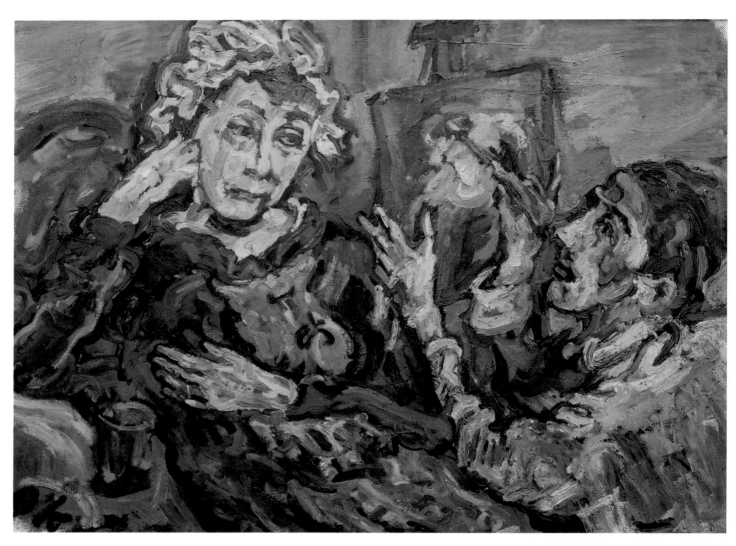

80 OSKAR KOKOSCHKA, Katja, 1918
90 x 126 cm; Von der Heydt-Museum, Wuppertal

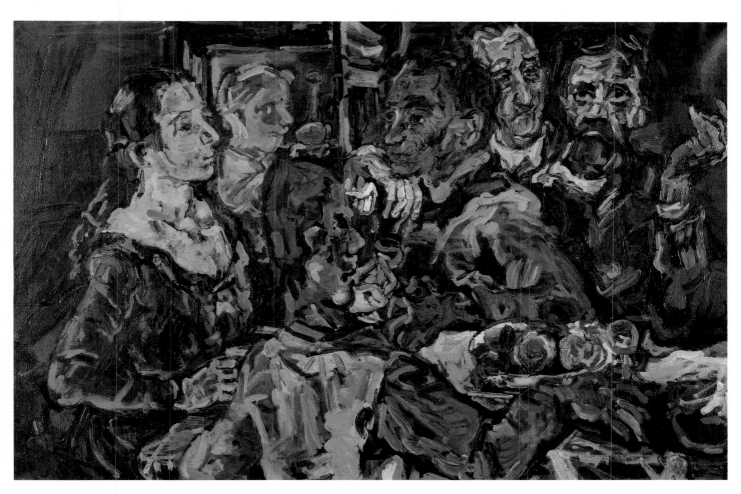

81 OSKAR KOKOSCHKA, The Friends *(Die Freunde)*, 1917/18
102 x 151 cm; Neue Galerie der Stadt Linz, Wolfgang Gurlitt Museum

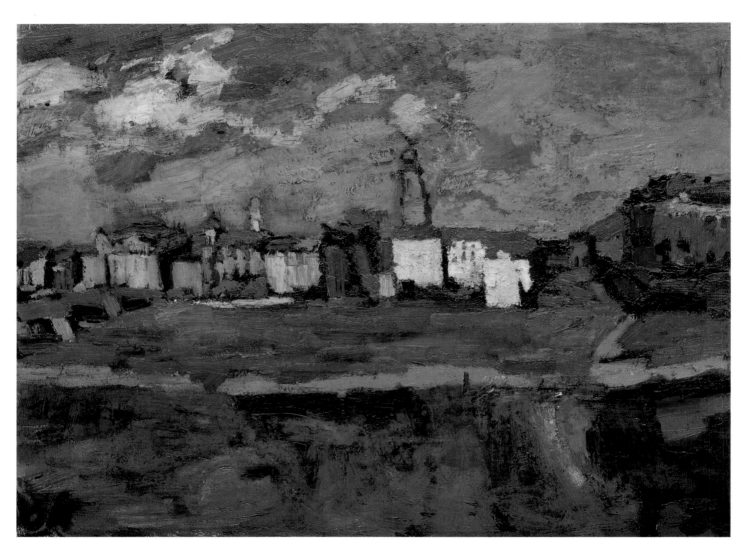

82 OSKAR KOKOSCHKA, The Elbe near Dresden II *(Dresden Neustadt II)*, c. 1921
59.7 x 80 cm; The Detroit Institute of Arts (City of Detroit Purchase)

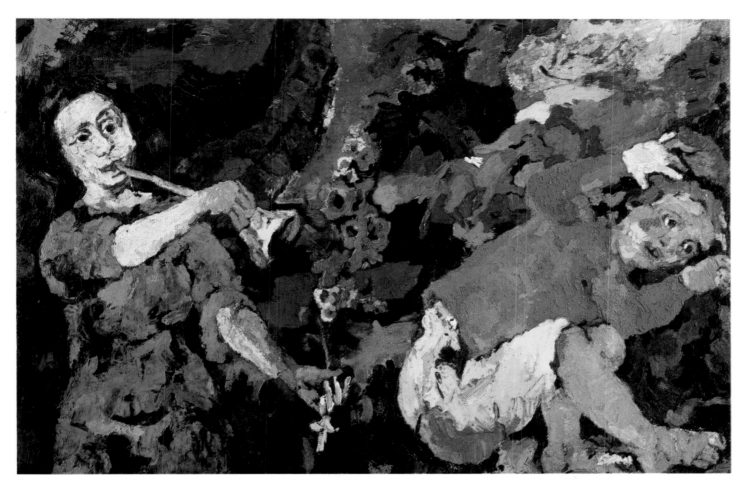

83 OSKAR KOKOSCHKA, The Power of Music *(Die Macht der Musik)*, 1918
100 x 151.5 cm; Stedelijk Van Abbemuseum, Eindhoven

84 OSKAR KOKOSCHKA, Hans Mardersteig and Carl Georg Heise *(Hans Mardersteig und Carl Georg Heise)*, 1919
108 x 150.3 cm; Museum Boymans-van Beuningen, Rotterdam

85 Oskar Kokoschka, Portrait of the Poet Ernst Blass (*Bildnis des Dichters Ernst Blass*), 1925
80 x 120 cm; Kunsthalle Bremen

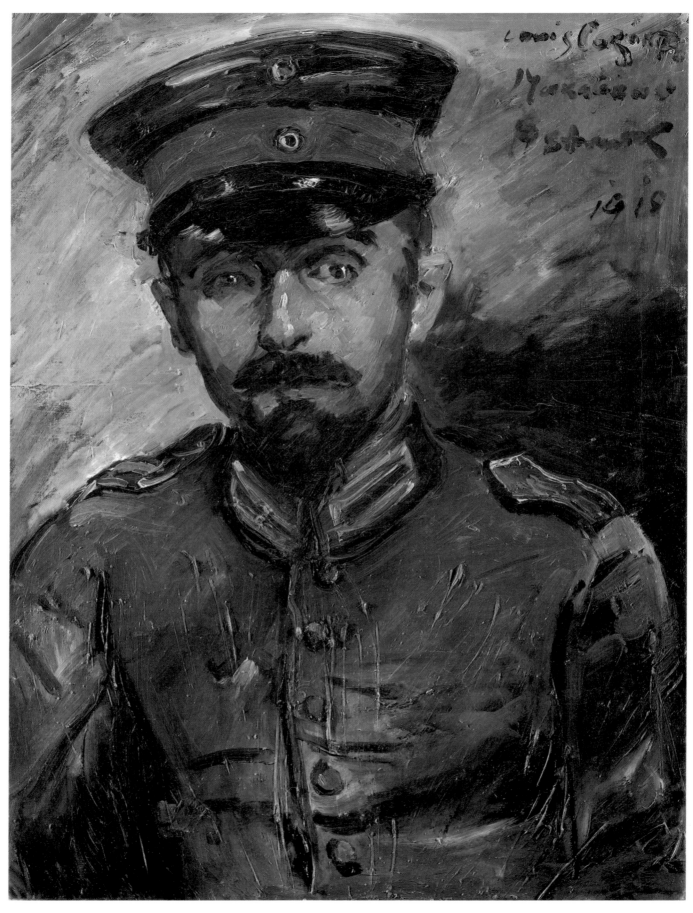

86 LOVIS CORINTH, Portrait of Makabäus – Hermann Struck *(Bildnis Makabäus – Hermann Struck)*, 1915
80.5 x 59.5 cm; Munich, Städtische Galerie im Lenbachhaus

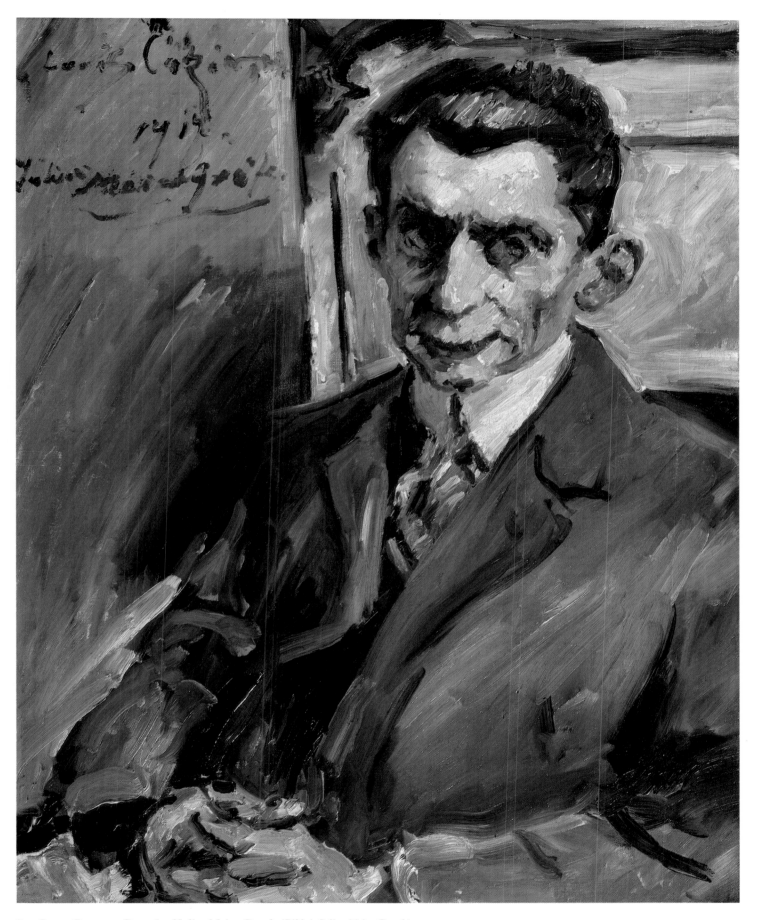

87 LOVIS CORINTH, Portrait of Julius Meier-Graefe *(Bildnis Julius Meier-Graefe)*, 1917
90 x 70 cm; Musee d'Orsay, Paris

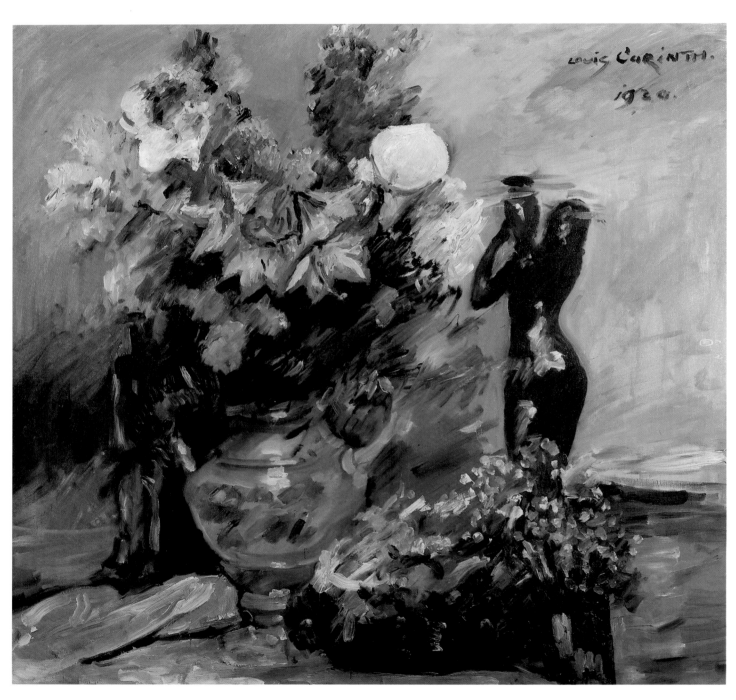

88 Lovis Corinth, Still Life with Flowers *(Blumenstilleben)*, 1920
120 x 125 cm; Von der Heydt-Museum, Wuppertal

89 Lovis Corinth, Nude with Putti *(Akt mit Putten)*, 1921
140 x 200 cm; Munich, Städtische Galerie im Lenbachhaus

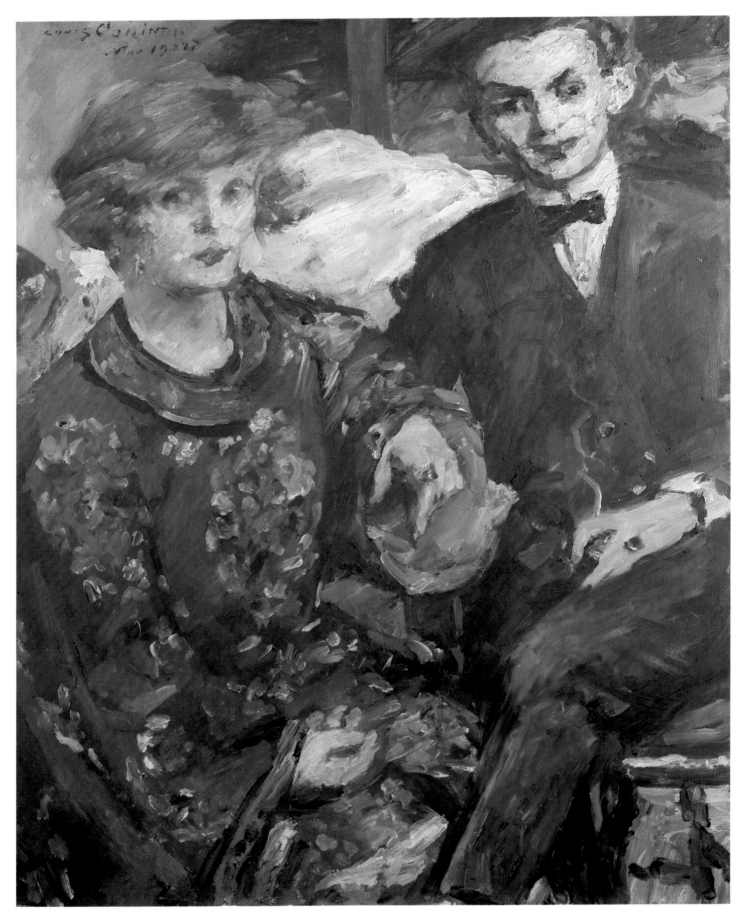

90 Lovis Corinth, Portrait of Mr and Mrs Erich Goeritz *(Bildnis Erich Goeritz und Frau)*, 1922
133 x 103 cm; Insel Hombroich

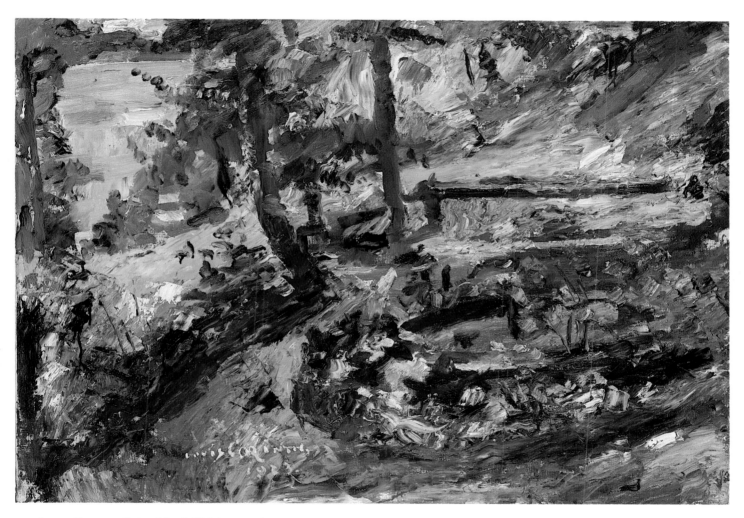

91 Lovis Corinth, Rainy Mood, Walchensee *(Regenstimmung am Walchensee)*, 1923
70 x 100 cm; Private Collection

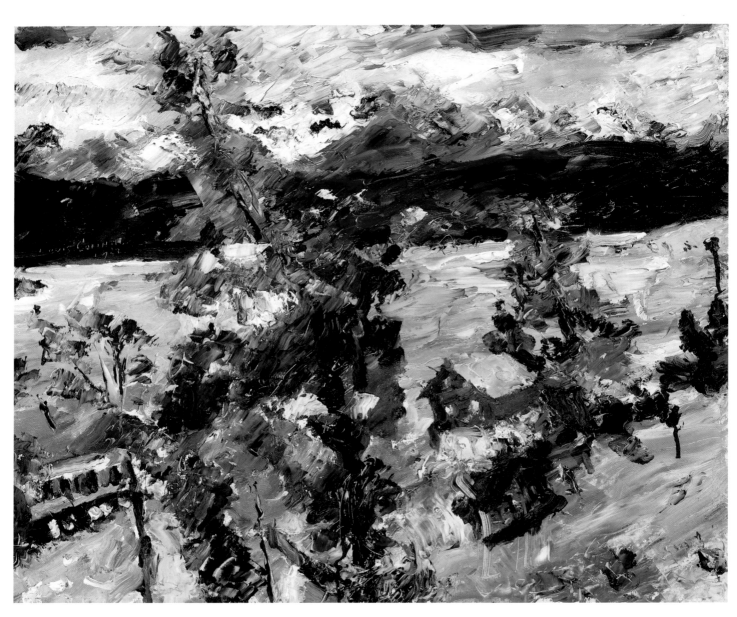

92 LOVIS CORINTH, Walchensee, Newly Fallen Snow *(Walchensee bei Neuschnee)*, 1922
 54 x 66 cm; Private Collection

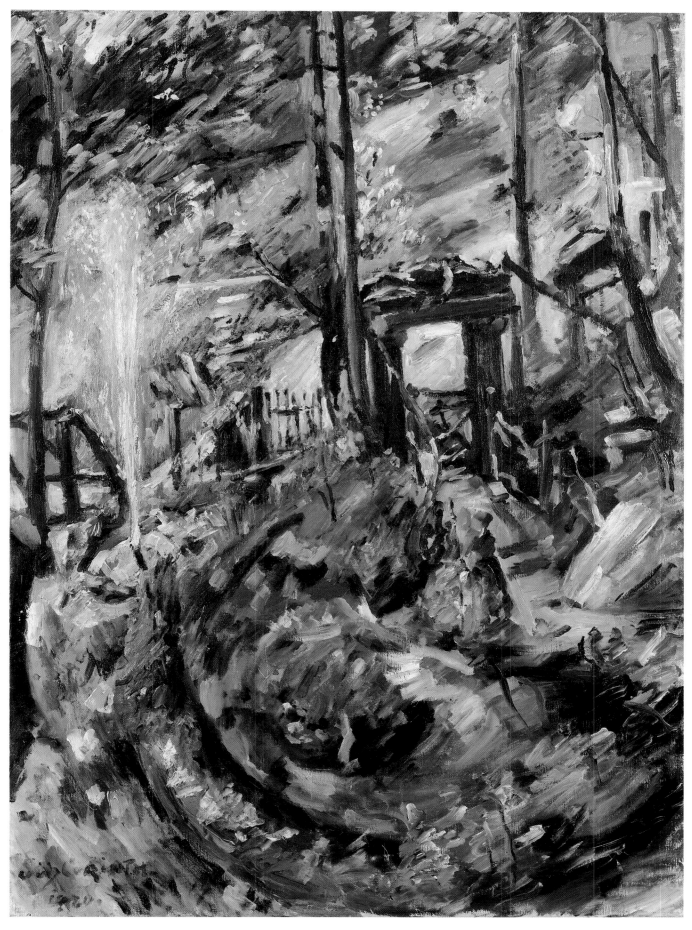

93 Lovis Corinth, Fountain at Walchensee *(Springbrunnen am Walchensee)*, 1920
110 x 80 cm; Insel Hombroich

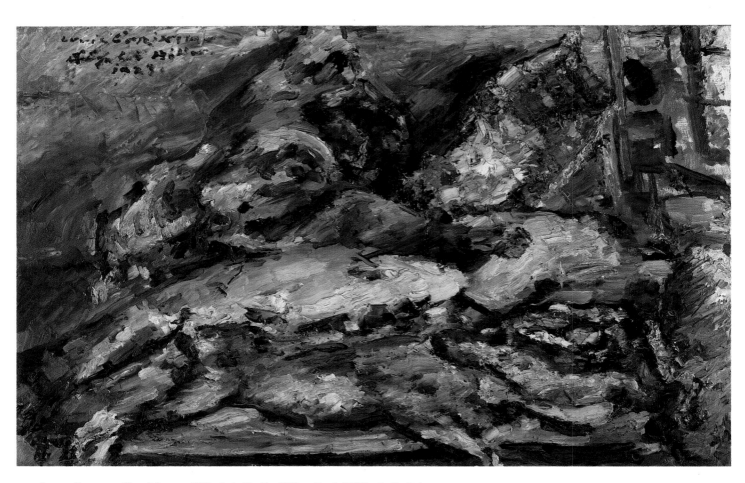

94　Lovis Corinth, Provisions at Hiller's in Berlin *(Viktualien bei Hiller in Berlin)*, 1923
　　90 x 140 cm; Staatsgalerie Stuttgart

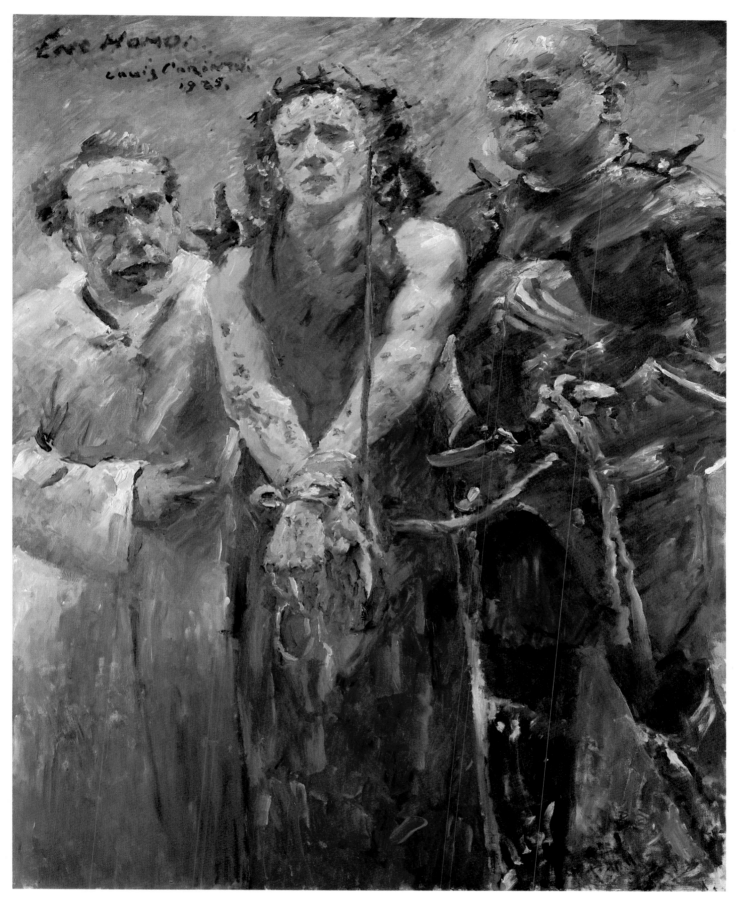

95 Lovis Corinth, Ecce homo, 1925
 190.5 x 150 cm; Öffentliche Kunstsammlung, Kunstmuseum Basle

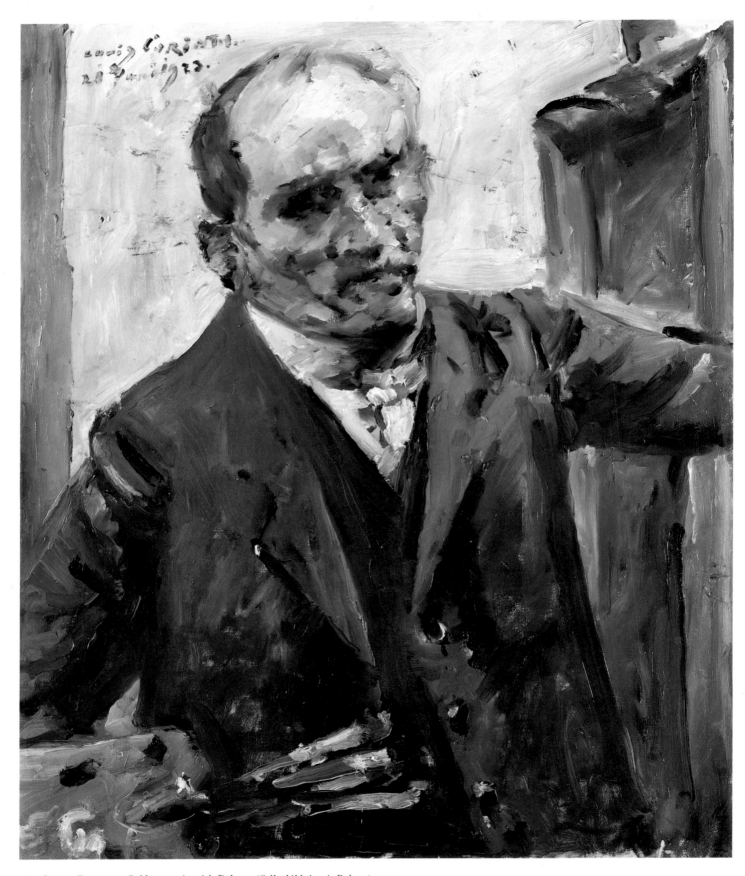

96 LOVIS CORINTH, Self-portrait with Palette *(Selbstbildnis mit Palette)*, 1923
 90 x 75 cm; Staatsgalerie Stuttgart

97 LOVIS CORINTH, Walchensee in Moonlight *(Walchensee im Mondschein)*, 1920
 78 x 104 cm; Munich, Städtische Galerie im Lenbachhaus

98 WILHELM LEHMBRUCK, Torso of a Young Girl Turning *(Mädchentorso sich umwendend)*, 1913/14
Stone cast; 98 x 46.5 x 36.5 cm; Staatsgalerie Stuttgart

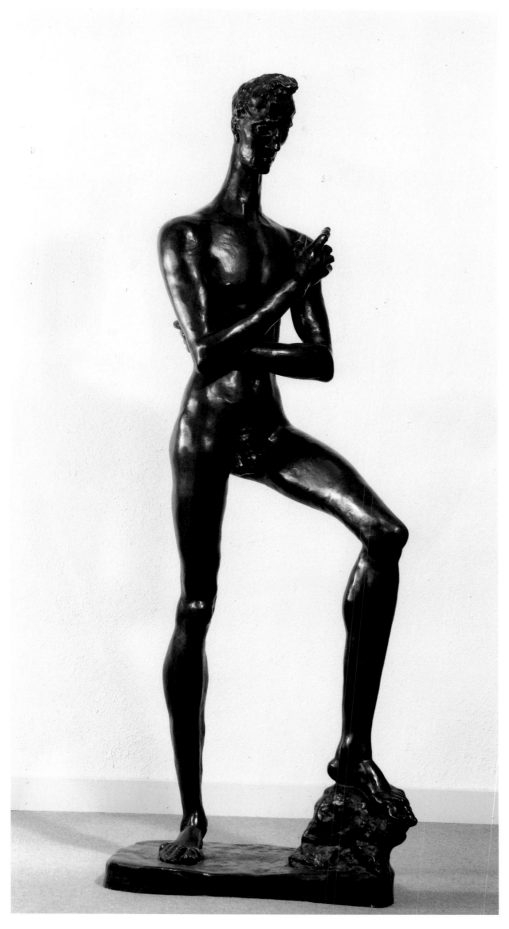

99 WILHELM LEHMBRUCK, Ascending Youth *(Emporsteigender Jüngling)*, 1913
Bronze; 221 x 84 x 55 cm; Kunsthaus Zürich, Vereinigung Züricher Kunstfreunde

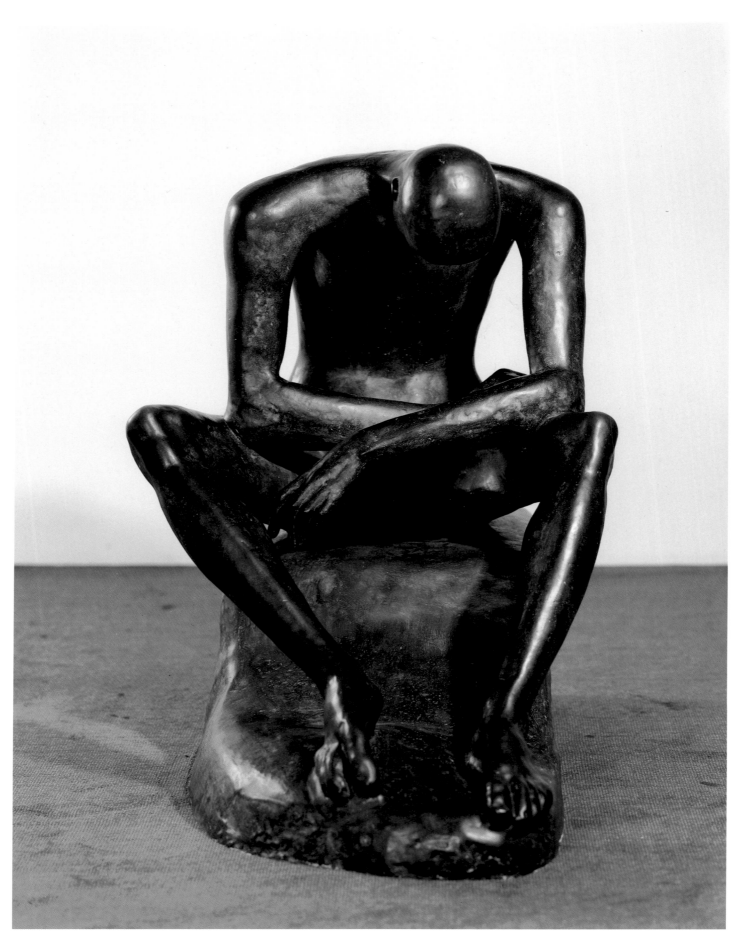

100 WILHELM LEHMBRUCK, Seated Youth *(Sitzender Jüngling)*, 1916
Bronze; 103.5 x 76.8 x 114.8 cm; Wilhelm Lehmbruck Museum der Stadt Duisburg

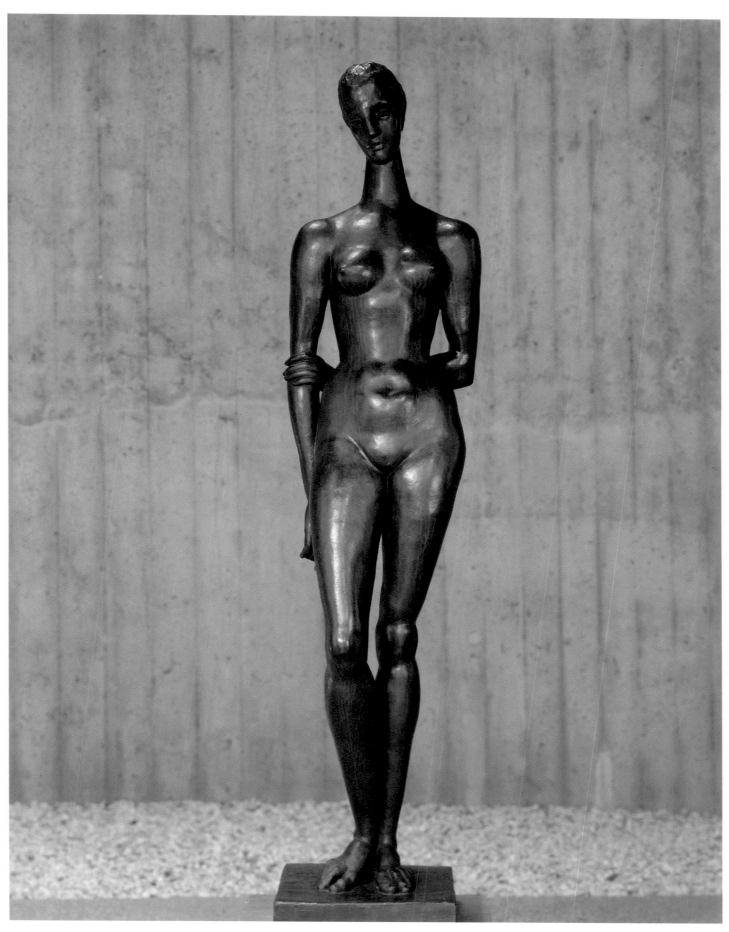

101 WILHELM LEHMBRUCK, The Contemplative One (*Die Sinnende*), 1913/14
Bronze; 208 x 47 x 43 cm; Nachlaß Lehmbruck

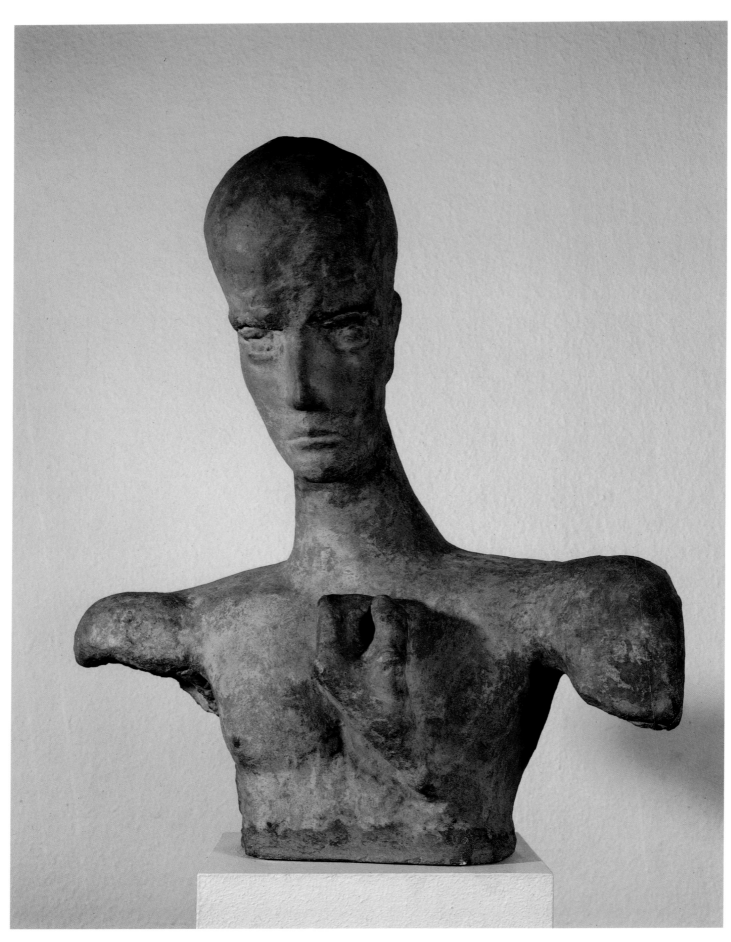

102 WILHELM LEHMBRUCK, Head of a Thinker *(Denkerkopf)*, 1918
Stone cast; 61 x 62 x 25 cm; Nachlaß Lehmbruck

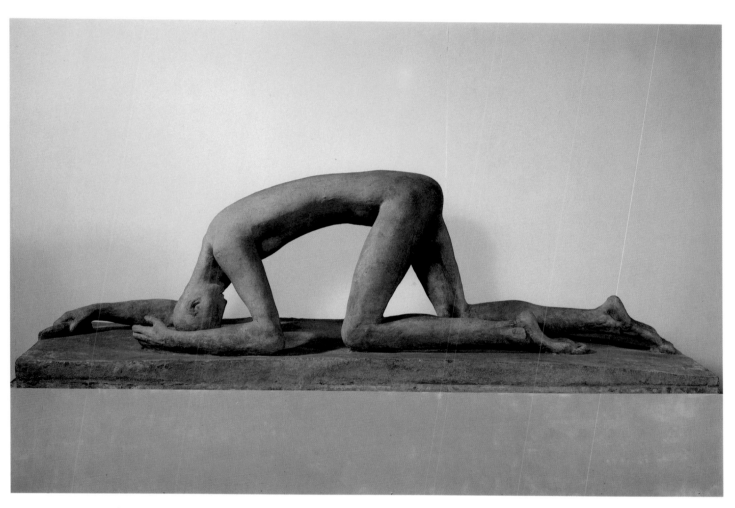

103 WILHELM LEHMBRUCK, The Fallen Man *(Der Gestürzte)*, 1915/16
Stone cast; 78 x 240 x 82 cm; Nachlaß Lehmbruck

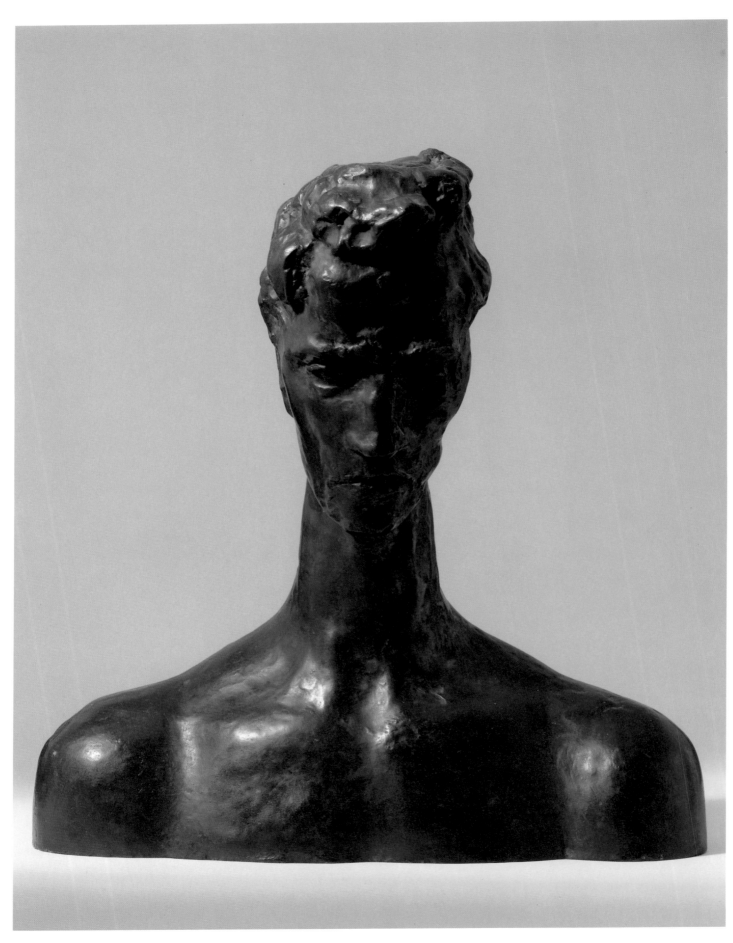

104 WILHELM LEHMBRUCK, Head of a Youth (*Jünglingskopf*), 1913/14
Bronze; 53 x 52 x 33 cm; Nachlaß Lehmbruck

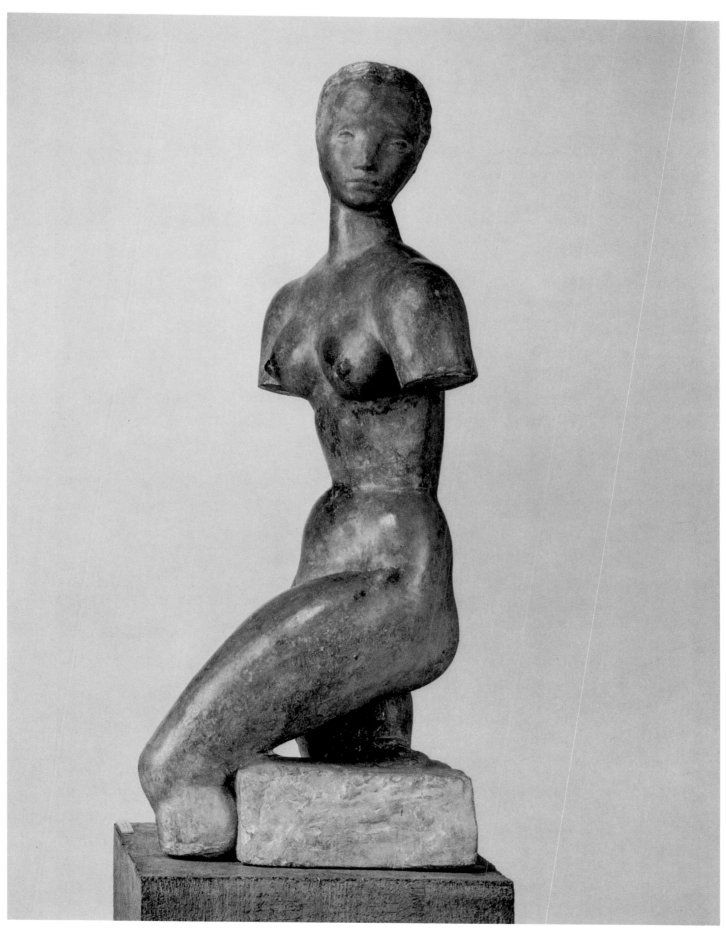

105 WILHELM LEHMBRUCK, Young Girl Turning *(Mädchen sich umwendend)*, 1913/14
 Bronze; 127 x 46.5 x 51 cm; Nachlaß Lehmbruck

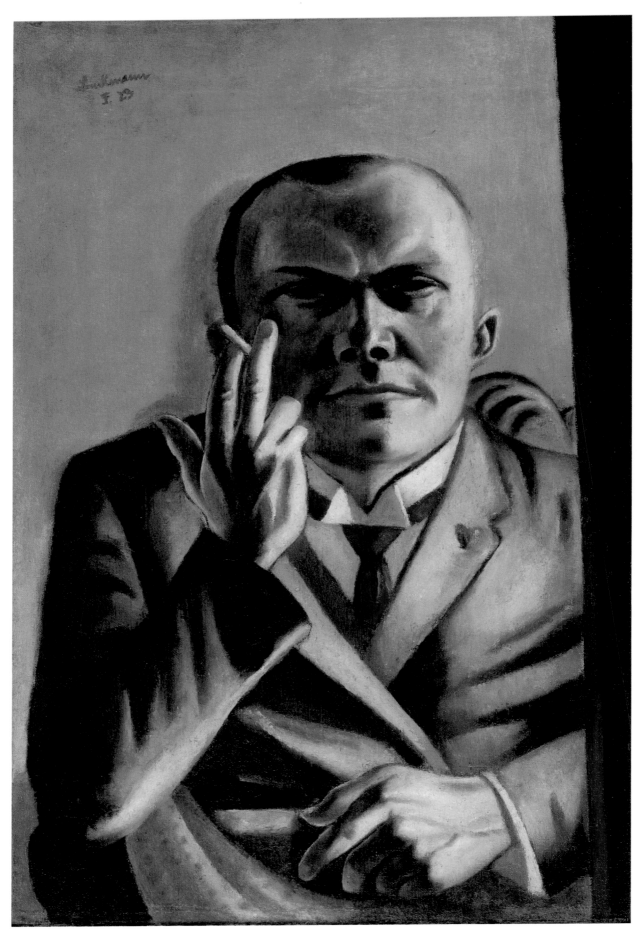

106 MAX BECKMANN, Self-portrait with Cigarette *(Selbstbildnis mit Cigarette)*, 1923
60.2 x 40.3 cm; The Museum of Modern Art, New York, Gift of Dr. and Mrs F. H. Hirschland

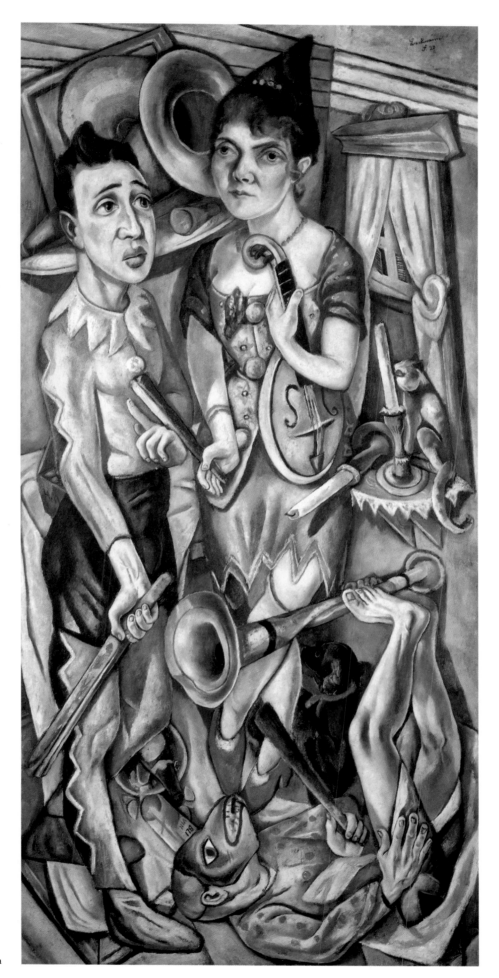

107
MAX BECKMANN
Carnival, 1920
Fastnacht
186.4 x 91.8 cm
The Trustees of the
Tate Gallery, London

108 MAX BECKMANN, Self-portrait with Black Cap *(Selbstbildnis mit schwarzer Kappe)*, 1934
100 x 70 cm; Museum Ludwig, Cologne

109
MAX BECKMANN
Self-portrait with
Saxophone, 1930
Selbstbildnis mit Saxophon
140 x 69.5 cm
Kunsthalle Bremen

110 MAX BECKMANN, Quappi with Parrot *(Quappi mit Papagei)*, 1936
110.5 x 65.5 cm; Städtisches Museum Mülheim an der Ruhr

111
MAX BECKMANN
Portrait of an Argentinian, 1929
Bildnis eines Argentiniers
125 x 83.5 cm
Munich, Bayerische Staatsgemäldesammlungen,
Staatsgalerie moderner Kunst

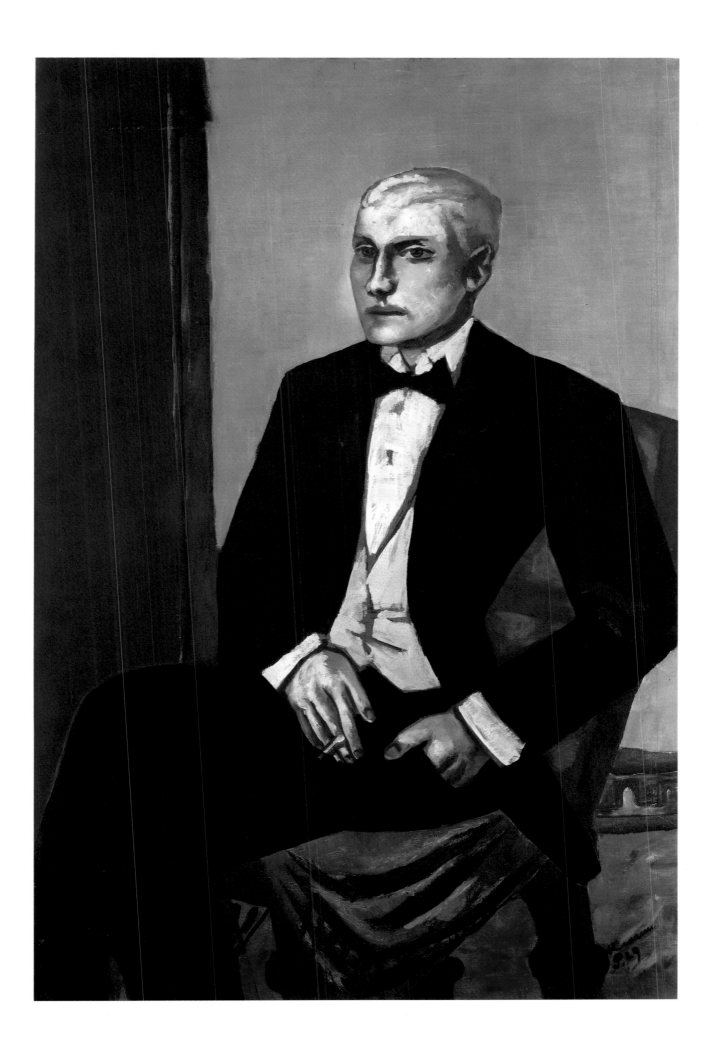

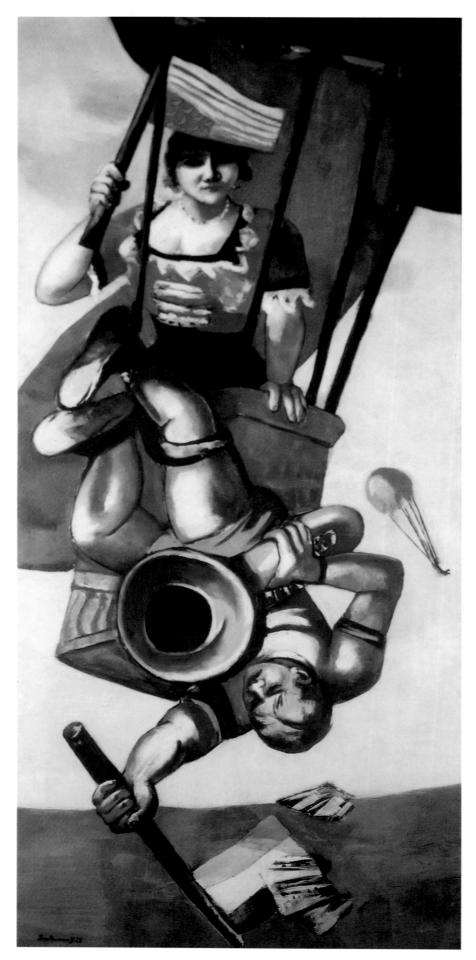

112
MAX BECKMANN
Aerial Acrobats, 1928
Luftakrobaten
215 x 100 cm
Von der Heydt-Museum,
Wuppertal

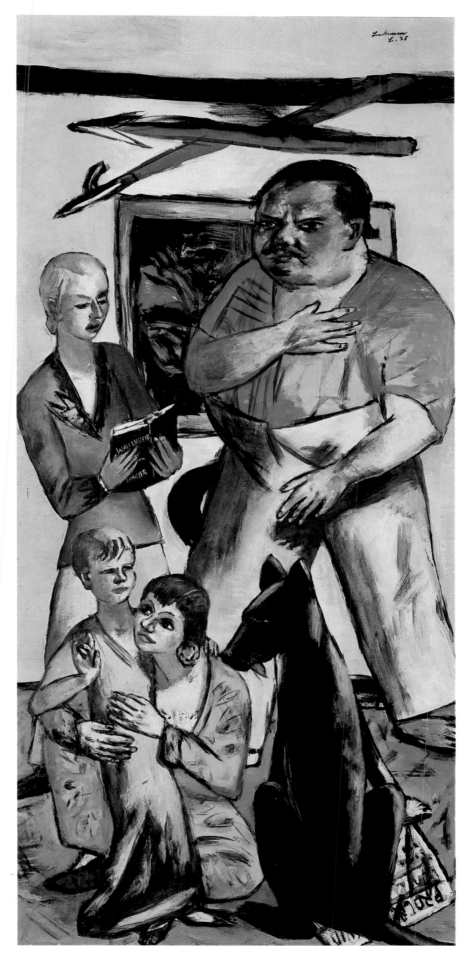

113
MAX BECKMANN
Portrait of Heinrich George
and his Family, 1935
Familienbild Heinrich George
215 x 100 cm
Staatliche Museen Preussischer
Kulturbesitz, Nationalgalerie
Berlin

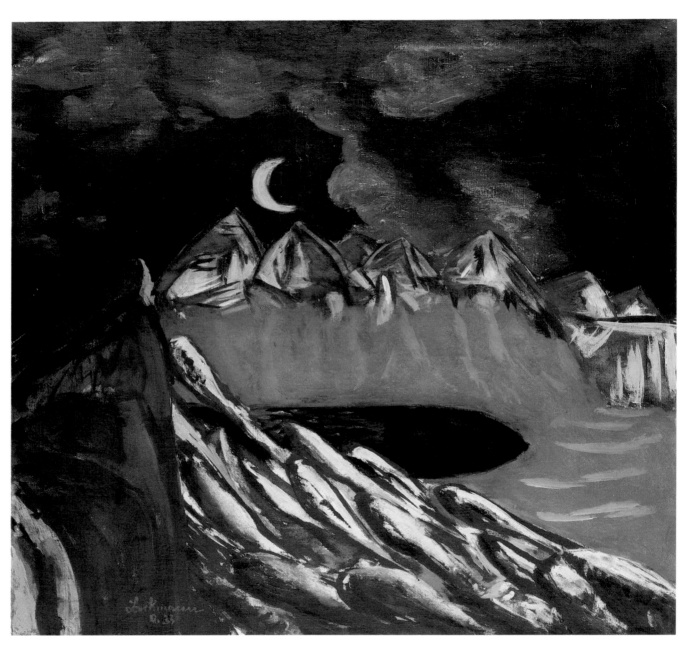

114 MAX BECKMANN, Walchensee, 1933
 75 x 78 cm; Museum Ludwig, Cologne

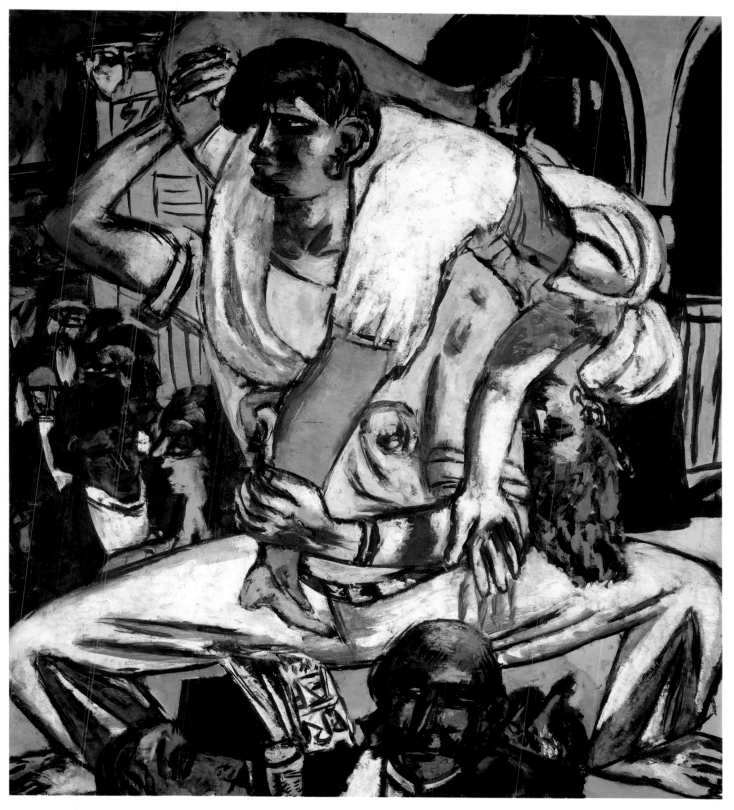

115 Max Beckmann, Dance of the Cut-throats *(Apachentanz)*, 1938
171.5 x 151 cm; Kunsthalle Bremen

116 Max Beckmann, Promenade des Anglais in Nice *(Promenade des Anglais in Nizza)*, 1947
80.5 x 90.4 cm; Museum Folkwang, Essen

117
Max Beckmann
The Theatre Box *(Die Loge)*, 1928
121 x 85 cm
Staatsgalerie Stuttgart

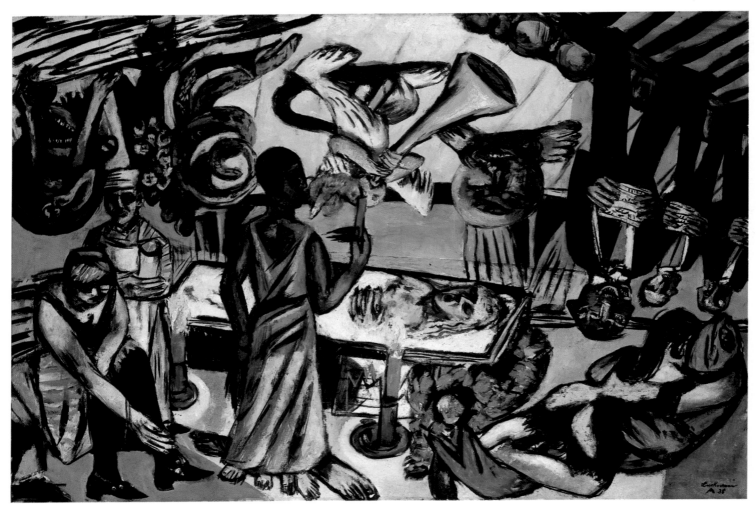

118 MAX BECKMANN, Death *(Tod)*, 1938
 121 x 176.5 cm; Staatliche Museen Preussischer Kulturbesitz, Nationalgalerie Berlin

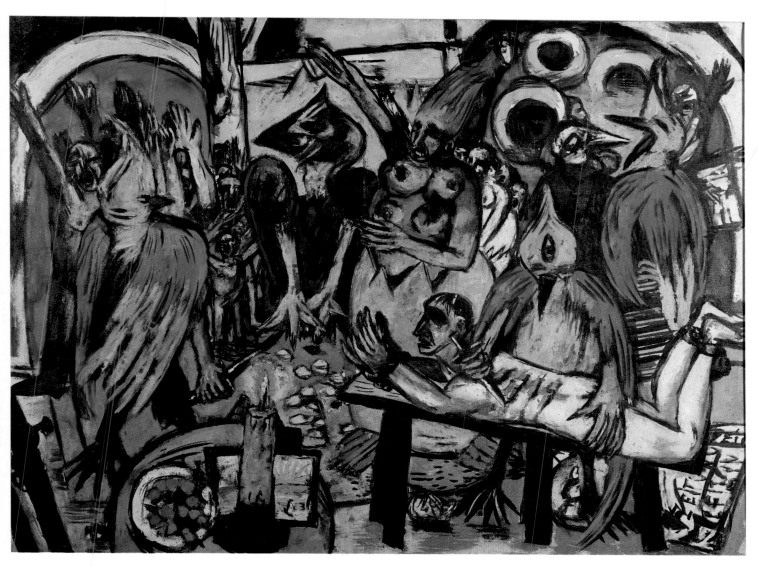

119 MAX BECKMANN, Birds' Hell (*Hölle der Vögel*), 1938
 120 x 160.5 cm; Richard L. Feigen, New York

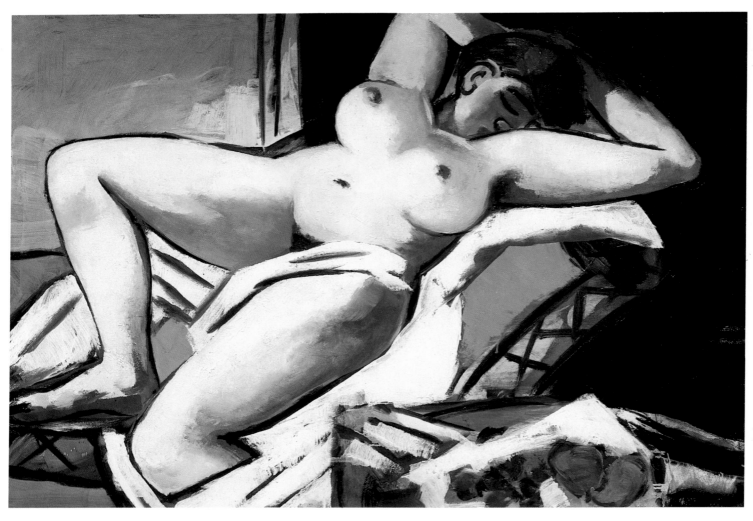

120 MAX BECKMANN, Reclining Nude *(Liegender Akt)*, 1929
83.5 x 119 cm; The Regis Collection

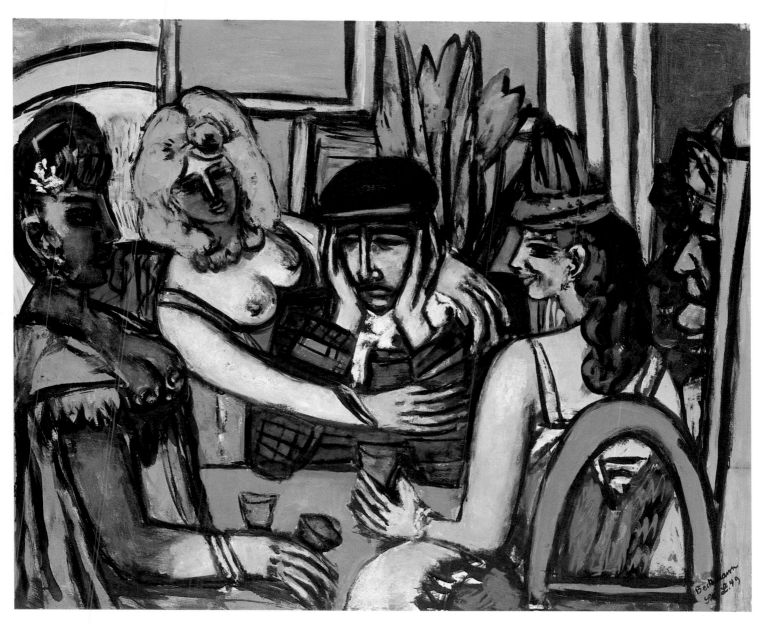

121 MAX BECKMANN, The Prodigal Son *(Der verlorene Sohn)*, 1949
 100 x 120 cm; Kunstmuseum Hannover mit Sammlung Sprengel

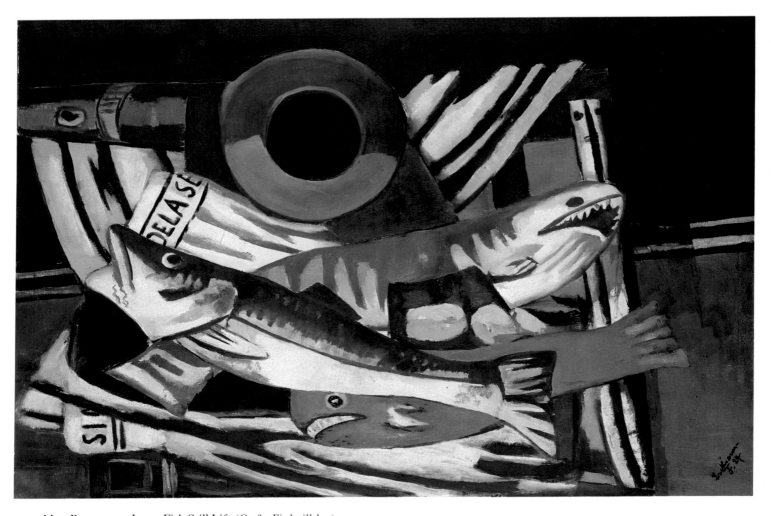

122　Max Beckmann, Large Fish Still Life *(Großes Fischstilleben)*, 1927
96 x 140.5 cm; Hamburger Kunsthalle

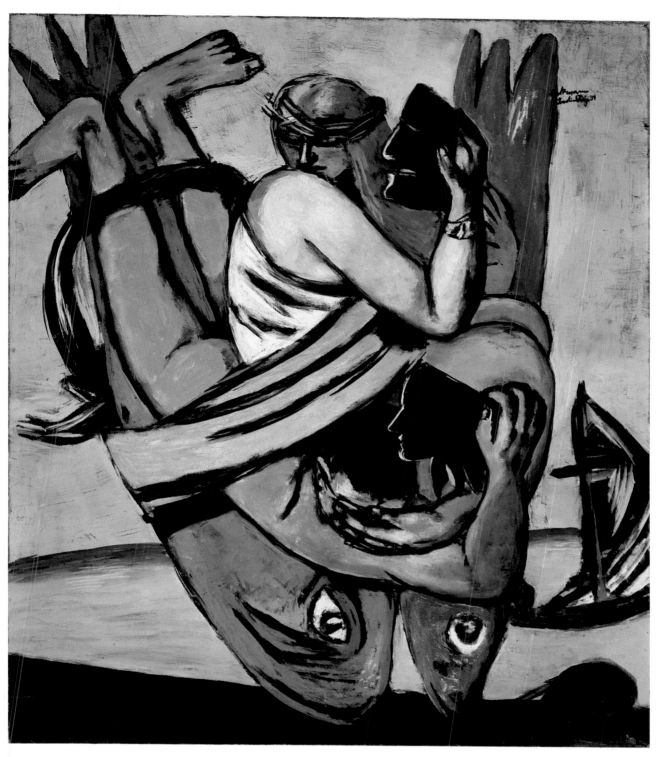

123 MAX BECKMANN, Voyage on the Fish *(Reise auf dem Fisch)*, 1934
 134.5 x 115 cm; Private Collection

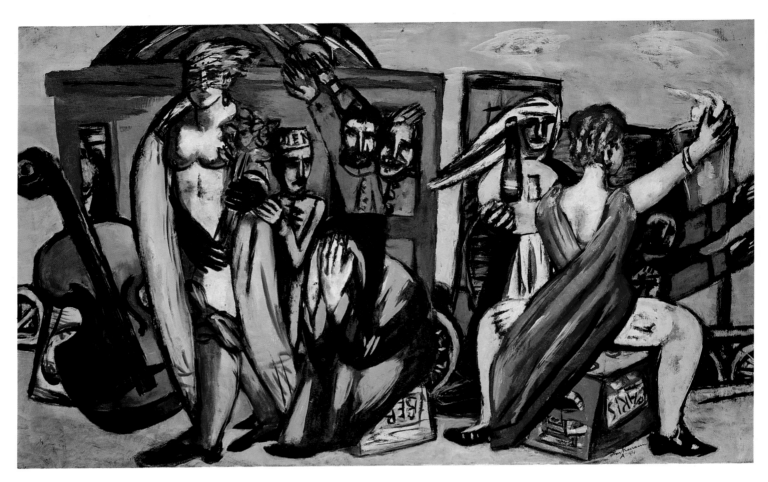

124
Max Beckmann
The Voyage *(Die Reise)*, 1944
90 x 145 cm; Private Collection

125
Max Beckmann
The Man in Darkness *(Der Mann im Dunkeln)*, 1934
Bronze; 57.3 x 20 x 25 cm
Munich, Bayerische Staatsgemäldesammlungen,
Staatsgalerie moderner Kunst

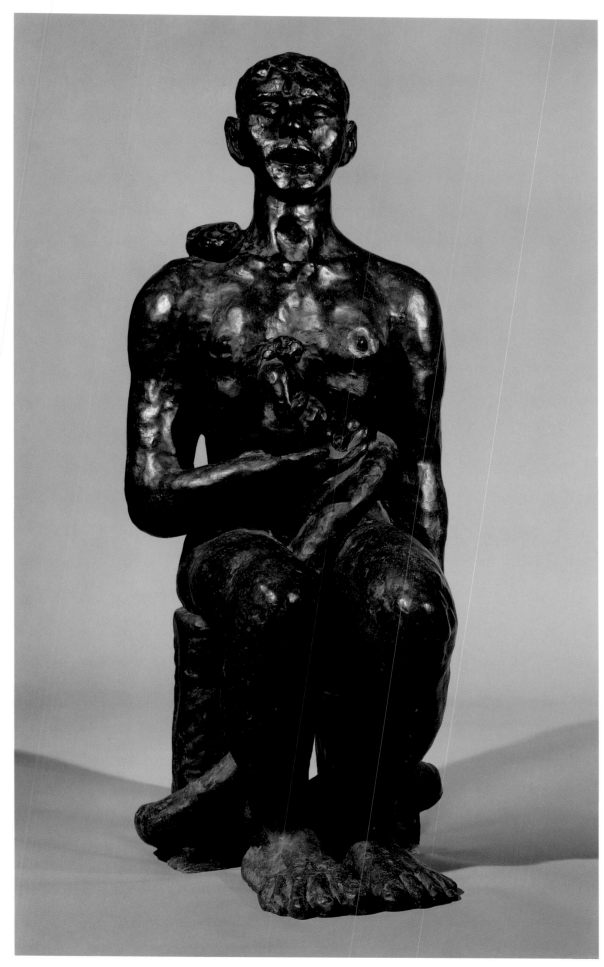

126
MAX BECKMANN
Adam and Eve, 1936
Adam und Eva
Bronze; 86.5 x 33 x 35.5 cm
Private Collection

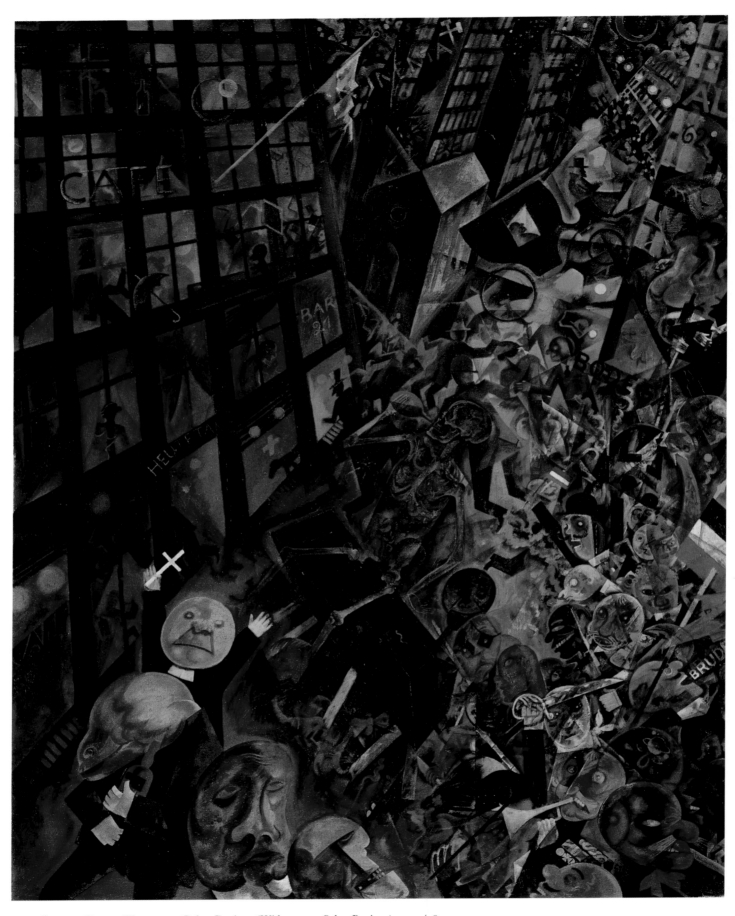

127 GEORGE GROSZ, Homage to Oskar Panizza *(Widmung an Oskar Panizza)*, 1917/18
140 x 110 cm; Staatsgalerie Stuttgart

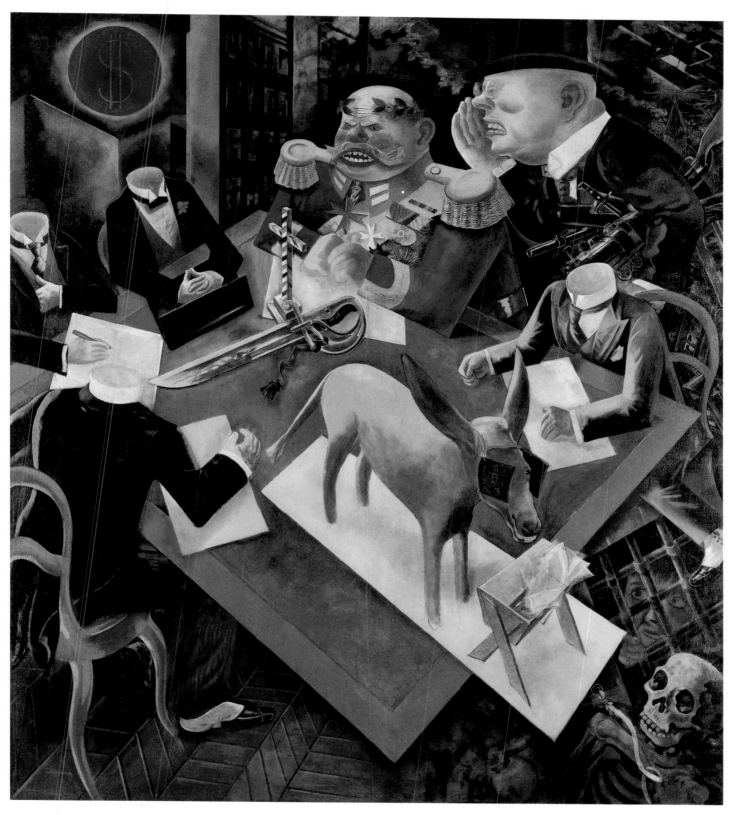

128 GEORGE GROSZ, Eclipse of the Sun *(Sonnenfinsternis)*, 1926
 218 x 188 cm; Heckscher Museum, Huntingdon, New York

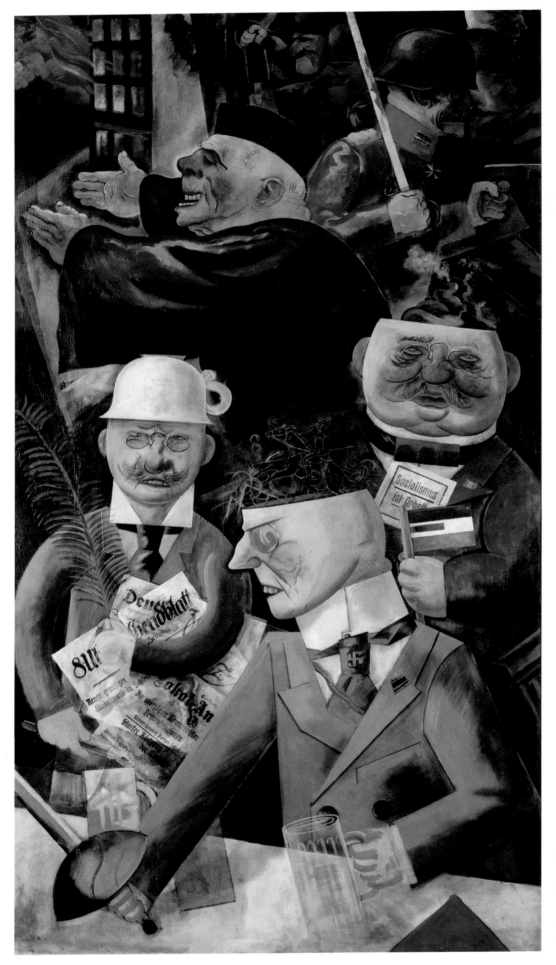

129
GEORGE GROSZ
Pillars of Society, 1926
Stützen der Gesellschaft
200 x 108 cm
Staatliche Museen
Preussischer
Kulturbesitz,
Nationalgalerie Berlin

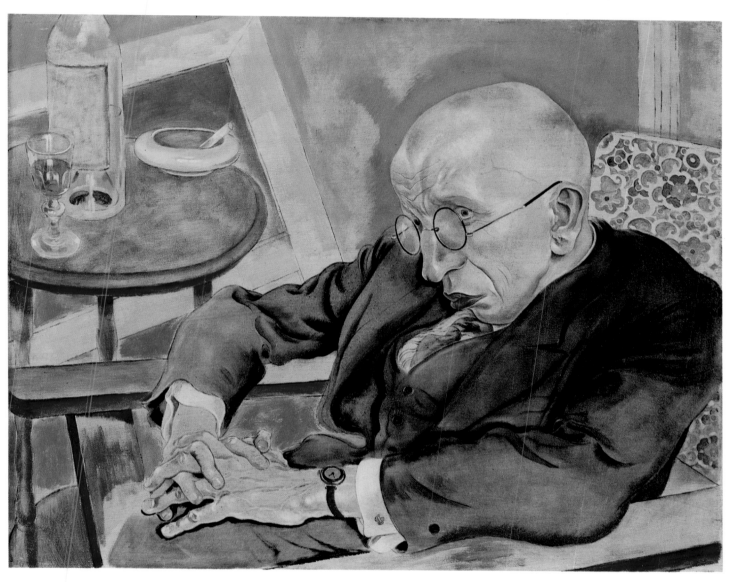

130 GEORGE GROSZ, Portrait of Max Herrmann-Neisse *(Bildnis Max Herrmann-Neisse)*, 1927
59.4 x 74 cm; The Museum of Modern Art, New York

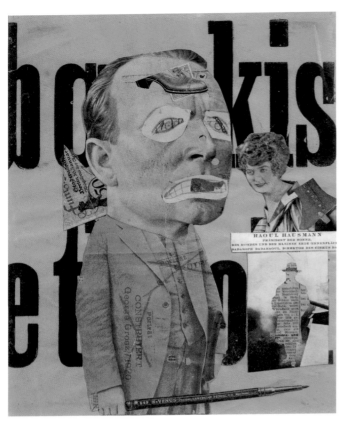

131
RAOUL HAUSMANN
The Art Critic (Der Kunstkritiker), 1919/20
Photomontage
31.8 x 25.4 cm
The Trustees of the Tate Gallery, London

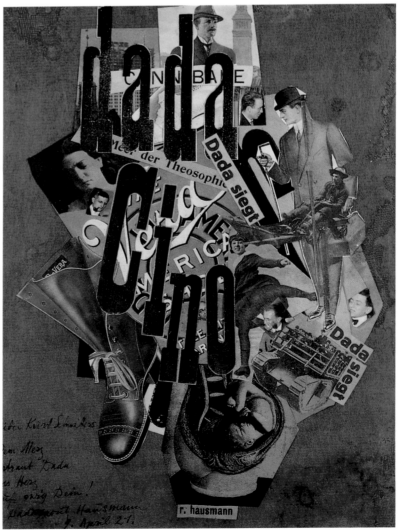

132
RAOUL HAUSMANN
dada-Cino, 1921
Gouache on collage
40 x 30 cm
Private Collection

134
Raoul Hausmann
Men are Angels and Live in Heaven, c. 1918
Die Menschen sind Engel und leben im Himmel
Collage and photomontage
31 x 20.5 cm
Berlinische Galerie, Berlin

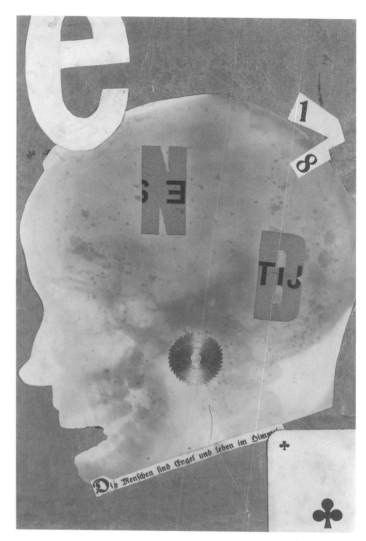

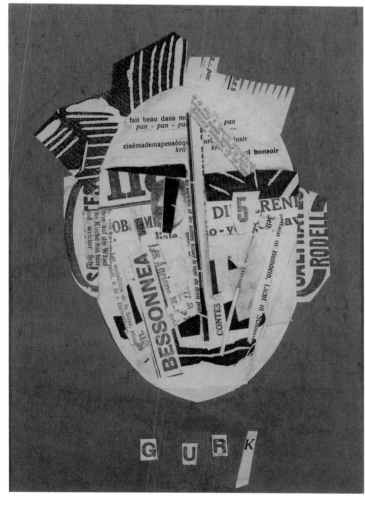

133
Raoul Hausmann
Gurk, 1919
Collage; 27 x 21.5 cm
Kunstarchiv Arntz, Haag

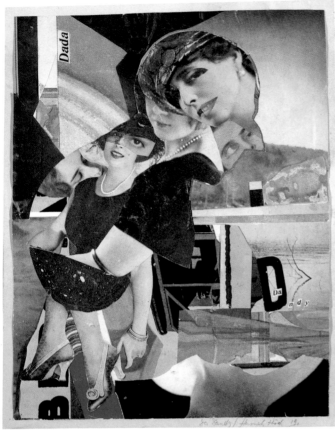

135
HANNAH HÖCH
DA-Dandy, 1919
Collage
30 x 23 cm
Private Collection

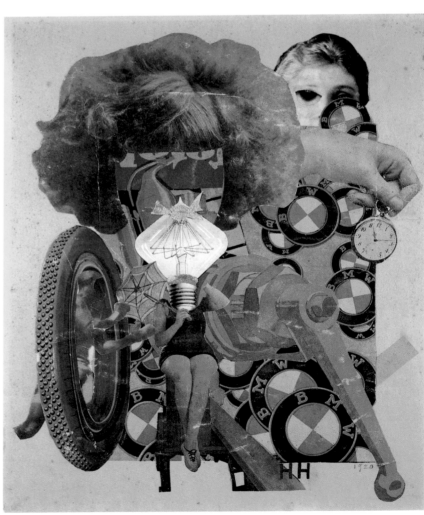

136
HANNAH HÖCH
The Beautiful Girl, 1919/20
Das schöne Mädchen
Collage
36 x 29.5 cm
Private Collection

138
HANNAH HÖCH
Mechanical Garden, 1920
Mechanischer Garten
Watercolour
73.5 x 46.4 cm
Collection H. Marc Moyens

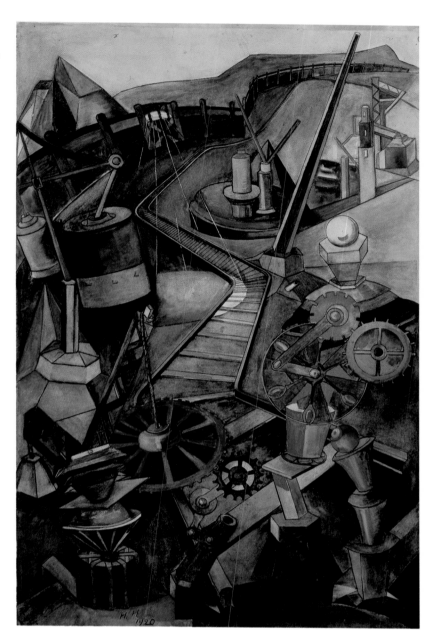

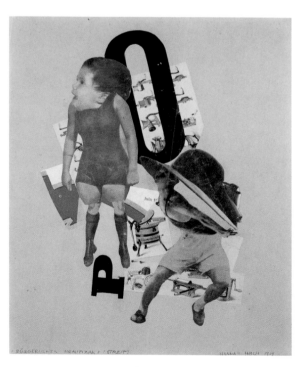

137
HANNAH HÖCH
Bourgeois Wedding — Quarrel, 1919
Bürgerliches Brautpaar — Streit
Collage; 38 x 30.6 cm
Private Collection

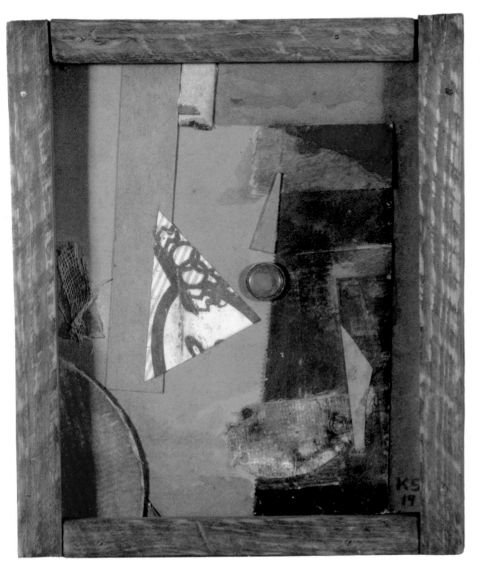

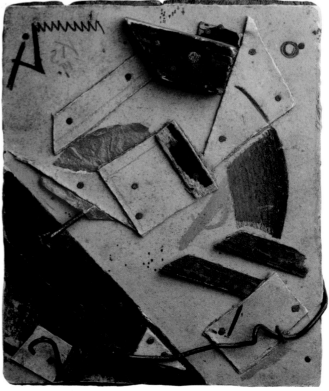

139
KURT SCHWITTERS,
Merzpicture 36 Cuba Button, 1919/20
Merzbild 36 Kuba Knopf
Assemblage on cardboard; 16.5 x 13.1 cm
Private Collection, France

140
KURT SCHWITTERS,
Merz Drawing, 1919
Merzzeichnung
Collage with board, paper,
wood and wire
18 x 14 cm
Private Collection

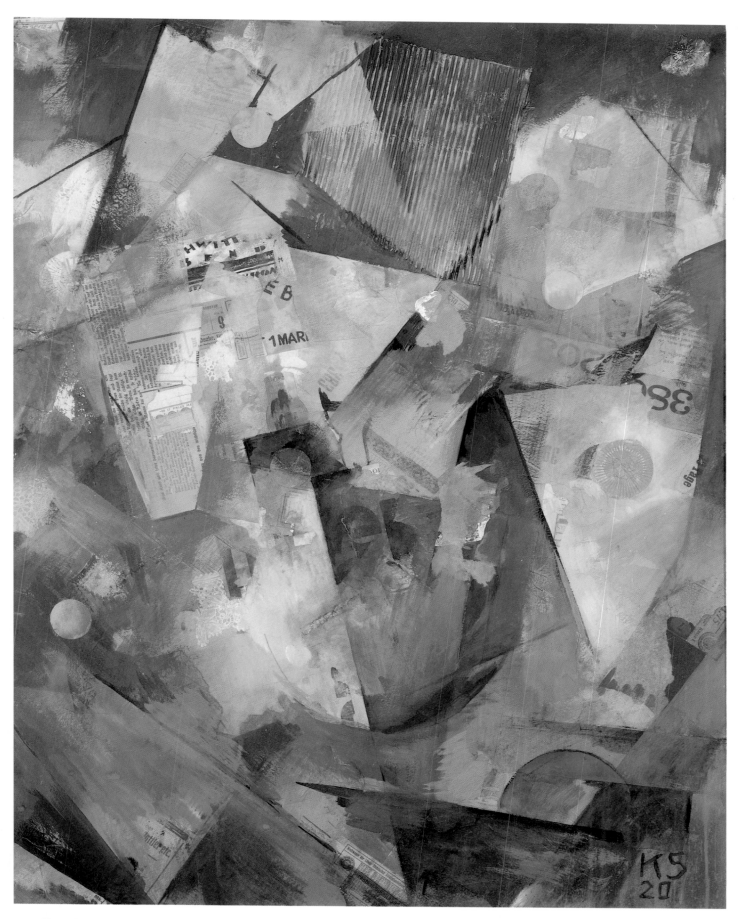

141 KURT SCHWITTERS, Spring Picture *(Frühlingsbild)*, 1920
Assemblage; 102.5 x 84 cm; Öffentliche Kunstsammlung, Kunstmuseum Basle

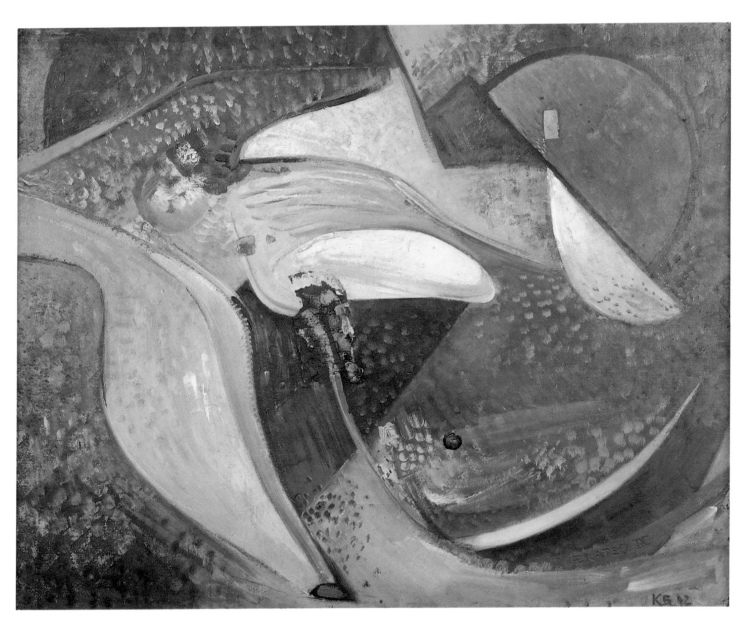

142 KURT SCHWITTERS, Aerated IX, 1942
Assemblage; 88 x 104 cm; Insel Hombroich

143
KURT SCHWITTERS
Merz Picture with Seaweed, 1938
Merzbild mit Algen
Assemblage
47.5 x 24.5 cm
Marlborough Fine Art (London) Ltd.

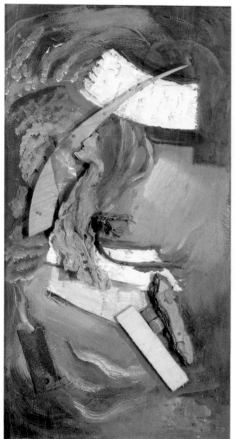

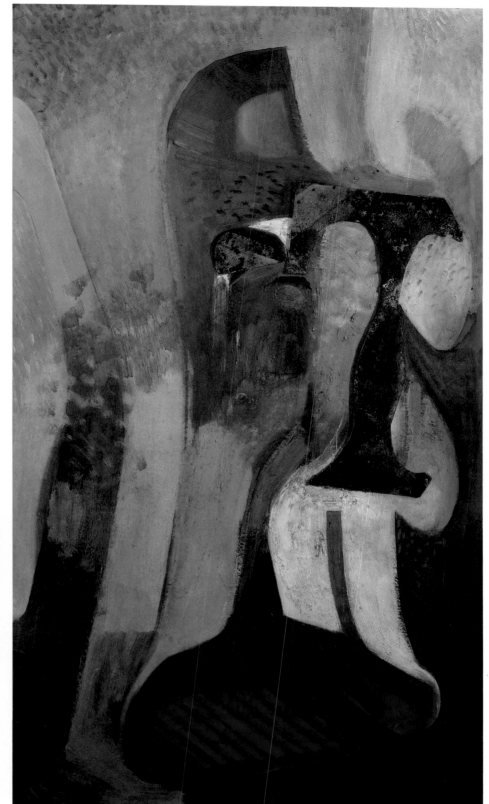

144 KURT SCHWITTERS, Big T, 1942
Assemblage; 105 x 60 cm
Insel Hombroich

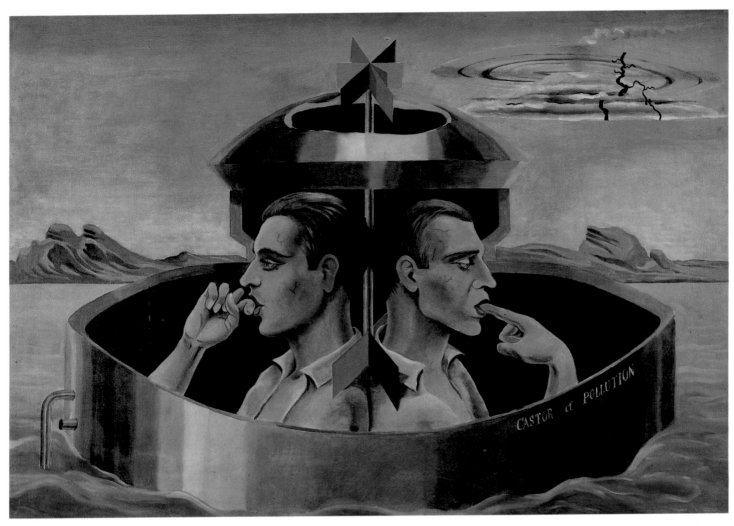

145
MAX ERNST
Castor and Pollux, 1923
Castor und Pollux
73 x 100 cm
Private Collection, Switzerland

146
MAX ERNST
Katharina ondulata, 1920
Gouache and pencil
31.2 x 27 cm
Private Collection

147 MAX ERNST, Long Live Love or: Pays charmant *(Es lebe die Liebe oder: Pays charmant)*, 1923
131 x 98 cm; The Saint Louis Art Museum, Bequest of Morton D. May

148 MAX ERNST, Sainte Cécile – The Invisible Piano *(Die heilige Cäcilie – Das unsichtbare Klavier)*, 1923
101 x 82 cm; Staatsgalerie Stuttgart

149 Max Ernst, The Elephant Celebes *(Der Elephant Celebes)*, 1921
125.4 x 107.9 cm; The Trustees of the Tate Gallery, London

150 Max Ernst, The Harmonious Breakfast *(Das Harmonische Frühstück)*, 1939
 56 x 66.2 cm; The Francesco Pellizzi Collection

151 MAX ERNST, The Painter's Daughters *(Die Töchter des Malers)*, 1940
73.5 x 60 cm; Private Collection, (on loan to Städelsches Kunstinstitut, Frankfurt)

152 MAX ERNST, Europe after the Rain II *(Europa nach dem Regen II)*, 1940-42
 55 x 148 cm; Wadsworth Atheneum, Hartford, The Ella Gallup Sumner and Mary Catlin Sumner Collection

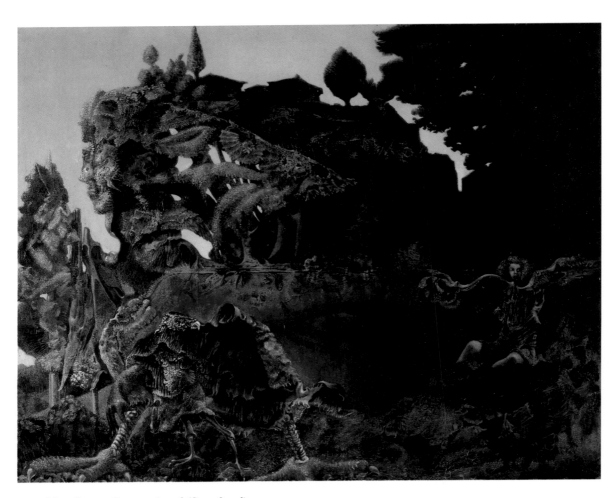

153 MAX ERNST, Swamp Angel *(Sumpfengel)*, 1940
65 x 80 cm; Private Collection Basle, Switzerland

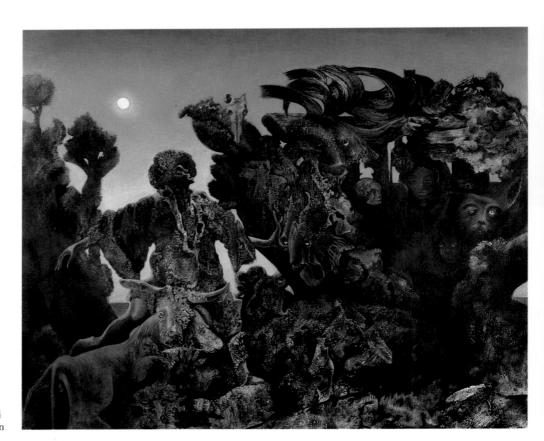

154
MAX ERNST
Epiphany, 1940
44 x 64 cm
Selma and Nesuhi
Ertegun Collection

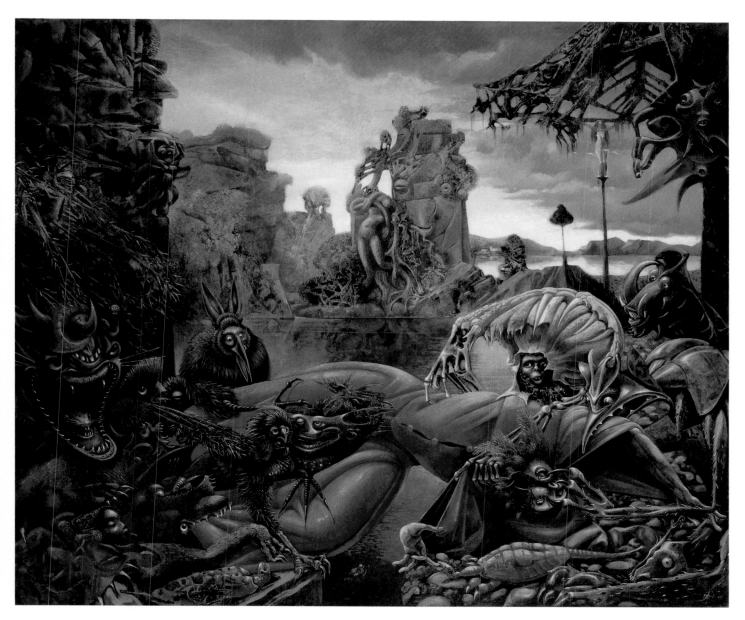

155 MAX ERNST, The Temptation of St. Anthony *(Die Versuchung des Hl. Antonius)*, 1945
 108 x 128 cm; Wilhelm Lehmbruck Museum der Stadt Duisburg

156 Max Ernst, La joie de vivre, 1936
 72 x 91 cm; Private Collection

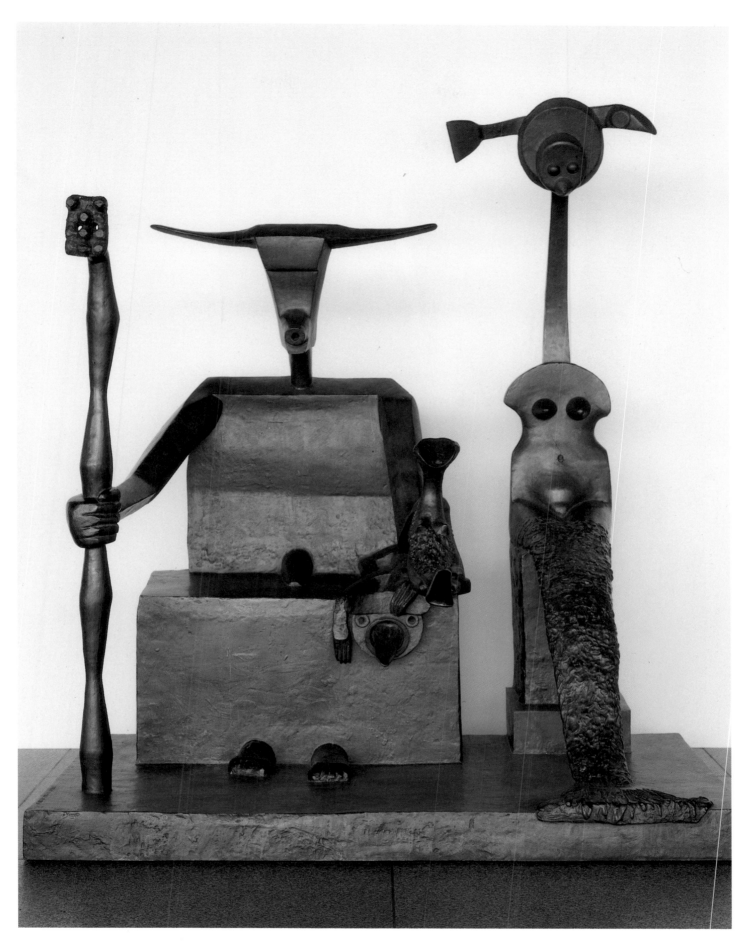

157 MAX ERNST, Capricorn, 1948
Bronze; 238 x 208 x 145 cm; Deutsche Bank AG, Frankfurt/Düsseldorf

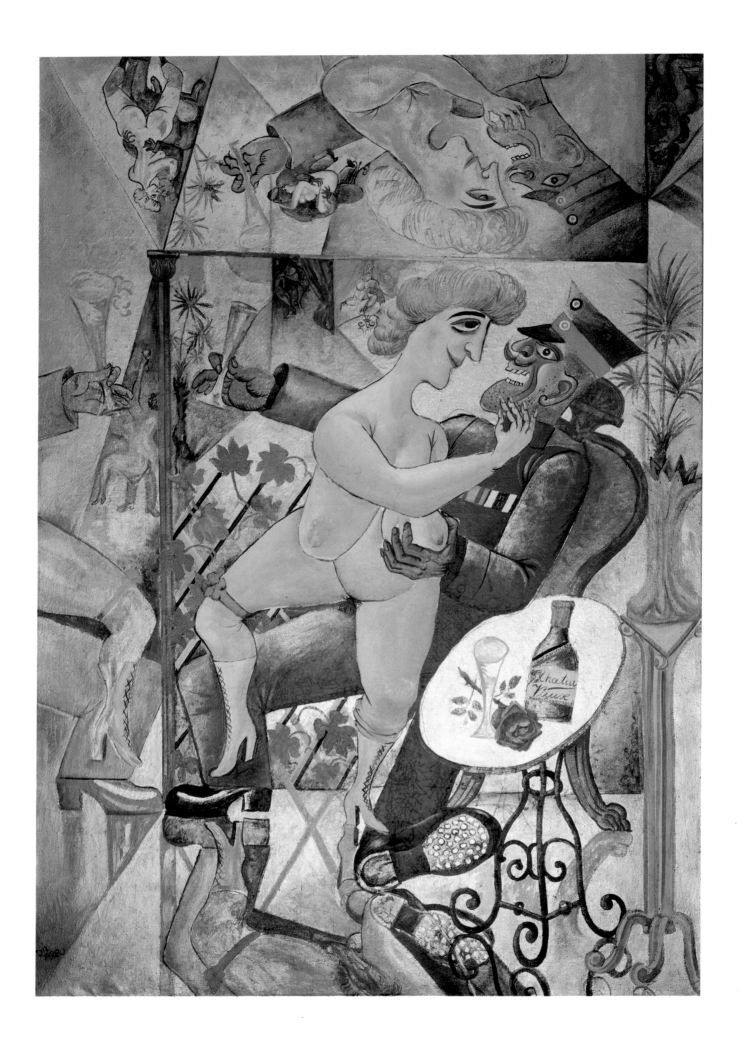

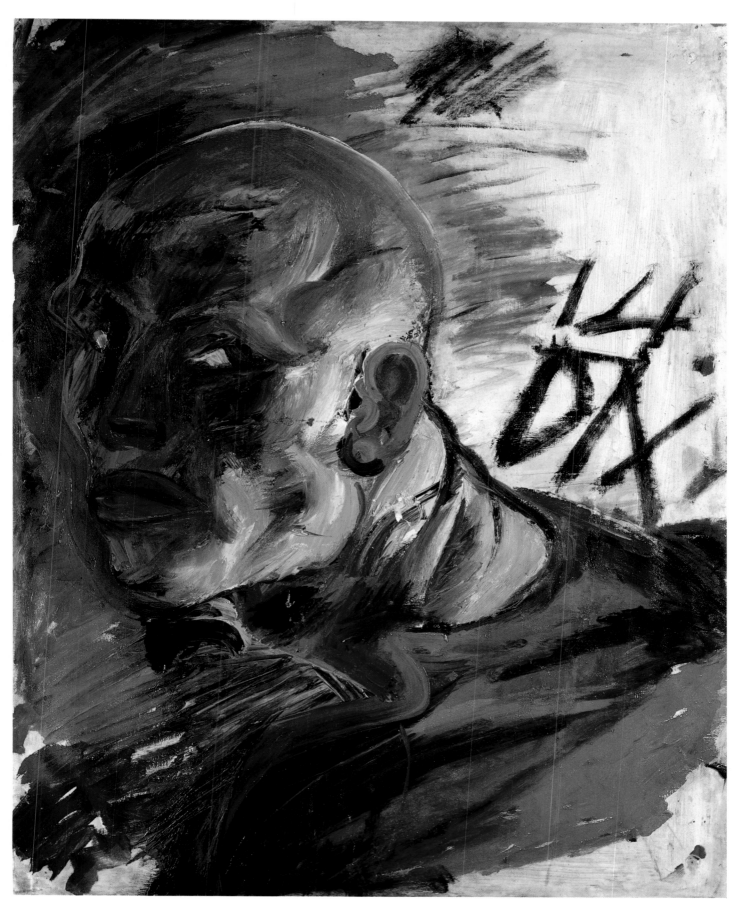

158 Otto Dix,
Souvenir of the Mirrored Halls in Brussels, 1920
Erinnerung an die Spiegelsäle in Brüssel
124 x 84 cm; Private Collection

159 Otto Dix,
Self-portrait as a Soldier, 1914/15
Selbstbildnis als Soldat
Oil on paper; 68 x 53.5 cm; Galerie der Stadt Stuttgart

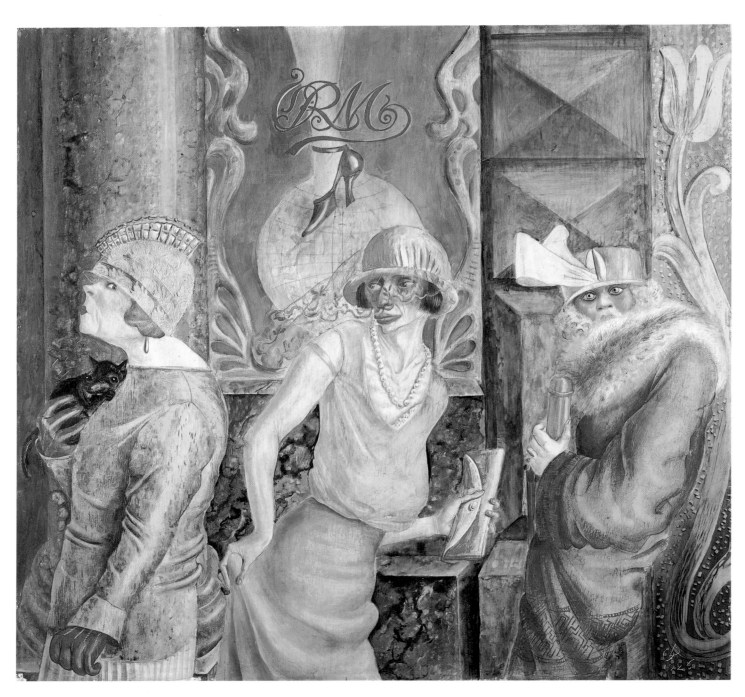

160 OTTO DIX, Three Prostitutes on the Street *(Drei Dirnen auf der Straße)*, 1925
Tempera on plywood; 95 x 100 cm; Private Collection

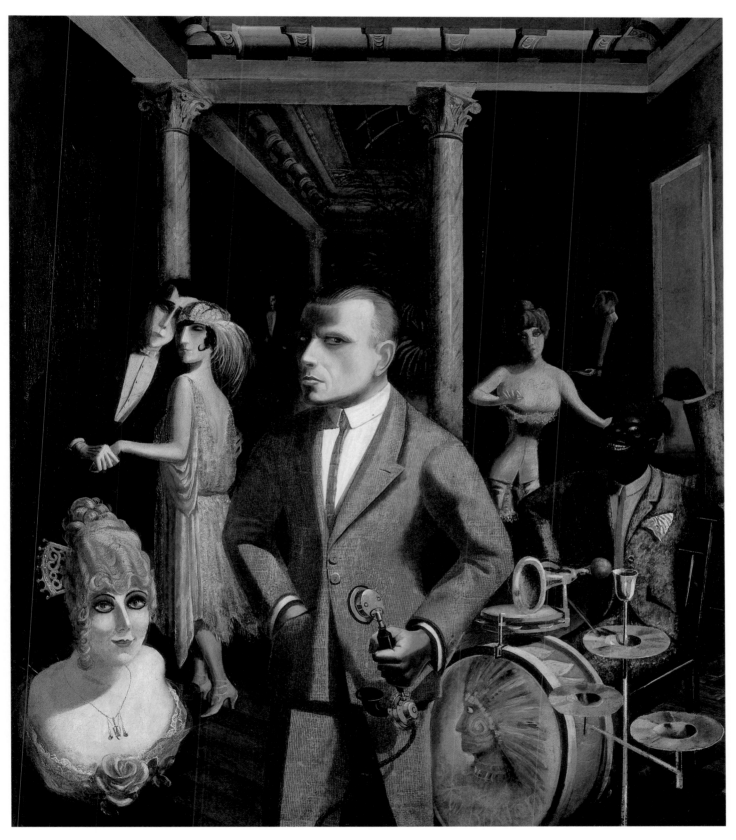

161 OTTO DIX, Hommage to Beauty *(An die Schönheit)*, 1922
 139.5 x 120.5 cm; Von der Heydt-Museum, Wuppertal

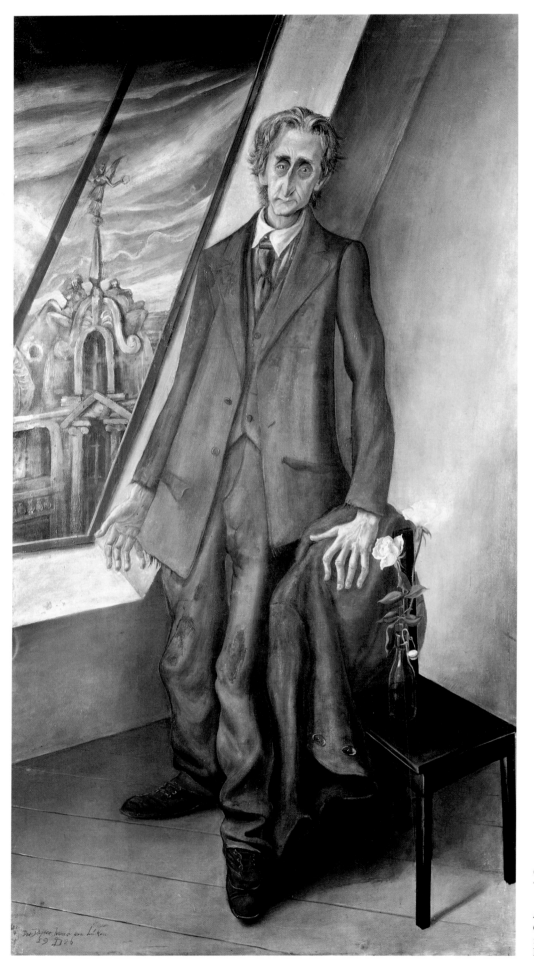

162
OTTO DIX
The Poet Ivar von Lücken,
1926
Der Dichter Ivar von Lücken
Oil and tempera on canvas
225 x 120 cm
Private Collection, Hamburg

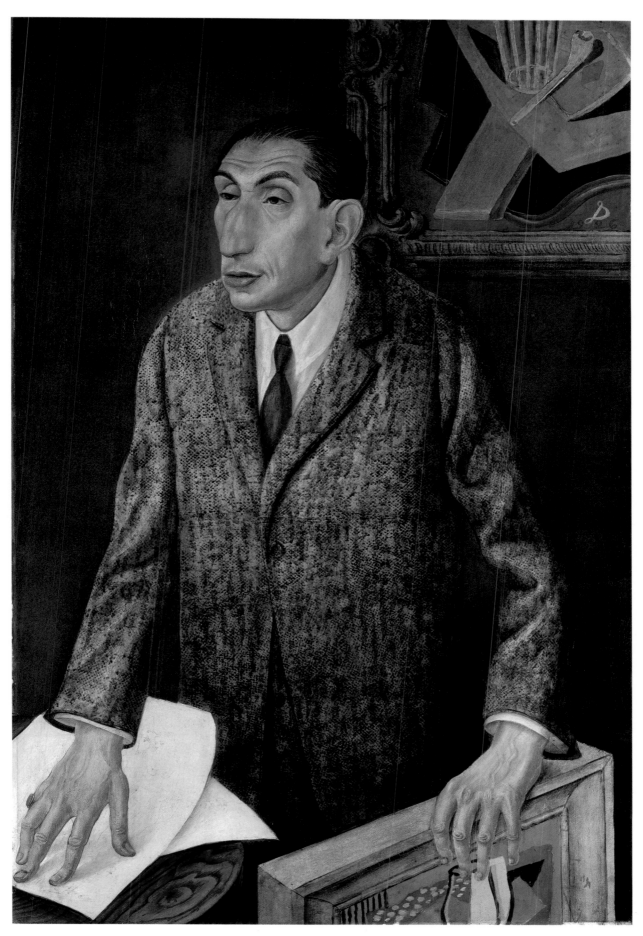

163 OTTO DIX, The Art Dealer Alfred Flechtheim (*Der Kunsthändler Alfred Flechtheim*), 1926
Oil on panel; 120 x 80 cm; Staatliche Museen Preussischer Kulturbesitz, Nationalgalerie Berlin

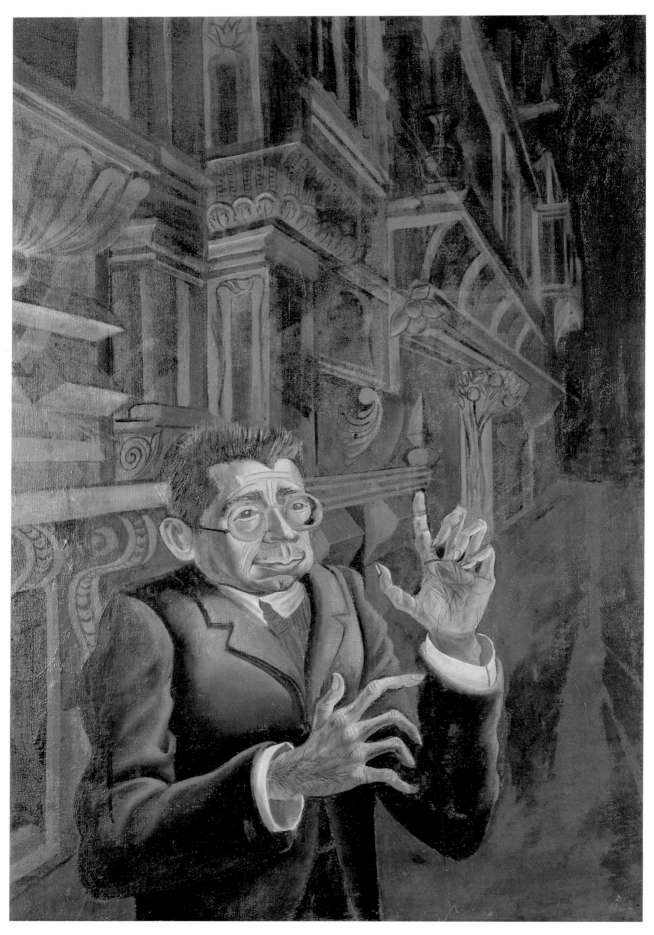

164　Otto Dix, Portrait of the Painter Adolf Uzarski *(Bildnis des Malers Adolf Uzarski)*, 1923
110 x 76 cm; Kunstmuseum Düsseldorf

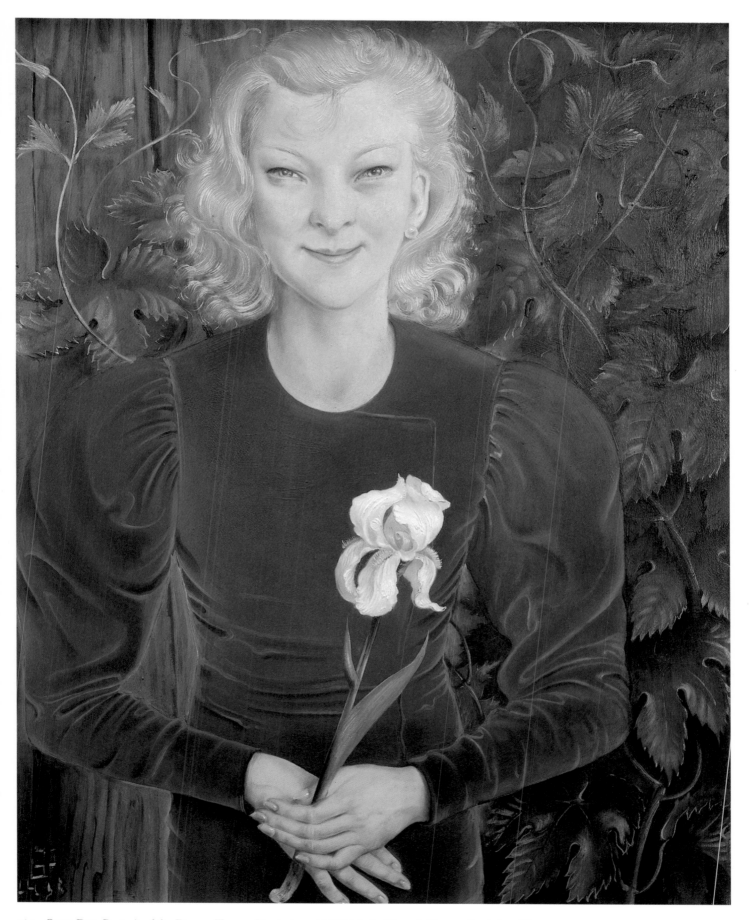

165 Otto Dix, Portrait of the Dancer Tamara Danischewski (*Bildnis der Tänzerin Tamara Danischewski*), 1933
 Oil and tempera on panel; 83 x 64 cm; Galerie der Stadt Stuttgart

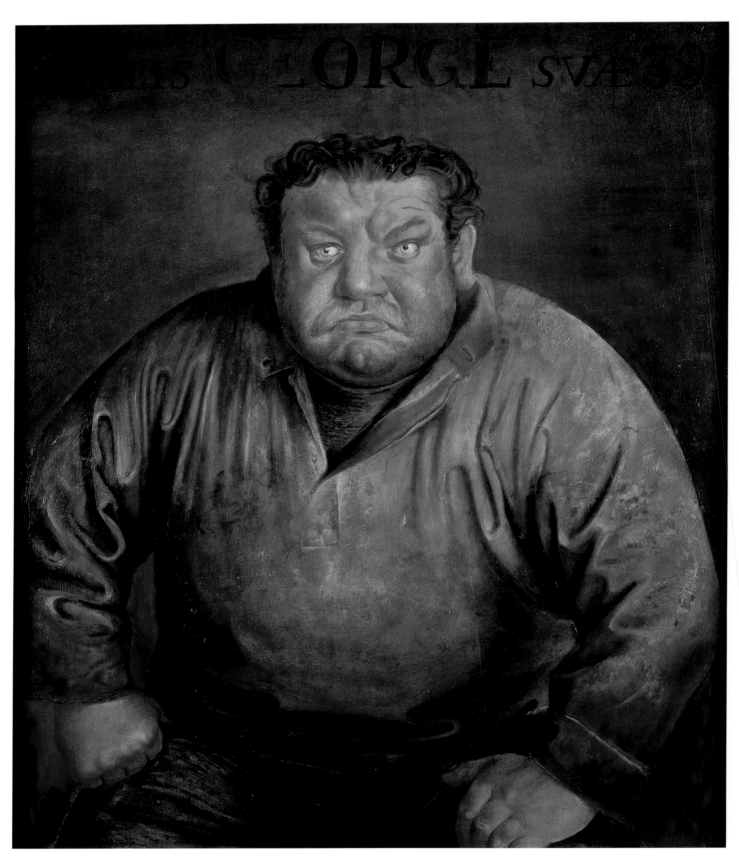

166 OTTO DIX, The Actor Heinrich George *(Der Schauspieler Heinrich George)*, 1932
 Oil and tempera on panel; 100 x 83.5 cm; Galerie der Stadt Stuttgart

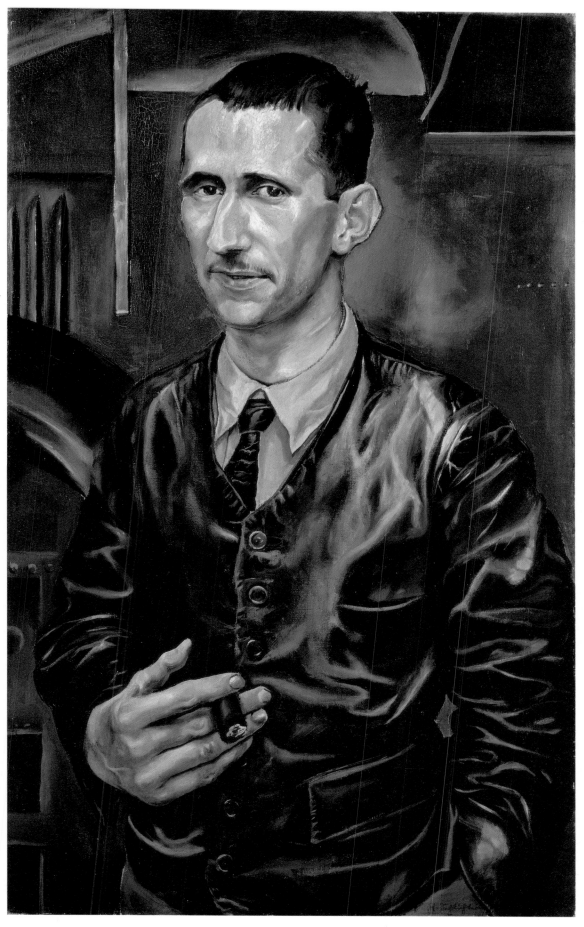

167 RUDOLF SCHLICHTER, Portrait of Bert Brecht *(Bildnis Bert Brecht)*, 1926
75.5 x 46 cm; Munich, Städtische Galerie im Lenbachhaus

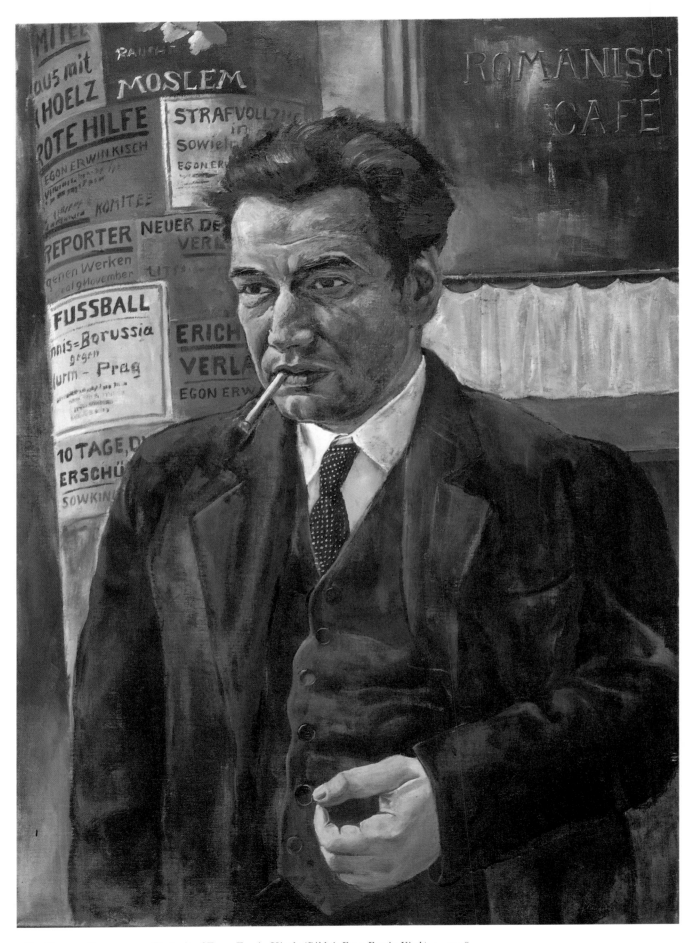

168 RUDOLF SCHLICHTER, Portrait of Egon Erwin Kisch *(Bildnis Egon Erwin Kisch)*, c. 1928
 88 x 62 cm; Städtische Kunsthalle Mannheim

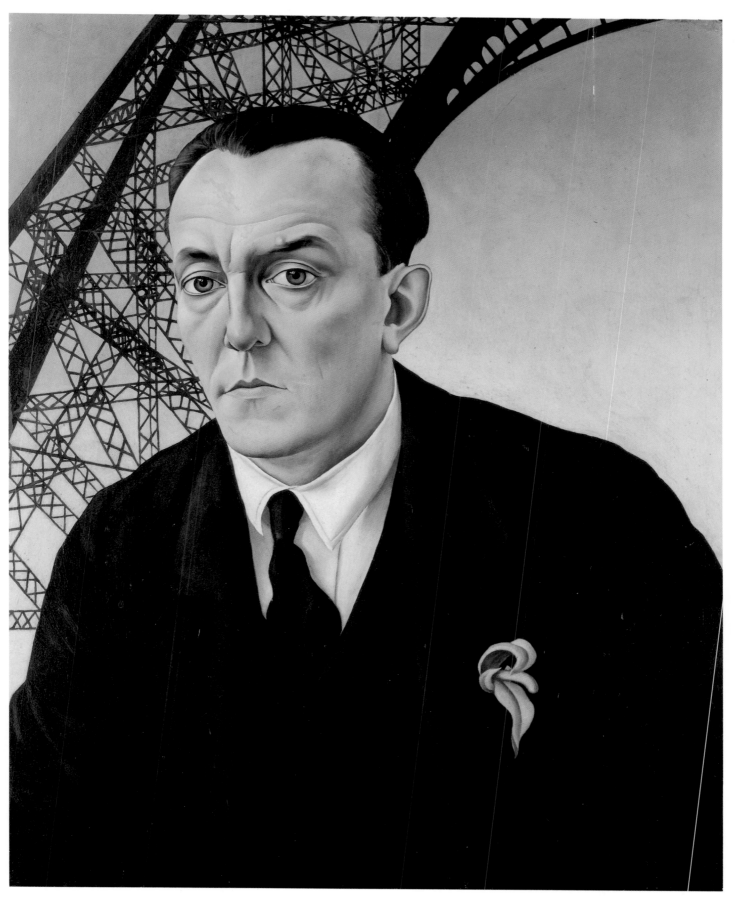

169 CHRISTIAN SCHAD, Portrait of the Composer Josef Matthias Hauer (*Bildnis des Komponisten Josef Matthias Hauer*), 1927
Oil on panel; 62 x 50 cm; Private Collection, Milan

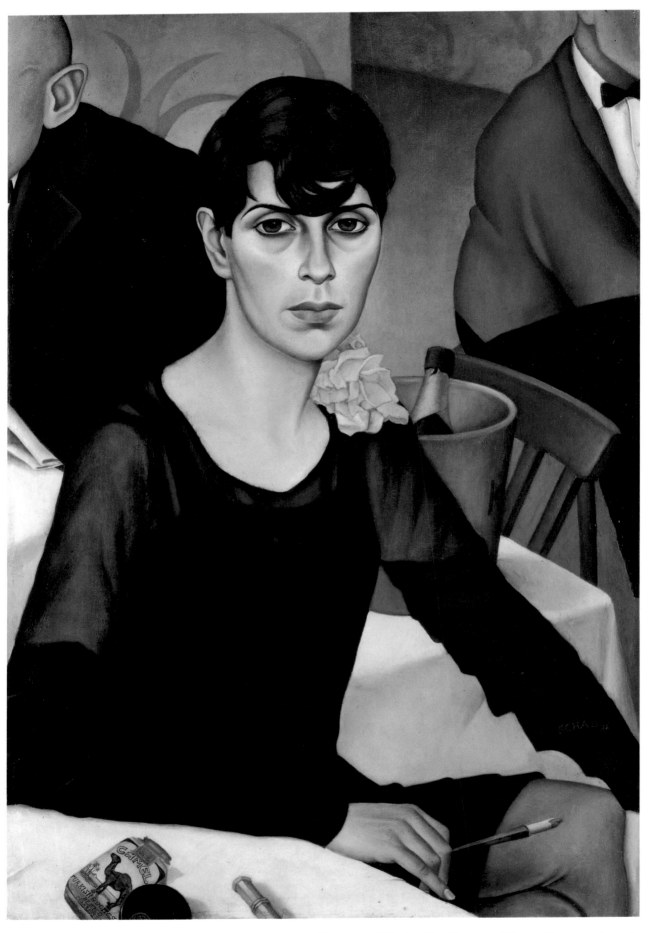

170 CHRISTIAN SCHAD, Sonja - Max Herrmann-Neisse in the Background *(Sonja – Max Herrmann-Neisse im Hintergrund)*, 1928
90 x 60 cm; Private Collection

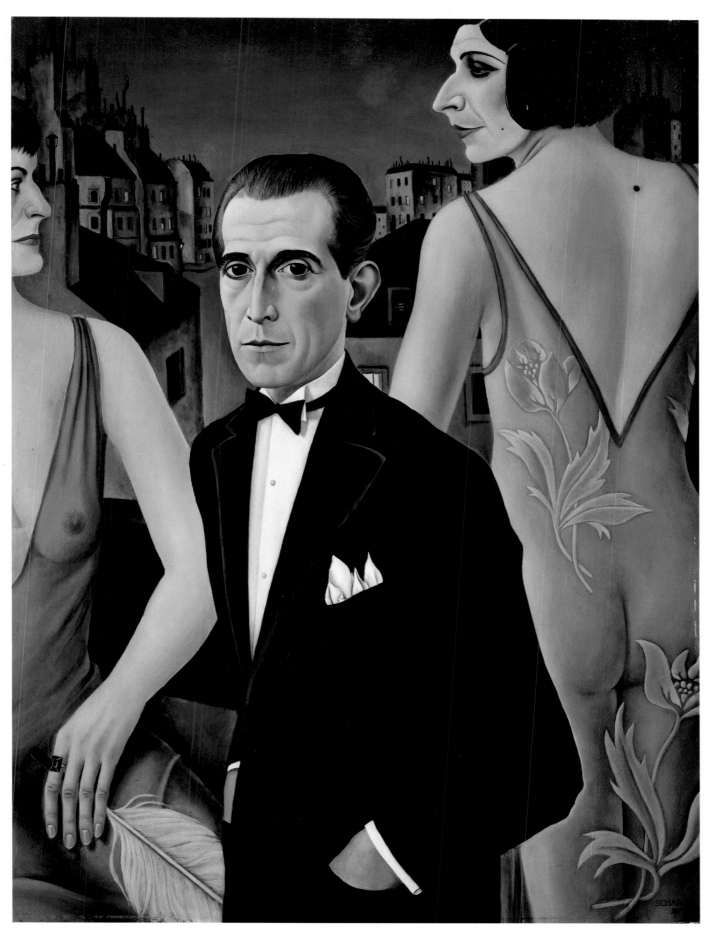

171　CHRISTIAN SCHAD, Count St. Genois d'Anneaucourt *(Graf St. Genois d'Anneaucourt)*, 1927
Oil on panel; 86 x 63 cm; Private Collection

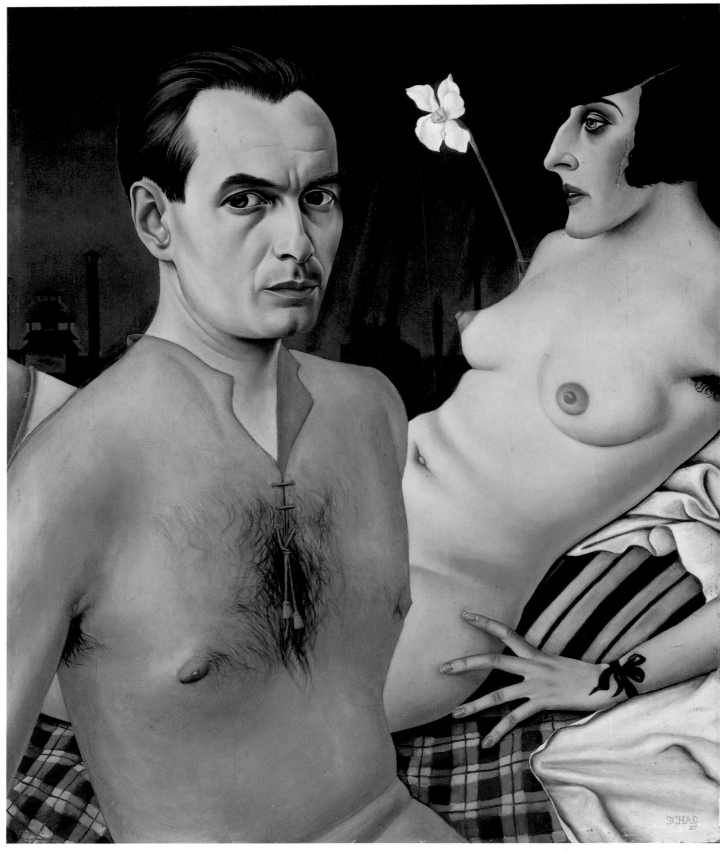

172　CHRISTIAN SCHAD, Self-portrait with Model (*Selbstbildnis mit Modell*), 1927
　　Oil on panel; 76 x 71.5 cm; Private Collection

173
CHRISTIAN SCHAD
Agosta the Pigeon-chested Man and
Rasha the Black Dove, 1929
*Agosta der Flügelmensch und
Rasha die schwarze Taube*
120 x 80 cm; Private Collection

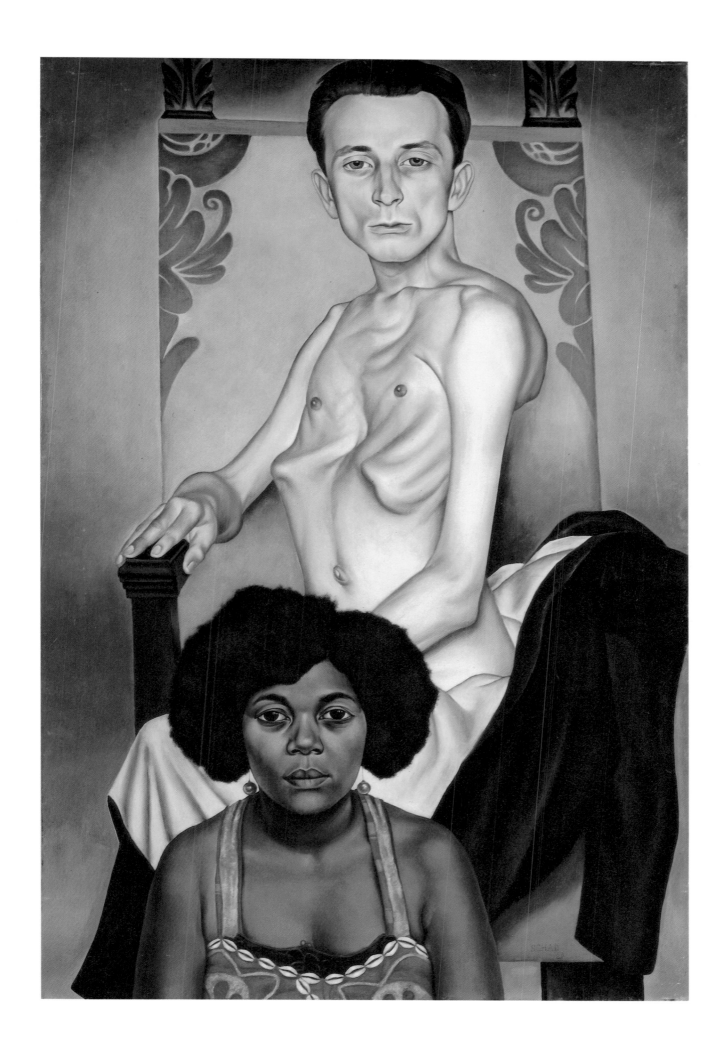

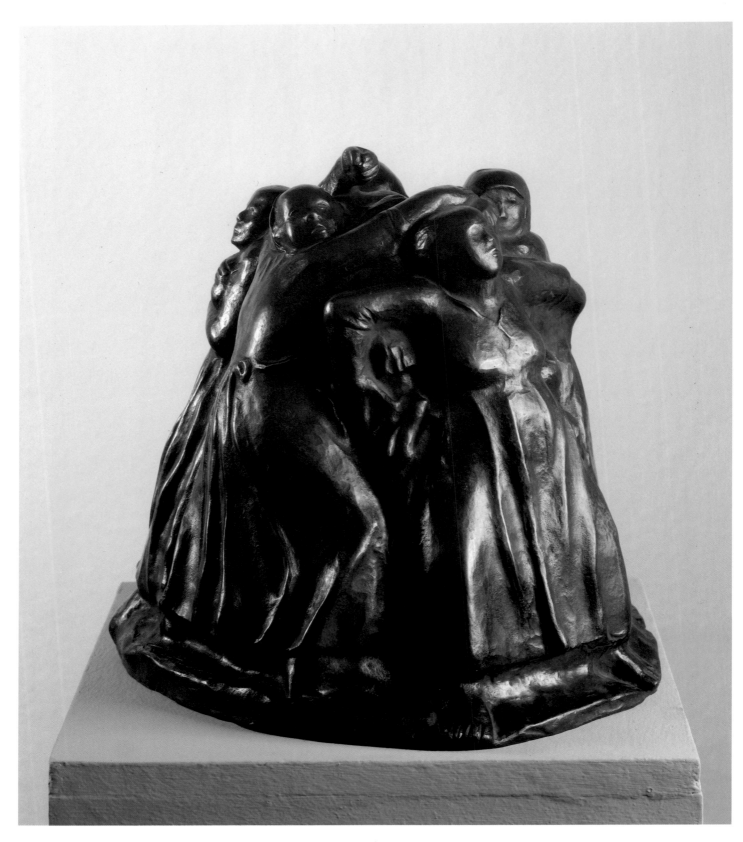

174 KÄTHE KOLLWITZ, The Tower of Mothers *(Turm der Mütter)*, 1937/38
 Bronze; 27 x 27.5 x 28 cm; Galerie Pels-Leusden, Berlin

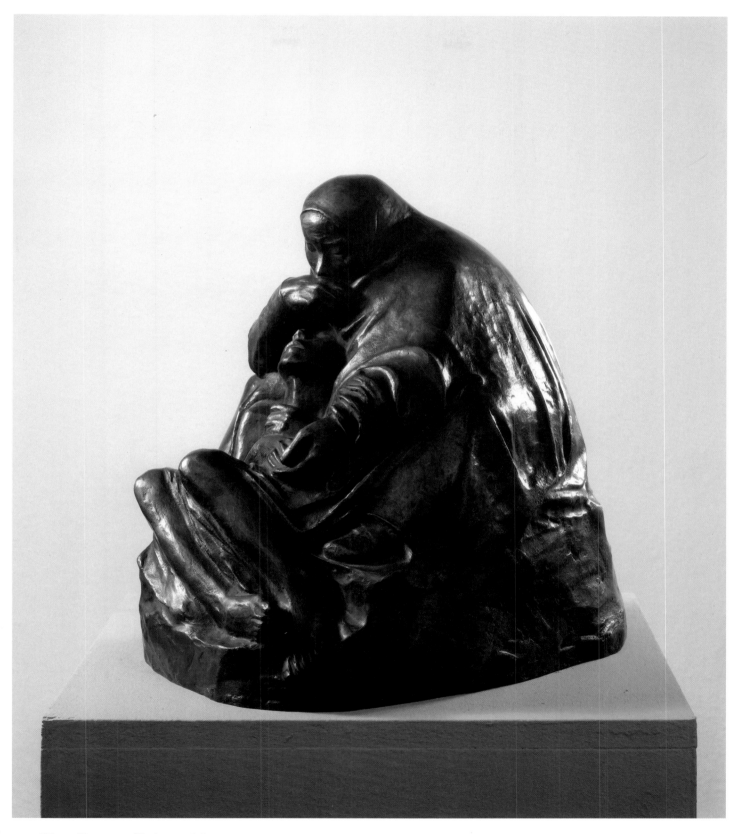

175 Käthe Kollwitz, Pietà, 1937/38
Bronze; 38 x 28.5 x 39 cm; Käthe Kollwitz, Berlin

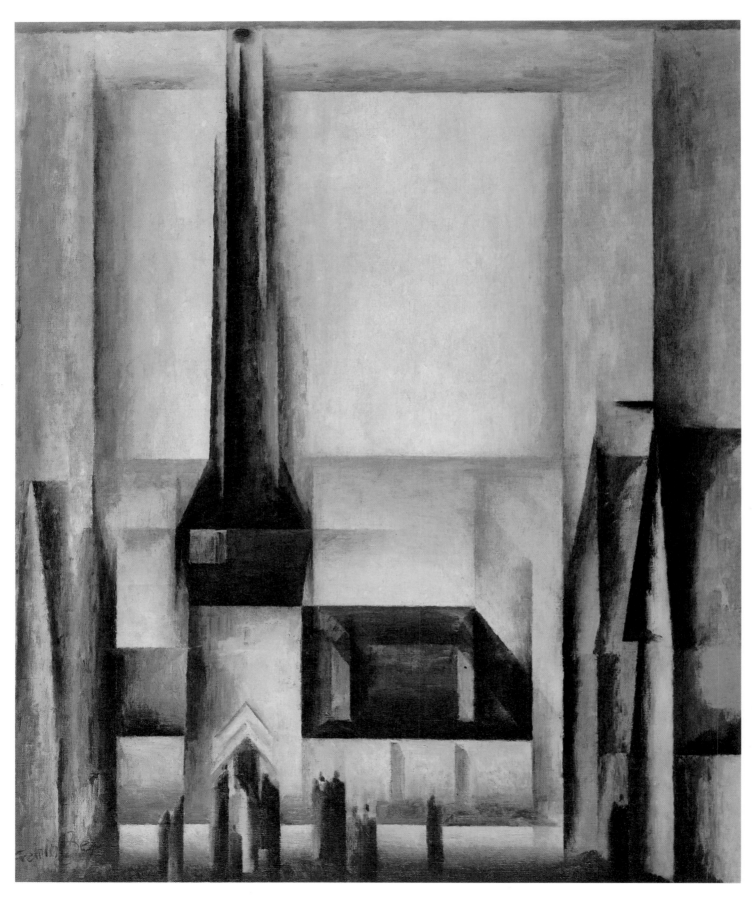

176 Lyonel Feininger, Gelmeroda ii, 1913
100 x 80 cm; Galerie Beyeler, Basle

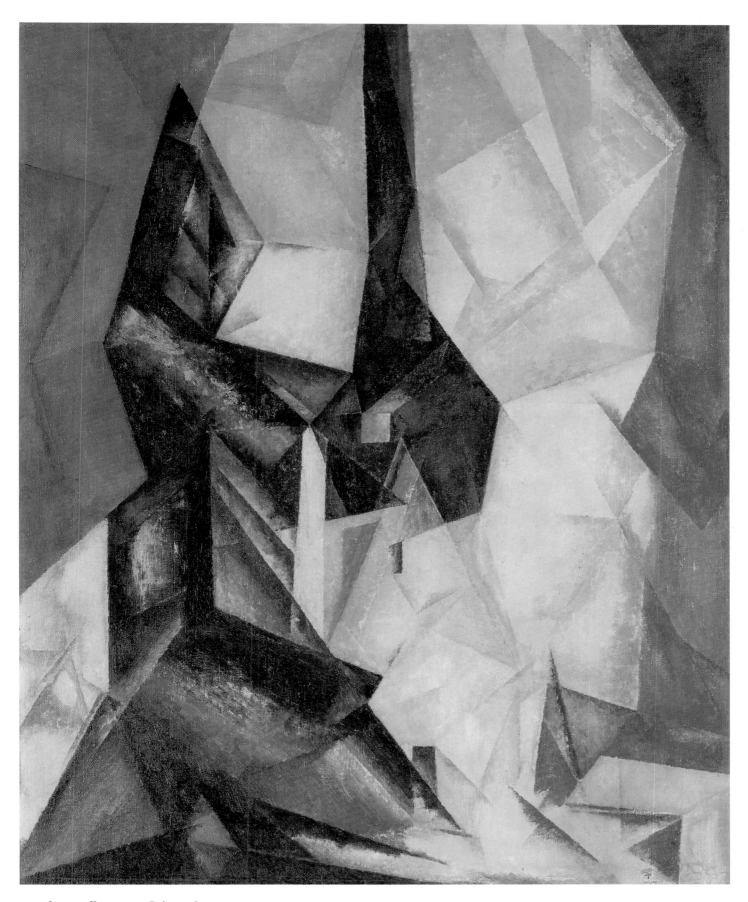

177 Lyonel Feininger, Gelmeroda IV, 1915
100 x 79.7 cm; The Solomon R. Guggenheim Museum, New York

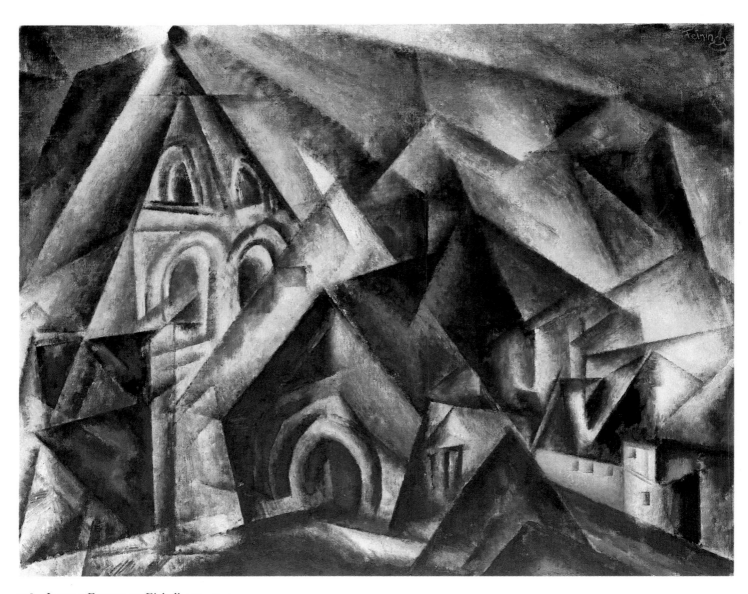

178 Lyonel Feininger, Eichelborn, 1920
 80 x 98.4 cm; Staatliche Museen Preussischer Kulturbesitz, Nationalgalerie Berlin

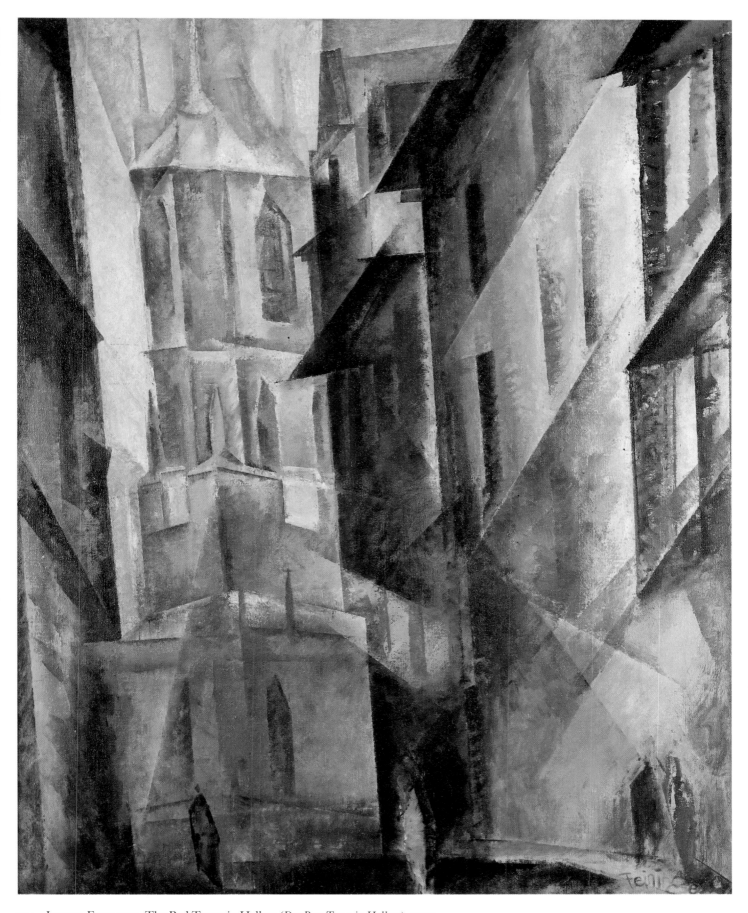

179　Lyonel Feininger, The Red Tower in Halle ii *(Der Rote Turm in Halle ii)*, 1930
100 x 85 cm; Städtisches Museum Mülheim an der Ruhr

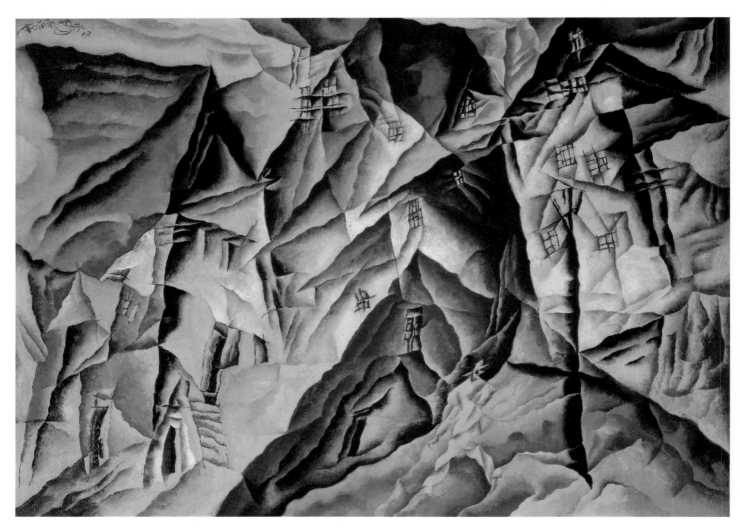

180 LYONEL FEININGER, Denstedt, 1917
 87 x 118 cm; Private Collection

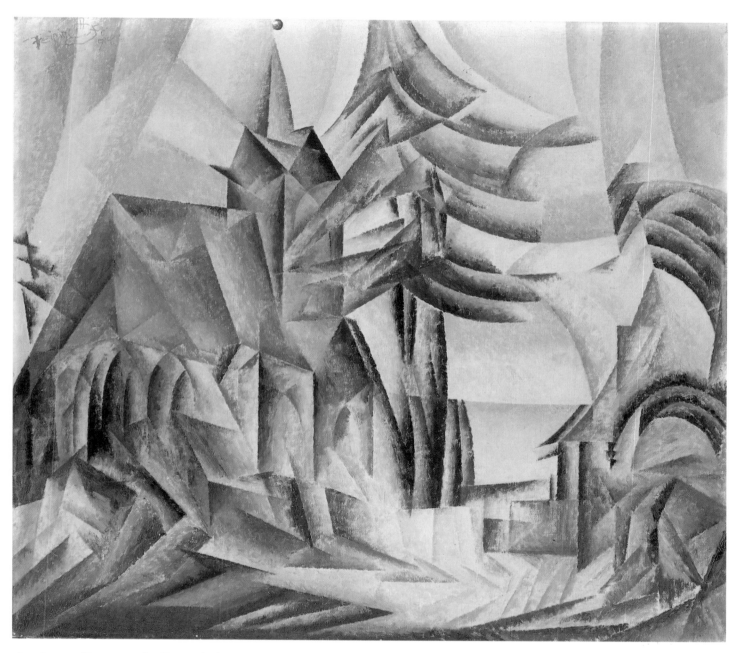

181 LYONEL FEININGER, Großkromsdorf Church *(Die Kirche von Großkromsdorf)*, 1914
 95 x 125 cm; Städtisches Museum Mülheim an der Ruhr

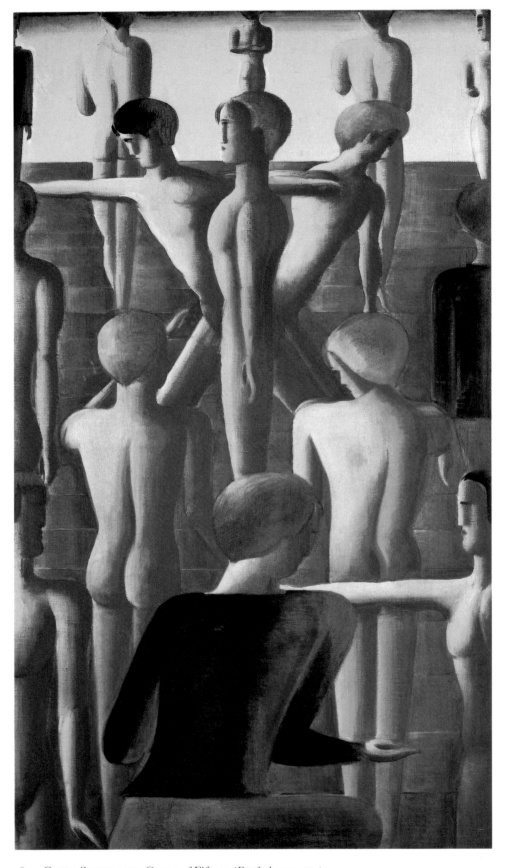

182 OSKAR SCHLEMMER, Group of Fifteen *(Fünfzehnergruppe)*, 1929
178 x 100 cm; Wilhelm Lehmbruck Museum der Stadt Duisburg

183
OSKAR SCHLEMMER
Fallen Figure with
Column, 1928
Gestürzter mit Säule
Oil and tempera on canvas
239 x 155 cm
Staatsgalerie Stuttgart

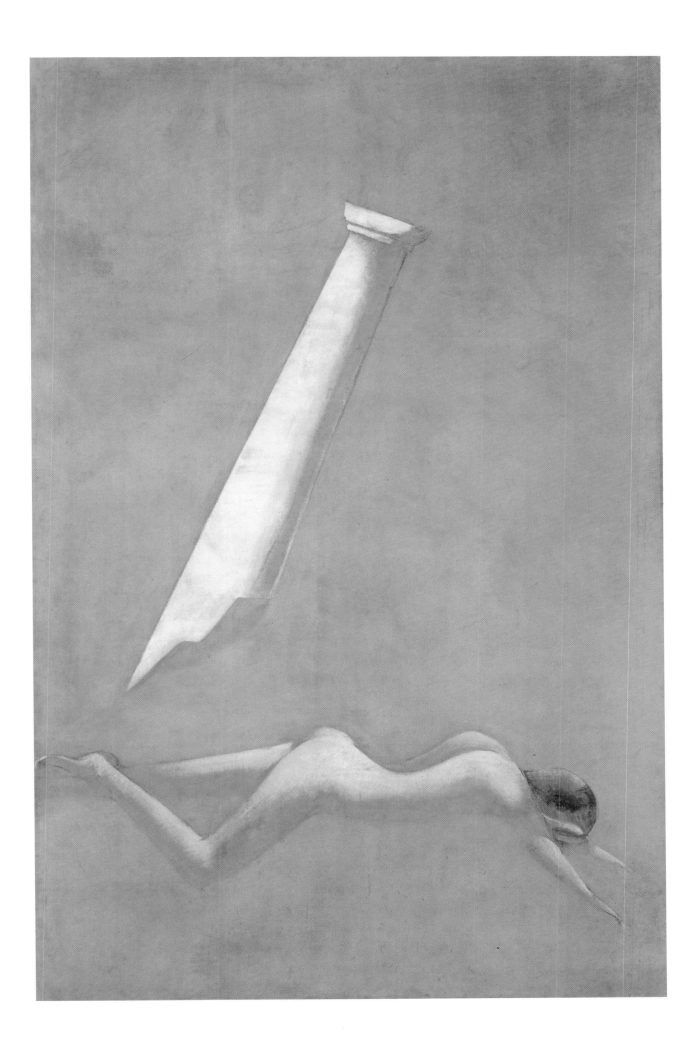

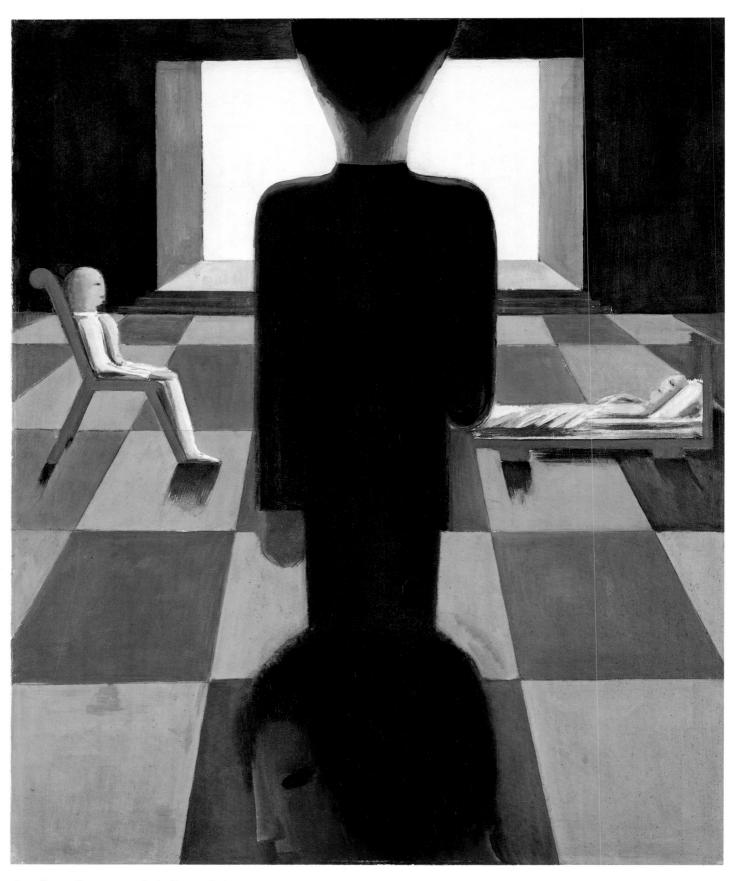

184 OSKAR SCHLEMMER, Quiet Room *(Ruheraum)*, 1925
110 x 90 cm; Staatsgalerie Stuttgart

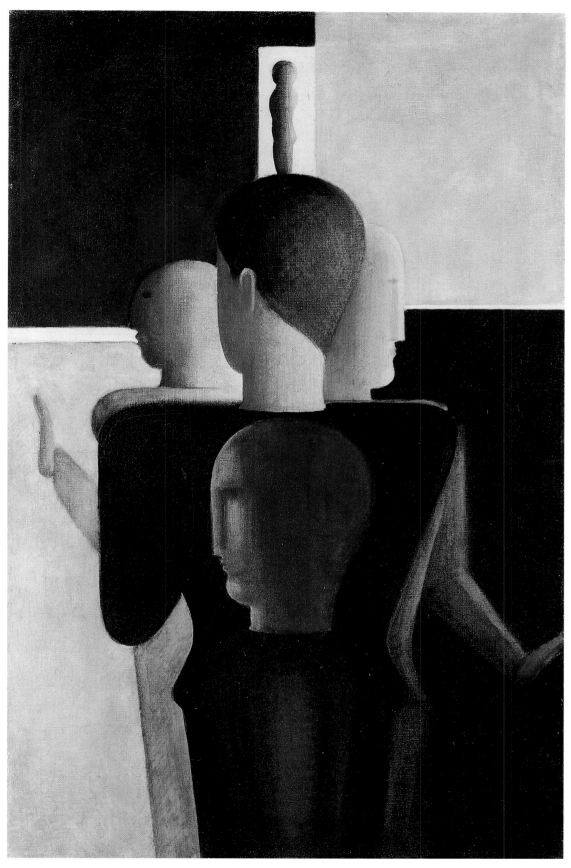

185 OSKAR SCHLEMMER, Concentric Group *(Konzentrische Gruppe)*, 1925
 97.5 x 62 cm; Staatsgalerie Stuttgart

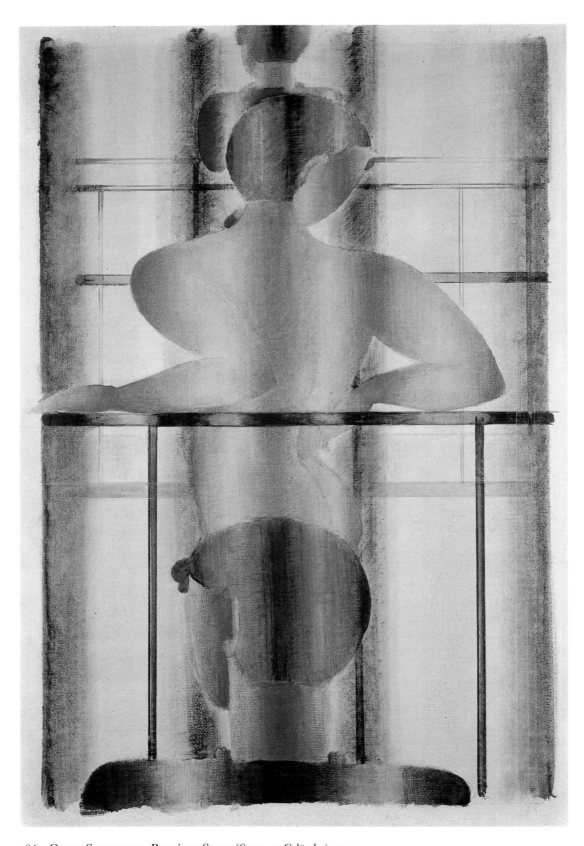

186 OSKAR SCHLEMMER, Bannister Scene *(Szene am Geländer)*, 1932
105.5 x 70.5 cm; Staatsgalerie Stuttgart

187
OSKAR SCHLEMMER
Entry to the Stadium, 1930/36
Eingang zum Stadion
162 x 98 cm
Galerie der Stadt Stuttgart

188　OSKAR SCHLEMMER, Paracelsus – The Legislator *(Paracelsus – Der Gesetzgeber)*, 1923
Oil and varnish on canvas; 99 x 74 cm; Staatsgalerie Stuttgart

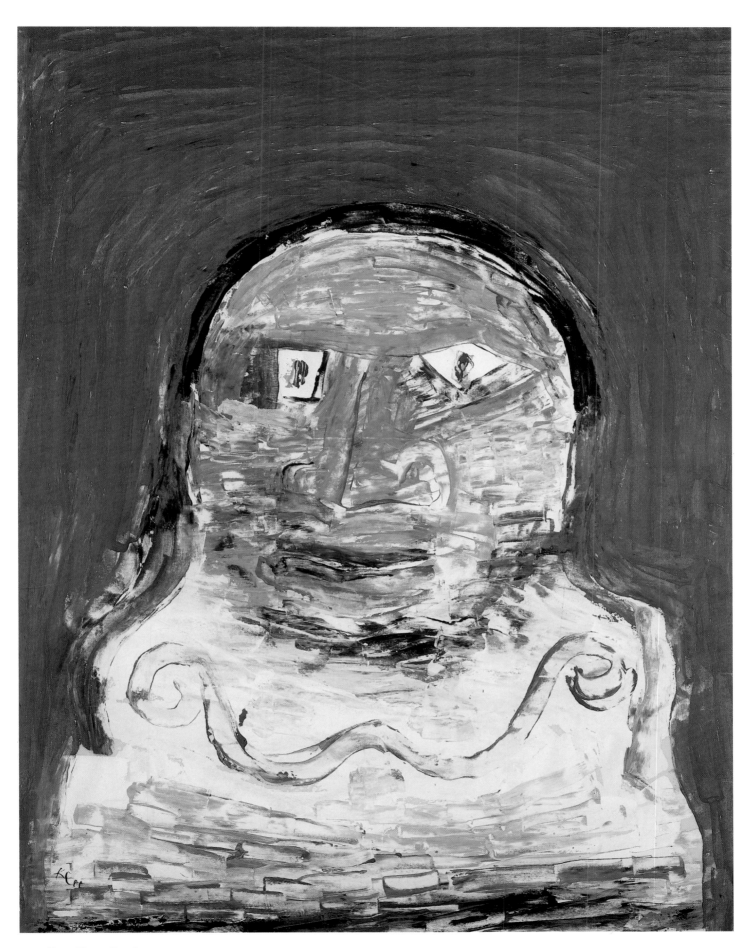

189 PAUL KLEE, Prophet, 1930
Distemper on paper; 61 x 47 cm; Galérie Karl Flinker, Paris

190 PAUL KLEE, Dark Message *(Schwere Botschaft)*, 1938
 Distemper on jute; 70 x 52 cm; Private Collection

191 PAUL KLEE, Fama, 1939
 90.5 x 120 cm; Paul Klee Foundation, Kunstmuseum Berne

192 PAUL KLEE, Pomona, Overripe – Slightly Inclined *(Pomona, Überreif – leicht geneigt)*, 1938
Oil on newspaper on jute; 68 x 52 cm; Paul Klee Foundation, Kunstmuseum Berne

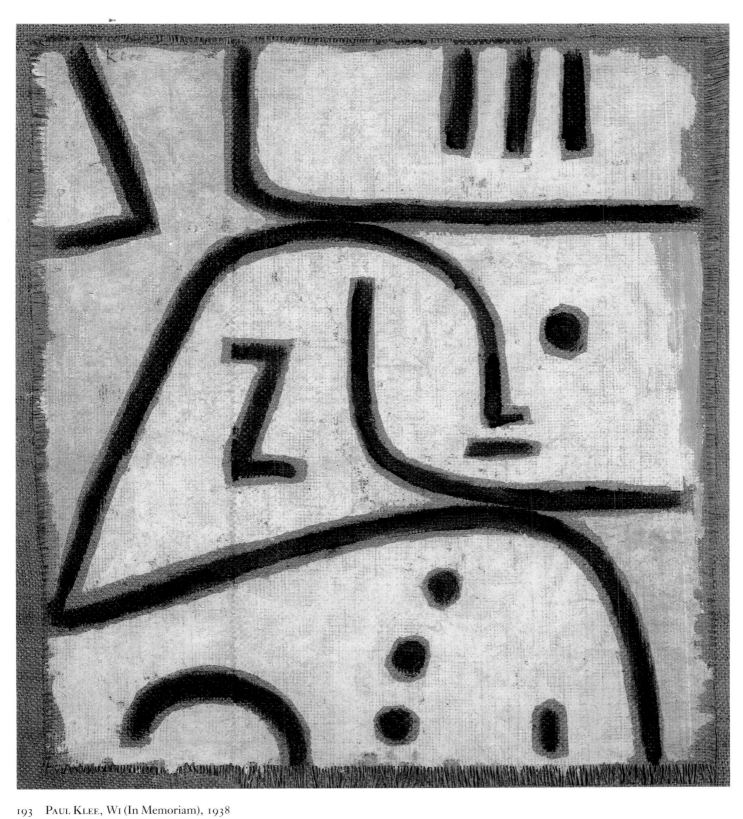

193 PAUL KLEE, WI (In Memoriam), 1938
Oil on jute; 55 x 50 cm; Galerie Beyeler, Basle

194 PAUL KLEE, To the Neighbour's House *(Ins Nachbarhaus)*, 1940
Distemper on paper on cardboard; 34.6 x 52.2 cm; Kunstmuseum Hannover mit Sammlung Sprengel

195 PAUL KLEE, Quarrellers' Duet *(Zank-Duett)*, 1938
71 x 102 cm; Munich, Bayerische Staatsgemäldesammlungen, Staatsgalerie moderner Kunst

196 PAUL KLEE, Captive *(Gefangen)*, 1940
 Oil on jute on canvas; 55 x 50 cm; Galerie Beyeler, Basle

197
PAUL KLEE
Forest Witches *(Waldhexen)*, 1938
Oil on paper on jute
100 x 74 cm
Private Collection, Switzerland

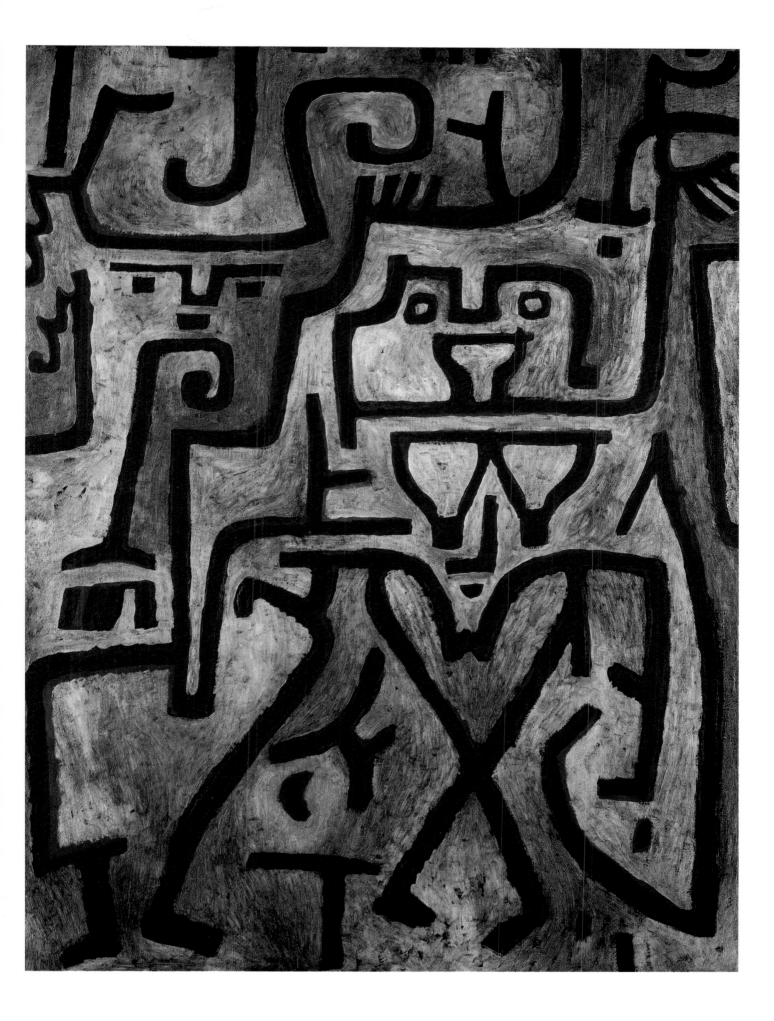

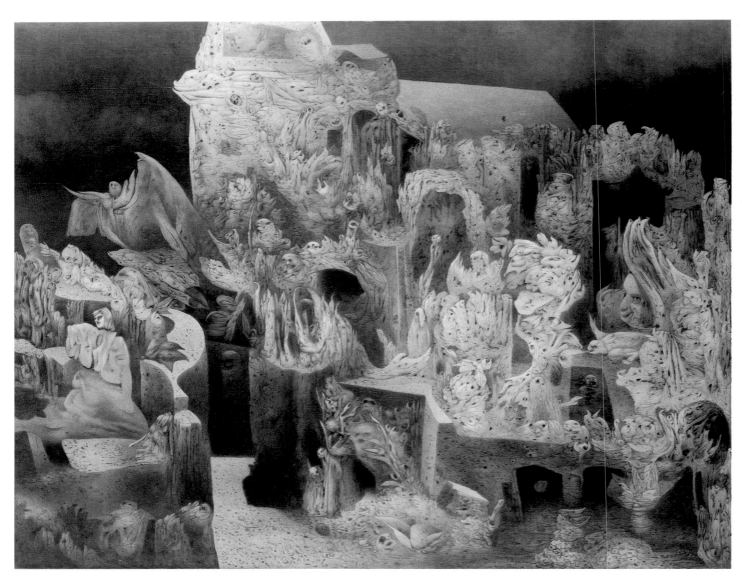

198 RICHARD OELZE, By a Church *(An einer Kirche)*, 1949-54
 81.3 x 101.6 cm; Private Collection Basle, Switzerland

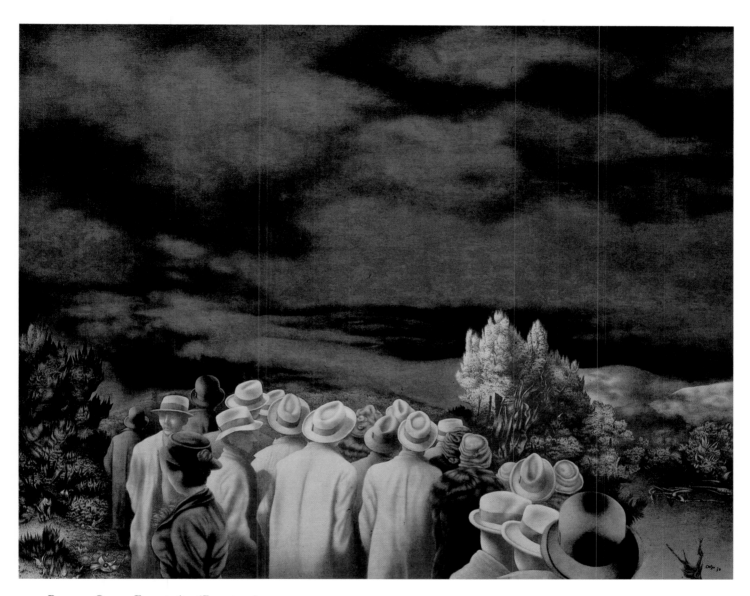

199 RICHARD OELZE, Expectation *(Erwartung)*, 1935
 81.5 x 100 cm; The Museum of Modern Art, New York, Purchase

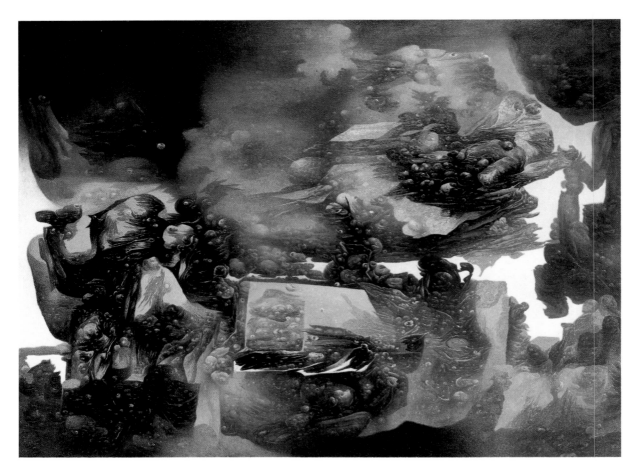

200 RICHARD OELZE, With the Accidental Family *(Mit der zufälligen Familie)*, 1955
 98 x 130 cm; Ellida Schargo von Alten

201
RICHARD OELZE
Inside *(Innen)*, 1955/56
98 x 125 cm
Kunsthalle Bremen

202 RICHARD OELZE, Oracle *(Orakel)*, 1955
100 x 125 cm; Private Collection

203
WILLI BAUMEISTER
Tennis Player *(Tennisspieler)*, 1935
Mixed media and sand on canvas
116 x 81 cm; Museum Folkwang, Essen

204
WILLI BAUMEISTER
Rock Garden *(Steingarten)*, 1939
100.5 x 81.5 cm; Staatsgalerie Stuttgart

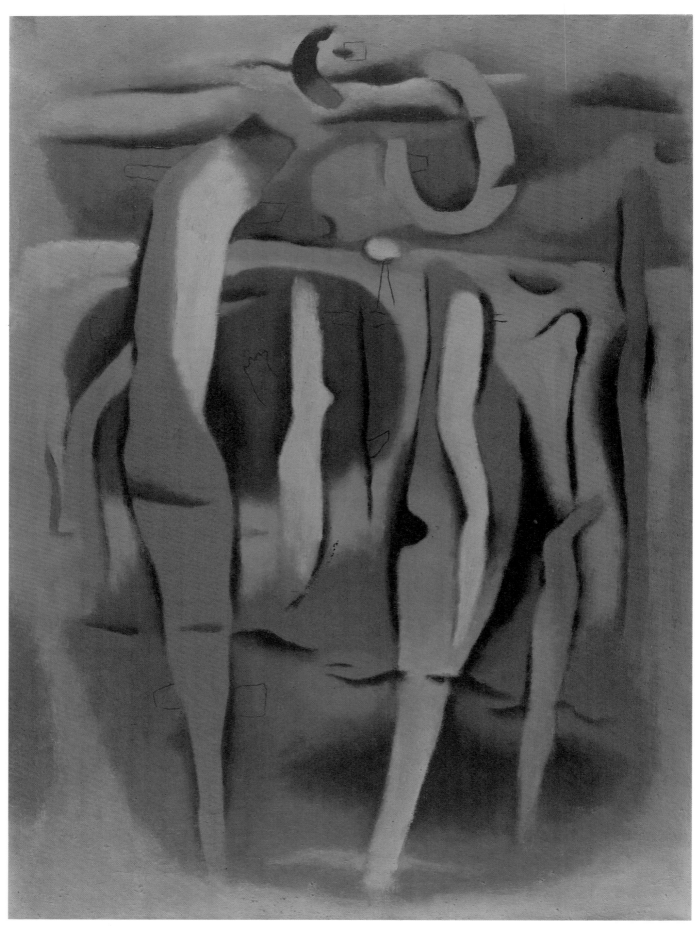

205 WILLI BAUMEISTER, Composition with three Figures *(Komposition mit drei Figuren)*, 1936
100 x 73.5 cm; Kunsthalle Bremen

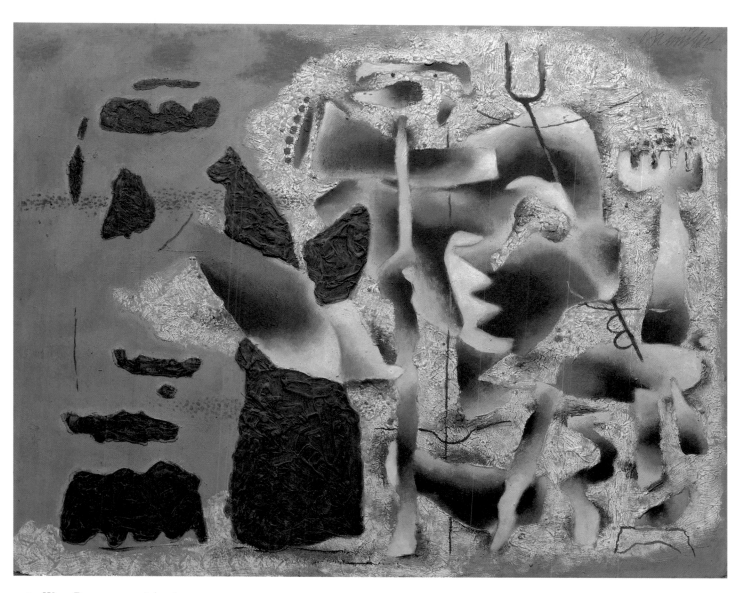

206 WILLI BAUMEISTER, Atlantis, 1949
 Oil on board; 80.5 x 99 cm; Wilhelm Lehmbruck Museum der Stadt Duisburg

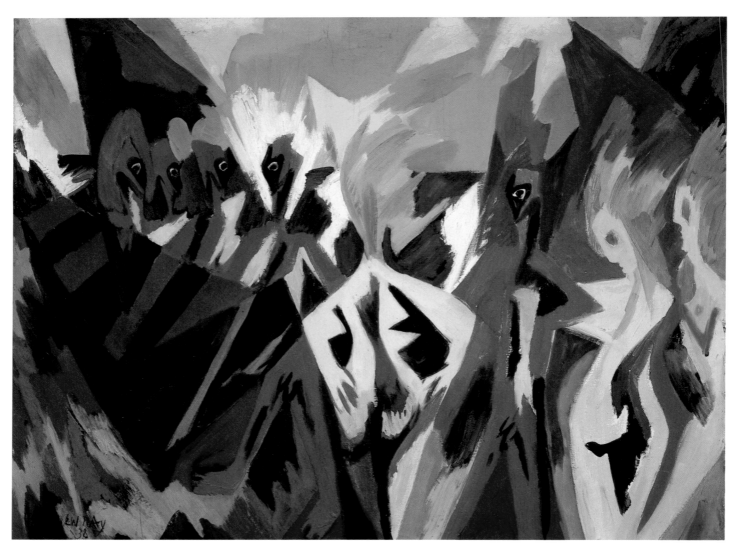

207 ERNST WILHELM NAY, Figures on the Lofoten Islands *(Menschen in den Lofoten)*, 1938
100 x 130 cm; Private Collection

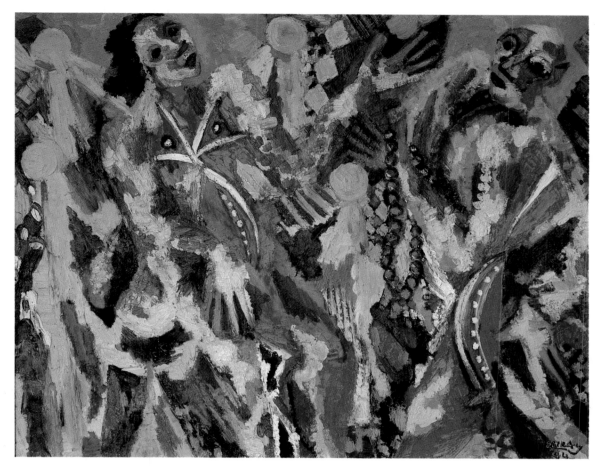

208 ERNST WILHELM NAY, Queen on Throne *(Königin auf Thron)*, 1944
 80 x 100 cm; Private Collection

209
ERNST WILHELM NAY
Annunciation, 1946
Verkündigung
75 x 100 cm
Private Collection

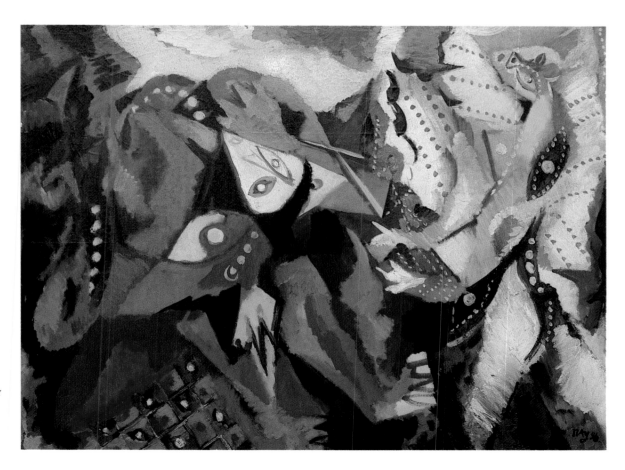

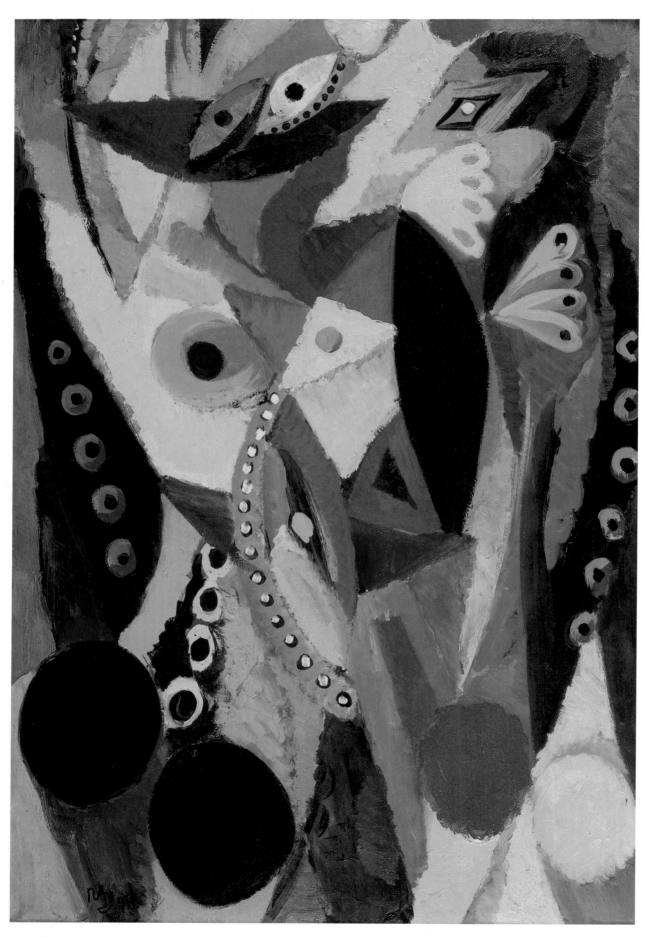

210 ERNST WILHELM NAY, Moroccan Girls *(Marokkanische Mädchen)*, 1948
 90 x 60 cm; Private Collection

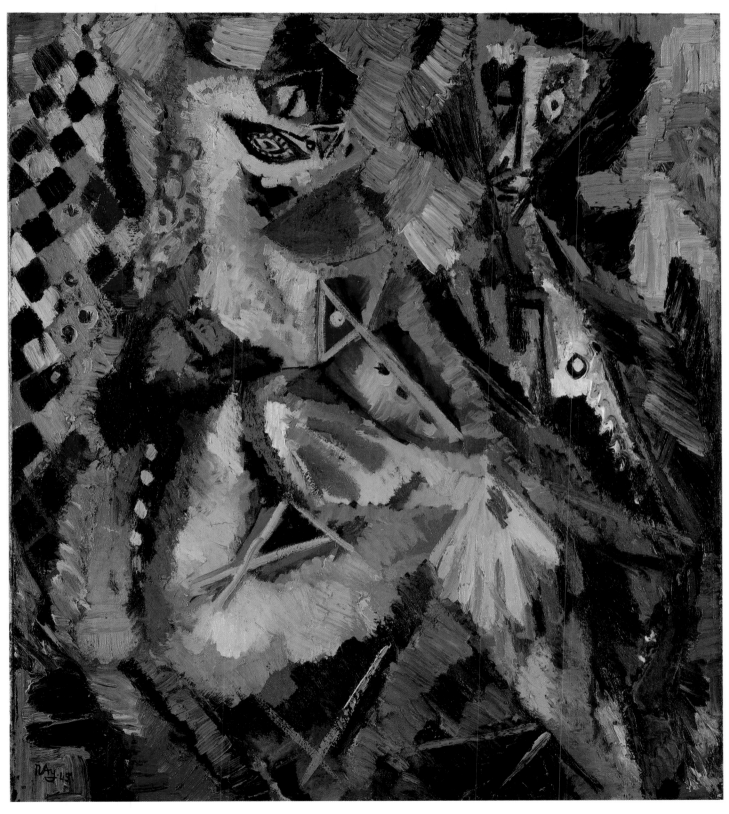

211 ERNST WILHELM NAY, Daughter of Hekate *(Tochter der Hecate)*, 1945
98 x 85 cm; Private Collection

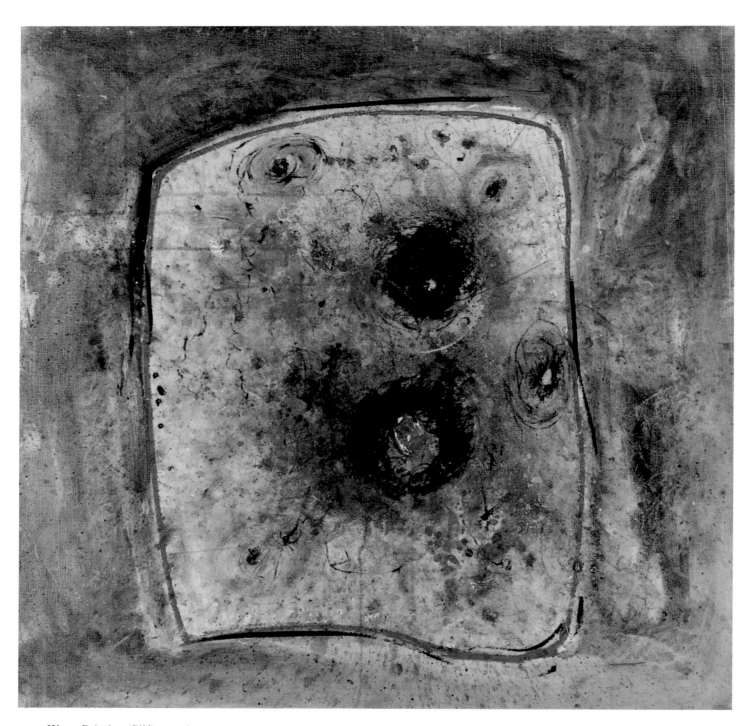

212 WOLS, Painting *(Bild)*, 1944/45
81 x 81 cm; The Museum of Modern Art, New York, Gift of Dominique and John de Menil

213
WOLS
L'Oiseau, 1949
92 x 65.5 cm
D. and J. de Menil Collection, Houston

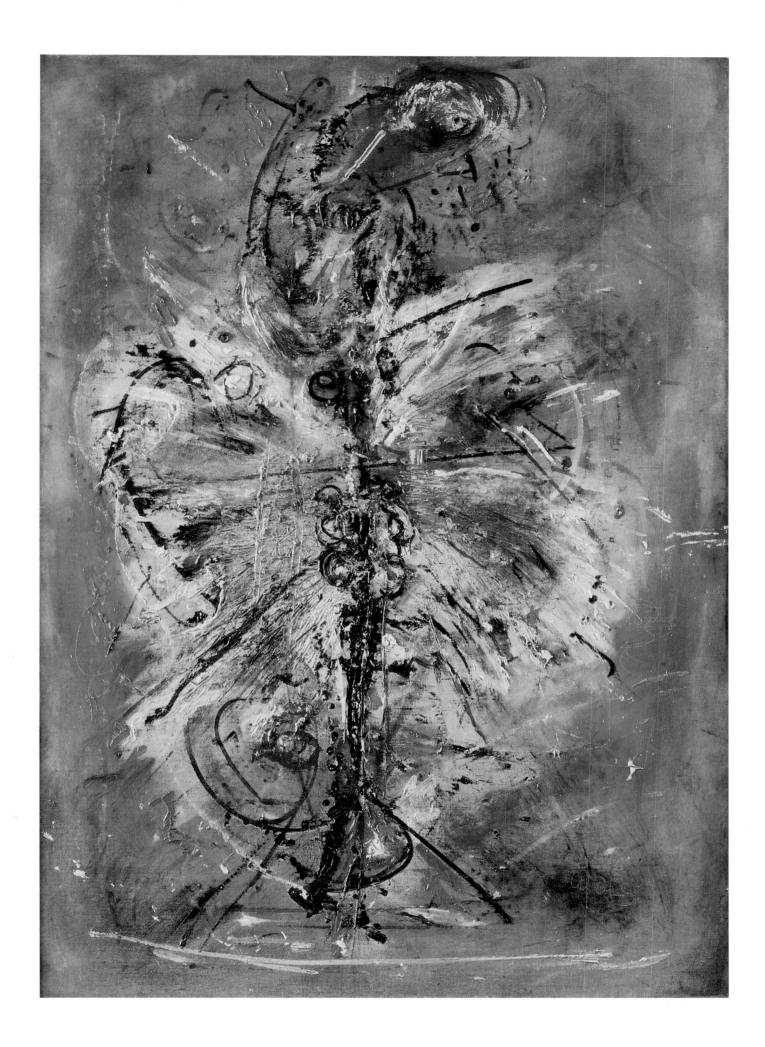

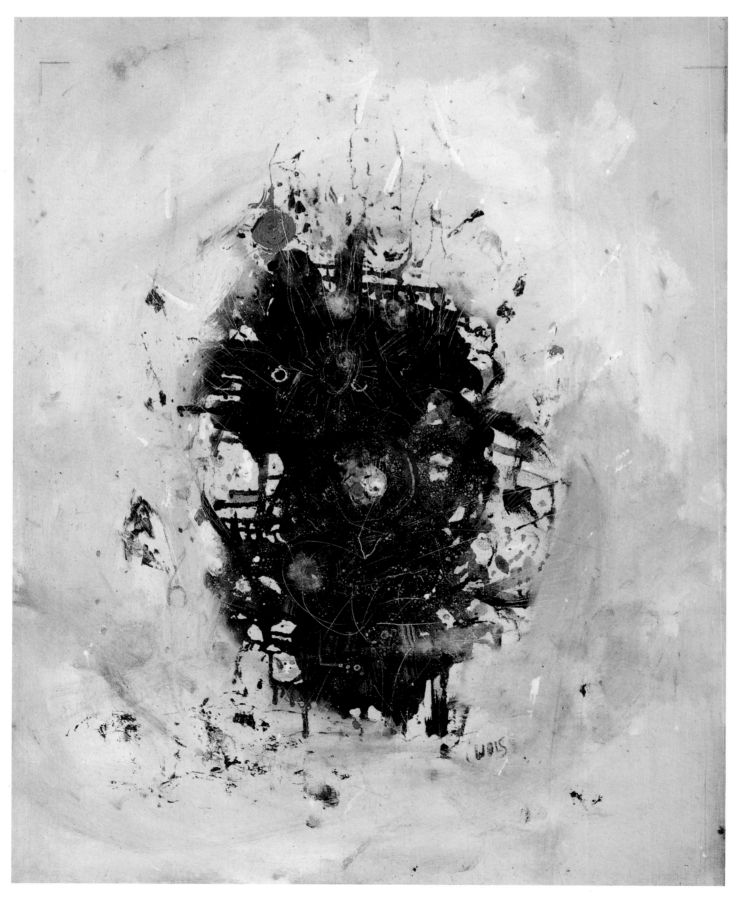

214 WOLS, Composition/Untitled *(Composition/Sans Titre)*, 1946/47
 81 x 65 cm; Private Collection

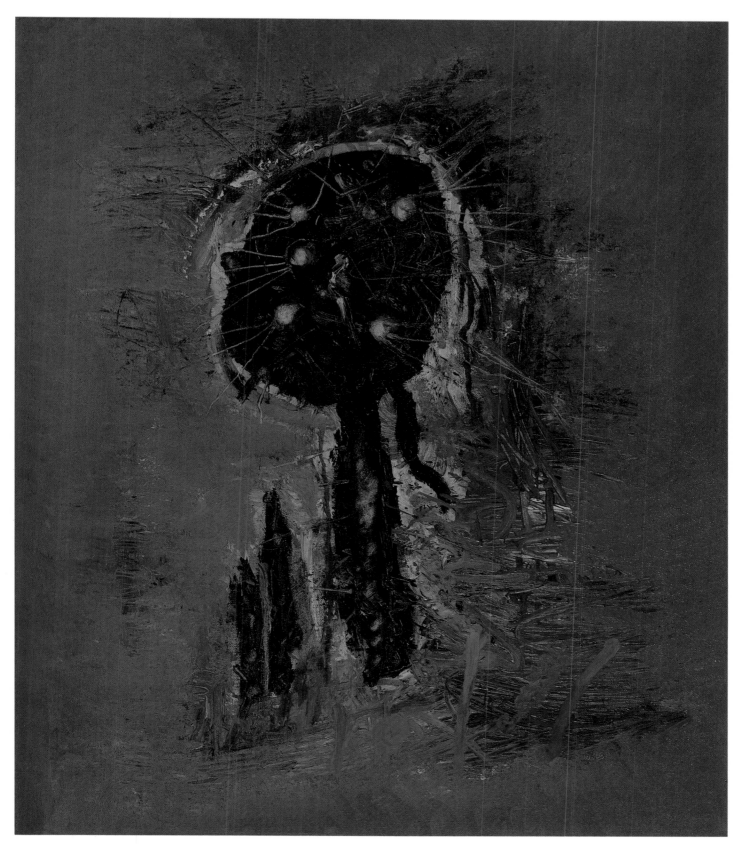

215 Wols, The Blue Phantom *(Das Blaue Phantom)*, 1951
 73 x 60 cm; Museum Ludwig, Cologne

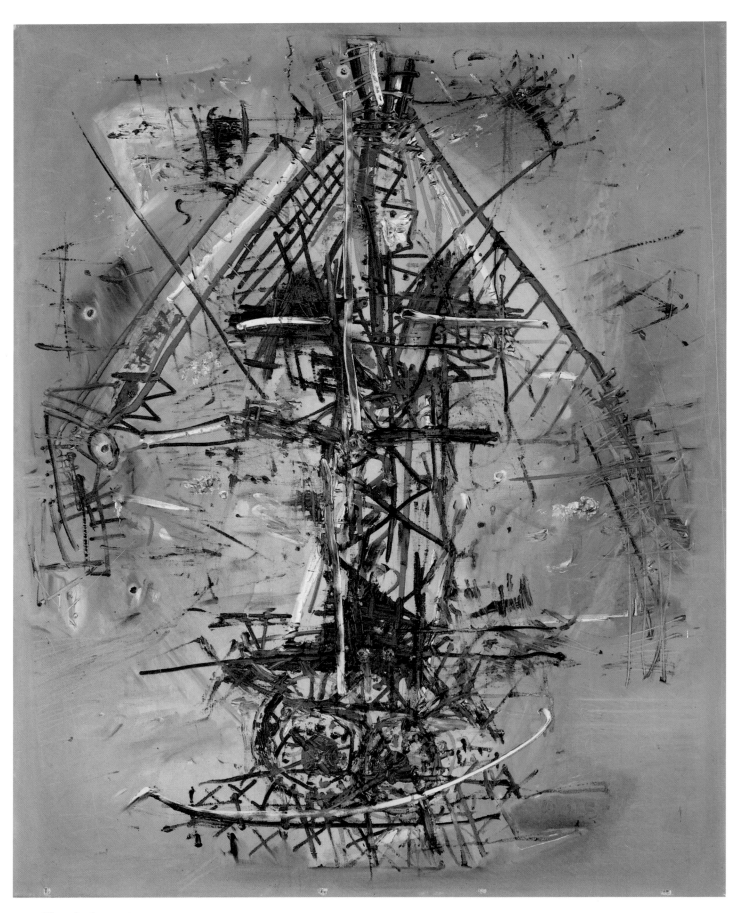

216 WOLS, Le bateau ivre, c. 1945
 92 x 73 cm; Kunsthaus Zürich

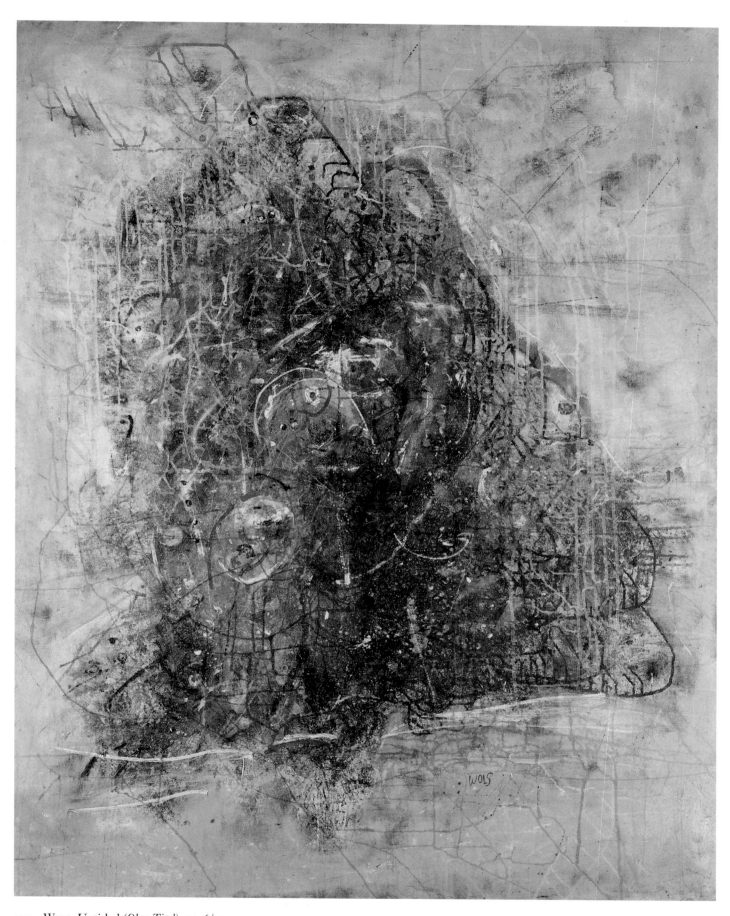

217 Wols, Untitled *(Ohne Titel)*, 1946/47
145 x 113.5 cm; Collection Dieter Grässlin, St. Georgen

218　WERNER HELDT, Thunderstorm by the Spree; Afternoon *(Gewitternachmittag an der Spree)*, 1951
80 x 140 cm; Private Collection

219 WERNER HELDT, Saturday Afternoon – Sunday Afternoon *(Samstagnachmittag – Sonntagnachmittag)*, 1952
60 x 100 cm; Private Collection

220 WERNER HELDT, Sunday Afternoon *(Sonntagnachmittag)*, 1952
60 x 100 cm; Kommunale Galerie, Berlin

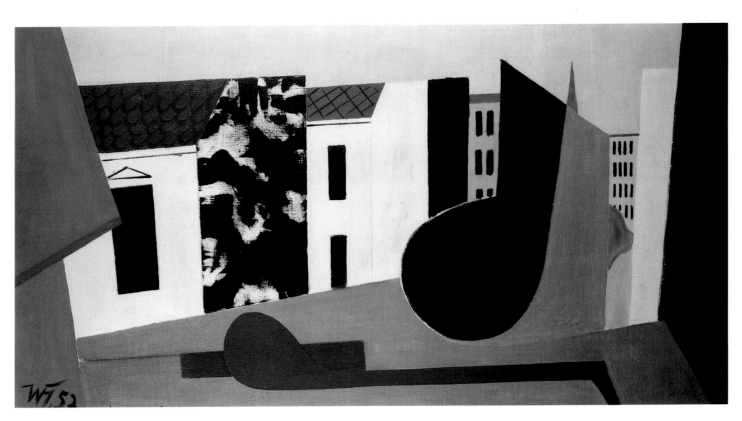

221 WERNER HELDT, Sunday Afternoon *(Sonntagnachmittag)*, 1952
61 x 108 cm; Dr., Dr. h. c. Christian Adolf Isermeyer, Hamburg

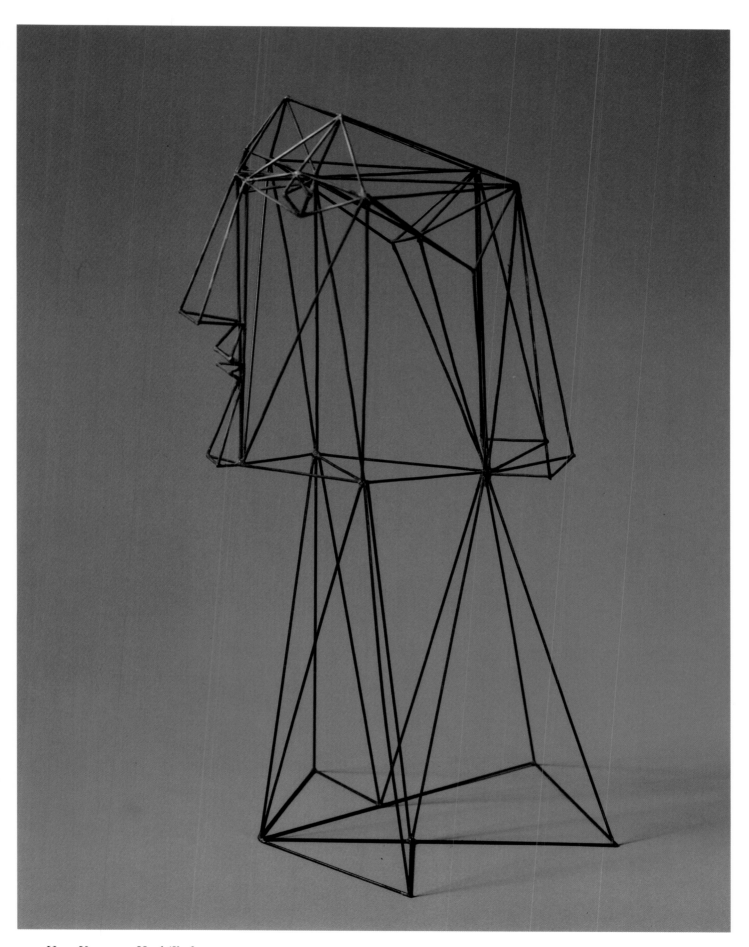

222 HANS UHLMANN, Head *(Kopf)*, 1937
Wire; 53.7 x 23 x 25.5 cm; Mrs Hildegard Uhlmann (on permanent loan to Wilhelm Lehmbruck Museum der Stadt Duisburg)

223 HANS UHLMANN, Steel Sculpture *(Stahlplastik)*, 1951
Steel and aluminium, painted red and black; 133 x 50 x 43 cm; Wilhelm Lehmbruck Museum der Stadt Duisburg

224 HANS UHLMANN, Large Fetish *(Großer Fetisch)*, 1958
Steel; 95.5 x 48 x 39.8 cm; Mrs Hildegard Uhlmann (on permanent loan to Wilhelm Lehmbruck Museum der Stadt Duisburg)

225
GÜNTHER UECKER
Nail Object *(Nagelobjekt)*, 1963
Distemper, nails, canvas on wood
110 x 110 cm
Collection Neuerburg, Cologne

226
GÜNTHER UECKER
Organic Structure X – Circular Formation A,
1962
Organische Struktur X – Kreisformation A
Distemper, nails, canvas on wood; 110 x 110 cm
Collection Edda and Werner Hund

227 GÜNTHER UECKER, Breathing Volume *(Atmendes Volumen)*, 1962
Nails, canvas on wood; 176 x 117 cm; Private Collection, Berlin

228
HEINZ MACK
Dynamic Structure White on Yellow, 1963
Dynamische Struktur weiß auf gelb
Acrylic on calico; 130 x 150 cm; Mack

229
HEINZ MACK
Untitled *(Ohne Titel)*, 1958
Acrylic on canvas, 113 x 91 cm
Kaiser Wilhelm Museum, Krefeld

230 OTTO PIENE, Venus of Willendorf *(Venus von Willendorf)*, 1963
 Oil and smoke on canvas; 150 x 200 cm; Stedelijk Museum, Amsterdam

231 GOTTHARD GRAUBNER, Colour-Space – Untitled *(Farbraum – ohne Titel)*, 1961/62
Mixed media on canvas; 190 x 140 cm; Insel Hombroich

232 GOTTHARD GRAUBNER, Colour-Space – Untitled) *(Farbraum – ohne Titel)*, 1961/62
Mixed media on canvas; 190 x 140 cm; Insel Hombroich

233
GOTTHARD GRAUBNER
Cross Navel *(Kreuznabel)*, 1961/62
Mixed media on canvas
170 x 190 cm; Private Collection

234
GOTTHARD GRAUBNER
Spacepink *(Raumrosa)*, 1961
Mixed media on canvas
160 x 130 cm; Private Collection

235
KONRAD KLAPHECK
The Weapon of my Seriousness, 1959
Die Waffe meines Ernstes
100 x 90 cm
Werner Ruhnau and Anita Ruhnau-Mijares

236
KONRAD KLAPHECK
The Ancestors, 1960
Die Ahnen
115 x 125 cm
Museum Ludwig, Cologne

239 KONRAD KLAPHECK, The Logic of Women *(Die Logik der Frauen)*, 1965
 110 x 90 cm; Louisiana Museum of Modern Art, Humblebaek, Gift of Celia Ascher

240 JOSEPH BEUYS, Pt Co Fe, 1948-72
Platinium, cobalt and iron; 195 x 120 x 34 cm; Collection Feelisch, Remscheid (on loan to Museum am Ostwall, Dortmund)

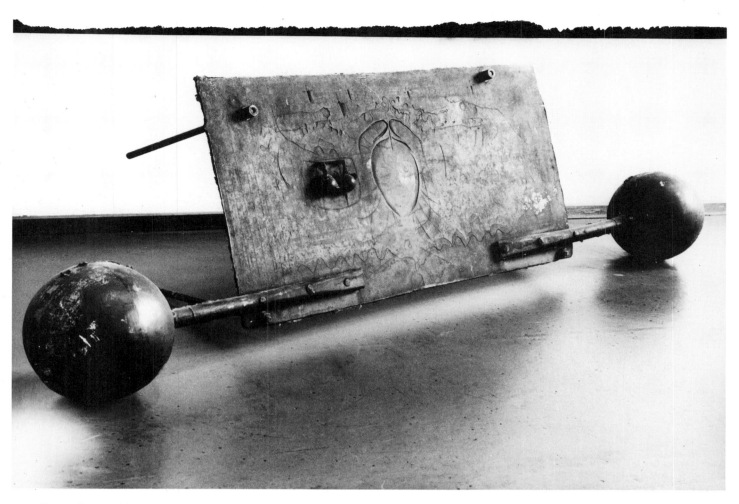

241 Joseph Beuys, Sibylla (Justitia), 1957
Bronze; 24 x 50 x 185 cm; Museum Ludwig, Cologne

241 a Joseph Beuys, Sibylla (Justitia) – detail

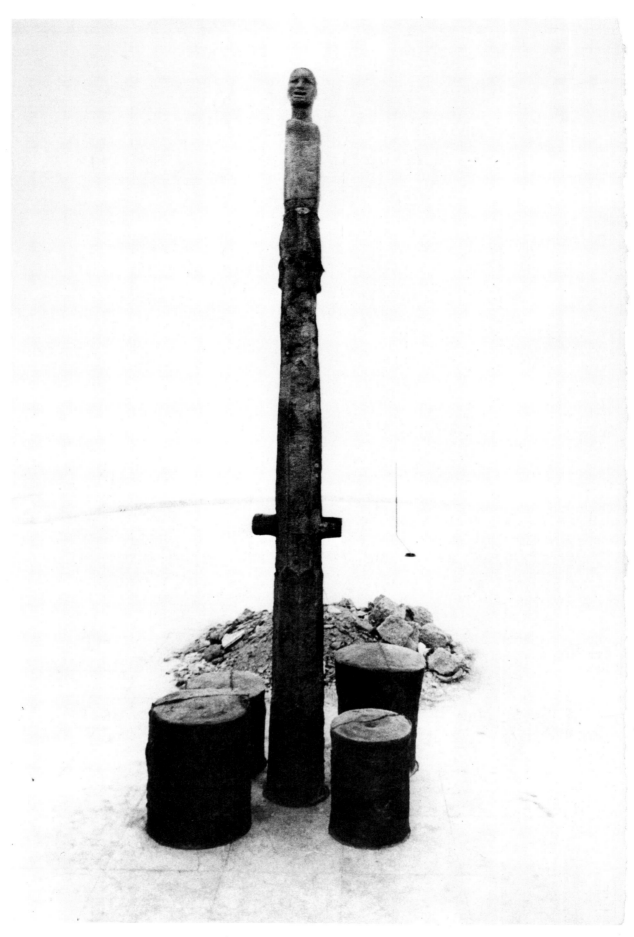

242a JOSEPH BEUYS, Tram Stop *(Straßenbahnhaltestelle)* – installation Venice 1976

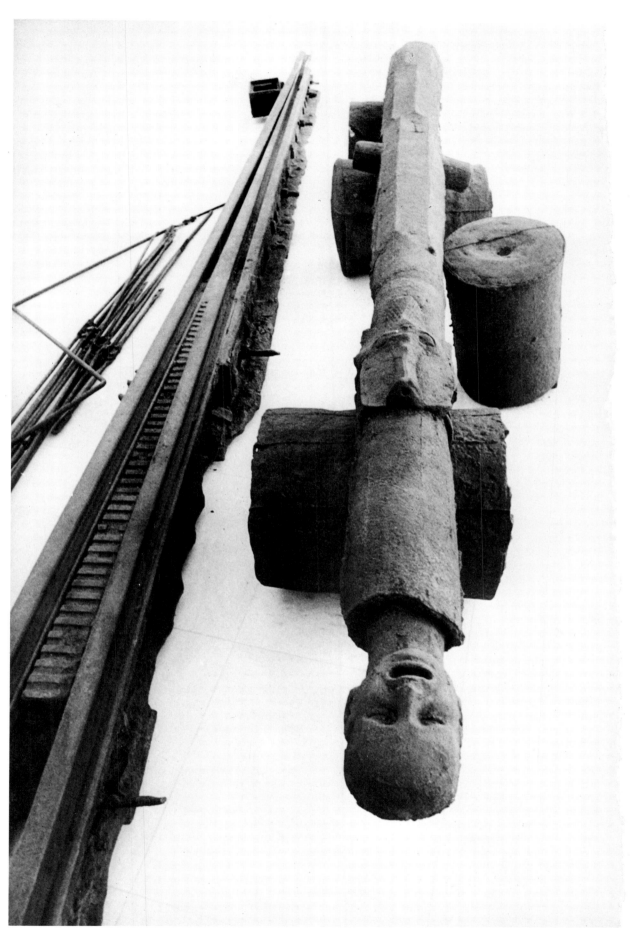

242 JOSEPH BEUYS, Tram Stop (*Straßenbahnhaltestelle*), 1976
Rail (iron): 860 x 15 x 10.5 cm; 4 cylinders (iron): 61 x 47 cm, 59 x 38 cm, 51 x 44 cm, 73 x 51 cm; barrel with mouth and head:
376 x 45 x 29 cm; 22 stanchions (iron), longest: 107 cm; shortest: 55.5 cm; 1 crank (iron): 103 x 101 x 104 cm; Rijksmuseum
Kröller-Müller, Otterlo

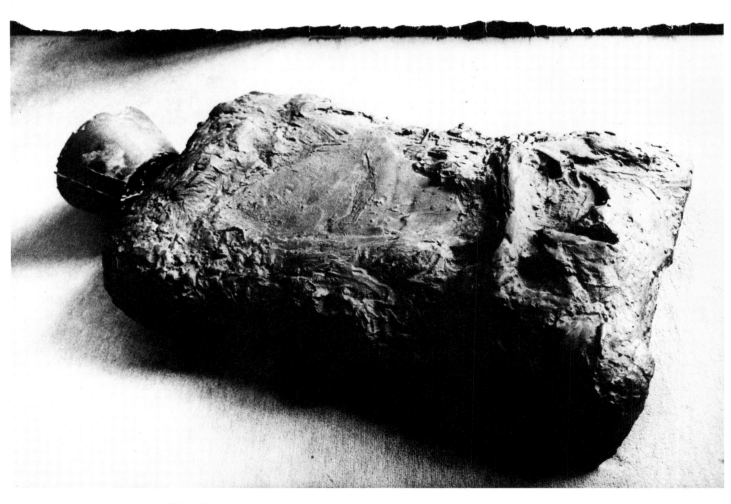

243 JOSEPH BEUYS, Mountain King *(Bergkönig)*, 1961
Bronze; 31 x 83 x 130 cm; Deutsche Bank AG, Frankfurt/Düsseldorf

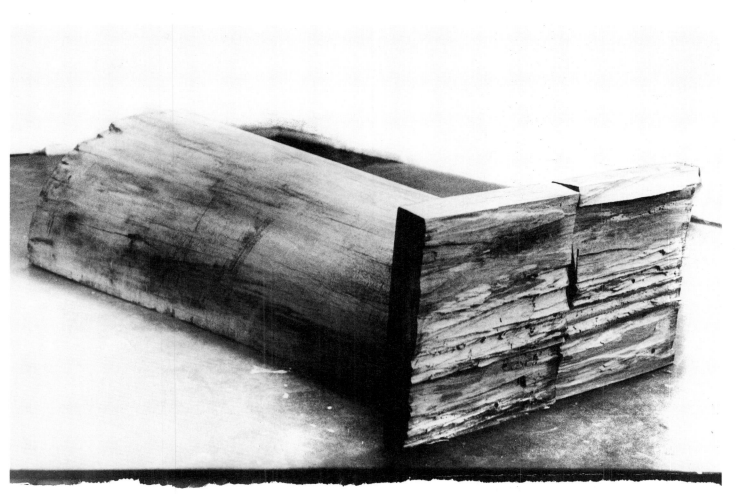

244 JOSEPH BEUYS, Wet Washing Virgin *(Nasse Wäsche Jungfrau)*, 1985
Wood; 291 x 140 x 83 cm; Anthony d'Offay Gallery, London

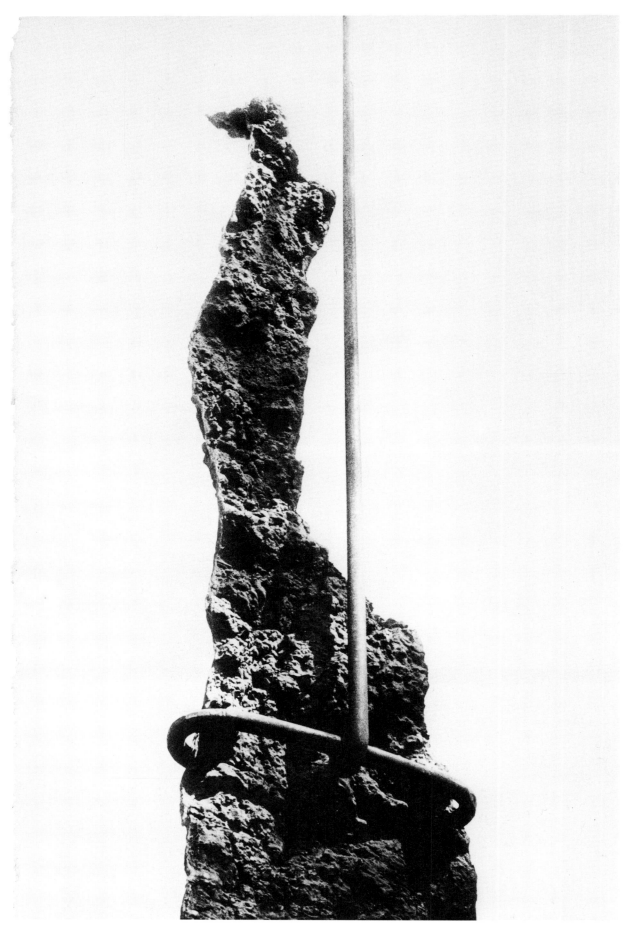

245 a JOSEPH BEUYS, Lightning *(Blitzschlag)* – detail

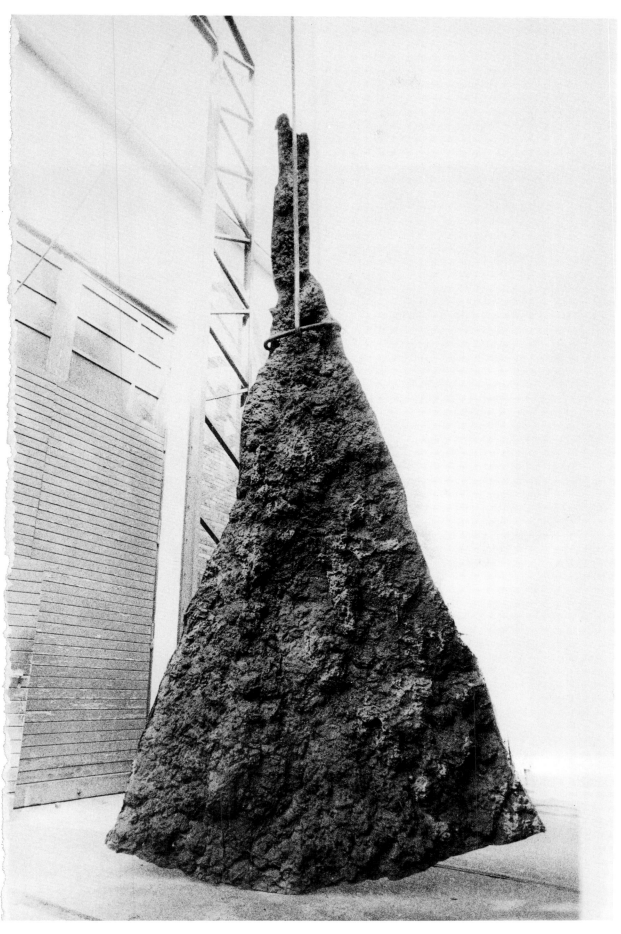

245 JOSEPH BEUYS, Lightning *(Blitzschlag)*, 1982-85
Bronze; c. 624 x 248 x 50 cm; Anthony d'Offay Gallery, London

246 Gerhard Richter, Lovers in a Forest *(Liebespaar im Wald)*, 1966
170 x 200 cm; Private Collection, Berlin

247
Gerhard Richter
Olympia, 1967
200 x 130 cm
Private Collection, Berlin

248 GERHARD RICHTER, Stag *(Hirsch)*, 1963
150 x 200 cm; Collection Reinhard Onnasch, Berlin (on loan to Staatliche Museen Preussischer Kulturbesitz, Nationalgalerie Berlin)

249
GERHARD RICHTER
The Gizeh Sphinx, 1965
Die Sphinx von Gizeh

150 x 170 cm
Collection Reinhard
Onnasch, Berlin (on loan
to Folkwang Museum,
Essen)

Die Sphinx von Gise (Sphinx des Königs Chephren).
Im Hintergrunde die Pyramide des Königs Cheops. 4. Dyn. (um 2600 v. Chr.)

250 GERHARD RICHTER, Christa and Wolfi *(Christa und Wolfi)*, 1964
 150 x 130 cm; Private Collection, Hamburg

Moderne Kunst

251 SIGMAR POLKE, Modern Art *(Moderne Kunst)*, 1968
Acrylic and oil on canvas; 150 x 125 cm; Anna and Otto Block, Berlin

252 SIGMAR POLKE, The Sausage Eater *(Der Wurstesser)*, 1963
Distemper on canvas; 200 x 150 cm; Reinhard Onnasch Galerie, Berlin

253 SIGMAR POLKE, Crane Painting II *(Reiherbild II)*, 1968
Distemper on flannel; 190 x 150 cm; Saatchi Collection, London

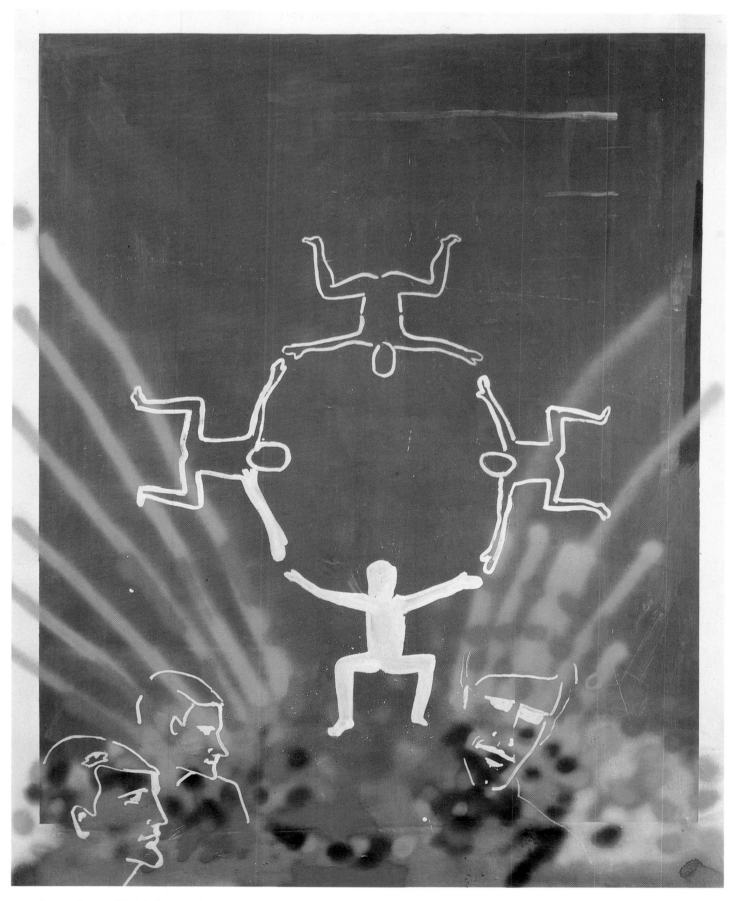

254 SIGMAR POLKE, Untitled – with Faces *(Ohne Titel – mit Gesichtern)*, 1969-72
Distemper and varnish on canvas; 190 x 150 cm; Private Colletion

255 SIGMAR POLKE, Untitled – Referring to Max Ernst *(Ohne Titel – auf Max Ernst bezogen)*, 1981
Acrylic on canvas; 200 x 180 cm; Städtisches Kunstmuseum Bonn

256 Sigmar Polke, Watch-Tower III *(Wachtturm III)*, 1985
 305 x 225 cm; Silver, silver nitrate, iodine, cobalt -II chloride, synthetic resin on canvas; Staatsgalerie Stuttgart

257 BLINKY PALERMO, Untitled *(Ohne Titel)*, 1967
 Distemper on calico on wood; 50 x 150 x 6 cm; Private Collection

258 BLINKY PALERMO, Untitled *(Ohne Titel)*, 1972
Object in two parts, casein on calico on wood; 248 x 146 x 4 cm; Munich, Bayerische Staatsgemäldesammlungen, Staatsgalerie moderner Kunst,
Wittelsbacher Ausgleichsfonds, Sammlung Prinz Franz von Bayern

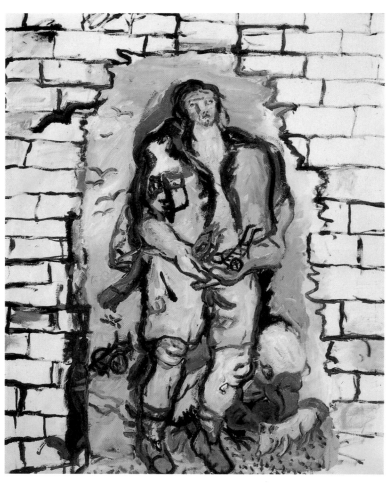

259
GEORG BASELITZ
The Shepherd, 1965
Der Hirte
162 x 130 cm
Private Collection

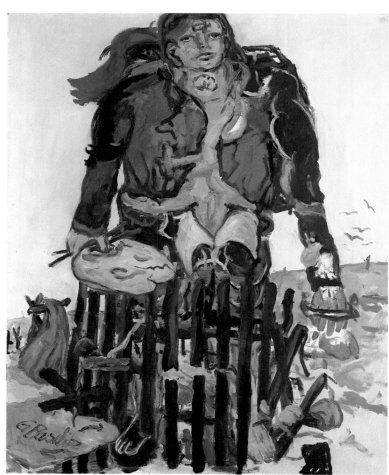

260
GEORG BASELITZ
Different Signs, 1965
Verschiedene Zeichen
160 x 130 cm; Hartmut and
Silvia Ackermeier, Berlin

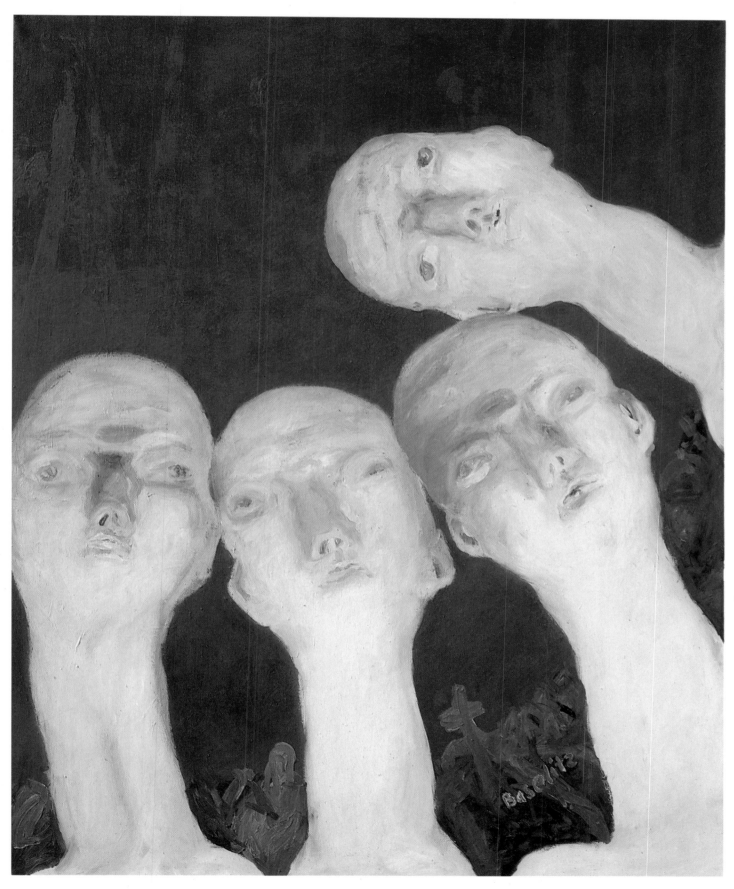

261　Georg Baselitz, Oberon, 1964
　　250.5 x 200.5 cm; Private Collection

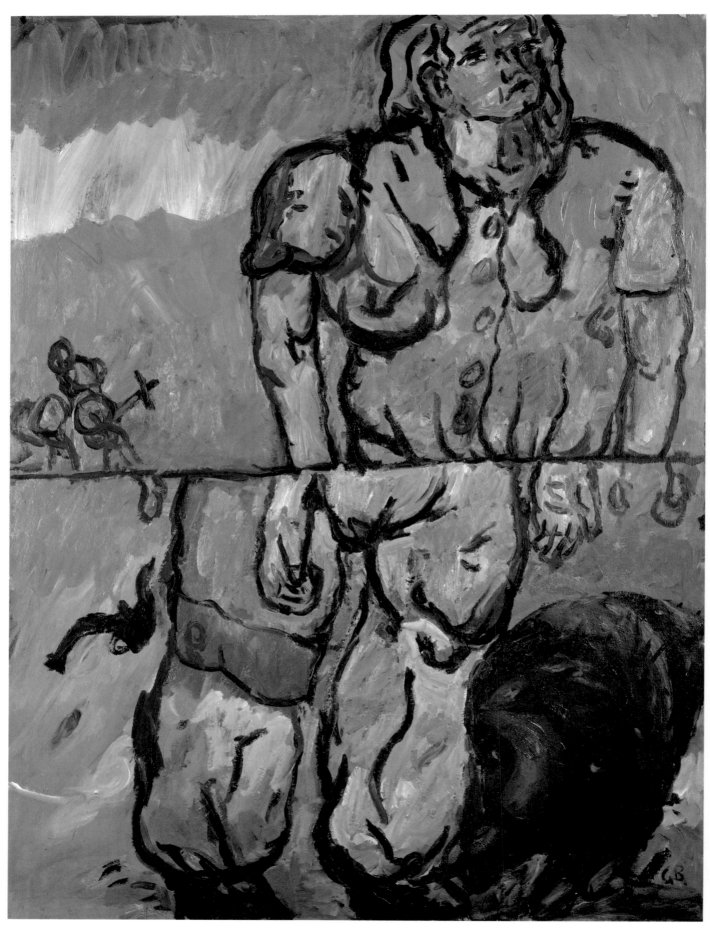

262 GEORG BASELITZ, MMM in G and A *(MMM in G und A)*, 1961/62/66
195 x 145 cm; Saatchi Collection, London

263 GEORG BASELITZ, The Forest on its Head *(Der Wald auf dem Kopf)*, 1969
250 x 190 cm; Museum Ludwig, Cologne

264
GEORG BASELITZ
Black Singer, 1982
Schwarze Sängerin
250 x 200 cm
Private Collection, Geneva

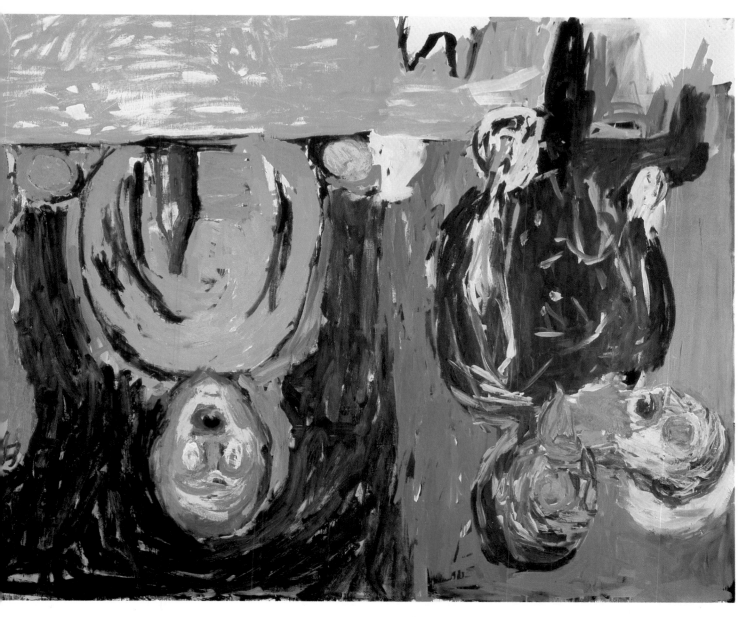

265 GEORG BASELITZ, Supper in Dresden *(Nachtessen in Dresden)*, 1983
280 x 450 cm; Saatchi Collection, London

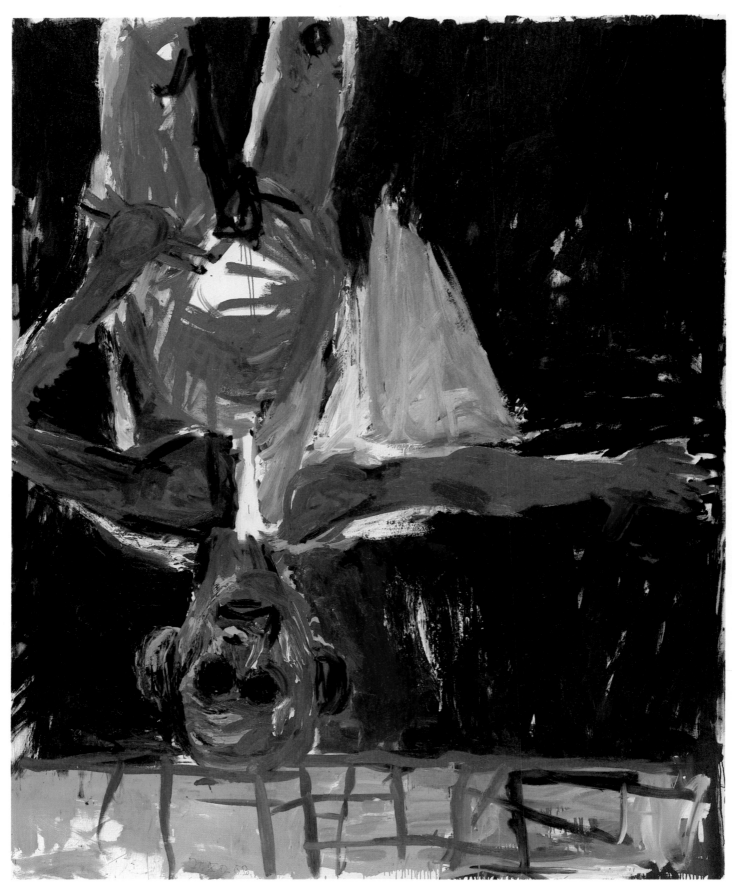

266 GEORG BASELITZ, Painter with Sailing Boat – Munch *(Maler mit Segelschiff – Munch)*, 1982
250 x 200 cm; Joe and Marie Donnelly, Ireland

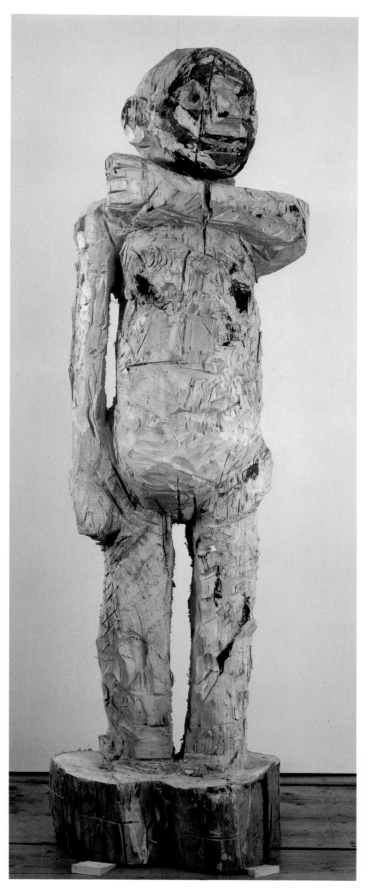

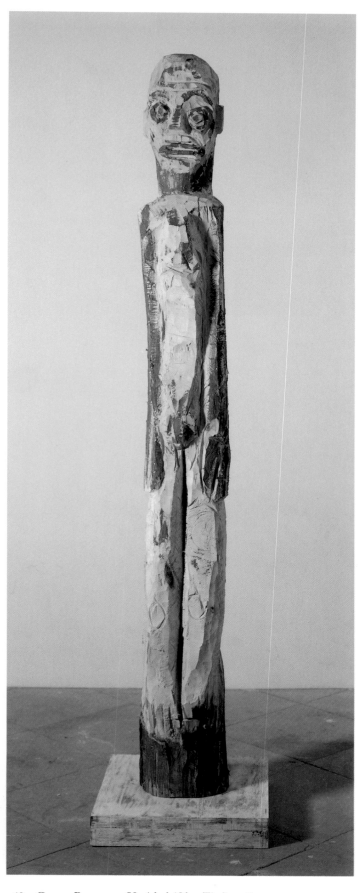

267　Georg Baselitz, Untitled *(Ohne Titel)*, 1982
Painted wood; 250 x 90 x 60 cm; Saatchi Collection, London

268　Georg Baselitz, Untitled *(Ohne Titel)*, 1983
Painted linden; 250 x 30 x 30 cm; Private Collection

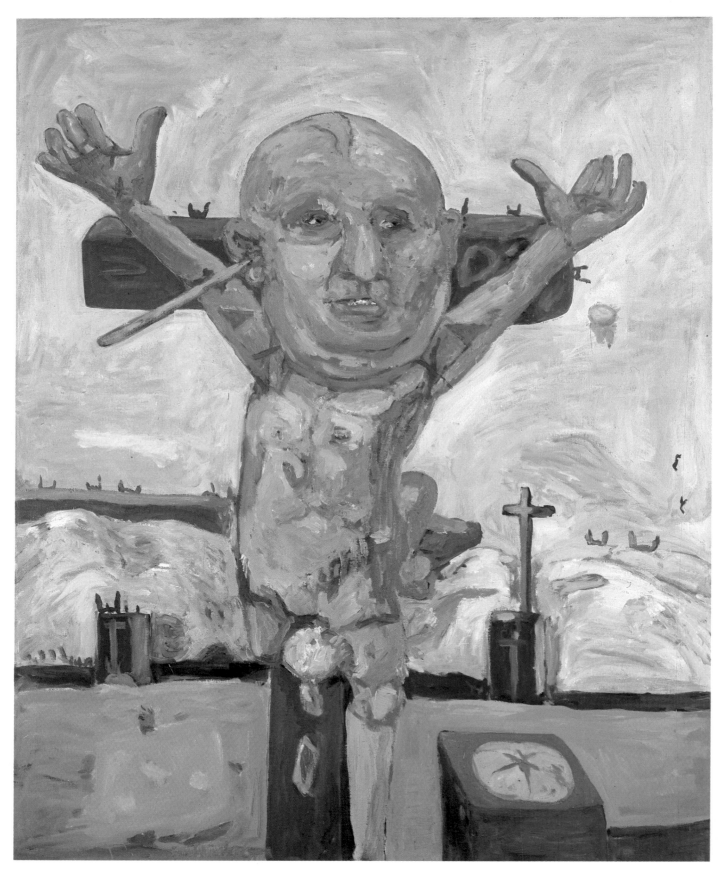

269 Eugen Schönebeck, The Crucified *(Der Gekreuzigte)*, 1964
 162 x 130 cm; Collection Dr. H. Rabe

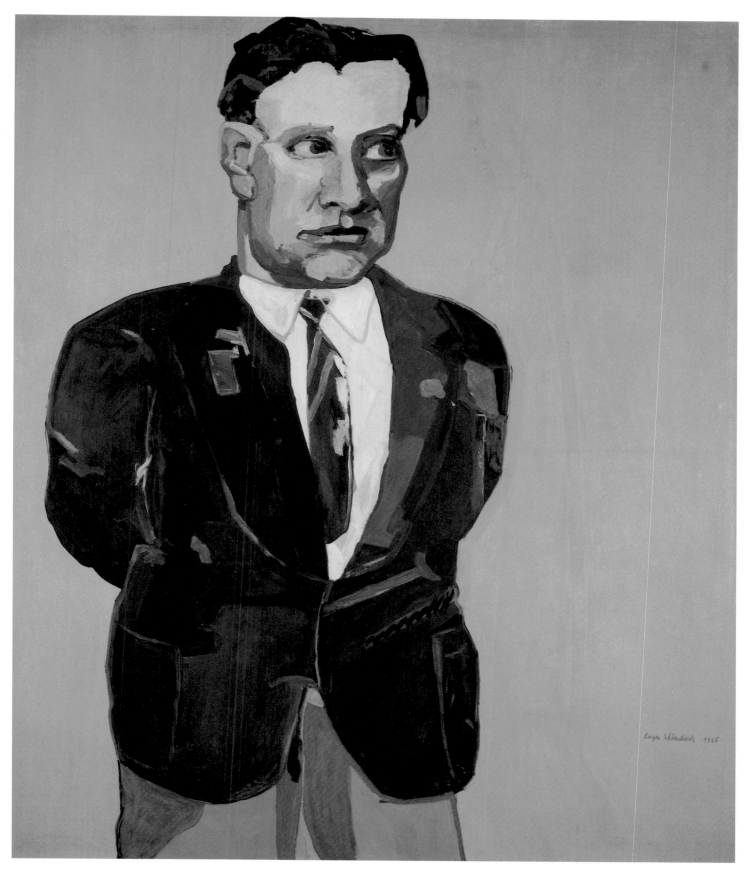

270　Eugen Schönebeck, Majakovski *(Majakowski)*, 1965
　　220 x 185 cm; Collection of the Artist

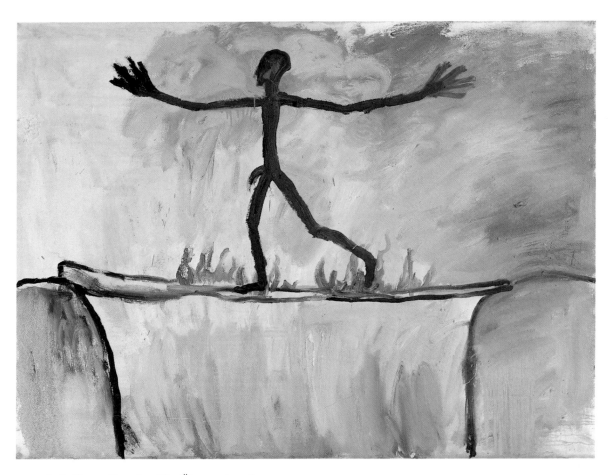

271 A. R. PENCK Crossing *(Der Übergang)*, 1963
94 x 120 cm; Stadt Aachen, Neue Galerie – Sammlung Ludwig

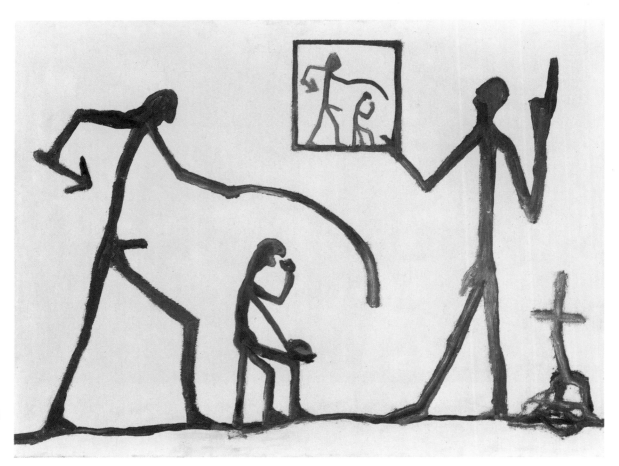

272
A. R. PENCK
Untitled/System
Picture, 1966
(Ohne Titel/Systembild)
100 x 130 cm
Staatliche Kunst-
sammlungen, Kassel

273 A. R. PENCK, Method of Coping *(Methode, fertigzuwerden)*, 1965
149 x 131 cm; Siegfried Adler, Hinterzarten

274 A. R. PENCK, Standart, 1971
Acrylic on canvas; 290 x 290 cm; Private Collection, Courtesy of Mary Boone/Michael Werner Gallery, New York

275 A. R. PENCK, Fritze, 1975
 Acrylic on canvas; 285 x 285 cm; Private Collection, Courtesy of Mary Boone/Michael Werner Gallery, Cologne

276 A. R. Penck, Metaphysical Passage through a Zebra *(Metaphysischer Durchgang durch ein Zebra)*, 1975
285 x 285 cm; Stadt Aachen, Neue Galerie – Sammlung Ludwig

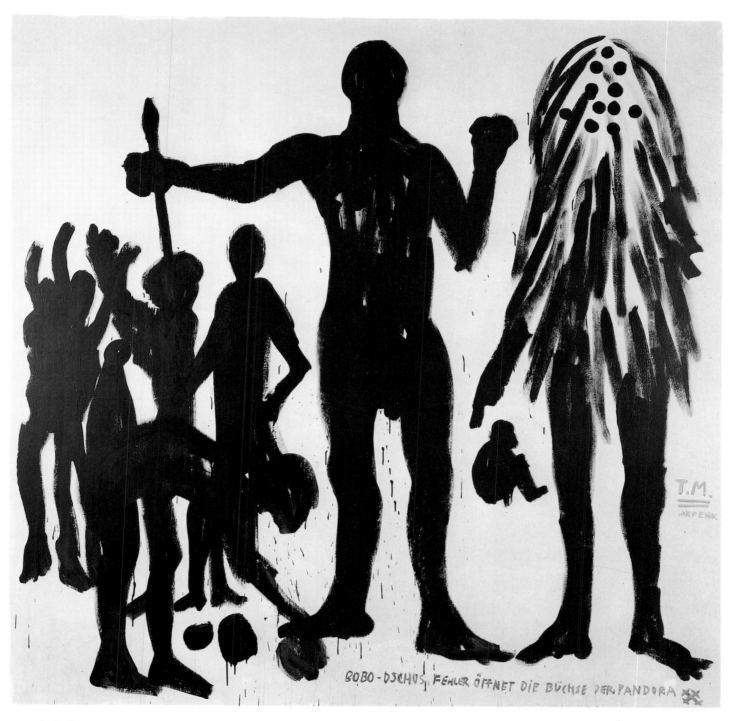

277　A. R. Penck, Bobo Dschu's Mistake opens Pandora's Box (*Bobo Dschus Fehler öffnet die Büchse der Pandora*), 1975
285 x 285 cm; Private Collection

279 K. H. Hödicke, By the Havel III *(An der Havel III)*, 1975
Acrylic on canvas; 200 x 200 cm; Collection Lilott and Erik Berganus

278
K. H. Hödicke
'Am Grossen Fenster', 1964
Acrylic on canvas
4 parts à 130 x 95 cm
Collection of the Artist

280 K. H. HÖDICKE, Ministry of War *(Kriegsministerium)*, 1977
 Acrylic on canvas; 185 x 270 cm; Berlinische Galerie, Berlin

281 K. H. Hödicke, Dessauerstraße 6-7, 1977
Acrylic on canvas; 200 x 200 cm; Collection Dr. Peter Pohl, Berlin

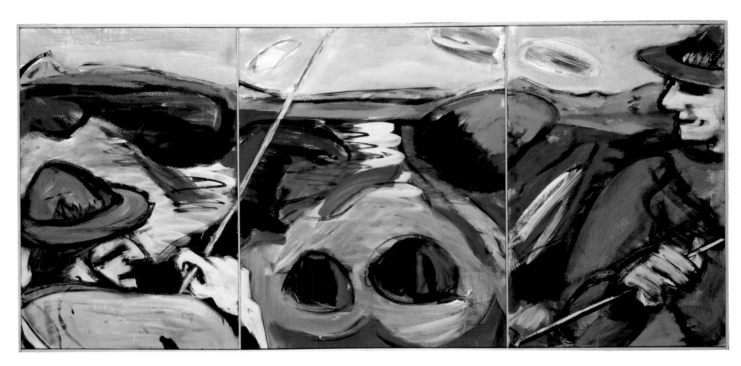

282 BERND KOBERLING, Fishermen *(Fischer)*, 1963
Egg tempera and silver paint on canvas; 100 x 210 cm; Collection of the Artist

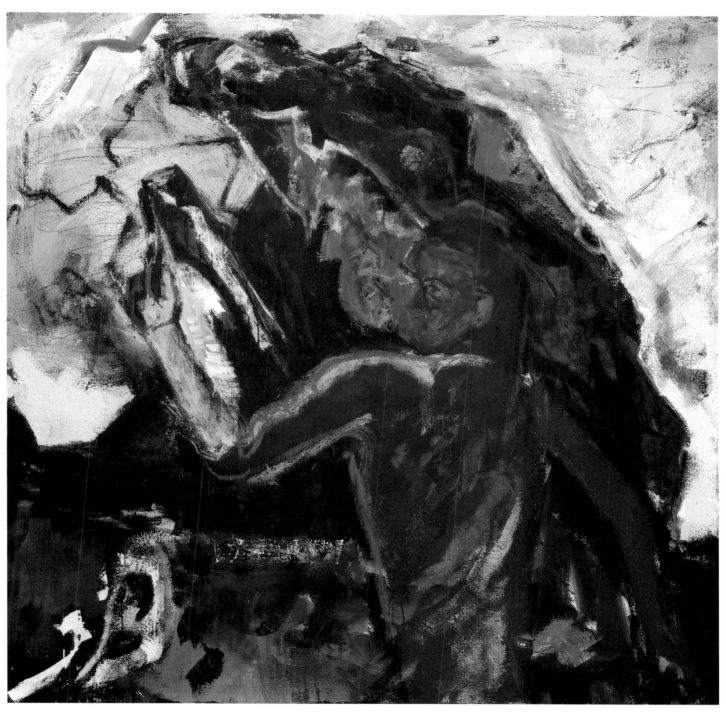

283 BERND KOBERLING, Woman within Stone *(Frau im Stein)*, 1982/83
Acrylic and oil on jute; 190 x 190 cm; Galerie Gmyrek, Düsseldorf

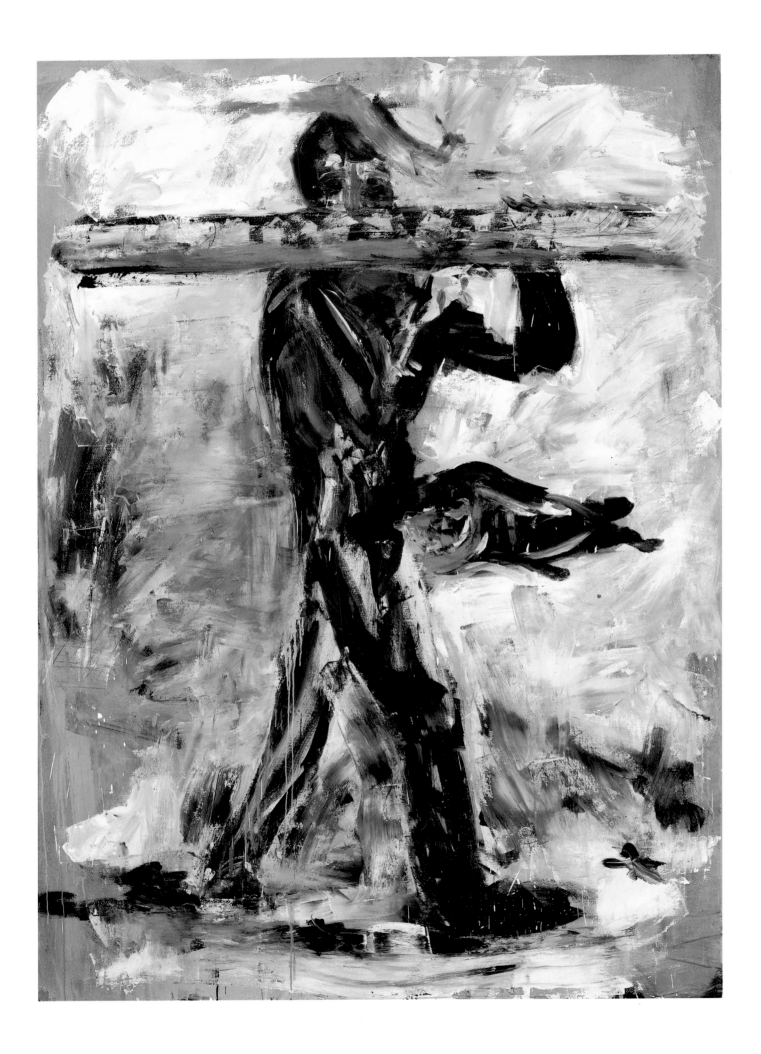

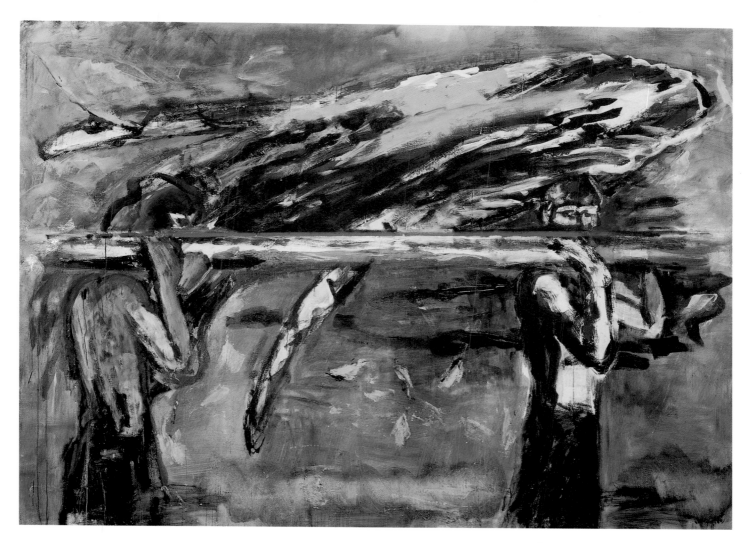

285
BERND KOBERLING
Passage of the Whale *(Walgang)*, 1984/85
Acrylic and oil on canvas; 220 x 300 cm
Reinhard Onnasch Galerie, Berlin

284
BERND KOBERLING
Shore 1 *(Strand 1)*, 1984
Acrylic and oil on canvas; 270 x 190 cm
Reinhard Onnasch Galerie, Berlin

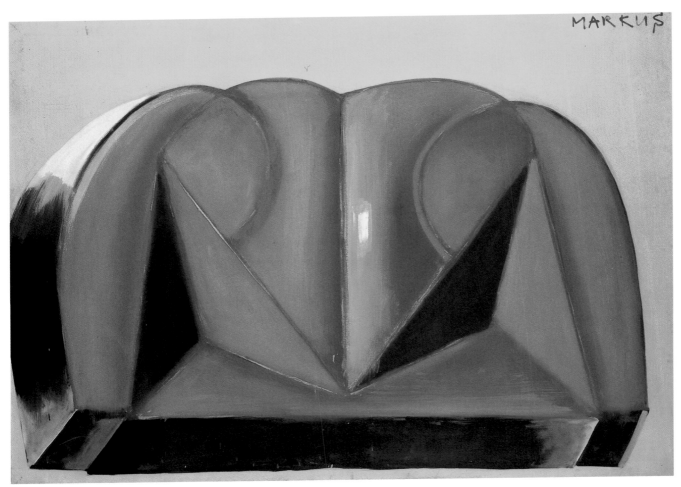

286
MARKUS LÜPERTZ
Mexican Dithyramb, 1964
Mexikanische Dithyrambe
Distemper on canvas
146 x 202 cm
Galerie Springer, Berlin

287
MARKUS LÜPERTZ
Coward – dithyrambic, 1964
Feigling – dithyrambisch
Distemper on canvas; 145 x 154 cm
Dr. Hans Hermann Stober, Berlin

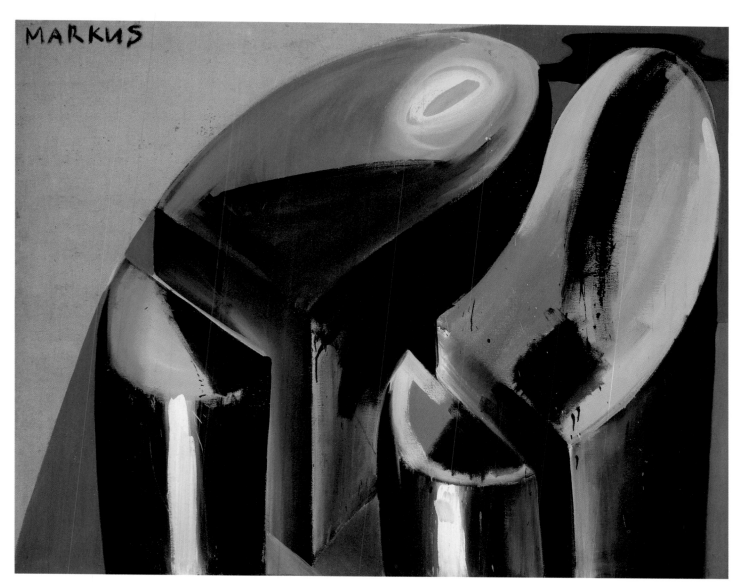

288 MARKUS LÜPERTZ, Traces *(Spuren)*, 1966
Distemper on canvas; 205 x 255 cm; Private Collection, Berlin

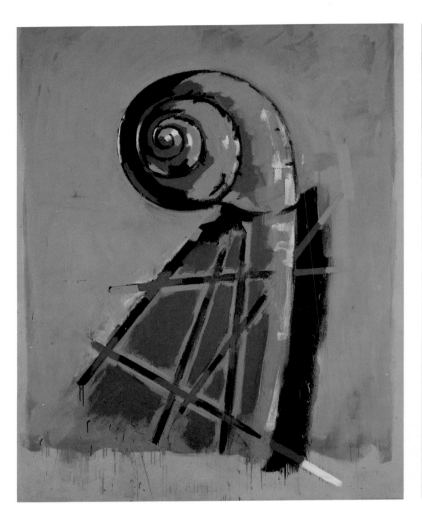

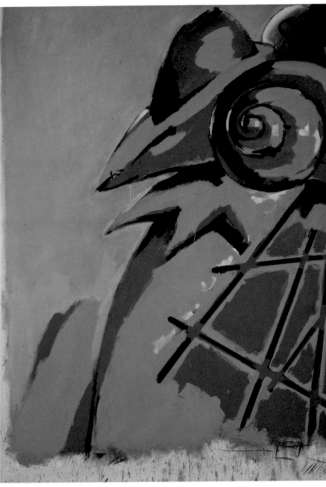

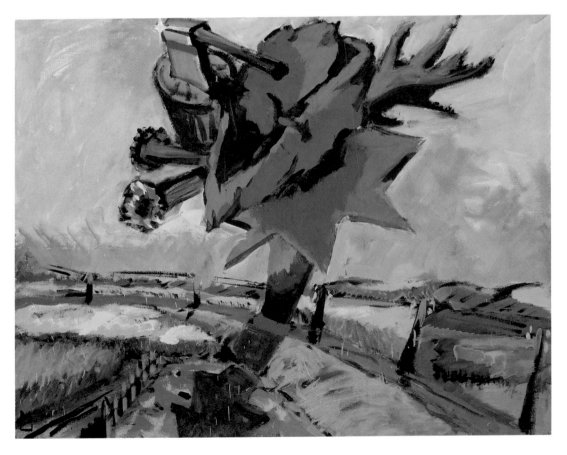

290
Markus Lüpertz
Sceptre – dithyrambic, 1972
Zepter – dithyrambisch
Distemper on canvas; 130 x 160 cm
Dr. Hans Hermann Stober, Berlin

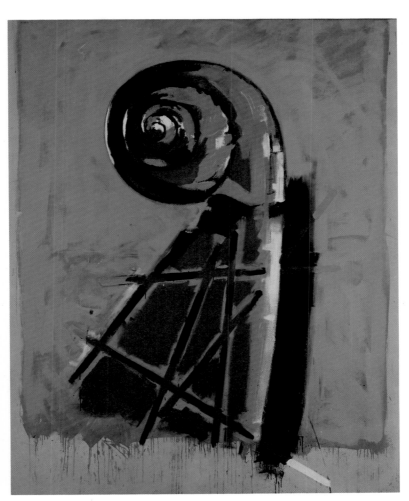

289
MARKUS LÜPERTZ
Apocalypse (Triptych), 1972
Apokalypse (Triptychon)
Distemper on canvas; 260 x 734 cm
Mary Boone/Michael Werner Gallery, New York

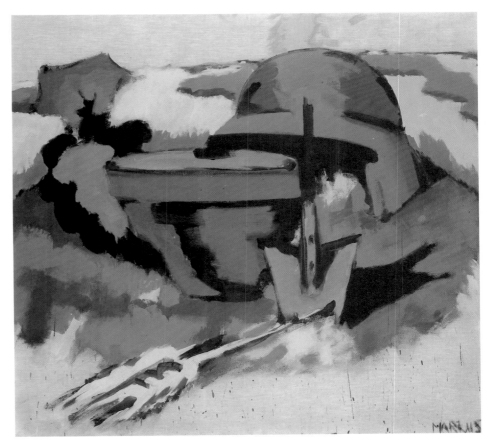

291
MARKUS LÜPERTZ
German Motif *(Deutsches Motiv)*, 1972
Distemper on canvas; 200 x 200 cm
Dr. Hans Hermann Stober, Berlin

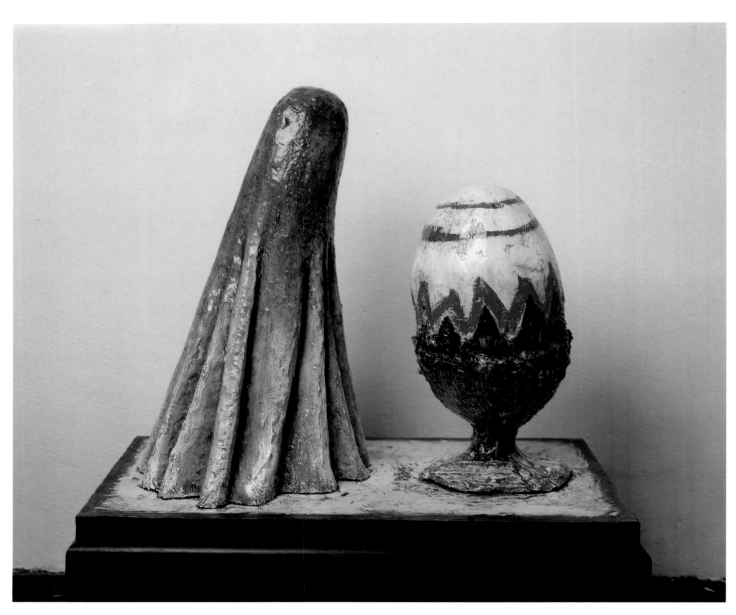

292 MARKUS LÜPERTZ, 'It…' the Mouse replied rather crossly (‚Es…' *versetzte die Maus ziemlich scharf*), 1981
Painted bronze; 109 x 128 x 79 cm; Dr. Hans Hermann Stober, Berlin

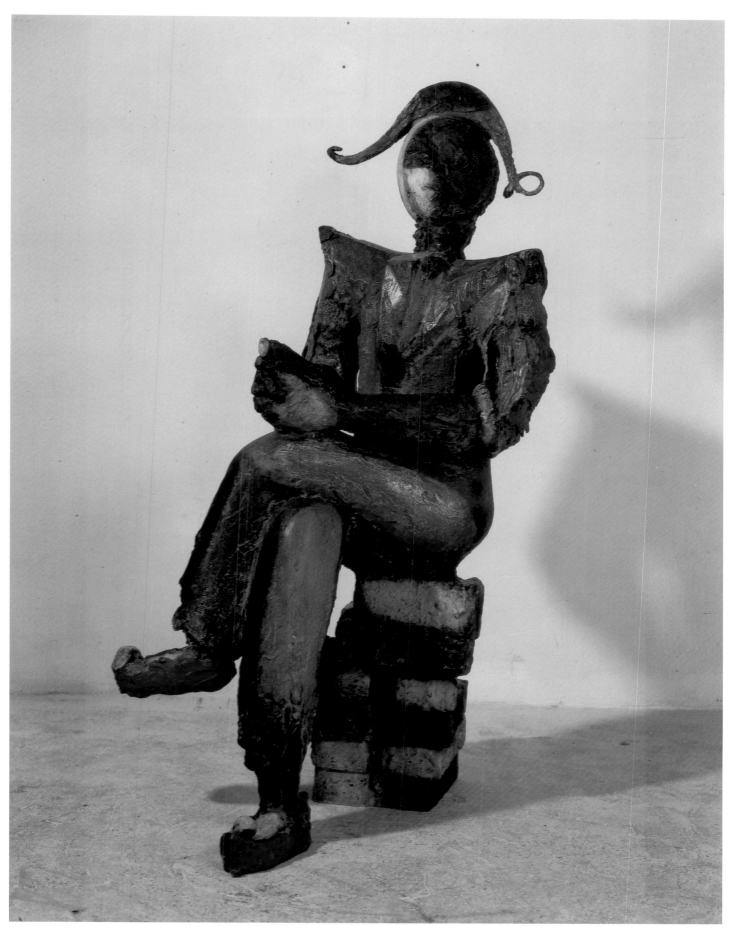

293 MARKUS LÜPERTZ, Pierrot Lunaire, 1984
Painted bronze; 140 x 100 x 100 cm; D. Hauert, Berlin

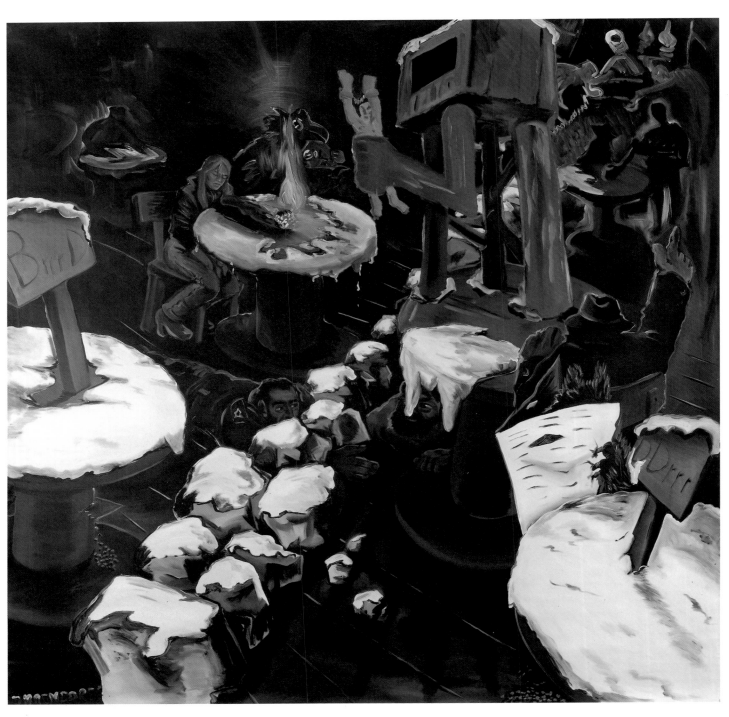

294 JÖRG IMMENDORFF, Brrrd – DDrrr (Café Deutschland – Winter), 1978
 290 x 290 cm; Stedelijk Van Abbemuseum, Eindhoven

295 Jörg Immendorff, Café Rehearsal *(Café Probe)*, 1980
 280 x 350 cm; Private Collection, Courtery of Mary Boone/Michael Werner Gallery, New York

296 Jörg Immendorff, Cold Blood *(Kaltmut)*, 1983
250 x 150 cm; Galerie Rudolf Zwirner, Cologne

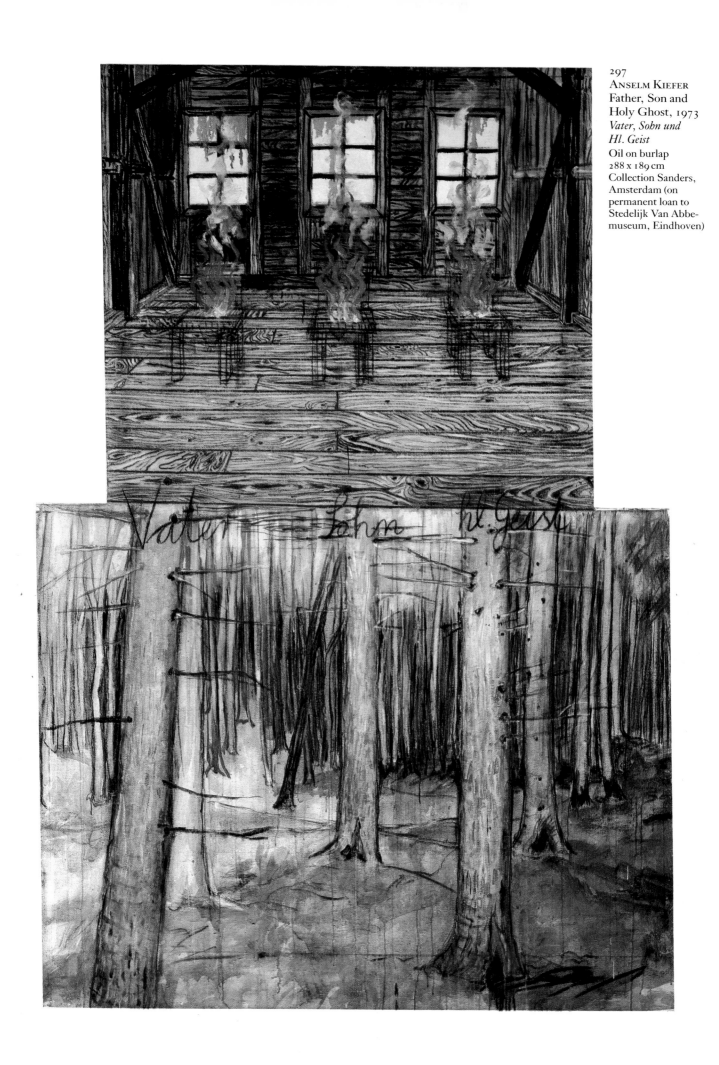

297
ANSELM KIEFER
Father, Son and
Holy Ghost, 1973
*Vater, Sohn und
Hl. Geist*
Oil on burlap
288 x 189 cm
Collection Sanders,
Amsterdam (on
permanent loan to
Stedelijk Van Abbe-
museum, Eindhoven)

298 ANSELM KIEFER, Mark Heath *(Märkische Heide)*, 1974
 118 x 254 cm; Stedelijk Van Abbemuseum, Eindhoven

299　ANSELM KIEFER, Painting = Burning *(Malen = Verbrennen)*, 1974
220 x 300 cm; Emily and Jerry Spiegel

Siegfried Gohr

Kirchner and 'Die Brücke'

I

Ernst Ludwig Kirchner, Erich Heckel, Karl Schmidt-Rottluff and Fritz Bleyl founded an association of artists in 1905. The group was called 'Die Brücke' (The Bridge) and was based in Dresden in Saxony. At that time an impressionistic style using subdued colours dominated art in Germany, and particularly art in Berlin, the capital. Its most important exponents were Corinth and Liebermann. This impressionistic style determined the aesthetics of the Secession exhibitions which had originally been founded in revolt against academic art. Paris still held considerable sway over influential painters, dealers and museum officials in Berlin, and the exhibitions therefore included works by post-Impressionist masters like Cézanne, van Gogh, Munch and Gauguin. Despite international influences, however, the realist Berlin tradition continued to direct artistic policy which staunchly resisted any change in prevailing attitudes. Liebermann in fact tended increasingly towards Dutch painting. German 'Impressionism' did not follow in the steps of French Neo-Impressionism and was actually rather slow in developing. It ignored the revolutionary possibilities of colour and became imbued with bourgeois mediocrity. By the turn of the century the movement had already ground to a halt. Corinth was alone in undergoing a change in direction after 1905/6 and colour attained a new significance in his late works. He was, however, destined to occupy a fringe position in the cultural life of Berlin and therefore retreated to the countryside bordering the Walchensee, a lake in Bavaria.

Around 1903/4 the art of the capital no longer held any attraction for the young artists of Dresden and Chemnitz who were to become members of 'Die Brücke'. *Art nouveau* was heralding the demise of the nineteenth century in England and in the smaller art centres in Germany, manifesting itself in magazine illustrations, graphic and commercial art. The artists of 'Die Brücke' after its foundation in 1905, made a rather conventional start in the wake of the international *art nouveau* movement. At that time graphic art was the main focus of their work. They then developed the woodcut, presumably at the instigation of Bleyl. Later Emil Nolde introduced etching and Schmidt-Rottluff contributed lithography.

The influence of *art nouveau* was particularly evident in their graphic art, but this influence was shortlived. The artists moved on to explore Neo-Impressionism which they had encountered in originals. In the 'Brücke'

Fig. 1 Ernst Ludwig Kirchner, *A Group of Artists* (Mueller, Kirchner, Heckel, Schmidt-Rottluff), 1926/27

Chronicle of 1913 Kirchner defined the aim of the painters at that time as being a "monumental Impressionism". They painted in a similar style to the Neo-Impressionists and exploited the effect and emotive force of pure colours. At the same time they shunned neo-Impressionist systematization and French theories. The use of colour had been developing in France since Courbet but this had not been paralleled in Germany, a fact which made the advent of bright colour there all the more sensational and significant.

Prior to the beginning of the First World War a state of conservatism and cultural reaction existed in Germany which did not permit continuity even for a comparatively short period of time. The bold revolt of the 'Brücke' artists in this early period might be defined as Expressionism using the techniques of Impressionism.

The dynamism of 'Die Brücke' as an association of artists may again be viewed in its historical context. Circumstances made it impossible for the individual painter to promote artistic innovation in the face of the power wielded by the academies and artists' associations. The driving force behind the group resembled that of previous secessional movements in France and Germany: a search for cooperation and mutual understanding founded on common artistic objectives (fig. 1). The close bond between the 'Brücke' painters lasted for several years, indicating that their cooperation was not only motivated by artistic considerations. The name of the group 'The Bridge' and the theories which they put forward reveal a will to create a revolution in the status of German art. Kirchner in particular argued in favour of German art being placed on an equal footing with French art. In order to root this claim in a German tradition, he went back as far as Cranach, Dürer and other masters of the early sixteenth century.

It is evident that the artists of 'Die Brücke' were concerned not only with developing their art, but also with changing their own status. 'Die Brücke' therefore accepted members who were not themselves artists. It was also keen to attract older artists to whom the young members in Dresden felt an

Fig. 2 Emil Nolde, *Yellow and Red Roses*, 1907

allegiance. Emil Nolde was a member for a short time in 1907 (fig. 2). In the same year, the Finnish painter Axel Gallén joined while on a visit to Dresden. Cuno Amiet became a member, although he held reservations as to the group's unrestrained style. The group also considered nominating Edvard Munch and Henri Matisse as members. Trips by individudal artists to Paris, Italy and Switzerland yielded other contacts. Max Pechstein had established contacts with Paris and had also begun to forge links in Berlin when he took part in the 1909 Secession exhibition there. 'Die Brücke' held a large number of exhibitions during the limited period of its existence and these entailed a great deal of organization and correspondence. The active involvement of the group testifies to its politico-artistic ambitions. These ambitions are illustrated by the way 'Die Brücke' took part *en masse* in the 1910 Berlin 'Neue Sezession' when conservative elements in the old Secession refused an exhibition of their works. In Berlin the painters go to know Otto Mueller who became the last member to join 'Die Brücke'.

II

Although 1910 marked the zenith of solidarity among the painters, that year also saw the beginnings of an estrangement which eventually led to the break-up of 'Die Brücke' in 1910. Ironically this estrangement was brought about by contact with Berlin. Kirchner retained his claim to artistic leadership of the group even after the association no longer existed. His ascendancy was based on the series of *Strassenbilder*, or street scenes, which he painted in Berlin to capture the human situation in the capital. In these pictures he went beyond the reactions of the other members and created a new form. By consciously including spatial constructions he transcended his own 'Brücke' style. He enriched

his work by the use of colour to create new surface effects while retaining nervous and splintery 'expressive' brushwork. Kirchner's work reflects an artistic problem which not all the 'Brücke' painters thought out with the same clarity. In 1913, like his friends, he was able to look back on a logical progression from 'monumental Impressionism'. The 'Brücke' style had manifested itself in various ways by virtue of the different personalities and periods involved. The style commenced in 1905/6 with impasto applications of colour in a wide brush-stroke. The group strove to achieve a shimmering effect with colour but did not use it only as an equivalent to light. They also brought out the value of colour as a substance. Later work was directed towards enhancing the surface effect. Around 1907 the 'Brücke' artists were applying impasto colour with a palette knife in building up a picture. Following Kirchner's study of Munch and Matisse, 1909 saw the break with impasto application of colour as favoured by van Gogh. The group now utilized impasto colour to achieve an impressive simplicity where figure and background blend into the composition. In particular Heckel, Kirchner and Pechstein employed this technique in 1910 when they were working at the Moritzburg lakes near Dresden. Nude and landscape were indissolubly united in the colour (fig. 3). The works which Pechstein executed from models in his studio early in 1910 also demonstrate the unusually close and fruitful cooperation of this period.

It is perfectly justifiable to talk in terms of a 'Brücke' style in the periods 1905/6 ('monumental Impressionism') and 1910. Differences in the type of development and individual characteristics can be easily discerned in the interlude and of course after 1910. Prior to 1910 it was very obvious which members of the group were working together. What is more, the style changed in

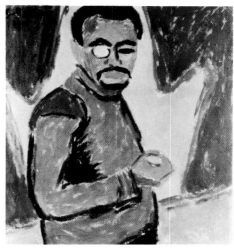

Fig. 4 Karl Schmidt-Rottluff, *Self-portrait with Monocle*, 1910

accordance with the themes. Landscapes painted in the open were mostly executed in a brisk, spontaneous style which was directly inspired by the subject. Figure studies and portraits were painted from models in the studio. Pictures of interiors include frequent contours and wide backgrounds in a single colour. The characteristic features of the artists' works precisely reflect the temperaments of the painters. Kirchner was the restless, nervous head of the group whilst Heckel assumed the role of coordinator. Schmidt-Rottluff imperturbably continued working in the 'Brücke' style longer than the other members. It is due to him that a museum was founded in Berlin to house the group's works. Max Pechstein was the most flexible of the group and travelled widely. It fell to him to establish contacts with other artists. His colour style was more attractive and less aggressive than that of the others and this earned him early success. Emil Nolde, who was of an older generation, was caught up in the exuberant colour style of 'Die Brücke' for only a short time in 1907. He then continued in his own style. Otto Mueller did not join until later on and did not change his technique of distemper painting and the lyrical tones of his pastoral scenes. The stylistic development of the painters brought different members to a leading position in the movement at different periods. In 1907, for example, Schmidt-Rottluff disrupted the Impressionist mode by applying colour in wild, broad sweeps (fig. 4). Heckel was the first to break away from the influence of van Gogh in his landscapes of 1908 (fig. 5). Kirchner took the decisive step in mastering surface under the influence of Matisse in 1909. These various influences finally merged in the characteristic style of 1910.

The group had gradually been drawn towards Berlin since 1908. The trend was finally brought to its logical conclusion when Heckel, Kirchner and Schmidt-Rottluff joined Pechstein and Mueller who had already settled there. At that time Berlin was becoming one of the largest European capi-

Fig. 3 Max Pechstein, *Open-air* (Bathers in Moritzburg), 1910

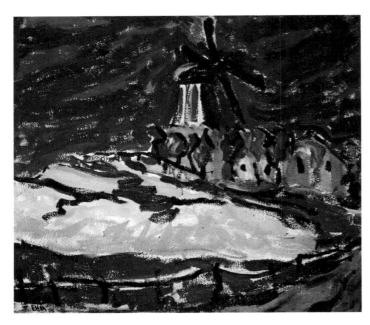

tals. In contrast to the baroque city of Dresden it offered a wealth of new ideas and challenges. The 'Brücke' painters were of course particularly attracted by the large exhibitions in which leading French artists of the time played a prominent role. Cézanne's work began to exert an influence following an exhibition at the end of 1909. This contrasted with the train of events in France where Cézanne stood in the forefront of modernity. The reaction of the painters to Berlin was very personal and by no means uniform. Pechstein, Schmidt-Rottluff and Mueller reacted only very sporadically in their choice of subjects and scarcely at all in terms of style. Quite the opposite applied to Heckel and Kirchner who were absorbed and stimulated by the city. Heckel painted some melancholic townscapes with added emphasis on graphic style. In Kirchner's work of 1912/13 the style became even more pronounced and led to the decisive innovations of form in the street scenes mentioned earlier.

III

The essential aim of 'Die Brücke' was to elevate German art to an international standing. During the short period of time between 1910 and the outbreak of the First World War in 1914 the artists were only partially able to achieve such a lasting change. Berlin provided impetus for the 'Brücke' artists but it did not actually accept their art. Only Kirchner had ultimately become completely involved in Berlin and he was alone in consistently integrating new ideas into his personal development. The street scenes of 1913/14, for example, were the fruit of his contact with the Futurist exhibition organized by Herwarth Walden in the first Berlin salon of 1913. Yet they were also a result of Kirchner's early attempts to establish the surface as the essential element of his colour style using simple basic forms. Kirchner considered the dialectic of picture construction and emotional colour as the central problem of his work and that of 'Die Brücke'. In order to attempt a solution he viewed the problem against the German tradition since the Middle Ages and in particular since Dürer. He became influenced by Picasso whilst pursuing this objective during his latter years and he attempted to solve the problem by simultaneously depicting many different aspects of a subject. However, he broke off this attempt in 1935 and turned to more tranquil techniques which sometimes resulted in a soft realism. Kirchner committed suicide in 1938. This may partly be explained by the political situation and Hitler's expurgation of modern art but also by his failure to accomplish his self-appointed tasks.

'Die Brücke' came to an end after about ten years and ceased to exert an effect on the history of German art. This was a not unfamiliar phenomenon. It was manifest after Dürer, and then around 1600 when Adam Elsheimer turned towards Rome. A further parallel is provided in the work of Karl Blechen when progress from Romanticism to Realism foundered. Ironically it was not until the campaign against 'degenerate' art in 1937 that the artists' work attained recognition abroad. In Germany the contribution of 'Die Brücke' to modern German painting had been the problem and challenge which remained at the end of the First World War.

Bibliography

Lothar-Günther Buchheim, *Die Künstlergemein-schaft Brücke*, Feldafing, 1956
Bernard S. Myers, *The German Expressionists*, New York, 1957
Peter Selz, *German Expressionists' Painting*, Berkeley, 1957
John Willett, *Expressionism*, London, 1970
Donald E. Gordon, 'Content by Contradiction', *Art in America*, December 1982, pp. 76-89
Rosalyn Deutsche, 'Alienation in Berlin: Kirchner's Street Scenes', *Art in America*, January 1983, p. 64-72

Kandinsky and 'Der Blaue Reiter'

Kandinsky was a master of the written word as well as of the painted image. His literary output comprises theoretical texts, essays, poetry and drama, and he devoted great care to everything he wrote, much of which exists in both Russian and German versions, for instance, parts of the treatise *On the Spiritual in Art* of 1912 and the collection of poems *Sounds* of 1913. In his pre-war sketchbooks and notebooks Russian and German phrases intermingle, sometimes on the same page. Virtually bilingual since his youth, Kandinsky wrote effortless German, although with occasional odd turns of phrase. German was almost, but not quite, his mother tongue, a fact which may account for his imaginative response to figures of speech in that language. Metaphors for him still seemed to retain some of their literal meaning, and his fertile imagination would conjure up vivid visual equivalents of metaphorical expressions that he happened to come across or that he made use of himself.

There is also another aspect of Kandinsky's double allegiance to Russian and German culture. Bilingualism gives a broader outlook, and a truly bilingual person may find it natural to experience different languages as incidental manifestations of a common deeper meaning. Kandinsky was almost obsessed with the innermost meaning of art, literature and music, which he referred to as the "inner sound". His search for the deeper strata of verbal and graphical expression led him on a metaphysical journey into the interior of language. According to him, the meaning of a literary work does not reside in the word, nor even in the sound of the word, but in "the inner sound of this sound". In the same way content in art consists of the inner sound of abstract form. Humanity, Kandinsky argued, is now *for the first time* freeing itself from the bond of language, the use of words. "This is precisely the characteristic of an epoch which is, if not the greatest, at any rate one of the greatest in Evolution. The Epoch of *Spirituality, of the Spirit*."[1]

All this may seem abstruse to us, but it had a very real significance for Kandinsky, who systematically employed words as starting points for his images. When working on his monumental *Composition VI*, for instance, he began with the word "Sintflut" ("deluge"), tried to free himself from concrete associations connected with the event of the deluge itself and finally reached a form that reflected the "inner sound" of the word instead of the event. Among the works in the exhibition, *Improvisation 31 – Seabattle*

(cat. 31) has a similar origin. In a commentary on similar pictures Kandinsky emphasized that such designations should not be taken to indicate the subject matter of the picture. The word was selected merely for the artist's own use, as a means of producing the appropriate pictorial associations.[2]

Apart from the advantages of bilingualism, there are, naturally, other circumstances which anchor Kandinsky firmly in a German cultural context. His choice of Munich as his place of study in 1896 was an unequivocal commitment. Despite such setbacks as being turned down by the Munich Academy, he remained faithful to that city, founding his own exhibition society and art school, the 'Phalanx' (1901-1904) there. After his *Wanderjahre* (1904-8) he settled again in Munich and Murnau with his companion Gabriele Münter. The name chosen for the second artists' group to be founded by Kandinsky has a proud ring: 'Neue Künstlervereinigung München' or 'NKVM' (1909). Kandinsky remained in Germany until the outbreak of war in 1914, and after his Russian episode he returned there once more, this time to make a decisive contribution to the Bauhaus.

Kandinsky launched his third major venture in Munich after a rupture with the 'NKVM', by whose jury a painting of his had been rejected. He seceded from the society together with Gabriele Münter and Franz Marc, but instead of founding a new group Kandinsky conceived the idea of a periodical edited by Marc and himself. This was *Der Blaue Reiter*, of which the first and only volume appeared in 1912. The editors also arranged exhibitions, the first in 1911, and the second and last in 1912; for this reason the circle of artists exhibited in the shows arranged by Marc and Kandinsky has come to be known as 'Der Blaue Reiter', although it was never a formally organized group. By this arrangement Kandinsky ensured that he maintained control over the publication as well as over the exhibitions bearing its name. He did not have to reckon with divergent opinions from his co-editor, who agreed with him on all important points.

Marc and Kandinsky both believed in an approaching Spiritual Epoch, and they felt it their duty to prepare humanity for this new era. Both were familiar with the tradition of German romanticism – Marc naturally more so – as well as with the transcendental beliefs of more recent artistic movements such as Symbolism. But there were important differences of emphasis. Marc seems to have avoided any deeper commitment to the contemporary mystical movements that im-

pressed Kandinsky so much, and he also served as a buffer against opposition among the 'Blauer Reiter'. August Macke, the 'angry young man' of the circle, complained to Marc of "big words about the beginning of the Great Spiritual" and warned his friend against believing too implicitly in Kandinsky's teachings.[3]

What Kandinsky really meant by "spiritual" has been interpreted differently by different art historians. Many scholars refuse to connect the idea with the various, often vulgar, forms of occultism that we know preoccupied the artist in the years 1908-11. Together with Gabriele Münter he owned a small but varied collection of esoterica.[4] His qualified approval of theosophy and Madame Blavatsky is expressed in a well-known passage in his treatise, where Rudolf Steiner is given credit for having rendered theosophical methods in a relatively precise form.[5] All this is known and acknowledged; it is the significance of these preoccupations for Kandinsky's move towards abstraction that still remains in dispute.

The crucial point is clearly whether these teachings had anything to offer Kandinsky in his particular situation. An examination of the relevant issues shows that they had indeed. In his *Reminiscences* of 1913 the artist described his strenuous struggle with all kinds of alarming questions. "And most important of all: what is to replace the missing object? The danger of ornament revealed itself to me; the dead semblance of stylized forms I found merely repugnant."[6]

In Steiner's writings Kandinsky had read the answer to his question. Steiner undertook to teach his readers the art of forming inner "images charged with content" without recourse to sense impressions of real objects. Such experiences were the ultimate goal of meditation practice: "In the occult disciple something has to replace the 'outer object'. He must learn to think in images, even when there is no object to arouse his senses."[7] Kandinsky had studied Steiner's methods, and later he noted that it took a very long time and many years of patient toil and strenuous thought to arrive at the correct answer to the question of the missing object. Over the years, and by means of deliberate training, he developed his "ability to conceive of pictorial forms in purely abstract terms, engrossing myself more and more in these measureless depths."[8]

But what did the inner images look like? Steiner had an answer even to this question: characteristic of the higher levels reached by

the clairvoyant is the emancipation of colour. Colours seem to detach themselves from the objects, to float around in space. Moreover, other people's thoughts and feelings manifest themselves as forms and colours, sometimes cloud-like, sometimes more definite in form. "The hovering of colours, etc. 'without ground or support' [i.e. without a physical object] is the manifestation of beings that surround us all the time," was how Kandinsky summarized his reading of Steiner's articles.[9] In his artistic vocabulary this phenomenon became a pictorial device of extraordinary importance. In 1911 he referred to it as "The running-over of colour beyond the boundaries of form,"[10] and it is no exaggeration to say that this device was the principal pictorial starting-point for the whole process of abstraction. The dissolution of the motif in Kandinsky's pictures had begun; outlines were becoming emptied of their colour; the contours were reduced to fragments dispersed over the surface; new configurations without a base in the original "abstracted objects" began to appear; and clouds, coils and spots of floating colour, also without "material" justification, were seen intermingling with the remnants of figurative forms.

In his attempts to visualize the spiritual Kandinsky was also greatly helped by the precedents set by the Anglo-Indian theosophists, who had hit on the idea of commissioning colour illustrations for their accounts of higher worlds (figs. 1, 2). In numerous colour-plates the effects of thoughts and feelings in the spiritual matter postulated by the Theosophists are represented as multi-coloured blots, rings, coils, etc. Two of these illustrated books appeared in German translation in 1908. One of them was in Kandinsky's possession, but he most probably knew both. Distinct echoes of the theosophical illustrations make themselves felt in Kan-

Fig. 2 *Floating thought-forms*. From Annie Besant and C. W. Leadbeater, *Thought-Forms*, 1905

dinsky's paintings of this period, and he even made a separate study of the configurations in a series of watercolours and diagrammatic drawings (fig. 3). The vocabulary of hovering spots and rings is employed on a lavish scale in several works in the present exhibition, notably *Painting with White Form* (cat. 33), *Fugue* (cat. 34) and *Improvisation Gorge* (cat. 35). There are other paintings by Kandinsky, which consist entirely of such elements.

The specific character of Kandinsky's sources helps us understand two circumstances which set his art apart from that of the other 'Blaue Reiter': the fluid softness of his pictorial idiom and his confident readiness to take the decisive step into abstraction. The former was foreshadowed in the theosophical texts and images, the latter reflected the strength of his belief in the imminent spiritual upheaval signalled by atomic science, spiritualism and theosophy.

The situation becomes clearer if we view it against the background of other trends that interested the 'Blaue Reiter'. Kandinsky expressed his admiration for the Cubists, and *Der Blaue Reiter* contained articles on Delaunay and other French moderns. Picasso's *La femme à la mandoline au piano* (fig. 4) was also reproduced in the almanac. Yet Kandinsky's paintings of this period show no signs of Cubist inspiration. In Marc's work, on the other hand, we see a consistent development precipitated by Cubist and Futurist impulses. The culminating points are marked by facet compositions such as *Forest with Squirrel* and *Tirol*. Like the Cubists and Futurists themselves, Marc is reluctant to abandon figurative content altogether; only in his very last paintings

from 1914 does he adopt a completely abstract mode, and even then with some hesitation. Marc's adherence to motifs of the visible world was in part simply due to his fondness for nature; to do away with his beloved animals must have seemed particularly sad to him. But his hesitation before the decisive step also reflects his more sober attitude to the issue of the Great Spiritual.

Nor did the other 'Blaue Reiter' follow Kandinsky all the way. Like him, they adopted the heavy contours and strong colours of Synthetism and Fauvism, but no more than the Fauvists themselves did they go on to "let colour run over the boundaries of form". Kandinsky's companion Gabriele Münter did not stray from the path chosen around 1908. For the period in question this also applies to Alexei Jawlensky, who had opposed Kandinsky in the 'NKVM' but soon exhibited again with the 'Blaue Reiter'.

Paul Klee's association with the 'Blaue Reiter' dates from 1911, and the most important exchange of impulses took place when he and Macke went to Tunisia together in 1914. By this time both painters were emerging from a Cubist phase, working from nature in the bright North African light. The really important interaction between Klee and Kandinsky was to follow only after the First World War, when the two worked side by side as masters at the Bauhaus.

The Spiritual Epoch may have failed to appear as expected, but another epoch materialized instead, that of abstract art. Kandinsky was not alone in bringing about this revolution. There were parallel developments in France, the Netherlands and Russia. Yet he was the first to publish a coherent programme for the new movement, while at the same time implementing it in his art. Without the support of the 'Blaue Reiter' this would hardly have been possible. It was through Marc and Macke that contact with Dr. Bernhard Koehler was established, and

Fig. 1 *Sudden burst of affection*. From C. W. Leadbeater, *Man Visible and Invisible*, 1902

Fig. 3 Wassily Kandinsky, Watercolour study, 1913, 3. Munich, Städtische Galerie im Lenbachhaus, Gabriele-Münter-Stiftung GMS 370

Fig. 4 Pablo Picasso, *La femme à la mandoline au piano*, 1911, published in *Der Blaue Reiter*, 1912

it was thanks to the financial support of this wealthy Berlin industrialist that the *Blauer Reiter Almanach* could be published. Koehler was the uncle of Macke's wife, Elisabeth, and he supported the 'Blaue Reiter' in many other ways; he bought their pictures and he helped them to gain a foothold in the Berlin art world.[11]

But even more important than this was the moral support provided by the 'Blaue Reiter'. None of them went down in history as a radical innovator of Kandinsky's stature, but they treated their leader with that blend of admiration and cautious reserve which seems so propitious for innovation. We might perhaps be allowed to apply Kandinsky's favourite metaphor: the spiritual triangle of the 'Blaue Reiter' required the down-to-earth base of Marc and the opposing angles represented by Macke in order to raise its blue apex towards the heights of abstraction.

Notes

1 Wassily Kandinsky, annotation on a leaf in the Gabriele-Münter-Stiftung, Städtische Galerie im Lenbachhaus, Munich (GMS 525 *recto-verso*); see Erika Hanfstaengl, *Wassily Kandinsky, Zeichnungen und Aquarelle*, Munich, 1974, no. 296, p. 175. The same idea is also developed in *On the Spiritual in Art*.

2 Wassily Kandinsky, 'Composition 6', in *Complete Writings on Art*, ed. Kenneth C. Lindsay and Peter Vergo, Vol. 1, London, 1982, p. 385. For Kandinsky's commentary on *Cannons*, see A. J. Eddy, *Cubists and Post-Impressionism*, Chicago, 1914, p. 125

3 August Macke and Franz Marc, *Briefwechsel*, Cologne, 1966, pp. 96 ff.: letter of 22/1/1912

4 Sixten Ringbom, *The Sounding Cosmos, A Study of the Spiritualism of Kandinsky and the Genesis of Abstract Painting*, Åbo, 1970 (Acta Academiae Aboensis, Ser. A., 38:2), esp. pp. 57-66 and Bibliography

5 Wassily Kandinsky, 'On the Spiritual in Art', in *Complete Writings*, I, pp. 143-45. For Kandinsky's interpretation of Steiner, see Sixten Ringbom, 'Die Steiner-Annotationen Kandinskys', in Armin Zweite (ed.), *Kandinsky und München, Begegnungen und Wandlungen 1896-1914*, Munich, 1982, pp. 102-105

6 Kandinsky, *Complete Writings*, I, p. 370

7 Rudolf Steiner, *Die Stufen der höheren Erkenntnis*, Dornach, 1959 (Rudolf Steiner-Gesamtausgabe), pp. 18 f.

8 Wassily Kandinsky, *Complete Writings*, I

9 Sixten Ringbom, 'Die Steiner-Annotationen', *op. cit.*, p. 103

10 Wassily Kandinsky, *Complete Writings*, I, p. 384

11 Klaus Lankheit, 'Die Geschichte des Almanachs', in *Der Blaue Reiter, Dokumentarische Neuausgabe* von Klaus Lankheit, Munich, 1965, pp. 253 ff., especially p. 295

Carla Schulz-Hoffmann

Emil Nolde: The Authenticity of Feeling

More than any other artist of the twentieth century, Emil Nolde seems to personify all the potentialities and hazards of the loner who is totally preoccupied with himself and his immediate milieu. The vividness and the conviction of Nolde's works, in no way impaired by the truly inflationary flood of reproductions which have appeared in school text books and on postcards, are irrevocably bound up with the artist's personal life and the close ties he had with his own particular topographical environment. Throughout his life Nolde embarked on a constant series of long journeys but his travels never succeeded in changing him fundamentally. Even his participation in 1913/14 in an expedition to New Guinea, which took him through Russia, Japan and China, though it precipitated numerous watercolours and oil paintings, did not bring about any emphatic change in his mode of expression. Indeed one might well say that his stay in the South Sea Islands only served to confirm and deepen his imaginative powers and style, his personalized mode of painting, which was the direct product of his relationship with his own home environment.

The vast breadth of the North German and Danish coastal landscape, the eternal proximity of the sea, the special colour characteristic of an environment exposed to extreme climatic conditions have all left their mark on Nolde the painter. So too have the reserve and taciturn character of the inhabitants of this region. They possess simple beliefs untouched by ostentation and although their way of life is founded upon a

direct, basic communication with Nature, they have a certain imaginative propensity for the grotesque and the fantastic, for fairy-tales and stories of sea-monsters. Nolde was an integral part of this simple, rural people. He always found urban life alien because it denied him the seclusion and peace which were essential to him (fig. 1).

On the other hand, it would be wrong to conclude from what we have said that Nolde was a landscape painter in the traditional meaning of that phrase. The external, visible world concerned him only if it corresponded with something subjective within. His understanding of Nature is clearly based, one might say, on a specifically North German, romantic way of feeling. The act of immersing oneself in Nature – a creative process which is the result of an intense dialogue with the visible world around one – and the idea of a parallel between 'inner' and 'outer' nature were determining factors in the creative activity of Philipp Otto Runge and Caspar David Friedrich. In Nolde these go hand in hand with a tendency, very characteristic of German Expressionism, to total self-surrender and the direct expression of subjective feelings and moods. Nolde's painting seems to erupt violently from beneath an apparently calm and restrained surface. "One afternoon I painted a picture in the full flush of the creative urge – waves breaking on rocks. As soon as I'd finished it I took my palette knife and scratched it all out. I stood there troubled and asked myself 'Why?' Great achievement and then the destructive urge."[1]

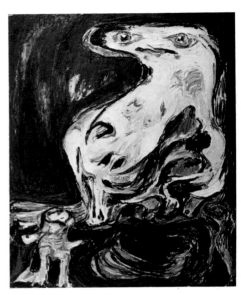

Fig. 2 Asger Jorn, *Little Interplanetary Woman*, 1953

The view of painting which emerges here anticipates the basic principles of the non-formal tendency which is particularly characteristic of the so-called 'Cobra' group of painters who together with Asger Jorn (fig. 2) were to be the successors of Nolde in the next generation. Colour as a sensuous, emotive mode of expression which can lend immediate material form to feelings, smells, and so forth; colour *per se* – not form – becomes the most important vehicle of expression and develops almost compulsively into painting. "I did not paint what I wanted to paint but what I had to."[2] This definition of creativity as a virtually unconscious process elucidates immediately the difference between Nolde (together with other members of 'Die Brücke') and French Expressionist or Fauvist painting. It is true that in Matisse, too, colour is an emotive force, but it always remains integrated into the mood characterizing the entire composition and is subject to a conscious concept ordering the whole.

In Nolde the situation is completely different: opposites in colour and form collide with each other and the standard notion of beauty as a unifying force is quite alien to his way of thinking. Finally we are confronted with the familiar controversial question concerning the relationship between truth and beauty. Nolde is unequivocally on the side of truth and the authenticity of feeling. Everything must be subjected to this truth and beauty is dependent on it, for beauty is not a category in itself. This concept, which has its roots in German Idealism, was put into

Fig. 1 Emil Nolde, *Frisian House*, 1910

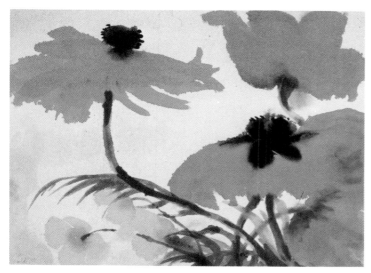

Fig. 3 Emil Nolde, *Red and Yellow Poppy*, undated

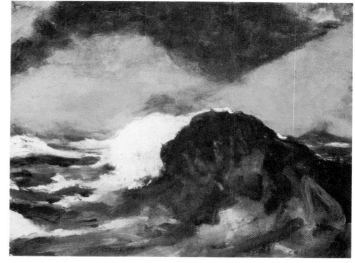

Fig. 4 Emil Nolde, *Tall Breaker*, 1948

words by Franz Marc, a South German Expressionist with romantic tendencies. He wrote: "Why should we not speak of true and untrue pictures? You say pure and impure instead but you mean the same thing. And those who see the beautiful and the pure as the true and label the ugly as untrue *also mean the same*."[3]

This attitude is clear throughout Nolde's work. His three predominating themes of flowers and gardens, sea and coastal landscapes and religious topics complement and elucidate each other. Domesticated nature in a Nolde flower painting (fig. 3) becomes, with its rich intoxication of colour, a symbol of vitality and vigour but at the same time of the limits and transitoriness of life. The sea paintings (fig. 4) show indomitable nature and express an unfettered vitality but they convey also the quintessence of permanence and eternity. The paintings of religious themes transfer these standards to the human

sphere. The *Dance round the Golden Calf* is therefore not so much an illustration of an event from the Old Testament as an expression of ecstatic feelings, of (self-) destructive vitality and 'unconscious' self-surrender.

Nolde is a painter whose works are founded on instinct: "Instinct is ten times more valuable than knowledge."[4] He is an unintellectual, vernacular painter and for this very reason he was susceptible to narrowly nationalistic theories. Ideas about racial purity, about a clear split between various ethnic groups and the "natural superiority of the Nordic peoples" found their way into the first version of the *Jahre der Kämpfe* (Years of Struggle) published in 1934.[5] He was therefore an early member of the NSDAP and he found the National Socialist verdict that he was a 'degenerate' artist and must therefore be prohibited from painting unjust. "My persecution began. It was dictated. In public

lectures with slides of my work my free, German art was abused and debased."[6]

These are significant words from an artist whose work must without doubt be considered among the outstanding and epoch-making achievements of German art in the twentieth century.

Notes

1 Emil Nolde, *Jahre der Kämpfe 1902-1914*, 2nd extended edition, Cologne, 1967, p. 33
2 *ibid.*, p. 96
3 Klaus Lankheit (ed.), *Franz Marc, Schriften*, Cologne, 1978
4 Emil Nolde, *Das eigene Leben*, 2nd, revised edition, Cologne, 1967, p. 198
5 The new edition published in 1967 (*op. cit.*) relies upon a version of the original text revised by Nolde.
6 Emil Nolde, *Reisen, Ächtung, Befreiung 1919-46*, Cologne, 1967, p. 116

Oskar Kokoschka in Berlin and Dresden

Oskar Kokoschka was not honoured with a one-man exhibition in Austria until 1937.[1] That same year the National Socialists in Germany confiscated 417 works by the 'degenerate' artist.[2] Such a number suggests that Kokoschka's works had been collected there for some years, yet in Vienna, the first picture was acquired directly from the artist only in 1931,[3] although a few had been trickling into museums via art dealers since 1922.[4] The art of Kokoschka, this *Wilde*, or Savage, found an appreciative public in Germany rather than his native Austria.

Kokoschka had been dubbed *Oberwildling*, or Chief Savage,[5] at the 'Kunstschau 1908' in Vienna. Goodwill and the occasional portrait commission were not, however, sufficient to support his impetuous talent. Adolf Loos was chiefly responsible for arranging portrait commissions which he often paid for out of his own pocket. He soon owned almost thirty oil paintings by his protégé.

Collaboration with Herwarth Walden in Berlin represented the first early break with the artist's native country at the age of 24. Walden's periodical *Der Sturm* was an ideal vehicle for Kokoschka's twin talents. It was here that his early Expressionist play *Murderers, the Hope of Women* and the accompanying drawings were published (figs. 1, 2, 3).

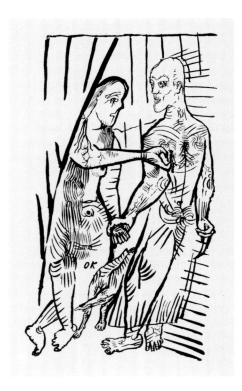

Twenty-eight of his drawings were published in this avant-garde periodical in its first year.

Kokoschka embodied many characteristics which could exasperate an art agent or dealer. Even though Walden did not give him a contract until 1912 Kokoschka nevertheless made heavy demands on his publisher. He expected international promotion of his genius and advance payments on pictures which were often outrageously high. Kokoschka also expected Walden to overlook unkept promises and he even demanded his quiescence when he transferred his allegiance to another dealer who offered him a high annual retainer in 1916. The other dealer was Paul Cassirer of Berlin.[6]

For the time being collaboration on the periodical took up most of Kokoschka's time. Before then, in addition to his portraits, he had painted postcards, pictorial broadsheets, fans, etc. for the 'Wiener Werkstätte'. He had already had experience of this kind of lucrative assignment whilst training at the Kunstgewerbeschule.[7] There was no market for his graphic works after 1909 but *Der Sturm* ensured the desired circulation, if only in restricted circles. Recognition of his works by a perceptive, dynamic man like Walden was useful in itself. That his art should undergo a change of course in this interlude was, however, hardly to be expected, given that Kokoschka had spent less than one year in Berlin. His already apparent tendency towards two-dimensionality, physical distortion and dense, interlacing clusters of strokes became accentuated. The commercial success and publicity for which he had hoped did not materialize in this lean year, although he did attract the attention of individual collectors, and a museum made the first public purchase of one of his works.[8]

Returning to Vienna his participation in an exhibition at the Hagenbund in 1911 prompted scornful reactions: the *Oberwildling* became the "most detestable of them all". This fostered his inner resentment towards the city.[9] Abroad, the hypersensitive Kokoschka could not initially expect to be graced with even indignant notice. Anyone who is ambitious ignores the lone voices in his favour and prefers aggressive deprecation to indifferent silence.[10]

His private life preoccupied him during the following years. In 1911 he met Alma, the widow of Gustav Mahler, later to become the wife of Walter Gropius and Franz Werfel. His love for her possessed his mind and body and wrought the subjects he treated in his work. The features of this well-known

woman recur in his work time and again. Their passionate relationship helped him to set aside adverse circumstances, and foreign places lost their charm as a place of refuge. Moreover, he was now able to sell his paintings from Vienna. For a time he earned his living as a drawing-master (1911/12) and as

Figs. 2, 3 Oskar Kokoschka, Drawings for *Murderers, the Hope of Women*, published in *Der Sturm*, I, no. 20

Fig. 1 Oskar Kokoschka, *Pietà*, 1908/09. Poster for the first performance of Kokoschka's play *Murderers, the Hope of Women* in 1909 in Vienna

a teaching assistant at the Kunstgewerbe-schule (1913/14).

Kokoschka never got over the break with Alma in 1914. He volunteered for the dragoons and maintained a correspondence with her even after being badly wounded. From the autumn of 1916 Kokoschka lived in Dresden with periods in Berlin, Stockholm and Vienna. Despite the new material security resulting from a gallery contract, and later from the post of professor at the Kunstakademie in Dresden, harmony eluded him. Following the separation from Alma Mahler the impasto restlessness in his pictures became more and more obvious (*Self-portrait*, 1915; *The Friends*, 1917/1918, cat. 81; *Katja*, 1918, cat. 80). Previously he had even scored through transparent colour on the canvas as if he were digging up the psychic roots of the sitter (*Herwarth Walden*, 1910; cat. 79). Now the colours are set in motion to form an outer impression. An acute inability to make contact is revealed in these superficially kinetic colour rhythms where the conceptual aspects are masked by expressive brushstrokes. Characteristically, he wrote little during his time in Dresden and hardly produced any published works.

The desperate attempt to embody a substitute muse in a life-like doll testifies to his morbid condition at that time. The disappointment occasioned by the end result cut Kokoschka to the quick. In his letters to Hermine Moos[11] he had unrestrainedly evoked the unattainable details of his "dream princess": the mouth should open, it should have teeth and a tongue, the skin should be like a "peach to the touch" and should show no signs of seams. At the same time he declared that he was "unable to endure living human beings" (10/12/1918). In a month he had become so involved in his dream that he reacted jealously to others seeing and touching the doll in her nakedness. A few days later he requested the genitalia to be fully and graphically fashioned and provided with pubic hair (23/1/1919).

The release from this fixation was not as simple as his autobiography implies.[12] The number of preliminary sketches which he did for the painting of the doll (*Woman in Blue*, 1919; fig. 4) exceeded all reasonable bounds. It has been suggested that about 160 studies were made.[13] Kokoschka remained fascinated

Fig. 4
Oskar Kokoschka,
Woman in Blue, 1919

by tangible subjects but the individual, linear colour contours now gave way to compact areas (*The Power of Music*, 1919; cat. 83). The open colour wounds of the previous years had set to masks in colour. Soon afterwards he actually painted a *Mask Still-life*. He thus finally succeeded in disguising his psychic tragedy after years of struggle. The fact that in 1922 he once again painted the doll (*Painter with Doll*) demonstrates the great impact of this episode. In the course of this year he quite fortuitously met Alma in Venice at the Biennale.[14]

Once again the stay in Germany had eased the departure from Vienna. A search for influences on his artistic development, for instance from the German Expressionists, would prove fruitless. During the ensuing years his work remained an expression of his own personality. Only when he matured and became wiser did quite a different art gain meaning for him: Impressionism freed the hand of the world traveller anew. Dresden was the first city Kokoschka painted several times but his growing interest in the world environment demanded new horizons. In 1924 his father died. That year he turned his back on the Akademie and commenced his travels. Immediately afterwards he broke out of the impasto, two-dimensional style which had been typical of his time in Dresden, in a new awakening.

Notes

1 Carl Moll organized this in the Oesterreichisches Museum für Kunst und Industrie.
2 Hans Maria Wingler, *Oskar Kokoschka – Das Werk des Malers*, Salzburg, 1956, time chart
3 *Vienna Seen from the Wilhelminenberg* in the Historisches Museum of the City of Vienna was the result of a commission by that city.
4 *Still-life with Lamb and Hyacinth*, 1909, from the Reichel Collection, was purchased by the Österreichische Galerie in Vienna in 1922.
5 Ludwig Hevesi, *Altkunst – Neukunst*, Vienna, 1909, p. 313
6 The letters edited in 1984 give a good impression of this: *Oskar Kokoschka – Briefe I 1905-1919*, ed. Olda Kokoschka and Heinz Spielmann, Düsseldorf, 1984
7 On this subject: Werner J. Schweiger, *Der junge Kokoschka, Leben und Werk 1904-1914*, Vienna-Munich, 1983, pp. 117 f.
8 K. E. Osthaus purchased the *Princess of Rohan* for his Folkwang Museum as early as 1910.
9 Karl Schreder in *Deutsches Volksblatt*, quoted after Schweiger, *op. cit.*, p. 185
10 Following the exhibition organized by Walden at Cassirer's Gallery in 1910 there were only two reviews, both in *Sturm*, one by Else Lasker-Schüler, Walden's wife.
11 *Briefe*, pp. 290 ff.
12 Oskar Kokoschka, *Mein Leben*, Munich, 1971, pp. 191 f.
13 Wingler, *op. cit.*, cat. 126
14 In his autobiography (*op. cit.*, note 12, pp. 190 ff.) he mentions several times that he identified the doll with Alma Mahler.

Lovis Corinth: The Late Works

"Corinth's large painting, *Ecce homo*, is one of the weakest works of his late period. His portrait of Brandes is not much better. This is academic painting in a state of pathological dissolution. These paintings arouse our pity for the artist who painted them when he was a sick man struggling against his own tragic fate. The paintings themselves are sick. But paintings do not exist in order to evoke human sympathy."[1]

This judgment pronounced by Karl Scheffler in 1931 on Lovis Corinth's late works is merciless and it is of little comfort to realize that this is one side of an argument where the opposing one was expressed with great enthusiasm by Ludwig Justi, Director of the National Gallery in Berlin, who had been fortunate enough to acquire the two works just mentioned. On the other hand, it is easy for contemporary art historians to condemn this criticism as 'a blatant misjudgement', making it appear as though art criticism during the National Socialist period, which a few years later condemned Corinth's late work as degenerate owing to "its lack of technical and artistic skill", arose as a direct consequence of these verbal polemics. Today Corinth's paintings, along with those of other 'degenerates', would appear to have won the day and his late works are acclaimed for their 'final maturity', while the artist himself is reckoned among 'the modern masters'. Situations like these tend to turn the history of art into hagiography where the art historian's principal role is that of picking holes in an unassailable reputation. It is therefore most profitable at such a moment to step back from one's subject, to take a fresh look at the artist and in this way to relate him to one's own time.

Let us therefore take Karl Scheffler literally – he was after all no nonentity; he was a man with a profound knowledge of Corinth and of the art of his time.[2] "Academic art in a state of pathological dissolution", were Scheffler's words. So Corinth was an academic painter? Why shouldn't he be? Not one of his known contemporaries in the art world served an extra year's apprenticeship as he did, and moreover his teacher was that real virtuoso of academic painting, William Bougereau.

Fig. 2 Lovis Corinth, *The Trojan Horse*, 1924

Throughout his life Corinth considered himself a figure painter who also sought to master the other genres of portrait, landscape and still-life painting. He always concerned himself with subject-matter of consequence, striving "to impress the public and his colleagues with the striking originality of his themes".[3] Even after 1918, when he was already an old man, it was his ambition to paint 'generals and politicians'. When he did not succeed with Hindenburg he had to try his hand at least on Tirpitz or Ebert. His career as a painter was carefully planned; it was carried on in the face of obstacles and it was finally crowned with success. Perhaps the mastery he hoped for was not meant for Corinth – at least not from the outset of his career – but within the Naturalism-Impressionism range he had control of his medium and was proficient in the various genres. His psychological skill made him a brilliant portrait painter and he was successful too in the field of religious and mythological themes (though here he was guilty of certain unintentionally grotesque and crude effects). He produced impressive show-pieces like *Salome* (1900; fig. 1), contributing here to a genre which by the end of the century involved the entire range of theatrically illusionist painting. Somewhat later the production of such work became the concern of the cinema. Corinth was therefore in every way a nineteenth-century painter. So what 'rehabilitates' him for us today? It is – to quote Scheffler once more – "the pathological process of dissolution". Something of this academic artificiality may be traced, too, in Corinth's late works. *The Trojan Horse* (fig. 2) is among other things an illustration; a rich garland of flowers and the fact that his

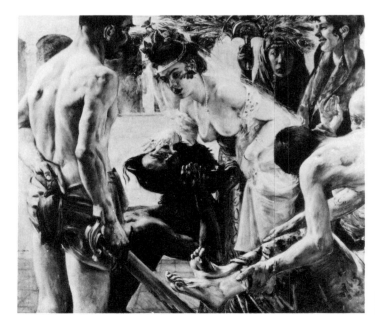

Fig. 1 Lovis Corinth, *Salome*, 1900

Fig. 3 Lovis Corinth, *Flora*, 1923

Fig. 4 Lovis Corinth, *Carmencita*, 1924

daughter was there to serve as a model is the occasion for *Flora* (fig. 3); while a blanket of a certain shade of red was the motivation for *Ecce homo* (cat. 95).

Corinth's inspiration never derived from a highly original personal imagination such as Beckmann's, but it did contain elements of drama. This drama resides less in the subject matter itself than in the actual painting. It constitutes the primary reality of a picture. It is the to-be or not-to-be of a picture. This does not mean that Corinth's paintings are without subject matter, nor that they lose contact with reality. Indeed, the contrary is true: by becoming aware of the inspiration of the picture, in the tension that exists between the subject matter and its expression on the canvas, painting becomes, as Corinth put it, tangible, like "a struggle with an angel". Painting is a struggle but so too is the act of accepting the permanence of what has been achieved. Painting is brought to the very brink of formlessness and a balance is established. "False steps and strokes are all forgiven once the aim within them is achieved . . . no spot must remain dead. Finishing a painting is synonymous with painting well."[4] For the viewer this means that by looking at a picture the form is discovered – we lose it again, find it and lose it yet again. All this may seem like a game, but it is also a form of tension, stretched to snapping point. Painting has become a simile for life itself.

If we consider Scheffler's critical assessment about 'the process of dissolution' from this point of view we see both what is right and what is wrong in his judgment. He is right in claiming that there are indeed some dubious elements in the later works of Corinth. For example in the *Walchensee landscapes* (cat. 91-93, 96) we wonder whether the blue would be adequate to sustain the picture if the horizon were shortened. In *Flora* the question arises as to what would remain were the light in the colours to be extinguished. And in *The Trojan Horse* we ask ourselves whether the weight of the horse's back brings stability into the mist of colours.

But on the other hand, it is clear that when we talk of the dissolution of form we are speaking from the standpoint of the viewer who sees the finished execution of the picture *in toto*. The painter's point of view is the reverse of this: he sees first of all the blank canvas, and anything that appears on its surface is a bonus, it is something painted, therefore a painting – or on its way to becoming one.

When Corinth in old age put his craft and skill as a painter to the test, when he tried out the obedience of his brush and the accuracy of his colours, he may very well have been taking a calculated risk. "The critics can find no praise too high for my mature style",[5] he wrote ironically at one point but, on the other hand, something seems to break in his vision of himself. His excessive concern about success as determined by others diminishes; the consequences of the stroke he suffered in 1911, which caused an unsteadiness in his hands; his realization that he was growing old, made his insistence on painting and repainting the same themes – Walchensee, still-lifes, people around him – into a kind of assertion about life itself (fig. 4). One feels that his personal enjoyment is involved and so too is a kind of rage. He rejoices in painting wet upon wet, in painting colour upon colour, in smudging them and then in stopping suddenly and simply allowing them to glow; there is a quality of rage in making all this into a picture, into forcing a vision to emerge. What is left behind brings a liberation. "I have discovered something new; true art is using unreality. That's the acme."[6]

The question as to whether Corinth's painting is mature Impressionism or whether it has already gone over into Expressionism is really more of concern to art historians. What matters is that here we have a man who reduces his painting as far as he dares and then uses this as his starting point. Painting is the ultimate great adventure and it is this fact that lends Corinth both a sense of history and of continuity. The work of the ageing Corinth, seen by himself to be completely in the tradition of Frans Hals and Rembrandt – "The one word Rembrandt shines through all the darkness"[7] – is confronted today with the open structure in the painting of de Kooning, Baselitz, Büttner and others. It is an open style of painting which accepts that it is the responsibility of a picture to make the artist's perception intelligible to us but also accepts the fact that a picture remains a picture and is not just the thing perceived *per se* but something different and new.

Notes

1 Karl Scheffler, in Ludwig Justi, *Corinths Ecce homo*, Museum der Gegenwart, 1930/31, p. 83
2 Karl Scheffler, 1896-1951: Head of *Kunst und Künstler* (1906-33); leading art journalist of the time.
3 Lovis Corinth, *Gesammelte Schriften*, Berlin, 1922, p. 16
4 Lovis Corinth, *Das Erlernen der Malerei*, Berlin, 1907-1920, p. 82
5 Lovis Corinth, *Selbstbiographie*, Leipzig, 1926, p. 184
6 *ibid.*, p. 185
7 *ibid.*

Reinhold Hohl

Wilhelm Lehmbruck: A German Preserve

Wilhelm Lehmbruck belongs among
the great European sculptors of the
twentieth century. Among them he is
the most German. Secret Gothic...

Werner Haftmann, 1973

Wilhelm Lehmbruck was born in 1881 into
the Germany of the Bismarck era at the
moment when the German protectorates of
the Cameroons (1883) and of German East
Africa (1884) were acquired. In the spring
of 1919, while the Versailles Treaty was
being drawn up, one aim of which was to
remove from German possession those
territories which had in the interval become
colonies, Lehmbruck committed suicide.
The interpretation of his work (and of his
death) has remained a German preserve.

His works *The Fallen Man* (1915, cat. 103;
exhibited a year later under the title *Dying
Warrior*) and *Seated Youth* (1916, cat. 100;
also known as *Bent Figure, The Mourner, The
Friend, Thinker*) have always been seen first
and foremost as memorials to the (lost) First
World War, disregarding any sculptural
quality that they may or may not possess.
They are seen as residual spiritual scars and
as memorials to pacifist thinking. Secondly,
they have been regarded as precursors of the
avant-garde sculpture of the twentieth cen-
tury. For from the Germans' point of view,
beginning with Julius Meier-Graefe[1] in 1912
and continuing to Siegfried Salzmann[2] in
1981 and Dietrich Schubert[3] in 1984, Lehm-
bruck is their trump card in the history of
modern sculpture.

Joseph Beuys is invariably quoted as the
main witness to this view since he wrote in
1938 that seeing photographs of Lehm-
bruck's work gave him his "first real feeling
for sculpture."[4] The historical evidence of
Lehmbruck's international and avant-garde
significance is the photograph (fig. 1) of
Room H ('foreign section') in the New York
Armory Show which took place in the spring
of 1913. Here in the background and on the
right-hand side were oblique three-quarter
views of Lehmbruck's *Kneeling Woman*
(1912) and of his *Large Standing Woman*
(1910), while on the left of the room a
platform was shared by, among others,
Archipenko's *La vie familiale* (1912) and
Brancusi's *Mlle Pogany* (1912) with Maillol's
relief *La Baigneuse* shown a little apart. The
fact that Joseph Bernard's *Jeune fille à la cruche*
(1910) was both centrepiece and inspiration
of this photograph is not mentioned in any
writings on Lehmbruck.

Lehmbruck's first successful works were
female figures, together with torsos and
busts, dating from 1910-14. These works
display a pensive and at the same time a sen-
sual character. But it must have been obvious
in the post-war years of the 1920s, at the time
of the Bauhaus, that they embody by then
obsolete, bourgeois symbols of a neo-classical
cult and of an idealized aesthetic morality
('intimate grace', 'chaste womanhood')
which only a neo-conservative view of art
could accept.[5]

Wilhelm Lehmbruck's place in the history
of sculpture is assured, if only through his

statements of principle: "Sculpture is the
essence of things, the essence of nature; it is
what is essentially human"[6] and "What we
expressionists seek is to extract accurately
from our material its spiritual content."[7]
These two principles are similar but not
identical and were not expressed simultan-
eously, but they do summarize Lehmbruck's
various stylistic developments in the short
time between 1908 and 1913. In 1883 Hans
von Marées had expressed a sentiment not
unlike Lehmbruck's first principle when he
wrote: "Only the man to whom the essen-
tial quality in the physical world is revealed
deserves to be called an artist."[8] Behind both
Lehmbruck and Hans von Marées we may
sense the idealized role of the sculptor, as
expressed by Charles Blanc in 1860 – the
sculptor should present the ideal behind
outer reality as its true essence.[9] Lehm-
bruck's own 'gothic' style – a catch-phrase in
Germany since 1912 applied to Cubism as
well as to Expressionism – emerges in *Kneel-
ing Woman* (1911), is fully developed in
Standing Youth (1913) and is evident in the
Thinker (1918, cat. 102). However, whether
or not today one calls these works 'Expres-
sionist' in the tradition running from Gau-
guin to Kirchner, will depend upon the
importance given to various features: the
primitive style, with its rejection of *contrap-
posto*; the carving and painting of the mate-
rial; and the violence of the figures.

In 1900 Lehmbruck brought to an end his
connection with the academic style of Düs-
seldorf, which embraced naturalistic histori-
cism as well as Meunier's severe realism and
Hildebrand's austere neo-classicism. The
break was marked by Lehmbruck's male
figure, *Man*. This is a large (279 cm) figure
in the style of Rodin and showing also the
influence of Michelangelo. In symbolic terms
the figure proclaims: human existence is an
act of strength expressed via the human
body. In 1918 at the end of his short period
of development Lehmbruck announces
through his virtually bodiless figure, *The
Thinker*, the opposite doctrine: the essence of
a human being is his own inward-directed
spirituality. Before and between these two
statements lies the drama of Lehmbruck's
sensual experiences (with venereal disease as
a consequence): –

1908: *Small Female Figure*: idea of a Marées-
like Hesperia.

1910: *Large Standing Woman*: intimations of a
Maillol-like female presence.

1913: *Large Contemplative Female Figure,
Standing Youth*: intensification and sublima-
tion in the style of Georg Minne.

Fig. 1 View of the Armory Show in New York in 1913, with Lehmbruck's sculptures *Large Standing
Woman* (far right) and *Kneeling Woman* (back centre)

1913/14: *Woman Walking, Woman Looking Back:* compromise with Munch's view of woman as chaste mother or vampirical virgin.

After that, failure, despair, suicide.

That is how the psycho-history of Lehmbruck's work might be told. But the question of its stylistic development is a more important topic.

In 1910 Lehmbruck moved to Paris and in the early summer of that year he exhibited the large plaster cast of *Man* in the Salon de la Société Nationale des Beaux Arts. Rodin was still alive and had indeed another seven years to live but the vital force in the sculptural work of the Salon now lay in other hands. It lay for example with Joseph Bernard (1866-1913) who exhibited the almost lifesize figure of *Jeune fille à la cruche* – a smooth neo-classically poised figure which had an immediate success. A girl with a pitcher has been making the same journey for a long time, at least since Greuze – "down to the well until the pitcher breaks" (the pitcher: the guarantor of intact virginity). The fact that Bernard – even before Brancusi – had initiated the *taille directe* and a return to the spirit of (French) Gothic cathedral sculpture could not have meant much to Lehmbruck at the time. But the steady public acclaim of this graceful literary charm achieved through the display of the naked body with its apparently innocent side-turn of the head must have impressed him. This was something different from Maillol who certainly remained exemplary in his treatment of sculptural posture and simplified modelling of the body. The difference was just as striking as that between Lehmbruck's frontal female nude of 1908 and his *Large Standing Woman* with head turned aside which he exhibited in the autumn Salon of 1910. The difference is clear, too, between Lehmbruck's figure and Maillol's *Pomona* (1907-1910) which is once again a totally front-facing figure with its hand outstretched to the viewer. The variants on this theme of Lehmbruck's (head and torso positioned at different angles) in marble, bronze and in cement – the material he most favoured – were immediately successful. The hand of the figure pointing back at itself (1908) is similar to one seen earlier in Georg Minne (1907) and in Maillol's *Cycliste* of the same year. Lehmbruck uses it again in the symbol-

ist *Kneeling Woman*, in the Nietzschean *Youth Rising*[10] and in the disembodied *Thinker*.

It is not possible to prove whether Lehmbruck conceived the *Large Thinking Woman* (1913, 208 cm) and the *Youth Rising* (bronze, 228 cm) as a pair but there is much to be said for this view.[11] The female nude is desensualized by its 'Egyptianizing' monumentality (though there is *contrapposto*) and by the hardness of the material used. The rhythm in the form of the entire body is modernized and envisaged in graduated stereometrical and analytical terms. To achieve this the inclining head which is turned away from the axis is more softly modelled and given a remote reflective expression. Compared with Maillol's figures the head seems 'too small' but in reality Maillol's heads – because they were modelled independently of the body – are unnaturally large. The obvious polarity of body and head ties the knot in the drama of body versus soul. The sentimental quality as the essential ingredient of womanhood is presented in this compact head. In the young man it is the spiritual quality which prevails.

The body of the *Youth Rising* is more naked than nude. He stands before us, stripped of all clothing and, what is even more to the point, his attenuated, skeletal form is free of any embellishment. It seems almost improper for it to be occupying the same museum space that we, the viewers, inhabit, whereas the female figure, on account of its hieratic poise and smoothness, seems to belong in another space reserved for art or images. This embarassingly naturalistic presence of the male body presents us with the opposite way of expressing the drama of body versus spirit. To do this adequately the sculptor would need the assistance of eurhythmics or mime, perhaps indeed of the theatre itself and the stance of a Hamlet.[12]

The *Fallen Man* (1915; cat. 103) does indeed kneel before us in a eurhythmic posture but even if he is a soldier wounded in battle and perhaps dying, all is not over with him. He uses his own strength to support himself on knee, head and lower arm (a position of horizontal *contrapposto*) while he holds the self-same sword that Lehmbruck once bestowed upon his young *Siegfried* (1904). It is not clear whether or not the sword is broken; sketches reveal it as intact.[13] By breaking the blade at the end of the plinth Lehmbruck has rendered a further extension of the

base unnecessary. No matter – this is symbolist sculpture. The nudity which is alleviated by the rounded smoothness of form (striking nevertheless when viewed from behind) speaks the timeless language of neoclassicism and is not a pacifist gesture of discarding a military uniform.

The fact that in Lehmbruck's later works the feeling of mass and space that is normally expected from sculpture is missing should not be interpreted as 'avant-garde' style, even if *The Thinker*, which comes at the end of Lehmbruck's career, renounces a body and as a variant on the *Youth Rising* is content to mime the spiritual role suggested there. Should we view this work as a precursor of the disembodied style of Giacometti or should we take it literally as Lehmbruck's German 'Secret Gothic', looking back not towards cathedral sculpture but to the elongated imagery of Picasso's Blue Period?

Notes

1 *Kunst and Künstler* (Berlin), X, June 1912, pp. 444-8
2 Exhib. cat. *Constantin Brancusi*, Wilhelm Lehmbruck Museum, Duisburg, 1976, pp. 117-41, and *Hommage à Lehmbruck*, Wilhelm Lehmbruck Museum, Duisburg, 1981, *passim* and pp. 220-2
3 *Pantheon*, XXXIX/1, 1981, pp. 55-69; Dietrich Schubert, *Die Kunst Lehmbrucks*, Worms, 1981; Stephanie Barron, *Skulptur des Expressionismus*, Munich, 1984, pp. 133-7
4 Quoted from Adriani / Konnertz / Thomas, *Joseph Beuys*, Cologne, 1973, p. 12
5 Schubert, Salzmann: see Notes 2 and 3
6 Paul Westheim, *Wilhelm Lehmbruck*, 1st ed., Potsdam, 1919, p. 61
7 To Fritz von Unruh. 1918. Quoted from Schubert, *op. cit.*, p. 154; see also Note 3
8 Quoted from Schubert, *op. cit.*, p. 136; see Note 3
9 Charles Blanc, *Grammaire des arts du dessin, architecture, sculpture, peinture*, Paris, 1867, p. 358
10 Excellent comments by Schubert, *op. cit.*, p. 168 f., with illustrative examples.
11 Schubert, *op. cit.*, p. 178, and plate 91. Schubert's monograph deserves our respect even though we may not agree with its fundamental position.
12 Comparison of Oto Gutfreund's sculptures *Hamlet I* and *Hamlet II* (1911) by Thomas Strauss: 'Lehmbruck, Meštrović, Štursa and Gutfreund', in *Hommage à Lehmbruck* (see Note 2), pp. 186-199
13 Schubert, *op. cit.*, pp. 195, 200-1

Max Beckmann

Max Beckmann remains curiously isolated, in both early twentieth-century German art and the history of Modernism. For despite stylistic and thematic affinities with Expressionism and 'Neue Sachlichkeit', his ideological standpoint was radically different: alone among realist painters of his generation he believed in the artist's duty to depict man's spiritual condition. *Art in and out of Season*, Beckmann's 1912 summary of his artistic aims, reveals that this moral commitment is closely related to his critical detachment from mainstream Modernism.[1]

In his allusion to Nietzsche's critique of nineteenth-century German historicism and cultural philistinism, *Thoughts out of Season*,[2] Beckmann ironically questioned the assumption that modernity necessarily meant progress. He therefore rejected Franz Marc's claim that only abstract art, such as that being pursued by 'Der Blaue Reiter', was truly progressive. He then disputed the Modernist argument that Cubism heralded a radical break with tradition, insisting that a Cubist or abstract composition was based on the same principles of order and harmony as all classical art. Accusing Gauguin and Matisse in particular of reducing art to the level of mere decoration by over-emphasis of surface aesthetics, Beckmann declared "painterly sensuousness, concrete objectivity and the tangible reality of all objects depicted", of which he saw Cézanne as the supreme exponent, to be the essential qualities of good art.[3]

This anti-Modernist stand matched his early reputation as a successful member of the conservative Berlin Secession, whose pathos-laden compositions, many on biblical and literary themes, led him to be dubbed "the German Delacroix".[4] The Romantic sensuousness of works such as *Scene from the Destruction of Messina* (1909; fig. 1) does indeed seem distinctly traditional and "out of season" by comparison with the contemporary achievements of 'Die Brücke' and 'Der Blaue Reiter.'

Beckmann's Nietzsche-inspired enthusiasm for war was shortlived: he rapidly grew to resent the calculated erosion of individuality necessary to reduce men to unthinking cannon-fodder, charted in numerous portraits and self-portraits. Unable to reconcile the idea of a loving, benign God with the appalling suffering he witnessed as a voluntary medical orderly, he was "filled with rage at God for having made us so we cannot love each other".[5] To find an explanation for such evil he turned to the mystical doctrines of Gnosticism, Buddhism and the Cabbala, and to the pessimistic philosophy of Schopenhauer.[6] His adoption of the Gnostic concept that the world was created by an evil demiurge as a prison for souls which must struggle to return to their original state in the realm of Good or Light beyond material creation, formed the basis of Beckmann's thought from about 1917 onwards. This led him to think in terms of dualities: the conflict between good and evil, between the individual soul and the material world. Believing that the only source of good in the world was in the individual meant that, unlike Grosz and Dix, he was able to love rather than despise his fellow-men.[7] From 1915, when he was discharged from the army and settled in Frankfurt, Beckmann determined to use his art to depict the individual's tragic fight against evil. To achieve this he gradually evolved the highly personal style which, with various shifts of emphasis, he used for the rest of his life.

The good-evil dichotomy translated most readily into the black-white tension of graphics. "It is the dream of many to see only the white and truly beautiful, or the black, ugly and destructive. But I cannot help realizing both, for only in the two, only in black and white, can I see God as a unity creating again and again a great and eternally changing terrestrial drama".[8] Beckmann's concentration on graphics – between 1915 and 1923 he made most of his 300 odd prints but only thirty paintings – reveals his judicious absorption of the Expressionists' use of graphics to evoke the modern spirit. However, whereas they exploited the primitive spontaneity of the woodcut, Beckmann was drawn to the acerbic detachment of the dry-point, combined with a fragmented Cubo-Futurist structure, to create a formal equivalent to the political chaos and spiritual dislocation of post-war Germany.[9] Although critical of the Expressionists for their lack of committed ideology, his graphic style owes much to their exploration of the psychological impact of distortion and ugliness. And like theirs, his new painting style grew out of his graphic innovations.

Despite his urgent desire "to throttle the throbbing monster of life . . . in sharp, cutting lines and surfaces", Beckmann remained a painter at heart.[10] He found the emotional intensity he sought in late medieval German painting, such as Grünewald's *Isenheim Altar*, with its spatial and formal distortions.[11] He fused this with the heightened realism or "transcendent objectivity" he found in artists such as Breugel, Rousseau, Van Gogh, Cézanne and Hogarth, from whom he derived the use of gesture to reveal moral character.[12]

These diverse modernist and traditional elements are synthesized in *The Night* (1918–19; fig. 2) to tear apart the abstract anonymity of war, revealing the compulsive irrationality of human aggression. It was not intended as a political statement, for Beckmann insisted he was concerned solely with

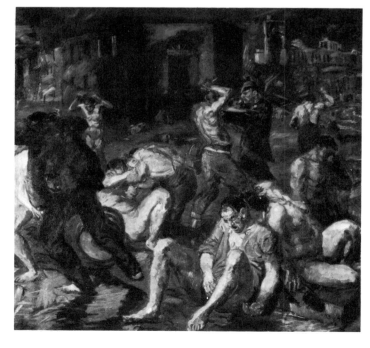

Fig. 1 Max Beckmann, *Scene from Destruction of Messina*, 1909

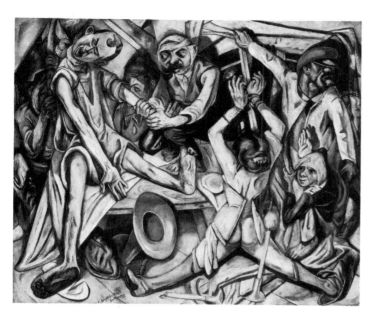

Fig. 2 Max Beckmann,
The Night, 1918-19

man's spiritual life, not with political reality. Conceived as a Christian martyrdom, *The Night* emerges as a tragically ironic anti-altarpiece testifying to his pessimism about the human condition.[13]

This religious allusion is pursued in *Carnival* (1920; cat. 107), where he adopted the vertical format of the wing of a Gothic altarpiece, exploiting its claustrophobic space and disturbing distortions to give transcendent objectivity to the Gnostic concept of the soul imprisoned in the finite world. The manipulation of space, "the infinite deity which surrounds us and in which we ourselves are contained", is the most consistent leitmotif in Beckmann's subsequent work.[14] By means of blocking and framing devices, every portrait, still-life, landscape or figure composition is transformed by Beckmann into a spiritual metaphor.[15]

The nine sketches for *Carnival* show him striving to emulate Cézanne's "creation of depth by the feel of the surface"[16] and to perfect his system of linear tension based on gesture, which would immediately signal the psychological or spiritual mood of a work. Thereafter, Beckmann used this "pictorial architecture" to work directly on to the canvas, even for major compositions. He chose the same format for almost all his important works of the 1920s, such as *The Bark* (1926; fig. 3) and *Aerial Acrobats* (1928, cat. 112). It is the key to his mature style and forms the basis of the nine triptychs painted during the 1930s and 1940s. *Carnival* introduces the use of colour, "the strange and magnificent expression of the inscrutable spectrum of eternity",[17] as an emotional and spiritual signifier. Beckmann never ceased to respond to sensuous beauty; but out of conviction that man had largely forfeited any right to it, he subordinated colour and sensuousness to the tense linearity of his pictorial architecture: an artistic version of Brecht's alienation effect, forcing the viewer to remain critically detached.

Carnival also ushers in the symbolism of carnival and *commedia dell'arte*, later augmented by that of the circus, cabaret, fairground and stage, as a metaphor for the artificiality of earthly existence.[18] Role-playing symbolized the survival strategies forced on the individual by the arbitrariness of life. Like a mask, the assumed role paradoxically revealed what it sought to conceal: the self "which has only one form and is immortal."[19] The key to this metaphysical quest was the self-portrait. Constantly charting the threat to the self seismographically revealed in his own face, Beckmann often adopted the roles of clown (cf *Carnival*), king, circus performer, convict or mythological hero to symbolize his changing reaction to world events.[20]

Stylistically, *Carnival* brings Beckmann far closer to the Modernist spirit. Yet the Gothic format and the revival of symbolism show him once again acting deliberately "out of season" to assert his spiritual

positivism in defiance of the nihilistic unreason of the Dadaists and the existential pessimism of the Verists. It also differs fundamentally from the humanist values being rediscovered at the time in Paris.

Critical reaction to Beckmann's new style was generally uncomprehending, even hostile, largely because the symbolic content of his work was neither politically committed like the Verists', nor idealistic like the Magic Realists'. Not until the 1925 Mannheim Neue Sachlichkeit exhibition was Beckmann acknowledged as the foremost realist painter in Germany.[21]

Strengthened both by public recognition and by the financial security it brought, Beckmann turned towards Paris.[22] He was the only German realist of the 1920s to attempt to integrate the probing intensity of his native art with contemporary French aesthetics.[23] Synthetic Cubist influence is discernible from the mid-1920s, but because of Beckmann's vibrant colour contrasts and tense surface rhythms, works such as *Large Fish Still Life* (1927; cat. 122) are injected with a disquieting undercurrent of suppressed dynamism.

Although Léger's mechanized beauty is hinted at in works such as *Aerial Acrobats*, the major challenge facing Beckmann in Paris was Picasso, the only contemporary he saw as a serious rival.[24] Beckmann's passionate introspection seems a far remove from the lyrical self-containment of Picasso's Neo-Classical *Mother and Child by the Sea* (1921), which he knew.[25] Yet works such as *Reclining Nude* (1929; cat. 120) and *Portrait of Minna Beckmann-Tube* (1930; fig. 4) reveal how profoundly he absorbed the dignified grandeur of Picasso's boldly modelled forms to achieve the dynamic monumentality which characterizes his work of the 1930s.

To give concrete objectivity to the horror and tragedy of the Third Reich, Beckmann turned to the epic format of the triptych in which Christianity had expressed the

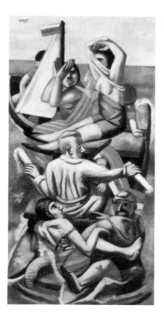

Fig. 3 Max Beckmann,
The Bark, 1926

Fig. 4 Max Beckmann,
*Portrait of Minna
Beckmann-Tube*, 1930

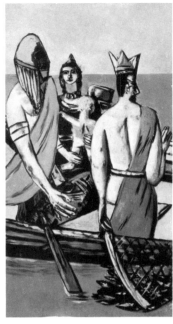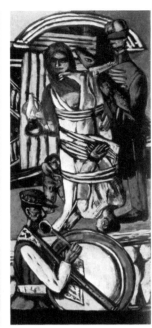

Fig. 5 Max Beckmann, *Departure*, 1932-35

dichotomy between heaven and earth, good and evil. The nine triptychs he painted between 1932 and 1950 contain complex philosophical statements about the most difficult period of his life, spanning his dismissal and proscription as a 'degenerate' artist by the Nazis, ten desperate years in exile in Amsterdam (1937-47), and three moderately successful years in America.[26]

Beckmann exploited the simultaneity of the triptych to expose the paradox that the fall and subsequent redemption co-exist within each individual. In *Departure* (1932-5; fig. 5), man's obsessive sensuality, compulsive physical and mental cruelty, and inescapable sense of guilt are crudely enacted in the claustrophobic intensity of the side panels. Significantly the first part of each triptych to be conceived, these are simultaneously separated from, yet formally linked to, the monumental open forms and glowing colours of the centre panel. This

scene, in contrast, is pervaded by a surging optimism as the majestic protagonists "emerge into the clear light of redemption, embarked for Eternity", symbolized by Beckmann's favourite spatial metaphor for spiritual freedom, the sea.[27] As in all his triptychs, the meaning lies not in the central resolution, but in the shifting dialectic between conflicting statements.

This formal flexibility found its conceptual parallel in his introduction of the timeless narrative of myth to fuse personal experience, historical fact and mystical truth to give concrete expression to the story of birth, passion and death which is human destiny. From the early 1930s Beckmann read widely in Greek, Indian and Nordic mythology, fascinated, like James Joyce, by their common themes and symbols and by the many analogies with Christian symbolism.[28] It was the multiple, often contradictory meanings of mythical symbolism that he wanted to

explore. Thus in *Departure* the fish appears both as Judaic fertility symbol and Christian symbol of redemption to emphasize the material-spiritual dichotomy in man. Likewise in *City of Brass* (1944; fig. 6), the story from *A Thousand and One Nights* in which the city of buried treasure is saved from conquest by virgins luring the invaders to their deaths, is translated by Beckmann into a universal allegory of mankind's enslavement to sexuality, symbolizing our fallen state. And in *Prometheus* (1942) he fuses the Greek myth with allusions to the Crucifixion to articulate the brutality of Fascism.[29]

Once again, Beckmann arbitrarily interweaves Modernist and traditional elements to create the greatest possible impact of form and content. But far from being anachronistic, he exploited the ambiguity of mythical symbolism to convey our human inability to grasp universal truth.

In *Birds' Hell* (1938; cat. 119), he experimented with grotesque Expressionistic distortion and shrill colour combinations, together with explicit references to National Socialism such as the 'Heil Hitler' salute, screaming crowds, the Prussian eagle adopted as an emblem by the National Socialists and a many-breasted Indian fertility figure symbolizing their "blood and soil" ideology – to create a chilling allegory of Fascist terrorism.

Returning in despair to Schopenhauer, theosophy and Buddhism, Beckmann found solace in the doctrine of the transmigration of souls.[30] *Death* (1938; cat. 118) depicts the cycle of immanence, death and reincarnation to which the soul is subject until, triumphing over evil, it can return to the realm of eternal Light. Although this belief enabled Beckmann to a certain extent to contain his deep pessimism during the Second World War,

Fig. 6 Max Beckmann, *City of Brass*, 1944

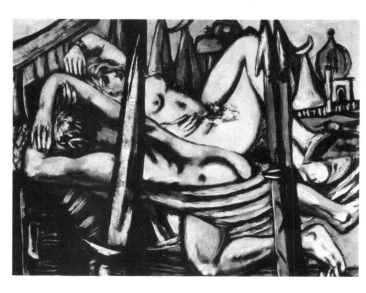

Fig. 7 Max Beckmann, *Self-portrait in Black*, 1944

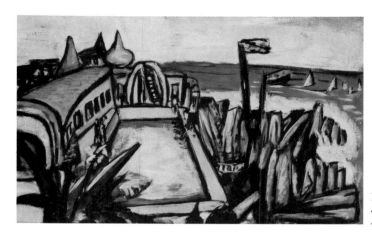

Fig. 8 Max Beckmann, *Swimming Pool at Cap Martin*, 1944

his work during that time is frequently characterized by even heavier black contours and still more claustrophobic suppression of space, for example in *Self-portrait in Black* (1944; fig. 7). In many works myth is fused with stage, carnival, circus and gambling symbolism to convey the utter futility of human endeavour. Only in occasional sea-scapes, mostly happy pre-war memories of the South of France such as *Swimming Pool at Cap Martin* (1944; fig. 8), did he permit himself a glimpse of possible spiritual re-demption.

Beckmann's existential gloom was too pro-found to be easily dispelled by the cessation of hostilities. His continued scepticism about mankind's genuine capacity or willingness for peace is expressed with tragic irony in the bizarrely mutilated dancers of *Begin the Beguine* (1946; fig. 9). In total contrast, numerous works of the immediate post-war period, such as *Afternoon* (1946; fig. 10) and *Actresses* (1946), reveal his continued belief in humanity's compulsion to obey the life force, forever propelled forward by their sex-uality into the next chain of being. In these

years, it is the demonic rather than the joyful in this process on which Beckmann dwells, conveying his ambivalent feelings about mankind's ability to learn from its errors.

From 1947 to 1950, the youthful optimism and vitality of the United States filled Beck-mann with fresh hope and vigour. In response to the dramatic scale of the country and the cosmopolitan energy of New York, his forms became bolder and his colours more strident, though always consciously interwoven with subtle references to Euro-pean aesthetics. For even in the freedom, sec-urity and relative success of America he never lost his acute sense of exile from the only reality that mattered, that of the spirit, poignantly reflected in *The Prodigal Son* (1949; cat. 121). *The Argonauts* (fig. 11), the triptych he completed the night before he died, testifies jubilantly to his defiant belief, as "out of season" in 1950 as it had been in 1912, in the unique potential of transcendent objectivity "to make the invisible visible through reality". The influence of Beck-mann's artistic philosophy on recent German art is easily seen; by the end of the century a thorough re-evaluation of his alleged outsider role in the history of Modernism will clearly be called for.

Notes

1 'Gedanken über zeitgemäße oder unzeitgemäße Kunst', *Pan*, II, March 1912, pp. 499-502.

Reprinted in *Max Beckmann, Die frühen Bilder*, Kunsthalle, Bielefeld, 1982
2 Friedrich Nietzsche, *Unzeitgemäße Betrach-tungen*, 1873-6
3 Also cited: Signorelli, Tintoretto, El Greco, Goya, Gericault and Delacroix
4 Peter Selz, *Max Beckmann*, New York, Museum of Modern Art, 1964, p. 19
5 Conversation with Reinhard Piper in 1917, cf Reinhard Piper, *Nachmittag*, Munich, 1980, p. 33
6 Beckmann had a copy of Schopenhauer's *Parerga und Palipomena* since 1906. Gnostic and Cabbalistic ideas he drew chiefly from Madame Blavatsky's *The Secret Doctrine* of which he owned the fourth German edition of 1919. His library still contains his well-anno-tated copy of *Die Reden Gotamo Buddhos*, Munich/Leipzig, 1919, translated and edited by Karl Eugen Neumann, whose footnotes linking Buddhism to Western philosophy are the source of Beckmann's ideas about the Self.
7 Peter Beckmann (ed.), *Max Beckmann: Sicht-bares und Unsichtbares*, Stuttgart, 1965, p. 106
8 *On My Painting*, New York, Bucholz Gallery, 1941. English translation of *Über meine Malerei*, a lecture he gave at the New Burlington Gal-leries, London, 1938. Reprinted in Herschel B. Chipp, *Theories of Modern Art*, Berkeley, 1968, pp. 187-92
9 Beckmann used the drypoint for the cycles *Faces*, 1918, and *The Annual Fair*, 1921. In the cycles *Hell* and *Trip to Berlin*, 1922, he renders the lithograph as sharp and cutting as the dry-point.
10 'Schöpferische Konfession', *Tribüne der Kunst und Zeit*, XIII, 2nd ed., Berlin, 1920. English translation by Victor H. Meisel in *Voices of Ger-man Expressionism*, ed. Meisel, Englewood Cliffs, New Jersey, 1970
11 He had been deeply moved by this work since seeing it in Colmar in 1903. He was also influ-enced by Curt Glaser, *Zwei Jahrhunderte Deutscher Malerei*, Munich, 1916
12 Beckmann owned a Hogarth engraving of *The Night*, which he praised to Piper in July 1919 while working on his own *Night*. Typescript, Piper Archive, Munich
13 All six sketches illustrated in Stephan von Wiese, *Max Beckmanns zeichnerisches Werk 1903-25*, Düsseldorf, 1978, pp. 160-1
14 *On my Painting*
15 cf. Carla Schulz-Hoffmann, 'Bars, Fetters and Masks: The Problem of Constraint in the Work of Max Beckmann', in *Max Beckmann Retrospec-tive*, The St Louis Art Museum, 1984, pp. 15-53
16 *Schöpferische Konfession*

Fig. 9 Max Beckmann, *Begin the Beguine*, 1946

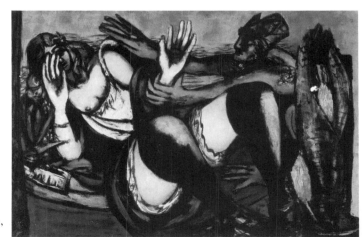

Fig. 10 Max Beckmann, *Afternoon*, 1946

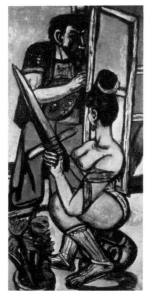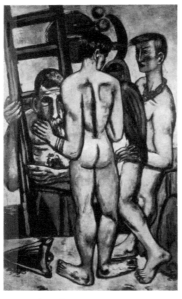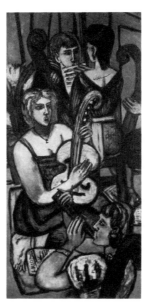

Fig. 11 Max Beckmann, *The Argonauts*, 1949/50

17 *On My Painting*
18 cf. Friedhelm Fischer, *Max Beckmann – Symbol und Weltbild*, Munich, 1972; Sarah O'Brien-Twohig, *Max Beckmann's Carnival*, Tate Gallery Publications, 1984
19 *On My Painting*
20 cf. Fritz Erpel, *Max Beckmann, Leben im Werk: Die Selbstbildnisse*, Berlin/Munich, 1985; Hildegard Zenser, *Max Beckmanns Selbstbildnisse*, Munich, 1984
21 cf. Franz Roh, *Nach-Expressionismus. Magischer Realismus. Probleme der neuesten europäischen Malerei*, Leipzig, 1925
22 In July 1925 he signed a new contract with I. B. Neumann giving him an assured annual income. In October he was called to the Städel-Kunstschule, a post he held until dismissed by the National Socialists in April 1933.
23 He visited Paris regularly from 1925 to 1929, and lived there between September and May from 1929 to 1931, and again from 1938 to 1939.
24 cf. Correspondence with I. B. Neumann,

reprinted in *Max Beckmann, Frankfurt 1915-33*, Städtische Galerie im Städelschen Kunstinstitut, Frankfurt, 1983, pp. 265-89. The art critic of *Le Figaro*, reviewing Beckmann's one-man show at the Galerie de la Renaissance in 1931, actually referred to Beckmann as "quelque chose comme un Picasso germanique" (Beckmann-Archiv, Munich).
25 As Beckmann destroyed all his diaries between 1915 and 1940 when the National Socialists occupied Amsterdam, it is difficult to ascertain exactly what he saw of Picasso's work in Paris. But he certainly knew Gottfried Reber's large collection at Lugano, which at the time included key works such as *Two Seated Women* (1920), *Mother and Child by the Sea* (1921) and *The Three Musicians* (1921). Beckmann's library contains a copy of the catalogue of the important Picasso retrospective exhibition at the Galerie Georges Petit in June 1932
26 For detailed analysis of the triptychs cf. *Max Beckmann: The Triptychs*, Whitechapel Art Gallery, London, 1980; Friedhelm Fischer, *Max*

Beckmann – Symbol und Weltbild, Munich, 1972; also Charles Kessler, *Max Beckmann's Triptychs*, Cambridge, Mass., 1970.
27 *Briefe im Kriege*, Berlin, 1916, reprinted Munich, 1984, p. 29
28 Beckmann's library, currently being catalogued by Dr. Peter Beckmann, contains a large selection of contemporary literature on mythology. He owned the 1927 first German edition of Joyce's *Ulysses*, and praised Joyce for his search for truth.
29 This work was painted at the request of Dr. Peter Beckmann after a visit to his father in Amsterdam, when he saw *Perseus* (1940-1), the triptych Beckmann created in response to the National Socialists' invasion of Holland.
30 Beckmann's habit of dating marginalia and annotations reveals that during the 1930s and 1940s he read and re-read works such as Nietzsche's *Also Sprach Zarathustra*, Madame Blavatsky's *The Secret Doctrine* and Schopenhauer's Collected Works.

Works in English on Max Beckmann

Peter Selz, *Max Beckmann*, New York, Museum of Modern Art, 1964
Max Beckmann, Tate Gallery, Arts Council of Great Britain, 1965
Stephan Lackner, *Max Beckmann. Memories of a Friendship*, Coral Gables, Florida, 1969
Charles Kessler, *Max Beckmann's Triptychs*, Cambridge (Mass.), 1970
The Complete Series of Drawings by Max Beckmann for Goethe's Faust II, Cat. of auction at Sotheby & Co., 1971
Friedhelm Wilhelm Fischer, *The Painter Max Beckmann*, transl. by P. S. Falla, New York, 1973
Max Beckmann, Marlborough Fine Art Ltd, 1974
Stephan Lackner, *Max Beckmann* (The Library of Great Painters), New York, 1977
Peter de Francia, 'Max Beckmann. A Homer in a Concierge's Lodge', *The Fine Art Letter*, May 1981
Sarah O'Brien-Twohig, *Max Beckmann's Carnival*, Tate Gallery, 1984
Max Beckmann Retrospective, The St Louis Art Museum, 1984

Hanne Bergius

Kurt Schwitters: Aspects of Merz* and Dada

"In the Elysian Fields of the Inventory"

"To Kurt Schwitters, the purest artist of my time." Thus did Herwarth Walden dedicate the new edition of his book *Einblick in Kunst*[1] in 1924.

These words also expressed Schwitters's deepest single desire to be an aesthete of "structural consistency". He was an aesthete for whom the various individual arts were all too specialized and who sought to embody within his own work not merely all art forms but also all contemporary materials and media. Indeed to Schwitters life itself only had justification if it could stand as an aesthetic phenomenon, and in his scheme of things "the Beautiful" – in contradiction to classical categories of art – could include the non-artistic, the banal, the trivial, the discarded, the temporary and the superficial. The Nietzschean spirit of the time found its indirect reflection in Schwitters's work, for he was not concerned with an all-embracing, exhaustive cohesion of meaning, but with truth. This truth lay in the both enlightening and deceptive surface of things and in their inflated appearance. If making all life into an aesthetic experience was one stage in the ultimate fusion of art and life into the complete work of art, the vitalizing of art was the second stage. In the *Merzbau*,[2] Schwitters's life-work which he started in 1920/3, these two tendencies are intertwined to create an aesthetic, solipsistic structure, for, as Hans Richter remarked, "he [Schwitters] was the synthesis of all the arts."[3] The only

Fig. 1 Kurt Schwitters with his *Merz* sculpture, *The Sacred Affliction*, about 1920

surviving remnants of this extensive life-work which was planned to extend over decades are now to be found in England. In 1937 political pressure forced Schwitters to break off his work in Hanover; he then continued it in 1940 during his Norwegian exile in Lysaker and resumed it in 1947/8 shortly before his death in England.[4]

Schwitters's allegiance to the primacy of the aesthetic was enlivened by the international Dadaists with some of whom he enjoyed lifelong friendships. Among these are to be numbered Raoul Hausmann and Hannah Höch, Hans Arp, Theo and Nelly van Doesburg, and Tristan Tzara. A later friend was Marcel Duchamp. But chief among these contacts was Katherine Dreier, a co-founder of the 'Société Anonyme', and it was thanks to her understanding of avant-garde art that Schwitters was accorded so excellent an introduction to the USA.[5] Constructivists were also of importance to Schwitters during the 1920s. Among them were Lissitzky, Moholy-Nagy, Domela, Vordemberge-Gildewart, Mondrian, Malevitch, Gropius and Mies van der Rohe. Many of these figures were to be immortalized in the *Friendship Grottoes* of the *Merzbau* by means of some objects typical of them. Cooperation with some of these artists can be discerned in Schwitters's *Merz* art.

His assemblage *The Sacred Affliction* (1920; fig. 1) gives us in allegorical form a many-sided vision of the Dada influences at work. It is connected with the further assemblages of the *Gallows of Desire* (fig. 2) and the *Cult of Pump* and not least with his concept of the *Cathedral of Erotic Misery*.

A legend of the "Sacred Affliction"[6] (also known as *Wilgeforte*, a derivation from *virgo fortis*) dates from the fifteenth century. Well-known in Europe and particularly in Bavaria, it tells of the daughter of a pagan king who after her conversion to Christianity refused to comply with her father's wish that she should marry another heathen ruler. She prayed that she should be so disfigured by Christ that she would prove unpleasing to all men. Another version relates that she prayed to look like Christ alone. Her wish was granted in that she received the face of a heavily bearded man. The Sacred Affliction was known in England as Liberata, who was said to have released all women from unhappy union with their husbands.

This legend alludes to the same "erotic misery" which the Dadaists so emphatically rejected. They refused to accept the principle of patriarchal authority which permeated all aspects of Wilhelminian society from the

Fig. 2 Kurt Schwitters, *Merz* Sculpture, *Gallows of Desire*, about 1920

small family unit through organized army cadres, to political and public life, and which, in the form of the First World War, had fashioned its own apocalyptic downfall. In the *Grotto of Love* in the *Merzbau*, Schwitters presented a grotesquely twisted and distorted image of the 'embryo cell' of society. "He has no head, she has no arms; he is holding a huge blank cartridge between his legs. The child with the syphilitic eyes in its big twisted-around head is telling the embracing couple to be careful."[7] This grotesque apparition, linking as it did dreams of virility with martial yearnings for potency, and injected with the deadly bacillus of syphilis, presented a rejection of society clearly influenced by Dadaist principles. It also laid the responsibility for the origins of the apocalypse at the door of the family unit. The post-war years, which in cultural terms took place against a background of the Passion and Redemption, orientated towards damnation and resurrection, were given an ironically twisted reflection in the *Sacred Affliction*. The martyrdom, with which many of the Expressionist artists were able to identify themselves, seemed to Schwitters to be a kind of *Gallows of Desire* principle or a *Cult of Pump* system calling for de-mystification.

He saw the *Cult of Pump* system in particular as the product of a deeply disturbed society clinging with superstitious fervour to var-

Fig. 3 Marcel Duchamp, *L.H.O.O.Q.*, 1919

ious fetishes. The *Sacred Affliction* was like a tailor's dummy fitted with a pear-shaped head and equipped like a reliquary with the words "Upper Silesia". Upper Silesia was at that moment the fetish of the Deutsch-national middle class, as a referendum was to be held in 1921 which threatened to hand the area over to Poland. This would have been a serious economic loss to the German bourgeoisie as Upper Silesia, along with the Ruhr, was the largest industrial area in Germany. A decoration for a Christmas tree, a burning candle, a notice reading "Upper Silesia" fitted on to a hurdy-gurdy , the words "Happy Christmas" as well as a label round the neck of the dummy saying "Give generously for Upper Silesia" – all these elements compose a picture of the time with an embellishment of Christian sentimentality, national interest and glorified family feeling which to Schwitters quite simply meant "Madness" – another word hung round the puppet's neck.

In the *Merzbau* Schwitters pointed to further bourgeois fetishes which he incorporated into the structure as trophies of cultural values and myths. The Grottoes of Goethe, of Luther, of Kyffhauser and of the Nibelungen, and those of the Grand Duchy of Brunswick-Luneburg, of the Ruhr, of the Disabled, of the Family Unit and of Sexual Murder[8] directed the gaze not to the marble halls of heroic and cultural history – as D'Annunzio was doing at this very moment (1923) for an Italian audience in the *Vittoriale degli Italiani*.[9] In Schwitters's *Merzbau* the display-cases of the Biedermeier epoch, where these memorials were honoured with a devotion approaching idolatry, are all trans-

formed into a panopticon of grottoes full of parodies intended to shock. In the Goethe grotto for example, laid out by Hannah Höch, one is confronted not with a bust of the poet but with his leg, in keeping with the Dadaist principle that anything in the world can be made into a cultural object. This reliquary of a leg is also a cynical reference to Germany's post-war manufacture of artifical limbs. These grottoes vibrate with the feeling of a culture in decline. A culture atrophied in fetishism is presented to us as ironic proof of the fact that the formerly enlightened bourgeoisie of Germany has surrendered all cultural life and is now mummified in superstitions and idolatries which make all cultural dialogue impossible.

The *Merzbau*'s grottoes reveal only some of the concepts underlying it. Other themes had already been indicated in the *Sacred Affliction*, ones which also affect substantially the *Cathedral of Erotic Misery*. The polymorphic eroticism which enable the saint in the fifteenth-century legend to succeed in her refusal to marry the heathen suitor permeates the entire Dadaist aesthetic. Do we not find concealed behind the bearded saint of the legend the moustachioed Mona Lisa, *L.H.O.O.Q.* (fig. 3), which Duchamp published in March 1920 in Picabia's journal *391*?[10] Duchamp himself was playing an ambiguous sexual game in his appearance as *Rrose Selavy*, an affront against the socially established unidimensional view of sex. Raoul Hausmann also assumed an androgynous role in *Monna Hausmann*, his *Friendship Grotto* in the *Merzbau*, by affixing his own portrait to the face of the Mona Lisa. Schwitters proceeded differently and in reverse, for he repeatedly attached the words "Anna

Fig. 4 Pasted-over portrait photograph of Schwitters on an advertising postcard

Blume" to his own portrait (fig. 4). And may we not see in the *Merzsäule* (fig. 5) with which Schwitters inaugurated the *Merzbau* a poor relation of the 'divine' androgynous Eros, solidified here into a bust, and who now appears with its doll's head as an echo of the hermaphrodite primeval child? A fantasy of melancholy encircles this column as it does the mourning Muses of de Chirico.

The *Cathedral* symbolically points the way to Revelation and Salvation; to Schwitters, androgyny seemed a necessary stage on this

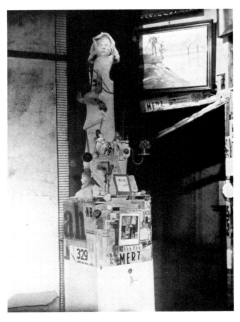

Fig. 5 Kurt Schwitters, *Merzsäule* in the Hanover *Merzbau*

path. The fetish grottoes had similarly contained a pale, fragmentary reflection of the libido. The word "Merz" is stuck on to the base of the hermaphroditic sculpture in many places as a kind of pictorial incantation. The conception of *Merz* art; the metamorphosis of certainty; the still undefined; the self-destroying logos of language as found in Schwitters's sound poetry; the obscuring of anything unequivocal as a result of the *Merzbau*'s disclosure of the multi-layered nature of subjectivity – all this was bound up with erotic-aesthetic drives which are deeply androgynous.

It becomes clear that Schwitters developed his ideas for *Merz* art in many respects from Dadaist principles. In his own arbitrary way he represented the notion, accepted by the Dadaists, of "buffoonery and requiem" being closely allied, as Hugo Ball had expressed it.[11] If we are to believe Huelsenbeck it was not foolhardiness, love of adventure, boldness, sharpness, personal effectiveness, nor a desire to proselytize[12] that characterized Schwitters. These were all important traits in the eyes of the Berlin Dadaists and partly determined the pamphleteer nature of their montages and socio-satirical works. Neither was Schwitters "the genius in the frock-coat"[13] as he was represented by the

Berlin Dadaists and by Huelsenbeck in particular. The black suit which Schwitters favoured and in which he is depicted on many portrait postcards was intimately connected with his vision of himself as a dandy. The Berlin Dadaists totally overlooked the fact that this black outfit was for Schwitters a disguise, particularly useful in the provincial town of Hanover. With this outfit of "black uniformity" Schwitters was resorting to a tactic already used by Baudelaire, for whom the black suit was a 'poetic' expression of a "public state of mind" – "the symbol of eternal sadness . . . as represented by an interminable series of invitations to funerals, invitations to political funerals, to erotic funerals, to private funerals. We are all celebrating some burial or other."[14]

Does not the melancholic interpretation of the black suit make the *Cathedral of Erotic Misery* more intelligible? In this guise its creator, in his ascetic black, integrated himself as an artefact unobtrusively and with dandyish humour into society. Schwitters's humour was a playful, conciliatory kind of narcissism which insulated him against the suffering of the real world.

With an apparently stoical calm he elicited from the doomed patchwork of society the small, insignificant word "und" – a word which was to become the dominating signal within the *Und Picture* (fig. 6). Things which seemed grotesque and indeed nonsensical (and which were meant to seem precisely that) took on a complex quality which expressed very accurately their cultural-critical coherence. "It appears that the *Und* between things has rebelled," wrote Franz Werfel as early as 1914, "we are all pushed into a terifying immensity. The very wealth of opinions and organisms make us despair. Faced with one detail, to which no order gives a unity, we are powerless. Everything is in chaos and a fearful loneliness renders us silent."[15] If the *Und* collage does contain this melancholy view, distance and indeed irony

are also attached to the little word "und" and the same may be said of "na und?!" ("so what?!").

This artistic strategy enabled Schwitters not only to develop aesthetic concepts out of the rootlessness sadly noted by Werfel, but even to exorcize this rootlessness by setting against it an all-embracing capacity for relationships. "Merz means creating relationships, preferably between all things under the sun."[16] The disturbed relationship between things and the world – which was the basic premise of the Berlin Dadaist montage work – was to be replaced in *Merz* art by the relationship arising from the things themselves. The material, the form, "the choice, the diffusion, the distortion 'of the materials', the separation, the twisting, the covering or painting over" – these things are now raised to the status of content.[17] The power to arrange things, which reality denies the artist, was now exercised to the full in the work of art in a vengefully many-sided and imaginative way and in the form of solipsistic rituals, in libidinous objects reflecting the self and in fetishes. This indicates that Schwitters referred only indirectly to reality. He needed to preserve mementoes of reality and this he did with his obsession for collecting things, "like a hunter in the Elysian fields of the inventory", as Walter Benjamin put it. In his collecting Schwitters secured traces of life and established a durable counterbalance to the ephemeral nature of existence and, as a narcissistic nature, paradoxically confronted his own obsessively accumulated objectification; this is the result of his "uncanny gift for reduplicating himself" (Hugo von Hofmannsthal). In this way traces of life and death mingled, and the same was true of subject and object.

"So that nothing shall be lost, even if it is false and dull"[18] – it was this attitude which he also had towards his academic training and his nature studies that formed an essential difference between Schwitters and the dynamic Dadaists of his day. "For I regard it as vitally important," he maintained, "that in the end the whole of life with all its aspirations should stand there in its entirety. I have nothing to hide."[19] The model for this was his *Merzbau* in which he included along with his collages and assemblages individual nature studies such as *Flooded Meadows* (1914) with the *Merzsäule* in the background.

Not only did he attempt to weave certain works into the *Merzbau*, he also wished to come to terms with an over-burdened memory of the period in which he lived. It was a time which was reproducing itself in an inflationary style as it surged forward. This inflation was particularly noticeable in the consumption of paper which proceeded at an ever increasing rate and in greater and greater volume. The city, too, Schwitters also saw as a body constantly bursting its bounds, constantly disintegrating and constantly reproducing itself. In all its fragments this was to be reflected in *Merz* art. All the

Fig. 7 Otto Dix, *Suleika, the Tattooed Wonder*, 1920

trivial documents of the hectic daily round of a town's life were drawn into Schwitters's work – tickets of all kinds, cuttings from newspapers and magazines, all are woven in. Urban man is reflected in these documents as the "restless slave of his own gadgets . . . less as a human being" (Kurt Tucholsky). He is there as a passenger, a diner in a restaurant, as a newspaper reader, a traveller on a bus, as a customer in places of entertainment. The big town jeopardizing itself in this way was not allegorized as it was by Dix in his *Suleika, the Tatooed Wonder* (1920; fig. 7); in the *Merzbau* and in Schwitters's collages we find echoes of the "erotic misery" of a dream industry which especially during the years of the inflation created appetites which could never be satiated. In the collage labelled *Mz 94: Grünfleck*[20] (1920; fig. 8) Schwitters juxtaposed the word "for" (which is shorthand for "Money paid for") with scraps of advertisements from the years of the inflation. These are for unobtainable luxury items like chocolate, coffee, cigarettes. They show the power of commerce from which the word "Merz" is derived, for in times of acute shortage "the heart goes from sugar to coffee" (Schwitters).

Perhaps the shortening of the *Kathedrale des erotischen Elends* to *KdeE* is not accidental since "KaDeWe" was the abbreviated name of one of the big stores in Berlin, the Kaufhaus des Westens.[21] If the big stores were in Baudelaire's eyes the "ivresse religieuse des grandes villes"[22] and if he saw in them "temples dedicated to this intoxication"[23] the *Cathedral of Erotic Misery*, with its cult-like presentation of things, also alienated the gleeful dressing-up of the wares in these new cathedrals.

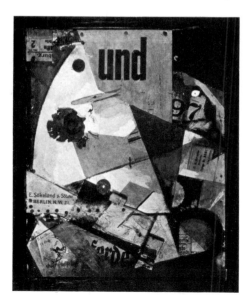

Fig. 6 Kurt Schwitters, *The Und Picture*, 1919

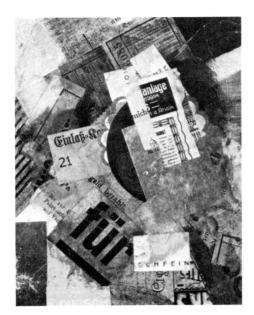

Fig. 8 Kurt Schwitters, *Merz 94: Grünfleck*, 1920

Just as "the lyrical frenzy of the material" has replaced "the long exhausted psychology of the human"[24] so did Schwitters in the *Grottoes of Friendship* replace friends with various objects associated with them. This he did with humorous objectivity. A thick pencil, for example, stands for Mies van der Rohe, a key and a prescription for Dr Steinitz, a pair of socks for Moholy-Nagy, a cut-off tie for van Doesburg, a tuft of hair for Hans Richter, while Sophie Täuber-Arp is represented by her brassière. In one way Schwitters secured the memory of his friends and gave life to those articles, and in another way the display of the objects reflected, albeit grotesquely, the material objectification of interpersonal relationships. These fetishes are selected with humour and make clear a fragmented perception of people which loses itself in details, taking them for the whole.

In the *Merzbau* (fig. 9) and in his *Merz* collages Schwitters allows associations of time, life, companionships, reality, play and imagination to filter through. These then set

loose a stream of consciousness which starts off further impressions and memories. This gives rise to an organic process of growth itself which transcends and excels the "dead body of the object".[25] In the *Merzbau* "the inner form of time seems to regain the three-dimensional extension"[26] of which it had been deprived by its functional use. The metamorphic subject has found its ideal location in the *Merzbau*. "Where experience in the strict meaning of the word prevails, certain contents of the individual past come into conjunction in the memory with elements of the collective past."[27] In this way the *Merzbau* is able to present a union between subjective and collective experience. It assumes the significance which originally belonged to "the cathedrals" and more especially to the cults with their ceremonials. In them the present, memory and expectation were fused into a revelation, and in the experience they formed a unity of disparate parts.

This mythical experience united Schwitters with Hans Christian Andersen's collages[28] which are uncannily similar to his own. Hans Christian Andersen (1805-1875) wove things filled with the spirit of the time into the enigmatic rebus of the private hieroglyphics of his collages. One example is given here in the collage from the *Kinderbuch der Agnete Lind* (1894; fig. 10) of which there are four further versions. It was not only the playful method of his collages that Andersen had in common with Schwitters; he also shared his passion for collecting. For his collages he compiled a wealth of cut-out silhouettes, glossy pictures, portraits, labels, series of comic pictures, lottery and entrance tickets, etc. An overt allegorized form of memory, very much like a "strange dream",[29] is visible in Andersen's collages, and then enclosed again in the theme of a fairy-tale. Just as the Surrealists found their nineteenth-century poetic forbear in Lewis Carroll, a kind of counterbalancing memory, so Schwitters unconsciously stepped into the mystical legacy of Hans Christian Andersen. Andersen and Carroll, who both lived in the

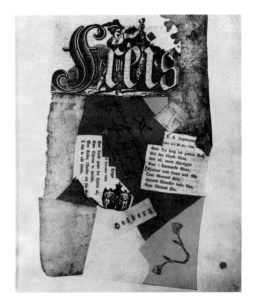

Fig. 10 Hans Christian Andersen, Page from the *Kinderbuch der Agnete Lind*, recalling Andersen's fellow poets Holberg, Ingemann and Kingo, and Weber's *Freischütz*

era of the great world exhibitions, based the fetishistic nature of things on a new poetic principle of construction – they supplied the dream, the unconscious and above all the element of play, knowing that "in this most arid century the entire dream-energy of society has fled into the silent, impenetrable nebulous world of fashion, into which reason cannot follow".[30] In Andersen's poetic vision of himself he was a fool, an outcast from society burying himself in drawing, painting, making cut-outs, composing lyrics, dramas, plays, ballets, writing memoirs and telling stories. So far the links in style, in the use of the grotesque, and in the use of humour in the poetry and art of this Pierrot of the North have not been investigated in relation to Schwitters's art. Another such Pierrot was Wilhelm Busch, whose "pious Helene" was an ancestress of Schwitters's Anna Blume and who is quoted in the *Merzbau*. In their work, both these artists reveal the subversive forces which lie beneath the surface of the cosy culture of the Biedermeier.

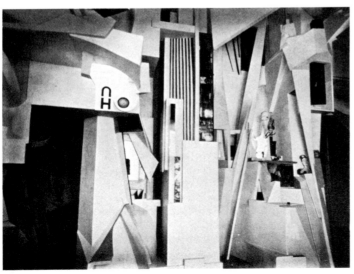

Fig. 9 The Hanover *Merzbau*, with the later state of the *Merzsäule* on the right

Notes

* Translator's note: Schwitters started to compose collages out of torn-up scraps of paper in 1918. On one such scrap was the syllable MERZ, from an advertisement for the German Commerz and Privatbank. From then on Schwitters described his assemblages as *Merz*.

1 Herwarth Walden, quoted from Werner Schmalenbach, *Kurt Schwitters*, Cologne, 1967, p. 43

2 Cf. Dietmar Elgers, *Der Merzbau, eine Werkmonographie*, Cologne, 1964

3 Hans Richter, *Dada-Kunst und Antikunst*, Cologne, 1964, p. 156

4 Surviving remains of the Elterwater *Merzbau* are to be found in the Hatton Gallery of the University of Newcastle-upon-Tyne.

5 Cf. Schmalenbach. *op.cit.*, pp. 61, 70

6 Cf. *Vollständiges Heiligenlexikon*, ed. Johann Evangelist Stadler and Franz Joseph Heim (contd. by J. M. Ginal), reprint of the Augsburg ed. of 1858, 5 vols., pp. 642 ff.

7 From the English edition of W. Schmalenbach, *Kurt Schwitters*, New York, 1967, p. 132. Cf. Schmalenbach, *op.cit.*, p. 137

8 Schwitters, quoted from Schmalenbach, *op.cit.*, p. 134 ff., and Elgers, *op.cit.*

9 Cf. Monika Steinhauser, 'Noch über dem Vaterland steht die Kunst'. Gabriele d'Annunzio's *Vittoriale degli Italiani* on Lake Garda', in *Beiträge zum Problem des Stilpluralismus*, ed. Werner Hager and Norbert Knopp, Munich, 1977, pp. 163-92

10 Marcel Duchamp, *L.H.O.O.Q.*, 1919, ready-made in *391*, ed. Francis Picabia, Paris, March 1920

11 Hugo Ball, *Die Flucht aus der Zeit* (1927), Lucerne, 1946, p. 78. Cf. Hanne Bergius, 'Dada als "Buffonade und Totenmesse zugleich"' in *Unter der Maske des Narren*, ed. Stefanie Poley, Stuttgart, 1981, pp. 208 ff.

12 Richard Huelsenbeck, quoted by Schmalenbach, *op.cit.*, p. 78

13 *Ibid.*

14 Charles Baudelaire, in Walter Benjamin, *Ein Lyriker im Zeitalter des Hochkapitalismus. Zwei Fragmente*, ed. with an epilogue by Rolf Tiedemann. See "Das Paris des Second Empire bei Baudelaire III", Die Moderne, Frankfurt, 1969, p. 76, and Hanne Bergius, 'Der Da-Dandy – Das Narrenspiel aus dem Nichts', in *Tendenzen der zwanziger Jahre*, Berlin, 1977, pp. 3, 12

15 Franz Werfel, 'Aphorismus zu diesem Jahr', *Die Aktion*, ed. Franz Pfemfert, III/4, Berlin, 1914, p. 903

16 Kurt Schwitters, 'Merz' (1924), *Der Sturm*, ed. Herwarth Walden, XVII/3, Berlin, 1927, p. 43

17 Schwitters; quoted from Schmalenbach, *op.cit.*, p. 98

18 Schwitters, *ibid.*, p. 78

19 *Ibid.*

20 Cf. Annegreth Nill, 'Rethinking Kurt Schwitters, Part Two: An Interpretation of Grünfleck', *Arts Magazine*, LV/3, New York, 1981, pp. 118 ff.

21 Carola Giedion-Weicker made the same connection in 'Einheit in Vielfalt', in *Kurt Schwitters*, exhibition catalogue, Städtische Kunsthalle, Düsseldorf, 1971, pp. 11 ff.

22 Charles Baudelaire, quoted in Walter Benjamin, *Das Passagenwerk*, ed. Rolf Tiedemann, Frankfurt, 1982, p. 109

23 *Ibid.*, p. 55

24 F. T. Marinetti, 'Technisches Manifest der Futuristischen Literatur', in Christa Baumgarth, *Geschichte des Futurismus*, Reinbek bei Hamburg, 1966, p. 168

25 Schwitters, quoted in Schmalenbach, *op.cit.*, p. 137

26 Elisabeth Lenk, *Die unbewußte Gesellschaft. Über die mimetische Grundstruktur in der Literatur und im Traum*, Munich, 1983, p. 313

27 Walter Benjamin, *op.cit.*, p. 107

28 Cf. Kjeld Heltoft, *Hans Christian Andersen als bildender Künstler*, Copenhagen, 1969

29 Heltoft, *op.cit.*, p. 106

30 Walter Benjamin, quoted by Elisabeth Lenk, 'Der Traum als Konstruktionsprinzip bei Lautreamont und Carroll', in Comte de Lautreamont (Isidore Ducasse), *Die Gesänge des Maldoror*, Munich, 1976, p. 303

Uwe M. Schneede

Max Ernst: 'Beyond Painting'

Ernst's work is consistent in its perception yet not as logically and continuously developed as that of other German artists of his generation, for instance Otto Dix and Max Beckmann. His style, subject matter and technique changed frequently; they were abandoned or modified as soon as he seemed to have mastered them. A certain lack of seriousness can be detected in all of his nevertheless highly profound work. Although it is firmly established in the German romantic spirit, it is more strongly fashioned by French *esprit* than by the German desire for expression. Max Ernst was born in the year 1891, "as a Prussian subject" – he himself wrote – in the Rhineland. At the age of 31, in 1922, he left Germany for good of his own free will; Paris became the artist's home and remained so, even when he went into voluntary exile in America.

The main characteristic of his work is a constant search for new motifs and techniques. They emerge in bursts of creativity: Dada collages, wood-engraved montages and pictorial novels, proto-surrealistic paintings, frottages, bird pictures, the *Hordes* (fig. 1), the *Shells of Flowers* (fig. 2), the *Forests*, the *Lop-lop* variants (fig. 3), the sculptures, the apocalyptic pictures of the 1930s, the decalcomanias. No stylistic category is sufficiently comprehensive to contain these experimental art forms which often point in very different directions. It is therefore pointless to try to define them. But the question remains: what is the motivation common to all these creative impulses?

In 1967 Max Ernst himself attempted to trace this motivation in a brief autobiographical note. The quest emerges as a recurrent theme and he sees its cause in his strict and regulated upbringing by Prussian parents and in a Wilhelminian school. The suppression of sensitivity and imagination which Ernst experienced was to become a continuous trauma affecting him throughout his life – the pictorial novels, particularly *Une Semaine de Bonté* (1934), make this abundantly clear.

"To resist the restrictions of his youth", Max Ernst continues, always talking of himself with ironic detachment in the third person singular, "was associated in his mind with a secret feeling of joy. This feeling was to have decisive importance for his later life: it opened up to him almost limitless possibilities of finding, wherever his destiny and the events of the world might take him, wonderful friends among like-minded people, among devils and angels all free as air. This accounts for the so-called 'many-sidedness' in his work."

Taking to his heels (as an artist, in Paris), he now put his work entirely and exclusively at the service of a developing quest: "A painter may know what he does not want. But woe betide him if he wants to know what he does want! A painter is lost if he finds himself. The fact that he has succeeded in not finding himself is regarded by Max Ernst as his only 'achievement'." This is indeed a thoroughly anti-bourgeois ideal, developing from early oppression and revealing itself again and again in his work.

In 1921, on the occasion of his exhibition in Paris at the invitation of André Breton, the 30-year-old Max Ernst discovered the key to his art: 'Beyond Painting'. He saw the painter, who had never been trained as such,

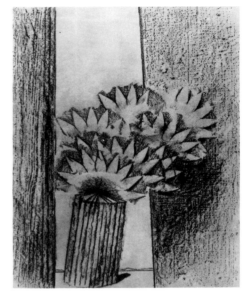

Fig. 2 Max Ernst, *Flowers grow between the walls*, 1925

moving 'beyond painting', which signifies not only the rejection of French *peinture*, but also a turning away from any kind of brushwork. It means going beyond 'art' in the traditional sense. "Hands off holy art," Max Ernst wrote in 1919 on one of his lithographs inspired by Giorgio de Chirico. What could at this point be interpreted as a Dadaistic provocation later on became the solid foundation for his life's work.

The search for painting beyond painting may also have its origin in the fact that Max Ernst, as an intellectual, obviously experienced an overwhelming sense of inhibition when faced with canvas or paper. Nothing could flow directly and immediately from within on to the surface: here the searching and doubting creative artist, there the white surface, in between an almost insurmountable abyss. From this starting point of creative activity developed the "aesthetics of distance" (Werner Spies). The crisis before the first stroke is executed is a permanent one. Inhibition and refusal go hand in hand and both are starting points for an art 'beyond painting'.

For Max Ernst, Dada was a fundamental breakthrough. But even when the Dada spirit had exhausted itself, rebelliousness and protest remained powerful forces in his work. The refusal to 'make art', in the traditional sense, carries over into the refusal to conform to the image society projects on to the artist. In the catalogue for the big Zurich exhibition of Surrealism in 1934 he wrote: "The final superstition, the last sad residue

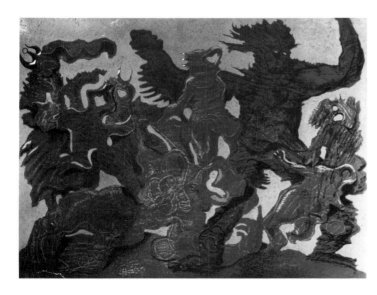

Fig. 1 Max Ernst, *The Horde*, 1927

of the myth of creation to remain in Western culture was the fairy-tale of the creativity of the artist. It was one of the first revolutionary acts of Surrealism to attack this myth in the sharpest manner and with objective weapons." One myth is attacked while another is created: in his autobiography Max Ernst evolves as a self-styled shaman.

Collage, frottage, grattage, décalcomanie – these are not so much categories of style as techniques. And it is these techniques which allow the image to emerge from a mode of hesitation and inhibition. This is how Max Ernst interprets one of his techniques: "Frottage is nothing other than a technical means to heighten the hallucinatory faculties of the mind, so that 'visions' occur automatically. It is a means of shedding one's blindness." Thus, the hallucinatory faculties are assumed to be present, but they need to be intensified and, above all, to grow into image, form and figure. The blindness when facing the blank canvas, the inhibition about painting, would remain unless the artist were

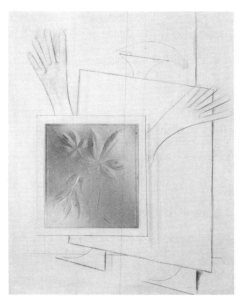

Fig. 3 Max Ernst, *Loplop présente*, 1931

able to develop techniques which set in motion the "mechanism of poetic inspiration" so that the images might become visible.

Contemporary advertisements, educational aids, scientific illustrations – these form the basic material for the collages; illustrations from the late nineteenth century for the wood-engraved montages; natural materials which are rubbed through for the frottages and grattages. All spark off the imagination. Through the intervention and revision of the artist, the picture then comes into being, now revealing shapes and forms but still reflecting the technical process of inspiration and the inhibition about painting which has still not been overcome. It is this open-endedness which puts the observer in the position of being partner to the creative process: his participation alone closes the circle of inspiration.

The process of creation thus described as experimental, and the transparency of the inspirational process, may give the impression that the work itself has no subject matter. But this is not so: the themes in Max Ernst's work become increasingly clear and distinct in the course of the 1920s and even more so in the 1930s and 1940s. Weightlessness and demonic acts of devouring mingle in the *Birds* and the *Brides of the Wind*, the pictures of erotic union tell of the voracious greed for death, the romantic *Forests* are expressive of menace rather than hope. In the *Hordes* and the *Forests* of the late 1920s, themes are introduced which are later developed in the Barbarians series of 1933-35: visionary anticipations of political events in Europe and of the resulting total destruction – premonitions, then, not only of dramatic natural events and phenomena but also of political catastrophes. *Europe after the Rain II* (1940/42; cat. 152) is an aerial view of the devastation of a continent which Max Ernst had depicted in *Europe after the Rain I* (1933) as a ground-level view. The *Angels of the Hearth* are an explicit reaction to the Spanish Civil War.

But during his period of emigration in America Max Ernst's early obsessions were once again summoned up. An important example is *Rhenish Night* (1944; p. 52, fig. 50): here the old technique of frottage is again employed, as is the motif of forest and sun. According to Günter Metken, this work, with the ruin on the left and the gable on the right (Ernst's parents' house in Brühl?) refers to the bombing of Cologne. It appears that the enforced distance from home has led to a more concrete pictorial reflection on the situation in Germany.

The complex, ironic, thoughtful and ambiguous works of Max Ernst first found acceptance in the USA, where he lived from 1941 to 1953 as an American citizen. Very soon after the Second World War he also found recognition in France, where he lived as a French citizen from 1958. In the Federal Republic of Germany, the first larger exhibitions at Brühl (1951), Cologne (1962), Stuttgart (1970) and purchases of his works by museums remained, for a long time, isolated events. In spite of his exceptional importance, Max Ernst remains to this day an outsider in the German art world.

His imagery never became as popular, never entered into the public consciousness to the same extent as that of Dali and Magritte. The reason may be that Max Ernst did not set out to be suggestive. His deliberate dispensation with a recognizable style, the unclassifiable diversity of his work, the constant violation of pictorial conventions, all make demands on the observer which stand in the way of popularity.

'Beyond painting': from a negation of traditional artistic concepts Max Ernst created an art which constantly made visible the paradoxes of creating and negating, at the same time using them as a stimulus. By shifting the emphasis from pictorial result to pictorial procedure, he pushed twentieth-century European art further without disengaging himself from it as completely as Marcel Duchamps did, contributing to it a new area of reflection.

Matthias Eberle

Otto Dix and 'Neue Sachlichkeit'[1]

New Objectivity refers to a style of the fine arts, in particular of painting, photography and design. However, New Objectivity was also the name given to an attitude, a frame of mind, which pervaded Germany after the First World War. Briefly, the difference between the two senses lies in the fact that the style repeatedly reveals that which the state of mind denies. The objective outlook is peculiar to the businessman, the engineer, the surgeon. They can ill afford to make mistakes for, other consequences apart, these cost time and money. In a world where objectivity and smooth running are advocated, the machine seems like a symbol of perfection and robots appear more reliable than human beings. Death and illness are not regarded as part of human destiny, but as risk and accident. It is thought best not to consider them, but rather to repress them. Poverty is not acceptable. Feelings act as a spanner in the works, they interfere. Love is limited to sex, in return for which one either owes or demands a favour. Loneliness is most agreeably alleviated by keeping oneself constantly amused. Now, if the artist sets about painting all of this objectively, soberly and without prejudice, then all the absurd, subjective and uncontrollable elements – which objectivity is attempting to drive out of the front – come in again through the back door.

Fig. 1 Otto Dix, *Self-portrait*, 1926

In the 1920s a Berlin cabaret launched the song, 'There is objectivity in the air', this phrase acting as the refrain. The lyrics went as follows:
"Earlier, those were the days . . ./If a little bird died in its cage the family immediately went into mourning!/Nowadays the times are different. If you come across Mr. Koch,/you ask him most objectively: What, are you still alive?" ("Früher, das warn Zeiten . . ./Starb das Vögelchen im Bauer, trug gleich die Familie Trauer!/Heut ist eine andere Zeit/Triffst zum Beispiel du Herrn Koch,/fragst du ihn voll Sachlichkeit: Was Herr Koch, Sie leben noch?").

The song went on to mention airships, aeroplanes, electricity, the radio, cars and records, all of which left their mark on the era. The triumphant progress of the machine seemed irresistible. The last verse of the song conjured up a concisely worded picture of the time:
"Away with your flourishes, your stucco and your loss!/The facades of houses are being built flat. Tomorrow they will build houses bare, wholly and utterly without facades./We are sick of trifling rubbish. Far too much is superfluous./Get rid of the furniture in the flat. Get rid of anything that does not belong there./We declare without mercy, Every person who happens to be there is in the way." ("Weg mit Schnörkel, Stuck und Schaden!/Glatt baut man die Hausfassaden! Morgen baut man Häuser, bloss, ganz und gar fassadenlos./Krempel sind wir überdrüssig. Viel zu viel ist überflüssig./Fort, die Möbel aus der Wohnung. Fort mit was nicht hingehört./Wir behaupten ohne Schonung, jeder Mensch der da ist, stört.")

The last sentences give voice not only to an ironic criticism of Functionalism and the Bauhaus, but also to a bitter censure of the growing unemployment which, towards the end of the first German Republic, turned six million people on to the streets. In the smooth running of businesses and of machines, man interfered, as did embellishment, emotion – in short, everything which had been valued most highly in the past.

The past represented ornamentation, a sense of emphasis, and exuberance, patriotism and pathos. It represented the German empire and its fervent sense of duty, to which the Expressionists had opposed their fervent sense of freedom; it meant war, many victories, but ultimately defeat. It represented assaults and trench warfare in which everything sank into oblivion. It represented courage, heroism and heavy bombardments which had pounded men into the

mud. It represented zealous idealism, tons of grenades and millions of bullets of every calibre, which had wiped men out. Also belonging to the past was the experience of the opposition between the will of the individual and the war machine, which denied all aspiration. Everything the individual strove for and pursued with supreme effort was proved unavailing by the power of technology and machinery. This experience had clear consequences for artists as well as for businessmen.

This brings us to Otto Dix, one of the leading exponents of New Objectivity. His pictures, smooth and perfect like machine products, are painted in the style of the old masters. He sets his manual skill against the machine technology of his time, and yet simultaneously introduces it into his work. In this way he ensures that he has some room in which to manoeuvre. Photography is the most dangerous rival of figurative painting. Dix surpassed it by making, or rather inventing, photographically accurate pictures. He clothed his vision, his inventiveness in the garb of technical perfection. As he explained in conversation: "Photography can never record more than a moment (and then purely from the outside). It can never create forms which are specific and personal, for this capacity depends on the artistic powers and intuition of the painter. And so a hundred photographs of a person would produce merely a hundred different momentary views, but never the miracle of the totality."[2] With Dix the painter this means no more nor less than that ideas and personal intuition triumph over the perfection and actuality of the photograph – with which he nevertheless has to come to terms.

The development of Dix the painter shows in exemplary form how the style of New Objectivity came into being. Born in 1891 in Gera, the son of working-class parents, he learnt to paint in various styles at the Dresden School of Arts and Crafts. The model provided by the German Renaissance, Cranach and Dürer, alternated with that of Italian Futurism and van Gogh. In spite of their differences these models did have something in common. Nietzsche, whose bust Dix had modelled in 1912, was not only an admirer of the Renaissance but also the prophet of a life which would be full, undivided and complete. Dix read Nietzsche's *Zarathustra* again and again, and even the late landscapes of the 1940s show traces of Nietzsche's influence in their choice of motifs.[3]

Upon the outbreak of war the young painter volunteered for service. He arrived as

a machine-gunner on the western front in 1915. In the intervals between battles he made hundreds of drawings which portray war as a mighty cycle of growth and decay, a release of gigantic, elemental forces. Flowers blossom on burial mounds, lovers are found standing on graves, and the assault troops surge forward out of the trenches for the attack against the enemy. Even in 1918 Dix reported, again voluntarily, for the *Luftwaffe*. His drawings from these years – he had no time for painting – are hard and cruel, but not objective. They could be described as cubo-futuristic Expressionism. Charcoal and black chalk are the preferred medium, and not the sharpened pencil and the pen which he adopted later on. The excitement over what he had seen found its way directly into his style.

Like many others of his generation Dix had entered the war expecting that things would change. The eruption of elemental forces would transform men, the world and society, it would eliminate narrow-minded, bourgeois restrictiveness and make life more genuine, more worth living. For the same reason in 1918 many others supported the revolution. But the war was lost, the revolution did not take place and what remained were narrow, humdrum, bourgeois social conditions, as well as indifference to the fate of those who had tried to alter the daily round. From this state of affairs George Grosz derived his profound dislike for the representatives and hangers-on of the old/new order, whilst Dix began to hate the very thing he had previously admired, as fascinated by it now as he had been then. The object of his hatred was the mighty, grotesque spectacle of human nature seen in all its ramifications, variations and manifestations. From about 1919/20, however, he no longer allows himself to be swept along by the river of life, but on the contrary approaches it from a distance. Now he reaches for the sharp pencil, the pen, the etching needle and the fine brush. The difference can be discerned most clearly if one compares his portrayals of women from before 1914 with those done after 1919. In the early period they are Bacchanalian, ecstatic, well-developed figures, full of desire and fruitfulness, whilst later on they are human wrecks out of whose hollows depravity, self-interest and lechery peep – or in other words the will to live, unbroken now as ever. This is what Dix investigates, only now with a more critical, malicious, and yet at the same time more enthusiastic detachment. What keeps him at a distance is his precise and craftsman-like technique, with which he simultaneously holds his own against the advance of the Machine Age. Dix, the despiser of the Machine Age, himself becomes a machine of precision. He records the unpredictability, the diversity, the horrible violence and the grotesque grandeur of human nature, things which are of no interest to the objectively minded businessman, engineer or

Fig. 2 Otto Dix, *The photographer Hugo Erfurth with Dog*, 1926

surgeon. This is what was meant by the difference between style and state of mind.

As an outlook, as a state of mind, New Objectivity is characteristic of an era. As a style it is the concern of a few individuals. They belonged to the generation born in the 1890s which was still not quite thirty years old by the end of the First World War. They came from different sectors of society, from different schools. They did not found their own school. The painters associated with New Objectivity never formed collective groups. Scattered over the whole of Germany, with centres in Dresden, Berlin, Munich, Karlsruhe and Hanover, they painted pictures of a world to which they did not actually belong. The name of the style did not appear on any syllabus. It was invented around 1925 by critics, observers and museum people, and then attached to the

phenomenon as a label. The distinction between a left and a right camp, between Verists (Dix, Grosz) and Magical Realists (Räderscheidt, Oelze), is more confusing than helpful. From the stream of occurrences the Verists single out just one or two, in order to make manifest in the isolated object those forces which, in their opinion, determine the course of events. They seek first of all to encounter in the object their respective opponent, which they then proceed to unmask, whether it is human nature as with Dix, or capitalism as with George Grosz. The Magical Realists leave the isolated object as it stands, and in so doing testify to the forces they discount: Life, Change, Nature. Their lack of sense of history comes out in their pictures in the sense of suspended time. Past and future are transformed into diaphanous distances, time is incorporated

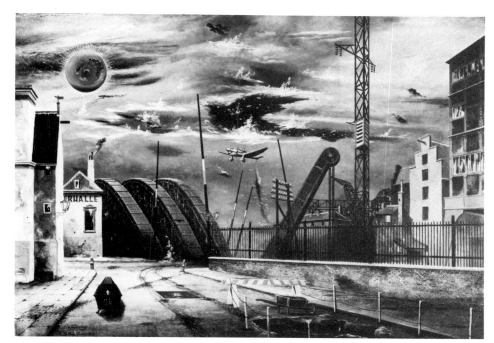

Fig. 3 Franz Radziwill, *The Strike*, 1931

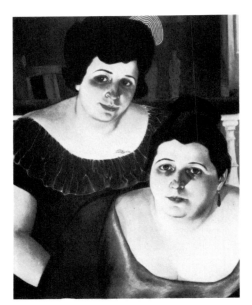

Fig. 4 Christian Schad, *Maria and Annunziata from the Port*, 1923

into space and imprisoned there, and in the reconstructed moment history is cancelled out. Since everyone knows that in reality time cannot be imprisoned, or history obliterated, the lively viewer generates of his own accord the impression that this seemingly stable, lucid order of things, these impeccable spaces, landscapes and streets, are either threatened or else threaten him.

However, this raises the subject of the disintegration of the style. Nature was not to be conquered, not even by Magical Realism, nor was society to be changed by art. A system lacking in movement and flexibility cannot endure. The painters of New Objectivity were at war on two fronts: using a technique

based on the old masters – self-taught in many cases – they fought against Machine Age technology; but in imitating the perfection of the latter they turned against nature. They fought a losing battle. In the late 1920s most of them abandoned their cool, precise style in favour of softer forms. Suddenly mood, feeling and sentimentalism came rushing in. Intense, critical detachment could no longer be universally upheld. Detachment had not proved the best means of reviewing the state of the world. Such means had to be found in form and colour, in the painter's own materials, and New Objectivity could not bring itself to do this. In their opinion, form still had to be subservient to the intellect, to some over-riding idea, and material facts had to be captured with the help of intelligence. But in fact the very opposite happened: rigid form, which required hard work, put a curb on imagination. Looking back, Otto Dix commented as follows on the precise style of the pictures he painted in the 1920s and 1930s: "Once one has started there is no turning back, and mistakes can be corrected only with difficulty. What is more, the fact that so much is pre-ordained means that one's originality is noticeably restricted."[4]

The restriction became so extreme that in the late 1920s there was an explosion which was caused above all by the occurrence of the very problem which it had attempted to contain, namely emotional chaos. The political mass movements took the individual's right to order and control to the limits of the absurd. Even before the National Socialists could thrust aside, drive into exile or destroy these painters, a whole generation of artists had foundered on account of its own contradictions.

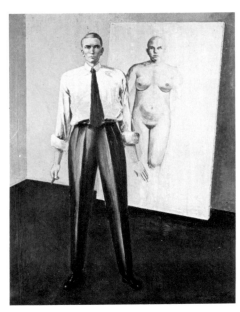

Fig. 5 Anton Räderscheidt, *Self-portrait*, 1928

Notes

1 A number of translations have been attempted for 'Neue Sachlichkeit': New Objectivity, New Sobiety, New Matter-of-Factness, none with satisfactory connotations. Within the context of this essay, the term 'New Objectivity' will be adhered to.

2 Otto Dix, 'Gedanken zum Porträtmalen', *Internationale Bodensee-Zeitschrift*, Amriswil, March 1955, pp. 59-60

3 Dietrich Schubert, *Otto Dix*, Reinbek, 1980; Otto Conzelmann, *Der andere Dix*, Stuttgart, 1983, especially pp. 211-251. Schubert was probably the first to point out clearly the influence of Friedrich Nietzsche on Otto Dix.

4 Maria Wetzel, 'Otto Dix – Ein harter Mann, dieser Maler', *Diplomatischer Kurier*, XIV (Cologne), 18, 1965, pp. 731-45.

Wulf Herzogenrath

Oskar Schlemmer – The Futility of Painting and the Compulsion to Paint

> Despite his talent Marcel Breuer relinquished painting of his own volition (at no mean sacrifice) to become a cabinet maker. I am "filled with inner images." Is that no longer right, no longer permissible? Or should the 'inner image' be transformed into reality? Forsake the idea of 'image' and make tables, boxes, jugs for the sake of a principle, a demand, existential necessity. Existential necessity in the sense that I proffer a favourite glass in order to repair a window... Was art ever as much free play as it is now? So aimless? Art always used to serve an idea, everything was simply a vehicle for the idea.
>
> Oskar Schlemmer,
> Diary, 25 October 1922[1]

From the viewpoint of the 1980s, with a profusion of art lovers around us, it is difficult to conceive that an entire generation of painters was beset with doubts on the purpose, function and 'necessity' of painting and of all art forms. Indeed these doubts were voiced by some of the foremost representatives of that generation. A period of sober stock-taking followed the turbulent upheavals after the First World War, the downfall of the monarchy and hopes of revolutionary rebirth. Nineteen-twenty-two may be seen as a decisive year in this reappraisal. A number of young artists changed direction around this time, disillusioned by unfulfilled hopes of radical change. Marcel Breuer stopped painting to design furniture and buildings. Chris Beekman of the Dutch De Stijl group abandoned his artistic endeavours completely. Max Burchartz terminated his successful Expressionist period, broke with his art dealer as a result, and only continued working in a constructivist manner. The change wrought in Juan Gris and Pablo Picasso introduced a new classicism to Germany which was eagerly adopted and reproduced in *Der Sturm*, *Querschnitt*, and elsewhere. Great public interest was also shown in the first large exhibition of Russian avantgarde art shown in the West. This was held at the Galerie van Diemen in Berlin, during the autumn of 1922. ("The profits are for starving Russia" was boldly printed on the second page of the catalogue.)

The foregoing remarks are intended to set the spirit of the time, the *Zeitgeist* which shaped Oskar Schlemmer as an artist. Schlemmer himself played a part in the creation of this *Zeitgeist* with his incisive contributions to discussion as well as with his works (paintings, sculptures, graphics, murals, and stage sets). Conflict is reflected in

Schlemmer's diaries and letters, and in his wide-ranging interests. The existential questioning of art in a hostile world was more evident in Schlemmer than in almost any other artist. This conflict and doubt explains the ethical, idealistic appeal of his *oeuvre* and its precise presentation of the relationship between individual and community, man and space.

Schlemmer wrote: "It is conceivable that a National Art Warder might prohibit painting for ten years or until the housing problem was solved."[2] Members of the Bauhaus would no doubt have discussed the political conception of art which Piscator was expressing in stage design, Heartfield in graphic art, Grosz and Dix in painting. It is, however, a fact that in the early period at Weimar (before the move to Dessau in 1926) very few Bauhaus students formally allied themselves with what is today termed *engagé* art. Schlemmer in particular did not view this discussion only in terms of the subject and themes of art, or the art form itself. He saw it in terms of the location of the action: that is to say, he entertained justified doubts concerning the value of painting pictures.

"Painting pictures is finished," wrote El Lissitzky in an article in *Kunstblatt* in 1925.[3] Consequently he turned to organizing and designing exhibitions, and to typography

and architecture. In 1924 the Hungarian constructivist Laszlo Peri who was living in Berlin gave up his 'free' artistic work for a four-year period, to work instead on an architectural project in the city planning department.

Schlemmer had arrived at similar conclusions. His pictures from 1922 to 1925 reflect his doubts concerning the validity of the painter's subject forming free art, which becomes a unique collector's item. He produced singularly oppressive interior designs like the *Dancer* or the *Dinner Party*. Does not the light area in the background of the *Quiet Room* (cat. 184) appear as a projector screen, an unfilled space which the people are about to occupy? The picture is clearly structured by the figures. The aligned placement of the figures and the focusing two-dimensional design both enhance and unify the three-dimensional spatiality. The tectonic quality of Schlemmer's pictures and the attraction of his austere spatial interpretation are reflected in a collage which Hans Leistikow designed as the cover illustration for the architectural journal *Das Neue Frankfurt*, 1928. Schlemmer's picture *Roman* is placed beside a curved house façade (fig. 1). Leistikow juxtaposed what many artists of that time saw as a dichotomous choice: it was not possible just to carry on painting while pressing social problems had not yet been solved. However,

Fig. 1 Hans Leistikow: Cover illustration for the architectural journal *Das neue Frankfurt*, 1928: Oskar Schlemmer's picture *Roman* beside a modern house façade.

Schlemmer did not use his political views to justify his eschewal of painting between 1925 and 1928 as overtly as did Lissitzky and Peri.

Of course it is impossible to provide any one explanation for Schlemmer's long rejection or at least eschewal of painting. Other factors must also be taken into account. Schlemmer must have been influenced by discussions about the pre-eminence of architecture. The emerging role of photography would also have played a part, in view of Moholy-Nagy's enthusiastic advocacy. Quite apart from these other factors, Schlemmer had begun a new life as full-time professor at the Dessau Bauhaus and had become increasingly involved in stage classes and lectures on 'Man'.

In 1928 Oskar Schlemmer resumed painting with an enthusiastic vigour which he almost incredulously described as "baroque." In the same year other Weimar artists abandoned their radical positions and returned to painting and a more moderate objective realism. "Honour and praise be to painting. Today has been a day of celebration. Despite everything I remain essentially a painter – all harmonious states of concord, peace, happiness at one with eternity. I am quite simply in my element," wrote Schlemmer.[4]

Two painters from Schlemmer's circle of Berlin friends may serve as a further example. In 1928 Laszlo Peri recognized the futility of his architectural work and began his small genre sculptures. Arthur Segal ended his series of prismatic paintings to which he owed his avant-garde reputation and started to paint apparently conservative *Focal point* still lifes.

This change of direction in some artists around 1928/29 was by no means as pronounced as in the period between 1922 and 1925. It must be interpreted in the context of cultural and socio-political events in the Weimar Republic. Consolidation of the economy at that time and initial right-wing successes perhaps endow such subtle changes in art with new significance. Changes in Kirchner's style and increasing naturalism in that of Otto Dix might be viewed in this light. Political considerations assumed control in 1930: Oskar Schlemmer's murals in the former Bauhaus building at Weimar were over-painted and destroyed by National Socialist cultural representatives. The Right celebrated this act as the inception of "purging the cultural temple." In 1932 the Bauhaus in Dessau was closed down for good and the building was only just prevented from being demolished. The elections con-

firmed the National Socialists at all levels and art professors like Schlemmer lost their posts. Schlemmer saw his stage work defiled in the same way that his murals had been destroyed. Hopes of influencing the public through his presentation of the human ideal were brutally shattered.

What avenue remained open to a sensitive artist who could be more appropriately described as a dancer than an intellectual contestant? He had no choice but to withdraw from public life, particularly as he also had his wife and three children to consider.

"Il professore: I acknowledge: I believe . . . that it is preposterous in this frantic, Philistine age to keep increasing *ad infinitum* the supply of painted canvases. The order of the day calls for performing more urgent tasks. Yet I am still painting."[5]

Notes

1 In: *Oskar Schlemmer – Briefe und Tagebücher*, ed. Tut Schlemmer, Munich, 1958, p. 137
2 Diary, 18 March 1924, *ibid.*, p. 160
3 El Lissitzky, 'USSR – Architectur', *Das Kunstblatt*, 1925, p. 18
4 Letter to Tut, 15 January 1928, cf. note 1, p. 224
5 Oskar Schlemmer, Diary, c. end 1932, cf. note 1, p. 304

Richard Verdi

The Late Klee

Paul Klee is popularly regarded as a painter of fantasy and enchantment whose works are among the most beguiling and poetical in all of modern art. In these Klee appears to stand apart from the mainstream of twentieth-century German art and rarely concerns himself with the social, psychological or political ills and anxieties of his age. Instead, he prefers to re-invent the world in his pictures and to restore to it some of its original magic and mystery in an art of modest size and rare sensibility which is at times deftly comic and, at others, truly cosmic, but which invariably avoids what Klee himself saw as an "excessive concern with personality."[1]

Admirers of this aspect of Klee's achievement may be surprised by the selection of the artist's works exhibited here, all of which date from the last ten years of his career. In their scale, simplicity and solemnity, these pictures inspire awe rather than affection and address the viewer with a power and directness which reveals another side to Klee – one which is intimately linked with the course of the artist's own life during these years and which gave rise to some of the most intensely personal and deeply moving late works by any twentieth-century master.

In 1933 Klee was dismissed from his post as Professor of Painting at the Düsseldorf Academy of Art, a position he had held since his resignation from the Bauhaus two years earlier. Realizing that it would no longer be possible for him to live and work in Germany, Klee returned to his native Berne, where he was to remain for the rest of his life. Two years later, in 1935, he experienced the first signs of the fatal illness (scleroderma) which was increasingly to rob him of his physical powers and which would eventually kill him in June 1940. Haunted by death, and by the collapse of the world about him, Klee embarked upon the most urgent and productive phase of his entire career and created nearly 2,500 works during his last five years.

Characteristic of these works is an uncompromising boldness and monumentality of approach and a new-found gravity of mood, which reveals the deepening insight and humanity of the late Klee. In their choice of subjects, too, these pictures differ from the cosmic and crystalline creations of Klee's youth and early maturity and show instead a decided preference for themes of terror, tragedy or transcendence, which reflect the pain and despair of a man – and a world – on the brink of death. "Is Europe limping or am I?" inquired Klee upon resettling in Berne in 1934.[2] The truth is that both were – arm in arm.

Prefacing the selection of late works exhibited here is the *Prophet* of 1930 (cat. 188), which already seems to anticipate the sterner moods of Klee's final years. Here, through a combination of paste and pigment applied with a palette knife, Klee creates one of a series of soulful heads which abound in his art of the early 1930s.[3] Conceived in the manner of a sculpted bust, Klee's *Prophet* takes on the smooth, appropriate shape of a crystal ball and wears an expression which is at once both anxious and omniscient. Adding to the intensity of the characterization is the turbulent paint surface, which suggests a visage weathered not only by thought but by time itself. Perhaps this explains the prominent omega worn on the chest of Klee's figure. As the last letter of the Greek alphabet, it is appropriate to one destined to have the last word, or even to foretell the end. By the latter reading Klee's figure may be seen as a prophet of doom.

Immediately following the *Prophet* in Klee's own catalogue of works is the stylistically related *Nekropolis* in the Kunstsammlung Nordrhein-Westfalen, Düsseldorf (fig. 1). In this the artist employs thick bands of clotted pigment to create serried rows of tablets and crosses which evoke the weathered remains of a prehistoric burial ground. The whole forms an image of death and decay comparable to Max Ernst's *Entire Cities* of the mid-1930s. Like Klee's *Nekropolis*, these are visions of vanished cultures and civilizations self-evidently intended to mirror the decline of Hitler's Europe – a Europe whose petrified remains would eventually form the subject of Ernst's own *Europe after the Rain II* of 1941-2 (cat. 151).

The remaining pictures by Klee included here date from the last three years of his life and exhibit that greater concentration and consistency of approach which is so striking a feature of his late art. Typically these pictures are built up from a series of fractured and fragmented forms – bars, forks and arcs – which Klee often employs with miraculous economy to evoke a world which is itself broken and disjointed. These forms are usually painted black, which endows them with a sombre and fateful import, and are set against a coloured background which either glows with a fiery intensity or else appears matt and chalky in consistency, creating an impression which is at times truly hellish, and, at others, simply deathly. Often the choice of support, too, can enhance the gravity of the mood, with Klee choosing a wide variety of materials, from newspaper to burlap, to serve his expressive needs during

these years. The effect of these thick black bars embedded in areas of intense colour inevitably calls to mind the leading and luminosity of stained glass, though the runic simplicity of many of Klee's late works more closely evokes the aura and mystery of an ancient hieroglyphic script carved upon an abandoned funeral stele or a sacred old wall. This is especially apparent in examples like *WI (In Memoriam)* of 1938 (cat. 193), where the pasty, bone-white colouring and the sorrowful expression of the figure suggested to Klee himself a graveyard monument.

Scarcely less doom-laden is *Dark Message* of this same year (cat. 190), in which Klee portrays a stricken head falling through the air, its pathway marked by a descending arrow. Further adding to the sinister impression of this work are the agitated paint surface, the ominous storm clouds which gather overhead, and the plainly visible newspaper support on which it is painted. This may be taken to chronicle not simply the storm clouds which gather over Klee's falling figure but the more day-to-day "dark messages" of the year 1938 – the year of the Anschluss and of the cession of the Sudetenland.

In a somewhat lighter vein is the ironically entitled *Quarrellers' Duet*, also of 1938 (cat. 195), in which two coiled and cantankerous figures with keyhole-like bodies appear locked in combat, or at least in dispute. With their boastful poses and bravura gestures Klee's quarrellers call to mind two

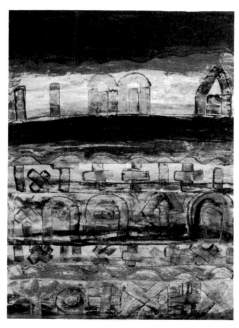

Fig. 1 Paul Klee, *Nekropolis*, 1930

buffo baritones plotting the downfall of an amorous tenor in a heated finale by Rossini. Enhancing the mockingly disputatious tone of the whole is Klee's spiralling and labyrinthine line, which vividly evokes an atmosphere of tension and discord, or of 'duel' as much as of 'duet'.

Among the most hopeful of all Klee's late pictures are those devoted to the broad theme of fecundity, fertility and fruitfulness in nature – a theme which the artist himself regularly compared to his own creative fruitfulness during these years.[4] One such work is *Pomona, overripe (slightly inclined)* of 1938 (cat. 192), which depicts the Roman goddess of fruit trees, whose head and torso here take on the swelling and rounded shapes of ripe fruits. Further references to these appear at the upper edges of the picture, where fruit-laden boughs weigh down upon the figure, creating a dense and oppressive effect. Although the theme of fruit and fruitfulness is normally one of bounty and fulfilment, Klee's image of Pomona strikes a much more discordant note. Set against a scorching red ground, she here reminds us that, in their very different ways, both fruit and fire are portents of the end.

Demonic natural beings of another kind form the subject of Klee's *Forest Witches*, also of 1938 (cat. 195), in which two looming and menacing presences stare out of the picture as though bearing evil tidings, or even a dark threat. With their thick, branching contours and mask-like faces these figures recall the primeval forest demons of German romantic folklore. Adding to the nightmarish intensity of the work is a third face, concealed within the body of the witch at the right – a transposition of the upper and lower parts of the body which is often to be found in late Klee.[5] As so often during these years, too, this startling image grew from more modest beginnings – in this case, from a watercolour in the Klee Foundation, Berne, entitled *Earth Witches* painted earlier the same year (fig. 2). In this the artist depicts two glowering heads hidden beneath a mountainous landscape lit by a pale moon, the whole rendered in a suitably earthy range of brown and reddish hues. When he came to paint *Forest Witches* Klee had only to add legs, breasts, and bodies to these faces to convert them from images of latent terror into beings of blind malevolence.

Equally metamorphic in form, and no less powerful in mood, is the large painting of 1939, *Fama* (cat. 191). Klee himself describes the genesis of this work in a letter to his wife dated 26 May 1939. "If I am not mistaken, this week was quieter. Frau von Sinner was here, Louis Moilliet and yesterday Fritz. Bimbo was nice to him this time. Now Louis had to paint the wall . . . The result of this relative quiet was a picture born to me and christened 'Fama'. I think it is good, rather large. On canvas, taken from the roll of a screen on the door."[6]

Fama depicts a ponderous and prodigious being created out of a sequence of swelling and interlocking curves which, as so often in late Klee, appear to be metamorphosing into even stranger and more alien shapes. Striding across the picture borne on short, red legs, this figure pursues a rolling ball in the manner of a child at play. Apart from her impressive physical stature and her levitating pose nothing in Klee's figure automatically links her with traditional depictions of the winged figure of Fame; and, indeed, the wheel-like ball which she chases is a recognized symbol of Fortune rather than Fame.[7] Gently rolling downhill at the left, it here serves as a poignant reminder of the fickleness of Fortune and of man's subjection to her inconstant ways. Although the Nemesis-like figure of Klee's picture may hold power over the rolling ball, ordinary humanity does not, as is apparent from a drawing Klee made slightly later in this same year entitled *The Wheel Triumphs* (fig. 3). Here an anguished and grimacing figure, who recalls any number of children at play in Klee's late art,[8] suddenly finds herself stopped in her tracks by an innocent child's toy – a rotating wheel – as though already foredoomed to obey its wayward revolutions. The result is one of many images in late Klee which bring together the opposite ends of man's life as though binding them to the predestining power of fate.

In January 1940 Klee wrote to his friend and future biographer Will Grohmann: "Naturally I have not struck the tragic vein without some preparation. Several pictures have pointed the way with their message: The time has come."[9] In the four working months which remained to him Klee continued to pursue this "tragic vein" with unremitting intensity and remarkable productivity. No less than 366 paintings and drawings were entered into his catalogue of works for these four months, and many more left untitled or unfinished in his studio at his death. The majority of these reveal the dying artist's preoccupation with the realms of heaven and hell – of the celestial and the demoniacal – and make it easy to see why one critic was led to characterize all of Klee's late works as "Variations on the theme 'The End – period'."[10]

Among these is *To the Neighbour's House* (cat. 194), which belongs to a group of late paintings of a lattice-like construction in which black bars contain coloured planes in a manner unmistakably reminiscent of stained glass.[11] Like the latter, too, these pictures appear to glow from within with a solemn and steady intensity. Such works ultimately derive from Klee's coloured square compositions of the 1920s and early 1930s and, like them, appear to represent his art at its purest and most irreducible. In *To the Neighbour's House* planes of rich but sombre colour create the forms of two adjacent buildings between which a single, stick-like figure moves. Surrounded by a fiery patch of red similar to that which burns atop of his own house, this figure appears less like a casual visitor than a messenger of fate poised between one realm and the next. No less ominous is the mesh-like construction of Klee's entire picture, which encloses both figure and surroundings in a tight and ensnaring grid, creating a claustrophobic impression familiar in late Klee.

A lattice of a different kind confines Klee's *Captive*, also of 1940 (cat. 196), a picture which recalls the better known *Death and Fire* of the same year in the Klee Foundation, Berne (fig. 4). In both works Klee acts out the last act of the drama in images of harrowing intensity, as though painting his own Requiem. In *Death and Fire* a spectral death's-head balances a motionless ball – the ball of a

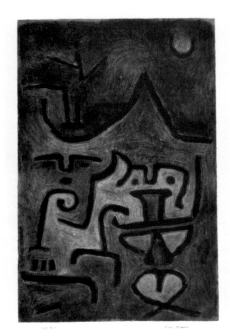

Fig. 2 Paul Klee, *Earth Witches*, 1938

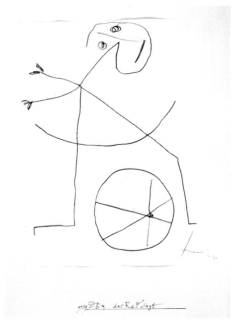

Fig. 3 Paul Klee, *The Wheel Triumphs*, 1939

Fig. 4 Paul Klee, *Death and Fire*, 1940

life which has run its course – while, from behind, an oarsman appears to ferry the deceased across the River Styx. In *Captive* a pained and suffering figure, broken in both body and spirit, stares out of the picture with poignantly misaligned features. Surrounding it on all sides is a menacing black grid, its deathly prongs pressing ever inwards. Adding to the portentous mood of the whole are the predominant hues of this picture. These are pale, otherworldly blues – ghostly, remembered hues – which at once call to mind the realms of the eternal and infernal in

nature; while slowly spreading across the picture is a mist of bone-dust white which appears to encroach upon the forms like an insidious blight. Embedded in the coarse mesh of a ragged burlap support, Klee's *Captive* addresses the viewer with all the authority of some timeless and unalterable law. Simple and powerful, it fittingly concludes the career of a solitary and meditative painter who had himself once claimed to "glow amidst the dead",[12] and who had repeatedly sought refuge from the world about him in the world beyond.

Notes

1 *The Diaries of Paul Klee 1898-1918*, Felix Klee (ed.), Berkeley and Los Angeles, 1964, p. 221, no. 809
2 *Paul Klee, Briefe an die Familie 1893-1940*, Felix Klee (ed.), Cologne, 1979, vol. II, p. 1242
3 Related works in this vein include *Namens Elternspiegel*, 1933, C 17 (Private Collection), *Büste eines Kindes*, 1933, 380 (Kunstmuseum, Berne), *Gelehrter*, 1933, Z 6 (Private Collection), *Trauernd*, 1934, 8 (Kunstmuseum, Berne), and *W-geweihtes Kind*, 1935, K 11 (Albright-Knox Art Gallery, Buffalo). For a selection of drawings on this theme of 1933, see: Jürgen Glaesemer: *Paul Klee, Handzeichnungen II, 1921-1936*, Kunstmuseum, Berne, 1984, pp. 412-19, nos. 672-96.
4 Cf. R. Verdi, *Klee and Nature*, London, 1984, pp. 113-18
5 See, for example, '*Als ich noch jung war*', 1938, 56 (Kunstmuseum, Berne) or *Ein Antlitz auch des Leibes*, 1939, 1119 (Felix Klee, Berne).
6 *Paul Klee, Briefe an die Familie 1893-1940*, vol. II, p. 1291. Frau Maria von Sinner-Borchardt, Louis Moilliet, and Fritz (Lotmar) were friends from Klee's youth. Bimbo was the family cat.
7 Cf. Guy de Tervarent, *Attributs et symboles dans l'art profane, 1450-1600*, Geneva, 1958, pp. 51-2
8 For a well-illustrated introduction to the child theme in Klee's art, see Tilman Osterwold, *Paul Klee, Ein Kind träumt sich*, Stuttgart, 1979
9 Will Grohmann, *Paul Klee*, New York, 1954, p. 92
10 Werner Haftmann, *The Mind and Work of Paul Klee*, London, 1957, p. 205
11 Cf. Jürgen Glaesemer, *Paul Klee, The Colored Works in the Kunstmuseum, Bern*, trans, Renate Franciscono, Berne, 1979, pp. 331-2 (and the examples cited there).
12 *The Diaries of Paul Klee 1898-1918*, p. 308, no. 931

Three further works on the late Klee not mentioned in the notes:

Max Huggler, *Paul Klee. Die Malerei als Blick in den Kosmos*, Frauenfeld/Stuttgart, 1969
London, Arts Council of Great Britain, *Paul Klee, The Last Years, An Exhibition from the collection of his son*, London, 1974
Jürgen Glaesemer, *Paul Klee, Handzeichnungen III, 1937-1940*, Berne, 1979

Peter-Klaus Schuster

The 'Inner Emigration': Art for No One

No one took William Morris's call for art for everyone, for art for the people with more fatal seriousness than Adolf Hitler. If William Morris, the craftsman, poet and social revolutionary, started out from a premise of opposition to the Industrial Revolution and dreamt of a world enhanced for everyone by popular art, it was Hitler who drew the cultural and political consequences of Morris's pious wishful thinking. In the speech he delivered at the opening of the 'Haus der deutschen Kunst' in Munich on 18 July 1937 Hitler set out the programme to be followed by German artists. He said, "The artist does not work for the artist but like everybody else he works for the people. And from now on we shall see to it that it is the people who are called upon to judge his art."[1]

This people's court of judgment on modern art was opened the following day with an exhibition entitled 'Degenerate Art'. The exhibition was held in the old gallery building, directly opposite the 'Haus der deutschen Kunst' in the Munich Hofgarten, and there the people could inspect an art that was presented to it as infantile, deranged, Jewish and Bolshevist. The immense success of this exhibition, which was meant to be a malicious parody of the aesthetics of the Dada school and calculated to terrify the middle classes, is well-known. Well-known too is the unperturbed reaction of the foreign press. Hitler's dislike of the German Moderns was, according to Raymond Mortimer in the *New Statesman and Nation*, "the best thing we've heard from this gentleman so far."[2]

This heinous exhibition settled once and for all the question of easy-come-easy-go liberal principles concerning freedom of opinion in matters relating to art. Inside Germany from this point on no one was free to dislike the Moderns. On 18 July 1937 the State had quite simply abolished them.

Ever since their seizure of power the National Socialists had sought the annihilation or the expatriation of the Moderns from the German cultural scene. As early as April 1933 those artists and art historians who were considered modern had been dismissed from academies and museums. Public collections of modern art were compulsorily closed. After 1937 the works of art in these galleries were either confiscated, sold abroad or destroyed. Confiscation was even considered for modern works in private collections.

The discredited artists were initially forbidden to exhibit their works and later a ban on their painting was introduced. This meant that they were unable to buy canvas or paints of any kind. The artists also had to be prepared for regular visits from the Gestapo and groups of the Hitler Youth. The latter were probably responsible for the destruction of Barlach's atelier.[3]

Faced with this hopeless situation the first exodus of the German Moderns into exile abroad began in 1933. Kandinsky went to Paris, Klee to Switzerland, Schwitters by devious routes to England and he was followed there in 1934 by Gropius. The fact that this exodus led to an extended knowledge of German art abroad is an unintended consequence of the National Socialist strategy of destruction. A second wave of emigration began after the 1937 exhibition. Max Beckmann, who had in 1933 been dismissed from his post as professor at the Academy of Art in Frankfurt, decided to leave for Amsterdam on the very day following the opening of the Munich exhibition. Kokoschka left Prague, where he had been in exile up until this date, and moved to England. A year later (1938) Mies van der Rohe emigrated to the USA. And in that same year Ernst Ludwig Kirchner, who had been living in Switzerland since 1917, reached such a state of depression following the Munich exhibition that he took his own life. Kirchner had declared repeatedly ever since the National Socialists first condemned his paintings that he was just as much a German artist as Albrecht Dürer.

The attempt to counter the accusation of degeneracy led many of the artists and defenders of the modern style who had remained in Germany to make protestations about their German-ness which strike us as odd today. This was particularly true of the Expressionist style. Ever since Paul Fechner's book on the subject had appeared in 1914 Expressionism had been accepted as the natural language of the German spirit. Accordingly, the newly appointed National Socialist directors of the museums in Hamburg and Berlin pushed Expressionists into the centre of their new, 'purified' galleries of contemporary art and strove to give Expressionism the status of art form accepted by the Nazi overlords just as the Italian Fascists were ready to condone Futurism in their country.[4] But this misjudgment concerning Expressionism was short-lived. Emil Nolde's watercolours which Goebbels had borrowed from the Berlin National Gallery for his private apartment roused Hitler's peremptory disapproval.[5] Hitler was also responsible for the fact that in the exhibition 'Degenerate Art' of 1937 Expressionism bore the brunt of the censure. After this exhibition it would seem that no German artist of any standing was prepared to have any truck with the National Socialists.

This integrity, from which the Moderns in Germany derive their moral position to this day, seemed obvious enough for those artists who chose to go into exile abroad. The distance that divided them from the new rulers was a natural consequence of their enforced remoteness from the scene. But things were different for the artists who remained inside the Third Reich. If they were not victims of racial or political persecution or if they were not murdered in concentration camps on account of their Jewish blood or their Communist convictions, they still continued to exist, as Barlach put it, like emigrants in their own country. An aura of melancholy isolation surrounded them. They turned inward, withdrawing typically into a small circle of friends, or retreating from the town to the country, preferably – as was the case with Dix and later Heckel, Ackermann and Schlemmer – to an area near the German-Swiss border. Artistically, they retreated to safe subjects like landscapes, still-lifes and portraits, usually painted on a small scale as painting materials were virtually unavailable for 'degenerate' artists.

In this apparently hopeless situation Käthe Kollwitz displayed an exemplary courage of endurance.[6] In February 1933 she had signed an appeal for all socialists to unite against Hitler and as a result she, together with a

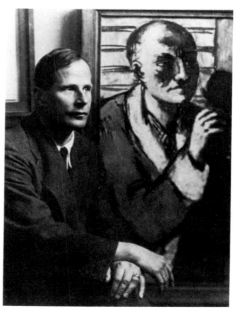

Fig. 1　Günther Franke beside Max Beckmann's *Self-portrait with Sculpture*, 1941. Photograph by Hugo Erfurth, 1942

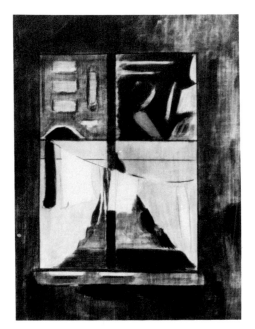

Fig. 2 Oskar Schlemmer, *Living-room with Standing Woman – Window Picture III*, 1942

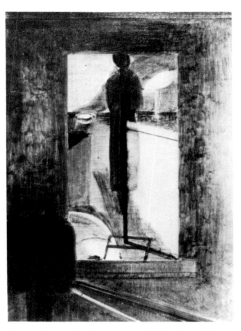

Fig. 3 Oskar Schlemmer, *At the Window – Window Picture IX*, 1942

fellow-signatory, Heinrich Mann, was immediately expelled from the Prussian Academy of Science. She also had to quit forthwith both her studio and her post as teacher of the master class for graphic arts at the Berlin Academy. Her works were removed from exhibitions, but nonetheless she stayed on in Berlin. She declined an offer to restore her to favour with the National Socialists: "I insist on standing by those who have been punished," she said.[7] The numerous messages of congratulation which reached her on her 70th birthday, including some from artists who had pledged themselves to the new régime, became unsolicited expressions of solidarity with a sculptress who, though she had been, as it were, compulsorily 'privatized', remained a public institution. In the fine Expressionism of her late works, for example in the *Pietà* of 1937 (cat. 175) and *Lament* of 1940 (a relief in memory of the death of Ernst Barlach), Käthe Kollwitz returned to traditional Christian art forms and endowed them with a universal human relevance. These works were meant to go against the grain and be read as an indictment of the prevailing spirit of the age. Käthe Kollwitz's courageous insistence on continuing with her work served as a model for many young artists and led to a rich post-war tradition of figurative sculpture, especially in East Germany.

The succour derived by the younger artists from older Expressionists who had stayed on in Germany is demonstrated, too, in the case of Ernst Wilhelm Nay, the youngest among the 'degenerate' artists in the Munich exhibition. The fact that Schmidt-Rottluff bought a picture of his was an immense help both financially and psychologically to Nay who was living totally isolated in Berlin.[8] Nay had subse-

quently been forbidden to exhibit and he had no supportive circle of patrons who could have made his financial position viable. He was also under constant pressure from the Chamber of Culture to change his style. He was dependent on his wife's modest income and he sank into a deep depression. Help came from Carl Georg Heise who, having been dismissed from his post as Director of the Lübeck museum, was living in Berlin as an art critic. He wrote to Edvard Munch and asked him to secure a scholarship for Nay which would enable him to travel to Norway during the summer of 1937. The pictures Nay then painted in Norway he was able to exhibit in Oslo, and from the sale of these works he financed himself for a further journey into Scandinavia away from the prison-house of Germany. Ultimately the decisive improvement in Nay's life came with the War. He travelled as a cartographer with his unit to France and there, under the protection of a fellow soldier interested in art, and with the support of a French sculptor who put his studio, his paints and his canvas at Nay's disposal, he painted those rich, glowing, Arcadian pictures which proclaimed a *joie de vivre* totally negating the events of the war around him. The elements of German Expressionism were now transformed by Nay into a style of painting in which mythical, pagan figures were increasingly subjugated to the power of colour. It was a style of painting that rejoiced in painting for painting's sake.

That this miracle of a re-birth in art for a 'degenerate' artist should occur in occupied France during his military service, indeed that Nay's art should find sponsors in high-placed army personnel such as Ernst Jünger and von Lilienthal, is ample proof that in spite of all National Socialist prohibitions there was both in Germany and in the German army a 'secret society of Moderns'. This society, with its discreet means of communication between its members, consisted, apart from the 'degenerate' artists themselves, of art historians, dealers and collectors who refused to be intimidated. Carl Georg Heise in Berlin, to whom we have already referred, was one of them; Edwin Redslob and Alfred Hentzen, who had been a curator at the Berlin Picture Gallery and was dismissed for disciplinary reasons, were two others, while in Munich there were Ludwig Grote and Günther Franke (fig. 1). In the back-room of his Munich gallery Franke continued to exhibit 'degenerate' art by Beckmann, Barlach, Nolde, Kirchner, Heckel, Nay and other artists, while in the front-rooms he carried on an orthodox trade in German Romantic painters. Franke conveyed by train to Munich the rolled-up paintings he bought from Beckmann in Amsterdam. When air raids destroyed houses and studios Franke transferred to his summer residence in Seeshaupt not only his own collection but also the works of Nay and other artists which he had in storage. Franke was one of the great

patrons of 'degenerate' modern art who had stayed on in Germany.[9]

Kurt Herberts,[10] a paint manufacturer in Wuppertal, played a similar role in the lives of Schlemmer and Baumeister. In 1937 Herberts established a research department in his factory to investigate the production and use of varnishes. This was known as the Döppersberg Institute of Painting Technique. Research there was undertaken by Baumeister and Schlemmer who had been expelled from their professorships in Frankfurt and Berlin as early as 1933. After this date Baumeister earned his living as a commercial artist. Schlemmer executed paintings for public buildings in South Germany while at the same time undertaking the camouflaging of barracks and gasworks. This work at the Döppersberg Institute in Wuppertal enabled both men to continue with their painting in the prohibited style. The atmosphere of secrecy and proscription surrounding 'degenerate' art in Germany at this time is made particularly clear in Schlemmer's series of *Window pictures* dating from 1942 (figs. 2, 3).

These pictures demonstrate how Schlemmer solved the problem of painting within the minimal space available to him. The concentrated window area in a sense represents the paintings of the 'Inner Emigration' in microcosm. The artist appears to us as someone expelled from human society who, every evening from 9 to 9.30 just before the nightly black-out, peers like a secret *voyeur* into the lit-up windows of his neighbour opposite. From this glimpse he creates pictures whose formal austerity is of the kind officially banned. And so this depiction of a neighbourly intimacy via barred windows becomes a portrait of the general social situation of the time. The perpetual threat under which the 'degenerate' artist lived is now

balanced for the first time by a corresponding threat to other members of the community, who are involved in making a judgment on the Moderns.

Baumeister, a long-standing friend of Schlemmer's, also experienced the same kind of intensification of his artistic life during the period of his submerged existence in Wuppertal. The very fact that the hurly-burly of the international art business in which he had been involved (he had still exhibited in Paris in 1937) was now a thing of the past had positive value for Baumeister. "I have no further connection with public events and all obligations to exhibit are over and done with. All things of no consequence have simply disappeared. Thoughts and feelings are purer."[11] Concentration on what is essential characterizes and reinforces Baumeister's art. With his attention now fixed on plant life and on archaic civilizations Baumeister turns away more and more from the area of geometric and rational patterns which the National Socialists had purloined from classical art and devotes himself completely to the unknown world of abstract art. In his article entitled *Das Unbekannte in der Kunst* which he had started in Wuppertal and which he published in 1947 Baumeister writes about this turning inward: "Art has progressed along the path from dependence to independence, from the commission which is given to personal responsibility. The free autonomous artist receives his commission from himself."[12] These words express the opposition adopted by the 'Inner Emigration' to the official art-for-all of the authorities. It is the ideal of an art for no one which derives its mandate and its consummation from within itself and which, for this very reason, is an expression of absolute freedom. The formulas employed up until now to define this 'Inner Emigration' seem in consequence irrelevant: "Resistance and adaptation" or, more pugnaciously, "resistance instead of adaptation."[13] Baumeister's abstract art certainly showed no signs of adaptation but it demonstrated resistance only in so far as it was totally unpolitical and paid no regard to anyone.

The non-representational art which characterizes the main artists of the 'Inner Emigration' such as Baumeister, Nay, Winter, Werner and others became once again after the defeat of Hitler's Germany the art of the future, at least in West Germany. Their awareness that they were the free part of Germany depended in large measure upon the fact that they knew it was in their area of the country that abstract art was permitted. Art in East Germany, it was thought, still had to serve the political needs of the people. In the sphere of the visual arts, in contrast to that of literature, there was no painful argument between the emigrants and the representatives of the 'Inner Emigration' as to whether those who had stayed behind had shown more courage than those who had chosen exile abroad. But ever since the days

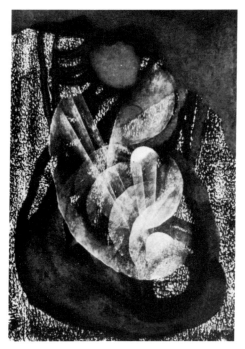

Fig. 4 Fritz Winter, *Formative Powers of the Earth*, 1944

of Hitler's Nazi art a lasting suspicion of all representational art has remained. It is true that the standing of Expressionists like Beckmann and Max Ernst was as high among post-war Moderns as that of the great master, Picasso. But in the dispute with Karl Hofer in 1955 concerning the power of representational art the esoteric exaltation of the representatives of abstract art is clear. What, asked Nay in 1946 (disregarding all social references), has art to do with politics?[14] Abstract art seemed to those who practised it an autonomous creation and something far more valuable precisely because it was a product of the intellect. An art which apparently transcended the events of everyday life, which set its sights on archaic and fundamental forces, on formative powers of the earth (fig. 4), on disembodiment and on spiritual overtones seemed to be born out of the ashes of Nazi Germany as a new art.

This precedence of the spiritual extends as the constant factor in modern German art from Kandinsky right down to Baselitz, with his insistence on seeing things in relative terms and his denial of the objects in his paintings. This yearning for a higher purity and truth in art beyond all triviality, all ugliness and all the political scandals of life is certainly a feature of modern German art which was decisively fostered by the exceptional circumstances of the 'Inner Emigration'. Similarly, the concept of the almost religious function of art as a means of lending a spiritual quality to life and, indeed, of transcending life itself, and the notion of the artist as a chosen member of society, pursuing his lofty *métier* away from the hurlyburly of everday life was the real rock on which the 'Inner Emigration' was founded.

Their art was for no one; their art served art alone – all this makes clear that the art of the 'Inner Emigration' was part and parcel of a very typically German vision of art and the artist. From 1800, from the days of Hölderlin, Runge and Caspar David Friedrich, the artist in Germany has felt himself a privileged expatriate, who sees himself as a stranger in his own land. To this vision Nietzsche added the dimension of the noble élitism of the heroic. German introspection and the 'Inner Emigration' would appear therefore to be two aspects of the same flight from life into higher, deeper areas of spiritual values. In the 'Inner Emigration' the everrecurring German theme is a vision of art and the artist accepting with pride the suffering involved in voluntary or involuntary exile. Art and abstract art in particular are seen to provide a utopian vision of a different world which is truer, better and purer than the tangible world around us. Nothing confirmed this notion more potently than Hitler's exclusion of modern art from his National Socialist state and its withdrawal into the 'Inner Emigration'.

Notes

1 Quoted from Günter Busch, *Entartete Kunst. Geschichte und Moral*, Frankfurt, 1969, p. 22. Ref. William Morris in same volume.
2 *ibid.*, p. 13
3 See Paul Ortwin Rave, *Kunstdiktatur im Dritten Reich*, Hamburg, 1949
4 See Alfred Hentzen, *Die Berliner National-Galerie im Bildersturm*, Cologne/Berlin, 1941, and exhib. cat. *Verfolgt und Verführt: Kunst unterm Hakenkreuz in Hamburg 1933-45*, Hamburger Kunsthalle, 1983, especially p. 50 ff.
5 See exhib. cat. *Kunst in Deutschland 1898-1973*, Hamburger Kunsthalle, 1974, special ref. to 1933
6 See cat. *Widerstand statt Anpassung. Deutsche Kunst im Widerstand gegen den Faschismus 1933-45*, Berlin, 1980, p. 46 f.
7 *ibid.*
8 *E. W. Nay 1902-68. Bilder und Dokumente*, Archiv für Bildende Kunst am Germanischen Nationalmuseum Nuremberg, Munich, 1980, p. 58 ff.
9 See exhib. cat. *Hommage à Günther Franke*, Museum Villa Stuck, Munich, 1983. Special note: contribution by Elisabeth Nay-Scheibler, p. 14 ff.
10 See exhib. cat. *Schlemmer, Baumeister, Krause, Wuppertal 1937-1944*, Von der Heydt-Museum, Wuppertal, 1979
11 *ibid.*: Baumeister to Heinz Rasch, 20 June 1942
12 Willi Baumeister, *Das Unbekannte in der Kunst*, Cologne, 1960, p. 106. This quotation serves as the motto for the catalogue *Abstrakte Maler der Inneren Emigration*, Bonn, 1984. Cf. extended catalogue *Abstrakte Maler der Inneren Emigration*, Landesmuseum Mainz, 1985
13 See exhib. cat. *Widerstand statt Anpassung*, (note 6) and catalogue *Zwischen Widerstand und Anpassung*, Akademie der Künste, Berlin, 1978
14 Nay to Erich Meyer, 25 February 1946, quoted from *E. W. Nay 1902-1968*, p. 89 (see Note 8)

Carla Schulz-Hoffmann

Wols

"He who dreams while he is awake has knowledge of a thousand things which elude him who dreams only in his sleep."[1] Wols frequently quoted this aphorism which, being of general as well as specific significance in terms of its historical context, took on for him the function of a *leitmotiv*. Stimulated by surrealistic thought patterns, in the widest sense, this statement typifies an approach to reality which deliberately breaks away from an attachment to the merely tangible and factual world and instead aims at what may be termed a 'somnambulistic' extension of consciousness.

It would be a mistake to interpret such an attitude as a product of that 'lost generation' to which Wols was posthumously appointed as its leading figure. For the self-destructive process of liberation through the creative act was as much a reaction to the extreme political and social conditions of his time as it was a part of his individual complexities. The notion of the *peintre maudit*, which art critics and art historians see exemplified in Wols, has for him a dimension far exceeding the problems specific to his time. Without deliberately intending it, Wols became the ultimate embodiment of the identity of art and life, an idea which became a central topic in the debates of the avant-garde.

Born in Berlin in 1913 as Alfred Otto Wolfgang Schulze, this exceptionally gifted boy grew up in Dresden in an upper-middle class environment which made every effort to foster his varied musical and intellectual talents and inclinations. At the age of seven, he learned to play the violin and breed rare fish – later bought by the Dresden Zoo – at home in his fish tank. He received a classical education, but in 1931 was unable to take the school-leaving examinations, as he was under age. Fritz Busch, at that time conductor of the Dresden Opera, offered to procure him a position as leader of the orchestra; however, Wols was more keenly interested in photography. Hugo Erfurth saw some of his photographs and considered it unnecessary for him to have further training in this field. Wols's genius was apparent in all he did during his childhood and adolescence, which by conventional criteria were privileged and happy, although the artist gave a starkly contrasting view in the following statement: "At the end of my rather unhappy youth, torn apart, in no way homogeneous, I was helpless in the face of all sorts of problems. I was never particularly well informed about the events affecting me and my environment, in spite of all my efforts in terms of work and observation."[2] This painful awareness of an inner lack of integration marked the life of the artist, even at times when it seemed to be in harmony with what was going on around him. In this sense, the later years were as much a consequence of this lack of 'homogeneity', as he called it, as they were the product of historical conditions.

In 1932, at the age of 19, Wols went to live in Paris, not only to experience the intellectual climate of the metropolis of the arts, but very definitely also to escape from Germany: although never really a political animal, Wols was, so to speak, an existential anti-Fascist and his 'public life' was significantly formed by this attitude. The subsequent stages of his life may be summarized as follows: in 1933 Wols travelled to Barcelona with his future wife Grety; there he refused to respond to his call-up to the German 'labour service'; this resulted in constant problems with the authorities. After a brief episode in Ibiza, during which Wols worked as a photographer and chauffeur and Grety as a seamstress, he spent three months under political arrest in Barcelona and in December 1935 was deported to France without identity papers. In 1937 there followed a period of comparative stability. Wols had an opportunity to work as official photographer at the Paris World Exhibition. In 1939, at the outbreak of war, he was interned. During this period he worked increasingly on drawings and watercolours. But he also began to drink heavily. After his release in 1940 Wols and his wife lived in depressing financial circumstances and in constant fear of the German occupying troops in Cassis and Dieulefit near Montélimar. In 1945, the Paris art dealer René Drouin organized Wols's first exhibition at the recommendation of his poet friend Henri-Pierre Roche. Wols made a last minute attempt to prevent it from taking place. He did not attend its opening but showed the exhibition to his dog, "explaining the pictures to him and reminding him how he, the dog, had helped him, when during the winter he had thawed the frozen Chinese ink with the warmth of his belly."[3] The exhibition did not bring Wols any financial success, but it was to make his name: he attracted the attention of Jean-Paul Sartre, who from then on repeatedly helped him financially, and of Jean Paulhan, Leon-Paul Fargue and Henri Michaux. The last years of the artist's life were marked by extreme hardship and constant see-saw periods of feverish work, illness and many unsuccessful attempts to control his drinking. In 1951, after a period in an institution for alcoholics, Wols died of food poisoning, at the age of 38.

The creative output from this relatively short span of time makes Wols the actual founder of 'non-formal' art as well as of 'poetic abstraction' and 'tachism'. He was probably the most important protagonist of these styles, as for him life and art were congruent: his *oeuvre* is an interpretation of his, by bourgeois standards, chaotic existence. "Wols fashions his drawings as a snail does its house – in a natural and painful process."[4]

Fig. 1 Wols, *The Bottle*, 1943/45

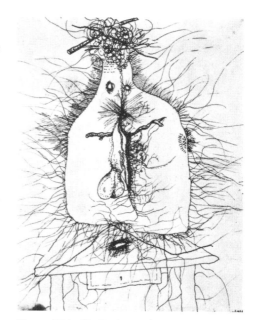

Fig. 2 Wols, *The Bottle*, 1943/45

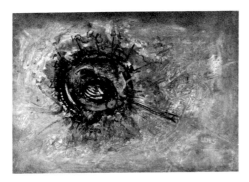

Fig. 3 Wols, *The Eye of God*, about 1949

This beautifully apt comparison, drawn by his friend Roche, describes an essential characteristic of Wols's *oeuvre*, reiterated very frequently by art critics: it is the fact that his art never becomes a separate object but always remains an integral part of his life, to the extent that it can give a more direct and immediate account of it than any real events or facts could. Paintings and drawings become the actual language in which the subjective psychological situation is described. This is not possible through objective representation; the 'non-formal' picture is more precise than any explicitly descriptive form, and this becomes directly apparent when Wols's photographic self-portraits are compared with any of his paintings. The photographs always have something strained, sometimes almost ridiculous, about them. They look as if Wols were embarrassed to meet himself eye to eye in front of the camera, and so he escapes increasingly into a pose and hides behind the mask of a dandy, a small-time crook, or just someone pulling stupid faces.

In the self-portrait with the sticking-plaster, too, there is something artificial and deliberate about the wound: the cross-shaped, clean, white plaster degenerates into a mere ornament. The actual wound does not lie in the realm of visible objects but transcends it: it is more 'existential' than its external form. In contrast, the real self-portraits are the paintings, drawings and water-colours, and to some extent the photographs with their extremely surrealistic structures and close-ups, the repulsive carcasses, garbage and poster fragments.

It may suffice to illustrate these observations with a few examples which also serve to demonstrate the extent to which, in Wols's work, the basically 'non-formal' approach results in quasi-organic formations, or at least formations which could be described in such terms.

The watercolour *The Bottle* (figs. 1 and 2), which originated between 1942 and 1945, achieves an almost devotional effect through the dissolving and blending of the object with its background, the combination of blood and earth colours as well as the 'elevation' of the simple bottle into a protagonist and determining factor of the picture. The bottle becomes an existential symbol, a metaphor both for Wols the artist and the man. In another version of the same theme, the bottle becomes a creature growing and expanding uncontrollably on all sides, containing within itself both vagina and phallus, and thus including and devouring identities of the greatest possible diversity.

The Eye of God (fig. 3) represents the sum of Wols's creative approach. It does not look down on mankind from an 'exalted' vantage point but emerges from within; it is like a whirlpool pulling the observer into the 'inner world'. The centre of being is deep inside the picture, it can be released only gradually, in 'age rings', from the incrustations and dross of human existence. And this is possible only through the constant renewal of wounds, as is directly indicated by the multiple eruptions of blood-red and black. Another characteristic is the oscillation between organic processes of growth – human, vegetable and psychological. Their form of expression is ambiguous, containing a wide range of associations and a wealth of possible transformations from one level of consciousness and reality to another. Thus, in *Peinture*, the suggestion of natural growth (leaf) and of destruction (innards) are contained in equal measure. The proximity of death communicates itself as an existential force, a force not verbally (and thus objectively) communicable but nevertheless 'real' and bound up with growth, life and vitality as indispensable preconditions. Connections have frequently been seen, particularly during the 1950s, between Wols's painting and the nuclear holocaust, resulting in some rather bizarre interpretations. (Compared to the explosive force of a Wols painting, "the terrible 'beauty' of an atomic mushroom seems merely ornamental").[5] But they did at least grasp one side of Wols's work: its unbreakable union of chaos and liberation, in which the act of liberation itself, leading inevitably towards death, is to be understood as a positive value. Seen from this angle, it is clear how Georges Mathieu arrived at his observation: "Après Wols, tout est à refaire . . ."[6] There can be no doubt that after Wols, everything had to begin anew: everything, that is, with regard to a 'non-formal' method of painting which can develop its criteria only from existential necessity, if it is not to sink to the level of superficial ornament.

Notes

1 Werner Haftmann (ed.), *Wols. Aufzeichnungen, Aphorismen, Zeichnungen*, Cologne, 1963, p. 53
2 *Préface*, unpublished manuscript by Wols, quoted from Laszlo Glozer, *Wols, Photograph*, Hanover/Munich, 1978, p. 14
3 Henri-Pierre Roche, 'Einige Notizen über Wols', in exhib. cat. *Wols 1913-1951. Gemälde, Aquarelle, Zeichnungen*, Berlin, 1973, p. 28
4 *ibid.*
5 *Magnum*, XXIV (on the 'documenta '59'), Cologne, 1959, quoted after Glozer, p. 8
6 Georges Mathieu, *Au-delà du Tachisme*, Paris, 1963, p. 35

Siegfried Gohr

Art in the Post-War Period

Essentially there are three different lines of inquiry into the art of the post-war period in the Federal Republic of Germany: one approach consists in finding out how thoroughly German artists familiarized themselves with developments outside Germany during the period of the Third Reich and the last war. The second question to be considered is how work on problems concerning the arts which was interrupted by the Nazi dictatorship was resumed. Thirdly, one needs to ask whether an analogy can be drawn between the split already dividing West and East German art and the hardening attitudes of the two political blocks. Such questions touch on three formative developments which, in the many diverse strata of the first post-war decade, cannot easily be brought together.

Such an investigation has, as its background, a situation which in Germany was different from all other European countries because of the 'Degenerate Art' campaign. Not one of the great artists active in the first half of the twentieth century had returned to Germany. Beckmann had been driven into exile, as had Schwitters, Klee, Feininger, Kandinsky and Kokoschka.[1] Foreign artists who had worked in Germany, for instance with the Bauhaus, had also left, at the latest after the enforced closure of that institution in 1933. The New Bauhaus, which had been re-established in the USA, had given fresh impetus to a great number of young American artists of the post-war period, and the work of Josef Albers deserves a special mention here.

Notwithstanding these losses, a certain continuity remained below the surface of official National Socialist art. A tenuous artistic current continued to use a moderate, if hardly intact, form of lyrical abstraction and figuration. However, it retained only a very few features of modern art. The extreme tendencies of pre-war art were collectively neutralized.[2]

In the 1930s, doubtless regarding it as something of an artistic outpost, a number of German artists made frequent visits to the Villa Romana. The painters and sculptors who went to Italy were mainly those who continued to pursue styles based on antiquity and late impressionism, such as Toni Stadler, Gerhard Marcks, Hermann Blumenthal and Josef Fassbender. For the most part, it was these artists, and those who had remained in Germany, who took over the reconstruction of the art academies and associations after the war. It becomes clear, then, that the above-mentioned continuity of

a moderate form of modern art also became important in the post-war period.

In the early post-war years, older artists like Willi Baumeister and Karl Hofer had become the protagonists of the two mainstream movements, the 'realistic' and the 'abstract'. There was a great deal of fierce argument about style. These discussions, however, stifled others which should have taken place, with the result that, particularly since a considerable amount of political zeal was brought into the debate, the final decision in favour of abstraction was not made on the basis of the 'right' kind of argument. What this decision was meant to prove was that the Germans, now liberated, had overcome the aberration of taste which had occurred during the National Socialist period, and were now in a position to understand and practise modern art. Here one can see the beginning of an involuntary and perhaps even unconscious repression of such questions as how art could react to Germany's catastrophic situation after 1945; how the new art should be linked to Germany's own artistic tradition and history; and what it wanted to achieve beyond simply adopting the latest ideas from abroad.

A further general observation remains to be made about developments in the arts after the First World War. The reaction then had been epoch-making in its seriousness and aesthetic radicalism. After the Second World War the reaction had more to do with content; confined to themes and motifs, with the aforementioned artists it had not raised any fundamental problems of form. The abstract and semi-abstract painters of the

older and interim generations neither came to terms with the reality bequeathed by the war, nor with history. Adorno saw this loss in the following terms: "the invisible relationship of the present to the twenties is conditioned by historical discontinuity . . . The tradition, even the anti-traditional tradition, has been broken off; half-forgotten tasks have been left behind."[3] Although the reception given to early Expressionism, which was perceived as a protest movement against the war, and intended also as a form of restitution to the artists who had been outlawed, did dominate the re-awakening art world, the focus was mainly on matters of exhibition and publication, rather than discussion and analysis. There followed the rehabilitation of Klee and Kandinsky, which meant the recognition of the art of the Bauhaus, and from which arose certain consequences for abstract painters. Absent entirely was the re-acceptance of Dada, which might have been conceivable as a reaction to the war. Thus the climate of the Weimar period was recaptured only selectively, as proof of a worthy tradition rather than as a means of taking over the unresolved problems of that tradition. Attempts to accommodate surrealism in art, which were undertaken by the Galerie Rosen in Berlin, remained generally isolated.

Today it has become manifest that Joseph Beuys was the only artist who unreservedly came to terms with the war. Only at the end of the 1950s did it become apparent that, albeit still in the background, a debate had started in German art about the consequences of the war, as Baselitz and A. R. Penck began to reflect upon their situation in

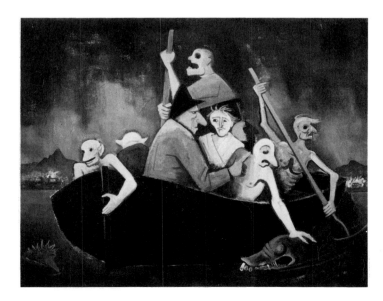

Fig. 1 Karl Hofer,
Descent into Hell, 1947

Fig. 2 Ewald Mataré,
*Abstraction of a
Reclining Cow*, 1946

a divided Germany. These painters re-examined problems of modern art, which made it possible for them to become aware of the conflict in their position between the seemingly successful progress of German art and 'the loss of memory' in respect of German art's pre-war roots. So it was only in about 1960 that serious thought was again given to the opposing viewpoints of the modern art movements in Germany before the Second World War.

Firstly, after 1950, non-representational painting symbolized the new-found feeling of freedom in its demonstrative rejection of the figurative, which had so totally imbued the style practised during the National Socialist period. On the other hand, however, contemporary abstract symbolism seemed fortuitous, since the many steps necessary to reach abstract Expressionism or the non-formal, via Surrealism and Realism, had not been taken for well-known historical reasons. Therefore a legitimising connection was sought, both in non-figurative art before the First World War, and also in the poetry of the German Romantic Movement, which had already shown signs of abstraction. Furthermore, the tendency towards expressiveness as a German characteristic was confirmed by the stylized handling of paint, which was perceived as a subjective act. Then the question was posed as to why the work of 'Cobra', the group of Belgian, Dutch and Danish artists tending towards Expressionism, had not really been able gain any influence; that is, if one disregards the group called 'Spur', whose activity was limited to Munich. The existence of this 'Expressionism', influenced by folk art, and within which Surrealism was taken up and debated, only started to be strongly felt, though claiming other sources, around 1960, in Berlin.

The polarization between unfashionable figurative and fashionable non-figurative movements was actively encouraged, particularly by the older protagonists of the two styles. The debate took place on many levels. Hans Sedlmayr and Wilhelm Hausenstein took a stand against Baumeister, and in 1950 'The First Darmstadt Dialogue' on 'The Human Image in our Time' resulted in a split

vote. Baumeister, against the background of his earlier contact with the French avant-garde, saw himself as the advocate of abstract art, vigorously pleading for the recognition of the non-figurative, while Karl Hofer took the part of the figurative artists. Nearly every large general exhibition gave rise to a quarrel about ideology. The argument, however, could not be resolved, since it rested on humanistic debates about the human image. If one looks closely at the apparently opposing trends, an odd and unexpected harmony becomes apparent, for example between Baumeister and Hofer. After the war, Baumeister returned to a form of abstraction which seemed to have been drawn from the alphabet of a mystical world language. Depicted as murals, as calligraphic images, and as patterns of decorative art taken from other cultures, abstract images once again became representational. The so-called realistic works by Carl Hofer, on the other hand, are really allegories. Scarcely a single scene or figure is substantiated by any narrative structure in the picture. Already abstracted figures stand as if divorced from their background, to which they cannot be related because of their angular outlines (fig. 1).

After the war, both these tendencies had become rather lifeless and lacked credibility. Abstract art never reached that degree of absoluteness, which characterized American art, or the work of Wols, for example; and realism, far from approaching reality, shrouded it in a kind of picturesque allegory. From today's viewpoint both of these polarities are wrong. Neither managed to create an art which was able to break out of its traditonal, one may say affirmative, framework and find new forms of imagery. This art was too easily satisfied with associations and strictures, without exposing itself to the existential search for a symbol. The problems inherited from the 1920s were not recognized and dealt with. The radicalism of certain approaches to handling colour in Expressionism was missing, as was the anti-traditional impetus, coming from Dada and Surrealism, and any radical geometrical abstraction. The extremes became inter-

mingled and blurred, and were no longer visible.

Therefore the following conclusion can be drawn: 'Abstraction' and 'Realism' were not what they were alleged to be; both were rather styles, marked by literary-humanistic trends, which pursued certain ideas, but did not introduce a revival of German art. And therein lies the cause of the weakness of a large proportion of post-war art in Germany.

Public art thus became increasingly standardized and abstract, but outside the mainstream a number of artists continued to work on authentic problems in a surprising and consistent way. In particular, the following names should be mentioned here: the sculptors Hans Uhlmann and Ewald Mataré (fig. 2), the painters Ernst Wilhelm Nay, Werner Heldt, Richard Oelze, Bruno Goller (fig. 3), Werner Gilles and Emil Schumacher (fig. 4), the etcher Otto Coester and the water-colourist Julius Bissier. They had all initiated independent ways towards an artistic solution which did not conform to increasingly entrenched official trends. These artists found it more important to adopt an individual approach than to form groups and adhere to programmes. Most of them, as one would expect, lived fairly secluded and isolated lives, in particular Heldt, Oelze and Goller, Gilles, Coester and Bissier.

The way of life of these remarkable artists can be seen as a symptom of the difficulties encountered by art in post-war Germany. Their alienation and evident exclusion from this newly developing society exposes the change in situation. Asgar Jorn wrote: "I believe that artists are becoming increasingly homeless, vagabonds and wanderers, who are also renewers. They fought hard before

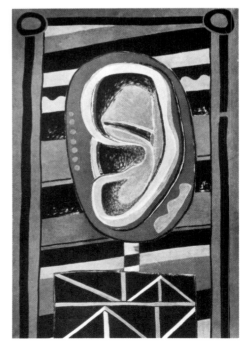

Fig. 3 Bruno Goller, *The Big Ear*, 1956

Fig. 4 Emil Schumacher, *Picture*, 1957

the war, but people then knew their place. After the war everything changed. We don't belong anywhere."[4]

For the artists represented in this exhibition, this new situation meant that, for example, Ernst Wilhelm Nay did not return to Berlin, since his studio had been destroyed. He went to live with friends at Hofheim, in the Taunus. Over the following years and eventually, after 1951, in Cologne, he did achieve the transformation from a late Expressionistic figurative style to pure colour forms. This did not entail an informal and gestural handling of colour, but rather a specific system of colour areas, in which he used colour in a complementary, as well as in a chromatic way. As a result, his system achieved spatial depth by the distribution of colour alone. The emotional content of his earlier figurative paintings was not repressed, but was translated into colour forms. In this way he worked out his Expressionistic legacy, and also resolved the colour/area problem of Kirchner's late works.

Just like Nay, the Berlin sculptor Hans Uhlmann did not yield to the prescribed post-war style. Had he done so, it would have meant the loss of the calculated geometrical severity, and of the inside-out logic, of his sculptures. Uhlmann even added colour to his work, which was unusual, since at that time the sculptor's material was meant to speak for itself, unadorned. Uhlmann, an engineer by profession, had come into contact with Russian constructivism before the war. At that time he began to translate the plastic volume of his work into tension between area and space. His work is significant in that it is not committed to a single constructive theme, but produces unexpected results in the opposition and conjunction of certain forms. At the same time, however, Uhlmann's method of construction is never

formally orientated. As well as a love of nature, there is something enigmatic and demonic in it. The distinguished corpus of drawings by the artist testifies to this (fig. 5).

After the war, Werner Heldt devoted himself wholly to the representation of Berlin, as the place where Germany's catastrophe and the confrontation between the new world powers from the East and the West could be experienced at first hand. In his paintings Heldt developed a system which combined overlapping cubes with a kind of vaulted plasticity. He achieved a synthesis between a universally valid solid structure and an existential experience of symbolism, where objects and colours intensify the sadness and melancholy in his pictures. Heldt had no illusions about Berlin, he saw no freedom for the city, but perceived it as a deserted place. His synopsis of 'Berlin and Sea' and 'Berlin and Still Life' has a certain visionary quality, though without being Surrealistic. After the war, a small group of artists had tried to find room for Surrealism within modern art, with the Galerie Rosen in Berlin as their meeting place. However, the distinguished Surrealist Max Ernst had for decades been absent in France and in the USA. The dominant personality in post-war Germany was Richard Oelze, who lived in Paris from 1933 to 1936, and during his time there had extensive contact with Surrealists. In 1935 Alfred Barr visited his studio and bought two paintings. One of these, *Expectation* (cat. 198), was a premonition, in visual terms, of the coming terror. Oelze remained an outsider in Paris. When he returned to Germany after the war, he settled in Worpswede, where he had lived in the early 1930s. He produced strange visions of landscapes, which engendered mysterious figures and fabulous creatures. In his work Oelze formulated the eerie and sinister events which surrounded him; it does not encourage escape into the realms of fantasy. The almost tangible spaces in his paintings are desolate and

terrifying. Oelze's visual concepts could be described as Surrealism without a narrative. As already perceived in *Expectation*, the causes and generators of horror, destruction and fear are not named, which conjures up terror all the more forcefully.

While certain artists quarrelled about the rightness of various stylistic formulae against the background of the emerging division between East and West, there were a few others who went on working logically, without allowing themselves to be forced into false alternatives. The political background of the arguments, however, came more and more to the fore. After 1953 Realism was considered a culturally backward concept. It was left to the Eastern Bloc, while West Germany, also in a cultural sense, joined the other victorious powers. The avant-garde, which before the war had encompassed a great range of possibilities, was now divided up into spheres and regions. Art, too, had been enlisted into the service of the Cold War.

Notes

1 A few general bibliographical references:
Paul Vogt, *Geschichte der deutschen Malerei im 20. Jahrhundert*, Cologne, 1976
Jutta Held, *Kunst und Kunstpolitik in Deutschland, 1945-49*, Berlin, 1981
Suzanne Page (ed.), *Art Allemagne Aujourd'hui*, Paris, 1981
Jost Hermand, 'Die restaurierte Moderne. Zum Problem des Stilwandels in der bildenden Kunst der Bundesrepublik Deutschland um 1950', in Friedrich Möbius (ed.), *Stil und Gesellschaft*, Dresden, 1984, pp. 270-302
See the article 'Die Überlebenden', *Das Kunstwerk*, 1, 1946, p. 39

2 Fritz Schmalenbach, *Die Malerei der Neuen Sachlichkeit*, Berlin, 1973, p. 52

3 Quoted from Gerhard Knapp, *Theodor W. Adorno*, Berlin, 1980, p. 22

4 Quoted from Jürgen Claus, *Kunst heute*, Hamburg, 1967, p. 39

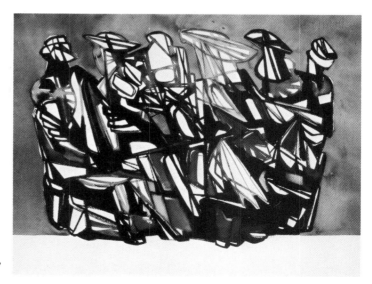

Fig. 5 Hans Uhlmann, *Black-Red*, 1951

Stephan von Wiese

1958-1966: ZERO Group

Considered in retrospect, the ZERO group appears as a league of artists sharing a specific intellectual and spiritual climate, rather than a group committed to a clearly defined formalistic concept. Otto Piene's screen and fire pictures, Mack's reliefs of light, Uecker's nail structures – to mention only a few of the most striking examples – do not entirely share the common denominator of a committed group programme. In 1965, Uecker expressed this as follows: "ZERO has been, from the beginning, an open space in which artists have experimented with various possibilities of giving visionary form to the concepts of purity, beauty and silence. This was perhaps a silent yet at the same time a very loud protest against Expressionism, against a society with an expressive mentality."

To this end, Yves Klein's contribution was of great importance in that it showed the way. His monochrome pictures were first exhibited in the Federal Republic in May/June 1957 by Alfred Schmela, owner of a Düsseldorf gallery. His work demonstrated that the artist is not merely a craftsman, a producer of artefacts, but a generator of limitless ideas. Thus art received new impulses which carried it far beyond its hitherto defined and restricted field, 'liberating' it from the burden of its tradition. Both Mack and Piene received important impulses from Yves Klein, and organized 'evening exhibitions' of the new artistic phenomena in Piene's Düsseldorf studio at Gladbacher Strasse 69. This was the beginning of the ZERO movement. On the occasion of the seventh evening exhibition, 'The Red Picture', in April 1958, the first of three issues

of the periodical *ZERO* was published. Manzoni's visit to Düsseldorf in July 1959 further strengthened the movement. The first German exhibition of Jean Tinguely's work in January 1959, held at Schmela's gallery and including Günther Uecker, had earlier on created the possibility of an international show: the exhibition 'Vision in Motion' in March 1959 at the Hessenhuis in Antwerp showed ZERO for the first time in an international context. A new international artistic language had now been established: Monochromy, as represented at the seventh evening exhibition, 'The Red Picture'; Vibration, the subject of the eighth evening exhibition and of the second issue of *ZERO* in October 1958, and Light. ZERO strove to go beyond a merely subjectivist mode of expression. The monochrome canvas dispensed with any gesture of movement. By the use of white, no preference was given to any particular colour: the totality of its spectrum contains all colours. Structuring a surface with a screen, for instance, allows inherent laws to be experienced which were objectively derived from the realm of natural phenomena. Many works were created with the intention of arriving at an expansion of the 'limited' human conception of reality, and are thus essentially an antithesis to any illusionistic, that is, goal-directed method of presentation, which merely reproduces the 'old' world over and over again. Even an associative or symbolic memory of this world must be eliminated as far as possible.

The first means, then, of obliterating reality, or at least of making it relative, was acquired by the movement in the form of phenomena. Many of the early ZERO works

came close to being experiments in an Op Art brand of psychological awareness: the observer faces a structural field rendered mutable by rotating movable sources of light. In this way he experiences the limitation of all immutable and directed relationships of reality and thus comprehends their relativity: "Our eyes will perceive the world all around us; single-directedness has made us blind" (Uecker).

But the visible world cannot be obliterated just by putting it into motion. The methods of Op Art thus prove to be too limited. Reality could be obliterated only if physical matter, as the grid that our eyes are, were to be transformed into a weightless field of energy. ZERO therefore developed the impulse given by Yves Klein to accomplish an "immaterial" work of art. Again and again, Uecker describes states of weightlessness: "light will enable us to fly . . . ; we shall see the sky from above . . . ; everything will permeate us."

It was light, then, which enabled the ZERO artists to overcome matter and gravity, at least mentally. This manifested itself pictorially in such a way that the substance of the works seems to dissolve. These structures of light and shadow, transposed to the realm of the monumental, extend to works like the *City of Pillars*, described by Uecker as a utopian architectural project. In such a "new realm of life", the human senses would become finely attuned to a new experience of reality.

Finally, though, the "play of light", which had been a vital element to the group for their elaborately worked out "mysticism of light", remained artificial. Therefore, as a further element besides light and movement, there emerged the "state of whiteness". This is a condition of totality: of the most intense brilliance of colours (as the whiteness of light includes the whole spectrum of colours), of the highest purity, and of the utmost spirituality – a condition, then, of hallucinatory insight, which is the goal of meditation and expansion of consciousness.

Having experimented with new spiritual artistic forms from the late 1950s, the 1960s were increasingly characterized by allowing art to 'enter life'. During this period of economic growth, before the following economic crisis, the ZERO artists now aimed at reaching all layers of society. They left their studios and galleries and went out into the streets with demonstrations in the form of happenings. On the occasion of the publication of the third issue of the periodical *ZERO* in July 1961, an exhibition was staged

Fig. 1
ZERO demonstration in Düsseldorf in 1961. Günther Uecker is painting Hunsrückenstrasse white.

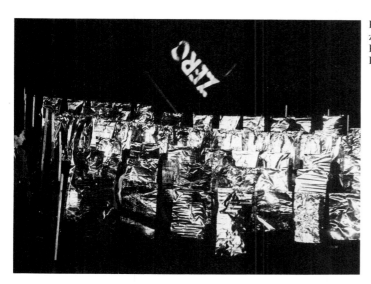

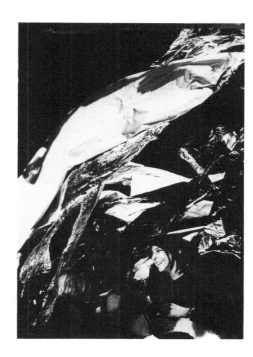

Fig. 2 and 3
ZERO Festival on the
Rheinwiesen in
Düsseldorf, 1962

at the Galerie Schmela, and the first ZERO Festival was celebrated in the Old Town of Düsseldorf. It was truly a celebration of light, with aluminium flags, metal foil, light reliefs, soap bubbles, balloons and spotlights, and there were even a parade and fireworks. Günther Uecker had painted a whole street – Hunsrückenstrasse – white, "in order to create an empty space outside the increasingly hardened mechanisms and principles of order" (fig. 1). In 1962 another ZERO Festival followed, this time on the recreation grounds along the Rhine, the Düsseldorfer Rheinwiesen (figs. 2, 3). These first Düsseldorf happenings brought the avant-garde into direct contact with public

life: artistic consciousness dealt directly with the social environment. The basic visual approach was that the power of the artistic imagination was to transform life.

In 1966 the ZERO group disintegrated, having been exposed to a constant series of new impulses. It had never conceived of itself as being a group of artists committed to one confined programme. The paths of Mack, Piene and Uecker had slowly begun to diverge. While Mack pursued his elevated idealism, using light as a purely spiritual medium, and Piene developed his cosmic utopia, Uecker moved away from the ZERO brand of mysticism to a realistic objectivity, or, in his own words, "Ideas which may

serve as examples for a new environment" (1969): "I have tried to attack certain taboo areas in order to create ever new associations of consciousness. In this way I have boarded up cultural fetishes..." (1970). Thus Uecker was able conceptually to expand the beginnings of ZERO. In contrast, Mack with his Sahara projects and Piene with his laser beam research projects at the Massachusetts Institute of Technology, have been working towards an expansion of the early methods and artistic means of the ZERO group.

Franz Meyer

Joseph Beuys

It is well known that Joseph Beuys has strong links with European pre-history, with the spirit of Romanticism and with *fin de siècle* Symbolism. But what about his relation to contemporary art history? Faced with the enormous and polymorphic body of work the usual art historical sequence which starts with the informal and ends with the trans-avant-garde, fails to apply. In addition, such simplistic notions are totally disqualified by the 'comprehensive conception of art' proclaimed by the artist, with its inclusion of theory, pedagogy and politics in artistic activity. One knows, to be sure, that much in Italian *arte povera* has its origins in Beuys; on the other hand, his artistic position is defined in part by his decisive opposition to the spirit of American art of the 1960s. However, did it not seem to us in 1970 as if Beuys and Minimal Art were just two aspects of the same artistic truth? The relationship appears real, even from the present-day point of view, when one looks back at the hiatus which first emerged in new American painting around 1950. Before that, pictures and sculptures always worked as finite systems; the viewer received messages from them concerning world views and models of identification, relationships of spatial tension or the note struck by specific colours. Jackson Pollock's 'all-over' – which one experiences as a total and self-governing form determined by the artistic process – or Barnett Newman's col-

our fields, whose precise form corresponds to the specific colour's potential for expanding – both involve the viewer in a new way. Abstract Expressionism influenced the sculpture of the 1950s and 1960s mainly by setting a precedent for the use of open form and energy impulses, as seen in the painting of Willem de Kooning and Franz Kline. But of greater importance was the fact that, in the wake of Pollock and Newman (of Mark Rothko too, to some extent), the viewer's relationship to the artistic product was changed. It did of course retain something of its original function. However, the proportion of formulated communication was reduced, and increasingly the artist used the work of art as an instrument with which to induce in the viewer, in the course of his perceiving it or becoming otherwise acquainted with it, a specific awareness of himself and of the world. Faced with the polyhedrons of Robert Morris and Donald Judd, just as with certain conceptual works of art, the viewer is aware of himself as someone involved in the act of perceiving. Moreover, he is confronted – sometimes as a partner in artistic events, but mostly as one engaged in their reconstruction – with decisive structures and courses of action which lead to a new knowledge of his own physical and social existence, and his surroundings.

So much for America. Certainly, if one compares the two, Beuys lacks the puritanical streak, the element of total spiritual unburdening. In addition, the cited models of artistic emulation influenced him hardly at all. What is of much greater consequence is that Beuys (and, afterwards, *arte povera*) also uses the work of art as an instrument for producing direct experiences.

The viewer must make active use of this instrument, and this explains the problems of comprehension and misunderstanding. Without further ado the contemporary public takes its bearings on signs, for example, from within the finite pictorial world of Paul Klee. In the case of Beuys, one is involved in a different kind of perceiving which is carried out in space and time, and this is experienced by the public as an intolerable strain. The structural similarities in the two approaches, which could provide a point of entry, are consequently overlooked.

Suspended Plastic Load → above ← Isolation Stand (fig. 1) may serve as an example. The components, which are evidently coordinated with each other, can be easily described, although one may not immediately come upon an explanation for their relationship. The actual process of observation

commences with a scrutiny of the character of the materials used and their configuration. Hanging down is a heavy length of amorphous, insulating felt material. It is protected by a fine wire mesh, so that this part of the sculpture almost appears to float. One's eye is then drawn to the thin wire connecting the gleaming copper strip attached to the upper part with the heavy sculpture stand below, which distributes weight evenly over the ground. Finally there is a stool, which provides a contrast to the stand and whose splayed legs project towards the floor; the felt bandage on one of the legs demonstrates the need for thermic protection in any contact with the ground. The materials and their configuration serve as plastic equivalents of this transmission, between the two poles of suspension and horizontality. Correspondingly, the connection brought about by the copper, between the spiritual energy contained in the Faraday cage and the 'fixed site' of sculptural realization, could perhaps be interpreted as a model for work on the 'new' sculpture. The stool, which is attuned to the forces of the earth, would then designate the position occupied by the artist. Such an explanation is, however, at the very most just one stage in a never-ending process. The following notes on the content of the works in the exhibition do not, therefore, present final conclusions, but are rather intended as an incentive to further exploration. What really matters are not isolated facts, but rather the

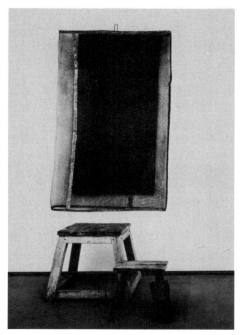

Fig. 1 Joseph Beuys, *Suspended Plastic Load → above ← Isolation Stand*, 1960

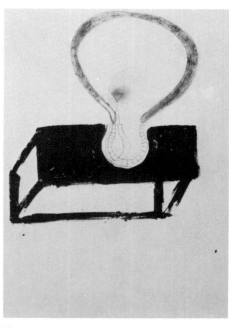

Fig. 2 Joseph Beuys, Drawing for *Suspended Plastic Load → above ← Isolation Stand*, 1960

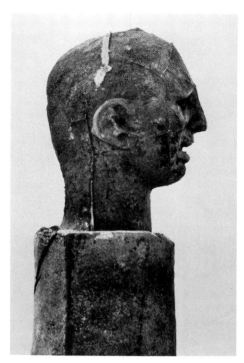

Fig. 3 Joseph Beuys, *Iron Head*, 1961; part of *Tram Stop*, 1976

open-ended process of a continuous mental experience embodied in images. Evidence of such transformation is also found in the treatment of similar themes in various works. Thus, in a related drawing (fig. 2), the "suspended plastic load" is here represented as a bubble protected with felt which has been lowered into the "isolation stand," whilst in the middle of the bubble a little funnel is placed above the electrical terminals.

Such themes of polarity and energy are already to be found in *Pt Co Fe* of 1948 (cat. 239), the earliest work in the exhibition. The four barred iron containers are once again to be understood as Faraday cages conserving energy. In one of them a cobalt-coated platinum bar hangs from a hook – hence the work's title. In 1948 Beuys had attached a small head of Mars at this point, replacing it in 1954 by a plaster head of Napoleon. Both emphasized the expressive significance of 'masculine', 'martial' iron. The next objects to be placed in this same position opposed the expressive world of the cage material: in 1958 it was plaster with organic fat and in 1963 a bar of heat-conducting, 'feminine' copper. Not until 1972 did the elements cobalt and platinum follow, ones belonging to the same group as iron and representing for Beuys a higher level of 'masculine' character.

The next two works, in the conventional sculptural material of bronze, belong to another area of meaning: *Sybilla (Justitia)* of 1957 (cat. 240) and *Mountain King* of 1961 (cat. 242) deal with the relationship between Man and Nature. In the first of these one sees the arms of the scales with their spheres as belonging to the head of the sibyl, which is

placed on a propped-up plate and has the moon and sun for eyes. The prophetess thus represents the principle of justice. Yet this holds true only because it agrees with the balance of forces in Nature, with the harmony of the universe. Accordingly, one recognizes the spheres as celestial bodies on a reciprocally stabilized course.

In *Mountain King* human form corresponds to that of the landscape: the arching bronze represents both the trunk of a figure and a mountain. At the same time the work treats Man's dealings with Nature. The hollow enclosed by the bronze shell stands for the space inside the earth, into which Man penetrates in order to seize materials and energy. The head, which is separated from the rest of the sculpture, was compared by Beuys himself with a compass, a gyroscope or a station clock, in other words with instruments needed by Man to help him find his bearings on the earth. But the head is also reminiscent of a crown, so that Man, who works and has control over the earth, becomes a "king of the mountains."

Also in 1961 Beuys modelled the head (fig. 3) which now emerges from the dragon's jaw of a seventeeth-century cannon in the sculpture *Tram Stop*, completed in 1976. Lying next to this culverin are the cast tops of four mortar bombs, as well as a tramline and various rods. Our perception of the work is dependent on a knowledge of its history, for it unites various times and areas of experience. After 1647, as a governor of Brandenberg in the duchy of Cleves, Johann Moritz von Nassau had tried to provide a physical image of his new philosophical standpoint by his arrangement of the gardens with their radial structure. His views thus became

common knowledge. The sole remaining relic of this scheme is a column which stood originally on an axis point. It consists of a culverin and some mortar bombs, and was formerly topped by a cupid who signified the submission of the warlike spirit. Beuys grew up in Cleves, and as a five-year-old he used to wait by the monument for the tram. From that time on he was fascinated by the relic's symbolic dimension, which survived the passage of time, as well as by the contrast to the modern use of metal – in this case the functional tramline. After making a first attempt in 1954, Beuys succeeded twenty-two years later, in the austere main hall of the German pavilion at the 1976 Venice Biennale, in portraying an experience which was of autobiographical significance in his career as a sculptor. In his reconstruction of the monument he included the head, which betokens the overcoming of war and destructiveness, not in the form of a principle (like the cupid), but rather in the form of readiness for action and for suffering.

A tramline, slightly curved both in ground-plan and elevation, leads from the historical site out into the expanses of the present. A few meters behind the monument Beuys bored a hole down to the waters of the lagoon, which could be brought into motion by use of an angled rod inserted into the hole. The rubble was heaped up behind the monument. This firm anchoring of the work in an actual location meant that, in addition to iron – standing for earth – and the cannon – standing for fire – the water of the deep – the liquid element – could be brought into play.

In the exhibition the immediate effect is different, for the parts are spread out on the

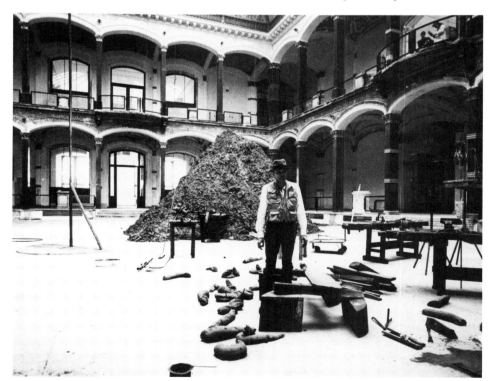

Fig. 4 Joseph Beuys, *Monuments to the Stag*, 1982

ground: *Tram Stop* has now become an arsenal in which one can equip oneself for the reliving of past events. Both the deeds of Johann Moritz von Nassau, as well as the artistic path which Beuys followed from his childhood experiences to the installation in Venice, have now become history, and although in reality they cannot be repeated, by reflecting upon them every age can gain new insights.

Lightning of 1985 (cat. 244) stems from *Monuments to the Stag* (fig. 4), the work which Beuys carried out in 1982 for the 'Zeitgeist' exhibition, held in the vast court-yard of the Martin Gropius building in Berlin. On the diagonal of a rectangle, somewhat displaced from the centre, stood a huge steep cone, just under 5 m high and made from lumps of brownish clay, whose bulk half concealed a narrow work bench at its base. On the same diagonal a group of other work tables, various utensils and sculptural working material could be seen. Nearby was a battery covered in earth, held together by pieces of wood and metal, stone slabs and a walking stick as well as a vertical pole with a sausage which extended above a black and white wooden cross to the level of the second storey. Work implements and objects with particular expressive potential served as working material, and in fact on two occasions Beuys had already exhibited accumulations of these: in 1961 as *Scenes from a Stag Hunt*, using a wooden cupboard divided into ten compartments, and in 1967 as *Barrack D'Dull Odde*, where the objects were displayed on an open rack. Objects and implements embody plastic energy, and so the assembly becomes in a metaphorical sense an 'accumulator'. This is also the case in *Monuments to the Stag* (and in a different way in *Capital*). The stag, which has now featured in two titles, symbolizes for Beuys the supreme life-force to be found in the material world, transforming the latter by its spiritual powers. The clay cone in *Monuments to the Stag* is the most fundamental expression of the material state in which the 'incarnation' should take place. The theme of the new work, *Lightning* – a bronze cast of one sector of the clay cone, from its vertex to its base – is the translation of this elementary substratum into movement. The earthiness, still perceptible in the bronze reproduction, recalls *Mountain King*, with its archetypal image of Man as a being still at one with Nature. On the other hand one experiences

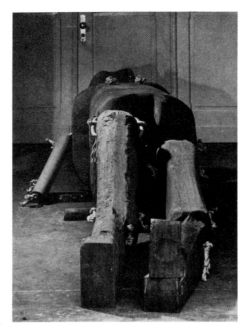

Fig. 5 Joseph Beuys, *Virgin*, 1961

the bronze ribbon darting down from the sky and widening into a broad tongue as a release of energy, as a penetration of cosmic force into the material state. It is an image comprehensible as a "flash of lightning."

Wet Washing Virgin (cat. 243) is the title of the latest work in the exhibition. The huge half-cylinder of a tree trunk suggests the arched torso of a reclining woman. Attached to it are two square-shaped vertical pieces of wood. Their outsides are roughly hewn which makes them seem like the cracked soles of gravel-worn feet, indicating the figure's connection with the earth's interior. *Virgin* was the name of a work created in 1961, the same year as *Mountain King*. A giant figure of a woman, its torso consisted of a square-shaped block and its limbs of round columns, square pillars and simple round pieces of wood. On its original site – a school playground – the parts were held together by ropes (fig. 5), but these were severed by a caretaker who wanted to get rid of the sculpture. Beuys accepted the fact of this destruction of the external form and, since then, has regrouped the blocks and pillars in such a way that their juxtaposition activates the mythical potential still more powerfully (fig. 6). The work of 1985, *Wet Washing Virgin*, unites the effects of both 'states', combining the expressive dimension of the earthy stretched-out figure with the open, sign-like

character of the free-standing blocks reminiscent of prehistoric monuments. The "wet washing" of the title points to another layer of meaning. This was also the name given to a work created for Vienna in 1979. At the time of the controversy surrounding the loan of works from the Ludwig Collection to this city and the choice of the Palais Lichtenstein as the Museum of Modern Art (where *Wet Washing* is now preserved) Beuys produced this representation of washing, the primal domain of women who, for thousands of years, have been removing traces of bodily secretion, blood and everyday dirt. One is inclined to think that the cleansing process which in 1979 related to the world of art, is now intended to make good the damage Man has done to Nature since feminine elemental force has been deprived of its power, though rooted in myth and a direct influence on life.

Ten years ago the use of traditional sculptural materials – wood, stone and bronze – found in Beuys's work up to the early 1960s appeared as a self-contained period in his *œuvre*. It seemed to have been replaced and overcome by the use of more strikingly symbolic materials such as felt, fat and pure metals, by the 'action', with its inclusion of the experiential dimension of time, and finally by theoretical, educational and political work in accordance with an extended notion of art. In works like *Lightning*, *Wet Washing Virgin* and *The End of the 20th Century* (stone; 1983) Beuys has returned to traditional materials. Returns of this kind, each of them completing a circle, are to be found time and again, and on all expressive levels, within the continuum of Beuys's *œuvre*. As in the 1960s and 1970s, a dialogue with the time plays a part in this. Thus one may understand his (by no means exclusive) use of traditional materials at present as a response to the style of the time, as an answer to the trans-avant-garde.

Fig. 6 Joseph Beuys, *Virgin*, details, 1961

Günther Gercken

Figurative Painting after 1960

When the First World War came to an end artists immediately began working with enormous zest. This marked a sharp contrast to the situation at the end of the Second World War. There was a fifteen year gap in creative activity, apart from the continuation of a few life works, and an adherence to the Paris School. At the end of this period of apathy the new generation made a fresh start. This new start not only reflected the break in tradition brought about by the war but also that induced by National Socialist cultural policy. Baselitz spoke of the father-less generation which had to seek out their own models and therefore went back beyond the generation of their fathers.

The beginnings of a new figurative painting made themselves felt around 1960. The figurative expressive painting at the Grieshaber school provided continuity with the pre-war era and was carried on by Horst Antes. There were two breaks with this tradition at the beginning of the sixties. Georg Baselitz and Eugen Schönebeck produced their first and second 'Pandämonium' in 1961 and 1962. The group entitled 'Vision' combined with the Galerie Grossgör-schen 35 in 1964 to form an exhibiting association of 15 artists, including K. H. Hödicke, Bernd Koberling and Markus Lüpertz.

For the first time in the post-war years independent art was developing which was not ashamed of its German origin and rejected international uniformity. Painting was once more recognised as offering the opportunity of formulating, revealing and communicating the specific experiences and sufferings of contemporary life. Some experiences were routine and obvious, particularly in the divided city of Berlin which was of both regional and universal interest. It was, after all, the focal point between East and West. These experiences could now be once again expressed in art. *Saxon Landscapes* (Baselitz), *Shopping Arcades* and *Subway* series (Hödicke) and *German Motifs* (Lüpertz) became acceptable subjects for the artist. Perhaps it was the provinciality as well as the objectivity which was shocking when homage was paid to the world-wide style of abstract art. Would it always be possible for art to grow only out of a particular culture, a specific landscape and a particular character? Even Cézanne's and Munch's art did not exist as an anonymous 'World Art' but was rooted in its origins in the Provence or in Kristiania and attained universal recognition by virtue of its artistic power.

The new art bore the stamp of the German, both in its positive and negative aspects. In its beginnings with Georg Baselitz and Eugen Schönebeck it was melancholic and impassioned, Markus Lüpertz's work displayed emphatic force in the Dithyrambs, and Anselm Kiefer's work was laden with the pathos of historical significance. A common feature was the preoccupation with boundlessness combined with morbid memories and existential fears.

These artists liberated themselves – and thereby liberated their painting – from the dogma of hidebound progression from Impressionism, to Expressionism, to Abstraction. They achieved their freedom by recalling the manifold possibilities of painting independent of these trends. Just as they resistet the temptations of abstraction when they set out on their task, so they did not submit to the pressure of a realistic art. They neither adopted its Western form (Pop Art) nor its variation from the East. They created the foundations for the re-emergence and recognition of a German art which reflected their cultural heritage and spiritual position.

These artists did not fulfil the expectations of the time by being avant-garde. Seen from today, however, the artists who continued with an empty abstract art appear academic, while the young painters appear revolutionary. The art which was initially regarded as regressive proved to be an unexpected and surprising advance, which continues to exert an effect to this day. It led to the reappraisal of traditional art and to the overthrow of the prevailing concept of avant-garde. Art which had become entrenched in academia was supplanted by a new avant-garde following the type of re-evaluation familiar from art history. The break with the 'Modernists', the developing pluralism of style and the propensity for art historical quotations from every age can be construed as symptomatic of post-modern painting.

The slogan Neo-Expressionism cannot be applied to this painting and impedes the essential differentiation of its various origins and influences. The term Expressionism only has precise meaning as a description of style for Post-Impressionist painting, particularly for the German art of 'Die Brücke' and 'Der Blaue Reiter', in the period from 1905 to the beginning of the new movements of the twenties like Dada and Realism. Neo-Expressionism suggests a connection with this art, at best in the revival of the aspirations of Expressionist art or at worst superficial imitation of the outer forms. It thereby not only serves as a demarcation but also as

criticism of an art which is judged to be epigonic and therefore incapable of innovation. Kirchner's creed that painting is a "transcription of the great secret which lies behind all events and objects in the environment" and a presentation "of the spirituality pervading the world, or of feeling"[1] cannot be attributed to any of these painters. They are less illustrative in their art and more realistic in their grasp of reality than their Expressionist forebears.

The art of the 'Neue Wilde' (New Savages – Mühlheimer Freiheit et al.) and the 'Heftige' (Angry Painters – exhibition at the Haus am Waldsee, Berlin, 1980) can be grouped with Neo-Expressionism. This blanket stylistic classification thereby encompasses painters from different generations who have little in common. Initially the artists who had introduced the revolution twenty years earlier were forgotten in the euphoria surrounding Savage Painting.

Even the artists cited here who were born between 1936 and 1945 did not display a common style. Each artist worked in an inimitable style although some of them repudiated the concept of personal style as such. During the sixties Hödicke's painting is bound up with his objective art and his film and video work. Markus Lüpertz deliberately varied the pattern of images in his Style painting by introducing not only alienating close-ups of objects in his decorative, almost abstract paintings, but also sketches by Picasso (*Alice in Wonderland*, 1980/81) or E. W. Nay (*Style Paintings*, 1977). Baselitz's terse assertion: "I work exclusively on inventing new ornaments"[2] links him with the approach adopted by Markus Lüpertz even if the type of ornament is quite different. What is so remarkable about Baselitz's work is that he retains continuity in his idiom despite radical changes in style. Schönebeck's work broke off in 1966 after it had undergone a period of development in parallel with Baselitz. He moved from non-formal beginnings as understood by Fautrier to a poster style depicting socio-revolutionary themes and portraits (*Mayakowski*, 1965, cat. 269; *Siqueiros*, 1966). Penck developed his own sign language as a means of communication. Kiefer's work is dominated by a romantic sense of cultural heritage, expressed in sketches which drew on a wide range of stimuli including psychiatric art at the one extreme and architectural subjects from the all too 'healthy' art of the Third Reich on the other.

Slowly two positions crystallized: the exploration and expansion of the medium of

painting (Baselitz and Lüpertz) and the creation of a visual language to convey particular subjects and themes. These might be historical events (Kiefer), the description of social systems (Immendorff and Penck) or experiences in town and country (Hödicke and Koberling).

At the beginning of the sixties the outsiders Baselitz and Schönebeck consciously developed an affinity with fringe art in protest against non-formal painting. They turned to psychiatric art – Prinzhorn's book provided a source of immense inspiration[3] – and to artists like Hill, Josephson and Wrubel. It is also indicative that Baselitz was attracted not to German Expressionism but to Munch whose work was rooted in the nineteenth century and drew on many sources from the history of European art. Baselitz's interest in Munch is evident in his earliest known works, and it is still evident in pictures from 1983 like *Bridge Choir* and *Edvard's Head*.[4] He admired Munch not for the existential subjects in his psychological painting (Przybyszewski)[5] but for his pictorial inventiveness.[6] This he transposed into his work in his Munch paraphrases *Painter with Sailing Boat (Munch)*, 1982 (cat. 266) and *Painter with Mitten*, 1982, thereby lifting them into prominence.

Baselitz always emphasised the non-objectivity of his paintings and defined the future development of art as the artist's true task. In order to liberate art from the limbo of abstract forms he first introduced the object into his anamorphotic works. After an initial culmination in the great figures of the 'New Type', he, in turn, nullified the image through the picture. The deconstruction of the object in the strip pictures and shred pictures accompanied construction of the image.[7] This dissolution of the object prepared the reversal of motif which took place in 1969. This was no throw-away effect, but was essential for the painter as a means of creating the freedom for artistic values. It provided the detachment from the object and simultaneously made painting accessible to public judgement as well as citing the objects which held his affection.[8] Nevertheless the reversal of motif can also be understood as a symbol which turns painting upside down: Baselitz conceived progress in painting as the destruction of habitual colour and form harmonies. The paintings disturb by their new colour combinations and extreme forms which create an "aggressive disharmony" (Baselitz). Baselitz is willing to brave any risk if this might roll back the frontiers of painting, balancing on a tightrope where success and failure go hand in hand. "B. plays high stakes, so high that to less hardened souls his art appears abhorrently superficial" (Per Kirkeby).[9]

Although pure painting was paramount in his work, the pictures also convey important subjects. The painting *The Shepherd* (1965; cat. 258) carries the impress of the times and of the painter's personal experiences, even

Fig. 1 Georg Baselitz, *The Cross*, 1964

though codified in the traditional guise of mercenary and standard bearer.[10] The pastoral idyll with the peasant, the animals and birds and the breach in the crumbling wall is an image for the destiny and fate of the painter who, leaving his Saxon homeland, comes to the West through the divisive Berlin Wall. With his painting gear on his back he sets out for new climes, namely the realm of painting. This too has to be conquered rather than enjoyed. *The Cross*, 1964, with the first reversal of the motif like a mirror image in the upper part of the picture, describes recollections of Deutschbaselitz (fig. 1). The picture *The Great Friends*, 1965, appears today like a symbol for the younger generation which found its identity in the student revolts of 1968. Two mythical friends, transfigured in a state of immobile suspension and marked by stigmata, rise above the dismasted flag of defeat and the devastated land bequeathed by their fathers. The *Brücke* paintings from 1983 form an interesting contrast with Kirchner's portrayal of 1925, depicting this artists' community as seen by one of their descendants. The formal construction of the painting *Supper in Dresden* (cat. 265) is reminiscent of medieval composition and symbolises the convergence of the group. In contrast, the passionate attitudes and gestures express the powerful tension between the artists which caused the group to fall apart.

Markus Lüpertz came to Berlin in 1963 from the Werkkunstschule in Krefeld. The founding year of the Galerie Grossgoerschen saw the beginning of his work proper with the invention of the Dithyramb. The form of the Dithyramb provided Lüpertz with the freedom to elevate painting beyond objectivity as a hymn unto itself. As in the works of Kiefer, the artist is the hero who diffuses a golden light around the cheerless world. We are reminded of Nietzsche's metaphysical concept of the artist according to which the world may be justified only in aesthetic

terms. Lüpertz's provocative statement, "The Dithyramb I have invented reveals the grace of the twentieth century" might be rephrased as follows: the Dithyramb of Markus Lüpertz is the grace of the twentieth century (fig. 2).

In the beginning the Dithyramb as an abstract form was developed to the point where it seemed objective. Later simple objects were re-interpreted as Dithyrambs (*Tree Trunk – dithyrambic*, 1966). From 1970 Lüpertz cites common objects such as a helmet, a spade, and old symbols like the grape and the ear of corn. In *Black-Red-Gold – dithyrambic*, 1974, with its allusion to the German flag, the image banishes, and triumphs over, relics of Germany's past on which the artist feels he must make a stand. Via the *Babylon* constructions of 1975 Lüpertz moved on to Style painting in 1977, in which areas of colour and decorative lines form pictures without imitating nature and without literature. After the pictures had thus approached abstraction, picture series like *Alice in Wonderland*, 1980/81, and *Expulsion from Paradise or The Archangel Puts His Foot Down*, 1982, with their quotation from art history, appear surprising owing to their new spaciality and objectivity.

"If one plumbs the depths of painting, the images are revealed," wrote K. H. Hödicke for his exhibition 'Berlin and More', 1984.[11] This quotation and the title are characteristic of his work: the analysis of the medium, not illustrative purpose, leads to pictoriality. The pictures relate to Berlin and beyond. Hödicke is a painter through and through who used the experiences gleaned from the Tachism of his mentor Fred Thieler to great effect. He used the intrinsic value of colour and the spontaneous application of colour to create pictures reproducing simultaneously sensual impressions of the city. In the *Shopping Arcades* pictures, 1964, he creates on canvas an equivalent to streets, artificial lighting, shop windows and the speed of passing cars. Reflections of glass façades and cobblestones are reflected in the picture (*Major Reflection*, 1965; *Pavement*, 1975). His paint-

Fig. 2 Markus Lüpertz, *Bunch of Grapes – dithyrambic*, 1971

ing approaches Conceptual and Objective Art in the *Blackboard and Chalk* pictures, 1972. The early cityscapes gave way to a series of neon advertisement studies. Hödicke then extended his range to large-scale landscapes and figure paintings which gain their distinctive quality from his confident mode of expression: *By the Havel*, 1975 (cat. 278), *Reflected Light*, 1976. Experiences from Action Painting and Expressionism fuse. He extends his everyday mythology by including ideas from Feuerbach, Böcklin and Rousseau to form a mythology of mankind (*Medea*, 1981; *Snake Charmer*, 1983). Hödicke refuses to be categorised in one style as this would prevent coming to grips with the fundamental problems of creativity.

Although pictorial reality is also the central concern of Bernd Koberling, his style (continuity rather than diversity) and subject (nature rather than city) differ from those of Hödicke. Areas of colour which produce space and penetrating light are combined to form pictures. These are characterized by the observation and experience of untouched northern landscapes. Their radiance magically submerges the landscapes in romantic transfiguration. In the *Blocklava* paintings (1980/81) daytime atmospheres merge with dreams.

The figure of man is only taken up in nature at a late stage. First he becomes part of the landscape (*Woman within Stone*, 1982/83; cat. 283) then in *Wing Spread* (1983/84) he becomes a bird-like form which dominates the picture. In the *Shore* series, 1984, he forms the picture (cat. 284).

Despite their friendship and common origin, Penck had a different beginning and a different goal to Baselitz. We may deduce from his early drawings, discovered only recently,[12] that he studied Rembrandt and Picasso around 1960. He then developed a conceptual style in which he strove to achieve a universal visual language for expressing social reality and the possibilities of living in mutual harmony. Stance was decisive, first as Ralf Winkler, then as A. R. Penck, Mike Hammer and α. Y. The art emerged of its own accord.

Penck worked on founding a new visual culture to communicate the problems of man's experience of the world and his understanding of the world. His visual apprehension is so highly developed that the thought can become as concrete in the visual sign as in the linguistic sign. In this sign language he fused graphic elements from different cultural epochs, selected from primitive cave paintings to the industrial age. By a process of transformation and simplification they became signals in the *Standart* series. The creation of symbols and the attitude towards these symbols are to Penck a question of survival.

Penck's anti-establishment goal in the *World* series (1961-1965; fig. 3), the *System* series (1965/66; cat. 272), *A Possible System* (1966) and *Standart* series (from 1968;

Fig. 3 A. R. Penck, *Large World Picture*, 1965

cat. 274) was bound to conflict with the reality of East Germany. The messages therefore appear more like the code of an underground movement than a public art. Penck intended to influence society with his art. In 1978, while still residing in the German Democratic Republik, he retrospectively judged this venture to have failed.[13]

His failure to influence a totalitarian system did not affect his aesthetic programme. This he addressed to the equally considerable political and social problems which beset the Western democracies where he now resided. An example is the momentous question he posed in 1984 regarding the fate of both German states (*Quo Vadis Germania*, 1984).

There are certain parallels between his paintings and Immendorff's early works. Although they employ a different visual language, they aimed to bring about social change. First of all a painter devoted to polit-

ical agitation (*Do what there is to do*, 1972; *Cityscapes*, 1973 – fig. 4) Immendorff then turned his attention to recent German history and joined Penck in *Café Deutschland*, 1978 (cat. 294) – an allusion to Guttoso's picture *Caffè Greco*, 1976 – in order to extend his hand over the Wall. Both artists are presented as jointly painting side by side in order to ward off cold, separation and violence. The cosy/stark café provides the setting for the frightening reality of the two German states. So that his pictures may be understood by everyone Immendorff uses techniques of a proletarian style of painting. He developed his early poster work on class struggle into a complex and evocative visual language.

Now that Anselm Kiefer has attained notoriety with his monumental paintings it is often forgotten that his conceptual beginnings lay in his relationship with his teacher Joseph Beuys. Photography and painting

Fig. 4 Jörg Immendorff, *Cityscapes: Hamburg*, 1973

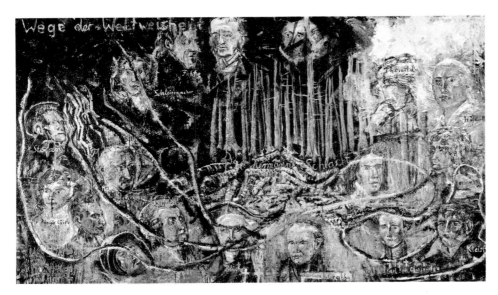

Fig. 5 Anselm Kiefer, *Ways of Worldly Wisdom*, 1976/77

(Heroic Symbols, 1970) in which the artist appears giving the Nazi salute in different landscapes, testify to his consternation and shame at Germany's Nazi past. Kiefer tries to come to terms with the historical legacy by presenting it in a non-historical, subjective manner which aims to touch raw nerves.

To apply the term 'Concept Art' to Kiefer's work would be to obscure the fact that the visual manifestation of the pictures is as important as their basic idea. Kiefer's media include photography, sand, straw and charred wood, and thereby differ from those of the Expressionists. The artist's books establish is an important link between concept and picture.

The unanimous condemnation of Kiefer's exhibition at the 1980 Venice Biennale by the German art critics says more about their own fear of involvement than it says about the paintings. They believed that in Kiefer's images they were looking at history, yet the light from these images is refracted by his insight that the course of history can be perverted by ideology. They thought they perceived an "overdose of Teutonic zeal" when it was in fact they who were introducing the Teutonic spirit. Werner Spies said, "The harvest and heritage are being reaped. This sower spells danger."[14] But Kiefer was not sowing, he was raking over the chaff for all to see.

The series on the *Arminius's Battle* is far less concerned with the beginning of the German Reich than with the vacillating significance it was accorded in different eras. Kiefer juxtaposes the heads of poets, philosophers and generals who were interested in Arminius's Battle.[15] *Ways of Worldly Wisdom,* 1976/77 (fig. 5) parodies the title of a book by the Jesuit Bernhard Jansen[16] in which the history of philosophy is interpreted by Christian Scholasticism as a progressive revelation of the Truth. The great thinkers cited by Kiefer demonstrate the utter absurdity of such a one-dimensional view. Confusion and illumination are closely related. This nation at the centre of Europe has no destiny progressing inexorably from the dark ages to enlightenment and wisdom.

The great heritage of all the poets and thinkers could not prevent this nation from plunging to the depths of barbarism.

The painting entitled *Painting = Burning* (1974; cat. 298) demonstrates the burning of the heritage in the act of painting, just as a cornfield is burnt so that the ashes may nourish the earth and bring forth new life. In his paintings Kiefer erects memorials *(Tomb of the Unknown Painter,* 1983) and pantheons (*To the Unknown Painter,* 1983). The destructive and creative power of the palette and the artist has been elevated beyond all measure. Yet during its short life Kiefer's work has proved that art can change historical interpretation. He lays bare memories which have been erased from consciousness.

Notes

1 Ernst Ludwig Kirchner, Letter to Eberhard Grisebach from 1 Dec. 1917. In: *Maler des Expressionismus im Briefwechsel mit Eberhard Grisebach,* ed. Lothar Grisebach, Hamburg, 1962
2 Walter Grasskamp, 'Gespräche mit den Künstlern', in: *Ursprung und Vision. Neue deutsche Malerei,* ed. Chrustos M. Joachimides, Berlin, 1984
3 Hans Prinzhorn, *Bildnerei der Geisteskranken,* Berlin/Heidelberg, 1922
4 Günter Gercken, 'Keime des Zukünftigen. Baselitz und Munch', in *Edvard Munch. Höhepunkte des malerischen Werks im 20. Jahrhundert,* Kunstverein, Hamburg, 1984/85
5 "Such landscapes are simply correlatives for emotional values. Just as the raw unmelodious interjection music of a 'Savage' is no more than an absolute correlative of his affects." Stanislaw Przybyszewski, *Das Werk des Edvard Munch,* Berlin, 1894
6 "Munch's pictures essentially consist of such primary elements as the circle in the branches of a tree which then becomes an eye. It always consists of these same elements which he really painted quite independently of any natural model." Georg Baselitz, 'Erfundene Bilder. Georg Baselitz über Edvard Munch', in *Edvard Munch. Sein Werk in Schweizer Sammlungen,* Kunstmuseum, Basle, 1985
7 Rafael Jablonka, *Ruins. Strategies of Destruction in the Fracture Painting of Georg Baselitz 1966-69,* London, 1982
8 "Some motifs are very important, in which a particular love is expressed which is nevertheless very personal." Georg Baselitz in conversation with Evelyn Weiss, in *Georg Baselitz. XIII. Bienal de São Paulo,* 1975
9 Per Kirkeby, 'B.', in *Georg Baselitz,* Kunstverein, Brunswick, 1981, p. 133
10 Günther Gercken, *Georg Baselitz. Ein neuer Typ. Bilder 1965/66,* Galerie Neuendorf, Hamburg, 1973
11 K. H. Hödicke, *Berlin & Mehr,* Kunstverein, Hamburg, 1984
12 Ralf Winkler (A. R. Penck), *99 Zeichnungen 1956-1964,* Zurich, 1985
13 A. R. Penck, 'Auf Penck zurückblickend (1978)', in *A. R. Penck – Y. Zeichnungen bis 1975,* Kunstmuseum, Basle, 1978
14 Werner Spies, 'Überdosis an Teutschem', *Frankfurter Allgemeine Zeitung,* 2. 6. 1980
15 Günther Gercken, 'Holz-(schnitt)-wege', in *Anselm Kiefer,* Groningen Museum, Groningen, 1980/81
16 Bernhard Jansen, *Wege der Weltweisheit,* Freiburg im Breisgau, 1924

Appendix

Biographies of the Artists

compiled by Walter Grasskamp

Ernst Barlach

was born at Wedel, near Hamburg, on 2 January 1870 and grew up at Schönberg and Ratzeburg. After attending secondary school he studied at the Hamburg School of Arts and Crafts from 1888 to 1891, and then at the Dresden Academy of Art, under Robert Diez, from 1891 to 1895. After leaving the Academy he devoted himself largely to literary work and also wrote a textbook on figure drawing. After two visits to Paris he worked in Hamburg, Berlin and Wedel, producing drawings, ceramics and large-scale sculptures, before taking up a post at a school of ceramics in the Westerwald, for which he was recommended by Peter Behrens and which he held from 1904 to 1905. In 1906 he visited his brother Hans in Kharkov; this "journey across the steppes" subsequently became a theme in his writings (*Russisches Tagebuch*) and also in his drawings and the 'beggar figures' in porcelain, terracotta and bronze which he produced in 1907. He now began work on his first drama, *Der tote Tag*. He joined the Berlin Secession and concluded a contract with the art-dealer Paul Cassirer, which carried a fixed annual salary. After a period in Florence in 1909 he withdrew to Güstrow, where he lived with his mother and his son, of whom he had gained custody after a two-year legal battle with the boy's mother, one of his models. Karl Ernst Osthaus tried unsuccessfully to persuade him to move to Hagen. By 1915, when he was called up for war service, Barlach had produced lithographs based on his drama *Der tote Tag*, his second drama *Der arme Vetter*, and the

wooden sculpture *The Madman* (1910). Through the intervention of Liebermann and Slevogt he was discharged from the infantry after two months' service. In 1917 he had his first important exhibition at Cassirer's gallery, where twenty wooden sculptures and graphic works were shown.

After the war Barlach turned down offers of teaching posts at the academies in Dresden and Berlin, and by the beginning of the twenties he had written three more dramas, *Die echten*

Sedemunds, *Der Findling* and *Die Sündflut*. In the course of the twenties, while continuing his literary work (*Der Blaue Boll*), he produced mainly woodcuts, monuments and sculptures. In 1930 his 60th birthday was marked by a retrospective at the Prussian Academy of Arts. At the peak of his success, however, he became a target of Fascist art criticism, and on 30 January 1933, in protest against the forced resignation of Käthe Kollwitz and Heinrich Mann from the Prussian Academy of Arts, he gave a radio talk entitled "Artists Now". His monuments and public sculptures were confiscated and destroyed. Only his ambivalent relations with his assistant Bernhard Böhmer, who had come to an arrangement with the new rulers, saved him from the personal consequences of Fascist machinations. He died of a heart attack on 24 October 1938.

Artist's Writings:

Ein selbsterzähltes Leben, Berlin, 1928
Die Dramen, Munich, 1956
Die Prosa, Munich, 1958/9
Güstrower Tagebuch 1914-1917, Munich, 1984

Major catalogues:

Ernst Barlach (3 vols.), Altes Museum, Berlin, 1981
Ernst Barlach – Das Graphische Werk, Hamburg, 1960
Ernst Barlach – Das Plastische Werk, Hamburg, 1960
Ernst Barlach – Werkkatalog der Zeichnungen, Hamburg, 1971

Georg Baselitz

was born at Deutschbaselitz in Saxony on 23 January 1938. He attended primary and secondary schools there until 1950, when his family moved to Kamenz. On leaving the grammar school he entered the East Berlin Academy of Fine and Applied Arts, where he was taught by Walter Womacka, but after his initial training he was expelled on grounds of "socio-political immaturity". From 1957 he studied under the abstract painter Hann Trier at the Academy of Fine Arts in West Berlin, where he was now living. Dissatisfied with both the 'Socialist Realism' of the East and the Tachism currently fashionable in the West, he arrived largely by himself at a definition of his own artistic position. At first he tended to go in for figurative paintings which indicate an attempt to come to terms with Tachism in composition and choice of colour: *G-Head*, 1960; *P.D.Feet*, 1963. However, with pictures like *The Great Piss-up* 1962/63, *The Hand*, 1963, or *Oberon*, 1964, and above all the programmatic picture *The Great Friends*, 1965, a broad and unmistakable spectrum of crude figurative painting begins to evolve, which is carried on into the 'hero' pictures of 1966. Two manifestos published in 1961 and 1962 (*Pandämonische Manifeste*) define his artistic and literary position, which finds expression in the 'poet' pictures; these were painted in 1965 while he was on a scholarship at the Villa Romana in Florence.

Meanwhile Baselitz and his family had moved to Osthofen, near Worms. Up until 1969 his pictures remain figurative, though characterized by an entirely new mode of composition. There are now gaps, shifts and fractures in the motifs, their com-

ponent parts being dispersed across the canvas in a seemingly arbitrary fashion. This reveals an aim which Baselitz has been pursuing since 1969 with the upside-down position of his motifs – that of reducing the narrative implications of the motifs while not altogether eliminating them. Since this date – in what seems like a delayed attempt to resolve the contradictions he had been faced with as a young painter trained in both East and West Germany – his painting seems poised between the figurative and the abstract, each work exploring a fresh balance between the two, a new tightrope along a private venturing through art history. To the many and varied interpretations prompted by his handling of motifs he responds in purely technical terms by saying that his mode of painting has enabled him to adopt an independent artistic stance and saved him from unwelcome associations and interpretations which have nothing to do with painting. Another formula he employs to characterize his elusive painting is "ornament in a climate of disharmony". Since 1980 he has widened the scope of his activities to include sculpture as well as painting and graphics.

In 1977 he became professor at the Karlsruhe Academy of Fine Arts, and in 1983 he began teaching at the Art College in West Berlin. Since 1975 he has lived at Derneburg, near Hildesheim.

Artist's Writings:

Georg Baselitz, *Warum das Bild 'Die großen Freunde' ein gutes Bild ist, Manifest und Plakat*, Berlin, 1966
Georg Baselitz/Eugen Schönebeck, '1. Pandämonium' and '2. Pandämonium', *Die Schastrommel*, VI, Berlin/Bolzano, 1972
'Vier Wände und Oberlicht. Oder besser, kein Bild an der Wand', *Kunstform International*, XXXIV/4, 1979

Major Catalogue:

Georg Baselitz, Kunstverein, Brunswick, 1981 (with bibliographical references, lists of exhibitions and a com-

prehensive collection of texts about Baselitz together with an interview with Johannes Gachnang and reprint of the manifestos and other publications by Baselitz)

Catalogues raisonnés:

Fred Jahn, *Georg Baselitz, Peinture-Graveur*, vol. 1: *Werkverzeichnis der Druckgraphik 1963-1974*, in collaboration with Johannes Gachnang, Berne/Berlin, 1983; vol. 2 for the period
1975-1983 in preparation
Siegfried Gohr (ed.), *Georg Baselitz, Druckgraphik 1963-1983*, Munich, 1984
Georg Baselitz, Zeichnungen 1958-1983, Kunstmuseum, Basle, and Stedelijk van Abbe Museum, Eindhoven, 1984
Baselitz, Sculptures, Bordeaux, 1983
Georg Baselitz, Holzplastiken, Cologne, 1983
Baselitz, Paintings 1960-1983, Whitechapel Art Gallery, London, 1983

Recent Publications:

Rafael Jablonka, *Ruins – Strategies of Destruction in the Fracture Paintings of Georg Baselitz 1966-1969*, London, 1982

Willi Baumeister

was born on 22 January 1889 into a family of Stuttgart craftsmen. After serving an apprenticeship as an interior decorator from 1905 to 1907 and spending a year in the army in 1908, he began his studies at the Stuttgart Academy, where he joined Adolf Hölzel's class (of which Oskar Schlemmer and Otto Meyer-Amden were also members) and was admitted to his master class. After living in Paris in 1911 and at Amden in Switzerland in 1912, he was called up for military service in 1914 and served until 1918. Whereas during his student years he had been largely influenced by Neo-Impressionism and a preoccupation with Cézanne, in 1919 he entered upon the first independent phase of his work. The *Wall Pictures* of 1919 to 1923 incorporate Constructivist elements with a relief-like application of a mixture of sand and putty, thus establishing a link between painting and architecture. Towards the mid-twenties his work became more figurative, as in the *Machine Pictures* and *Sport Pictures*. This won him great acclaim in Paris, where he got to know Léger, Le Corbusier and Ozenfant. Important exhibitions in Germany were followed in 1927 by his first French exhibition at the Galerie d'Art Contemporain. Though by now a successful and respected artist, Baumeister, who also worked as a typographer, made common cause with Schwitters, Vordemberge-Gildewart, Tschichold and Domela in 1927 to form the 'ring neuer werbegestalter' ('circle of new commercial designers') and when he was offered a professorship at the Städel School it was as a professor of typography. In 1930 he joined the 'Cercle et Carré' and in 1931 'Abstraction-Création', which

reflected his move towards abandoning figurative elements in his paintings in favour of abstraction. At this period his lifelong interest in ancient pictorial imagery, especially that of the Middle East and Africa, was already relevant to his own imagery.

In 1933 he was deprived of his Frankfurt professorship by the Nazis and retired to Stuttgart, where he supported himself and his family by working as a typographer and was able to organize exhibitions abroad – in Milan in 1935 and in Paris in 1939 to mark his fiftieth birthday. Four of his works were shown in the exhibition 'Degenerate Art' in 1937, and in 1941 he was banned from exhibiting his work. With his friend Schlemmer he became a prominent figure of the 'Inner Emigration'. From 1938 onwards pictures like *Ideogramme* and *Eidosbilder* demonstrate his growing interest in archaic picture formulae and Asiatic calligraphy. The relief pictures which he produced from 1942 signal, even in their titles, the exotic and archaic references deriving from Baumeister's precise study of this field, especially as he envisaged the possibility that they would invest abstract imagery with an anthropological character of a kind which had been postulated, though in a highly subjective way, by Kandinsky. Like Schlemmer, Baumeister was protected and supported during the war by commissions from the lacquer manufacturer Herberts of Wuppertal, and before the war ended he was already working on his book *On the Unknown in Art*, which was first published in 1947. This book was highly esteemed in the postwar years as an apologia for abstract art, taking its place beside Kandinsky's *Concerning the Spiritual in Art*. Its impact coincided with that of another study which was also begun during the war, Hans Sedlmayr's *Verlust der Mitte*, which propagated a critical approach to modern art. The Darmstadt Conversation of 1950, one of the last great art debates to take place in West Germany, brought the two opponents face to face. The speech which Baumeister made on this occasion was included in later editions of his book. It is a curious instance of conservative avant-gardism. From 1946 until his death in 1955 Baumeister was professor at the Stuttgart Academy. His late work retains the familiar archaic features, which now merge into an informal, almost light-hearted choice of forms and colours.

Artist's Writings:

Willi Baumeister, *Das Unbekannte in der Kunst* [Stuttgart, 1947], Cologne, 1968

Catalogues:

Willi Baumeister 1945-1955, Württembergischer Kunstverein, Stuttgart, 1979
Willi Baumeister Zeichnungen und Gouachen, Kunsthalle Tübingen, 1975

Monograph:

Will Grohmann, *Willi Baumeister – Leben und Werk*, Cologne, 1963

Max Beckmann

was born on 12 February 1884 in Leipzig, where his father, a Brunswick estate agent and flour merchant, carried out chemical experiments. From 1892 to 1894 he lived with his sister at Falkenberg in Pomerania, returning to Brunswick with his mother after his father's death in 1894. Here he attended various schools, leaving without any qualifications, and began to draw. Having been rejected at the Dresden Academy in 1899, he was admitted to the Weimar School of Art in 1900 and attended the nature class conducted by the Norwe-

gian Frithjof Smith, whose method of preparing the canvas with charcoal Beckmann later retained. In 1903 he left for Paris, where he lived until 1904 and was impressed by the painting of Cézanne. After his first known self-portrait of 1897 he developed an abiding interest in coastal landscapes and sea-pieces, which he began to paint in 1904 while staying by the sea. Before taking up a scholarship at the Villa Romana in Florence in 1906 he married the painter Minna Tube, who eventually became a singer. The couple later lived in Berlin with their son Peter. Beckmann was prominently represented in exhibitions at home and abroad, and had his first retrospective exhibition at Paul Cassirer's gallery in Berlin in 1913. The ground was now laid for an artistic career full of controversy, which erupted in the dispute with Franz Marc (in the journal *Pan*, 1912), in the attack on

abstract and "over-artistic" art and in the leading part he played in the withdrawal of numerous artists from the 'Berlin Secession' in 1913, followed by the founding of the 'Free Secession' in 1914.

Beckmann volunteered for service as a medical orderly in the First World War, but though he had at first been a fearless advocate of the War, his experience at the front led to a nervous breakdown. He was finally sent on leave to Frankfurt, where he remained from 1915. Work on his unfinished painting *Resurrection*, 1916-1918, marked a turning point in his development, of which striking evidence is afforded by a series of lithographs, *Hell*, 1919, and paintings such as *The Night*, 1918/19. He moved away from the impasto of his pre-war work to an even application of colour, which nevertheless modelled volume and still to a large extent lacked the strong black contours typical of his later work. A displaced, extremely foreshortened perspective, often producing a disturbing effect, characterizes his interiors and townscapes, which, together with still lifes, portraits, masquerades and circus scenarios, supply the dominant subjects of this period. By the age of 35 Beckmann had become a highly individual artist who could not be clearly assigned to either Expressionism or New Objectivity and whose pictures became ever more enigmatic and esoteric, especially the triptychs which dominate his late, post-1932 period.

In 1919 he declined an invitation to become the director of the nature class at the Weimar School of Art (later the Bauhaus). In 1925 he took over a master studio at the Städel School of Arts and

Crafts in Frankfurt, being appointed to a chair in 1929. From 1929 to 1932 Beckmann always lived in Paris from September to May. Like his colleagues Willi Baumeister, Richard Scheibe and Jakob Nußbaum he was dismissed from his post by the Nazis on 31 March 1933. In 1937 some ten of his paintings and as many drawings were included in the exhibition 'Degenerate Art' in Munich, and a day after hearing Hitler's speech at the opening of the 'Haus der Deutschen Kunst', on 19 July 1937, he and his second wife Mathilde, known as Quappi, left Germany and settled in Amsterdam.

After the war he turned down invitations to teach in Munich, Darmstadt and Berlin, but in 1947 he accepted one from Washington University Art School to take over Philip Guston's chair during the latter's absence. From September 1949 he taught at the Art School of the Brooklyn Museum in New York, where he died on 27 December 1950 on his way to the Metropolitan Museum to see his *Self-portrait in Blue Jacket*, which he had painted that year.

Apart from his oil paintings, his work includes watercolours and drawings, as well as lithographs, etchings and woodcuts, and a total of eight bronze sculptures from the mid-thirties and 1950. A large number of writings, including two dramatic works, complete the artistic profile of Beckmann, who himself was an avid reader, much influenced by Nietzsche and above all Schopenhauer as well as by a great variety of other texts of an esoteric and mystical character.

Artist's Writings:

Max Beckmann, *Briefe im Kriege* [Berlin, 1918], collected by Minna Tube, Munich, 1984
'Schöpferische Konfession', *Tribüne der Kunst und Zeit. Eine Schriftensammlung*, Kasimir Edschmid (ed.), vol. XIII., Berlin, 1920
On My Painting, New York, Buchholz Gallery, 1941
Letters to a Woman Painter, *College Art Journal*, IX, 1949
Tagebücher 1940–1950 [Munich, 1955], Munich, 1984
Speech given upon conferral of Honorary Doctorate by Washington University, 6 June, 1950, English typescript, Washington University, Archives
Leben in Berlin, Tagebücher 1908/03, 1912/13, Hans Kinkel (ed.), Munich, [1966], 1983

Major catalogue:

Carla Schulz-Hoffmann and Judith C. Weiss (eds.), *Max Beckmann Retrospective*, Munich, 1984, German and English versions (contains documentation on life and works by Doris Schmidt, a bibliography of the artist's writings, exhibition catalogues and monographs)

Catalogues raisonnés:

Erhard and Barbara Göpel, *Max Beckmann, Katalog der Gemälde* (2 vols), Berne, 1976
Stephan von Wiese, *Max Beckmanns zeichnerisches Werk 1903–1925*, Düsseldorf, 1978
Max Beckmann, Aquarelle und Zeichnungen 1903–1950, exhibition catalogue, Kunsthalle Bielefeld, 1977
Klaus Gallwitz (ed.), *Verzeichnis der Druckgrafik Max Beckmanns* (in preparation)
Klaus Gallwitz, *Max Beckmann. Die Druckgrafik, Radierungen, Lithographien, Holzschnitte*, Karlsruhe, 1962

Recent Publications:

Matthias Eberle, *Die Nacht – Passion ohne Erlösung*, Frankfurt, 1984
Hans Belting, *Max Beckmann – Die Tradition als Problem in der Kunst der Moderne*, Berlin, 1984

Joseph Beuys

was born in Krefeld on 12 May 1921, the son of a corn and animal feed merchant, and had a strict Catholic upbringing. In the year of his birth his family moved to Rindern, near Cleves, and from 1931 Joseph attended the Hindenburg-Oberschule in Cleves, where his first exhibition of drawings and watercolours was held. At this time he was more interested in science than in the humanities

which dominated the curriculum. His experience in the Hitler Youth was strongly coloured by a political march to Nuremberg and a book-burning ceremony in the playground of his school. His reading at this time included German classical authors, Norse myths, and history. Photographs of Lehmbruck sculptures gave him his first real feeling for sculpture, and he visited the sculptor Achilles Moortgart in his studio. Stationed at Poznan and Erfurt during his war service, he became a radio operator and was later trained as a dive-bomber pilot at Königsgrätz. In 1943 he crashed in the Crimea and sustained heavy injuries. In 1944 he was again in action in northern Holland and on the North Sea coast. Having been taken prisoner by the British, he returned to Cleves on his release in 1945. In 1946 he joined the local League of

Artists, and it was in this year that his friendship with Hans and Franz van der Grinten began. In 1947 he began studying at the State Academy of Art in Düsseldorf, first under Josef Enseling (until 1949), then under Ewald Mataré (until 1954). In 1953 he had his first one-man exhibition at the Haus van der Grinten and at the von-der-Heydt-Museum in Wuppertal. In 1954 he took a studio in Düsseldorf-Heerdt, where he worked on minor commissions and collaborated with Mataré on some of his projects. In 1955 and 1956 he was laid low by a grave personal crisis which was due in no small measure to his wartime experiences and injuries and the difficulty he had in coming to terms with them, and until 1957 he worked on the van der Grinten farm. In 1958 he began work on a memorial to soldiers who fell in the Second World War. In 1959 he married Eva Wurmbach. In 1961 he was appointed to the chair of monumental sculpture at the Düsseldorf Academy of Arts. After Fluxus events in Copenhagen, London and Wiesbaden, he arranged for the first Fluxus concert to take place at the Düsseldorf Academy in 1963. In the next few years he took part in Fluxus events in Aachen, Wuppertal, Copenhagen, Berlin and Düsseldorf, and at 'Documenta 3' in 1964 he exhibited sculptures and drawings.

November 1965 saw *irgend ein strang*, Beuys's first exhibition in a commercial gallery (Schmela, Düsseldorf), and in 1967 his exhibition at the Kunstmuseum, Mönchengladbach, was acquired by the Ströher Collection. In the same year he

founded the German Students' Party, the first of the organizations with which he sought to counter the domination of West German democracy by the political parties and the bureaucrats: the 'Organisation der Nichtwähler, Freie Volksabstimmung' (Organization of Non-voters, Free Plebiscite), 1970; the 'Organisation für direkte Demokratie durch Volksabstimmung' (Organization for Direct Democracy by Plebiscite), 1971; the 'Freie Internationale Hochschule für Kreativität und interdisziplinäre Forschung' (Free International University for Creativity and Interdisciplinary Research), 1973. As early as 1968 his political activities outside the rules of the game earned him the first expression of distrust from his colleagues at the Academy, who accused him of "arrogance, dabbling in politics and having an undesirable influence on the students", and in 1972 he was dismissed from his post for having admitted to his class all the student applicants who had failed to get through the Academy's admission procedure (142 students in 1971).

In subsequent years he stepped up his public speaking activity and was a guest, together with the 'Freie Hochschule', at 'documenta 6' in 1977, having already run an office for the 'Organisation für direkte Demokratie' at 'documenta 5' in 1972. In 1978 he was offered the chair of Design at the Hochschule für angewandte Künste (College of Applied Arts) in Vienna, but turned the offer down in 1979. In the same year he was a candidate for the European Parliament, and in 1980 he stood in the elections to the Landtag of North Rhine-Westphalia as a candidate for the ecology party, the Greens, in whose occupation of the legal department of West German Radio he participated in order to protest about the disadvantages suffered by alternative groups in the news reporting of the media. In 1982 he met and spoke with the Dalai Lama in Paris. Coinciding with the Berlin *Zeitgeist* exhibition, in which he had the whole Lichthalle at his disposal, was his sponsorship of an occupied house in connection with the Berlin "fight for housing".

Artist's Writings:

'All men are artists', *Museumsjournal*, XIV/6, 1969
'The Pack', *Louisiana Revy*, X/3, 1970
'Iphigenie-Materialien zur Aktio', *Interfunktionen*, IV, 1970
'Action' (with T. Fox), *Interfunktionen*, VI, 1971
'Der Erfinder der Dampfmaschine', *Interfunktionen*, IX, Cologne, 1972

Monographs:

Caroline Tisdall, *Joseph Beuys*, New York, 1979
Götz Adriani, Winfried Konnertz and Karin Thomas, *Joseph Beuys – Leben und Werk*, Cologne, 1981

Recent publication:

Franz-Joachim Verspohl, *Joseph Beuys. Das Kapital Raum 1970-77. Strategien zur Reaktivierung der Sinne*, Frankfurt, 1984

Lovis Corinth

was born at Tapiau in East Prussia on 21 July 1858, the son of a tanner. On leaving the grammar school in Königsberg in 1873, he went on to study painting, first in Königsberg (from 1876 to 1880), then in Munich (from 1880 to 1882), and finally in Antwerp and Paris (from 1884 to 1886). Though resistant to the cloying academic style of his last teacher, Adolphe William Bouguereau, he was relatively unaffected by his encounter with Impressionism, being at that time an admirer of the naturalistic painting of Wilhelm Leibl, a pupil of Courbet. After living in Berlin in 1887 and 1888 he returned to Königsberg, where he stayed until he moved to Munich in 1891. In the years which fol-

lowed his work consisted of portraits and figure compositions, *plein-air* painting and slaughter-house scenes, in all of which his painting appears at first somewhat lacking in stylistic incisiveness.

In 1896 he painted his *Self-portrait with Skeleton*. Encounters with Max Liebermann and Walter Leistikow in Berlin reinforced his resolve to move from Munich to Berlin, where he was a member of the organization committee of the Secession and was soon in demand as a portrait-painter. In 1903 he married Charlotte Berend, the first female pupil at his painting school. In the first decade of the new century his palette became brighter, and his painting, hitherto somewhat academic at times, began to employ the freer brush work characteristic of German Impressionism, which was represented by Liebermann, Slevogt and himself. At the height of his fame as a painter of portraits and still lifes, though even at fifty still copying the old masters (Rembrandt, Velazquez, Frans Hals), he suffered a stroke from which he never made a complete physical recovery. Though his left side was paralyzed, he began to paint again in 1912 while convalescing on the Riviera. In the years that followed he made numerous journeys to Italy, France and Switzerland for his health, until in 1919 he settled down with his wife and two children by the Walchensee. It was here, as he struggled against increasing debility, which had now begun to affect his right side, that he painted his late pictures. The expressive elements discernible in his early work now come to dominate his paintings (*Walchensee landscapes*), and the extreme pastosity of the colour makes him into an eleventh-hour convert to modern art. In the year of his death he painted the pale and impressive *Ecce Homo*. He died on 17 July 1925 on a visit to Holland, where he had gone to see pictures by Rembrandt and Frans Hals. His late works were condemned by the Nazis as 'degenerate'.

Artist's Writings:

Lovis Corinth, *Das Leben Walter Leistikows – Ein Stück Berliner Kulturgeschichte*, Berlin, 1910
Über deutsche Malerei, Leipzig, 1914
Gesammelte Schriften, Berlin, 1920
Von Corinth über Corinth, Leipzig, 1921
Selbstbiographie, Leipzig, 1926

Major Catalogue:

Lovis Corinth 1858-1925. Gemälde und Druckgraphik, Lenbachhaus, Munich, 1975 (with detailed biography)

Catalogue raisonné:

Charlotte Berend-Corinth, *Die Gemälde von Lovis Corinth*, Munich, 1958

Recent Publication:

Georg Bussmann, *Lovis Corinth – Carmencita*. Malerei auf der Kante, Frankfurt, 1985

Otto Dix

was born into a working class family at Gera, Thuringia, on 2 December 1891. After serving an apprenticeship as a painter and decorator between 1905 and 1909, he was awarded a scholarship by the Prince of Reuss to attend the Dresden School of Arts and Crafts, where he studied until 1914. In autumn 1914 he volunteered for war service and served first in the field artillery and then as a machine-gunner in France and Russia, with the rank of corporal and acting sergeant. Towards the end of the war he applied for training in the air force. His first reading of Nietzsche made a decisive impression on him, and the war left him neither a militarist nor a pacifist. His experience of the war, like Beckmann's, was probably determined by the realist's hunger for reality, though unlike Beckmann, Kirchner or Grosz he was able to endure the experience of extreme fear without losing his composure. The theme of war, which played a dominant part in his work right up to the forties, was for him an occasion for the depiction of man's suffering, not for political agitation. As a consequence he turned to the paintings of the Middle Ages and the Renaissance to find not only models of craftsmanship, but also an imagery which could give valid expression to the modern experience of war. After trying out and rejecting Cubist, Futurist und Expressionist models during the war, he went on in the twenties – and continued until the forties – to cultivate a meticulous use of glazing in the manner of the old masters, with frequent recourse to the pictorial formulas of pre-modern painting. His vision, while not precluding political alliances, was essentially unpolitical, though this did not prevent his being victimized by the Nazis and seeing his public recognition and career brought to an end by dismissal, arrest and defamation. (He had been a professor in Dresden since 1927.) His picture *The Trench*, 1923, became a central icon in the Nazis' campaign against 'degenerate art'.

After being released from arrest Dix withdrew to southern Germany, where he painted landscapes and political allegories: *Jewish Cemetery at Randegg in the Snow*, 1935; *Triumph of Death*, 1934/35; *Flanders*, 1934/36. Despite the danger of his situation, of which his temporary arrest on suspicion of being implicated in an attempt on Hitler's life in 1939 is further proof, he remained in Germany, with only the meagre protection afforded

him by his friendship with Franz Lenk, a professor at the Berlin Academy with whom he had exhibited Hegau landscapes in Berlin until 1935. In 1945, at the age of 54, he was called up to serve in the militia and taken prisoner in Alsace: *Self-portrait as Prisoner of War*, 1947. In the last years of the war he gave up the use of glazes in favour of an expressive *alla prima* painting. His use of the Passion of Christ as a theme testifies to his continuing tendency to employ traditional formulas to encapsulate modern experiences: *Crucifixion of Christ*, 1946. After the war Dix received many honours and invitations to exhibit in both East and West Germany, and he also taught as a part-time professor in both Dresden and Düsseldorf. He died at Singen on 25 July 1969.

Major Catalogues:

Otto Conzelmann, *Otto Dix, Handzeichnungen*, Hanover, 1968
Florian Karsch, *Otto Dix, Das graphische Werk*, Hanover, 1970
Fritz Löffler, *Otto Dix, Werkverzeichnis der Gemälde*, Recklinghausen, 1981

Monograph:

Fritz Löffler, *Otto Dix – Leben und Werk*, 4th ed., Dresden, 1977 (with extensive biographical and bibliographical information)

Max Ernst

was born at Brühl, near Cologne, on 2 April 1891. His father was a teacher of deaf and dumb children and a talented amateur painter. From 1898 to 1910 Max attended first the elementary school, then the grammar school in Brühl, and then studied at the university in Bonn until 1914. In addition to seminars on classical and modern literature, philosophy and the history of art, he attended classes on law and criminal psychology. His interest in psychology and psychiatry led to his becoming acquainted with the collection of pictures and sculptures produced by patients in the university's psychiatric clinic. Long before Hans Prinzhorn had published his book on *Bildnerei der Geisteskranken* Ernst was already incorporating into his work the impressions made on him by this first encounter with the artistic productions of the mentally ill, and he later found this artistic leaning confirmed by the interest which Prinzhorn's book aroused in other artists, especially Surrealists. Having met August Macke in 1911, he exhibited with the Rhenish Expressionists in Bonn in 1913 and made the acquaintance of Guillaume Apollinaire, Robert Delaunay and Hans Arp, and paid his first visit to Paris in 1913.

On 24 August 1914 he and his brother Carl volunteered for war service. After training in the field artillery he was sent to the western front in January 1915. In 1917 he was posted to the 36th East Prussian Regiment and in 1918 promoted to the rank of lieutenant. During the war Ernst exhibited at the *Sturm* Gallery in Berlin (1915), becoming acquainted with George Grosz and Wieland Herzfelde, and before the end of the war he visited James Ensor in Ostende. As a leading figure in the Dadaist scene in post-war Cologne he collaborated with Johannes Theodor Baargeld, Otto Freundlich and others on publications and exhibitions, visiting Paul Klee in Munich in 1919 and being visited in Cologne by Hans Arp and Kurt Schwitters the following year. After lively contacts with Paul and Gala Eluard and André Breton, he moved to Paris in 1922, where he rented his first studio in 1924 after returning from a voyage to South-East Asia. His collages had begun to appear in 1919 and were elaborated into collage novels in collaboration with Eluard; also in 1919 he had come across a Cologne

catalogue of educational materials and now painted over the pages. In 1925 he began to do frottages, which form another typical group of works. An important landmark in his painting career was his encounter, also in 1919, with works by de Chirico, and he became one of the most ingenious exponents of the Surrealism inaugurated by Breton in 1924. His first one-man exhibition in the United States in 1931 was followed in 1933 by a journey to Italy and in 1934 by a visit to Alberto Giacometti in Switzerland, where he first turned his hand to sculpture. In 1938 Ernst withdrew from the Surrealist circle and settled in the Ardèche.

After being interned at the beginning of the Second World War he emigrated to the United States in 1941. Here he met his third wife, Peggy Guggenheim. He had been married previously to Luise Straus, a fellow student, and Marie-Berthe Aurenche. After travelling widely in the United States he settled at Sedona, Arizona, with his fourth wife, the painter Dorothea Tanning. After the war he travelled to Europe, spending some time in Paris in 1950 and returning there in 1953. To mark his 60th birthday his home town of Brühl put on a retrospective of his work, which, roughly fifteen years earlier, had been included in the exhibition 'Degenerate Art'. In 1955, having settled with Dorothea Tanning first at Huimes and then at Seillans, he became a French citizen; this was his second change of nationality. Numerous retrospectives and distinctions testified to his international reputation. After suffering a stroke in 1975 he died in Paris in 1976, on the eve of his 85th birthday.

Artist's Writings:

Max Ernst/Paul Eluard, *Das Innere der Sicht*, Paris, 1947
Beyond Painting and other Writings by the Artist and his Friends, New York, 1948
Ecritures, Paris, 1970

Major Catalogues:

Werner Spies (ed.), *Max Ernst. Retrospektive*, Munich, 1979
Wulf Herzogenrath (ed.), *Max Ernst in Köln. Die rheinische Kunstszene bis 1922*, Cologne, 1980

Catalogues raisonnés:

Werner Spies (ed.), *Max Ernst. Œuvre Katalog: Das Graphische Werk* (prepared by Helmut R. Leppien), Cologne, 1975
Werke 1906-1925 (prepared by W. Spies and Günter and Sigrid Metken), Cologne, 1975

Werke 1925-1929 (prepared by W. Spies and G. and S. Metken), Cologne, 1976
Werke 1929-1938 (prepared by W. Spies and G. and S. Metken), Cologne, 1979

Monographs:

Werner Spies, *Max Ernst-Collagen/Inventar und Widerspruch*, Cologne, 1974
Werner Spies, *Die Rückkehr der schönen Gärtnerin – Max Ernst 1950-1970*, Cologne, 1979

Lyonel Feininger

was born in New York on 17 July 1871. His father, who came from Durlach in Baden, was a concert violinist, his mother a singer and a pianist. At the age of eight he had his first violin lessons from his father, and when he accompanied his parents to Europe on a concert tour in 1887 his obvious talent made it seem a foregone conclusion that he would take up the study of the violin in Leipzig. However, he managed to persuade his parents to let him study drawing and painting at the Hamburg School of Arts and Crafts instead. The following year, at the age of seventeen, he was admitted to the Berlin Academy. Apart from attending classes at the Academy, he attended the private art school of Adolf Schlabitz and subsequently, from November 1892 to May 1893, that of the Italian sculptor Filippo Colarossi in Paris. Drawings and caricatures by him began to appear in 1890 in such magazines as *Humoristische Blätter*, *Ulk* and *Lustige Blätter*. From 1893 to 1906 he lived in Berlin. In 1901 he married Clara Fürst; two daughters were born in 1901 and 1902. He supported himself and his family with his earnings from his caricatures and illustrations, which were at first fairly conventional, but soon began to take on some of the rough-hewn, grotesque distortion which he borrowed from the *Jugendstil* and Japanese coloured woodcuts; this style remained typical of his work for a time, earning him an international reputation. A contract from the *Chicago Sunday Tribune* for two series of comic strips enabled him to move to Paris with Julia Berg, who bore him a son in 1906. The comic strips 'Kin-Der-Kids' and 'Wee Willie Winkie's World' appeared weekly in the Sunday supplement of the *Tribune* in 1906 and 1907. As early as 1906, after producing his first lithographs and etchings, he turned, somewhat surprisingly, to painting, which was from now on to be his main medium.

In his youth he had observed and admired the late Gothic towns of Belgium; now, in 1905, when he was in his mid-thirties, he got to know the towns and villages of Thuringia in the course of journeys made with his second wife Julia. This experience determined the character of his architectural pictures. In 1907, while visiting the island of Rügen, he was drawn to a second subject area which was to prove of lasting importance in his later work – seascapes and sailing ships. For a time he returned to Paris to work in the Colarossi studio, where Amadeo Modigliani was now a student. He fell in with Matisse's German pupils in the 'Café du Dôme' circle and met Robert Delaunay, who, along with the Cubists, considerably influenced his painting. In 1908 he returned to Berlin, where two more sons were born in 1908 and 1910. In 1913 he was invited by Franz Marc to exhibit with the artists of 'Der Blaue Reiter', having in the previous year met the painters of 'Die Brücke'. His first one-man exhibition took place in 1917 at the 'Sturm' gallery. In 1918 Feininger joined the 'November Group' and in 1919 he was one of the first artists to be invited by Walter Gropius to join the newly founded Bauhaus in Weimar, where Feininger had thought of moving as early as 1907. At the Bauhaus he taught drawing and painting, but only until it moved to Dessau in 1926, after which he maintained his connection with it by editing its publications, though he no longer had any teaching duties and spent the summer months by the Baltic. In the same year he joined Klee, Kandinsky and Jawlensky in founding 'Die Blauen Vier'.

Having become no less successful as a painter, than he had formerly been as a caricaturist, he was honoured by the National Gallery in Berlin with a retrospective exhibition in 1931, his sixtieth year. After the Bauhaus had been closed by the Nazis he returned to Berlin. In 1936 he went to teach at Mills College in Oaklands, California, and in 1937 he finally settled in New York, where he designed the decorations for the pavilion of 'Masterpieces of Art' at the World Exhibition of 1939. He died in New York on 13 January 1956 at the age of 84.

Major Catalogues:

Lyonel Feininger 1871-1956, Kunsthaus, Zurich, and Haus der Kunst, Munich, 1973 (with outline biography, select bibliography and a list of the major exhibitions)
Hans Hess, *Lyonel Feininger, Monographie*, Stuttgart, 1959; New York and London, 1961 (with catalogue of works revised by Julia Feininger)
Leona E. Prasse, *Lyonel Feininger – A Definitive Catalogue of his Graphic Work, Etchings, Lithographs, Woodcuts*, Cleveland Museum of Art, 1972, Berlin, 1972

Recent Publications:

Lyonel Feininger: The Kin-Der-Kids, Wee Willie Winkie's World, Darmstadt, 1975
Lyonel Feininger – Karikaturen, Comic strips, Illustrationen 1888-1915, catalogue of the Museum für Kunst und Gewerbe, Hamburg, and of the Wilhelm-Busch-Museum, Hanover, 1981

Gotthard Graubner

was born at Erlbach in the Vogtland on 13 June 1930. From 1947 to 1948 he studied at the Hochschule für Bildende Künste in Berlin, and then, until 1952, at the Academy of Art in Dresden. After moving to the West he continued his studies at the Düsseldorf Academy of Art from 1954 to 1959. He worked as an art master for a year before being appointed to a teaching post at the Hochschule für Bildende Künste in Hamburg, where he has held a professorship since 1969. He has also been a professor at the Düsseldorf

Academy since 1973. Between 1955 and 1957 Graubner's imagery moved away from the geometrical colour forms he had used hitherto. At first in watercolours and then on canvas he began to try out different ways of applying pigments which would ensure priority to the numerous applications of colour rather than limiting them to specific forms and the confines of pictures. In contrast with the monochrome painting and new pictorial conceptions of the ZERO artists Piene, Mack and Uecker, his work is not concerned with either the symbolic value of monochrome colours or the crea-

tion of light effects by means of screens and movement. His procedure is rather to intensify the effect of colour in his pictures not only by repeated saturation, but above all by a subtle internal differentiation of the colour surface. When exploring this surface, the eye experiences the colour in many gradations and movements, yet the picture does not give the slightest hint which would create the illusion of an identifiable and memorable structure. The viewer loses himself in this maze of colour landscape, and the radiation of the many layers of colour finally produces a spatial effect.

In order to intensify this effect, in the early 1960s Graubner began to mount picture-sized colour-pads (which he had previously used to transfer the colour to the canvas) into the picture itself and then to stretch a perlon fabric over them. The colour-pads shone through the perlon fabric without taking on a clearly outlined form. The transparent white of the cover dominated these montages around the mid-sixties. Graubner conceived a fogroom as an environment which would correspond to this dissolving of colour and realized it in 1968. Since the early seventies the plastic foam pads – or at times ready-made overstretches such as quilts – have had the colour applied only after being covered with stretched nylon. The absorbent effect of the pads causes the numerous applications of colour on the surface to appear as large colour areas, the spatial effect of which is supported by the three-dimensional character of the base to which the colour is applied. The application of the colour is carried out with brushes and pads as the base lies on the ground; sometimes it is done on the spot at an exhibition, so that the interaction with specific light conditions can be precisely controlled.

Catalogues:

Gotthard Graubner – Arbeiten auf Papier, Triennale New Delhi, Kunstmuseum, Düsseldorf, 1980
Gotthard Graubner, Kunsthalle, Baden-Baden, 1978
Monograph:
Dietrich Helms, *Gotthard Graubner*, Recklinghausen, 1974

George Grosz

was born Georg Ehrenfried Groß on 26 July 1893 in Berlin, where his parents kept a pub. In 1898 the family moved to Stolp in Pomerania. When his father died in 1900 Georg and his mother returned for a time to Berlin, but returned to Stolp in 1902. Here he attended the grammar school, but was obliged to leave in 1908 after retaliating in kind when one of the masters boxed his ears. From 1909 to 1912 he lived in Dresden and attended the Academy of Arts there. In 1912 he studied under Emil Orlik at the School of Arts and Crafts in Berlin and in 1913 at Colarossi's studio in Paris. As a volunteer for war service in 1914 he was at least able to choose the regiment in which he was to serve, but in May 1915 he had an operation for sinusitis, after which he was found physically unfit for service and discharged. In Berlin he met Wieland and Helmut Herzfeld. Taking his lead from the latter, who had changed his name to John Heartfield, Groß anglicized his name to George Grosz; this was his way of reacting to the militaristic hatred that was being whipped up against the enemy. He was called up again in 1917, this time to the militia, but was at once sent to a military hospital, where he lost his temper and assaulted a sergeant. He escaped being sentenced to death for desertion, not least through the intervention of his patron Harry Count Keßler, and was sent to an institution for "mentally disabled war victims", from which he was discharged on 20 May 1917 as "permanently unfit for service".

In the same year Wieland Herzfeld's publishing firm Malik brought out his first two portfolios. Unlike his early *Jugendstil* caricatures which had begun to appear in *Ulk* and *Fliegende Blätter* in 1910, these first portfolios of lithographs display a

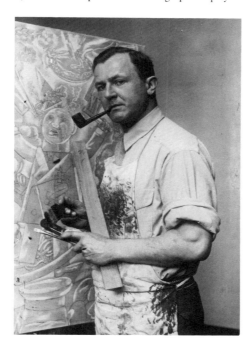

fully developed style and a thematic control which was to remain typical of Grosz's portfolios until the last of them appeared in 1930 and formed the basis of his legendary reputation. His oils of the period – *Dedication to Oskar Panizza*, 1917/18 – testify to the impact made on him by an exhibition of Italian Futurists when he first saw them at Herwarth Walden's gallery in 1913, as well as to his capacity for using identical means to produce an autonomous painting which is at once a historical record, a criticism of society and a diagnosis of the crisis afflicting art and society in the aftermath of

the First World War. His mordant drawings and his contributions to Dadaist happenings and journals made him a popular figure of the twenties, assuring him of the unbounded admiration of his artistic and political allies, but equally putting him on his guard against attacks and even murder threats from nationalistic and bourgeois reactionaries. The life he led embodied all the contradictions which made for the artistic and political disunity of the Weimar Republic: Dadaist anarchy and membership of the Communist Party, bohemianism and Spartacus, a longing for America and a journey to Russia, animosity towards art and painting in oils, private collections and graphics for editions, dandyism and social criticism, commercial cynicism and the danger of political prosecution - these are just some of the many contradictions which he managed to combine in his life in a unique and unpredictable synthesis. The title of his autobiography, *A Little Yes and a Big No*, fittingly sums up the declaration of independence embodied in these years. Early recognition in the United States was followed by a visiting professorship in New York, whence he returned once more to Germany to arrange for his final emigration to the United States on 12 January 1933. He went on to contribute illustrations to various periodicals and other publications and taught at various schools. In 1954 he had a retrospective exhibition at the Whitney Museum in New York. This was followed by a visit to Germany. On 28 May 1959 he returned to West Berlin, where he died on 6 July.

Artist's Writings:

John Heartfield/Georg Grosz, 'Der Kunstlump', *Der Gegner*, 1919/20
George Grosz, 'Statt einer Biographie' (1925), Uwe Schneede (ed.), *Die zwanziger Jahre*, Cologne, 1979
Die Kunst ist in Gefahr, Berlin, 1925
Ein kleines Ja und ein großes Nein, Hamburg, 1955

Major Catalogues:

George Grosz, Seine Kunst und seine Zeit, Kunstverein, Hamburg, 1975 (with bibliography)
Georg Grosz, Frühe Druckgraphik, Sammelwerke, Illustrierte Bücher 1914-1923, Staatliche Museen Preußischer Kulturbesitz, Kupferstichkabinett, Berlin, 1971

Recent Publications:

Hans Hess, *George Grosz*, London, 1974
Uwe M. Schneede, *George Grosz, der Künstler in seiner Gesellschaft*, Cologne, 1975
Lothar Lang, 'George-Grosz-Bibliographie', *Marginalien*, XXX, 1968

Raoul Hausmann

was born in Vienna in 1886, the son of a painter, from whom he had his first lessons about 1900. From 1901 he lived in Berlin, where he made friends with Johannes Baader in 1905. His work for the periodicals *Sturm* and *Aktion* was in keeping with the Expressionist and Futurist orientation of his painting, which he abandoned during the war to devote himself to photomontage, in collaboration with Hannah Höch. Being a central figure in the Berlin Dadaist scene, he took part in numerous exhibitions, events, manifestos and tours, which he organized until 1920 with his friends Baader and Richard Huelsenbeck. The political polarization of the Dadaist scene in Berlin gave rise to an Anti-Dada-Merz tour to Prague, which he undertook with Hannah Höch and Kurt Schwitters. During the next few years he was on terms of close friendship with Schwitters, who, like him, experimented with sound-poems and typography, and also with Otto Freundlich, Hans Arp and Lászlo Moholy-Nagy. He was also in touch with Constructivist groups and the Cologne Progres-

sives. In 1922 he parted from Hannah Höch and also abandoned painting to take up experimental photography and writing. In 1926, while staying on Ibiza, he started work on his novel *Hyle*, and it was to Ibiza that he fled when Hitler assumed power in Germany. He remained there until 1936, when the outbreak of the Spanish Civil War forced him to seek refuge in Zurich, Prague and, finally, Paris, whence he escaped to the south of France during the war. After the war he spent his time painting, photographing and writing, as well as attempting a historical interpretation of Berlin Dadaism in various publications and exhibitions. He died on 1 Februar 1971 at Limoges, where he had lived in seclusion since 1944.

Major Catalogue:

Raoul Hausmann Retrospective, Kestner Gesellschaft, Hanover, 1981 (with biography, bibliography and list of exhibitions and works)

Monograph:

Michael Erlhoff, *Raoul Hausmann: Dadasoph*, Hanover, 1982

Erich Heckel

was born the son of a railway engineer at Döbeln in Saxony on 31 July 1883. His father's profession entailed frequent moves, so that Heckel attended the elementary school at Olbernau in the Erzgebirge and the grammar schools at Freiberg (Saxony) and Chemnitz. At Chemnitz he made friends with Karl Schmidt from Rottluff, both of whom belonged to 'Vulkan', a debating club and literary circle which drew its membership from the various grammar schools in Chemnitz. At that time their chief interest was in Nietzsche, Dostoevsky, Strindberg and Ibsen. Between 1904 and 1906 Heckel studied architecture at the local technical college, where he met Ernst Ludwig Kirchner. Kirchner passed his qualifying examinations that year, but Heckel left college and found work in the office of the architect Wilhelm Kreis. In June 1905 he joined with Karl Schmidt, Ernst Ludwig Kirchner and Fritz Bleyl in founding the 'Künstlergemeinschaft Brücke', becoming the group's business manager for the next few years. The artistic position of the group was determined against the background of exhibitions of works by van Gogh, Gauguin and the Neo-Impressionists which were shown in Dresden, Heckel himself being

strongly influenced by van Gogh in particular. In the same year an exhibition which included works by Munch was put on in Dresden, but according to Heckel's account it was only later that they came to take notice of his work. Within the complicated chemistry of artistic affiliations Heckel probably played a dominant role, and it was above all due to his mediation that the group maintained its unity until 1912. After the first joint exhibitions in Leipzig (1905), Dresden and Hagen (1906), Oldenburg (1908), the Düsseldorf 'Sonderbund' exhibition (1910) and the Cologne 'Sonderbund' exhibition (1912), Heckel had his first one-man exhibition at Fritz Gurlitt's gallery, Berlin, in 1913. The group had developed into an itinerant artists' colony as a result not only of their general move to Berlin in 1911, but above all of their communal visits to Dangast (Oldenburg) and the Moritzburg lakes (near Dresden), and even after it broke up Heckel continued to lead a peripatetic existence until the end of his life.

He volunteered for service in the First World War as a Red Cross orderly. His unit was commanded by Walter Kaesbach, the art historian, who later became curator of the Angermuseum in Erfurt. Through him Heckel not only came into close contact with other artists in the unit, but during spells of service in Flanders got to know Max Beckmann and the Belgian artist James Ensor. When the war ended Heckel joined the 'Work Council for Art', on which his friend Franz Pfemfert *(Die Aktion)* was active, and also the 'November Group'. From 1919 to 1944 he spent the summer months at Osterholz, near Worpswede, and made numerous excursions to Berlin. In Erfurt he carried out a commission from Kaesbach to paint the interior of a medieval room which had previously been used as a store-room. His decorations in his attic studio at Osterholz were destroyed after the war. In the pictures he painted in the twenties there are unmistakable traces of the influence of New Objectivity, and right up to his death this influence combines with the Expressionism of his early years. In 1937 the Nazi Chamber of Art banned him from exhibiting. Seven hundred and twenty-nine of his works were confiscated, some of them being shown later in the exhibition 'Degenerate Art'. His Berlin studio was destroyed in an air raid, and a large quantity of his works, particularly drawings, were also destroyed.

In 1949 Heckel was invited to teach at the Karlsruhe Academy of Art, where he remained until 1955. He died at Radolfzell by Lake Constance in 1970, aged 86. Apart from his paintings, an important part of his work is made up of watercolours as well as drawings, woodcuts, etchings and lithographs.

Major Catalogue:

Zdenek Felix (ed.), *Erich Heckel 1883-1970. Gemälde, Aquarelle, Zeichnungen und Graphik*, Munich, 1983 (with detailed biography, documents on the artist's reception and select bibliography)

Catalogues raisonnés:

Paul Vogt, *Erich Heckel, Monographie mit Werkverzeichnis*, Recklinghausen, 1965
Annemarie and Wolf-Dieter Dube, *Erich Heckel. Das Graphische Werk* (3 vols), 2nd ed., New York, 1974

Werner Heldt

was born in Berlin on 17 November 1904, the son of a pastor. His strict upbringing at home was continued at the grammar school he attended (the Gymnasium zum Grauen Kloster) until 1922. This upbringing left him with a lasting sense of guilt, which weighed all the more heavily on him as he grew into his role as an outsider. From 1923 to 1924 he attended the School of Arts and Crafts in Berlin and then went on to study at the Berlin Academy until 1930. At this period his work consists predominantly of townscapes and scenes from the night-life of the Berlin suburbs; one may discern in it the influence of Heinrich Zille, his boon companion at the time, as well as that of Lesser Ury's city pictures. When Heldt went to Paris in 1930 it was to see Maurice Utrillo, whom he admired for his paintings of town scenes. A heavy drinker like Utrillo, Heldt sought to regain his stability by painting pictures in which empty streets come to be a dominating feature. Whereas, however, Utrillo's success led to his authenticity being subverted by a tourist perspective, Heldt's work admits no meretricious mitigation of his personal and political anguish. A course of psychoanalysis which he underwent in Berlin from 1929 to 1933 led to his giving up painting for a time and producing instead a series of drawings in which he no longer sought out the picturesque features in

the night-haunts of drunks and prostitutes, but rehearsed another kind of night-life, that of his dreams. In 1933 he went into exile on Majorca, but had to quit this refuge after the Spanish Civil War broke out in 1936. He returned to Berlin, where he occupied a studio with Werner Gilles and Hermann Blumenthal until 1940. There are few pictures from this period. In 1940 he was called up for war service, and it was in 1945, while a prisoner of the British in Ostfriesland, that he took up painting again.

When he returned to Berlin and saw the destruction caused by the war, he reacted with pictures which have earned him his unique position in German painting. The *View from a Window with Dead Bird*, 1945, was the prelude to his preoccupation with the ruined landscape of Berlin, for which in the years that followed he often chose the title *Berlin by the Sea*. This superficially nonsensical geographical combination gives expression to a merging of his personal obsessions with prehistory, natural history and postwar reality: he sees this Berlin, built on the Brandenburg sands of a primeval sea, as both a landscape of ruins and a landscape of dunes. Streets and areas of waste ground appear as canals hollowed out by the sea in a city which has not sunk, but drowned, as though a flood had destroyed the man-made architecture. A new twist is thus given to the strategy which was used by the Expressionists in their criticism of the city (one thinks of Bertolt Brecht's words: "All that will remain of these cities will be what went through them, the wind"): the ever-threatening triumph of nature over history is symbolized by the sea lapping around a city which has become the victim of its own history and been engulfed in prehistory. Up to his death in 1954 Heldt remained the painter of Berlin, represented finally in views from windows and part-abstract compositions in which the city has come to rest as a still life, a *nature morte*.

Monograph:

Wieland Schmied, *Werner Heldt*, Cologne, 1976 (with catalogue of works by Eberhard Seel)

Hannah Höch

was born at Gotha on 1 November 1889, the daughter of a senior employee in an insurance company. In 1912 she began her studies at the School of Arts and Crafts in Berlin-Charlottenburg, where she attended Harold Bengen's class in

glass design. In 1914 she worked briefly for the Red Cross and other auxiliary services in Gotha, then in 1915, back in Berlin, she attended painting classes given by Emil Orlik at the school of the State Museum for Arts and Crafts. In 1916 she produced her first collage, and from then until 1926 she was employed as a designer by the publishing firm of Ullstein. Until 1922 she lived with Raoul Hausmann. Together they belonged to the Dadaist scene in Berlin and developed the principle of photocollage. In 1919 she was represented at the Dadaist exhibition at I. B. Neumann's gallery, and in 1920 she exhibited her *Dada Dolls* at the First International Dada Fair in Berlin. A journey on foot from Munich to Rome in 1920 was followed in 1921 by the Anti-Dada-Merz Tour, which took her to Prague with Hausmann and Helma and Kurt Schwitters. After parting from Hausmann she worked with Hans Arp and Kurt Schwitters, contributing the first grotto to the latter's *Merz-Bau* in 1922. In 1924, through Theo van Doesburg, she met Piet Mondrian in Paris. From 1926 to 1929 she lived with the Dutch authoress Til Brugman in The Hague, where she had close connections with the Stijl movement. After returning to Berlin in 1929, she took part in the 'Werkbund' exhibition *Film und Foto* in Stuttgart, but a one-woman exhibition with photomontages and watercolours, planned to take place at the Bauhaus in Dessau in 1932, had to be cancelled when the Bauhaus was closed down. She survived the Nazi period, living in seclusion in north Berlin. In 1935 she parted from Til Brugman and married Kurt Matthies, a businessman and pianist, from whom she was divorced in 1944. Synoptic exhibitions on Dadaism and the history of photocollage after the war revived the fame of this long-forgotten pioneer of photocollage. She died in Berlin on 31 May 1978.

Monographs:

Götz Adriani (ed.), *Hannah Höch – Fotomontagen, Gemälde, Aquarelle*, Cologne, 1980
Herbert Remmert, *Hannah Höch – Werke und Worte*, Berlin, 1982

Karl Horst Hödicke

was born in Nuremberg on 21 February 1938, the son of a railway engineer, and grew up in Düsseldorf until the family was evacuated to Vorderheide in Silesia. In early 1945 they fled to Vienna, where his mother died, and then to Oberpfaffen-Germering in Bavaria. Here he attended the elementary school and the grammar school until 1956. He gained his matriculation certificate in 1959 in West Berlin, where the family settled in 1957. After training as a builder he went on to study architecture at the Technical University in 1959, but after one term he moved to the College of Fine Arts, where he joined the class of the non-formal painter Fred Thieler. After several more terms his interest in figurative-expressive painting took precedence over the predominantly abstract style he had at first practised and in 1961, together with Bernd Koberling, he joined a group calling itself 'Vision'. He and eleven other more or less like-minded artists formed a co-operative which took its name from the address of the premises where they exhibited their work, 'Großgörschen 35'. This was inaugurated with a one-man exhibition by Hödicke. This group, in conjunction with the Springer, Werner and Katz galleries, contributed decisively to the establishment of a new kind of figurative painting in Berlin between the heyday of abstraction and the incipient impact of Anglo-American Pop Art. However, after only a year the

differences between those members of the group who were "realistically" orientated and those with "expressive" inclinations led to a schism, and Hödicke, together with Lüpertz, Koberling and Wintersberger, left the group, which now established itself as the nucleus of the movement known as 'Critical Realism', soon to prove successful. In 1966 and 1967 Hödicke lived in New York, after which he spent a year at the Villa Massimo in Rome on a scholarship.

In his early two-part painting *Hairdresser's Mirror* of 1964, which, set up at an angle of 90 degrees, depicts the twofold reflection of a section of an interior, Hödicke formulated a theme which was to occupy him for more than ten years, that of reflection. Since then, however, he has treated this theme not so much within the intimate framework of an interior as in tandem with another theme, that of city lights at night. The subject matter for a series of pictures called *Passages*, executed in 1964, is provided by the various levels at which the nocturnal city is perceived, the mixing of lights reflected in window-panes with figures and rooms on both sides of the panes. A further series, *Reflections*, from 1965, is devoted to reflections isolated from their context, in which the reflected reality can scarcely be deciphered and almost dissolves into abstraction as a set of optical stimuli. This is precisely the kind of painting which Duchamp rejected as the "art of the retina", but for which Hödicke opened up new vistas before 'Photorealists' like Richard Estes and Don Eddy developed their American versions.

In the seventies Hödicke directed his attention to the artificial sources of light, neon lighting being a particularly frequent theme in his pictures. A series dealing with artificial light as reflected on pavements and sections of sky seen from back yards – *Sky over Schöneberg* – rounds off his treatment of these themes. They are succeeded by depictions of architecture in which Hödicke shows the monumental buildings of the Berlin city landscape immersed in the evening twilight. Latterly his work has been preoccupied with the human form – *Statues*, 1980-82 – and narrative scenes, though the themes of light and reflections have not been entirely abandoned.

Hödicke, who since 1974 has been a professor at the College of Fine Arts where he was once a student, has never been a 'pure' painter. Apart from his paintings and drawings he has made numerous experimental films, especially during his time in New York, as well as installations, which form no

small part of his total oeuvre. This 'media freedom' has been characteristic of his teaching, of which Helmut Middendorf and Salomé are products.

Artist's Writings:

Anatomie – Autonomie – Anomolie, Berlin, 1976
Kalenderblätter, Berlin, 1980

Major Catalogues:

K. H. Hödicke, Badischer Kunstverein, Karlsruhe, 1977

Jörg Immendorff

was born at Bleckede, near Lüneburg, on 14 June 1945. He had his first one-man exhibition in Bonn in 1961, while still a schoolboy. In 1963 he was admitted to the Düsseldorf Academy of Art. There he studied drama for three terms under Teo

Otto before switching to Joseph Beuys's class in 1964. In the course of a lively controversy over the role of painting he produced pictures and picture happenings in which he attacked the vacuity and arbitrariness of abstract painting, which still enjoyed considerable esteem. *Please Carry Straight On* is the title of one happening, in which a slashed canvas represents, in its one-dimensionality, the surrogate character of art. When one of his paintings was accidentally misused by the mason Gansäuer to catch falling mortar, the incident sparked off an ironic demonstration of the 'usefulness' of painting. In 1965 paintings like *Stop Painting* and *Teine Tunst mehr mache* (baby language for *Keine Kunst mehr machen: Don't do any more art*) demonstrated that he was starting to be serious in his reservations about unpolitical painting. Suspecting that the political irrelevancy of art was due not least to the venality of artists and their readiness to compromise, he subjected the ambition and political naïveté of the artist to a ruthless analysis in his *Report on the Accounts* ('documenta 5', 1972) and in his book *To do what has to be done*, Cologne/New York, 1973, in which he cited himself as a case in point: *I wanted to be an artist; Social Action as a Pretext; Dreams don't get you anywhere.*

Carried over from the happenings policy of Fluxus into politics of the student movement, his exhibition happenings such as *Vietnam-Aktion*, Aachen 1966, the anarchic *Lidl-Akademie*, 1968/69, and *Bureau for Tenants' Solidarity*, 1970, supply a marked contrast to this rigorous and unparalleled general confession. Following the shift towards dogmatism which accompanied the break-up of the

originally anti-authoritarian student movement, Immendorff fell in with a Maoist faction, and for a time he allotted a central position in his painting to the heroes of Maoism, the causes espoused by its followers, and the depiction of its practice in the sphere of political agitation. Being a teacher at a secondary modern school from 1968 to 1980, he carried on the micropolitical debate about his own role as an artist in representations of his work as a schoolteacher. In the late seventies he involved himself in the activities of the incipient ecological movement represented by the 'Greens'. An encounter with A. R. Penck, whom he visited more than once in the German Democratic Republic, prompted him to treat the division of Germany as a relevant theme in his *Café Deutschland* pictures, which began to appear in 1978. In these theatrical panoramas of post-war German reality Immendorff links the technique of didactic theatre *à la* Brecht with his own metaphorical imagery, which is developed in accompanying panel pictures and graphics, an imagery which has also dominated his sculptures since 1977 *(Seam/Brandenburg Gate – World Question*, 1982/83). The *Akademie* pictures of recent years reflect his various teaching activities at the academies in Stockholm (1981), Hamburg (1982), Zurich and Trondheim (1983), Cologne and Munich (1984/85): *Academy East/Exercise Hans Albers, Academy West/Exercise Standards*, 1984. These too demonstrate that for all his polemical vehemence Immendorff manages to maintain a certain degree of ironic detachment between himself and his ambivalent role as a political painter.

Artist's Writings:

Jörg Immendorf, *Lidlstadt*, Düsseldorf, 1968
Hier und jetzt/Das tun, was zu tun ist, Cologne/New York, 1973
Jörg Immendorf/A. R. Penck, *Deutschland mal Deutschland*, Munich, 1979

Major Catalogues:

Jörg Immendorff, Kunstverein, Brunswick, 1985 (with biography, bibliography and list of exhibitions)
Immendorff, Kunsthaus, Zurich, 1983 (Cologne, 1984)
Immendorff. Café Deutschland/Adlerhälfte, Kunsthalle, Düsseldorf, 1982

Alexej Jawlensky

was born at Torsok in Russia on 26 March 1864, the son of an army colonel. He grew up in White Russia, near the Prussian border, until he and his mother moved to Moscow in 1874. There he attended a grammar school, a private school and,

from 1877, a boarding school for officer cadets. After his father's death in 1882 he entered the military school in Moscow and became a lieutenant in 1884. He applied unsuccessfully several times to be allowed to attend art school while serving in the army, but in 1889 he was able to begin his studies at the Academy in St Petersburg. Here he was taught by Ilya Repin and met Marianne von Werefkin, another pupil of Repin, who became his companion until the 1920s. In 1896 he left the army and moved to Munich. There he attended Anton Azbè's painting school, where he met Wassily Kandinsky. About the turn of the century he spent lengthy periods in Russia, Italy and France. In France he met Henri Matisse. In 1909 he was one of the founder members of the 'Neue Künstlervereinigung München', but he left the association in 1912 to join 'Der Blaue Reiter'. He lived in Switzerland during the First World War, and in Ascona from 1918 to 1921. He finally parted from Marianne von Werefkin and moved to Wiesbaden. In 1929 he joined Feininger, Klee and Kandinsky to form 'Die Blauen Vier'. In the same year he began to suffer from arthritis, which became increasingly severe and finally left him completely paralysed. He died in Wiesbaden on 15 March 1941. Since 1933 the National Socialists had forbidden him to exhibit, and three of his works were shown in the exhibition 'Degenerate Art'.

Catalogue:

Armin Zweite (ed.), *Alexej Jawlensky 1864-1941*, Munich, 1983 (with biography, bibliography, and list of exhibitions)

Wassily Kandinsky

was born in Moscow on 4 December 1866. His father, a tea merchant, came from Siberia, his mother from Moscow. His parents divorced in 1871. In 1876 he entered the grammar school in Odessa and learned to play the piano and the cello. He began to paint at an early age, but when he went to Moscow University in 1886 it was to study economics and law. Specializing in the sociological and ethnological study of peasant law in the Vologda province, he wrote his dissertation on the legality of workers' wages. At the age of thirty he gave up a career as an academic lawyer and moved to Munich in 1896. Here he first attended a private art school, but in 1900 he began to study at the Academy. From 1901 to 1904 he belonged to a group of artists calling itself 'Phalanx'. Numerous journeys to Holland, Tunis and elsewhere and a year's stay in Paris (1906/1907) were followed in 1909 by the founding of the 'Neue Künstlervereinigung München', of which he became president, living partly in Murnau and partly in Munich with Gabriele Münter. In 1911, together with other artists, he left the New Artists' Association to join Franz Marc in setting up the editorial board of the almanac *Der Blaue Reiter*. The same year saw the appearance of his book *Über das Geistige in der Kunst (On the Spiritual in Art)* and the following year the first number of the almanac.

After the outbreak of the First World War he first went to Switzerland and then returned to Moscow, where he held various posts in organizations and institutes set up after the October Revolution. In 1921 he returned to Germany with his second wife Nina, and from 1922 he lived in Weimar, where he took up a professorship at the Bauhaus. In Weimar he founded the group 'Die Blauen Vier' ('The Blue Four'), whose members included Paul Klee and Alexej von Jawlensky, whom he had first met years before in Munich, as well as Lyonel Feininger, who like Klee was a col-

Catalogues raisonnés:

Hans K. Roethel and Jean K. Benjamin, *Kandinsky. Werkverzeichnis der Ölgemälde*, 2 vols. (1900-1915, 1916-1944), Munich, 1982 and 1984

Erika Hanfstaengel, *Wassily Kandinsky. Zeichnungen und Aquarelle* (catalogue of the collection in the Städtische Galerie im Lenbachhaus, Munich), 2nd revised ed., Munich, 1981

Monograph:

Will Grohmann, *Wassily Kandinsky*, 2nd ed., Cologne, 1981 (with detailed bibliography)

Recent Publication:

Armin Zweite (ed.), *Kandinsky und München – Begegnungen und Wandlungen 1896-1914*, Munich, 1982

Anselm Kiefer

was born at Donaueschingen on 8 March 1945. After attending the primary school at Ottersdorf and the grammar school at Rastatt (from 1956 to 1965), he read French and law at university, but in 1966 switched to the study of painting, first under Peter Dreher in Freiburg (1966-68), then under Horst Antes in Karlsruhe (1969). After graduating he studied under Joseph Beuys. In 1971 he moved to Hornbach in the Odenwald (South Germany), where he still lives with his wife and family in a former schoolhouse. He turned the attic into a studio, and it is to this attic that many of his paintings and "Photobearbeitungen" from the early seventies refer. Since his photo-series *Occupations*, published in 1969 in the periodical *Interfunktionen* and showing him at various places in France, Italy and Switzerland with his right arm raised in the Fascist salute, his work has concentrated on gestures, symbols and myths, and on literary themes and authors who were subjected to nationalistic 'Teutonizing' interpretations in the nineteenth century and could thus be readily exploited in the celebration of 'German culture' as taken over by National Socialism during the Third Reich. As a result of his simultaneous use of the devices of analysis and mimicry, his works are open to inevitable and at times deliberate misconstruction. Such misconstruction demonstrates how the stigma from which German culture has suffered as a consequence of nineteenth-century chauvinism and twentieth-century Fascism was treated as taboo rather than attempting to come to terms with it. Far from being merely an illustrator of problem areas in German cultural history, Kiefer has developed an independent and highly individual painting style which often takes the form of a dialectic between painting and photography, photographs frequently being used as the picture ground. Successive applications of thick layers of pigment often produce a massive impasto which has to be cut away with an axe or burnt off before further pigment is applied. This procedure is referred to in such pictures as *Painting = burning*. The close link between subject matter and style is obvious in his repeated treatment of the theme of political iconoclasm: *Iconoclastic Controversy*, 1976/77, 1978 and 1980. An abiding theme in his works is supplied by forms of hubris and motifs deriving from the expectation of salvation, as they have been adapted to varying political and artistic traditions in order to establish particular political or artistic positions. Apart from the paintings, which themselves often employ a mixture of techniques, he has produced photo-paintings, photo-series and staged photographs bound together as one-off books, which prepare or accompany certain themes in his paintings. Among other techniques he employs are woodcut and watercolour.

Being very reticent about his private life (except in the early, allusive 'Autobiography' in the catalogue of his one-man exhibition at the Kunstverein, Bonn, in 1977), he expressly requests that catalogues and other publications about his work should contain no portrait photographs.

Artist's Writings:

'Besetzungen', *Interfunktion*, XII, Cologne, 1969
Die Donauquelle, Cologne, 1978
Hoffmann von Fallersleben auf Helgoland, Groningen, 1980
Numerous books issued as one-offs and numbered editions

Major Catalogue:

Anselm Kiefer, Catalogue of the one-man exhibition in the Städtische Kunsthalle, Düsseldorf, 1984 (with a list of exhibitions and the accompanying catalogues, together with their texts)

Monograph:

Anselm Kiefer, Watercolours 1970-1982, with notes on the plates by Ann Seymor, Anthony d'Offay Gallery, London, 1983 (850 numbered and signed copies)

Additional Literature

Walter Grasskamp, 'Anselm Kiefer – Der Dachboden', in Christos M. Joachimides (ed.), *Ursprung und Vision – Neue deutsche Malerei*, Berlin, 1984, pp. 32-35

Ernst Ludwig Kirchner

was born at Aschaffenburg on 6 May 1880. His father, a chemist and engineer, frequently changed his place of work, so that the family moved repeatedly, first to Frankfurt, then to Perlen in Switzerland, and finally to Chemnitz, where Kirchner attended the elementary school and grammar school. Having himself once had ambitions to become a painter, his father encouraged the talent which his nervous and highly-strung son displayed at an early age. After leaving school in

1901 Kirchner enrolled in the faculty of architecture at the Technical College in Dresden and studied there until 1903. In the winter term of 1903/04 he studied in Munich at the 'Teaching and Experimental Studio for Applied and Pure Art' run by Hermann Obrist and Wilhelm von Debschitz. In Munich he became acquainted with the exoticism and primitivism associated with the *Jugendstil* and also visited museums and numerous exhibitions of contemporary art. At an exhibition of works by members of Kandinsky's group

league at the Bauhaus. In 1926 he published his book *Punkt und Linie zu Fläche*, and in 1928 he designed the scenery for a performance of Mussorgsky's *Pictures at an Exhibition* given at the theatre in Dessau. When the Bauhaus was finally closed by the National Socialists in 1933 he emigrated to Neuilly-sur-Seine near Paris, where his first one-man exhibition in 1929 had been proof of his international reputation. Apart from visiting Paul Klee in Switzerland in 1937 and temporarily moving to Cauterets in the Pyrenees to avoid the invading Germans, he lived there until his death in 1944.

Having become acquainted with the Impressionists early in his career – at a Moscow exhibition in 1896 – he began his development in the ambience of Neo-Impressionist painting, which was influenced by the *Jugendstil*, especially by its early tendency towards abstraction. In the early stages of the international trend towards abstract painting special importance attaches to the phases of his own *rapprochement* around 1910, especially as he supplied a theoretical justification in his writings. His conception of abstract painting incorporates notions of synaesthesia together with ideas deriving from theosophy and the theory of culture. Having imbibed folkloristic tendencies in art ever since his early visits to the Russian provinces, he was led by the rustic culture of his new home at Murnau to try to come to terms with naive painting traditions, which in the almanac *Der Blaue Reiter* figure no less prominently than exotic and primitive sources of artistic inspiration. Folkloristic elements are also present in the later variety of abstraction, with its more geometrical orientation, which is characteristic of his late work from the twenties onwards.

Artist's Writings:

Wassily Kandinsky/Frank Marc, *Der Blaue Reiter* [Munich, 1912], Klaus Lankheit (ed.), Munich, 1965
Über das Geistige in der Kunst [Munich, 1912], 8th ed., Berne, 1965
Rückblicke, Berlin, Sturm 1913
Klänge, Munich, 1913
Punkt und Linie zur Fläche [Munich, 1926], Max Bill (ed.), 7th ed., Berne 1973
'Essays über Kunst und Künstler', [*Cahiers d'Art*, 1931], Berne, 1963
Wassily Kandinsky/Frank Marc, *Briefwechsel, mit Briefen von und an Gabriele Münter und Maria Marc*, Klaus Lankheit (ed.), Munich, 1983

'Phalanx' he saw paintings by the Neo-Impressionists. He was also attracted to the work of Toulouse-Lautrec, Vallotton and van Gogh. On a trip to Nuremberg he visited the Germanisches Museum, where he saw Albrecht Dürer's woodcuts and incunabula, and it was during his stay in Munich that he did his first woodcut.

In the spring of 1904 he returned to Dresden to continue his studies. Here he and his fellow student Fritz Bleyl began to paint with Erich Heckel. A photograph from this period shows him with what look like Neo-Impressionist pictures. He was one of the founding members of the 'Brücke' group in 1905.

Having obtained the mark 'good' in his final examination in 1905, Kirchner devoted himself exclusively to art. During the few years of his Dresden period he developed a repertoire which included subjects taken from the circus and the variety theatre, landscapes and townscapes, nudes and portraits, as well as carved wooden figures. It was also at this time that he painted his first 'street picture'.

In 1910 he met Otto Mueller in Berlin, where he and the remaining founder members of 'Die Brücke' moved in the following year and where he and Max Pechstein founded the 'MUIM' ('Moderner Unterricht in Malerei' – *Modern Teaching in Painting*). The *Chronicle of the Brücke*, which he wrote at the behest of the group's original and later members, led to a quarrel and the official dissolution of the group in 1913. In early 1914 he and his companion Erna Schilling took an attic studio at Friedenau. This, like his previous premises in Dresden and Berlin, he furnished with carved furniture and batik, and woven and painted wall-hangings.

On the outbreak of the First World War Kirchner volunteered for service as a driver in an artillery regiment, but in the spring of 1915 he was posted to the field artillery. As early as October 1915 he was sent on sick leave because of a lung infection and general debility. There followed various stays in sanatoriums, but these failed to cure his nervous condition and the consequences of drinking and narcotics (morphium), intensified by his constant state of panic at the prospect of being redrafted for active service. In 1918 he was released, semi-cured, and sent to convalesce on the Stafelalp in Switzerland.

At this period Kirchner began to revise his early pictures, altering the dates of certain works – sometimes pre-dating them – in order to 'correct' his position in art history. His statements about his own development and about 'Die Brücke', never particularly reliable, became even more capricious, and as a critic, writing under the pseudonym Louis de Marsalle, he took a hand in the reception given to his own work, which was not going according to plan. An exhibition in the Kronprinzenpalais of the Berlin National Gallery in 1921 was followed in 1923 by another at the Kunsthalle in Basle, which brought him into contact with artists belonging to the Swiss 'Rot-Blau' (Red-Blue) group, some of whom, like Hermann Scherer, subsequently worked under his guidance. In 1933 he had an exhibition at the Kunsthalle in Berne. From 1926 he was troubled by bouts of depression and debility. Developments in Germany, which he followed closely from Switzerland, including the confiscation of 639 of his works judged as 'degenerate' (32 of which were shown in the touring exhibition 'Degenerate Art' in 1937), robbed him of the will to live, which had in any case been undermined by various diseases, and he died on 15 June 1938.

Exposed in his early years to the most varied influences – chief among them being the *Jugendstil*, Neo-Impressionism, Fauvism, and 'primitive' art

from the Palau Islands and the Cameroons – Kirchner first distanced himself from van Gogh, then from Munch, until by 1909 or 1910 he had evolved an independent style of painting, that of 'Die Brücke', though this was soon overtaken by his rapid artistic development. As early as 1910, under the influence of the Ajanta wall pictures of India, his palette moved from complementary colours to adjacent and secondary ones; the stylized marginal hatchings used in Ajanta paintings to elaborate the volume are transformed in Kirchner's Berlin street scenes into nervous fan-shaped contours. His revisions of pictures from the twenties, as well as the new works done at this period, employ colour interspersed with white. During the twenties, while in Switzerland, he made designs for embroidery and tapestries, and it was in connection with these that he evolved a monumental kind of painting characterized by areas of uniform colour. Around 1930 his work entered its final phase: he now adapted a style of linear abstraction in which line and colour are dissociated from each other. Throughout his life he produced prints and painted wood sculpture as well as paintings, and photographs of his studio testify to his abiding interest in wooden furniture carved in a 'primitive' style and in textile paintings and murals.

Artist's Writings:

Lothar Grisebach, *E. L. Kirchners Davoser Tagebuch. Eine Darstellung des Malers und eine Sammlung seiner Schriften*, Cologne, 1968

Major Catalogues:

Ernst Ludwig Kirchner 1880-1938, Nationalgalerie, Berlin, 1980; book edition: Munich, 1980 (containing detailed visual and written documentation by Hans Bollinger and Georg Reinhardt)

Catalogues raisonnés:

Donald E. Gordon, *Ernst Ludwig Kirchner*, Monograph and catalogue raisonné of paintings, Munich, 1968
Annemarie and Wolf-Dieter Dube, *E. L. Kirchner – Das graphische Werk* (2 vols), 2nd edition, Munich, 1980

Detailed Bibliography in:

Roman Norbert Ketterer (ed.), *E. L. Kirchner, Zeichnungen und Pastelle*. Bibliography by Hans Bollinger

Konrad Klapheck

was born in Düsseldorf on 10 February 1935. His father, who died in 1939, was professor of art history at the State Academy of Art in Düsseldorf, where his mother, a writer on art, taught from 1953 to 1966 and herself became professor of art history. Evacuated to the east during the later stages of the war, Klapheck witnessed the bombing of Leipzig in 1943 and saw the Red Army march into Saxony, two experiences which he even mentions in his curriculum vitae. From 1954 to 1958 he studied painting at the Düsseldorf Academy, where he was taught by the reserved and unconventional Bruno Goller, with whom he developed a strong affinity in both his attitudes and his work. It was from Goller that he received the necessary training and encouragement for his object painting. His first academy picture of 1955 was a meticulously executed painting of a typewriter. While the lyrical figuration of his teacher was made up of hats, coffee-grinders, umbrellas and machine parts, Klapheck's cooler imagery is dominated by typewriters, sewing machines, telephones, sirens, showers and taps. With seeming matter-of-factness he succeeds in monumentalizing these and other objects so that they give the impression of being latter-day baroque emblems that have been bereft of their explicatory,

rationalizing epigrams in their passage through 'New Objectivity'. Klapheck gives his object pictures titles which invest his machines and machine-made consumer durables with an anthropomorphic dimension, while ignoring the technical aspects of their production and the social aspects of their circulation as commodities. Far from simply reproducing his motifs, he introduces idiosyncratic and technically absurd modifications whose interpretative significance is often clinched by the titles he gives the pictures. During a stay in Paris in 1956/7 he became acquainted with the work of Marcel Duchamp and Raymond Roussel. In 1961 he became associated with the circle of Andre Breton, who adopted him as an exponent of the "third phase" of Surrealism. Writing in 1965, Breton interpreted Klapheck's machine pictures in the light of the machine metaphors employed by the Dadaists and Surrealists. In 1960 he met Richard Oelze, with whom he found he had an affinity similar to the one that had drawn him to Goller, and he began to collect Oelze's works. Klapheck lives in Düsseldorf, where he is professor of painting at the Academy.

Major Catalogue:

Konrad Klapheck-Retrospektive 1955-1985, Kunsthalle, Hamburg, 1955, pub. Munich, 1985

Paul Klee

was born at Münchenbuchsee near Berne, Switzerland, on 18 December 1879. His father was a music teacher and his mother a singer. He himself had both musical and artistic talents, and on passing his school leaving examination in Berne in 1898 he had to choose which of these interests to pursue. He decided in favour of painting and went to study in Munich, first at a private art school and then, from 1900, at the Academy, where he was taught by Franz von Stuck. After a journey through Italy in the company of the sculptor Hermann Haller he lived in Berne from 1902 to 1906, paying visits during this time to Munich, Paris and Berlin. In 1906 he and his wife Lily Stumpf moved to Munich, where he became acquainted through exhibitions with the work of van Gogh and Cézanne and where he had his first exhibition in 1911 at the Galerie Thannhauser. He met Alfred Kubin and the painters of 'Der Blaue Reiter' and participated in their second exhibition

of 1912. In 1914 he travalled to Tunis with August Macke and Louis René Moilliet. He returned to Switzerland in 1915, and in 1916 was called up to join the German infantry, in which he served until 1918. After the war monographs on his work began to appear, and in 1920, having been invited to teach at the Bauhaus, he moved to Weimar. 1924 saw his first exhibition in New York, and in that year he joined with Jawlensky and two Bauhaus colleagues, Kandinsky and Feininger, in founding the group 'Die Blauen Vier'. He moved to Dessau with the Bauhaus in 1925. His *Pädagogisches Skizzenbuch* (Pedagogical Sketchbook) appeared as a Bauhaus publication, and he was represented at the Surrealist exhibition in Paris. By 1929 he had made journeys to Italy, France and Egypt. His 50th birthday was marked by an exhibition at Alfred Flechtheim's gallery in Berlin; in 1930 the exhibition moved to the Museum of Modern Art, New York. In 1931 he became professor at the Düsseldorf Academy, but was relieved of his post by the National Socialists in 1933. He moved to Berne, where despite the onset of a fatal illness he went on working intensively. In Germany more than 100 of his works were confiscated, seventeen of them being included in the 1937 exhibition 'Degenerate Art'. In Berne he received visits from Ernst Ludwig Kirchner, Pablo Picasso and Georges Braque. He died in the Tessin on 29 June 1940.

Artist's Writings:

Über die moderne Kunst, (Speech in Jena, 1924), Berne, 1945
Tagebücher von Paul Klee 1898-1918, Felix Klee (ed.), Cologne, 1956
Das bildnerische Denken, (Basle/Stuttgart, 1956), Jürg Spiller (ed.), 4th ed., Basle/Stuttgart, 1981
Gedichte, Felix Klee (ed.), Zurich, 1960
Schriften (Reviews and articles), Christian Geelhaar (ed.), Cologne, 1976
Beiträge zur bildnerischen Formlehre, Jürgen Glaesemer (ed.), Basle/Stuttgart, 1979

Catalogues raisonnés:

Eberhard W. Kornfeld, *Verzeichnis des graphischen Werkes von Paul Klee,* Berne, 1963
Jürgen Glaesemer, *Paul Klee – Handzeichnungen I. Kindheit bis 1920* (Sammlungskatalog des Berner Kunstmuseums), Berne, 1973
Jürgen Glaesemer, *Paul Klee – Die farbigen Werke im Kunstmuseum Bern,* Berne 1976

Monograph:

Will Grohmann, *Paul Klee,* Stuttgart, 1954

Bernd Koberling,

born in Berlin on 4 November 1938, served an apprenticeship as a cook from 1955 to 1958, after which he worked as one until 1968. At the same time, in 1958, he began to study art at the West Berlin Academy of Fine Arts under Max Kaus, a

pupil of Heckel and a second-generation Expressionist with a leaning towards abstraction. While Koberling was still a student Kaus's influence was replaced by others following his encounter with the work of contemporary Italians such as Vedova and Corpora, and Americans such as Pollock, de Kooning, Francis and Guston. Later he became preoccupied with the painting of Ernst Wilhelm Nay.

A holiday in Swedish Lapland in 1959 presented Koberling, who has a passion for fishing, with a theme that has occupied him ever since, though at the time he could see no way of giving it suitably modern pictorial expression: the landscape and atmosphere of the far north. Early attempts to find figurative images for this theme – at a time when he was trying to come to terms with American Abstract Expressionism – were impeded less by the continuing predominance of abstract art in West Germany than by the sudden irruption of Anglo-American Pop Art, which he first encountered at the Berlin exhibition of 1964. This collision with the 'second-hand landscape picture' (Lichtenstein, d'Arcangelo) led Koberling to abandon the direct, colourful, figurative imagery which he had evolved: *Self-portrait in Red Fishing Jacket* (1963). He now developed a new form of landscape painting which involved stretching several lengths of calico, each painted separately, above one another: *Overstretches* (1965-73). In the sixties the Lapland landscape provided the sole subject matter for these 'overstretches', which were more in the nature of objects than pictures and were often covered with plastic film. A whole series was devoted to the systematic representation of a river landscape in northern Sweden: *Kaitum-Kalixälv, Course of a River in 21 Pictures* (1969). He had hardly found his feet artistically (and financially, through his first sales) when another crisis arose: having won a scholarship to the Villa Massimo in Rome – scarcely the place for a painter of northern landscapes – he was suddenly plunged into the contemporary revolutionary climate. Koberling had never drawn upon his considerable experience of the world of work to find subjects for his painting, and now he came to regard his land-

scapes as a form of escapism. As a result he produced pictures which took up ecological and political themes: *Red Snow* (1969), *Melting Snowfields, Terror* (1972). In 1973 he also created two China pictures, which were inspired by his commitment to the Maoist League against Imperialism. A way out of this crisis seemed to present itself with the series *Paint Water*. Living in Cologne, he encountered a growing hostility to painting in artistic circles there; the prospect of increasing demands for political commitment finally led him to return to Berlin and to a kind of painting which from now on involved the direct application of pigments, chiefly on jute, as well as a resumption of his original theme, the life and landscape of northern Europe. He began to make regular lengthy visits to northern Scandinavia, Ireland and Iceland, though during these visits he hardly ever painted the landscape directly, but took photographs and "learned by heart".

In 1981, after holding various visiting lectureships at the academies in Hamburg, Berlin and Düsseldorf, Koberling was appointed professor at the Hamburg College of Fine Arts.

Artist's Writings:

Vision, Zeitschrift für Kunst (with Manfred Laber, J. A. Marxmüller, J. K. S. Hohburg, K. H. Hödicke), Munich/Berlin, 1960-1963 (appeared at irregular intervals).
Text in *Bernd Koberling – Malerei 1962-1977* (see below)

Catalogues:

Bernd Koberling – Malerei 1962-1977, catalogue of the one-man exhibitions in the Haus am Waldsee (Berlin) and the Städtisches Museum, Leverkusen, Schloß Morsbroich, 1978

Oskar Kokoschka

was born at Pöchlarn in Austria on 1 March 1886, the son of a goldsmith from Prague, and grew up in Vienna. From 1905 to 1909 he attended the Vienna School of Arts and Crafts, and during this time he also worked in the Vienna Workshop, founded by Josef Hoffmann in 1903. His illustrations and printed graphics were influenced by the Vienna *Jugendstil,* his painting partly by van Gogh and Hodler and partly by the Viennese Secession. His first patron was Adolf Loos, who introduced him to the intellectual circles of Vienna and obtained portrait commissions for him. From 1910, while living in Berlin, he worked on Herwarth Walden's periodical *Der Sturm,* which published not only drawings by him, but also some of his

writings, including the drama *Murderers, the Hope of Women*. From 1911 to 1914 he had a liaison with Alma, the wife of Gustav Mahler. In 1914 he volunteered to serve in the cavalry, and in 1916 he was discharged in Vienna after being seriously wounded. In the same year he met the actress Käthe Richter in Berlin. The couple moved to Dresden, where Kokoschka took up a professorship at the Academy of Art. He resigned the post in 1924 and spent much of the next few years travelling in Italy, Switzerland, France, Spain, Holland and England, as well as in Africa, Egypt and the Middle East. During these travels he painted many landscapes and townscapes. All this time he was based in Paris, but in 1931 he returned to Vienna. In 1934, however, alarmed by the ascendancy of right-wing radicalism in Vienna, he moved to Prague, only to emigrate to London in 1938 with Olga Palkovska, whom he later married. In 1937 the National Socialists had confiscated 417 of his works. In Great Britain he moved between London, Cornwall and Scotland. After 1949 he paid several visits to the United States. In 1953 he settled in Switzerland by Lake Geneva; he also taught at the 'School of Seeing' during the Salzburg Summer Academy which was founded in the same year. He died at Montreux, Switzerland, on 22 February 1980.

Artist's Writings:

Dramen und Bilder, Leipzig, 1913
Vier Dramen, Berlin, 1919
Spur im Treibsand, Geschichten, Zurich, 1956
Schriften 1907-1955, Munich, 1956
Mein Leben, Munich, 1971
Das schriftliche Werk, Heinz Spielmann (ed.), 4 vols, Hamburg, 1973-1967
Briefe I (1905-1919), Olda Kokoschka and Heinz Spielmann (eds), Düsseldorf, 1984

Catalogues raisonnés:

Hans Maria Wingler, *Oskar Kokoschka – Das Werk des Malers*, Salzburg, 1956
H. M. Wingler and F. Welz, *Oskar Kokoschka – Das druckgraphische Werk* (2 vols), Salzburg, 1975 and 1981

Monograph:

Werner Joseph Schweiger, *Der junge Kokoschka – Leben und Werk 1904 bis 1914*, Vienna/Munich, 1983

Käthe Kollwitz

was born in Königsberg (Kaliningrad) on 8 July 1867. Her home background was coloured by the liberal Protestantism of her grandfather, Julius Rupp, and the socialist commitment of her father, Carl Schmidt, who had given up a legal career in the Prussian civil service to work as a master mason. In 1881 she began taking drawing lessons in Königsberg, and from 1885 to 1886 she studied

at the school for women artists in Berlin. From 1888 to 1889 she continued her studies in Königsberg and Munich. In 1891 she married Karl Kollwitz, whom she had known for many years and who had grown up in a similar left-wing atmosphere. They moved to Berlin, where he set up a practice as a medical doctor. In 1893 she began work on the *Weavers' Revolt*, having been impressed by the first performance of *Die Weber* by Gerhard Hauptmann, whom she had met in Munich in 1885. This cycle of pictures was shown at the Great Berlin Art Exhibition in 1898, and a year later she was admitted to the Berlin Secession. From 1898 to 1903 she taught at the Berlin school for women artists. Work on her cycle *Peasants' Revolt*, from 1903 to 1908, was interrupted by a visit to Paris in 1904 and a journey to Italy in 1907. From 1907 to 1909 she did drawings for *Simplicissimus*, and in 1910 produced her first sculptures. One of her two sons, Peter, volunteered for service in the First World War against his parents' wishes and was killed in Flanders in 1914. After the war, which she publicly opposed ("There has been enough dying"), she made a death-bed drawing of the murdered Karl Liebknecht, who had also campaigned against the war. In the 1920s a series of woodcuts entitled *War* appeared, as well as works for the portfolios *Parting and Death* and *Hunger*. In 1927 she travelled to the USSR, where exhibitions of her works were mounted in Moscow and Kazan. In 1933 she was obliged to leave the Prussian Academy of Arts, of which she had become the first woman member in 1919, and in 1936 she was forbidden to exhibit. Having been evacuated from Berlin, where her studio had been gutted by fire during an air-raid in 1943, she died at Moritzburg, near Dresden, on 22 April 1945.

Major Catalogues:

August Klipstein, *Käthe Kollwitz. Verzeichnis des graphischen Werkes*, Berne, 1955
Hans Kollwitz, *Käthe Kollwitz – das plastische Werk*, Hamburg, 1967
Uwe M. Schneede, *Käthe Kollwitz: Das zeichnerische Werk*, Munich, 1981
Renate Hinz (ed.): *Käthe Kollwitz 1867-1945. Druckgraphik, Plakate, Zeichnungen*, Berlin, 1980

York in 1913. In Berlin he joined up as an orderly in a military hospital. This experience of war brought on bouts of deep depression, and in 1916 he fled to Switzerland, where his family joined him. After living in Zurich until 1918, he returned to Berlin when the war was over and committed suicide in his Berlin studio on 25 May 1919. The public controversy over the setting up of his sculpture *Kneeling Woman* in the garden of the Tonhalle, Duisburg, in 1927 was a foretaste of the operation against 'degenerate art' of ten years later, in which 116 of his works were confiscated, *Kneeling Woman* becoming a prominent item in the notorious propaganda exhibition.

Catalogue:

Wilhelm Lehmbruck. Katalog der Sammlung des Wilhelm-Lehmbruck-Museums der Stadt Duisburg, Recklinghausen, 1981 (with texts by Siegfried Salzmann)

Monograph:

Dietrich Schubert, *Die Kunst Lehmbrucks*, Worms, 1981

Recent publication:

Siegfried Salzmann, *Hinweg mit der Knienden. Ein Beitrag zur Geschichte des Kunstskandals*, published by the Kunstverein, Duisburg. 2nd ed., 1981.

Wilhelm Lehmbruck

was born in a mining community at Meiderich, near Duisburg, on 4 January 1881, the fourth child in a family of eight. On the recommendation of his elementary school teacher and supported by a scholarship from the local authority, he attended the Düsseldorf School of Arts and Crafts from 1895 until his father's death in 1899, after which he managed to support himself by working as an illustrator and an assistant in sculpture workshops. In 1901 he joined a master class at the Düsseldorf Academy of Art, where he studied until 1906, with breaks for study visits to Italy, Holland and England. After his successful participation in the exhibition of the Société National des Beaux-Arts at the Grand Palais, Paris, in 1907, he continued to exhibit there every year, and in 1910 he settled in Paris with his wife, Anita Kaufmann, and the first of his three sons. He failed to establish contact with Auguste Rodin, whom he greatly admired, but he did meet Brancusi, Archipenko, Derain, Modigliani and Picasso, as well as Aristide Maillol, for whom he had a particularly high regard.

Before the outbreak of the First World War he left Paris, where his first important one-man exhibition had just testified to his international success, which was due in large measure to his participation in the 'Sonderbund' exhibition in Cologne in 1912 and in the Armory Show in New

Markus Lüpertz

was born in Liberec, Czechoslovakia, on 25 April 1941. In 1948 his family settled in the Federal Republic of Germany. He grew up at Rheydt in the Rhineland, where he had to leave the grammar school at the age of 13. After completing his elementary education he began an apprenticeship with a painter of wine-bottle labels, but gave it up after only a month. He next worked for a friend who was a commercial artist and who gained him admission to the College of Commercial Art in Krefeld. He started his training here in 1956 and later studied under the master painter and lecturer Laurens Goossens. After a year's break, during which he worked as a collier, he resumed his training at the Düsseldorf Academy of Art and on a study visit to the monastery of Maria Laach in the Eifel. After another break, this time spent as a road-builder, he moved to West Berlin in 1963.

Together with K. H. Hödicke, Bernd Koberling and Lambertz Maria Wintersberger he founded the self-help gallery Großgörschen 35. In contact with these artists he defined his own position as a representative of 'dithyrambic painting', to which he devoted his *Dithyrambic Manifesto* of 1966. In its literal sense the word 'dithyramb' denotes an

ancient Greek hymn associated with the cult of Dionysus, but in Lüpertz's early work it denotes both isolated formal inventions and modes of presentation as a kind of artistic pathos formula. It designates a kind of painting which conforms neither to the non-formal influences of his student years nor to Expressionist figuration, but which is dedicated to the theme of "representationalizing abstract forms" by a variety of methods. In a "formal phase" (as Theo Kneubühler calls it) Lüpertz experimented between 1963 and 1968 with pronounced perspectives and volume contrasting with sometimes extreme oblong formats (*Asparagus Field – dithyrambic*, 1966). This was followed by a phase of 'motif painting' (1970 to 1974), in which the predominant feature is the interplay of colour patches and planes in pictures which are devoted to "motif as form" (the artist's own term). Specifically German motifs which he took up at this period (*Helmet – dithyrambic*, 1970, *Arrangement for a Cap*, 1973) have been seen as a conscious attempt to come to terms with "German iconography" (Siegfried Gohr), but also as an attempt to introduce contrast into the painting style (Michael Schwarz) and have given rise to doubts about his political sympathies. From 1975 his painting has been devoted to the theme of "form as motif" (Kneubühler). The 'urban landscapes' – *Babylon* (1975), *Lüpolis* (1975) – extend the initial abstract form of a flat, spontaneous brushstroke into a fictitious architectonic volume. The 'style pictures' such as *Ship* (1977) explore the possibilities of re-dissolving a suggested volume by the manner in which its surface is designed. In 1978 the ever-present tendency to create a firmly contoured form which nevertheless oscillates between abstraction and figuration was re-inforced in *Triumph of Line*. Seemingly illustrative series like *Alice in Wonderland* (1980) represent a playful exploration of painting's claim to autonomy *vis-à-vis* the idea of illustration. This traditional area of conflict between the artist's and the writer's modes of work is one with which Lüpertz is familiar,

being both an artist and a poet. Having been an exponent of virtually every pictorial and graphic technique, he added sculpture to his artistic activities in 1981. In 1974 he began teaching at the Karlsruhe Academy of Arts, first as a visiting lecturer and later as professor. Since 1984 he has been professor at the Academy of Arts in Düsseldorf.

Artist's Writings:

Dithyrambisches Manifest, Berlin, 1966
9 x 9 / Gedichte und Zeichnungen, Berlin, 1975
Gedichte 1961-1983, Verlag Zwölf Träume, 1983 (with illustrations)

Die Erschaffung der Welt, Verlag Zwölf Träume, 1983
Über den Schaden sozialer Parolen in der bildenden Kunst (in the Hanover catalogue of 1983, see below)
Tagebuch New York 1984, Berlin, 1984
Bleiben Sie sitzen Heinrich Heine, Vienna, 1984

Major Catalogues:

Markus Lüpertz – Bilder 1970-1983, Kestner Gesellschaft, Hanover, 1983
Markus Lüpertz, Kunsthalle, Hamburg, 1977

Additional Literature:

Theo Kneubühler, 'Markus Lüpertz' in *Dithyrambische und Stil-Malerei*, catalogue of the Kunsthalle, Berne, 1977, pp. 7-17

Heinz Mack

was born at Lollar in Hessen on 8 March 1931. He originally intended to train as a pianist after leaving school, but this intention was thwarted by an injury to his hand, and in 1950 he began to study painting at the Düsseldorf Academy of Art, joining Paul Bindel's class, where he met Otto Piene. After graduating in 1956 he worked for five years as a schoolmaster. At first he found an artistic home in the circle of the Tachist-influenced informal group which called itself 'Gruppe 53', but he soon tired of panel pictures, finally giving them up in 1963 in favour of plaster and metal reliefs. In 1958 he produced his first light reliefs and light cubes, which made it possible to formulate one of the dominant themes of his work, the dynamic handling of light in reflection and movement. About 1957, in collaboration with Otto Piene, he developed the periodical *Zero* from the 'evening exhibitions' of work by himself and other members of 'Gruppe 53'. The two of them, who were later joined by Günther Uecker, adopted the name of the periodical and put on numerous exhibitions and festivals before breaking up in 1966. At the 'documenta III' in Cassel it was represented by its own Zero Room (*Hommage à Fontana*). The idea of a "vibrating column of light in the desert", the first model of which he exhibited at Iris Clert's gallery in Paris in 1959, led first to two monumental concrete reliefs at Leverkusen (*Sahara Reliefs*, 1960), then to his first light experiments in the desert, which he carried out during a visit to Morocco and Algeria in 1962. At the same period he was collaborating with Uecker and Piene in designing water sculptures, light sculptures and wind sculptures. After giving up his teaching job he moved to New York in 1964, returning to Düs-

seldorf in 1966. Since 1967 he has lived at Mönchengladbach. In 1970 he represented the Federal Republic at the Venice Biennale together with Uecker, Piene and Karl Pfahler. Working with the most varied materials and drawing upon the resoures of modern technology, he has developed a spectrum of various forms in which artificial and natural sources of light play a central role and not only the proper movement of his objects, but also the calculated alignment of static sculptures towards the changing influences of natural light, contribute to the effect. Apart from numerous commissions for outdoor sculptures and architectural designs he has been involved with the design of stage sets since 1968. In 1977 he published a volume of poems entitled *that silver is my colour*.

Monograph:

Karin Thomas, *Heinz Mack*, Recklinghausen, 1975

August Macke

was born at Meschede, Westphalia, on 3 January 1887 and grew up in Bonn and Cologne. From 1904 to 1906 he studied in Düsseldorf at the Academy of Art and simultaneously at the School of Arts and Crafts under Fritz Hellmut Emcke, designing decorations and costumes for the civic theatre. After a journey to Italy in 1905 and another through Belgium, Holland and England in 1906, he spent the summer of 1907 in Paris, where he became acquainted with the works of the Impressionists and Matisse. In 1907/8 he attended Lovis Corinth's school of painting in Berlin and then travelled to Italy and Paris with his patron Bernhard Koehler, the uncle of Elisabeth Gerhardt, whom he later married. After their wedding in 1909 he had his first encounter, in Paris, with the work of the Fauves. He and his wife lived for a year by the Tegernsee, near Munich. Here he met Franz Marc, Kandinsky and Jawlensky, with whom he collaborated on the almanac *Der Blaue Reiter* and took part in exhibitions. In 1911 he returned to Bonn. A year later he went to Paris with Franz Marc to visit Robert Delaunay, who subsequently visited Macke in Bonn, accompanied by Guillaume Apollinaire. In 1913 he went to live by Lake Thun, in Switzerland, where he associated with Louis Moilliet,

whom he had first met while on his honeymoon in 1909, and also with Paul Klee. They travelled to Tunis together in April 1914. After returning to Bonn Macke was called up for war service. Having reached the rank of warrant officer he was killed in France on 26 September 1914 at the age of 27.

Artist's Writings:

'Aufsätze', *Kampf um die Kunst*, Munich, 1911
August Macke/Franz Marc, *Briefwechsel mit Franz Marc*, Cologne, 1964

Major Catalogues:

Dierk Stemmler, *Die rheinischen Expressionisten: August Macke und seine Malerfreunde*, Recklinghausen, 1980
Ernst-Gerhard Güse, *Die Tunisreise*, Westfälisches Landesmuseum, Münster, 1982

Monograph:

Gustav Vriesen, *August Macke*, 2nd enlarged ed., Stuttgart, 1957

Franz Marc

was born in Munich on 8 February 1880. His father came from a family of civil servants in Upper Bavaria and he qualified as a lawyer before choosing painting as a profession. His mother came from a French family in Alsace. Although his

father was a Roman Catholic, Franz Marc had a Protestant upbringing and was strongly influenced by his Calvinist mother. While being prepared for confirmation as an adolescent he conceived a desire to become a pastor. In 1899, however, he enrolled at the University of Munich for a course of literary study. After completing his year of military training he moved from the University to the Munich Academy of Fine Arts and began to study painting under Wilhelm von Diez. Kandinsky and Klee were studying at the same time under Franz von Stuck, though Marc, who was reserved and solitary, did not meet them until later. After a visit to northern Italy he went on a study tour to Paris, through France and Germany, at the invitation of Friedrich Lauer, a well-to-do fellow student. Returning in September 1903, Marc did not resume his studies at the Academy, but took a studio of his own and worked by himself, without any strong contacts with colleagues or fellow students. Working in Munich, on the Staffel-Alm and in Kochel – with a break in 1906 for a visit to Mount Athos – Marc produced landscapes, portraits and animal drawings, at first adhering to the

traditional nineteenth-century style of the Munich Academy. During his lengthy visits to Kochel in 1906 and to the Staffel-Alm in 1902 and 1905 he devoted himself to *plein-air* painting. A second visit to Paris in 1907, during which he made a careful study of van Gogh's works, was to influence his style in the years to come. His difficult financial situation, which he tried to alleviate by producing bronzes of animals and giving private lessons, suddenly took a turn for the better when he was visited by three "very young and rather elegant gentlemen" early in 1910. These were the two painters Helmuth and August Macke, and Bernhard Koehler jnr., the son of the Berlin collector Bernhard Koehler, who shortly afterwards was to give considerable financial support to Franz Marc and 'Der Blaue Reiter'.

In the same year Marc saw the exhibition of the 'Neue Künstlervereinigung München' at the Tannhauser Gallery. As a direct consequence he came into close local contact with Kanoldt, Jawlensky, Marianne von Werefkin, Gabriele Münter, Bechtejeff, Klee, Kubin and Kandinsky. Helmuth Macke lived and worked for some time in Marc's house which he rented at Sindelsdorf, south of the Starnberger See, near Murnau, where Kandinsky and Gabriele Münter had been living since 1908. Late in 1911 he and Kandinsky left the 'Neue Künstlervereinigung München' to collaborate in editing the almanac *Der Blaue Reiter*.

In the following year Marc visited Kirchner and Pechstein in Berlin and was invited to join the art committee of the Cologne 'Sonderbund' exhibition of 1912. In Cologne he saw a Futurist exhibition which greatly impressed him. For a time Marc lived in the Tyrol, before moving into his own house at Ried, near Benediktbeuern. When war broke out he immediately volunteered for service, expecting the war to bring about "a cleansing of Europe". He fell at Gussainville Castle (Verdun) on 4 March 1916.

Among the most important influences which contributed to the development of Marc's independent work at the age of almost thirty was that of Vincent van Gogh. From 1910 onwards, under the influence of Kandinsky and Macke as well as Delaunay and the Futurists, Marc developed an imagery which at first tended towards the monumental and later towards the abstract, his subjects being almost exclusively animals. From the period after 1914 we can only judge from the sketchbooks he kept during the war how he might have developed as a painter of romantic-transcendental abstraction.

Artist's Writings:

Franz Marc/Wassily Kandinsky, *Der Blaue Reiter* [Munich, 1912], Klaus Lankheit (ed.), Munich, 1965
Briefe, Aufzeichnungen und Aphorismen, vol. 1, Berlin, 1920
Briefe aus dem Felde, Berlin, 1940
Aufzeichnungen und Aphorismen, Munich, 1946
Franz Marc/August Macke, *Briefwechsel mit August Macke*, Cologne, 1964
Klaus Lankheit (ed.), *Franz Marc, Schriften*, Cologne, 1978

Major Catalogues:

Franz Marc 1880-1916, Städtische Galerie im Lenbachhaus, Munich, 1980 (with detailed biographical documentation by Rosel Gollek)
Mark Rosenthal (ed.), *Franz Marc 1880-1916*, University Art Museum, University of California, Berkley, 1979/80

Catalogue raisonné:

Klaus Lankheit, *Franz Marc. Katalog der Werke*, Cologne, 1970

Detailed Bibliography in:

Klaus Lankheit, *Franz Marc. Sein Leben und seine Kunst*, Cologne, 1976

Ludwig Meidner

was born on 18 April 1884 at Bernstadt in Silesia, where his parents ran a textile business. After taking his first public examination at the grammar school in Kattowitz he temporarily gave up his plan to study painting in order to take an apprenticeship as a mason (1901-1903); this was in preparation for the study of architecture which his parents favoured. From 1903 to 1905 he studied painting at the Breslau art school, and from 1905 to 1906 he worked in Berlin as a fashion artist. Having become interested in Impressionism he managed to obtain the necessary financial help from a relative to move to Paris, where he studied the works of Manet and, to a lesser extent, of Cézanne and van Gogh. He also witnessed the *succès de scandale* of the Fauvists and became a friend of Amadeo Modigliani.

In 1908 he returned to Berlin, where he managed to subsist without paid employment and spent most of his time drawing, since his finances did not run to oils and canvas. In 1911 he was put forward for an anonymously endowed private scholarship, which he obtained on the strength of a testimonial from Max Beckmann. About 1912 the paintings which established his early reputation as "the most Expressionist of the Expressionists" began to appear. Landscapes on the outskirts of towns, hitherto dominated by industrial buildings, gasometers and building sites, are now transformed into apocalyptic visions. His *Apocalyptic Landscapes* were done in 1912 and 1913. *The Burning City* of 1913 treats a recurrent theme. Pictures like *Cholera* (1912) and *Vision of an Infantry Trench* (1912) anticipate the civilian and military disasters of the First World War. Discernible in these works are echoes of Cubism and Futurism, as well as a late reflection of his Parisian encounter with Fauvism. In a mere four years Meidner incorporated them into his own idiosyncratic brand of Expressionism which is evident in his numerous self-portraits and the portrait drawings in which he captured many of the denizens of the artistic and literary circles he moved in. In 1912 he and two other painters, Richard Janthur and Jakob Steinhardt, founded a group calling itself *Die Pathetiker* ('The Exponents of Pathos') which broke up after an exhibition shown at Herwarth Walden's gallery, not least because of Meidner's overwhelming success. He was acquainted with members of 'Die Brücke', which had now moved to Berlin, though he stood aloof from their 'primitivism', occupying an unmistakably individual position within Expressionist painting, the theme of which he outlined in his *Guide to the Painting of Townscapes*. In 1914 he moved for a time to Dresden, where he

and his friend the poet Ernst Wilhelm Lotz wanted to take advantage of an invitation they had received from Franz Kochmann, a wealthy patron of the arts, to edit a periodical and bring out portfolios of lithographs. However Lotz was killed in the war in 1914; Meidner returned to Berlin and stayed there until he was called up in 1916.

While serving in the forces he did some drawings; he also wrote Expressionist prose – *September Cry* and *Behind my Head the Sea of Stars* – which was in keeping with his wide literary education and his literary vocation, which later was to compete for a time with his painting. From 1919 he was back in Berlin, but now, besides his many portrait drawings, a new theme came to dominate his work, which was largely graphic. Jewish traditions, the Bible, and his reading of Catholic mystics inspired his expressive and highly emotional figure drawings. While he believed that his wife Else Meyer, whom he had married in 1927, was a highly gifted painter, he began to have growing doubts about his own talent. As a result he gave up painting and, finally, drawing as well, to become a successful writer of humorous stories for a Berlin newspaper, thus confounding those remaining followers and admirers who had not already been put off by his new-found religiosity and his move towards conservatism. In 1935, with the increasing persecution of the Jews, he moved to Cologne and taught drawing at a Jewish school. Here he produced two cycles of drawings – *Allegories*, 1935, and *Visions*, 1938. In 1939 he and his family fled to England, where he met Kurt Schwitters in an internment camp. He lived in London until 1953, discovering William Blake, whom he greatly admired and felt to be a kindred spirit. Almost forgotten in Germany by now, he lived in a Jewish old people's home in Frankfurt from 1953 to 1955 and at Marxheim (Taunus) from 1955 to 1963. In 1963 the town of Darmstadt provided him with a studio flat. At this late stage exhibitions held at Wiesbaden in 1959, at Recklinghausen in 1963, and in Berlin and Darmstadt in 1964, together with celebrations to mark his eightieth birthday, recalled to public attention the painter who had been a successful, much admired, and highly individual representative of Expressionism two world wars earlier. He died at Darmstadt on 14 May 1966.

Monograph:

Thomas Grochowiak, *Ludwig Meidner*, Recklinghausen, 1966 (with detailed biography, list of exhibitions and bibliography)

Paula Modersohn-Becker

was born at Dresden-Friedrichstadt on 8 February 1876, the daughter of a railway engineer. Because of her father's profession the family moved to Bremen in 1888. While staying with relatives in England for six months in 1892 she took her first drawing lessons, and while training as a teacher in Bremen from 1893 to 1895 she had lessons from the painter Bernhard Wiegandt. With the help of relatives she was able, from 1896 to 1898, to attend the drawing and painting school of the 'Association of Berlin Women Artists of 1867', being precluded as a woman from studying at the Academy. Her enthusiasm having been aroused by an exhibition of works by the members of the artists' colony at Worpswede, shown at the Art Gallery in Bremen in 1895, she paid a visit to Worpswede in 1897 and moved there in 1898, intending to continue her artistic training unter Fritz Mackensen. In Worpswede she became acquainted with the artists Hans am Ende, Fritz Overbeck, Otto Modersohn, Heinrich Vogeler and their families. She also met Marie

Bock and Clara Westhoff, who later married Rainer Maria Rilke. From January to June 1900 she lived in Paris with Clara Westhoff, working at the Colarossi Academy and becoming acquainted with the Barbizon school, the Nabis and, in particular, the works of Cézanne. A number of painters from Worpswede, including Heinrich Modersohn, were visiting Paris when news arrived of the death of Modersohn's wife Helene. On 12 September of the same year Paula Becker became engaged to the widower, who was eleven years her senior; they married in May 1901.

It was at this time that Rilke visited the artists' colony. While staying with the Rilkes in Paris in 1903 she made her first acquaintance with Japanese art in the Hayashi Collection and was introduced to the work of Rodin. Frequent visits to Paris museums kindled an interest in ancient art, and she was also impressed by the coloured death tablets of the first millennium from Fayum in Upper Egypt, which suggested an affinity with the idea of reduced portraiture. She probably also saw pictures by Gauguin, and on her third visit to Paris in 1903 she saw Gustave Fayet's Gauguin collection. Back in Worpswede, where Clara Westhoff was living once more, she began to find the artistic domination of her husband oppressive, as we learn from the diaries he kept. Moreover he did not share her passion for Paris, being of a somewhat stay-at-home disposition. Above all, although she was constantly painting pictures of mothers and children, her own longing for children remained unfulfilled. While visiting his family at Christmas, Rilke realized that the cause of the conflict was her independent development, which sought to break out of the confines of Worpswede. He supported her in her plans to leave this rustic idyll, not least by his appreciation of her works, one of which he bought.

In February 1906 she left Modersohn to return to Paris, where she met Bernhard Hoetger, who supported her in her work. It was in this period that she did her portrait of Rilke and probably also her portrait of Werner Sombart, the German economist she had met in the winter of 1905/1906 while staying with Carl Hauptmann in the Sudeten mountains. Her last experience of Paris were an exhibition of Cézanne's early works and a retrospective exhibition of Gauguin. On 2 November 1907 she gave birth to her daughter Mathilde, but on the 20th, when she was at last

allowed to get up and hold the child in her arms for the first time, she died of an embolism. Endowed with great discipline and perseverance and pitting industry against a weak physical constitution for the occasional recognition that came her way, she painted about 650 pictures in her ten years of artistic activity.

Artist's Writings:

Paula Modersohn-Becker in Briefen und Tagebüchern, edited by Günter Busch and Lieselotte von Reinken, Frankfurt, 1980

Monographs:

Christa Murken-Altrogge, *Paula Modersohn Becker, Leben und Werk*, Cologne, 1980

Günter Busch, *Paula Modersohn-Becker – Malerin, Zeichnerin*, Frankfurt, 1981

Otto Mueller

was born at Liebau, Silesia, on 16 October 1874, the son of a former officer and revenue official who had himself wanted to be a sculptor. After attending the elementary school and the grammar school in Görlitz, he took an apprenticeship in lithography from 1890 to 1894. This was followed by study at the Academy of Art in Dresden until 1896. From 1898 to 1899 he studied at the Munich Academy, but left in disgust after having his work corrected by Franz von Stuck for the first time. The young artist received considerable support from the family of Gerhart Hauptmann, with whom he travelled to Switzerland and Italy in 1896/7. From 1899 to 1908 he lived a fairly seclud-

ed life with his wife Maschka Meyerhofer in Dresden, Liebau and other places in Silesia. Through the Hauptmanns he became acquainted with Paula Modersohn-Becker. In 1908 he moved to Berlin, where he met Lehmbruck, Emil Orlik and Rainer Maria Rilke. When his works were rejected by the Berlin Secession in 1910 je joined forces with others who had had their works rejected to found the New Secession; among them were members of 'Die Brücke', which he too joined. In 1916 he was called up for war service. When the war ended he returned to Berlin, where an exhibition of his works was put on at Paul Cas-

sirer's gallery. In 1919 he received an invitation from August Endell to teach at the Breslau Academy of Art. Between 1924 and 1930 he travelled to Dalmatia, Hungary, Romania and Bulgaria to study gipsy culture, with which throughout his life he felt he had an affinity and which plays a dominant role in his pictures. He died in Breslau on 24 September 1930.

Monograph:

Lothar-Günther Buchheim, *Otto Mueller – Leben und Werk*, Feldafing, 1963 (with biography, bibliography, catalogue of exhibitions and a catalogue of the graphic work prepared by Florian Karsch)

Catalogue raisonné:

Florian Karsch, *Otto Mueller – Das graphische Gesamtwerk*, Berlin, 1974

Ernst Wilhelm Nay

was born in Berlin on 11 June 1902, the son of a senior civil servant. He attended the classical grammar school at Steglitz, but after his father died he moved to Schulpforta, a boarding school in Thuringia, where he passed his matriculation examination in 1921. Among other activities he took up painting, and in 1925 he showed his pictures to Karl Hofer, who was professor of painting in Berlin. Hofer admitted Nay to his class, which he attended on a scholarship until 1928. He developed an early style which owed much to the influence of Kandinsky, Klee, painters of the 'Sturm' group, Picasso, Matisse and Chagall, as well as Caspar David Friedrich and Nicolas Poussin. He won wide recognition with his portraits, still-lifes and landscapes. A visit to the island of Bornholm, where he painted coastal scenes, was followed by nine months on a scholarship at the

Villa Massimo in Rome, where "surrealist-abstract" paintings and "mythical-ornamental" animal pictures prepared the ground for his autonomous development and for his early and enduring success. Visits to the Baltic coast and to Norway, where he was a guest in Munch's studio, as well as trips to the Lofoten Islands, were devoted to pictures of dunes and fishermen and to the *Lofoten Pictures*, which he worked on until 1938 after returning to Berlin. Banned from exhibiting by the Nazis and having had some of his works included in the exhibition 'Degenerate Art', he was called up into the army in 1940. He served in France,

eventually as a cartographer. Here he had his own studio, which was put at his disposal by the French sculptor Pierre Térouanne. This enabled him to go on working during the war, and a visit paid to his studio by Ernst Jünger testifies to the wide recognition enjoyed by this forty-year-old artist, whose *Elk's Head* had been acquired in the thirties by Schmidt-Rottluff, himself one of the artists classified as 'degenerate'. After the war his *Hecate Pictures* take up motifs and modes of painting which he had employed in the later war years to produce a powerfully coloured, expressive figure picture deriving in equal measure from abstraction and Cubist fragmentation. From 1949 to 1954, in his "fugal and rhythmic pictures", the abstract component, which had previously been counterbalanced by figuration, gains the upper hand. During this period his pictures tend at first towards the colourfully ornamental, but later an expressive, almost graphic handling of line comes to predominate and so prevents the pictures from producing merely decorative effects. From 1955 to 1963 he painted the *Disk Pictures*, in which round patches of colour combine to produce subtle modulations of space and colour on the picture plane.

It was at this period that Nay came to be acknowledged at home and abroad as one of Germany's leading artists. He was accorded a prominent place in the first three 'documenta' exhibitions in Cassel in 1955, 1959 and 1964, and he represented the Federal Republic at the Biennale in Venice in 1964. However, the controversy surrounding Nay's contribution to the 'documenta' of the same year marked the end of the first phase of consolidation in West German art and cultural policy after the war, a phase characterized by "abstraction as a universal language". In the last two years of his life, from 1966 to 1968, Nay produced pictures with flat, simplified forms and less variety of colour. He died in Cologne, where he had moved in 1951, on 8 April 1968.

Artist's Writings:

Ernst Wilhelm Nay, *Vom Gestaltwert der Farbe*, Munich, 1955

Major Catalogue:

Ernst Wilhelm Nay 1902 - 1968. Bilder und Dokumente, Munich, 1980, published by the Archiv für Bildende Kunst, Germanisches Nationalmuseum, Nuremberg (with extensive documentation on the artist's life and work by Hermann Maué, references to secondary literature and a list of important exhibitions)

Catalogue raisonné:

Ernst Wilhelm Nay – Die Druckgraphik 1923 - 1968. Introduction and catalogue raisonné by Karlheinz Gabler, Stuttgart/Zurich, 1975

Emil Nolde

was born Emil Hansen at Nolde in Schleswig-Holstein on 7 August 1867. He came of peasant stock. From 1884 to 1888 he took an apprenticeship as a cabinet maker and carver, and until 1890 he worked in various furniture factories in Munich, Karlsruhe and Berlin. From 1892 to 1898 he taught ornamental drawing and modelling at the School of Arts and Crafts at St Gall, Switzerland. Here he began to make drawings of masks and to do postcard-size watercolours in which the Swiss mountains appear stylized as giants. Two of these watercolours were published in the periodical *Jugend*, and the surprisingly rapid sale of large numbers of postcard versions of these enabled Nolde to give up his post and live the life of a free artist. His application for admission to the Munich Academy of Art was rejected, and so he began attending a private school of painting in Munich.

In summer 1899 he moved to the Hölzel Summer School in Dachau, then to the Académie Julien in Paris, where he stayed until summer 1900. It was while in Paris that he became acquainted with pictures by the Impressionists, Cézanne and van Gogh. After this he lived in Schleswig-Holstein and Denmark. In 1902 he married the Danish actress Ada Vilstrup and adopted the name of his birthplace as his surname. In 1903 he settled in Guderup on the island of Alsen, now Danish, but which then belonged to Germany. He lived there until 1917, spending the winter months in Berlin. As a result of an exhibition of his works at the Galerie Arnold in Dresden in 1906 he met the painters of 'Die Brücke': he joined the group for a year and remained on friendly terms with its members. In the same year he met Karl Ernst Osthaus in Hagen, Christian Rohlfs in Soest and Edvard Munch in Berlin. From 1909 to 1912 Nolde lived not only on Alsen and in Berlin, but also in the Schleswig village of Ruttebüll, where he painted his first pictures with biblical themes. In 1910 the Berlin Secession, to which he had belonged since 1901, once more rejected the works he had submitted, together with those of his friends in 'Die Brücke'. An open letter from Nolde to the president, Max Liebermann, led to his being expelled from the Secession. In 1912 he was represented at the second exhibition of 'Der Blaue Reiter' and at the 'Sonderbund' exhibition in Cologne. Since 1911 he had studied the art of primitive peoples in the Berlin Museum of Anthropology, and in 1913 he went to New Guinea as a member of an expedition set up by the German Colonial Office. The route took him through Moscow, Siberia, Manchuria, Korea, Japan, China and the Palau Islands. The paintings he did in the South Seas were lost as a result of the outbreak of the war and only turned up in 1921 in Plymouth. Nolde's plans to travel to Iceland, Greenland, America and Africa after the war came to nothing, but he did make journeys to England, Spain, France and Italy until 1925. From 1918 to 1926 he no longer spent the summer months on Alsen, but in Utenwarf. In 1926 he bought a farm at Seebüll, which remained his home until he died, although he kept his studio in Berlin. Having been sympathetic to National Socialism at an early stage and a member of the Nazi party, he was nevertheless a victim of Nazi iconoclasm. In 1937 over 1,000 of his works were confiscated, and forty-eight were shown in the exhibition 'Degenerate Art'. In 1941 he was expelled from the Reich Chamber of Art and prohibited from painting. A series of pictures from the period

of disfavour was given the title *Ungemalte Bilder* (Unpainted Pictures). After the death of his first wife Ada, he married Jolanthe Erdmann, in 1948. He died at Seebüll on 13 April 1956 at the age of 89.

Artist's Writings:

Briefe, Sauerlandt (ed.), Berlin, 1927
Mein Leben, [Berlin, 1931], Cologne, 1976
Jahre der Kämpfe 1902-1914, Berlin, 1902-14

Major Catalogues:

Emil Nolde – Gemälde, Aquarelle, Zeichnungen und Druckgraphik. Exhibition of the Wallraf-Richartz-Museum and the Stiftung Seebüll Ada und Emil Nolde in the Kunsthalle, Cologne, 1973 (with a summary biography by Martin Urban and a select bibliography by Martin Urban and Manfred Reuther).
Emil Nolde – Gemälde, Aquarelle und Druckgraphik, Kunstmuseum, Hanover, 1980

Richard Oelze

was born in Magdeburg on 29 June 1900 and this is all that we know of the family and early life of this exceedingly taciturn painter. From 1921 to 1925 he studied at the Bauhaus in Weimar and from 1926 to 1929 in Dresden, from where he paid frequent visits to the Bauhaus, by that time in Dessau. As a student he travelled extensively, which was symptomatic of the unsettled and unstable life he led; he went to Ascona in 1929, to Berlin and Lake Garda in 1930, to Paris in 1933, to Ascona again in 1936 and to Positano in 1937. He returned to Germany in 1938, and in 1939 he settled in Worpswede. This was an unlikely setting for Oelze, who had even less affinity with its tradition as a haven for artists than he had with the Bauhaus, of which his only favourable recollections concerned the preliminary course given by Johannes Itten. Equally strange is the fact that he should have returned to Germany in 1938, one year after the exhibition 'Degenerate Art' and one year before the clearly predictable outbreak of the war, in which he was called up for service in 1940. Why had he left Germany in 1933, making off for Paris on the last train before the frontier was closed? 'Made off' is an appropriate phrase to describe the wandering life Oelze led in his first forty years. He always preferred to live near railway stations, knowing that he had an escape route when obligations and contacts began to crowd in, however hard he sought to avoid them. When abroad he did not even learn the language of the country he was

living in; he seems not to have cared for communication. In Paris he was taken up by the Surrealists, with whom he maintained loose contacts from 1933 to 1936 (Breton, Dali, Eluard, Max Ernst). However, after being prominently involved in exhibitions for the first time and having some of his works purchased by the New York Museum of Modern Art, he withdrew from this early public recognition by severing his contacts and going back to Germany.

On being released from captivity as a prisoner of war he returned to Worpswede, where he remained until 1962. His fringe existence was now determined by poverty just as it had been earlier by his constant flitting from place to place. Recognition came again when he was nearing sixty: it was natural that he should be represented in retrospective exhibitions of Surrealist art – in Paris in 1959 and New York in 1960 – and it was equally natural that he should be put on display as a representative of German art in 'documenta II' (1959) and 'documenta III' (1964) in Cassel. Yet even now he was at pains to evade recognition. Even after moving to Posteholz in the Weser hills in 1962, he went on fiercely defending his solitude which, right up to his death on 27 May 1980, he allowed no one to share except the family of his life-companion and his early patrons, the Hamburg art collectors Siegfried and Gesche Poppe. One-man exhibitions at the Karl Ernst Osthaus Museum in Hagen in 1961 and at the Kestner-Gesellschaft in Hanover in 1964 were followed by various distinctions, the last of these being the Max Beckmann Prize of the City of Frankfurt, which was conferred in his absence in 1978.

Trained in the precise painterly craftsmanship that he admired in Otto Dix's paintings during his spell in Dresden, from the thirties onwards Oelze produced carefully glazed oil paintings, the figurative elements of which still determine the character of his post-war landscapes. In the fifties we find those elements coming to the fore which had previously served to break up a figurative impression or provide a contrast to it; these now led Oelze's painting off in the direction of an abstraction in which anthropomorphic, vegetable and geological forms remain no less hermetic than the life he himself led.

Major Catalogue:

Richard Oelze, Kestner Gesellschaft, Hanover, 1964 (with a list of works and bibliography edited by Wieland Schmied)

Monograph:

Wieland Schmied, *Richard Oelze*, Göttingen, 1965 (with a biography)

Blinky Palermo

was born in Leipzig on 2 June 1943 as Peter Schwarze and adopted by a couple called Heisterkamp. In 1954 he started attending grammar school in Münster, where the family had moved in 1952. In 1959 he was sent to boarding school at Burgsteinfurt (Westphalia). In 1961 he began his studies at the School of Arts and Crafts in Münster and in 1962 his application for a place at the Düsseldorf Academy of Art was accepted. At first he attended Bruno Goller's class, but by 1963 he had switched to that of Joseph Beuys, in which Imi Knoebel, Imi Giese, Norbert Tadeusz, Jörg Immendorff and Anatol Buchholz were also student at this time. Among his friends were Sigmar Polke and Gerhard Richter. A radical change in his painting was matched in 1964 by his choice of a new name, indicating a resemblance to Blinky Palermo, the boxing promoter and *mafioso*. His

early orientation towards Constructivist picture elements and colour field painting remained a determining factor in his whole work, which nevertheless was subsequently to undergo a rapid shift of pictorial forms and painting techniques. 'Picture objects', on the borderline between painting and object, begin to appear in 1964 and led to wall installations and a unique handling of exhibition space as an 'environment'. Wall drawings and wall paintings which are cleverly designed to fit a certain room and are hence unrepeatable, being limited to the period of one exhibition, continue this development from 1968 onwards – *Wall Drawings*, Galerie Friedrich, Munich 1968/69; *Wall Painting*, 'documenta 5', Cassel 1972. At the same time he did not neglect graphics and panel pictures. If his prints can be seen as charting his development, his panel pictures undergo a mutation from the *Textile Picture*, which he began to

compose in 1966 from monochrome materials to be found in any department store, to acrylic pictures on aluminium or steel, which occupy an intermediate position in a precisely balanced series, being at one and the same time a series and a wall installation.

After completing his studies in 1967 Palermo shared a studio in 1968 with Imi Knoebel in Düsseldorf, then in 1969 with Ulrich Rückriem in Mönchengladbach. A visit to New York with Gerhard Richter in 1970 was followed in 1973 by his move to New York with his second wife and a journey round the USA with Imi Knoebel in 1974. He returned to Düsseldorf in 1976 und died at 34 in 1977 on a visit to the Maldives.

Gradually, through a series of crises Palermo developed his own language, retaining the detachment of a sympathetic observer in the midst of the events that were underway in the Beuys circle. Despite all the temptations facing him at the time his work, which was the product of only fourteen years, he remained committed to painting, varied and difficult to categorize though it is. Nor is this made any easier by pointing to recognizable influences and correspondences with Russian Constructivism, American colour field painting and the 'shaped canvas', to Minimal Art and *Arte Povera*. His tentative treatment of colour and form appears ascetic, yet achieves an intimate monumentality in its purposeful exploitation of colour values and their precisely calculated spatial allocation. It is this balance which led Joseph Beuys to say of Palermo's pictures: "His pictures should be perceived as a breath is perceived."

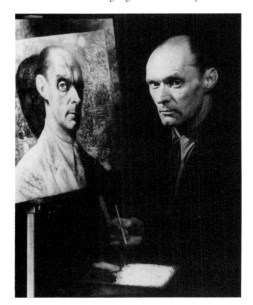

Major Catalogue:

Palermo – Werke 1963-1977, Kunstmuseum Winterthur, Kunsthalle Bielefeld, Van Abbe Museum Eindhoven, 1984/85, book edition Munich, 1984 (with biography and select bibliography)

Catalogues raisonnés:

Fred Jahn (ed.), *Palermo – Gesamte Grafik und Auflagen-objekte 1966-1975*, Munich, 1983 (printed graphics, J. W. Froehlich Collection)
Palermo – Zeichnungen 1963-1973, Kunstraum, Munich, 1974
Palermo – Objekte, Städtisches Museum, Mönchengladbach, 1973

A. R. Penck

was born in a working-class district on the outskirts of Dresden on 5 October 1939. His name at birth was Ralf Winkler. From 1945 to 1953 he attended the local elementary school and then served an apprenticeship in commercial drawing. When only ten he began painting in oils. Among his first subjects were paths through fields and woods, 'views into the open' which throw into contrast the restrictions of urban life. Other subjects were family scenes, kitchen scenes and urban motifs from Dresden. The first pictures he sold were portraits. About 1955 he decided to become a professional painter, but his repeated applications for admission to the academies in Dresden and East Berlin were turned down. Penck associated with artists of his own age and others who were older, one of them being Georg Baselitz. He took various jobs – as a boilerman, a night watchman and a postman. In his paintings he stayed with the same themes until 1961, adding nudes to his repertoire. 1961 was a decisive year in his career. Some of his work was shown at an exhibition in the Academy of Arts. This would seem to have marked the end of his existence on the fringe of the art world, but he was still not allowed to study. He applied to join the army, hoping to put an end to his Odyssey by becoming a professional officer, but his application was rejected because he could not produce educational or professional qualifications. Moreover, the authorities suspected him of being "anti-social" and "associating with crimi-

nal elements". On the day before the building of the Berlin Wall he visited Georg Baselitz, who was by then living in West Berlin, but in the evening he returned to the East; this meant that he would not go over to the West for the next nineteen years. He had hesitated to do so not least because he took his Socialism and the traditions of the workers'

movement very seriously. Now, however, he experienced the cultural and political 'ice age' which followed the building of the Wall and restricted social and intellectual movement in the German Democratic Republic. It was at this time that he chose as a pseudonym the name of the geologist Albrecht R. Penck, the author of *The Alps in the Ice Age*, 1909.

In a studio shared with a friend he painted the first of the pictures which are considered typical of his work, even though he has also retained the themes and modes of painting of his early years alongside the new up to the present day. His first painting, *World Picture*, was preceded by a number of abstract drawings. In the years that followed Penck moved around as a casual worker in a familiar underground environment where he could remain safe and inconspicuous. His output of paintings was blocked by an artistic and political crisis until 1964, when he set up his own studio and took up sculpture. In the same year some of his nudes and family scenes were shown at an exhibition in the Puschkin-Haus, and in 1966 he was nominated for membership of the Association of Plastic Artists, though he was not admitted. His subsequent development, notably his work on the *World Pictures* and *Standart Pictures*, was guaranteed from 1965 onwards by his contact with the gallery owner Michael Werner, his representative in the West, where his importance has been acknowledged at least since he was represented in 'documenta 5' in 1972, even though it is still disputed in the East. The *World Pictures*, in which he attempts, with great economy of means, to present a schematic account of social states of affairs, were followed from 1968 to 1973 by the *Standart Pictures*, which ring the changes on an archaic vocabulary evolved from the *World Pictures*. In 1973 he was drafted into the People's Army and served as a reservist for six months in the groundcrew of an airport. After this he moved to Lindenau in Prussia, where he painted the colourful, fully covered pictures of the *Ninotschka* series, the *Mike Hammer* and *TM* pictures and made numerous films of different kinds. After a stay in Budapest, where he was able to put on an exhibition, he returned to Dresden in 1977. In 1980 Penck was able to leave the German Democratic Republic and now lives with his family in London. Apart from having published a number of books (*Was ist Standart*, Cologne/New York, 1970), he edits the journal *Krater und Wolke (Crater and Cloud)*. He is also active in music and poetry.

Artist's Writings:

Standart making, Munich, 1970
Was ist Standart, Cologne and New York, 1970
Ich – Standart Literatur, Paris, 1971
'Der Adler', *Interfunktionen*, XI, 1974; 'Ich über mich selbst', *Kunstforum*, XII, 1974/75
Ich bin ein Buch, kaufe mich jetzt, Jörg Immendorf an A. R. Penck, Deutschland mal Deutschland, Munich, 1977
Der Begriff Modell – Erinnerungen an 1973, Cologne, 1978
Ende im Osten, Berlin, 1981
Je suis un livre achète-moi maintenant, Paris, 1981

Catalogues:

A. R. Penck – Zeichen als Verständigung, Museum Haus Lange, Krefeld, 1971; Kunsthalle, Basle, 1976
A. R. Penck – Y. Zeichnungen bis 1975, Kunstmuseum, Basle, 1978
Concept – Conceptruipte, Museum Boymans-van Beuningen, Rotterdam, 1979
Bilder 1967-1977, Munich, 1980; Kunsthalle, Cologne, 1981
A New Spirit in Painting, Royal Academy of Arts, London, 1981
Mythe, Drame, Tragédie, Musée d'art et d'industrie, Saint Etienne, 1982
Zeitgeist, Martin-Gropius-Bau, Berlin, 1982
Expressions. New Art from Germany, The Saint Louis Art Museum, St. Louis, 1983

Recent Publications:

Günther Gercken, 'Information on Ralf Winkler alias Mike Hammer', *Louisiana Revy*, II, Dec. 1978
Theo Kneubühler, 'Malerei als Wirklichkeit', *Kunst-Bulletin*, II, Feb. 1978
Christos M. Joachimides, 'Ein neuer Geist in der Malerei', *Kunstforum*, XLIII/1, 1981
Siegfried Gohr, 'A. R. Penck – Expedition to the Holy Land', *Flash Art*, Nov. 1983

Otto Piene

was born at Laasphe, Westphalia, on 18 April 1928 and grew up in Lübbecke, Westphalia. Called up for war service as an anti-aircraft gunner at the age of 16 and taken prisoner, he was released in 1946. Having passed his matriculation examination in 1947 he studied at he Hochschule der Bildenden Künste in Munich, the Academy of Art in Düsseldorf, the University of Cologne, and elsewhere.

From his student days until 1964 he taught at the fashion school in Düsseldorf. Out of the "evening exhibitions" which he put on in his Düsseldorf studio there emerged the periodical *ZERO*, which he edited with Heinz Mack from 1958 to 1961. Starting in 1957 with *Rasterbilder* (Screen Pictures) which were squeezed on to canvases through sieves of his own construction, he tried out a great variety of artistic and technical possibilities resulting from experimentation with colour and light and with new working methods and picture spaces. About 1960 he evolved programmed kinetic light-sculptures from the earlier *Rasterbilder*. At the same time he became interested in various forms of the mechanical light-ballet and light-theatre. Through the use of fire and smoke he arrived at novel conceptions for panel pictures (*Smoke Pictures*, from 1959, and *Fire Pictures*, from 1960) and experimented with multi-media combinations. In 1968, in collaboration with Aldo Tambellini, he produced the light-play *Black Gate* for the third television programme of West German Radio as the video project *Black Gate Cologne*. Since 1968 air projects have been realized; these go back to early ZERO projects of 1960, but still interest him today in the context of 'Sky Art'.

In 1964 Piene was visiting professor at the University of Pennsylvania in Philadelphia. In 1965 he had his first one-man exhibitions in New York and later moved there. In 1972 he became professor of Environmental Art in the Department of Architecture at the Massachusetts Institute of Technology, and since 1974 he has been the director of the Institute's Center for Advanced Visual Studies, where he supervises a variety of experimental projects,

including laser projects. He lives partly in Boston and partly in Düsseldorf.

Major Catalogue:

Jürgen Claus and Heiner Stachelhaus, *Otto Piene*, Galerie Heimeshoff, Essen, 1983 (with full biography, synopsis of works and bibliography)

Sigmar Polke

One of the few pieces of information about Polke's life to which we can give any credence is that he was born at Oels in Lower Silesia on 13 February 1941. Otherwise one should preserve a healthy scepticism, especially when he tells his own story, as he did for instance in 1976 in collaboration with Friedrich Wolfram Heubach: "Early influences, late results, or: How did the apes get into my scapes? and other icono-biographical questions" (in the catalogue *Bilder – Tücher – Objekte (Pictures – Cloths – Objects)*. It may be true that the twelve-year-old who moved from the German Democratic Republic to the Federal Republic with his family in 1953 was fascinated by the world of trivial images and the florid consumer economy of the western petty bourgeoisie, which was witnessing a cultural version of the Economic Miracle within a climate of excess. At all events the twenty-one-year-old student at the Düsseldorf Academy soon set about celebrating the inventory of his experience in paintings which transported things like socks, sausages and plastic bathtubs on to canvas. Subsequently Polke incorporated his view of the West German craze for *kitsch* into figurative paintings which produced a serio-comic effect when set against the prevailing background of abstract painting, not least the painting of his teachers, K. O. Goetz and Gerhard Hoehme. This 'Capitalist Realism' which he helped to launch with Gerhard Richter and Konrad Fischer, alias Lueg,

won him the Youth Art Prize in 1966, the prize of the Biennale in São Paolo in 1975 and a professorship at the Hamburg College of Fine Arts in 1977, but a curious development prevented him from taking this recognition at more than its face value. The painter of the *Rasterbilder* (1963-69), having previously denounced West German media and consumer ideals by revealing the stuff they were made of, now became the medium of "higher beings" whose orders he claimed to be selflessly executing in his paintings. Since then his sporadic appearances and disappearances from the artistic scene have been characterized by a mixture of truth and fiction, the genuine article and the fake, as well as astrology and economics. When the invasion of Anglo-American Pop Art temporarily

threatened to devalue his methods, he managed to extricate himself by travelling extensively, doing photographic work, and painting pictures in which his favourite set of motifs culled from trivial myths was amalgamated with devices employed in the surrealistic palimpsests of Picabia. For several years colours rather than motifs have been gaining the upper hand in his large-format pictures, while obscure allusions and a marked degree of technical mystification make it difficult for the outsider to decide whether the pictures are still of this world.

Artist's Writings:

Sigmar Polke, *Höhere Wesen befehlen*, Berlin, 1968. *Bizarre*, Heidelberg, 1972

Catalogues:

Sigmar Polke, Kunsthaus, Zurich, and Kunsthalle, Cologne, 1984
Sigmar Polke, Museum Boymans-van Beuningen, Rotterdam; Kunstmuseum, Bonn, 1984
Sigmar Polke, Bilder Tücher Objekte – Werkauswahl 1962-1971, Kunsthalle, Tübingen and Düsseldorf; van Abbe Museum, Eindhoven, 1976

Additional Literature:

Bice Curiger, 'Sigmar Polke', *Parkett Kunstzeitschrift*, II, Zurich, 1984, pp. 36-56 (in German and English)
Walter Grasskamp, 'Kleinbürgerlicher Realismus – Das Frühwerk von Sigmar Polke', *Wolkenkratzer Art Journal*, II, 1984, pp. 40-42

Gerhard Richter

was born in Dresden in 1932. From 1949 to 1952 he worked in Zittau as a painter of stage sets and advertising designer, among other things. Having studied at the Hochschule für Bildende Künste in Dresden from 1952 to 1956, he was in the master class there until 1960. Until 1961 his development was determined by the inevitable attempt to come to terms with Socialist Realism and classical painting, and by his keen interest in modern art. In 1961 he moved to Düsseldorf and until 1963 continued his studies at the Academy of Art under K. O. Götz, a representative of non-formal painting. Under the influence of Alberto Giacometti, Francis Bacon and Jean Dubuffet his painting until 1962 was mainly figurative. In this year he produced the first of the pictures that have since come to be regarded as typical of his work. Like Polke, who was also a pupil of Götz, Richter distrusted subjectivist and vitalist abstraction; both artists found significance in ephemeral subjects culled from the world of mass media imagery and treated them in their own idiosyncratic manner. Richter produced blurred, indistinct paintings based on newspaper pictures and amateur photographs in which the claims of two realistic genres (painting and photography) are played off against each other. For Richter the ephemeral motifs of the originals obviously held less fascination than for Polke; in his early paintings he was rather concerned to undermine the certainty of perception where it was generally held to be at its greatest – in photography and in realistic and naturalistic painting. Since then he has produced many pictures which operate on a borderline where the viewer's eye attempts to recognize familiar objects despite the interference of painting methods. Examples are *Town Pictures*, 1968/9; *Clouds*, 1968, 1970, 1971, 1976; and *Mountains*, 1968/9. In 1963 Richter and Konrad Fischer-Lueg staged a happening, in which Polke also took part, in a Düsseldorf furniture store. Because of its title, *A Demonstration for Capitalist Realism*, this happening led to Richter's painting being misconstrued for some time as Pop Art. Yet as early as the 1960s it was patently clear that in his paintings he was not simply treating the stuff that media dreams are made of, but rather

subverting the stuff of painting itself. This found typical expression in the use of ordinary fabrics which, together with Polke and Palermo, he bought from department stores and drapers' shops. While Polke used deco fabrics with cheap printed patterns as the basis of his paintings and Palermo used monochrome materials to construct his cloth pictures, Richter painted *Colour samples* which are shown to customers in shops to help them choose the colour they want. Just as ephemeral motifs had been simply a pretext for painting, painting itself now became a motif: in the first *Abstract Paintings* it is clear that abstract modes of painting are being handled with the same nonchalance as the magazine photographs were treated earlier and classical archetypes later – as in *Annunciation after Titian*, 1973. Since the 1960s Richter has brought a melancholy virtuosity to the consistent invention of new variations on the repertoire he built up at that time. In keeping with his concern to make painting objective is his reticence about himself and his personal life. After a period as a visiting lecturer at the Hochschule der Bildenden Künste in Hamburg in 1967 he worked as an art master in Düsseldorf from 1968 to 1969, and since 1971 he has taught there at the Academy of Art.

Major Catalogues:

Jürgen Harten (ed.), *Gerhard Richter. Katalog der Retrospektive in der Kunsthalle Düsseldorf* (with full bibliography and a complete list of paintings), to be published in January 1986
Gerhard Richter, Aquarélle, Staatsgalerie, Stuttgart, 1985

Recent Publication:

Ulrich Loock and Denys Zacharopoulos, *Gerhard Richter*, Munich, 1985

Christian Rohlfs

was born at Niendorf in Holstein on 22 December 1849 and grew up at Fredesdorf. At the age of 15 he suffered a severe injury to his leg and was consequently bedridden for two years. It was at this time that he did his first drawings. Because this injury led to the amputation of his leg in 1874, he was unable to take over his father's farm, as had been intended, and attended the grammar school at Segeberg from 1866 to 1869. On the advice of the writer Theodor Storm, and with a recommendation from him, he began to train as a painter, first in Berlin and later at the Weimar Academy. Having been trained in historical and genre painting, he came to the notice of the Grand Duke of Saxe-Weimar, who was to support him over the years, and was therefore able to move into a studio

of his own when he fell out with his teachers at the Academy in 1881. The development of an individual style, parallel to French Impressionism, is recognizable in the works he painted from 1888 onwards. Through Henry van de Velde he became acquainted with Impressionism and Post-Impressionism. In 1900 he was invited to move to Hagen by Karl Ernst Osthaus, whose Folkwang Museum in Hagen was to be furnished by van de Velde. He accepted the invitation in 1901. During summer visits in 1905 and 1906 to Soest, not far from Hagen, he met Emil Nolde. The early form of Expressionism represented by 'Die Brücke', to which early exhibitions at the Folkwang Museum were devoted, corresponded with Rohlfs' own leanings towards expressive painting.

Though Rohlfs' work in the twenty years after his academic beginnings bore the stamp of Impressionism, this contemporary of Liebermann and Uhde managed at the age of 60 to establish the expressive style of his late period. He now favoured tempera on canvas and paper, at the same time producing watercolours and prints. At the invitation of the collector Commerell he lived in Munich and the Tyrol from 1910 to 1912, afterwards returning to Hagen. Numerous celebrations which were held to mark his 75th birthday testify to the recognition his late work achieved. From 1927 onwards he spent most of the year at Ascona (Tessin) for health reasons. In 1929 the town of Hagen founded a Christian Rohlfs Museum. In 1937 he was banned from exhibiting in Germany, had 412 of his works confiscated as 'degenerate' and was excluded from the Prussian Academy of Arts. A year later he died in his Hagen studio at the age of 88.

Major Catalogues:

Christian Rolfs – Das Spätwerk, Kunstverein, Darmstadt, 1960

Catalogues raisonnés:

Paul Vogt (ed.), *Christian Rohlfs – Œuvre der Ölgemälde*, Recklinghausen, 1978

Monograph:

Paul Vogt, *Christian Rohlfs*, Cologne, 1953

Christian Schad

was born at Miesbach, Upper Bavaria, on 21 August 1894. He grew up in an affluent and cultured middle-class family, and was able to realize his wish to study painting even before he finished school. His father, who was a lawyer, went on supporting him long after he had completed his studies. At the age of 19 he studied for a short time under the Munich animal-painter Heinrich von

Zügel, but it was in Schwabing, the artists' quarter of Munich, that he developed his real tastes in art. In 1915 he avoided military service by inventing a heart complaint and went to live in Switzerland, first in Zurich and then, from 1916 to 1920, in Geneva. There he joined with the writer Walter Serner in running the less well-known Geneva section of the Dadaist movement. In 1919 they organized the first Dadaist world congress, in which, among others, Hans Arp, Tristan Tzara, Alexander Archipenko and Igor Stravinsky took part. At this time he produced graphics and paintings under Expressionist and Cubist influence, as well as photograms (*Schadographs*, 1918). These were followed in 1919 and 1920 by wood reliefs and relief assemblages. In 1920 he returned briefly to Munich, only to leave Germany again the same year to live in Rome and Naples until 1925. Faced with the realities of post-war Germany he was convinced that the Dadaist phase was over, and his encounter with the works of Raphael and the contemporary artistic scene in Italy provided the decisive impulse to develop his own objective style. In 1925, when the Mannheim exhibition of 'New Objectivity' showed the work of the German painters representing this new artistic mood, Schad left Italy to live in Vienna until 1927, when he moved to Berlin. Here, until the early 1930s, he did pen-drawings and oils which earned him a reputation as an extreme representative of 'New Objectivity'. The work produced during these

years consists of portraits which, while they may seem chilly, re-create the field of tension – mainly erotic – in which the subjects led their lives, together with erotic drawings and scenes from the life of the bohemian world Schad inhabited.

From 1935 Schad lived the life of a businessman and produced little work – a few landscapes and portrait drawings – during the National Socialist period, until in 1942 he was commissioned by the town of Aschaffenburg to make a copy of Matthias Grünewald's *Stuppach Madonna* in the original dimensions. This was finally completed in 1947. After the war he painted more portraits and nudes and produced etchings, drawings and *schadographs*.

Schad died in 1982 at Keilberg, near Aschaffenburg, where he had lived part of the time since the destruction of his Berlin studio, finally settling there in 1962.

Major Catalogue:

Christian Schad, Staatliche Kunsthalle, Berlin, 1980 (with a list of exhibitions, bibliography, and texts by Matthias Eberle and Hanne Bergius)

Oskar Schlemmer

was born in Stuttgart on 4 September 1888. He attended the local grammar school until his father's death in 1902, after which, from 1903 to 1905, he served an apprenticeship as a commercial artist. After a term at the School of Arts and Crafts he won a scholarship to the Stuttgart Academy of Fine Arts and studied there until 1910. After spending a year in Berlin he returned to Stuttgart, where, as a member of Adolf Hölzel's master class, he was given a studio of his own. It was during his student years that he met Willi Baumeister and Otto Meyer-Amden. In 1913 he opened his own art salon, where he showed works by artists of the international avant-garde, among them Klee, Kandinsky, Kokoschka and Braque. A commission for a mural to be shown at the 'Werkbund' exhibition in Cologne in 1914, which he executed in collaboration with Baumeister and Hermann Stenner under Hölzel's supervision, brought him into contact with Ernst Ludwig Kirchner, Walter Gropius and other contemporary artists and architects. Except for spells of leave he spent the whole of the First World War in active service, first as a volunteer medical orderly and later as an infantryman and cartographer. An officer training course in 1918 took him to Berlin, where he witnessed the ending of the war and the November Revolution. Returning to Stuttgart, he was elected as a students' representative at the Academy and a delegate on the Council of Intellectual Workers. Together with Baumeister and four other artists he founded the Üecht Group, which in 1919 mounted an avant-garde exhibition entitled 'Herbstschau Neuer Kunst' (Autumn Show of New Art) at the Kunstverein, Württemberg; this included not only their own works, but a selection of works by artists of the Berlin 'Sturm' and a special collection of works by Klee, whom the group had unsuccessfully campaigned to have appointed to the Academy.

In 1921 Schlemmer moved to Weimar with his wife, having been invited by Gropius to accept a three-year contract with the Bauhaus. His wide range of activities led him to assume various duties which he performed either simultaneously or in succession, among them being stone sculpture, murals, metallurgy, the teaching of life drawing and the theory and practice of drama. Outside the Bauhaus he often went to Berlin in connection with the designing of stage-sets. His own *Triadic Ballet*, on which he had worked since the early twenties, was performed several times to music composed by Paul Hindemith. Apart from his successful work for the stage, his three-dimensional figurative painting, especially the *Gallery Pictures*, won wide recognition, and in 1929 he was invited by Oskar Moll to teach at the Breslau Academy of Fine and Applied Arts, where he remained until it was closed in 1932. In the same year Paul Schultze-Naumburg had Schlemmer's Bauhaus murals destroyed, and in 1933 Schlemmer lost his new post at the State School for Fine and Applied Arts in Berlin. His wall paintings in the Fountain Room of the Folkwang Museum in Essen were removed.

From 1933 to 1937 Schlemmer and his family lived in Switzerland, but in 1937 he took a house at Badenweiler on the German side of the border. Exhibitions and commissions for murals in Berlin and Stuttgart did something to improve his situation, but the exhibition 'Degenerate Art' put an end to his artistic freedom inside Germany. He was obliged to support his family by working for a firm of painters, doing small wall paintings and, after 1939, an increasing amount of work on the camouflaging of military installations. In 1940 he accepted an offer from Herberts, the lacquer

manufacturer in Wuppertal, to set up a laboratory for experiments in lacquer technique. As a result he spent most of his time in Wuppertal. He died in 1943 after a protracted illness while taking a cure at Baden-Baden.

Schlemmer was one of the most versatile artists of the twentieth century, not only successful in the conventional genres – painting, wall design, sculpture, drawing and graphics – but responsive to the challenges of advertising and utilitarian art, and inventive in the devising of lively teaching models for the educational activities of the Bauhaus. More than anything else it is the close connection between his work for the ballet and the theatre and his concern as a painter with the mutations of figures in space which demonstrates that his range of activities did not lead to a dissipation of his talents, but must be viewed as an endeavour to arrive at what Richard Wagner called a *Gesamtkunstwerk*.

Artist's Writings:

Oskar Schlemmer, *Die Bühne im Bauhaus*. Bauhausbuch, 1925
Briefe und Tagebücher, Munich, 1958

Major Catalogue:

Karin von Maur, *Oskar Schlemmer*, Staatsgalerie, Stuttgart, 1977; book edition: Munich, 1982 (with biographical documentation, references to secondary literature and synopsis of the artist's work)

Catalogues raisonnés:

Karin von Maur, *Oskar Schlemmer, Monographie und Œuvrekatalog der Gemälde, Aquarelle, Pastelle und Plastiken*, 2 vols, Munich, 1979
Wulf Herzogenrath, *Oskar Schlemmer – Die Wandgestaltung der neuen Architektur*, Munich, 1973
Will Grohmann and Tut Schlemmer, *Oskar Schlemmer – Zeichnungen und Graphik*, Stuttgart, 1965

Rudolf Schlichter

was born at Calw on 6 December 1890, the sixth child of a jobbing gardener. After leaving the elementary school he attended grammar school, which he left in 1904 to serve an apprenticeship as an enamel painter in Pforzheim. After attending the School of Arts and Crafts in Stuttgart from 1907 to 1910, he studied at the Karlsruhe Academy of Art until 1916, when he was called up for war service. However, after going on hunger strike, he was discharged from the forces and returned to Karlsruhe. After the war he helped to found the artists' group 'Rih', which regarded itself

as a local branch of the Berlin November Group, which he joined after moving to Berlin in 1919. In Berlin he joined the Dadaists and became a member of the Communist Party. In 1920, when works by Dix and Schlichter were excluded from the Great Berlin Art Exhibition, the November Group split up; not only Dix and Schlichter, but also Grosz, Hausmann, Hannah Höch and Georg Scholz reacted to 'opportunism' on the part of the November Group with an open letter explaining why they were withdrawing from it. In 1924 Schlichter became secretary of the Communist artists' association known as the 'Red Group'. After the end of the Dada phase Schlichter, like Dix and Grosz, came to be regarded as a 'Verist', a representative of the New Objectivity, and as such he won considerable recognition. Among his acquaintance were Bertolt Brecht, Afred Döblin, Oskar Maria Graf, Erich Kästner and Egon Erwin Kisch, as is attested not least by his portraits (*Bertolt Brecht*, 1926; *Egon Erwin Kisch*, 1928; *Oskar Maria Graf*, 1923). At this time Schlichter's favourite motifs are drawn from the big city and its street-life and the subculture of bohemianism and left-wing intellectuals; he also painted portraits and depictions of sexual obsessions. He earned his living from drawings and illustrations done for various publishers. Towards the end of the 1920s he withdrew from the workers' movement and associated with conservative nationalist intellectuals like Ernst Jünger. His return to the Catholic Church determined the milieu he frequented until the end of the war. In 1932 he moved to the episcopal city of Rottenburg on the Neckar. He and his wife Speedy lived there until 1935, then in Stuttgart until 1939, and finally in Munich, where he maintained contacts with the Catholic periodical *Hochland*, which was critical of the National Socialist regime. One of his drawings which criticized the régime appeared in 1934 in the Catholic youth magazine *Junge Front*. It was entitled *Goliath Mocks the People of the Jews*. This led to his temporary exclusion from the Reich Chamber for the Fine Arts. For his painting *Blind Power*, 1937, he received a reprimand, and in the same year seventeen of his works were confiscated, among them his portrait of Ernst Jünger in the National Gal-

lery, Berlin. Some were included in the exhibition 'Degenerate Art'. In 1938 he was imprisoned for three months. The work Schlichter did after the war has a Surrealist character. He died in Munich on 3 May 1955.

Artist's writings:

Zwischenwelt, Ein Intermezzo, Berlin, 1931
Das widerspenstige Fleisch, Berlin, 1932
Das Abenteuer der Kunst, Stuttgart, 1949

Catalogue:

Rudolf Schlichter 1890-1955, Staatliche Kunsthalle, Berlin, 1984 (contains a biography by Gabriele Horn, a list of exhibitions, a preliminary list of the book illustrations, and contributions by Günter Metken, Hanne Bergius and others)

Karl Schmidt-Rottluff

was born in Rottluff, near Chemnitz, on 1 December 1884, the son of a miller. He attended the local elementary school until 1895, when he went to the grammar school in Chemnitz. Here he met Erich Heckel. After leaving school in 1905 he started to study architecture at the Technische Hochschule in Dresden, but soon left, as Heckel had done earlier, to work as an independent artist, after joining with Kirchner, Heckel and Bleyl to form the group known as 'Die Brücke'. In 1906 he visited Emil Nolde in Alsen, and in 1907 spent the summer with Heckel in Dangast, where he returned every summer until 1912. In 1912 he moved from Dresden to Berlin and participated in the 'Sonderbund' exhibition in Cologne. From 1915 to 1918 he served in a labour battalion stationed in northern Russia. After returning to Berlin he was a member of the 'Arbeitsrat für Kunst'. The 1920s were marked for him by numerous exhibitions and journeys abroad, during which he visited Italy, Paris, Dalmatia and the Tessin, accompanied by Richard Scheibe, Georg Kolbe and his wife Emmy Frisch. In 1933 he left the Prussian Academy of Arts, of which he had been elected a member in 1931. In 1937 more than 600 of his works were confiscated and twenty-five of them shown at the exhibition 'Degenerate Art'. Like Emil Nolde he was excluded from the Reich Chamber of Fine Arts in 1941 and prohibited from painting. He now confined himself to watercolours. Works of his that had been evacuated to Silesia were destroyed, as was his studio in Berlin. From 1943 to 1947 he lived in Chemnitz. In 1947 he was appointed to a professorship at the West Berlin Hochschule für Bildende Künste. In 1967, on his initiative, the Brücke-Museum was opened in Berlin, and he presented sixty of his works to it. He died in Berlin on 10 August 1976 at the age of 91. With the money he left in his will a scholarship was created and named after him; this is awarded every year to six young artists. As well as his paintings his work includes wooden sculptures and woodcuts. In his pictures landscapes remain a dominant theme, even though other artists of 'Die Brücke', notably

Kirchner, made the city the chief theme of Expressionist painting. Also important among his works are figure pictures, portraits and still-lifes.

Major Catalogues:

Rosa Schapire, *Karl Schmidt-Rottluff. Das graphische Werk bis 1923*, Berlin, 1924 (reprint New York, n. d.)
Ernst Rathenau, *Karl Schmidt-Rottluff. Das graphische Werk seit 1923* (2 vols.), New York, 1976
Karl Schmidt-Rottluff. Ausstellungskatalog des Folkwang Museums, Essen, 1964

Monograph:

Will Grohmann, *Karl Schmidt-Rottluff*, Stuttgart, 1956

Eugen Schönebeck

was born in Dresden in 1936 and attended the School of Wall Painting in East Berlin before moving to West Berlin in 1955. Here he studied at the Hochschule für bildende Künste from 1955 to 1961 under Hans Jaehnisch and Hans Kuhn. In 1957 he met Georg Baselitz, with whom he drew up the first *Pandämonisches Manifest* in 1961 on the occasion of a joint exhibition; the second followed in 1962. After his training in the figuration of Socialist Realism in the East, his early drawings and paintings leant towards the non-formal style. From the amorphous structures of this type of painting figurative elements began to emerge, which soon came to dominate his pictures and led to 'expressive-monumental' paintings like *The Crucified*, 1964, and *Figure with Bird*, 1963, 1964. This development was due not least to Schönebeck's encounter with the work of Jean Fautrier. In 1965 and 1966 the "subjective-expressive devices are further reduced and a kind of painting is developed which employs a thin, transparent application of pigment and transforms figures, objects and landscape into planar elements

which evoke light and plasticity and permit of an enlargement into broad plane painting" (Gercken). It was during this period that Schönebeck discovered his own style, which he now once more designated as 'Socialist Realism', though this is neither a term of approval nor an indication of irony such as that implied by Gerhard Richter, Konrad Fischer-Lueg and Sigmar Polke when they invented 'Capitalist Realism' in 1963. He understands his paintings – for instance the portrait of *Majakowski* (1965), the artist of the Russian Revolution – as being 'socialist' in a

utopian sense; and he sees them as 'realistic' by contrast with the 'naturalism' of official East German art. Apart from some hundred drawings, Schönebeck produced eight of these paintings in 1965 and 1966. Their conception was closely bound up with his study of the work of Fernand Léger and the Russian realist Alexander Deineka, and equally closely with his interest in the Mexican wall painters (*Siqueiros*, 1966). Shortly before the student revolt began to propagate utopian socialism and to choose as its heroes figures who had already been subjects of Schönebeck's portraits (*Mao*, 1965), and the international success of Pop Art made figurative painting respectable once more, Schönebeck suddenly gave up painting at the age of 30. This artist before his time is also a shy, withdrawn person who has since shunned all public interest in his painting and himself.

Artist's writings:

Eugen Schönebeck/Georg Baselitz, '1. Pandämonium' and '2. Pandämonium', *Die Schastrommel*, VI, Berlin/Bolzano, 1972

Catalogue:

Eugen Schönebeck. Bilder, Skizzen, Zeichnungen 1962-1973, Berlin, 1974 (with texts by Klaus Gallwitz, Günter Gercken and Christos M. Joachimides and a list of exhibitions)

Kurt Schwitters

was born in Hanover on 20 June 1887, the only child of parents who ran a ladies' outfitting business. After the grammar school he attended the local arts and crafts school from 1908 to 1909, then went on to study at the Dresden Academy of Art until 1914. Combined with a prosperous family background, the years of solid academic training he had received in Dresden – of which he spoke appreciatively – and in particular under Bantzer, an admirer of Frans Hals, provided the foundation for a conventional painting career. Paintings from this period reveal at most reactions to contemporary artistic currents and little in the way of striking originality. In 1917, at the age of thirty, he was called up into the army, where he served in the orderly room, having been graded unfit as a result of the epilepsy from which he had suffered since youth. His efforts to prove that he was unfit even for clerical duties were successful, and after only four months he was discharged. The war, inflation and the cultural upheavals of the post-war years threatened his previous economic security, yet at the same time they transformed him from a follower of Expressionism into a real contemporary artist. His first collages date from 1918, and the volume of prose and poetry *Anna Blume*, which he published a year later, turned the Dadaist from provincial Hanover into a well-known figure overnight, even in the centres of the avant-garde. Contacts with Herwarth Walden (of *Der Sturm*), Hans Arp and Tristan Tzara soon followed, as well as 'Sturm' exhibitions in which he was represented in New York and Zurich. Of decisive importance for him was his close connection with the Dutch Dadaists and Constructivists, to whom he devoted the first number of the journal *Merz* in 1923, and with artists at the Bauhaus in Weimar, where he took part in the international meeting of Dadaists in 1922. Such affinities also suited his professional work as a typographer, which the loss of his financial resources obliged him to pursue, but for which he also had a distinct liking and aptitude. Having worked for firms in Hanover and elsewhere as a graphic artist and commercial designer since 1923, he received a commission from Walter Gropius in 1929 to work as commercial artist on the building of the Dammerstock estate in Karlsruhe. In 1927,

together with Cesar Domela, Moholy-Nagy and Friedrich Vordemberge-Gildewart, he founded the 'ring neuer werbegestalter' (circle of new commercial designers), which was joined by Willi Baumeister, Walter Dexel, Hans Leistikow and Jan Tschichold, among others.

Apart from this professional work, which should be seen as closely linked with his artistic activities, he not only continued with the collages and material pictures of the *Merz* series (begun in 1919), but developed an interest, beginning about 1923, in reliefs, architectural models and stage sets, culminating in the laborious completion of the *Merzbau*; this provided a remarkable contrast to the frequently derided bourgeois milieu in which he lived and is one of the most enigmatic and bizarre constructions of modern art. The international response to his work did not immediately bring commensurate museum purchases; in fact, these did not begin until the mid-thirties, by which time he had inherited his father's estate (his father died in 1931) and was once more able to lead the life of an independent artist. However, this freedom was soon brought to an end by the change in political conditions after 1933. In 1931 he began making long annual visits to Norway, where he painted naturalist landscapes, and early in 1937 he finally emigrated to Norway. The exhibition 'Degenerate Art', mounted in the same year, included pictures by him, among them the first *Merz* picture (now lost) which gave the series its name. Exile in Norway was followed by flight to England in 1940 when the Germans invaded. In Norway he had been underrated and isolated; his position did not change noticeably in England. He planned to return to Hanover, hoping to salvage the remains of his *Merzbau* ("my life's work") from the ruins of his house and to reconstruct it. Nothing came of this plan. He died in 1948 after a period of illness, and it was only after his death that his work found international recognition. To his cultivation of the most varied genres in the sphere of the visual arts must be added his literary production, which is characterized, like his *Merz* works, by an idiosyncratic fusion of humour and Dadaism.

Artist's Writings:

Kurt Schwitters, *Anna Blume. Gedichte*, Hanover, 1919 and 1922
Das literarische Werk, Friedhelm Lach (ed.), 5 vols, Cologne, 1973-81

Detailed Monograph:

Werner Schmalenbach, *Kurt Schwitters*, 2nd ed., Munich, 1984 (with detailed biography, list of exhibitions and a select bibliography by Hans Bollinger of the artist's publications and of writings about his work)

Recent Publication:

Dietmar Elger, *Kurt Schwitters – Der Merzbau*, Cologne, 1984

Günter Uecker

was born in Wendorf, Mecklenburg, on 13 March 1930 and grew up on the island of Wustrow, in the Baltic. After attending a boarding school he studied painting in Wismar and at the Art Academy in Berlin-Weissensee from 1949 to 1953. In 1955 he left the German Democratic Republic and moved to Düsseldorf, where he continued his studies until 1958 at the Academy of Art under Otto Pankok and others. Starting with the non-formal panel picture, he tried to remove all subjective content by an anonymous kind of composition, first by finger painting and then by the use of tools which were so conceived as to produce out of the pastose oil pigments a structure which would occupy the place of anything recognizable as deriving from the artist personally. These *Structure Paintings*, which began to appear in 1955, were further developed by the inclusion of plastic ele-

ments which give the pictures the character of reliefs. One of the instruments which Uecker used to produce structural grooves in the paint became the prototype for a device which has characterized his pictures since 1957. It is a 'comb' constructed of nails which started as a tool but was transformed into an object. This became a model for a new structuring of the panel picture by means of nails which are driven into oil paintings and function as plastic elements – as in *Painting*, 1956/8 – and are used above all as the predominant compositional device in the pictures, which lose much of the dramatic interest associated with colour and often contain only white. An example is *Informal Structure*, 1957. Nails are used in profusion to cover not only variously structured panel pictures, but also items of furniture and musical instruments: examples are *Television*, 1963; *Chair*, 1963; and *Piano*, 1964. Their structure varies from undulating reliefs to geometrically precise constructions which are nailed on to purpose-made bases, to illuminated discs which are activated by an electric motor as light is played on to them (1961), and to spatial constructions which take on the character of installations, an example being *Corner*, 1968. The interplay of light and shade is an integral part of these constructions and is realized either through

the movement of the viewer or through the proper movement of the objects. Random assemblages of nails – as in *Scattered Nails*, 1972 – are exceptional. The pictures are for the most part laboriously constructed out of large numbers of nails which are assigned to the emergent formations with a high degree of artistry. In his programmatic rigour and his interest in light phenomena outside the panel picture Uecker was close to the Zero group founded by Mack and Piene. His development, like theirs, received a new impetus from encounters with the work of Lucio Fontana and Yves Klein. Sculptures with ropes and strings, such as *String Chair*, 1969, represent other aspects of his work, as do stage sets, outdoor sculptures, music projects – such as *Terror Orchestra* – and happenings. He is a professor at the Academy of Art in Düsseldorf.

Monograph:

Dieter Honisch, *Uecker*, Stuttgart, 1982 (with a list of works compiled by Marion Haedecke)

Hans Uhlmann

was born in Berlin on 27 November 1900. While studying engineering at the Technische Hochschule in Berlin from 1919 to 1924 he continued to play and study the violin. After completing his studies he first worked in industry and then, from 1926, taught electrical engineering at the Technische Hochschule. In 1925 he made his first sculptures. In 1933 he was imprisoned for two years by the National Socialists for high treason, and after his release he went back to work in industry. He now began to produce sculptures of wire and sheet iron whose abstract geometrical forms were akin to those of Constructivism.

In 1950 Uhlmann was appointed to the Hochschule für Bildende Künste in West Berlin, where in 1953 he took over the metal sculpture class. At this period his designs tend to assume broad, sweeping, dynamic forms, though in the course of the 1950s their contours become more austere and compact. He died in Berlin on 28 October 1975.

Monograph:

Werner Haftmann, *Hans Uhlmann – Leben und Werk*, Berlin, 1975 (with a catalogue of the sculptures compiled by Ursula Lehmann-Brockhaus)

Wols

was born in Berlin as Alfred Wolfgang Schulze on 27 May 1913. In 1919 his family moved to Dresden, where his father, a lawyer by profession, had been appointed assistant secretary in the Saxon state chancellery. From 1922 to 1931 he attended a classical grammar school in Dresden. He became a friend of Otto Dix, who began teaching at the Dresden Academy in 1927, and of the son of Fritz Busch, the conductor of the Dresden State Opera. In 1931 Busch invited Wols, who had played the violin since the age of 6, to become the leader of the orchestra, but Wols decided instead to work in

a photographic studio and in a car repair workshop. In 1932 he planned to go on an expedition with Leo Frobenius, the Frankfurt anthropologist, but then decided to study at the Bauhaus. Moholy-Nagy advised against this and suggested that he should go to Paris instead. In Paris Wols met Ozenfant, Léger, Arp and Domela. He worked as a teacher of German and as a portrait photographer and also met his future wife, Gréty. In 1933 he returned to Germany briefly to take charge of his father's estate. He planned to use the money to run a touring cinema in the south of France, but the scheme came to nothing for want of a residence permit. From 1933 to 1935 Wols and his future wife lived in Barcelona and on Ibiza; then from 1936 they lived in Paris, where among other things he was an official photographer at the World Exhibition of 1937. Having had a running battle with the Spanish and French authorities since 1933, he was interned in various camps at the beginning of the war but then released in November 1940. He settled in Marseilles, whence he fled into the interior in 1942, often changing his place of abode in order to escape the German invaders. A plan to emigrate to the USA was thwarted by his wretched economic circumstances.

From the time of his internment Wols concentrated on drawings and watercolours, and in 1945 an exhibition of these was held in Paris. He met Jean-Paul Sartre, who helped him out financially on a number of occasions. He now began painting in oils, which he had been unable to do before because of his financial situation. This still did not improve substantially, despite growing recognition among fellow artists. Having been a heavy drinker since his time as an internee, he underwent treatment for alcoholism in 1951. In the same year he died of ptomaine poisoning at the age of 38.

Catalogue:

Wols. Gemälde, Aquarelle, Zeichnungen, Fotos, Frankfurter Kunstverein, 1966

Monographs:

Werner Haftmann (ed.), *Wols. Aufzeichnungen, Aquarelle, Aphorismen, Zeichnungen*, Cologne, 1963 (American edition, New York, n. d.)

Laszlo Glozer, *Wols Photograph*, Munich, 1978

Chronology

	Politics	Art	Culture
1900	Boxer rising in China; German troops are sent to China. Second naval law provides for expansion of German naval forces. Launching of the 1st Zeppelin.	Franz von Stuck and Franz von Lenbach exhibit at the Paris *Décennale* world exhibition.	Sigmund Freud: *Die Traumdeutung* (The Interpretation of Dreams). Georg Simmel: *Philosophie des Geldes* (Philosoph of Money). Stefan George: *Der Teppich des Lebens* (The Carpet of Life). Nietzsche dies.
1901	Breakdown of talks on an Anglo-German alliance. Tsar Nicholas II of Russia attends German naval manoeuvres.	Kandinsky founds the 'Phalanx' in Munich. *Dokument Deutscher Kunst* (Retrospective Exhibition of German Art) on the Darmstadt Mathildenhöhe. Van de Velde becomes the founding director of the *Großherzoglich-Sächsische Kunstgewerbeschule* in Weimar (School of Arts and Crafts under the aegis of the Grand Duke of Sachsen-Weimar-Eisenach).	Edmund Husserl: *Logische Untersuchungen* (Logical Investigations). Alois Riegl: *Spätrömische Kunstindustrie* (Late Roman Art Industry). Thomas Mann: *Die Buddenbrooks*. *Die Elf Scharfrichter* (The Eleven Executioners) cabaret in Munich.
1902	Renewal of the Triple Alliance between Germany, Austria and Italy. Italy concludes Reinsurance Treaty with France. Krupp buys the Germania Shipyards in Kiel.	The *Museum Folkwang* is opened in Hagen (Karl Ernst Osthaus). Max Klinger: Beethoven monument.	Hugo von Hofmannsthal: *Ein Brief* (Chandos Letter). Rainer Maria Rilke: *Buch der Bilder* (Book of Pictures). Aby Warburg founds the Warburg Library (in London since 1933).
1903	Strike by textile workers in Crimmitschau. In the Reichstag the Centre holds 100 seats, the SPD (Social Democratic Party) 81, the Conservatives 52, the National Liberals 50, the Progressive People's Party 21 out of a total of 384 seats.	Art education days in Weimar. Rainer Maria Rilke in Worpswede.	Gerhard Hauptmann: *Rose Bernd*. Thomas Mann: *Tristan*. Six novellas.
1904	Construction of the 1st German submarine. Foundation of the *Reichsverband gegen die Sozialdemokratie* (Imperial Association against Social Democracy). Strikes in the Ruhr industrial area. The 'Entente Cordiale' defines English and French interests in Morocco.	*Internationale Kunstausstellung* (International Exhibition of Art) in Düsseldorf. First exhibition of the *Deutscher Künstlerbund* in Weimar.	Otto zur Linde and Rudolf Pannwitz found the *Charon* Group. Julius Meier-Graefe: *Entwicklungsgeschichte der modernen Kunst* (History of the Development of Modern Art).
1905	Strikes in Central Germany in support of socio-political changes and abolition of the third-class franchise. Wilhelm II visits the Sultan of Morocco to secure German interests.	Foundation of the artists' group *Die Brücke* in Dresden.	Max Weber: *Die protestantische Ethik und der Geist des Kapitalismus* (The Protestant Ethic and the Spirit of Capitalism). Albert Einstein: *Spezielle Relativitaetstheorie* (Special Theory of Relativity). Heinrich Mann: *Professor Unrat* (The Blue Angel). Richard Strauss: *Salome*.
1906	Suppression of the uprising in German South West Africa. Dissolution of the Reichstag which had refused 29 million Marks for this campaign. France's claim to Morocco is recognised.	The *Jahrhundertausstellung 1775-1875* (Centennial Exhibition) is organized by Hugo von Tschudi at the Nationalgalerie in Berlin. This leads to the rehabilitation of 19th-century art and particularly Romanticism.	Robert Musil: *Die Verwirrungen des Zöglings Törleß* (Young Torless). Hermann Hesse: *Unterm Rad* (Beneath the Wheel). Max Reinhardt opens the Kammerspiele in Berlin with Ibsen's *Ghosts*, stage set by Edvard Munch.
1907	The SPD loses about 50% of its seats in the Reichstag election ('Hottentot' election). Russian, French and English alliances complete Germany's isolation.	*Der Deutsche Werkbund* is founded in Munich by artists, architects and manufacturers.	Robert Walser: *Geschwister Tanner* (Tanner Sisters). Stefan George: *Der Siebente Ring* (The Seventh Ring). AEG employs Peter Behrens as artistic adviser.
1908	Germany becomes the strongest sea power after England as a result of its arms programme. Austria-Hungary annexes Bosnia with German support. Protests from England, Russia and Serbia.	Wilhelm Worringer, *Abstraktion und Einfühlung* (Abstraction and Empathy). A contribution to the psychology of style. *Sonderausstellung* by 7 painters in the Düsseldorf Kunsthalle leads to formation of the *Sonderbund*.	Karl Kautsky: *Der Ursprung des Christentums* (The Origin of Christianity). Adolf Loos: *Ornament und Verbrechen* (Decoration and Outrage). Arno Holz: *Sonnenfinsternis* (Eclipse of the Sun). Alfred Kubin: *Die andere Seite* (The Other Side). Else Lasker-Schüler: *Die Wupper*.
1909		*Sonderbund* exhibition in Düsseldorf, Cologne, Münster and Barmen. Foundation of the *Neue Künstlervereinigung München* (New Artists' Association of Munich). Exhibition in Munich, Elberfeld, Barmen and Hagen.	Foundation of the *Deutsche Gesellschaft für Soziologie* (German Society for Sociology). Thomas Mann: *Königliche Hoheit* (Royal Highness). Heinrich Mann: *Die kleine Stadt* (The Little Town). Gustav Mahler: *Das Lied von der Erde* (The Song of the Earth). Arnold Schoenberg: *George-Lieder*

	Politics	Art	Politics
1910	Tsar Nicholas II visits Potsdam, agreement on a Russo-German alliance.	Herwarth Walden's periodical *Der Sturm*, published until 1932. Second *Sonderbund* exhibition, Düsseldorf. Exhibition of the *Neue Künstlervereinigung* in Munich, Mannheim and Karlsruhe ('Karlsruhe art scandal').	Dilthey: *Der Aufbau der geschichtlichen Methode in den Geisteswissenschaften* (Organisation of Historical Methods in the Humanities). Paul Natorp: *Die logischen Grundlagen der exakten Wissenschaften* (The Logical Foundations of the Exact Sciences).
1911	Despatch of a German gunboat to Agadir causes 2nd Moroccan crisis. Germany recognises Morocco as a French protectorate in the Morocco Congo Agreement and in exchange receives French territory in the Congo.	Marc and Kandinsky found the editorial office of *Der Blaue Reiter* (The Blue Rider). The *Brücke* artists move to Berlin.	Wilhelm Wundt: *Einführung in die Psychologie* (Introduction to Psychology). Worringer: *Formprobleme der Gotik* (Gothic Problems of Form). Hauptmann: *Die Ratten* (The Rats). Georg Heym: *Der ewige Tag* (The Eternal Day). Franz Pfemfert: periodical *Die Aktion* (until 1932).
1912	First Balkan War involving the First Balkan Alliance (supported by Russia) against the Ottoman Empire. Renewal of the Triple Alliance between Italy, Germany and Austria-Hungary.	Walden opens his gallery *Der Sturm* in Berlin. Futurists exhibition in Berlin, Cologne and other towns. Fourth *Sonderbund* exhibition in Cologne is the precursor of the *Armory Show* (New York, 1913).	Alfred Weber: *Religion und Kultur* (Religion and Culture). Alfred Adler: *Über den nervösen Charakter* (The Neurotic Constitution). C. G. Jung: *Wandlungen und Symbole der Libido* (Psychology of the Unconscious. A Study of Transformations and Symbolisms of the Libido). Strauss/Hofmansthal: *Ariadne on Naxos*.
1913	2nd Balkan War between the 2nd Balkan Alliance and Bulgaria, supported by Austria-Hungary. The SPD, the strongest party in the new Reichstag, supports the armament programme.	Dissolution of *Die Brücke*. Formation of the artists' group *Das junge Rheinland* in Bonn (Macke). *Rheinische Expressionisten* exhibition. Alfred Flechtheim opens his gallery in Düsseldorf.	Werner Sombart: *Der Bourgeois*. Husserl: *Phänomenologie*. Franz Kafka: *Das Urteil* (The Judgment). Frank Wedekind: *Lulu*. Georg Trakl: *Gedichte* (Poetry). Thomas Mann: *Tod in Venedig* (Death in Venice). Max Reger: *Böcklin Suite*.
1914	Rivalry between Russia and Austria-Hungary for influence in the Balkans develops into a conflict which results in war. On 1st August Germany declares war on Russia, on 3rd August war on France.	Klee, Macke and Moilliet travel to Tunis. *Werkbund* exhibition in Cologne.	Heinrich Mann: *Der Untertan* (Man of Straw). Walter Hasenclever: *Der Sohn* (The Son). Erich Mühsam: *Wüste, Krater, Wolken* (Desert, Crater, Clouds). Georg Kaiser: *Die Bürger von Calais* (The Citizens of Calais). Ernst Stadler: *Der Aufbruch* (The Departure).
1915	Poison gas is used for the first time on the Western Front by the German armed forces. The British liner Lusitania is sunk by torpedos from a German submarine. Protest by the USA.		Heinrich Wölfflin: *Kunstgeschichtliche Grundbegriffe* (Principles of Art History). Carl Einstein: *Negerplastik* (Negro Sculpture). Gustav Meyrink: *Der Golem* (The Golem). August Stramm: *Du* (You). René Schickele: *Hans im Schnakenloch* (Hans in the Mosquito Hole). Benn: *Gehirne* (Brains).
1916	Trench warfare and the war of attrition. The German army issues steel helmets and gas masks. Social democratic opponents of the war form the Spartacus League.	The first Dada proclamation in Zurich. Foundation of the *Kestner-Gesellschaft* in Hanover as secession of the *Kunstverein* (Society for the Promotion of Fine Arts).	Martin Buber: *Vom Geist des Judentums* (The Spirit of Judaism). Franz Kafka: *Die Verwandlung* (Metamorphosis). Johannes R. Becher: *An Europa* (To Europe). Albert Ehrenstein: *Der Mensch schreit* (Man Screams). Theodor Däubler: *Der neue Standpunkt* (The New Point of View).
1917	Food and coal shortages in Germany. 5000 sailors mutiny in the German fleet. Unrestricted submarine warfare. USA declares war on the German Reich. Formation of the USDP (Independent German Socialist Party).	The Malik-Verlag, founded by Wieland and Helmut Herzfelde, publishes the first folio of lithographies by Grosz. First issue of the magazine *Dada* in Zurich. Paul Westheim launches *Das Kunstblatt*.	Ivan Goll: *Requiem. Für die Gefallenen Europas* (Requiem. For Europe's Fallen). Hasenclever: *Antigone*. Hans Pfitzner: *Palestrina*. German film companies are centralized in Universum Film AG (Ufa).
1918	Germany and Russia sign the Treaty of Brest-Litowsk. Mutiny in the fleet, strikes and insurrection in Germany, November Revolution. William II abdicates. Armistice on the Western Front. Proclamation of a republic.	The first Dada evenings in Berlin. Foundation of the *Arbeitsrat für Kunst* (Work Council for Art). Foundation of the *Novembergruppe* (November Group). *Das junge Rheinland* exhibitions in the Cologne *Kunstverein*. Re-establishment of *Das Junge Rheinland* in Düsseldorf.	Ernst Bloch: *Geist der Utopie* (Spirit of Utopia). Oswald Spengler: *Der Untergang des Abendlandes* (The Decline of the West). Jakob von Hoddis: *Weltende* (Doomsday). Ernst Barlach: *Der arme Vetter* (The Poor Cousin). Anton Wildgangs: *Dies irae*. Thomas Mann: *Betrachtungen eines Unpolitischen* (Reflections of a Nonpolitical Man)
1919	Foundation of the KPD (German Communist Party), Spartacus uprising in Berlin, communes in Munich. Liebknecht and Rosa Luxemburg are murdered. Inflation. Versailles peace treaty.	Dada performances in Berlin. First issues of *Die Pleite*, *Proletkult* and *Der Dada*. Prohibition of *Der Ventilator* and *Bulletin D* in Cologne. Walter Gropius founds the *Bauhaus* in Weimar.	Theodor Lessing: *Geschichte als Sinngebung des Sinnlosen* (History Interpreting the Absurd). Fritz von Unruh: *Der Opfergang* (The Self-sacrifice). Karl Kraus: *Die letzten Tage der Menschheit* (The Last Days of Mankind). Kafka: *In der Strafkolonie* (In the Penal Settlement). Franz Werfel: *Der Gerichtstag* (Judgment Day).

	Politics	Art	Culture
1920	Adolf Hitler disseminates the party programme of the NSDAP (National Socialist German Workers' Party) in Munich. Kapp Putsch. Spartacist uprising in the Ruhr area.	*1. Internationale Dada Messe* (Fair) in Berlin. *Dadavorfrühling* exhibition in Cologne (Arp, Ernst, Baargeld). Foundation of the *Gruppe Stupid* in Cologne (Hoerle, Raederscheidt, Seiwert). George Grosz: *Gott mit uns* (God be with us).	Spengler: *Preussentum und Sozialismus* (Prussianism and Socialism). Natorp: *Sozialidealismus* (Social Idealism). Kurt Pinthus (ed.): *Menschheitsdämmerung* (Decline of Mankind). Ernst Toller: *Masse Mensch* (Mass Man). Ernst Jünger: *In Stahlgewittern* (In Storms of Steel).
1921	French occupy Düsseldorf, Duisburg and Ruhrort to enforce payment of reparations. General strike in Central Germany. Influence of extreme right-wing secret organizations incresases.	Lawsuit against Herzfelde and Grosz on account of *Gott mit uns*. Grosz, *Das Gesicht der herrschenden Klasse* (The Face of the Ruling Class, Malik-Verlag). Dada spring festival in Weimar. Dix, Grosz, Hausmann and others leave the *Novembergruppe*.	Hugo Dingler: *Physik und Hypothese* (Physics and Hypothesis). Werner Weisbach: *Barock als Kunst der Gegenreformation* (Baroque as Art of the Counter Reformation). Andreas Heusler: *Nibelungensage und Nibelungenlied* (Nibelung Legend and the Song of the Nibelungs). Hindemith/Kokoschka: *Mörder, Hoffnung der Frauen* (Murderers, the Hope of Women).
1922	Treaty of Rapallo between Germany and Russia. Right-wing extremists murder the Foreign Minister Walther Rathenau. The *Stahlhelm*, an extreme right-wing paramilitary organization formed in 1918 is banned.	Conference of the *Union fortschrittlicher internationaler Künstler* (Union of Progressive International Artists) in Düsseldorf. International Congress of Constructivists and Dadaists in Weimar.	Hans Prinzhorn: *Bildnerei der Geisteskranken* (Psychiatric Art). Karl Valentin: *Der Firmling* (The Candidate for Confirmation). Barlach: *Der Findling* (The Foundling). Bert Brecht: *Trommeln in der Nacht* (Drums in the Night). Hesse: *Siddharta*. Kurt Weill: *Zaubernacht* (Magic Night).
1923	NSDAP and KPD are banned. French occupation of the entire Ruhr area. Militarization of the SA (*Sturmabteilung* or storm detachments) in Bavaria, state of emergency and martial law in the Reich. Putsch by Hitler and Ludendorff in Munich.	Grosz, *Ecce Homo* (folio). First edition of MERZ. First edition of *G-Zeitschrift für elementare Gestaltung* (Periodical for Elementary Design). *Die Reichswehr* (imperial armed forces) search Gropius's private house.	Georg Lukacs: *Geschichte und Klassenbewußtsein* (History and Class Consciousness). Herbert Kühn: *Die Kunst der Primitiven* (Primitive Art). Brecht: *Im Dickicht der Städte* (In the Jungle of Cities), *Baal*. Rilke: *Duineser Elegien* (Duino Elegies), *Sonette an Orpheus* (Sonnets to Orpheus). Stefan Zweig: *Amok*.
1924	2.6 million unemployed, inflation reaches its climax. Elections for the Reichstag result in substantial gains for the SPD and setbacks for right-wing extremists and the reinstated KPD.	The printing plates of *Ecce homo* are confiscated and destroyed. Grosz receives a fine of 6,000 Marks. Foundation of the *Rote Gruppe* (Red Group) and the *Blaue Vier* (Blue Four). The *Bauhaus* in Weimar is closed.	Thomas Mann: *Der Zauberberg* (The Magic Mountain). Piscator/Gasbarra: *Revue Roter Rummel*.
1925	The French occupation of the Ruhr ends. Friedrich Ebert, President of the Weimar Republic since 1919, dies. Paul von Hindenburg is elected president of the Reich. Hitler rebuilds the NSDAP from its cover organizations (27,000 members).	*Neue Sachlichkeit* (New Objectivity) exhibition in Mannheim (Gustav F. Hartlaub). The *Bauhaus* is re-opened in Dessau.	Nicolai Hartmann: *Ethik* (Ethics). A. Weber: *Die Krise des modernen Staatsgedankens in Europa* (The Crisis of the Modern Concept of the State in Europe). Lion Feuchtwanger: *Jud Süß* (Jew Suess). E. E. Kisch: *Der rasende Reporter* (The Mad Reporter). Alban Berg: *Wozzeck*.
1926	Formation of the Hitler Youth. The SA concept of 'national socialism' loses ground within the NSDAP. Treaty of neutrality between Germany and Russia. Germany enters the League of Nations.	*Internationale Kunstausstellung* in Dresden. *The Infant Jesus Being Spanked by the Virgin Mary* by Max Ernst is removed from the exhibition and from the catalogue of the Cologne secession.	Erich Rothacker: *Logik und Systematik der Geisteswissenschaften* (Logic and Systematics of the Humanities). Barlach: *Der blaue Boll*. B. Traven: *Das Totenschiff* (The Funeral Ship). Hans Grimm: *Volk ohne Raum* (People without Space). Marieluise Fleisser: *Fegefeuer in Ingolstadt* (Purgatory in Ingolstadt).
1927	Allied control over the German Reich ends. Ban on Hitler's speaking in public is lifted in Saxony, Bavaria and Prussia. Ban on NSDAP in Berlin is renewed (until 1928).	In Hanover El Lissitzky completes *Abstract Cabinet*. *Werkbund* exhibition in Stuttgart with the *Weissenhofsiedlung*.	Martin Heidegger: *Sein und Zeit* (Being and Time). Oskar Maria Graf: *Wir sind Gefangene* (We are Prisoners). Hesse: *Der Steppenwolf* (Steppenwolf). Hanns Eisler: *Zeitungsausschnitte op. 21* (Newspaper Cuttings). Brecht/Weill: *Aufstieg und Fall der Stadt Mahagonny* (Rise and Fall of the City of Mahagonny).
1928	Elections for the Reichstag: NSDAP 12 seats, SPD 153 seats, KPD 54 seats, nationalist parties 73 seats. Sixth congress of the Comintern widens the breach between socialists and social democrats.	Blasphemy/Profanity lawsuit against Grosz. Dix, Grosz, Karl Hubbuch, Kollwitz et al. found the *Assoziation revolutionärer bildender Künstler* ('Asso' – Association of Revolutionary Visual Artists). Hannes Meyer takes over directorship of the *Bauhaus*.	Rudolf Carnap: *Scheinprobleme in der Philosophie* (Fictitious Problems in Philosophy). Paul Schultze-Naumburg: *Kunst und Rasse* (Art and Race). George: *Das neue Reich* (The New Realm). Walter Benjamin: *Einbahnstraße* (One-way Street). Brecht/Weill: *Dreigroschenoper* (Threepenny Opera).
1929	World economic crisis ('Black Friday'). The KPD brands the SPD as 'social fascists' and resolves to create its own trades-union opposition. Split in the German workers' movement.	Foundation of *A–Z* as a mouthpiece of the Cologne Group of Progressive Artists. *Werkbund* exhibition entitled *Film & Foto* in Stuttgart. August Sander *Antlitz der Zeit* (Face of the Times) is published with a Foreword by Alfred Döblin.	Ernst Cassirer: *Philosophie der symbolischen Formen* (Philosophy of Symbolic Forms). E. M. Remarque: *Im Westen nichts Neues* (All Quiet on the Western Front). Alfred Döblin: *Berlin Alexanderplatz* (Alexanderplatz. The Story of Franz Biberkopf). Hindemith/Brecht: *Badener Lehrstücke* (didactic dramas).

	Politics	Art	Culture
1930	4.4 million unemployed. First national socialist participation in a *Land* government (Thuringia). In the Reichstag elections the NSDAP increases its 12 mandates to 107.	Hannes Meyer resigns as director of the *Bauhaus* owing to pressure from right-wing extremist groups. Mies van der Rohe becomes director.	Joseph Roth: *Hiob*. Robert Musil: *Der Mann ohne Eigenschaften* (The Man Without Qualities). Hans Fallada: *Bauern, Bonzen, Bomben* (Peasants, Bosses, Bombs). Lion Feuchtwanger: *Erfolg* (Success). Manfred Hausmann: *Kleine Liebe zu America* (Small Love for America). E. E. Kisch: *Paradies Amerika* (Paradise America).
1931	Withdrawal of funds by foreign investors leads to the banking crisis. 5.7 million unemployed. Formation of the 'Harzburg Front' (NSDAP/National People's Party/*Stahlhelm*).	The group *Abstraction-Creation* (Paris) accepts Baumeister, Freundlich, Kandinsky and Schwitters as German members.	Otto Neurath: *Empirische Soziologie* (Empirical Sociology). Max Planck: *Positivismus und reale Außenwelt* (Positivism and the Real Outside World). Hermann Broch: *Die Schlafwandler* (The Sleepwalkers). J. Roth: *Radetzkymarsch*. Kurt Tucholsky: *Schloß Gripsholm*
1932	Formation of the 'Iron Front' (SPD/trades unions/workers' athletic clubs. The NSDAP emerge from the Reichstag elections in July and November as the strongest party.	The *Bauhaus* in Dessau is closed down by the municipal council and migrates to Berlin as a private institute. All the teachers at the Folkwang school in Essen are dismissed. The Academy of Art in Breslau is closed.	Karl R. Popper: *Logik der Forschung* (Logic of Scientific Discovery). Victor von Weizsäcker: *Körpergeschehen und Neurose* (Bodily Function and Neurosis). H. Fallada: *Kleiner Mann, was nun* (Little Man, What Now?). Brecht. *Die heilige Johanna der Schlachthöfe* (Saint Joan of the Stockyards). E. Jünger: *Der Arbeiter* (The Worker).
1933	Hitler becomes Chancellor. The Reichstag is burnt down. KPD and SPD are outlawed and the trades unions are dissolved. The first of 85 concentration camps is established in Dachau.	Political opponents of the regime and artists branded as 'degenerate' begin to go into exile in Spain, France, England, Holland, the USA, the USSR and Switzerland.	Anarchist, socialist, communist, Jewish and antifascist intellectuals begin to emigrate. Books are burnt in the German Reich. Franz Werfel: *Die 40 Tage des Musa Dagh* (The 40 Days of Musa Dagh).
1934	Establishment of the 'People's Court'. The SA is deprived of its power and its leaders are murdered. The SS is expanded and takes over administration of concentration camps from the SA.		Willi Bredel: *Die Prüfung. Roman aus einem Konzentrationslager* (The Test. Novel from a Concentration Camp), London.
1935	Plebiscite in the Saarland on reunion with the Reich. Development of the Luftwaffe. Reintroduction of conscription. Nuremberg laws.		International Writers' Congress on the Defence of Culture (Paris). Werner Bergengruen: *Der Großtyrann und das Gericht* (The Tyrant and the Court). Stefan Andres: *(El Greco malt den Großinquisitor* (El Greco Paints the Grand Inquisitor).
1936	Germany occupies the demilitarized Rhineland. Austro-German agreement. Olympic Games in Berlin. The Condor Legion supports Franco's fascist coup in Spain.		Ödön von Horvath: *Jugend ohne Gott* (Youth without a God). The Nobel Peace Prize is awarded to Carl von Ossietzky, imprisoned in Papenburg Esterwegen concentration camp since 1933.
1937	Renewal of the 'Enabling Act' for 4 years. Mussolini visits Germany.	The 'Degenerate Art' exhibition is opened in Munich. It is later shown in various German cities.	
1938	German troops invade Austria. The Munich Agreement settles the cession of the Sudetenland by Czechoslovakia. 'Reichskristallnacht' ('Crystal Night', a large-scale pogrom against the Jewish population).	'20th-century German Art', New Burlington Galleries, London. Herbert Read is the chairman of the exhibition, aided by Oto Bihalji-Merin. Max Beckmann gives the opening speech 'On my theory of painting'.	Carl von Ossietzky dies as a result of torture in the concentration camp. Karl Jaspers: *Existenzphilosophie* (Philosophy of Existence). Brecht: *Furcht und Elend des Dritten Reichs* (Fear and Misery of the Third Reich). Reinhold Schneider: *Las Casas vor Karl V.* (las Casas before Charles V).
1939	Annexation of the whole of Bohemia and Moravia. Russo-German Non-Aggression Pact. Invasion of Poland. Britain and France (Poland's allies) declare war.	Auction in Lucerne.	Thomas Mann: *Lotte in Weimar* (Lotte in Weimar), Stockholm. E. Jünger: *Auf den Marmorklippen* (On the Marble Cliffs).

	Politics	Art	Culture
1940	Germany occupies Denmark and Norway, and invades Holland, Belgium and Luxemburg. Franco-German armistice. Three-Power Pact between Germany, Italy and Japan, also co-signed by Romania and Hungary.		
1941	The war spreads to Africa; invasions of Yugoslavia, Greece and the Soviet Union. Germany declares war on the USA.		Herbert Marcuse: *Reason and Revolution. Hegel and the Rise of Social Theory*. Brecht: *Mutter Courage und ihre Kinder* (Mother Courage and Her Children), Zurich. Johannes R. Becher: *Abschied* (Farewell), Moscow.
1942	The Battle of Stalingrad begins. Anglo-American forces land in Morocco and Algeria.		Stefan Andres: *Wir sind Utopia* (We are Utopia). Anna Seghers: *Das siebte Kreuz* (The Seventh Cross), Mexico.
1943	The German advance is at last brought to a halt. The Sixth Army surrenders at Stalingrad. The Allies land in Sicily and step up bombing of German cities.		The Frankfurter Zeitung (newspaper) is banned. Hesse: *Das Glasperlenspiel* (The Glass Bead Game). Heinrich Mann: *Lidice*. Stefan Zweig: *Schachnovelle* (Chess Novella), Stockholm. Brecht; *Galileo Galilei* (Life of Galileo), Zurich.
1944	The Allies land in northern France. A plot to assassinate Hitler fails.		Anna Seghers: *Transit* (Mexico/Boston).
1945	German armed forces surrender. England, France, USSR and USA, the four victorious powers, assume supreme power in their occupation zones and in Berlin.		Hermann Broch: *Der Tod des Vergil* (Death of Virgil), New York/London. Karl R. Popper: *Die offene Gesellschaft und ihre Feinde* (The Open Society and Its Enemies), London.
1946	Churchill coins the expression 'Iron Curtain'. The 'Cold War' begins. The Allies begin dismantling German industrial installations. Nuremberg trials of major war criminals.	*Allgemeine Deutsche Kunstausstellung* (General Exhibition of German Art) in Dresden, *Fantasten* exhibition in the Galerie Gerd Rosen, Berlin.	Eugen Kogon: *Der SS-Staat* (The SS State). W. Bergengruen: *Dies irae*. Carl Zuckmayer: *Des Teufels General* (Satan's General). Ernst Kreuder: *Die Gesellschaft vom Dachboden*. (The Attic Pretenders). Nelly Sachs: *In den Wohnungen des Todes* (In the Dwellings of Death).
1947	Failure of all-German meeting of minister-presidents. Marshall Plan. Fusion of the American and British zones to form the 'Bizone'.	*Meister des Bauhauses* (Masters of the Bauhaus) exhibition at the Hochschule der Künste, Berlin. 'Modern German Art', Baden-Baden.	Adorno/Horkheimer: *Dialektik der Aufklärung* (Dialectic of Enlightenment), Amsterdam. Karl Jaspers: *Die Schuldfrage* (The Question of German Guilt). Wolfgang Borchert: *Draußen vor der Tür* (The Man Outside). Hermann Kasack: *Die Stadt hinter dem Strom* (The City beyond the River). Foundation of *Gruppe 47*.
1948	Currency reform in the three Western zones. Berlin Blockade.	K.O. Götz and Emil Schumacher receive the *Junger Westen* (Young West) art prize.	Hans Sedlmayr: *Verlust der Mitte* (Art in Crisis). Brecht: *Herr Puntila und sein Knecht Matti* (Mr Puntila and His Man Matti). Hans Erich Nossack: *Interview mit dem Tode* (Appointment with Death).
1949	Common Occupation Statute for the Western zones. Parliamentary Council ratifies the Grundgesetz (Basic Law) as a constitution for the Federal Republic. Elections to the German Bundestag.	'Modern German Painting and Sculpture' exhibition in Cologne. Foundation of the artists' group ZEN (Geiger, Baumeister, Winter, Meyer-Denninghoff et al.). Modern French Masters exhibition in Berlin.	Georg Lukacs: *Thomas Mann*. Wolf von Niebelschütz: *Der blaue Kammerherr* (The Blue Chamberlain). Heinrich Böll: *Der Zug war pünktlich* (The Train was on Time). Arno Schmidt: *Leviathan*. Hermann Broch: *Die Schuldlosen* (The Innocents).

	Politics	Art	Culture
1950	The Federal government refuses to recognize the Oder-Neisse Line as the frontier between the GDR (German Democratic Republic) and Poland. The Minister of the Interior, Heinemann, is dismissed because he opposes re-armament.	Heiliger, Uhlmann, Karl Hartung, Heldt and others receive the *Deutscher Kunstpreis* (German Art Prize). *Das Menschenbild in unserer Zeit* (The Image of Man in our Time) exhibition, Darmstadt. Georg Meistermann receives first prize in the Blevin-Davis competition.	Martin Buber: *Pfade in Utopia* (Path to Utopia). Martin Heidegger: *Holzwege*. Walter Jens: *Nein – die Welt des Angeklagten* (No – the world of the Accused). Luise Rinser: *Mitte des Lebens* (Midlife).
1951	Revision of the Occupation Statute strengthens the independence of the Federal Republic. Co-determination Law for the coal and steel industry. Interzone trade agreement.	Foundation of the *Hochschule für Gestaltung* in Ulm.	Adorno: *Minima Moralia*. Hans Reichenbach: *Der Aufstieg der wissenschaftlichen Philosophie* (The Rise of Scientific Philosophy). Günter Eich: *Träume* (Dreams). Heimito von Doderer: *Die Strudlhofstiege*. Wolfgang Koeppen: *Tauben im Gras* (Pigeons in the Grass).
1952	The USSR demand for a peace treaty with a unitary Germany fails as a result of the insistence of the Western powers on free elections preceding such an agreement.	*Mensch und Form unserer Zeit* (Man and Form in our Time), Recklinghausen. *Quadriga* exhibition in the Zimmer-Galerie, Frankfurt (Schultze, Goetz, Kreutz, Greis).	Alfred Andersch: *Die Kirschen der Freiheit* (The Cherries of Freedom). Paul Celan: *Mohn und Gedächtnis* (poems). Friedrich Dürrenmatt: *Der Richter und sein Henker* (The Judge and His Hangman). Ilse Aichinger: *Rede unter dem Galgen* (Speech below the Scaffold).
1953	The London Debt Agreement regulates the discharge of German debts since the First World War. Again, the CDU/CSU (Christian Democratic Union / Christian Socialist Union) with Konrad Adenauer emerge victorious after the second Bundestag election.	*Gruppe 53* Düsseldorf (Brüning, Dahmen, Gaul, Hoehme, Sackenheim). *Neue Rheinische Sezession* (New Rhenish Secession) (Berke, Fassbender, Herkenrath, Meistermann, Hann Trier).	Heinrich Böll: *Und sagte kein einziges Wort* (And Never Said a Word). W. Koeppen: *Das Treibhaus* (The Greenhouse). Ingeborg Bachmann: *Die gestundete Zeit* (The Respite). Werner Egk/Boris Blacher: *Abstrakte Oper* (Abstract Opera). Gottfried von Einem: *Der Prozeß* (The Trial)
1954	The Four-Power Conference on the reunification of Germany fails. The Paris agreements endorse the claim of the Federal Republic that it should have the sole right to represent the German people.		H. Böll: *Haus ohne Hüter* (The Unguarded House). Max Frisch: *Stiller* (I'm Not Stiller).
1955	The Federal Republic achieves sovereignty and becomes a member of the Western defence alliance NATO. Adenauer visits Moscow and the last prisoners of war return from the USSR.	Documenta I in Cassel. *Tendences actuelles 3* in Berne. Picasso exhibition in Munich.	Herbert Marcuse: *Eros und Civilisation*. Leonhard: *Die Revolution entläßt ihre Kinder* (Child of the Revolution). Günter Eich: *Botschaften des Regens* (Messages from the Rain). H. Böll: *Das Brot der frühen Jahre* (The Bread of Those Early Years). Ernst Krenek: *Pallas Athene weint* (Pallas Athena is Crying).
1956	First units of the *Bundeswehr* (Federal Armed Forces). Ambassadors are exchanged with Moscow. The KPD is banned.	'A Century of German Art' Tate Gallery, London. Cézanne exhibition in Munich.	Ernst Bloch: *Prinzip Hoffnung* (Principle of Hope). Bachmann: *Anrufung des Großen Bären* (Call of the Great Bear). Günter Grass: *Die Vorzüge der Windhühner*. Arno Schmidt: *Das Steinerne Herz* (The Heart of Stone).
1957	Foundation of the European Economic Community (EEC). Appeal of the *Göttinger Achtzehn* (Göttingen Eighteen) against nuclear weapons for the Federal Armed Forces. The CDU obtains an absolute majority in the third election for the Bundestag.	'German Art of the 20th Century', Museum of Modern Art, New York. *Verkannte Kunst* (Unrecognised Art), Recklinghausen. *Spur* group, Munich (Fischer, Prem, Sturm, Zimmer et al.).	Hans Magnus Enzensberger: *Verteidigung der Wölfe* (Defence of the Wolves). Max Frisch: *Homo Faber* (Homo Faber). Alfred Andersch: *Sansibar oder der letzte Grund* (Flight to afar . . .). Karl Heinz Stockhausen: *Klavierstück XI* (Piano Piece XI).
1958	Protest rallies against the stationing of atomic weapons in the Federal Republic. The Constitutional Court rejects a referendum. Beginning of the Berlin crisis.	*Dada-Dokumente einer Bewegung* (Dada – Documents of a Movement), Düsseldorf. First ZERO magazine. *Das rote Bild* (The Red Picture) seventh evening exhibition, Düsseldorf. Wols Retrospective at the Venice Biennale.	Helmut Schelsky: *Die skeptische Generation* (The Sceptical Generation). Gerd Gaiser: *Schlußball* (Final Ball). Frisch: *Biedermann und die Brandstifter* (The Fire Raisers). John Cage: *Concerto for Piano and Orchestra* (Cologne). Hans Werner Henze: *Undine*.
1959	The SPD adopts the Godesberg Programme.	'German Art of Today', Smithsonian Institute, Washington. Documenta II: Art after 1945.	Grass: *Die Blechtrommel* (The Tin Drum). Böll: *Billard um halbzehn* (Billiards at Half Past Nine). Wolfgang Staudte: *Rosen für den Staatsanwalt* (Roses for the Prosecutor). Bernhard Wicki: *Die Brücke* (The Bridge). Luigi Nono: *Diario Polacco 1958* (Darmstadt).

	Politics	Art	Culture
1960	First draft of the Emergency Powers Act.	*Arte alema desde 1945* (German Art after 1945), Rio de Janeiro. *Vision* group (Hohburg, Marxmüller, Hödicke, Koberling). *Monochrome Malerei* (Monochrome Painting), Leverkusen.	Hans Georg Gadamer: *Wahrheit und Methode* (Truth and Method). Martin Walser: *Halbzeit* (Half Time). Arno Schmidt: *Kaff auch Mare Crisium*. Andersch: *Die Rote* (The Red).
1961	The Wall is built between West and East Berlin. In the fourth Bundestag election the SPD and FDP (Free Democratic Party) make gains at the expense of the CDU/CSU which loses its absolute majority. The SPD splits from the SDS (Socialist Students' Association).	*1. Pandämonisches Manifest* by Baselitz/Schönebeck. The *Bauhaus* archives are opened in Darmstadt.	West German stage boycotts Brecht. Grass: *Katz und Maus* (Cat and Mouse). Johnson: *Das dritte Buch über Achim* (The Third Book about Achim). Frisch: *Andorra*. Gyoergy Ligeti: *Atmosphères*.
1962	The USSR denounces the Four-Power Statute for Berlin. FDP ministers resign in the wake of the *Spiegel* Affair. They are followed by CDU/CSU ministers. The government is re-formed without F. J. Strauss.	*Fluxus* festival of contemporary music in Wiesbaden.	Jürgen Habermas: *Strukturwandel der Öffentlichkeit* (Evolution of Society). Dürrenmatt: *Die Physiker* (The Physicists).
1963	Franco-German Treaty. Konrad Adenauer resigns and Ludwig Erhard is elected his successor as Federal Chancellor.	*Demonstration für den Kapitalistischen Realismus* (Demonstration for Capitalist Realism), Richter/Fischer. *Festum Fluxorum Fluxus*, Düsseldorf.	Böll: *Ansichten eines Clowns* (The Clown). Grass: *Hundejahre* (Dog Years). Rolf Hochhuth: *Der Stellvertreter* (The Deputy).
1964	An all-German team takes part in the summer Olympics in Tokio for the last time. Formation of the extreme right-wing party NDP (National Democratic Party).	Opening of the Lehmbruck Museum in Duisburg. Foundation of *Grossgoerschen 35*. Documenta III: Museum of the Hundred Days. *Fluxus* commemoration of 20th July 1944 in Aachen. *Neue Realisten* (New Realists), Berlin	H. Marcuse: *Der eindimensionale Mensch* (One-dimensional Man). Hans Magnus Enzensberger: *Politik und Verbrechen* (Politics and Crime). Peter Weiss: *Marat*. Heiner Kipphardt: *In der Sache J. Robert Oppenheimer* (In the Matter of J. Robert Oppenheimer). Helmut Heissenbüttel: *Textbuch 4*.
1965	Diplomatic relations are opened with Israel. The twenty-year limit for punishment of Nazi war crimes is extended. Judgments in the Auschwitz Trial.	*24 Stunden* (24 Hours), Parnass, Wuppertal.	Peter Weiss: *Die Ermittlung* (The Investigation . . . Oratorio in 11 Cantos). Hubert Fichte: *Das Waisenhaus* (The Orphanage). Wolfgang Hildesheimer: *Tynset*. Johnson: *Zwei Ansichten* (Two Views). 'Clean Screen Campaign' against eroticism in films.
1966	The Federal government supports US intervention in Vietnam. The left-wing protest movement forms around this issue. Kiesinger becomes Chancellor of a 'Great Coalition' between the CDU/CSU and SPD.	*Dithyrambisches Manifest* by Lüpertz.	Karl Jaspers: *Wohin treibt die Bundesrepublik?* (The Future of Germany). H. Marcuse: *A Critique of Pure Tolerance*. Peter Handke: *Publikumsbeschimpfung* (Offending the Audience). Ernst Jandl: *Laut und Luise*. Martin Sperr: *Jagdszenen aus Niederbayern* (Hunting Scenes from Lower Bavaria).
1967	Protests against the state visit of the Shah of Iran. On 2nd June the student Benno Ohnesorg is shot at a demonstration in Berlin.	Opening of the *Brücke* museum in Berlin.	Margarete und Alexander Mitscherlich: *Die Unfähigkeit zu trauern* (The Inability to Grieve).
1968	A murder attempt is made on the student leader Rudi Dutschke. Demonstrations and campaigns by the *Außerparlamentarische Opposition* (APO), or extra-parliamentary opposition, against the Axel Springer publishing house. Torchlight demonstration against the Emergency Powers Act.	Documenta IV. The Nationalgalerie building is opened by Mies van der Rohe. *Prospect*, Düsseldorf.	Jürgen Habermas: *Erkenntnis und Interesse* (Knowledge and Human Interests). Siegfried Lenz: *Deutschstunde* (The German Lesson). Alexander Kluge: *Die Artisten in der Zirkuskuppel: ratlos* (The Artistes in the Big Top: Helpless). Peter Zadek: *Ich bin ein Elefant, Madame* (I am an Elephant, Madame).
1969	The combined votes of the SPD and FDP elect Gustav Heinemann as Federal President. The sixth Bundestag election results in the formation of a (social-liberal) coalition between the SPD and FDP with Willy Brandt as Chancellor.	'When attitudes become form' exhibition in Berne, Krefeld, London	Rainer Werner Fassbinder: *Liebe ist kälter als der Tod* (Love is Colder than Death), *Katzelmacher*, *Götter der Pest* (Gods of the Plague). Hans Werner Henze: *Sixth Symphony*, Havanna.

	Politics	Art	Culture
1970	Willi Stoph (GDR) and Willy Brandt meet in Erfurt and Cassel. The Moscow and Warsaw agreements are signed. Andreas Baader is released from prison.	*Fluxus und Happening* in Cologne. *Jetzt – Künste in Deutschland* (Current Art in Germany), Cologne.	Heissenbüttel: *D'Alemberts Ende*. Thomas Bernhard: *Das Kalkwerk* (The Lime Works). Johnson: *Jahrestage I* (Anniversaries I). Arno Schmidt: *Zettels Traum* (Bottom's Dream).
1971	Four-Power Agreement on Berlin. Nobel Peace Prize for Willy Brandt. Inter-German agreement on transit routes.		Adorno: *Ästhetische Theorie* (Aesthetic Theory). Weiss: *Hölderlin*. Dieter Wellershoff: *Einladung an alle* (Invitation to Everyone). Franz Xaver Kroetz: *Wildwechsel* (Wild Game). Mauricio Kagel: *Staatstheater* (State Theatre).
1972	The 'Radicals' Decree' permits political vetting of public servants and applicants for public office. Arrest of Andreas Baader, Ulrike Meinhof and Gudrun Ensslin.	Documenta V: Individual Myths – Parallel Picture Worlds. Hans Makart, Baden-Baden.	
1973	Willy Brandt visits Israel. The Federal Republic and the German Democratic Republic join the United Nations (UN).	*Kunst im politischen Kampf* (Art in the Political Struggle), Hanover. *Kunst in Deutschland 1898-1973* (Art in Germany, 1898-1973), Hamburg. Jörg Immendorff: *Das tun, was zu tun ist* (Do what there is to do).	Konrad Lorenz: *Die Rückseite des Spiegels* (Behind the Mirror). Peter Schneider: *Lenz*. Böll: *Die verlorene Ehre der Katharina Blum oder Wie Gewalt entsteht und wo sie hinführen kann* (The Lost Honour of Katharina Blum or how violence arises and where it can lead to). Karin Struck: *Klassenliebe* (School Love).
1974	Willy Brandt resigns when Guillaume, one of his personal assistants, is found to be a GDR spy. Helmut Schmidt becomes Chancellor of the social-liberal coalition.	Caspar David Friedrich, Hamburg. *Spurensicherung* (Establishing the Trend), Hamburg. 'Project 74', Cologne. 'Art into Society, Society into Art', London.	Andersch: *Winterspelt*.
1975	The trial of the Baader-Meinhof Gang begins in Stammheim. Terrorist attack on the German embassy in Stockholm. Peter Lorenz, a CDU politician, is kidnapped.	*Als der Krieg zu Ende war* (When the War Came to an End), Berlin. Willi Sitte, Hamburg.	Handke: *Falsche Bewegung* (False Move). Botho Strauss: *Marlenes Schwester* (Marlene's Sister). Peter Weiss: *Ästhetik des Widerstands* (Aesthetic of Resistance) Nicolaus Born: *Die erdabgewandte Seite der Geschichte* (The Ethereal Aspect of History). Bernhard Sinkel: *Lina Braake*.
1976	4.7% unemployed, law for the protection of minors at work. Ulrike Meinhof is discovered dead in her cell. Wolf Biermann is deprived of his GDR citizenship.	Beuys, Jochen Gerz, Reiner Ruthenbeck, Venice Biennale. 'Prospect Retrospect', Düsseldorf.	Botho Strauss: *Trilogie des Widersehens* (Trilogy of Reunion). Handke: *Die linkshändige Frau* (The Lefthanded Woman). Wim Wenders: *Im Lauf der Zeit* (Kings of the Road).
1977	Terrorist attacks on Siegfried Buback and Jürgen Ponto. Hans Martin Schleyer is kidnapped. GSG 9 (anti-terrorist unit) storms an airliner hijacked to Mogadischu. Baader, Ensslin and Raspe discovered dead in their cells.	*Tendenzen der zwanziger Jahre* (Trends of the Twenties), Berlin. *Dreißiger Jahre – Schauplatz Deutschland* (The Thirties – Location Germany). Documenta VI: Art and Media.	Grass: *Der Butt* (The Flounder).
1978	Demonstrations against nuclear power in Gorleben and other places.	13° East (London). *Deutsche Malerei 1890-1918* (German Painting 1890-1918), Frankfurt. Beuys/Nam June Paik: 'In Memoriam George Maciunas'. 'Paris-Berlin', Paris. Dieter Krieg, Ulrich Rückriem, Venice Biennale. *Neue Sachlichkeit*, London	Wolf Biermann: *Preußischer Ikarus*. Siegfried Lenz: *Heimatmuseum* (Museum of Local History and Culture). Martin Walser: *Ein fliehendes Pferd* (A Fugitive Horse). Pina Bausch: *Kontakthof*. Kluge, Schlöndorff et al.: *Deutschland im Herbst* (Germany in Autumn).
1979	In Bremen 'The Green List' become the first ecological party to gain entry to a *Land* parliament. Nato twin-track option on deploying nuclear medium-range weapons.	Beuys exhibition in the Guggenheim Museum, New York. Kirchner Retrospective, Berlin. *Eremit? Forscher? Sozialarbeiter?* (Hermit? Scientist? Social Worker?), Hamburg. Max Ernst retrospective, Munich, Berlin.	Peter Härtling: *Nachgetragene Liebe* (Grudging Love). Nicolaus Born: *Die Fälschung* (Circle of Deceit). Peter Rühmkorf: *Haltbar bis 1999* (Best before 1999). Bausch: *Keuschheitslegende* (Legend of Chastity). Fassbinder: *Die Ehe der Maria Braun* (The Marriage of Maria Braun).

	Politics	Art	Culture
1980	'The Greens' are established as a federal party. The ninth Bundestag election confirms the social-liberal coalition in government. Demonstrations against the nuclear power station in Brokdorf.	Schad Retrospective, Berlin. *Die Neuen Wilden* (The New Savages), Aachen. *Heftige Malerei* (Angry Painting), Berlin. *Rundschau Deutschland* (Review of Germany), Munich.	Michael Schneider: *Das Spiegelkabinett* (The Hall of Mirrors). Bausch: *Bandoneon*.
1981	Squatting in West Berlin. Demonstrations against the western runway at Frankfurt airport. Mass arrests of demonstrators in Nuremberg. Peace demonstrations in Bonn.	*Mülheimer Freiheit* (Mülheim Freedom), Cologne. 'A New Spirit in Painting', London. *Westkunst*, Cologne. *Art allemagne aujourd'hui*, Paris. *Bildwechsel* (Change of Scene), Berlin. *Gegenbilder* (Anti-Pictures), Karlsruhe. *Treibhaus* (Greenhouse), Düsseldorf. *Schwarz* (Black), Düsseldorf.	Wolfgang Hildesheimer: *Marbot*. Botho Strauss: *Paare, Passanten* (Couples, Passersby). Fassbinder: *Lili Marleen*.
1982	A vote of no confidence leads to Helmut Kohl being elected Chancellor after four FDP ministers resign. A government is formed by the CDU/CSU and the FDP.	Documenta VII. *Zeitgeist*, Berlin. '60/80', Amsterdam. *Gefühl und Härte* (Feeling and Hardness), Munich. *Neue Skulptur* (New Sculpture), Vienna. *12 Künstler aus Deutschland* (12 Artists form Germany), Basle. Darboven, Graubner, Laib, Venice Biennale. Beckmann Retrospectives: Frankfurt, 1983; Munich, Berlin, St. Louis, Los Angeles, 1984/85.	Peter Schneider: *Der Mauerspringer* (The Wall Vaulter). Werner Herzog: *Fitzcarraldo*. Wim Wenders: *Der Stand der Dinge* (The State of Things).
to 1985	The tenth Bundestag election gives a clear majority to the 'Christian-Liberal' coalition. 'The Greens' poll 5.6% of the votes and enter the Bundestag. Commission of enquiry into the Flick charitable contributions affair.	*Ursprung und Vision* (Origin and Vision) – Modern German Painting, Spain, Mexico City. *Von hier aus* (Starting from Here), Düsseldorf. *Kunstlandschaft Bundesrepublik* (Art Scene in the Federal Republic) representing 48 art associations, 1984. Penck, Lothar Baumgarten, Venice Biennale. Otto Dix, Bruxelles, 1985. Kurt Schwitters, New York, London, Hanover, 1985.	Johnson: *Jahrestage I–IV* (Anniversaries I–IV). Peter Sloterdijk: *Kritik der zynischen Vernunft* (Critique of Cynical Reason). Herbert Achternbusch: *Das Gespenst* (The Ghost).

Selected Bibliography

compiled by Kryszof Z. Cieszkowski

Barr, Jr., Alfred H., *German Painting and Sculpture* (catalogue of exhibition, March-April 1931), New York, Museum of Modern Art, 1931; reprinted as *Modern German Painting and Sculpture*, New York, 1972

Barron, Stephanie, *German Expressionist Sculpture* (catalogue of exhibition in the Los Angeles County Museum of Art, October 1983-January 1984), Los Angeles, 1983

Bayer, Herbert; Gropius, Walter; Gropius, Ise (eds.), *Bauhaus 1919-1928*, New York, Museum of Modern Art, 1938; reprinted, Boston, 1952

Berlin, Akademie der Künste, *Zwischen Widerstand und Anpassung: Kunst in Deutschland 1933-1945* (catalogue of exhibition, September-October 1978), Berlin, 1978

Berlin, Bauhaus-Archiv, *Bauhaus-Archiv-Museum: Sammlungs-Katalog (Auswahl)*, Berlin, 1981

Berlin, Neue Gesellschaft für Bildende Kunst, *Wem gehört die Welt: Kunst und Gesellschaft in der Weimarer Republik* (catalogue of exhibition in the Staatliche Kunsthalle, Berlin, August-October 1977), Berlin, 1977

Berlin, Staatliche Kunsthalle and Neue Gesellschaft für Bildende Kunst, *1933 – Wege zur Diktatur* (catalogue of exhibition, January-February 1933), Berlin, 1983

Berlin (DDR), Staatliche Museen zu Berlin, *Revolution und Realismus: Revolutionäre Kunst in Deutschland 1917 bis 1933* (catalogue of exhibition in the Altes Museum, Berlin, November 1978-February 1979), Berlin, 1978

Bie, Richard, *Deutsche Malerei der Gegenwart*, Weimar, 1930

Bourdaille, Georges, *Expressionists*, New York, 1981

Buchheim, Lothar-Günther, *Die Künstlergemeinschaft Brücke: Gemälde, Zeichnungen, Graphik, Plastik, Dokumente*, Feldafing, 1956

Buchheim, Lothar-Günther, *Der Blaue Reiter und die Neue Künstlervereinigung München*, Feldafing, 1959

Buchheim, Lothar-Günther, *The Graphic Art of German Expressionism*, New York, 1960

Carey, Frances; Griffiths, Antony, *The Print in Germany 1880-1933: The Age of Expressionism - Prints from the Department of Prints and Drawings in the British Museum* (catalogue of exhibition, September 1984-January 1985), London, British Museum, 1984

Claus, Jürgen (ed.), *Entartete Kunst, Bildersturm vor 25 Jahren* (catalogue of exhibition, October-December 1962), Munich, Haus der Kunst, 1962

Cologne, Museen der Stadt Köln, *Expressionisten, Sammlung Buchheim* (catalogue of exhibition in the Stadtmuseum, Cologne, April-May 1981), Feldafing, 1981

Cowart, Jack (ed.), *Expressions: New Art from Germany – Georg Baselitz, Jörg Immendorff, Anselm Kiefer, Markus Lüpertz, A. P. Penck* (catalogue of exhibition in the Saint Louis Art Museum, June-August 1983), Saint Louis, Art Museum/Munich, 1983

Damus, Martin, *Sozialistischer Realismus und Kunst im Nationalsozialismus*, Frankfurt-on-Main, 1981

Dienst, Rolf-Gunter, *Deutsche Kunst: eine neue Generation*, Cologne, 1970

Doede, Werner, *Berlin: Kunst und Künstler seit 1870*, Recklinghausen, 1961

Dube, Wolf-Dieter, *The Expressionists*, London, 1972

Duisburg, Wilhelm-Lehmbruck-Museum der Stadt Duisburg, *Verboten, Verfolgt: Kunstdiktatur im 3. Reich* (catalogue of exhibition, April-May 1983), Duisburg, 1983

Elliott, David (ed.), *Tradition and Renewal: Contemporary Art in the German Democratic Republic* (catalogue of exhibition in the Museum of Modern Art, Oxford, June-July 1984; subsequently in Coventry, Sheffield, Newcastle and London), Oxford, Museum of Modern Art, 1984

Evers, Ulrika, *Deutsche Künstlerinnen des 20. Jahrhunderts: Malerei, Bildhauerei, Tapisserie*, Hamburg, 1983

Faust, Wolfgang Max; de Vries, Gerd, *Hunger nach Bildern: Deutsche Malerei der Gegenwart*, Cologne, 1982

Fetscher, Iring (ed.), *Kunst im 3. Reich: Dokumente der Unterwerfung* (catalogue of exhibition in the Frankfurt Kunstverein, October-December 1974), Frankfurt, 1974

Fischer, Otto, *Das Neue Bild: Veröffentlichung der Neuen Künstlervereinigung München*, Munich, 1912

Franciscano, Marcel, *Walter Gropius and the Creation of the Bauhaus in Weimar: The Ideals and Artistic Theories of its Founding Years*, Urbana, 1971

Frankfurt, Frankfurter Kunstverein, *Zwischen Krieg und Frieden: Gegenständliche und realistische Tendenzen in der Kunst nach 45* (catalogue of exhibition, October-December 1980), Berlin, 1980

Gassner, Hubertus; Gillen, Eckhart (eds.), *Kultur und Kunst in der DDR seit 1970*, Lahn-Giessen, 1977

Gerhardus, Maly & Dietfried, *Expressionism: From Artistic Commitment to the Beginning of a New Era*, Oxford, 1979

Glozer, Laszlo, *Westkunst: Zeitgenössische Kunst seit 1939* (catalogue of exhibition, May-August 1981), Cologne, 1981

Gollek, Rosel, *Der Blaue Reiter im Lenbachhaus München: Katalog der Sammlung in der Städtischen Galerie*, Munich, 1982

Grohmann, Will (ed.), *Art in Revolt: Germany 1905-25* (catalogue of exhibition, October-November 1959), London, 1959

Grzimek, Waldemar, *Deutsche Bildhauer des zwanzigsten Jahrhunderts: Leben, Schulen, Wirkungen*, Munich, 1969

Haftmann, Werner, *Painting in the Twentieth Century*, London, 1961

Hamann, Richard; Hermand, Jost, *Deutsche Kunst und Kultur von der Gründerzeit bis zum Expressionismus*, Berlin, 1959-67; revised ed., *Epochen deutscher Kultur von 1870 bis zur Gegenwart*. Munich, 1971-6 (4 vols.)

Hamburg, Altonaer Museum, *Norddeutsche Künstlerkolonien I: Nidden und die Kurische Nehrung* (catalogue of exhibition, December 1976-February 1977), Hamburg, 1976

Hamburg, Altonaer Museum, *Norddeutsche Künstlerkolonien II: Rügen, Vilm, Hiddensee* (catalogue of exhibition, August-October 1977), Hamburg, 1977

Hamburg, Altonaer Museum, *Norddeutsche Künstlerkolonien III: Ahrenshoop, Darss und Fischland* (catalogue of exhibition, October 1978-January 1979), Hamburg, 1978

Hamburg, Altonaer Museum, *Norddeutsche Künstlerkolonien IV: Ekensund und die Flensburger Forde* (catalogue of exhibition, September-November 1979), Hamburg, 1979

Händler, Gerhard, *German Painting in our Time*, Berlin, 1956

Hanover, *Kunstmuseum Hannover mit Sammlung Sprengel: die Künstlergruppe Brücke – Gemälde, Aquarelle, Zeichnungen und Druckgraphik: Verzeichnis der Bestände*, Hanover, 1982

Harten, Jürgen; Honisch, Dieter; Kern, Hermann (eds.), *Neue Malerei in Deutschland* (catalogue of exhibition in the Nationalgalerie, Berlin, September-October 1983), Munich, 1983

Barry, Herbert; Hinshelwood, Alisdair, *The Expressionist Revolution in German Art, 1871-1933: A Catalogue to the 19th and 20th Century German Paintings, Drawings, Prints and Sculpture in the Permanent Collection of Leicestershire Museums and Art Gallery*, Leicester, 1978

Barry, Herbert, *German Expressionism: Die Brücke and Der Blaue Reiter*, London, 1983

Hinz, Berthold, *Art in the Third Reich*, New York, 1979; Oxford, 1980

Jähner, Horst, *Künstlergruppe Brücke: Geschichte, Leben und Werk ihrer Maler*, Berlin, 1984

Jensen, Jens Christian (ed.), *Vom Realismus zum Expressionismus: Norddeutsche Malerei, 1870 bis um 1930*, Kunsthalle, Kiel, 1984

Kent, Sarah; Gillen, Eckhart (eds.), *Berlin, a Critical View: Ugly Realism 20s-70s* (catalogue of exhibition at the I.C.A., London, November 1978-January 1979), London, Institute of Contemporary Arts, 1978

Klotz, Heinrich, *Die Neuen Wilden in Berlin*, Stuttgart, 1984

Krempel, Ulrich (ed.), *Am Anfang: Das Junge Rheinland – Zur Kunst- und Zeitgeschichte einer Region 1918-1945* (catalogue of exhibition in the Städtische Kunsthalle, Düsseldorf, February-April 1985), Düsseldorf, 1985

Kuhirt, Ullrich (ed.), *Kunst der DDR, 1945-1959*. Leipzig, 1982

Kuhirt, Ullrich (ed.), *Kunst der DDR, 1960-1980)*, Leipzig, 1983

Lang, Lothar, *Malerei und Graphik in der DDR*, Leipzig, 1978

Lankheit, Klaus (ed.), *The 'Blaue Reiter' Almanac: edited by Wassily Kandinsky and Franz Marc*, London, 1974

Lehmann-Haupt, Hellmut, *Art under a Dictatorship*, London, 1954; repr. New York, 1973

London, Institute of Contemporary Arts, *Art into Society – Society into Art: Seven German Artists: Albrecht D., Joseph Beuys, K. P. Brehmer, Hans Haacke, Dieter Hacker, Gustav Metzger, Klaus Staeck*, (catalogue of the exhibition, October-November 1974), London, 1974

Miesel, Victor H. (ed.), *Voices of German Expressionism*, Englewood Cliffs (NJ), 1970

Minneapolis Institute of Arts, *German Realism of the Twenties: The Artist as Social Critic* (catalogue of exhibition, September-November 1980), Minneapolis, 1980

Morschel, Jürgen, *Deutsche Kunst der 6oer Jahre: Plastik, Objekte, Aktionen*, Munich, 1972

Muller, Joseph-Émile, *A Dictionary of Expressionism*, London, 1973

Müller-Mehlis, Reinhard, *Die Kunst im Dritten Reich*, Munich, 1976

Munich, Haus der Kunst. *Die dreißiger Jahre: Schauplatz Deutschland* (catalogue of exhibition, February-April 1977), Munich, 1977

Munich, Städtische Galerie im Lenbachhaus, *Kunst und Technik in den 2oer Jahren: Neue Sachlichkeit und Gegenständlicher Konstruktivismus* (catalogue of exhibition, July-August 1980), Munich, 1980

Myers, Bernard S., *Expressionism: a Generation in Revolt*, London, 1957

Paris, Centre Georges Pompidou, *Paris-Berlin, 1900-1933* (catalogue of exhibition, July-October 1978), Paris, 1978

Paris, Musée d'Art Moderne de la Ville de Paris, *Art/Allemagne/Aujourd'hui: différents aspects de l'art actuel en République Fédérale d'Allemagne* (catalogue of exhibition, January-March 1981), Paris, 1981

Prinz, Ursula; Roters, Eberhard (eds.), *Kunst in Berlin von 1930 bis 1960* (catalogue of exhibition in the Berlinische Galerie, 1980), Berlin, 1980

Raabe, Paul (ed.), *The Era of Expressionism*, London, 1974

Rathke, Ewald (ed.), *1885-1985: 100 Years of Art in Germany* (catalogue of the exhibition in Ingelheim-am-Rhein, April-June 1985), Ingelheim-am-Rhein, 1985

Rave, Paul Ortwin, *Kunstdiktatur im Dritten Reich*, Hamburg, 1949

Richard, Lionel, *Phaidon Encyclopedia of Expressionism*, Oxford, 1978

Ritchie, Andrew (ed.), *German Art of the Twentieth Century* (catalogue of exhibition in the Museum of Modern Art, New York, October-December 1957), New York, 1957; repr. New York, 1972

Roethel, Hans Konrad, *Modern German Paintings*, New York, 1957

Roethel, Hans K., *The Blue Rider, with a Catalogue of the Works by Kandinsky, Klee, Macke, Marc, and other Blue Rider Artists in the Municipal Gallery, Munich*, New York, London/1971

Roh, Franz, *Deutsche Plastik von 1900 bis heute*, Munich, 1963

Roh, Franz (with Juliane Roh), *German Art in the Twentieth Century: Painting, Sculpture, Architecture*. London/Greenwich (Conn.), 1968

Roh, Juliane, *Deutsche Kunst der 6oer Jahre: Malerei, Collage, Op-Art, Graphik*, Munich, 1971

Rosenblum, Robert, *Modern Painting and the Northern Romantic Tradition: Friedrich to Rothko*, London, 1975

Roters, Eberhard, *Painters of the Bauhaus*, New York, 1969

Roters, Eberhard (et al.), *Berlin 1910-1933*, New York, 1982

Scheffauer, Herman George, *The New Vision in the German Arts*, New York, 1924; repr. Port Washington (NY), 1971

Schmidt, Georg, *Die Malerei in Deutschland 1918-1955*, Königstein in Taunus, 1960

Schmied, Wieland, *Zero. Mack, Piene, Uecker*, Kestner-Gesellschaft, Hanover, Hanover 1965

Schmied, Wieland, *Neue Sachlichkeit und Magischer Realismus in Deutschland 1918-1933*, Hanover, 1969

Schmied, Wieland, *Malerei nach 1945 in Deutschland, Österreich und der Schweiz*, Frankfurt-on-Main/Vienna, 1974

Schmied, Wieland (ed.), *Neue Sachlichkeit and German Realism of the Twenties* (catalogue of the exhibition in the Hayward Gallery, London, November 1978-January 1979), London, 1978

Schneede, Uwe M. (ed.), *Die zwanziger Jahre: Manifeste und Dokumente deutscher Künstler*, Cologne, 1979

Schulz, Bernhard (ed.), *Grauzonen, Farbwelten: Kunst und Zeitbilder 1945-1955* (catalogue of exhibition in the Akademie der Künste, Berlin, February-March 1983), Berlin, 1983

Selz, Peter, *German Expressionist Painting*, Berkeley, Los Angeles, 1957

Spalek, John M., Broerman, Bruce M.; Paul, Carol L.; Smith III, Henry A., *German Expressionism in the Fine Arts: A Bibliography*, Los Angeles, 1977

Von Sydow, Eckart, *Die Deutsche expressionistische Kultur und Malerei*, Berlin, 1920

Thiele, Ernst, *Die Situation der bildenden Kunst in Deutschland*. Stuttgart, 1954

Thoene, Peter (= Oto Bihalji-Merin), *Modern German Art*, Harmondsworth, 1938

Thomas, Karin, *Die Malerei in der DDR, 1949-1979*, Cologne, 1980

Vierhuff, Hans Gotthard, *Die Neue Sachlichkeit: Malerei und Fotografie*, Cologne, 1980

Vogt, Paul, *Geschichte der deutschen Malerei im 20. Jahrhundert*, Cologne, 1972

Vogt, Paul (ed.), *Expressionism, a German Intuition, 1905-1920* (catalogue of exhibition in the Solomon R. Guggenheim Museum, New York, November 1980-January 1981), New York, 1980

Vogt, Paul, *Expressionism: German Painting, 1905-1920*, New York, 1980

Vogt, Paul, *The Blue Rider*, Woodbury (NY), 1980

Whitford, Frank, *Expressionism*, London, 1970

Willett, John, *Expressionism*, London/New York, 1970

Willett, John, *The New Sobriety, 1917-1933: Art and Politics in the Weimar Period*, London, 1978

Wingler, Hans M., *The Bauhaus: Weimar, Dessau, Berlin, Chicago*, Cambridge (Mass.)/London, 1969; 2nd. ed. 1976

Zimmermann, Rainer, *Die Kunst der verschollenen Generation: Deutsche Malerei des Expressiven Realismus von 1925-1975*, Düsseldorf/Vienna, 1980

Lenders to the Exhibition

Stadt Aachen, Neue Galerie – Sammlung Ludwig
Hartmut and Silvia Ackermeier, Berlin
Siegfried Adler, Hinterzarten
Ellida Schargo von Alten
Stedelijk Museum, Amsterdam
Kunstarchiv Arntz, Haag
Galerie Beyeler, Basle
Öffentliche Kunstsammlung, Kunstmuseum Basle
Lilott and Erik Berganus
Berlinische Galerie, Berlin
Brücke Museum, Berlin
Kommunale Galerie, Berlin
Staatliche Museen Preußischer Kulturbesitz,
 Nationalgalerie Berlin
Paul Klee Foundation, Kunstmuseum Berne
Anna and Otto Block, Berlin
Städtisches Kunstmuseum Bonn
Kunsthalle Bremen
Gregory Callimanopulos
Museum Ludwig, Cologne
Statens Museum for Kunst, Copenhagen
The Detroit Institute of Arts
Joe and Marie Donnelly, Ireland
Museum am Ostwall, Dortmund
Wilhelm Lehmbruck Museum der Stadt Duisburg
Kunstmuseum Düsseldorf
Stedelijk van Abbemuseum, Eindhoven
Selma and Nesuhi Ertegun Collection
Museum Folkwang, Essen
Helene Rohlfs Foundation, Essen
Collection Feelisch, Remscheid
Richard L. Feigen, New York
Mr and Mrs Marvin L. Fishman
Galérie Karl Flinker, Paris
Städelscher Museums-Verein e. V., Frankfurt

Deutsche Bank AG, Frankfurt/Düsseldorf
A. and G. Gercken
Galerie Gmyrek, Düsseldorf
Collection Dieter Grässlin, St. Georgen
Hamburger Kunsthalle
Sprengel Museum, Hannover
Wadsworth Atheneum, Hartford
D. Hauert, Berlin
Erich Heckel Estate, Hemmenhofen
Insel Hombroich
Collection Edda and Werner Hund
Leonard Hutton Galleries, New York
Louisiana Museum of Modern Art, Humblebaek
Dr., Dr. h. c. Christian Adolf Isermeyer
Staatliche Kunstsammlungen, Kassel
Käthe Kollwitz, Berlin
Kaiser Wilhelm Museum, Krefeld
Werner and Erika Krisp, Munich
Nachlaß Lehmbruck
Leicestershire Museums and Art Galleries
Neue Galerie der Stadt Linz, Wolfgang Gurlitt
 Museum
Tate Gallery, London
Los Angeles County Museum of Art
Mack
Kunsthalle Mannheim
Marlborough Fine Art (Ltd.), London
D. and J. de Menil Collection, Houston
Städtisches Museum Abteiberg, Mönchenglad-
 bach
Collection H. Marc Moyens
Städtisches Museum, Mülheim an der Ruhr
Munich, Bayerische Staatsgemäldesammlungen,
 Staatsgalerie moderner Kunst
Munich, Städtische Galerie im Lenbachhaus

Westfälisches Landesmuseum für Kunst und Kul-
 turgeschichte, Münster
Collection Neuerburg, Cologne
The Solomon R. Guggenheim Museum, New York
Heckscher Museum, Huntingdon, New York
The Museum of Modern Art, New York
Allen Memorial Art Museum, Oberlin College
Anthony d'Offay Gallery, London
Collection Reinhard Onnasch, Berlin
Reinhard Onnasch Galerie, Berlin
Rijksmuseum Kröller-Müller, Otterlo
Museé d'Orsay, Paris
The Francesco Pellizzi Collection
Galerie Pels-Leusden, Berlin
Collection Dr. Peter Pohl, Berlin
Collection Henry G. Proskauer
Collection Dr. H. Rabe
The Gore Robert Rifkind Collection, Beverly
 Hills, California
The Regis Collection
Museum Boymans-van Beuningen, Rotterdam
Saatchi Collection, London
Collection Sanders, Amsterdam
Nolde Foundation, Seebüll
Emily and Jerry Spiegel
The Saint Louis Art Museum
Galerie Springer, Berlin
Dr. Hans Hermann Stober, Berlin
Galerie der Stadt Stuttgart
Staatsgalerie Stuttgart
The Tel Aviv Museum
The National Gallery of Art, Washington D. C.
Von der Heydt-Museum, Wuppertal
Mary Boone/Michael Werner Gallery, New York
Galerie Zwirner, Cologne

Notes on the Authors

Becker, Dr. Werner, born 1937, Professor of Philosophy in Frankfurt.

Bergius, Dr. Hanne, born 1947, lecturer in History of Art at the University of Dortmund.

Bussmann, Dr. Georg, born 1933, formerly Director of the Art Associations in Karlsruhe and Frankfurt, now Professor of History of Art in Cassel.

Eberle, Dr. Matthias, born 1944, Curator at the Hamburger Kunsthalle.

Frenzel, Ivo, born 1924, editor of the Nietzsche edition published by Hanser-Verlag, Munich, 1967; lives in Meerbusch near Düsseldorf as a free-lance writer.

Gercken, Dr. Günther, born 1931, Professor of Biochemistry, art collector and Chairman of the Hamburg Art Association.

Gohr, Dr. Siegfried, born 1949, Director of the Museum Ludwig in Cologne.

Grasskamp, Dr. Walter, born 1950, Professor of History of Art in Münster.

Herzogenrath, Dr. Wulf, born 1944, Director of the Art Association in Cologne.

Hohl, Dr. Reinhold, born 1939, Curator of the Graphic Collection of the Institute for Technology in Zurich.

Joachimides, Christos M., born 1932, art theorist and free-lance curator in West-Berlin.

Lloyd, Jill, born 1955, lecturer in History of Art at University College, London.

Meyer, Dr. Franz, born 1919, formerly Director of the Kunsthalle Berne and the Kunstmuseum Basle.

O'Brien-Twohig, Sarah, born 1945, free-lance art historian and lecturer at the Tate Gallery, London.

Pross, Dr. Harry, born 1923, formerly Professor of Media Studies at the Freie Universität, Berlin.

Ringbom, Dr. Sixten, born 1935, Professor of History of Art and Art Theory at the Åbo University, Åbo, Finland.

Rogoff, Irit, born 1949, former lecturer in History of Art at the University of Warwick and the Courtauld Institute in London.

Rosenthal, Norman, born 1944, Exhibitions Secretary, Royal Academy of Arts, London.

Rothe, Dr. Wolfgang, born 1929, Sociologist and historian of literature, lecturer at various universities.

Schmied, Dr. Wieland, born 1929, Director of the Artists' Programme of the DAAD (German Academic Exchange Service).

Schneede, Dr. Uwe M., born 1939, formerly Director of the Art Associations in Stuttgart and Hamburg, now Professor of History of Art in Munich.

Schulz-Hoffmann, Dr. Carla, born 1946, Chief Curator, responsible for art in the 20th century at the Bayerische Staatsgemäldesammlungen in Munich.

Schuster, Dr. Peter-Klaus, born 1943, responsible for German art in the 20th century at the Bayerische Staatsgemäldesammlungen in Munich.

Verdi, Dr. Richard, born 1941, senior lecturer in the History of Art at the University of York.

vorn Wiese, Dr. Stephan, born 1943, curator and head of the Modern Department at the Kunstmuseum Düsseldorf.

Zaunschirm, Dr. Thomas, born 1943, lecturer at Salzburg University.

Photographic Acknowledgments

Catalogue illustrations

Neue Galerie Sammlung Ludwig, Aachen 271, 276
Stedelijk Museum, Amsterdam 1, 230
Jörg. P. Anders, Berlin 113, 118, 129, 163, 178
Atelier 53, Berlin 214
Alexander Beck, Frankfurt 226
Foto Studio Bergerhausen, Mannheim 168
Berlinische Galerie, Berlin 134, 280
Kommunale Galerie, Berlin 220
Paul Klee Foundation, Kunstmuseum
 Berne 191, 192
Joachim Blauel Artothek 42
Robert Braunmüller, Baldham 91
Kunsthalle Bremen 44, 51, 85, 109, 115, 201, 205
Museum Ludwig, Cologne 215, 236, 263
A. C. Cooper Ltd., London 8, 18
Statens Museum for Kunst, Copenhagen 64
The Detroit Institute of Arts 55, 82
Walter Dräyer, Zurich 14
Kunstmuseum Düsseldorf 164
Stedelijk van Abbemuseum, Eindhoven 83, 294, 298
Museum Folkwang, Essen 9, 19, 38, 52, 59, 60, 65, 66, 203, 210
Städtische Galerie im Städelschen Kunstinstitut,
 Frankfurt 151
Reinhard Friedrich, Berlin 102, 157, 248
Fotostudio Gerd Geyer, Hattingen 90, 93
Rolf Giesen, Krefeld 46
Fotostudio Grünke, Hamburg 136
Carmelo Guadagno, New York 34, 177
Gerhard Häsler, Saarbrücken 11
Kunstmuseum Hannover 121, 194
Wadsworth Atheneum, Hartford 152
Jürgen Hinrichs Artothek 125
Colorphoto Hinz, Allschwil – Basle 17, 95, 102, 141, 153, 157, 198, 238, 248
D. and J. de Menil Collection, Houston 213
Museum of Modern Art, Humblebaek 239
Ruth Kaiser, Viersen 57
Staatliche Kunstsammlungen Kassel 272
Bernd Kirtz BFF, Duisburg 101, 103, 155, 182, 206, 222
Walter Klein, Düsseldorf 181
Ralph Kleinhempel, Hamburg 4, 122, 160
Ute Klophaus 240, 241, 241 a, 242, 242 a, 243, 244, 245, 245 a
Kaiser Wilhelm Museum, Krefeld 32, 229
Leicestershire Museums and Art Galleries 75
Studio Reinhold Lessmann, Hanover cover, 211
Neue Galerie der Stadt Linz, Wolfgang Gurlitt
 Museum 81
Jochen Littkemann, Berlin 162, 174, 175, 227, 237, 246, 247, 269, 270, 282-284, 287, 290, 291
The Tate Gallery, London 107
Los Angeles County Museum of Art 77
Foto Majer-Finkers, Gelsenkirchen 235

MAK-Photoline, Berlin 285
Wolfgang F. Meier, Cologne 225
Lee Miller Archives, Chiddingly 146, 156
Willi Moegle fotodesign, Leinfelden-Echter-
 dingen 104
Wolfgang Morell Fotostudio, Bonn 233, 234, 255
Städtisches Museum Mülheim an der Ruhr 110, 179
Westfälisches Landesmuseum für Kunst- und Kul-
 turgeschichte, Münster 45, 78
Bayerische Staatsgemäldesammlungen, Staats-
 galerie moderner Kunst, Munich 25, 27, 40, 111, 195, 258
Städtische Galerie im Lenbachhaus, Munich 30, 35, 37, 86, 89, 97, 167
Otto Nelson, New York 48
Heckscher Museum, Huntingdon, New
 York 128
Museum of Modern Art, New York 106, 130, 199, 212
Allen Memorial Art Museum, Oberlin Col-
 lege 10
Landesmuseum Oldenburg 54
Musée d'Orsay, Paris 87
Prudence Cummins Assoc. Ltd. 126
Nathan Rabin, New York 29
The Robert Gore Rifkind Collection, Beverly
 Hills, California 13
Thomas Rittershaus, Wuppertal 80
Henning Rogge, Berlin 21
Friedrich Rosenstiel, Cologne 100, 218, 219, 224, 249
Museum Boymans-van Beuningen, Rot-
 terdam 84
The Saint Louis Art Museum 147
Thomasz Samek, Münster 223
Nolde Foundation, Seebüll 67, 70-73
Struwing Reklamefoto 239
Studio Service, Bonn 20, 108, 114
Galerie der Stadt Stuttgart 159, 165, 166, 187
Staatsgalerie Stuttgart 5, 7, 15, 16, 68, 69, 94, 96, 98, 117, 127, 148, 183-186, 204, 256
The Tel Aviv Museum 24
The National Gallery of Art, Washington DC 31
John Webb, London 131, 149
Jörg Winde Fotodesign, Dortmund 28
Von der Heydt-Museum, Wuppertal 88, 112, 161
Zindman, Fremont 299
Kunsthaus Zurich 62, 63, 99, 216

Black and White Illustrations

Figure references are given in italics

Jörg P. Anders, Berlin 436/2
Bildarchiv Preußischer Kulturbesitz, Berlin 118/6
Paul Klee Foundation, Kunstmuseum Berne 15/1; 458/2, 3; 459/4

Photoarchiv Hans Bolliger and Roman Norbert
 Ketterer, Campione d'Italia 110/6
Galerie Brusberg, Berlin-Hanover 140/11; 141/13
Grete Dexel 446/4
Martha Dix 79/5
Leopold-Hoesch-Museum der Stadt Düren 452/1
DVA, Stuttgart 94/5
Sulca Hübner 94/6
G. Incandella 135/17
Hermann Kiessling, Berlin 453/2
Ralph Kleinhempel, Hamburg 437/3
Bundesarchiv Koblenz (BA/3/22/11) 113/1
Germaine Krull 95/7
Holger Kulick, Berlin 90/12
Jochen Littkemann, Berlin 471/4
Manfred Lowack, S. Fischer Verlag GmbH 92/1
Stefan Moses, Munich 93/3
Westfälisches Landesmuseum für Kunst und Kul-
 turgeschichte, Münster 109/3, 5
Anthony d'Offay Gallery, London 19/4
Kurt Pinthus, *Menscheitsdämmerung*, Berlin, 1920 97, 98/1, 2, 3; 104/19
Die Aktion, Berlin, volumes 1912-18, 98-104/ 4-18, 20
Michael Ruetz 93/4
Reiner Ruthenbeck 469/2, 3
Herbert Schwöbel 471/3
Edition Staeck, Heidelberg 125/1
Süddeutscher Verlag, Munich 92/2
Manfred Tischer, Düsseldorf 472/5

Photographs of the Artists

Peter Berkes: Beuys
Print Library of the Akademie der Künste, Berlin:
 Heldt, Uhlmann
Photoarchiv Hans Bolliger and Roman Norbert
 Ketterer, Campione d'Italia: Kirchner
Edwin K. Braun: Mack
Hugo Erfurth, Photographic Collection, Museum
 Folkwang, Essen: Beckmann, Rohlfs
Helga Fietz: Nolde
Hans Geißler, Bequest Heckel, Hemmenhofen:
 Heckel, Mueller
Studio Grünke, Hamburg: Oelze
Marta Hoepffner, Hofheim: Baumeister
Benjamin Katz, Cologne: Baselitz, Graubner,
 Immendorff, Lüpertz, Penck, Polke, Richter
Hans Kinkel, Munich: Schmidt-Rottluff
Dr. Guido Lehmbruck, Stuttgart: Lehmbruck
Stefan Moses, Munich: Dix, Höch, Meidner
Horst Ossinger, Düsseldorf: Klapheck
Rolf Schroeter, Zurich: Uecker
Bilderdienst Süddeutsche Zeitung, Munich:
 Jawlensky
Ullstein Bilderdienst, Berlin: Grosz
Hilde Zenker, Berlin: Piene

*All uncredited illustrations are taken from the publishers'
and the authors' archives.*

Index of Names

Numbers in italics refer to text illustrations

The exhibition has been made possible by

Lufthansa

Deutsche Bank

Mercedes-Benz

BECK'S BIER

BOSCH

Hoechst

Melitta

SIEMENS

The exhibition has received generous financial assistance
from the Government of the Federal Republic of Germany
through the Federal Ministry of Foreign Affairs.
The Royal Academy of Arts is also grateful to Her Majesty's Government
for its help in agreeing to indemnify the exhibition
under the National Heritage Act 1980.